BERENICE
ABBOTT

ALSO BY JULIA VAN HAAFTEN

From Talbot to Stieglitz: Masterpieces of Early Photography from the
New York Public Library

Berenice Abbott, Photographer: A Modern Vision
(editor)

Aperture Masters of Photography: Berenice Abbott
(revised edition)

The View from Space: American Astronaut Photography, 1962–1972
(with Ron Schick)

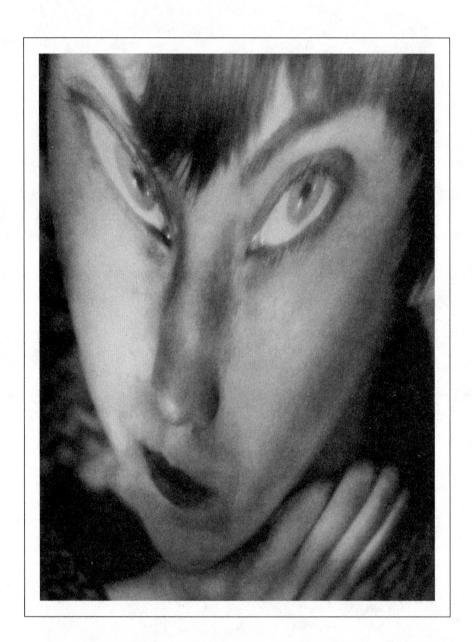

BERENICE ABBOTT

A LIFE IN PHOTOGRAPHY

JULIA VAN HAAFTEN

W. W. NORTON & COMPANY

Independent Publishers Since 1923

New York | London

For information about permission to reproduce selections from this book, write to
Permissions, W. W. Norton & Company, Inc., 500 Fifth Avenue, New York, NY 10110

For information about special discounts for bulk purchases, please contact
W. W. Norton Special Sales at specialsales@wwnorton.com or 800-233-4830

Manufacturing by Quad Graphics Fairfield
Book design by Chris Welch Design
Production manager: Julia Druskin

Library of Congress Cataloging-in-Publication Data

Names: Van Haaften, Julia, author.
Title: Berenice Abbott : a life in photography / Julia Van Haaften.
Description: First edition. | New York : W.W. Norton & Company, 2018. |
Includes bibliographical references and index.
Identifiers: LCCN 2017056400 | ISBN 9780393292787 (hardcover)
Subjects: LCSH: Abbott, Berenice, 1898–1991. | Photographers—United States—
Biography. | Photography, Artistic.
Classification: LCC TR140.A25 V36 2018 | DDC 770.92 [B]—dc23
LC record available at https://lccn.loc.gov/2017056400

W. W. Norton & Company, Inc., 500 Fifth Avenue, New York, N.Y. 10110
www.wwnorton.com

W. W. Norton & Company Ltd., 15 Carlisle Street, London W1D 3BS

1 2 3 4 5 6 7 8 9 0

To artists and inventors, everywhere.

ON BIOGRAPHY

There are so many hidden corners in your life I could never write one of you.
—ELIZABETH MCCAUSLAND (1959)[1]

*I usually say something foolish and then it's printed. . . . People are too complex
to know anything about.* —BERENICE ABBOTT (1986)[2]

ON PHOTOGRAPHY

The quality most essential in a photographer is "a good eye."
—EDNA BENNETT, MANAGING EDITOR, U. S. CAMERA

A good I.Q. —ELIZABETH MCCAUSLAND,
REPLYING TO EDNA BENNETT (1944)[3]

*Some time ago, I decided for myself that the inherent value
of photography is realism.* —BA (1946)[4]

*Goethe said it—"Few people have the imagination for reality."
Photography doesn't teach you to express your emotions;
it teaches you how to see.* —BA (1980)[5]

CONTENTS

INTRODUCTION

*Photography is the most modern of the arts. . . . It is more suited
to the art requirements of this age of scientific achievement
than any other. . . . Photography born of this age of steel
seems to have naturally adapted itself to the necessarily
unusual requirements of an art that must live in skyscrapers.*

—ALVIN LANGDON COBURN[1]

I like this picture so well because it re-creates for me
some of the feeling I got from the original scene—and
that is the real test of any picture. —BA (1953)[2]

It's twilight in late December 1932. Thousands of streetlights and office
windows blaze in electrified concert for a scant half hour between the
winter-solstice sunset and the lights-out, five o'clock end of the office
workers' day. Just weeks earlier, after three crushing years of the Great
Depression, fear-defying FDR had won the presidency by a landslide.
Optimism was in the air.

High up in the northwest corner of the new Empire State Building,
thirty-four-year-old Berenice Abbott aims her bulky wooden view
camera at the exuberance below—the glittering, boundless cityscape of

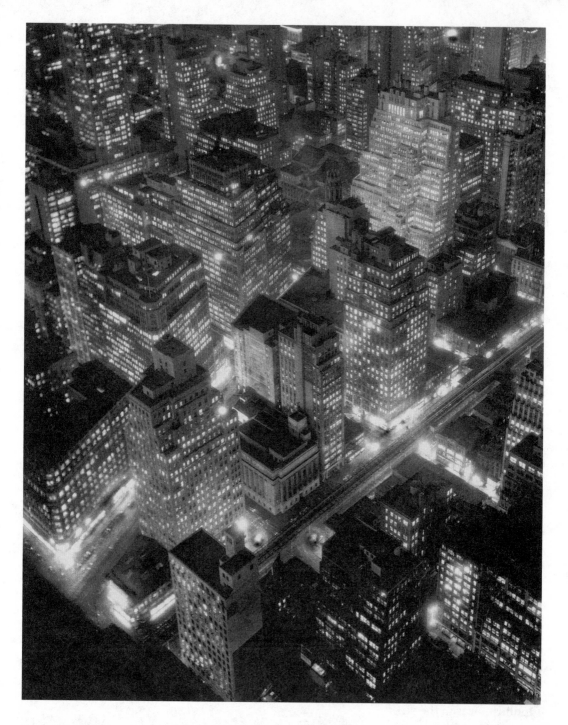

Night View *(also entitled, variously,* Skyscrapers by Night*;* Night
View, New York*; and* New York at Night*), December 1932–33.*

Berenice Abbott

midtown Manhattan, diffused just slightly by a sheltering glass window. She opens the shutter and begins a fifteen-minute exposure. Her triumphant photograph, *Night View, New York*, will forever signal "modern metropolis"—as futuristic to us in the twenty-first century as it was to Berenice's Depression-weary contemporaries.*

Shortly before she took *Night View*, Berenice vowed to "rip to pieces" any picture she caught herself making "arty." She held that "subject matter creates form" but scorned random, meaningless photographs—of "some spit on the sidewalk"—just to "make a big design." Her *Night View* is utterly realistic in the documentary sense: Its streets are mappable, its buildings anchored in time. Yet it remains her most sublimely expressive *arty* image, its luminous beauty offering a fairylike ethereality. She bristled at the notion of emotional photographs, but *Night View* makes us feel what she saw.[3]

Teaching this artistic paradox, the style now called "documentary modernism," Berenice required her technically capable students to summon "a creative emotion. Unless you see the subject first, you won't be able to force the camera . . . to see the picture for you," she wrote in 1941. "But if you have seen the picture with your flexible human vision, then you will be on the road to creating with the camera a vision equivalent to your own."[4]

Introspective all her life, Berenice was never so forthcoming as when she mused, in 1922, "Just as a city weaves unceremoniously its design, as one form spins out of another, so a small life is governed by impressions of environments according to the degree of sensitive receptiveness." In *Night View* she has handed us the key to her self-image and inner life. The creative contradictions she harbored so productively—between classicism and romanticism, science and intuition, description and essence—are evident in that single, enduring work. "The photog-

* The work became a mainstay of her oeuvre: Published first in 1934 as *Skyscrapers by Night*, it was subsequently titled *Night View* in 1941; *Night View, New York* in 1953; and, last, *Night View (New York at Night)* in her 1982 *Retrospective Portfolio*. In the present book the image is called *Night View* throughout.

rapher cannot miss that picture of himself," she wrote in 1964, "it is his stamp and map, his footprint and his cry."[5]

○

BERENICE ABBOTT WAS raised without direction in a troubled family and fled her native Ohio at age nineteen for Greenwich Village, fixing her sights first on journalism and then sculpture. She fell in with older modernists including American Djuna Barnes and Europeans Baroness Elsa von Freytag-Loringhoven and Marcel Duchamp, among others, who inspired her, in the spring of 1921, to head for Paris. Two years on, she abandoned sculpture and became a darkroom assistant to her New York Dada friend Man Ray. In photography she discovered her true artistic calling and began with portraiture.

Fashionable and successful, she returned to New York in 1929 with the archive of the photographer Eugène Atget, comprising thousands of glass plates and original prints, which she had rescued. She segued to urban photography only to find her prospects dashed by the Great Depression. When the Federal Art Project, a government work relief program, provided support in 1935 for her classic documentation *Changing New York*, she began by photographing scenes on the Bowery, then Manhattan's Skid Row. An older male supervisor warned her that "nice girls" didn't go there. Berenice, unaccustomed to solicitude or restriction, shot back, "I'm not a nice girl. I'm a photographer. I go anywhere."[6]

As the Federal Art Project wound down in 1938, she turned to visualizing the twentieth century's salient modern subject: science. She photographed industrial subjects and devised imaging techniques before joining the Physical Science Study Committee (PSSC), based at the Massachusetts Institute of Technology (MIT), from 1958 to 1960. She also taught hundreds of students at the New School for Social Research, authored nearly a dozen books, and received four patents for photographic inventions.

Art critic Elizabeth McCausland sought out Berenice in 1934 and transformed her life. For thirty years, until McCausland's death, the two women were devoted companions and professional soul mates. In

1939 *Time* magazine described Berenice as "a direct girl who still talks harsh Ohio, still wears a Left Bank haircut and beret;" a photographer "scared of heights and crowds until she gets her head under the black cloth." To Hank O'Neal, her 1980s biographer, she was a "barrelhouse girl" who put on no airs.[7]

Berenice's creative ambition and profession took her into the ranks of upper-class life in Europe and the United States, but she was an outsider and had a feast-or-famine existence. One icy 1960s New Year's in remote central Maine, in a rundown stagecoach inn patronized by Thoreau a century before, she came close to burning furniture to keep from freezing. For a 1979 party celebrating a book of Atget's garden photographs that Jacqueline Kennedy Onassis edited, she splurged on a sable fur jacket to have something suitable to wear. All her life Berenice clashed stylistically and temperamentally with the sophistication and privilege of the women she met and photographed. Emotionally aloof and distractible, naturally compelled to root for the underdog, she was marginalized her entire life for her lower-class origins and family disarray, her personal style and indiscretions, her inability and unwillingness to play by art-world rules, and her seemingly impersonal but hardly egoless style of realism.

She detested being corralled into the subclass of "woman" anything, yet her youthful androgynous energy still earned her the epithet "girl photographer" when she was past forty. She was also a sentimental friend of the helpless, both human and four-legged. Throughout her life she was attracted to down-and-out father figures. A communist sympathizer long after the Stalin-Hitler pact, she was surprised and saddened by the collapse of the Soviet Union in 1991, the last year of her life.

She was stubborn with colleagues and impulsive with her own desires, methodical behind the camera, and demanding in the darkroom. Her closest friends called her "Berry." She kept them and other acquaintances in nonintersecting circles; out of touch for years, she would write or phone effusively as if no time had elapsed. For a self-employed person she was stubbornly and dangerously lawless about the practicalities

of budgets, taxes, and copyrights. Independent, direct, intelligent, and hardworking, she was not intimidated by authority or convention, and sometimes paid dearly for that, though rarely with her freedom.

<p style="text-align: center;">o</p>

BERENICE WAS ALMOST ninety when I met her in New York, on the occasion of her July 1988 induction into the Légion d'Honneur as Officier de l'Ordre des Arts et des Lettres. She was being honored not only for her work but also for rescuing Eugène Atget's archive six decades earlier. I was a lifelong admirer, beginning with Berenice's wave images in my high school physics class, and had recently written about her for Aperture's Masters of Photography series.

Many fans filled the reception room of the French embassy on Fifth Avenue, where I was the guest of photographer and filmmaker Morris Engel, our mutual friend. He introduced me to Berenice. I was then the first curator of photographs at the New York Public Library (NYPL), and I leaned in to mention Romana Javitz, late curator of the library's long-established Picture Collection and Berenice's old friend and supporter. Berenice invited me to visit her in Maine, sit by the lake, and really talk. (I learned later that several of her friends had been named Julia or Julie, a not inauspicious coincidence.)

Berenice had the habit of freely extending invitations, but this one was real. In late August 1988 I took a three-legged flight to Bangor, Maine, juggling a package of pickled tongue and sauerkraut juice, the New York delicacies Berenice had requested, and drove an hour or so north to Monson. When I wasn't enjoying secluded Lake Hebron and the guest cabin, which flew a Jolly Roger a hundred yards from the main house, I perched on a little wrought-iron stool next to Berenice's black leather Eames chair listening to her talk and taking notes while Susan Brown Blatchford, her heir and companion since 1985, tended the wood stove's constant low fire.

Collector Ronald A. Kurtz and I had envisioned an Abbott retrospective at the library; he owned Abbott's archive. I visited again in the summer of 1989, and Berenice herself climbed the ladder to the guest

cabin's sleeping loft to approve the arrangements. My husband and our two school-age daughters had joined me for the last of our exhibition-planning visits.

Berenice had a grand celebration at the NYPL opening, and the exhibition went on tour into late 1991, ending at the Portland (Maine) Museum of Art. By then, Berenice was too frail to travel, so following a talk I gave there I drove north to visit with her and Susan at home. Berenice died on December 9, 1991, and I organized her memorial service, broadcast by the Voice of America, at the library the following February.

I last visited in August 2002, for Susan's interment, next to Berenice. Throughout, I have been grateful for the opportunity to tell the story of a remarkable artist—"a self-taught risk taker," she told me during our last visit—whose brief friendship I treasure.

BERENICE
ABBOTT

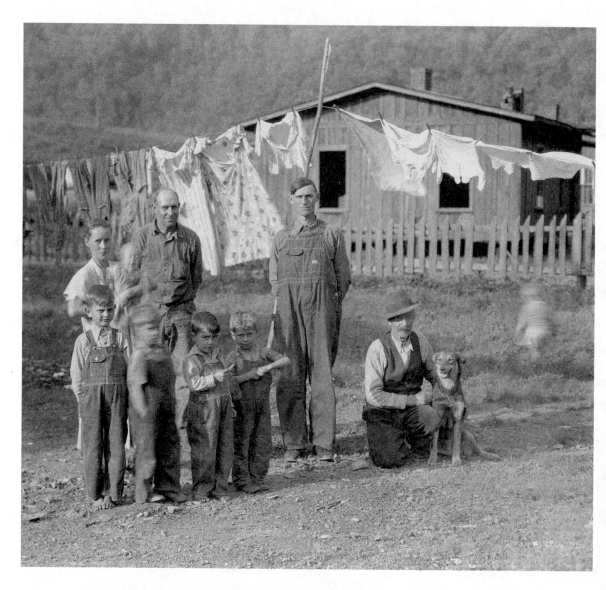

Miner's Family, Greenview, West Virginia, *May 1935. Abbott viewed rural West Virginians through the lens of her scant family history, but did not venture farther southeast to her father's reputed birthplace, Hinton, West Virginia.* Berenice Abbott

I

BIG LIE ALL MY LIFE

Ohio (1898–1918)

*If people only realized what a war goes on in a child's mind
and heart in a situation of this kind, I think they would try
to explain more than they do, but nobody told me anything.*

—ELEANOR ROOSEVELT[1]

The whole thing was . . . as bad a way of being brought up
as I can imagine, so the less we discuss it the better. —BA (1975)[2]

Berenice called her ancestry "native stock," a once common term for descendants of Anglo-Saxon Protestant settlers to distinguish them from more recent immigrants, particularly Catholics and Jews from eastern and southern Europe. Her father, Charles Abbott, was born in 1860 near what became the small Appalachian town of Hinton, West Virginia. C. E., as he was known, was the only child of his father's remarriage and grew up to be a traveling man, an itinerant salesman—these details were all Berenice knew about the Abbott side of her family. In the southern Ohio city of Chillicothe, C. E. found Alice Bunn, a headstrong, dark-haired teenage beauty who aspired to a

life bigger than that of her oldest sister, who taught school, or her brothers, who were farm laborers.[3]

Berenice's maternal grandfather, Joseph P. Bunn, also taught school and sidelined as a sewing machine sales agent, one breadwinner in a large extended family of small businessmen, farmers, laborers, and a few landowners spread throughout Ross County, Ohio. In 1850, Joseph met Mary Redd, a descendant, according to family lore, of an old English slaveholding family of Virginia, who was visiting relatives in Ohio and just stayed. In middle age Joseph served four months in the Union army, enough to obtain a Civil War pension. "We always said that anything aristocratic about any of us," recalled a cousin, "come from Grandma Bunn."[4]

Berenice's mother, Alice, was born in 1866, the next to youngest of the Bunns' nine children, and the youngest girl. She stood out among the family's blond daughters, and grew up wanting to be an actress. In Alice, Berenice saw "a man's woman," an old-fashioned term for a flirtatious female who thrives in male company. She also saw her mother as a caricature of femininity—vain, frivolous, and petty but also fearful, seductive, and controlling; marriage "finished her."[5]

C. E. and Alice married in November 1886 in the local Methodist church, the last time they seem to have participated in organized religion. They set up housekeeping at the opposite end of the state, in Cleveland, the biggest city between New York and Chicago. C. E. sold cement, and, as the state became a center of heavy industry, demand was steady. The family grew fast and moved constantly between Cleveland and Cincinnati, with several addresses in each city. Alice gave birth to three children—Hazel Dell, in 1887; Frank Bunn, in 1891; and Earl Stanley, in 1895—and delivered stillborn twins. In 1896, the family landed in Springfield, again renting one place after another. On Sunday, July 17, 1898, in a two-story frame house on Cedar Street, a baby girl with her father's auburn hair and blue eyes was born. This youngest of the four surviving children received the homespun name "Bernice Alice" on her birth certificate, a careless document that identified her sex as "male" and misspelled her parents' names.[6]

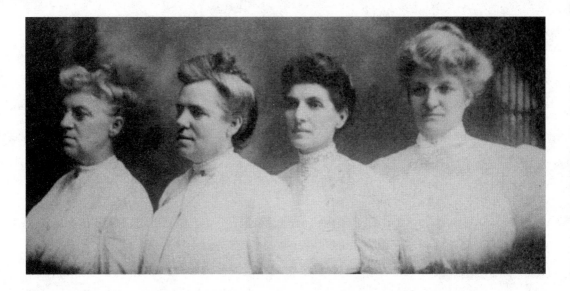

Bunn sisters, ca. 1900. Abbott's dark-haired mother, Alice, stands out.
Photographer unknown

C. E. traveled often for work, leaving sociable but increasingly frustrated Alice home alone with their brood. She hated being married, Berenice would later realize, and never wanted children—"and let them all know it." On May 8, 1900, when Berenice was not yet two, C. E. publicly accused Alice of adultery "at diverse times since July 1899," petitioning the county court for a divorce and custody of their children. He cited as corespondent an unspecified neighbor, "Mr. Keesecker," the family name of several nearby households. At that time, in all but the richest or most freethinking families, divorce meant scandal and humiliation: adultery charged by husbands was especially rare in lower-middle-class families like the Abbotts', as was divorce involving so many children.[7]

Alice had already fled with her two daughters to the Cincinnati household of her brother Joseph L. Bunn, a widowed day laborer with two school-age children; their sister Ella Bunn worked there as a milliner. The two Abbott boys stayed with their father. For decades Berenice rationalized what she had been led to believe about a court-decreed

division of her family: girls with their mother, boys with the father, producing the "grisly" Dostoevsky-worthy childhood she believed to be worse than anyone's. There had been nothing of the sort, however, for C. E. never followed through and the court took no action on his petition. Still, Alice immediately considered herself not merely separated but no longer married; on June 8, 1900, just one month after C. E.'s filing, she told the census taker that she was divorced. Eighty years later, private archival research brought Berenice face-to-face with her mother's lifelong lie.[8]

A year after C. E.'s petition, Alice brought her two girls to the familiar landscape of Chillicothe, where she assumed the respectability-preserving guise of C. E. Abbott's "widow." After her very proper mother died, in 1902, Alice took an apartment forty-five miles north, in Columbus, the state capital, to work as a seamstress. Hazel and four-year-old Berenice remained behind with relatives and their aunt Ella, who made fetching hats for Alice, to keep her pretty and attract a new husband.[9]

One day a young cousin surprised Berenice with the news that she had "a new poppa" and that she and Hazel would be moving away to live with her mother in Columbus. Berenice's ostensible stepfather was Charles O. Wilson, a Western Union employee whose brass-buttoned navy-blue uniform resembled a police officer's. Alice routinely used this similarity to threaten Berenice into behaving. "It was wild . . . [a] crazy, midwestern family situation. I don't know anyplace where they could be worse," Berenice explained, likening James Thurber's Columbus, Ohio, "weird experiences" in *My Life and Hard Times* to her own.[10]

In Columbus, Alice took Wilson's name and Berenice began her formal education as a first grader at the local Broad Street School, registered, she said, as Bernice Wilson. All her life, she remembered the East Town Street address of Wilson's brick apartment house. Inside, however, she felt unwelcome. Her resemblance to C. E. Abbott, Berenice believed, gave her mother ample reason to dislike her. The sharp contrast between her fair coloring and her mother's dark brunette beauty even made Berenice wonder if she was really her mother's child. In this

atmosphere of constant rejection, sixteen-year-old Hazel left to keep house for her father and brothers in Cleveland. It likely suited Alice to lose this fast-maturing reminder that she was no longer as young as she might wish to appear—or claimed. But she also resented losing control to C. E. and spitefully told little Berenice that C. E. had kidnapped her big sister.[11]

Within two years, Charles Wilson moved out. Berenice's mother stayed on as Mrs. Alice Wilson. Decades later, Berenice called Wilson a madman and intimated that "hanky-panky" toward her and teenaged Hazel lay at the heart of his split with their mother. Alice continued to work as a seamstress, and Berenice became a self-described latchkey kid. She began each day with five cents in her pocket for lunch and spent much time alone and on her own. Among her favorite places to play was the city's stately classical revival train station. Once, in a snowstorm, she and a little friend trudged all the way across town holding hands for dear life to get home.[12]

In contrast with this solitary and independent city life, Berenice spent childhood summers in the countryside around Frankfort, Ohio, with the extended family of her mother's oldest sister, Flora Morgan. With the other kids, she feasted on fried chicken from their uncle Berty's store and ran to see a car drive down a dusty country road. To get to Frankfort, Berenice loved riding the interurban electric trains, which just flew along. She traveled unaccompanied and one time arrived with her little suitcase, 104 degrees in the shade, and nobody to meet her, only to collapse with relief when relatives finally showed up.[13]

"This was always happening," Berenice said matter-of-factly, her hurt still evident. Around Christmas 1908, after Alice told Berenice that she had "found" the other children, they visited Cleveland, where she met her father and brothers for the first time since babyhood and reunited with Hazel, who had married a local workingman, Otto Ross, the son of German immigrants. The court's dismissal of C. E.'s 1900 divorce petition after eight years of inaction may have engendered a stab at reconciliation. But Alice's success at instilling fear of C. E. was

further reinforced for Berenice when her nearly grown brothers each in turn left their father's home in Cleveland to live with their mother in Columbus.[14]

Regardless, Alice moved them all north to Cleveland sometime in 1909. Berenice went first, alone on the train, to live temporarily with Hazel. They failed to connect in the city's vast Union Depot, forcing Berenice to make her way on her own to Hazel's house in the modest but respectable Clark-Fulton neighborhood. Though she had been considered a frail child, Berenice felt these experiences taught her the survival skill of self-reliance. This armored independence would undergird the strongest traits of her character, the ones she wanted remembered at the end of her life.[15]

By spring 1910, the Abbott children were settled with their mother not far from Hazel, in a two-family house at 3637 Woodbridge Avenue SW. Alice again publicly claimed to be a widow, but now of Charles Wilson. Only slightly more truthfully, she told the census taker—who recorded her children's last names as Wilson—that she was divorced. Berenice's teenage brothers were out of school and working: as a drug store clerk and a paper collector, respectively. Predictably, C. E. kept moving, generally around Cleveland's east side. Berenice and her mother together had planned a special dress for her eighth-grade graduation, at the Sackett School, but Alice, the accomplished seamstress whose skills supported her family, somehow failed to complete the garment in time. Among her dressed-up peers, Berenice endured the commencement ceremony wearing everyday clothes. Her resentment lasted a lifetime.[16]

For somebody who might have been a terrific

softy, I got pretty hard early. —BA[17]

SHE ENTERED LINCOLN High School, a new multistory building, in February 1913. Historically progressive, Cleveland had been the first city

west of the Alleghenies to open a public high school. During Berenice's time in the school, the system continued to swell to accommodate the children of the immigrant population that supplied labor for the city's growing heavy industry and manufacturing. Teenage Berenice was deeply impressed by the city's bright electric street lighting; much later she would realize that Cleveland was also headquarters of the General Electric Company's then brand-new Nela Park research facility.[18]

For half his married life, C. E. Abbott had lived apart from his wife and children. Late on April 28, 1915, he arrived alone at his two-story wood-frame rooming house on the eastern edge of downtown Cleveland. The once-genteel residential neighborhood was rapidly transforming; most noticeable was a new brick high-rise YMCA to accommodate the influx of immigrant men and rural boys moving to the city for work. C. E., 54, shut himself in his room, leaving word that he wanted to see the proprietress, a widow named Lillian Gorman. But neither she nor fellow roomers responded to the groans and mumbles they heard throughout the night from behind his closed door. At noon the next day he was found dead, an empty poison bottle and a suicide note by his side. The *Cleveland Plain Dealer* reported the death in detail and quoted the note: "Please notify my son, Frank Abbott and Mrs. Alice Wilson. May blessings come to all those I love. This is my last wish." He was survived, the paper said, by a widow and the four children of his first marriage.[19]

Though raised apart from her father and taught to fear him, Berenice had begun to visit C. E. on her own in Cleveland; she even liked his "lady friend," Bertha. For the rest of her life, she spun a tale of his suicide that belied his early abandonment of her and elevated her as the special object of his affection. In Berenice's version, he embraced and kissed her, then removed himself to another room and put a gun to his head. Her fabrication may have been inspired by the family drama of her wealthy Paris friends Hadley Hemingway and Jean Cocteau, both of whose fathers killed themselves by gunshot. Her transformation of the lonely truth presaged other moments in her life when she would attempt to engender a father-daughter connection.[20]

After years of family indifference, if not neglect, and of fending for herself, teenage Berenice naturally resisted direction or restraint. She skied, tobogganed, and ice-skated with tomboyish bravado. She was willing to try almost anything boys did and would take any dare, especially one that said she couldn't because she was a girl. Taunted one winter at high school by the laughter of male students, she went all out to slide really fast on the ice and jump over a row of barrels; the crash-landing blackened her eyes. At home, Alice once chased her around a table for refusing to do housework. She was fifteen when a parade of more than ten thousand marchers for women's rights and suffrage captivated the city center with a pageant called A Dream of Freedom. A rebel, she fought with her mother about clothes—Alice wanted her in frilly styles and a corset, while Berenice preferred the look and feel of a loose blouse and skirt. One summer she purposely lost her bathing stockings underwater—it was illegal to swim in public without them— hoping to get arrested.[21]

As she grew up, she intended to avoid marriage; after her mother's "two flops," she thought little of the institution. In grade school, when she insisted she would never marry, her teacher unconvincingly replied that a Prince Charming would change her mind. In old age, after three decades with her late partner Elizabeth McCausland, Berenice said she saw no point to being married, then allowed that only people who had grown up in "good homes"—unlike hers—would or could. From her mother, a "so innocent" Berenice heard all kinds of things designed to instill fear—mostly vague and worried advice about sex. As a teenager, she met a young man while skating (or playing tennis, she couldn't recall) and accepted a ride home on the back of his motorcycle, then walked the last block to preempt her mother's anticipated disapproval.[22]

Yet the unfairness of being restricted in any way simply because she was not male had been awakened early—and she received no convincing evidence that flirtatious, demanding, or wily behavior would compensate. Nor, given her family's history, could she delude herself into regarding women universally as the moral superiors of men. During the

rise of the women's liberation movement in the 1970s, she acknowledged that her mother's warnings about how "the cards were stacked against women" had long ago liberated her. Rather, Berenice felt most strongly the depth of the injustice of arbitrary inequality, and in this sense her evolving identity as a lesbian was as much political as physical.[23]

In high school, she had her first girl crush, on a classmate, Elfrieda Gaeth, whose family owned Gaeth Motor Car Company. "I see you as plainly as when we were two poor shrimps coasting down Brookside hill," she wrote to "Fritzy" soon after graduating; "riding our wheels, walking to Lincoln, and all sorts of things which make me enthusiastic to see you." In conventional circles, Berenice's youth coincided with rising disapproval toward emotional same-sex relationships, based on fears that they provided opportunities for sexual activity, which preceding generations had repressed. Congenial "romantic friendships"—associations sustained by earlier generations of grown women primarily through work, financial independence, and simple privacy—were made difficult due to social opprobrium and moral condemnation that relied on the newly labeled deviant behavior of "sexual inversion," or homosexuality.[24]

> All the interesting students there were sort of leftist.
> I didn't know what the hell it meant. But they had a
> different attitude from what I had seen. —BA[25]

IN HER LAST YEAR of high school, Berenice's grades recovered from the tumble they had taken after C. E.'s suicide, and she qualified to enter Ohio State University, in Columbus, in February 1917. Her mother had wanted her to stay in Cleveland and become a teacher or get married, but even Alice on occasion sympathized with her daughter's desire for independence, such as in the contested arena of hairstyles. "I must tell you (don't think I'm crazy for truly I feel more sensible than ever)," Berenice confided to Fritzy that March, "that my hair is bobbed!"—

Berenice Abbott, high school senior, December 1916–January 1917.

Webb Studio, Cleveland, Ohio

bluntly chopped below the ears. "When I grew too big to leave it down my back I nearly went wild when I tried to comb it. I looked fierce and even my mother thought it would look better so here I am, for better or worse. Now, have you lost respect for me?"[26]

The well-publicized haircut of the popular and respectable ballroom dancer Irene Castle had given Berenice the courage to take the step. Beyond fashion or comfort, hair bobbing also had the direct psychological result of proclaiming modernity and freedom. "Having the barber put scissors to that braid was my first ever act of rebellion," Berenice wrote decades later. "Thereafter, rebellion would not be rare. But this first act was a glorious moment . . . I felt lighter and freer."[27]

As a young, motivated Ohioan, free of the class-bound distinctions of the East, Berenice expected OSU, a welcoming state-supported institution, to provide her with a world of experience and learning. "We didn't have the money . . . but I went anyway." Several Bunn families lived in Columbus, offering Berenice a ready link to home. OSU, then as now, was among the Midwest's leading public universities, though its total enrollment for 1916–17 was a mere fraction of today's 65,000 students. Situated around a grassy oval with older redbrick buildings and newer ones in Romanesque and classical revival styles—under construction when Berenice had roamed the city as a child—the campus drew talented students who offered a cosmopolitan mix of beliefs and backgrounds. Some were Jews who could not be admitted to private universities due to enrollment restrictions. Others chose OSU for its solid academic reputation. Berenice registered in the College of Arts, Philosophy and Science, where just a third of the 1,221 matriculants were female.[28]

Her "bobbed hair startled that campus," she said, and a few students from the East "mistook me for a sophisticate . . . became friends, and a new life began for me." Among them was Pittsburgh native Susan Jenkins, an extraordinary woman, Berenice said, whom she "latched on to . . . right away." Jenkins, who later became a New York editor and a confidante of poet Hart Crane, told Berenice that she was living with

fellow student James Light. Berenice "was so innocent that [she] didn't know what the devil [Jenkins] really meant." (To satisfy the proprieties demanded by the dean of women, the couple supposedly disguised their shared off-campus location by each using one of the cross-street addresses for the single room they rented in a corner boardinghouse.) While visiting them, Berenice saw Light's shaving mug and other details, which made her understand and realize that her mother wouldn't approve. But she admired the couple so much and thought them so smart in class that "if they had told me they had murdered somebody, I think I would have gladly gone along with it."[29]

Friendship with Jenkins and Light led Berenice to the student group around a short-lived literary magazine, *The Sansculotte*, a modernist effort praised by beloved literature professor Ludwig Lewisohn as crude but hopeful. Future critic Malcolm Cowley, whose Harvard undergraduate work found its way into the magazine, wrote of the pacifism espoused by its editors and the realism and free verse to be found in its pages. Along with Jenkins and Light, Jack Lewis (later a noted translator and literary agent) and Louis Lozowick (who became an artist and printmaker) formed the editorial core, which Berenice identified as "Jewish." Like Jenkins, editor Jimmy Light came from Peabody High School in Pittsburgh, where the two were part of a literary crowd that included Cowley and his lifelong friend the future philosopher Kenneth Burke. Russian-born Lozowick was older and more worldly, the first of several protective father and big-brother figures Berenice sought out and trusted throughout her adulthood. He had studied art in Kiev and New York, at the National Academy of Design, and came to OSU for the liberal arts education he felt an artist needed in order to become cultivated. He was also the first visual artist Berenice ever met.[30]

Other *Sansculotte* contributors included students such as Charles Ellis, the painter and writer who later married Edna St. Vincent Millay's sister Norma, and older outsiders such as Ashcan School painter John Sloan. Berenice eagerly helped out in the editorial offices and peddled each new issue on campus. As further experience informed her under-

standing of this liberating time, she realized that the most interesting students had also been politically leftist, but she "didn't know what the hell" this new attitude meant then. Her own, indifferent upbringing had given her no such grounding.[31]

Another classmate and friend was Margaret Batterham, the beauty of a large English family in North Carolina whose members entangled themselves in modern American intellectual and religious life: sisters Lily and then Elizabeth married Kenneth Burke; their brother, Forster, fathered soon-to-be-radicalized Dorothy Day's only child. Margaret and her older sister entertained Berenice at the apartment where they boarded with a sociology instructor's family, the women sitting around the hearth in the cozy living room, eating popcorn and talking. In her own quarters Berenice had the habit—surprising to Batterham—of sitting on the carpeted floor to put on her shoes. Though freshmen were expected to live either at home or in the dormitory, Berenice didn't get along with her assigned roommate and arranged off-campus housing in exchange for housework. When that situation became too disagreeable in her second semester, she simply walked out and found a nonaffiliated room on her own, for $2 a week, winning even more disapproval from the dean of women. Aunt Ella intervened by agreeing to act as Berenice's guardian from her millinery business in nearby Lancaster, Ohio. Berenice also took friends to a local movie theater where she had connections, sometimes to attend a private showing of first-run films when the manager made his selections—most memorable was Theda Bara in *Cleopatra*.[32]

Berenice's OSU friends were "intelligent people" who read a great deal and got her "started on a lot of things that appealed to me," she said. "Books that opened the world to me." One of these volumes was *The Sexual Question: A Scientific, Psychological, Hygienic and Sociological Study* (1906), by the pioneering Swiss sexologist Auguste Forel, which attempted to interpret and classify human sexual behavior. She read it with Susan Jenkins, who concluded that she was a type of nymphomaniac and Berenice a psychosexual hermaphrodite. Decades later,

Berenice still marveled at Forel's forthright handling and analysis of subjects that had been taboo to her.[33]

As an adolescent, Berenice had expressed a desire to be a farmer, an astronomer, and then a journalist. Journalism was among the few fields offering adventure and autonomy to enterprising women. And that a "girl reporter" had covered a story could be enough to make it newsworthy. Believing a literary background to be the best training, Berenice did not select OSU's new College of Commerce and Journalism but took traditional liberal arts subjects. She felt adrift among the coeds who just went to college for the social life and to catch a good husband. Lack of family understanding and guidance left her a "pretty undisciplined kid," she realized; she didn't care about grades, and studied only what interested her. She did passably well in three English courses but failed American History, which seemed to her to consist entirely of memorizing dates, and Astronomy, whose dull presentation made her a major classroom discipline problem. She also took Philosophy and European History without distinction, receiving a high grade only in French.[34]

Though OSU had an active photography department whose students deployed their equipment around campus on assignments, Berenice never registered for a class there. Aviation, barely a decade old, made her imagination soar. The Wright brothers were headquartered in nearby Dayton. When OSU launched its School of Military Aeronautics to train pilots for the U.S. Army Signal Corps after America entered World War I in April 1917, Berenice had enthusiastically visited, only to get the brushoff she mimicked years later: "We're not taking any girls. What do you mean being here?"[35]

The summer of 1917 found her at home in Cleveland. Alice, hearing about her new university friends, asked her to drop out, but Berenice defiantly returned to OSU in the fall. The effects of America's sudden deep commitment to the war in Europe were evident on campus: The ROTC seemed to have taken over; heating coal was scarce, and classrooms were cold, if not closed. Two of the best-known professors, including Ludwig Lewisohn, were let go because they were German.

Moreover, Jim Light had graduated, and Sue did not return for the fall term; soon the pair married in New York City. Berenice took a paying job modeling for a life drawing class, though her enthusiasm was tempered by concern that she might be asked to pose nude, a fear that would evaporate the following year in Greenwich Village.[36]

Restlessness set in at the end of her second semester at OSU—she felt that she simply had to get away from her mother and Ohio. She always took chances, she later told poets Robert Creeley and Allen Ginsberg. In this case, her need was specifically catalyzed by Alice's irritation at what she thought of as her OSU friends' corrupting influence. Berenice had arrived home for Christmas with a copy of Théophile Gautier's *Mademoiselle de Maupin* (1835), the supposedly historical if immoral story of a tangled love triangle based on the life of a seventeenth-century cross-dressing French opera star. Her horrified mother confiscated it.

In January 1918, at the close of the semester, Berenice accepted a $20 loan from the Lights for one-way train fare to New York, where, they assured her, she could stay with them and continue her education. To her family, she seemed to have just picked up and left college. But the cultural and psychological imperative to escape was not exclusive to Berenice. Witness, the following year, the publication of Sherwood Anderson's *Winesburg, Ohio*, a compendium of small-town character vignettes culminating in the young protagonist's departure for a wider world.[37]

On a cold night, with a snowstorm raging, Louis Lozowick and a few other "sympathetic souls," Berenice said, helped her get to the Columbus train station. The pull to New York and to people "who were not stifled by the permeating spirit of conformity," she wrote decades later, was powerful, compulsory. It outweighed the real anguish and profound emotional wrench she felt at leaving her mother, her roots, and her entire world. Over the years, she returned to her home state for brief visits, but she confided long after her leave-taking that Ohio made her "ill": "I remember nothing about it without horror."[38]

CENTER OF EVERYTHING

Greenwich Village (1918-21)

Everyone was cooking up some sort of revolution . . .
socialism, sex, poetry, conversation, dawn-greeting—
anything so long as it was taboo in the Middle West.
—JAMES OPPENHEIM[1]

And I thought, *This will put some punch in you . . . this, by God,*
will knock something out of you. I was so timid. —BA (1975)[2]

The February snowstorm that ushered nineteen-year-old Berenice out of Ohio followed her east to New York. In Greenwich Village she found the Lights and another OSU friend, Charles Ellis, huddled in a small room at 137 MacDougal Street, trying to keep warm. The winter of 1917–18 was one of the coldest ever in New York, and America's entry into the war had forced cold houses and glum faces upon the Village's freewheeling optimism, the same deadening changes Berenice had experienced in Ohio.[3]

The Lights and Ellis lived above the Liberal Club, next door to the Provincetown Players, and around the corner from the Washington

Square Book Shop, in the heart of the nation's Bohemia. Geographically, the Village in 1918 was a square-mile pocket of narrow crisscrossing lanes and aging real estate along the Hudson River south of Fourteenth Street. Low rents in the historically African American neighborhood attracted antimaterialists and artists from all over the United States escaping middle-class backgrounds.[4]

Psychically, it presented an arena for new ideas and behavior, a "spiritual zone of mind," said Hippolyte Havel, an anarchist who soon befriended Berenice. Unlike her middle-class contemporaries, Berenice did not romanticize working-class life, which she knew was hard and full of disappointment and envy, yet she joined wholeheartedly in rejecting the repression and formality of bourgeois life to relish honest expression and freedom from convention.[5]

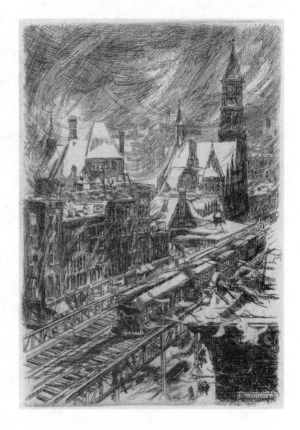

Snowstorm, 6th Ave "El" *(also called* Snowstorm in the Village), *New York, 1925.* John Sloan

The Lights and Ellis had discovered the Provincetown Players by accident when they rented in the adjacent building. The theater group was the brainchild of George Cram "Jig" Cook and his wife, Susan Glaspell, based on their interpretation of ancient Greek ideals of ritual and community. Beginning in the summer of 1915 in Provincetown, on Cape Cod, with like-minded writers and associates including Eugene O'Neill, John Reed, and Hutchins Hapgood, they wrote and produced short plays exploring contemporary topics and personal experiences. In 1916 the group began a winter season in New York, selling tickets by subscription to the same audience that enjoyed little literary magazines and 291, the modern art and pho-

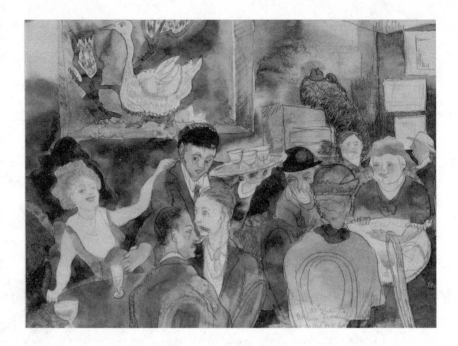

At "The Golden Swan," Sometimes called the "Hell Hole," *New York, 1919.*
The artist has depicted himself seated at the left table with Marcel Duchamp.
Charles Demuth

tography gallery of Alfred Stieglitz, the eminent impresario and art-
ist. Light, a scholarship graduate student at Columbia, soon ingratiated
himself with O'Neill and accepted a leading role in a successful play,
effectively ending his academic career. In a few years he became the
company's director.[6]

On her first night in the city, Berenice fell into the center of every-
thing at the "Hell Hole," a nickname for the dark and smoky Irish
working-class tavern that was one of O'Neill's and her friends' favorite
hangouts. Tucked under the Sixth Avenue El at the southeast corner of
West Fourth Street, the seamy bar, really called the Golden Swan, pro-
vided inspiration for the setting and characters of O'Neill's disturbing
play *The Iceman Cometh* a quarter-century later. But to the young people
in 1918, there was "joy in the discovery of people and ideas," recalled

Dorothy Day, a Hell Hole regular before she converted to radical Roman Catholicism in the 1920s. They couldn't talk without others overhearing, and "everyone table-hopped," she said. "No one ever wanted to go to bed, and no one ever wished to be alone."[7]

Just shy of twenty, Berenice felt "definitely bewildered," she said, "like a little lost lamb," with her "eyes bulging out" at this completely different world. Within days she had met O'Neill and others who remained her friends for decades, including Norma and Edna St. Vincent Millay. The liberalism of their long-divorced and self-sufficient mother, Cora, and her closeness to her daughters, contrasted profoundly with Berenice's own experience. Berenice also liked young critic Malcolm Cowley's first wife, Peggy Baird Johns, with her lovely narrow face, bobbed hair, and "careless" clothes. Another stalwart in these unmoored months was the multitalented Hol-

Berenice Abbott, New York, 1918–19.
Lejaren Hiller

ger Cahill, later Berenice's boss as national head of the Federal Art Project in the 1930s. Cahill understood how young people's flight from their hometowns was also a search.[8]

The Hell Hole also led Berenice, who thought herself the youngest thing around, to three men she came to adore—Havel, Terry Carlin, and Sadakichi Hartmann. Everyone in the Village seemed to know these middle-aged eccentrics, at least by sight. To Cahill they were "the tribe . . . the three famous characters of the period." All were at least a generation older than the young artists and writers who sought, or tolerated, their company; each was also self-destructive, a vulnerable alcoholic. And each provided Berenice with opportunities to endear herself to the father who was never there.[9]

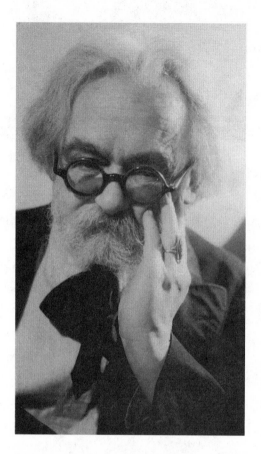

Hippolyte Havel, 1930s. Photographer unknown

Czech-born Hippolyte Havel told her that "he had three women in his life: his wife, his sweetheart, and his baby"—Berenice; she, in turn, was delighted to have him as a father. Short and stocky, Havel veered toward caricature, with his spats and cane and calling everybody "darling." But as a younger man, before attaching himself to O'Neill and the Provincetown Players in the summer of 1916, he had been associated as a writer and editor with the eminent anarchist and polemicist Emma Goldman and her companion Alexander Berkman (Berenice photographed Berkman later in Paris). Goldman and Berkman were deported from the United States in December 1919 as part of the federal crackdown on leftists after the Russian Revolution, but Berenice later claimed ignorance of the issues then raging around radical American politics. She knew that Havel "was an anarchist," but she had been "too young" to care—most "important was that he liked" *her*.[10]

Havel was simply a decrepit old character to some young people, but O'Neill defended him for having suffered in jails throughout Europe. He survives today as the character Hugo Kalmar in *The Iceman Cometh*, though Berenice found O'Neill's rendering of "dirty bourgeois," her protector's signature epithet, repetitiously simplistic. Havel had a minor heart ailment, which he exploited for female attention. On one occasion, while walking with a young friend who may or may not have been Berenice, he sank to the pavement. Minutes passed in a misery of panic and, strangely for the friend, protocol: How should a seasoned Villager behave in such an emergency? Finally,

Havel murmured to himself, "Now, Hippolyte, die nicely." Moments later he stood and they resumed their stroll.[11]

Berenice described Terry Carlin as a rare, beautiful person who refused to work and lived rather than wrote poetry, she said, with the "courage of poverty." An hour spent with him, she said, was "exhilarating, challenging, and unforgettable." A true philosopher, he read widely and listened sympathetically; but Berenice's adoration was not shared by those who tired of Carlin's hobo philosophy, drink cadging, and drug use. Carlin was the model for another *Iceman Cometh* character, anarcho-syndicalist Larry Slade, right down to his dirty clothes and, in O'Neill's words, his "mystic's meditative pale-blue eyes with a gleam of sardonic humor."[12]

Berenice did not meet the third man in her grizzled triumvirate, Sadakichi Hartmann, until a bit later, but he was closest to the visual arts community to which she

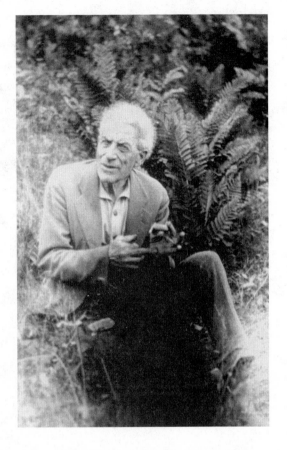

Terry Carlin, New Jersey, 1930. Berenice Abbott

felt increasingly drawn. Fleeing his cultivated and complicated German and Japanese heritage, the teenaged Hartmann came to America in time to befriend Walt Whitman, then elderly. With his long hair and flowing cape, Hartmann adopted the manner of his heroes Oscar Wilde and James McNeill Whistler.[13]

In the two decades before and after 1900, Hartmann ruled as a forward-thinking and fashionable art critic, lecturer, and promulgator of modernist values. His *History of American Art* (1901) analyzed the then relatively obscure painters Thomas Eakins, Winslow Homer, and

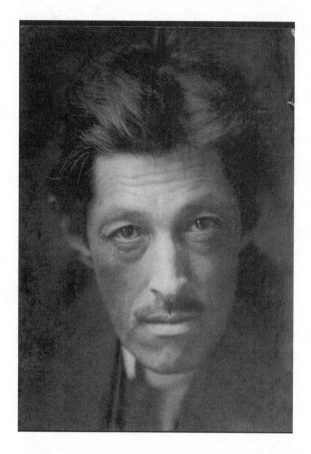

Sadakichi Hartmann, New York, 1913. Hubert Bros

Albert Pinkham Ryder and included the first serious discussion in America of photography as an art form. He wrote on music, dance, and photography, contributing frequently to Alfred Stieglitz's journal *Camera Work*. Even more enduringly, he encouraged the young Romanian Marie Marchand to open the first of her five legendary Greenwich Village teahouse restaurants, all referred to as "Romany Marie's."[14]

Hartmann was the "youngest old man" Cahill knew, individualistic and beyond the confines of modern American life. When Berenice met him, his reputation as a rowdy frequenter of Village studios and bars was much diminished. Likewise, his reign as a self-proclaimed "King of Bohemia" had been supplanted by Max Bodenheim, whose wife, Minna, was Berenice's occasional dancing partner. To the critic Benjamin De Casseres, Hartmann was a "grinning, obscene gargoyle on the Temple of American letters." Once, Berenice accompanied Hartmann, De Casseres, and a man she remembered as Charlie Thompson to a Fortieth Street club near Sixth Avenue frequented by newsmen and other Times Square regulars. There she spotted "lots of questionable women . . . kind of whores," she realized. Later at a dance hall in the West Fifties, there were more prostitutes, which made Berenice so uncomfortable that she got "some guys" to take her home. "You learn a lot about life like that, knocking around."[15]

Lacking a stipend that friends like Cowley received from home, Berenice scrambled for jobs: secretary, waitress, reader for a clipping service, debt collector. The last she abandoned because she felt sorry for her targets. She rejected working at Macy's, believing the department store took advantage of young women eager to become buyers and then fired them just before promotions were due. She swore she would sit on the street and starve before working there.[16]

For Berenice and many other female Villagers, the cause of the "New Woman" was simply their own lives. Without marching or campaigning, they adopted a code of free behavior in manner, dress, and relationships that set them apart from convention, sometimes beyond the expectations of their male Village contemporaries. The historian Matthew (Matty) Josephson, whose acquaintance with Berenice dates from this period, recalled some Village women as big-bodied and dressed in masculine clothes; others wore shapeless, loosely flowing robes. With short hair and makeup-less faces, they smoked cigarettes constantly, which was new to him. This picture was seconded by Malcolm Cowley, who found the liberated women of the Village unattractive and unappealing; in his unhappiness over their implicit threat to him, he fell just shy of calling them all lesbians. Edna St. Vincent Millay, the most popular American woman poet of the time, gave voice to the New Woman's sensuality even as she and her sister Norma lived it. Millay's high spirits and courage, her freedom and the explicit pleasure she took in straight and gay sex, exemplified the permission that the Village gave women to be themselves.[17]

The world that flourished below Fourteenth Street during the 1910s and 1920s grew out of earlier, quieter tea rooms catering to gays, which blossomed into clubs, bars, cafés, and eventually speakeasies for "fairies and lady lovers" in the Prohibition era. In New York City, wrote Ralph Werther, one of the earliest transgender individuals to publish an autobiography in the United States, "one can live as Nature demands without setting everyone's tongue wagging." And within the city,

Greenwich Village had become the place where homosexuals could go to play, experiment, and try out new aspects of their identities, as a song from the era proclaimed: "Here the modernist complexes / And the intermediate sexes— / Fairyland's not far from Washington Square."[18]

Berenice knew both the Millay sisters and Djuna Barnes well, disliked the spurious distinctions drawn between strong independent women and lesbians, and would complain of the futility of such distinctions all her life. For lesbians, the feminist movement, which asserted the equality of men and women both in the public realms of property, politics, and agency and in the privacy of home, provided encouragement and opportunities to explore alliances and feelings disdained by straight bohemian men. Free-love and open-marriage philosophies notwithstanding, many men regarded female-only alliances as threats. Despite the Village's worship of nonconformity, heterosexual men who may have prided themselves on their understanding of Freud believed that lesbianism, like young women's romantic friendships, was just a phase—perhaps a necessary one, to get rid of repressions. Such men were confident that same-sex attraction could be banished by a good psychoanalyst or a good man. As Provincetowner Harry Kemp wrote:

> men differ with the titles they wear.
> A woman's just a woman everywhere . . .
> give her a necklace, sweetmeat, poem, flower,
> a kiss, yourself!—but never give her power![19]

BERENICE HAD ARRIVED in New York expecting to pursue journalism. However, at Columbia University's new school of journalism, she found crowded classrooms that seemed, she said, "like a hell of a sausage factory." Moreover, as at OSU, progressive Columbia professors— philosopher John Dewey, anthropologist Franz Boas, and historian Charles A. Beard, in particular—had been dismissed for "unpatriotic" (antiwar) activities. At the end of the spring 1918 term, Columbia closed for the duration of the war.[20]

Gosh, I paid $6.00 a month rent. . . . Djuna Barnes lived

there, Kenneth Burke, Malcolm Cowley, and Sue, and

Jim, and I. Matthew Josephson came in and out all the

time. This was quite a group is all I can say. I had a little

triangular room off the kitchen. . . . what put the halt to that

was the fact that I came down with Spanish pneumonia

double influenza during the big, big deal. —BA[21]

THAT SUMMER, JUST MONTHS after what Berenice called "the kaleido-scopic days on MacDougal Street," she and a few Provincetown friends moved to a large apartment in a triangular wood-frame building at 86 Greenwich Avenue. It was nicknamed Clemenceau Cottage for the French premier Georges Clemenceau, who had lived there in exile before the 1871 Paris Commune. The critic Edmund Wilson visited his first wife, Mary Blair, also a Provincetowner, and in his diary described the ramshackle building's "stretches of linoleum . . . rambling halls . . . exhausting climbs of stairs . . . the smell . . . the sound of dripping bath-tubs and defective toilets." Hell Hole regulars O'Neill, Dorothy Day, and Peggy Johns were frequent visitors.[22]

On the ground floor lived a teacher from upstate, Margaret Rappleye, who roomed with an Australian draft evader and befriended Berenice. On the next floor were Victor and "Romany" Marie Marchand, staples of Village life by then, who operated ever-relocating restaurants well into the 1940s, their clientele tending to visual artists rather than writ-ers. The members of Berenice's apartment commune, continuously in flux, included Malcolm Cowley, Kenneth Burke, James and Sue (Jen-kins) Light, and Djuna Barnes. Barnes was a prolific, well-paid free-lance reporter who had received artistic recognition for her 1915 book of poetry, *Book of Repulsive Women*, and was disentangling herself from her common-law husband, Courtney Lemon, a journalist and a social-ist. Tall and imperious, often dressed in a dramatic black cape, Barnes

shared Berenice's lack of family support as well as a complex, ambiguous sexuality. She dismissed Berenice as a mere child of fifteen (five years too young) but treated her like family. Although the two eventually became romantic rivals, they remained intermittent confidantes into old age.[23]

In these early months in New York, Berenice wrote her OSU friend Margaret Batterham letters (now lost) filled with accounts of the lively gatherings at Clemenceau Cottage. Kenneth Burke, small and wiry, with a great mop of black hair and large eyes framed in spectacles, resembled Trotsky. He had left Columbia to study on his own, and subsisted on oatmeal and milk. To him, writing was a revolutionary act intended to shake up the reader and lead to reforms: socialism, emancipation of women and blacks, and recognition of the alternative lifestyles of gays and lesbians. He soon gave up his room at Clemenceau Cottage and, distracted by the activity among the commune, moved back home to Weehawken, New Jersey. In 1919, he married Margaret Batterham's sister Lily and moved to a primitive farmhouse in Andover, New Jersey, remaining there the rest of his life. Another Columbia student, the future biographer and historian Matthew Josephson, took over Burke's room. Berenice found Josephson, like Cowley, almost pompous, and their rebellion against their parents' conventionality merely indulgent and spoiled. Their conspicuous iconoclasm, self-righteous confidence, opinionated manner, and dilettantish interest in the "new" grated on Berenice. She also felt that they dismissed both the humanity and the art of her new friends in Djuna Barnes's circle: Elsa von Freytag-Loringhoven, the legendary mother of America Dada, and others they regarded as freaks.[24]

Painter Claude Monet's stepgrandson, Jim Butler, lived near Clemenceau Cottage with his parents. They also owned a hilltop farm near Candor, New York, in Tioga County—on the Pennsylvania border. In a run-up to Prohibition, the county was already dry. For two weeks that summer Berenice joined Burke, Cowley, and his Harvard classmate Samuel Foster Damon, a writer, already vacationing there. Burke gid-

dily advised friends to bring their own trunks of whiskey and rum, and to expect the most mixed company imaginable. After his spring crush on Norma Millay, who subsequently married Charles Ellis, Burke set his sights on Berenice. She had been expected to arrive with Margaret Rappleye but instead came alone. Slipping and sliding in the muddy road to town and back, Berenice and Burke ran errands and got the mail. The townspeople didn't know what to think of the young man's relationship with this newcomer, and the quartet let them infer that Burke and she were siblings.[25]

The young writers enlisted Berenice as an accessory in a literary hoax aimed at poets Witter Bynner and Arthur Davison Ficke (all rivals and suitors of Edna St. Vincent Millay). Cowley and Damon created a fictitious writer named Earl Roppel, dubbing him the "plowboy poet of Tioga County" and "the bard of the rushing Catatonk," a local creek. They gave Berenice the task of transcribing, in her best "unformed, ingenuous handwriting," a letter and a sheaf of poems they authored as Roppel's, which they mailed to Boston Brahmin poet and Imagist Amy Lowell as well as to Bynner. The latter pursued "Roppel" for two years until Cowley finally disclosed their prank.[26]

Cowley and Burke also began percolating ideas that soon surfaced in their much-edited but ultimately unfinished satire "Ultra-Modern Love," which sought to skewer such free-love advocates as Floyd Dell and Freudian popularizers like Havelock Ellis. Based on Shakespeare's *Hamlet*, the work included a sensitive romantic poet, Hamlet/Peter; a virginal Ophelia/Virginia, who feared life itself; and (new to the Shakespearean roster) Berenice, a New Woman amalgam of the real Berenice Abbott, Norma Millay, and Ira Rauh, Provincetown's leading actress.[27]

The Berenice character is a conflation of strong, independent feminist women and lesbian man-haters (the kind of typically "male chauvinist" illogic Berenice bemoaned all her life, as if there were no strong straight women or any weak lesbians). Toward the end of one of the play's later iterations, Cowley and Burke have their character, dressed in green velour, enter "briskly, clapping her left hand with a glove . . . talking angrily:"

O virgin, perils surround you
thus wandering through the forest of your days
when evening comes a man will cross your ways
and try to slip his hairy arms around you
observe the passion written on his face
obvious as a scuttle
observe his eyes that cover with a glaze
one should be far more subtle.[28]

Script revisions into the early 1920s, after Berenice and Cowley had relocated to Paris, use Abbott's *new* spelling of her first name, perhaps to emphasize the presumed posturing they sought to deflate, or simply to keep current with her European update—a private joke between old friends.

While still in New York Berenice found Cowley increasingly tiresome, a smart-aleck bohemian who "wanted to go around kissing all the girls." At Clemenceau Cottage Susan Light had tried to convert Berenice from any same-sex inclinations by getting her friend and Burke romantically involved. Djuna Barnes countered with strict instructions to ignore Burke, rendering Susan's plan moot. During the 1918 summer vacation in Candor, the two had groped each other one afternoon on a straw mattress in a barn loft and found themselves "about as well matched as Ladybird Johnson and Woody Allen," Burke wrote a half-century later. "Sans any ultimate entry," he added. He suggested, in a poem about fertilization, that the frustrating adventure led him to masturbate, unseen, in a nearby field. Burke soon married his first Batterham sister, leading to the next summer's being "the striking opposite of Candor plus Bernice," he told Cowley at the time.[29]

During the summer of 1918 the Provincetown Players had moved two doors away on MacDougal Street to larger quarters. In the restaurant above the theater, Agnes Boulton, the first Mrs. Eugene O'Neill, noticed Berenice, "a thin, interesting, pallid and dazed young girl who seemed for the moment as out of things as I was, who seemed indeed

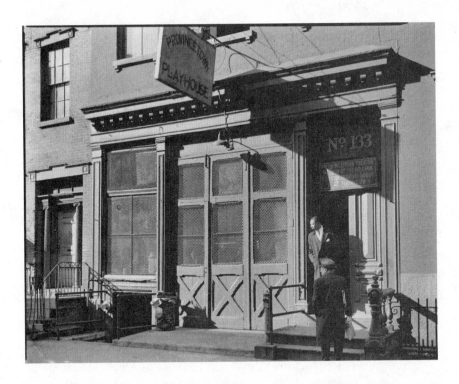

Provincetown Playhouse, Manhattan, *December 29, 1936*. Berenice Abbott

to be in or belong to another world." Long after Berenice Abbott had become a world-renowned photographer, Boulton wrote that she had been "just silently sitting there, her eye fixed like the eye of a dazed camera on the open door of the crowded room."[30]

A false armistice on November 7, 1918, sent war-weary celebrants into the streets; the real one ended the war on November 11. Berenice supposedly had her first cigarette on one of those days, though she had likely taken up smoking earlier. It was an act of rebellion similar to bobbing her hair, and initiated a habit that lasted four decades. The Provincetown Players' fifth season was the last where Jig Cook was in charge before turning the theater over to the professionalizing control of Jimmy Light and Ida Rauh, and he still believed in encouraging the earnest young people who were drawn to him. He gave Berenice a part

in *Moon of the Caribbees*, one of O'Neill's early sea plays, training she felt helped ease her shyness. She played her character, Susie, in blackface. It was a nonspeaking role, important for moving the action. In one scene, Susie dances with a British sailor until they are deliberately tripped and fall flat on the deck, to a roar of laughter. O'Neill himself oversaw rehearsals, but when the play opened, on December 20, 1918, he didn't think much of the production—perhaps because no one thought much of the play.[31]

Berenice got a speaking role for the next bill, in January 1919, playing Minnie Thompson in Otto K. Liveright's *From Portland to Dover*, but she never got to perform. Right after New Year's, she and many other Provincetowners, including most of the *Moon* cast, were "just carried out on stretchers," felled by the deadly influenza virus then circling the globe. Nothing else had killed in such great numbers so quickly—many strong and healthy people in their twenties among them.[32]

Berenice went to nearby St. Vincent's Hospital, where her anti–Roman Catholicism was indulged by one kind nun when she declined last rites. She spent most of January and February in the hospital's charity ward, bundled up on bright days in the sunporch. The staff confiscated the package of molasses cookies Margaret Batterham sent via Clemenceau Cottage roommates. Early on, the hospital had notified Berenice's mother in Cleveland of her daughter's imperiled condition. In January, one of the warmest in years, without snow, Kenneth Burke visited, telling Lily that "poor Berry" seemed to him a candidate for early death—"so much a part of her character"—but that he hoped he was wrong.[33]

When Berenice was well enough to be released, she continued her recuperation in the comfortable suburban home of her cousin Dr. Guy Morgan, superintendent of the Children's Village orphanage in Dobbs Ferry, New York. A tall and handsome dandy to his Ohio relatives, Morgan had a very spoiled young daughter, Hope, whose very existence Berenice found a trial. It was an atmosphere more dutiful than

welcoming, and an enfeebled Berenice scooted up and down the stairs on her bottom and learned to walk all over again.[34]

By summer she returned to New York, debilitated by her illness but able to manage alone if, as she groused, "without a dime." Feeling entitled to largesse, monetary or emotional, from "haves" when she "had not" would remain a continual theme. She did not return to 86 Greenwich Avenue; the constant trooping past her tiny room, the noise and disruption—the utter bohemianism—was more than she could stand. Sue Light found her a little place behind a theater on Clothesline Alley, off Christopher Street.

Inspiring and generous though the Lights had been, Berenice increasingly resented the bossiness of their protective mentoring and sexual advice. She also valued her privacy, and was consciously honing her ability to avoid little coteries and cliques. Many in the Provincetown group believed, when she was recuperating in Dobbs Ferry, that she had simply disappeared. Susan Glaspell's first long play, *Bernice*, which opened in her absence, revolves around a wake for the title character who lies unseen in a coffin offstage.[35]

> I liked sculpture very much. . . . You have to be
> interested in something. Really, you have to. Otherwise,
> I don't know what would happen. —BA[36]

DETERMINED TO FIND DIRECTION despite her "dirty, stupid jobs," Berenice discovered that the hands-on physicality of sculpture felt restorative and gave her an anchor. With no formal art training, she just grew, she said, "like Topsy: from inside out." In January 1920, the US Census Bureau listed her at 300 West Tenth Street, down by the Hudson River waterfront; her self-reported occupation: "Artist." One of her first pieces was *Lady in a Hoop Skirt*, a stylized figurative form modeled in clay and cast in plaster (or Plasticine). Berenice had seen Jig Cook use

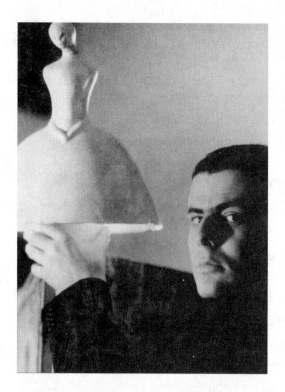

Lincoln Kirstein holding Berenice Abbott's sculpture Lady in a Hoop Skirt *(ca. 1920), New York, 1932. John Storrs purchased the sculpture from her in Paris and then returned it. She and Kirstein became friends in New York in 1930; the present location of the sculpture, which she described in 1975 as "stolen," is unknown.* Leonie Sterner

the technique for the figures he sculpted and cast for amusement or stage props. She also made some andirons on commission and a head of Edgar Allan Poe, which, like *Hoop Skirt*, survives only in photographs. She had used printed reproductions to model Poe's portrait, demonstrating her intuitive grasp of the plasticity of the photographic image, a quality that would later characterize her facility behind the camera. She later explained her ready ability to visualize: "An object viewed with one eye appears two dimensional; a photograph viewed with one eye appears three dimensional."[37]

Sometime before her illness, Berenice had met Elsa von Freytag-Loringhoven, whom she would call a "free spirit . . . a mixture between Shakespeare and Jesus." Born on the Baltic coast into a prosperous family, Else Hildegard Ploetz drifted into the Munich circle of poet Stefan George as an artist's model and married Felix Paul Greve, a felon and the German-language translator of Oscar Wilde and André Gide. She followed Greve to New York in June 1910, but the couple broke up after, bizarrely, trying to farm in Kentucky.

Berenice first encountered Elsa while walking down the street with a young man who was a mutual musician friend—possibly Harrison Dowd or Allan Ross Macdougall, both associated with the Provincetown Players. The baroness, limber and striking, invited the pair to a poetry reading. Berenice went alone. The poet was Charles Duncan,

a member of the Stieglitz circle, who earned his living as a sign painter. Elsa considered Berenice too young to understand Duncan's poetry, in particular the line "Perhaps her eyes had not been kissed enough." Nonetheless, a friendship was launched, Elsa taking Berenice under her tutelage.[38]

Elsa's unpublished poem "Kentucky Trail" captures her abandonment by Greve: "Night pitched / Swift ere thought / Trail switched / Into naught — / Befogged trees / Stifled maze / Tappt I through / Of intricate menace." She gave Berenice a copy of the work, covered in her characteristic brightly colored ornamental script and drawing—perhaps referencing their mutual connection to Ohio, where a traumatized Elsa had found refuge and employment as a model in the German and artistic communities of Cincinnati. Elsa's 1913 marriage to Baron Leopold von Freytag-Loringhoven, a black sheep from a distinguished German family, gave her the title by which she became known. The baron, drawn back to Europe by World War I, committed suicide during the Atlantic crossing to avoid service in the German military, an act Elsa considered heroic. She stayed in the United States and resumed posing for artists in New York and Philadelphia.[39]

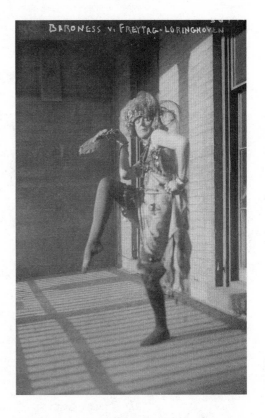

Baroness v. Freytag-Loringhoven, *New York, ca. 1918*. Bain News Service, Publisher

Young Berenice thought Elsa "mad as a hatter" but also a wonderful, wild character. The baroness's eccentricity attracted rather than repelled her. She thought Elsa "man-crazy" for her aggressive and unrequited pursuit of poet William Carlos Williams and Marcel Duchamp ("I love you like Hell, Marcel"), two creative men she

regarded as her artistic equals. Contemporary accounts luridly emphasize details of the baroness's most destructive and poverty-driven behavior, typified by painter George Biddle's oft-quoted account of his 1917 studio model interview with her. Biddle, like others, found it hard to see past her unconventionality—her tin can bra, dead canary pendant, celluloid bracelets pilfered from a department store furniture display, and red-dyed scalp (a common fungus remedy). Unable to value her humanity or humor, he failed to realize that her excesses were part performance.[40]

Elsa considered herself a member of New York's avant-garde artistic elite, her very life her chief expressive medium, and her body her primary canvas. More Dadaist by personality and feeling than by design, she fabricated sculpture and collage portraits from scavenged and found materials, which fellow artists such as Charles Sheeler and Morton Schaumberg treasured and photographed for posterity. Her decorated poems, usually written on small scraps of paper, were just beginning to make the transition to print, appearing in *The Liberator* and *The Little Review*. Sympathetically, a guest editor for the latter, the expatriate Jamaican poet Claude McKay, said he appreciated her "delirious" verse as much as "her crazy personality" and gaudy "rainbow" clothes.[41]

The baroness and Berenice visited the *Little Review* editors' home and office on West Sixteenth Street, with its gold-painted walls and enormous bed suspended from the ceiling at the four corners. Margaret Anderson had started the magazine in Chicago in 1914 and moved to New York three years later with her lover and coeditor Jane Heap. Publication was supported partly by the modern art collector John Quinn. Berenice recalled "breathlessly waiting for each issue" and being especially impressed by Djuna Barnes's short stories, beginning with "A Night Among the Horses" (1918). Quickly, Berenice became the *Little Review*'s "young little floating something or other," she said.[42]

A year later, the baroness briefly shared Berenice's apartment on West Tenth Street, lighted by feeding quarters into the gas meter. She was a

difficult and unbalanced roommate, but Berenice came to appreciate the constructive aspects of her nature. If she seemed to need to be admired, particularly by those younger than herself, she was equally appreciative of their creative efforts. She could be critical; Berenice described her slashing comments and cutting appraisals as being applied "with typical German Junker arrogance." But the overall effect was stimulating and salutary. Berenice admired Elsa's poetry and in turn received praise for her efforts in sculpture.[43]

Berenice also met Man Ray while living on West Tenth Street and, through him, Marcel Duchamp. She became good friends with both, credibly claiming that she never sought them out—or sought anyone out—for their reputations or prestige: "You either like them or you don't."

Dark-haired and compact, eight years Berenice's senior, Man Ray was a Brooklyn-raised artist whose style was revolutionized by the cubist and expressionist art he saw in the Armory Show in 1913. He had recently turned his photography to portraiture to enhance his income; before, he had used a camera only to document his own and others' artwork. He searched for subjects on whom to practice his technique in Village cafés, spying Berenice, "with bobbed hair and boyish figure," a self-described sculptor. She seemed skeptical when he asked her to pose for him, so he "hastened to add that it was only for a portrait—a head. She agreed," he wrote in a memoir. He responded sympathetically to her independence and recognized her hunger for the artistic and intellectual sophistication he himself had eagerly sought as an aspiring young artist.[44]

He later showed his portrait portfolio to Alfred Stieglitz, who singled out an image of Berenice and advised him to send it to an upcoming photographic show at the Wannamaker department store; Stieglitz was on the jury. *Portrait of a Sculptor* (it was inappropriate to exhibit pictures of young women by name; rather, their occupation or accomplishment identified them) won a $10 prize and was exhibited. Berenice disliked the melancholy it telegraphed; recalling herself during this time as a "crazy kid," she said she grew "sick and tired of that sad face." Berenice

considered Man Ray and her "buddies"; the two would "toot around the Village" and have fun drinking and dancing. She called dancing the best of all exercise; for her it combined the pleasures of physicality and a relaxed state of mind. She had offered to teach Man Ray. Once, the pair was put off the floor for obscenity, an infraction she dismissed as a function of her pupil's novice awkwardness.[45]

May Ray had married the French poet Adon Lacroix in 1914. The couple separated three years later. Hoping to hasten his divorce, Man Ray once asked a great favor of Berenice. The only ground for divorce in New York State was adultery—would she be willing to be named as corespondent in court? Amused, she agreed.

The two often went to galleries together. Alfred Stieglitz meant little to Berenice when, on one occasion, she and Man Ray visited him and the painter Georgia O'Keeffe, later his wife. Stieglitz brought out a picture that didn't impress Berenice, and she advised him to see some of Man Ray's photographs—presumably she did not know or he had not yet seen and chosen Man Ray's portrait of Berenice, for the dates of these encounters are unknown. Nobody was happy, Berenice realized later, with her "little miss foot-in-it" behavior. When she herself became a photographer and authoritatively dismissed Stieglitz's aestheticism, she took an unrepentant contrarian's pride in her early blasphemy against his "hallowed cult."[46]

Berenice loved the abstractions, including work by Kandinsky, shown by Katherine Dreier in her gallery, Société Anonyme. Decades later, she said she guessed that the appeal of abstract work had something to do with "trying to shut the world out." Dreier's trusted advisor was Duchamp, Man Ray's "awfully nice" friend, Berenice said, whose *Nude Descending a Staircase (No. 2)* had been the sensation of the Armory Show in 1913. Duchamp would become one of the first of Berenice's friends to encourage her efforts in sculpture. He was not patronizing, as she felt Elsa was, and his praise provided "the greatest boost."

Born in Normandy, Duchamp survived on a modest monthly stipend from home. Unlike most Frenchmen of his generation—and Americans, including Man Ray—he did not believe in the natural superiority of men. He respected the suffrage movement and admired the uninhibited behavior and athletic look of many New Women. All her life Berenice respected Duchamp's lack of pretense, ready experimentation, and open but temperate enjoyment of life.[47]

Following a self-imposed exile during World War I, Duchamp had returned to the United States from Argentina via Europe in early 1920. Prohibition had just begun, and he initially found New York too quiet, though the Village soon filled with speakeasies that drew a new and noisy clientele. In Buenos Aires, Duchamp had designed and carved a wooden chess set for the game that was his passion and obsession. In New York, he rejoined the Marshall Chess Club on West Fourth Street, where Man Ray also played, and contemplated the possibility of marketing a chess set he had designed. Berenice had skill casting small objects, and he sought her help making copies of the pieces in plaster and glue.[48]

One fall day in 1919, Berenice and her friends played local color extras in a Vitagraph silent short film, *A Philistine in Bohemia*, directed by Edward H. Griffith and starring Rod La Rocque and Edna Murphy. Selected by the production company right off the streets of the Village, "Hippolyte was the star, of course; then, there was the baroness," Berenice said, "the big star." Based on O. Henry's 1908 short story of the same title, the plot involved an Italian restaurant owner and the daughter of the Irish woman who owns his boardinghouse. Norma Millay reported earning ten dollars for a half-day's effort. "Me was in a movie Tuesday morning—played one of five Greenwich Village artists," she wrote to her sister, "Just to move about naturally and rather cute—." Berenice never saw the finished film, released in March 1920, but later identified herself—should a print surface—as the young woman with bobbed hair parted down the middle.[49]

A strong desire to know Europe grew in me, fanned chiefly by
the baroness's memories, accounts and fantasies. Others who
encouraged me were John Cowper Powys, Marcel Duchamp,
and Man Ray, in whom I had the best of friends. —BA[50]

THE BRITISH NOVELIST, critic, and lecturer John Cowper Powys walked
Berenice home one evening, and the gentlemanly shock and concern he
expressed when he saw her meager living arrangements impressed her
deeply; she photographed him a decade later in New York. Powys was
Margaret Anderson and Jane Heap's friend and confidant. In February
1921 he served as a defense witness in the obscenity trial of *The Little
Review*, which had published the Gerty MacDowell episode of James
Joyce's *Ulysses*. Powys wittily claimed that the book was incapable of
corrupting the minds of young girls who did not understand it and could
not further corrupt those who did, and it helped get the editors off with
a minimum fine. The case was further evidence to Berenice that Amer-
ica would never treat sex as natural or accept her nonstandard identity.[51]

Her circle of friends continued to widen. In the Provincetown group,
she got to know Helen Winner, the first wife of actor, newsman, and
novelist Frank Percival (Percy) Winner. Both were from Brooklyn,
and were high school friends of Clemenceau Cottage resident Matthew
Josephson. With Helen, who played the violin, Berenice had one more
success on stage (the revue or play is unknown), belying what she later
called "her drippy personality." Though still weak from a recent bout of
pneumonia, she auditioned with Winner and surprisingly turned out to
be "rather good," she recalled—"if you are not gay and full of laughter,
you're out." She designed her performance costume with fabric drag-
ging from the arms and legs to symbolize all the things in life that one
drags along, or cannot shed. That show "fell apart after a few perfor-
mances," but the pair kept auditioning in order to secure a paying role
somewhere.[52]

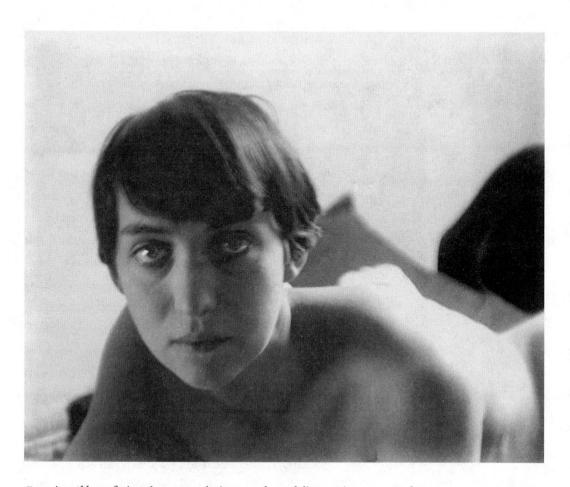

Berenice Abbott, facing the camera during a nude modeling session, New York, 1920. Man Ray

Modeling for artists was another source of income. The baroness had posed for Man Ray's camera, draped and nude, and was proud of her ability to strike and hold difficult poses for long stretches. Her example liberated Berenice to pose. The earliest surviving nude is a 1919 photograph by her contemporary Nickolas Muray, a Hungarian-born artist living near the Provincetown Playhouse who went on to do stylish portrait photography for *Vanity Fair* magazine. Despite Man Ray's earlier assurance of limiting his interest to her portrait, Berenice also

dadaphoto™, *in* New York Dada, *April 1921. Printed horizontally across the page bearing Tristan Tzara's essay on the Dada movement in New York, the image is better known as a photograph,* The Coat Stand, *without the magazine's obscuring paper overlay.* Man Ray

posed nude for him in 1920/21. The series shows an elfin but somber Berenice at rest and posing acrobatically on a classically draped modeling platform. She now wears the short, flattering, boy-cut hairstyle she preferred for the rest of her life. Also part of the series is a head-and-shoulders portrait of a prone, obviously unclothed, Berenice, unsmilingly returning the camera's gaze.[53]

The most extraordinary nude image of Berenice is Man Ray's 1921 *dadaphoto*, which does not show her face at all and in whose creation she never directly acknowledged participating. As a trademarked "dadaphoto," the work is entirely contrived, a subject set up to be photographed. Against a black background and behind a commercial painted cardboard mannequin of head, shoulders, and jointed arms stands a nude woman, her torso and lower body completely exposed. One leg is also bare, the other truncated by a black stocking that blends with the background; her arms are hidden behind her back. Her fully visible triangle of pubic hair was required to be censored in the printed magazine with a concealing paper stamp. Soon after, Berenice left the country. That spring, *dadaphoto*™ appeared in the sole issue of the limited-circulation magazine *New York Dada*. When still in its planning stage, the folded broadside elicited opprobrium—"a most exotic and worthless review . . . billets in bag printed backwards, on rubber deluxe"—from poet and *Little Review* contributor Hart Crane, isolated that summer in Cleveland.[54]

The "little American girl" in Léonide Massine's 1919 ballet *Parade* and war veterans who longed for the freedom of Gay Paree heralded a wide popular interest in expatriation. Sherwood Anderson's *Winesburg,*

Ohio (1919), and then Sinclair Lewis's *Main Street*, published to critical and popular acclaim in 1920, struck the final blow against the sentimental myth of the friendly, wholesome American heartland. Man Ray's 1921 photograph of spilled ashtray contents entitled *New York (Transatlantic)* was a harbinger of further change.[55]

> I was just such a crazy kid. . . . In March 1921 I set sail on the
> great big sea, like Ulysses, and I said to myself, "Whatever
> happens, happens." . . . I always liked wild characters, and
> you could say I was wild myself. A rebel, anyway. —BA[56]

RATIONALIZING THAT SHE might as well be "poor there as poor here," twenty-two-year-old Berenice applied for a passport in late January 1921. Man Ray, swearing he had known her for five years, served as witness. She told the State Department that she intended to depart soon aboard the SS *La Touraine* and travel two years in France for the purpose of studying art. Berenice later confided that her motivation was less to go to France and more to get out of America, whose commercialism repelled her. "How was I going to earn a living here? I wasn't trained. I wasn't going to be a stenographer and the things open to girls." Her explanation of the absence of acceptable roles echoed her rationale for the flight from Ohio three years earlier.[57]

Ultimately, Berenice could afford only a one-way ticket and booked second-class passage on the SS *Rochambeau*, the ship that had first carried Duchamp to the United States in 1915. Before she left, Sadakichi Hartmann grasped her shoulders firmly and shook her, commanding her to "become somebody." Setting sail, Berenice took along everything she owned, including her sculpture, all of it barely filling a small steamer trunk. The baroness sent her off with a genuflection, hip to hip and then forehead to crotch, and saw her off at the dock on March 21; she provided a letter of introduction, ornamented in her distinctive style, to André Gide, whom she had known before

World War I. Berenice would notify her family of her move only after arriving in Paris.[58]

On board ship, she encountered another member of the Province-town circle, the lively Allan Ross Macdougall, who had become Edna St. Vincent Millay's European agent—she teased him as "li'l Alling" and her "agint." (How Macdougall made a living mystified Berenice, though he would become Isadora Duncan's secretary, a minor stage and Hollywood player in the 1930s and 1940s, and most notably the editor of Millay's published letters in 1952.) An elegant older passenger, the sculptor John Storrs, a Chicago native, took an immediate interest in the young ex-midwesterner who had struck out on her own. Traveling with Berenice was Helen Winner, who had been to Paris once before with her husband Percy, from whom she would soon be divorced. Percival Winner, late of the Provincetown Players, had just become a writer for the Paris edition of the *Chicago Tribune*. In May 1920 he wrote to Matty Josephson, "[E]veryone seems to be coming or preparing to come" to France.[59]

BLAZING CHISELS

Paris and Berlin (1921-23)

American lady learning painting, sculpture, etching,
fashion, architecture, caricature, agriculture, literature,
and making a thousand conjectures about nature.
—GUILLAUME APOLLINAIRE[1]

By going to France I found myself and my own country—I just

sort of thank God for France—vive la France! —BA (1989)[2]

"Lousy with art" was twenty-three-year-old Berenice's enduring
first impression of Paris as Helen Winner showed her the ropes.
Despite formal study, Berenice found the language difficult but
managed simply because she had to. As always, money was a prob-
lem. With less than six dollars to her name, she relied on her shipboard
acquaintance John Storrs, whose trust fund supplemented his assign-
ments to illustrate the socialist magazines *The Masses* and *The Liberator*.
When Storrs's family used his expatriate status to threaten his inheri-
tance, he started dealing in arts and antiques to help with the upkeep
on his rustic chateau in the Loire Valley, and was generous with fellow

artists. He readily purchased Berenice's sculpture, *Lady in a Hoop Skirt*, and paid her to pose for a portrait head.[3]

She had planned to attend the Académie de la Grande Chaumière, the art school run by sculptor Emile-Antoine Bourdelle, a modern classicist who had studied with Auguste Rodin. Compared to the old, established Académie Julian, where male and female students took separate classes and the women never worked from the nude, La Grande Chaumière seemed advanced. But Bourdelle's master classes required official enrollment, which Berenice could not afford, so she started with pay-as-you-go life drawing sessions of quick poses called *croquis*. The nude model assumes a pose for five or ten minutes—long enough for the artist to make a rough sketch—and then changes position: it is a time-honored method of training the eye to analyze form quickly and the hand to express it decisively. Requiring no commitment, *croquis* were especially popular with expatriate amateurs who tried, as famed Montparnasse bartender Jimmy Charters said, to "make a stab at art." In May, signing off as "Your bad little Berenice," she happily wrote to Storrs, who now took on the role of long-distance father confessor, that she was not interested in sculpture for now—only drawing—and would soon have stacks of sketches to show him. She rationalized that sculptors needed to draw, not paint.[4]

Berenice quickly adopted the third *e* in her name and signature. The French pronunciation and spelling of *Bérénice* likely made the change seamless; Marcel Duchamp, from their earliest acquaintance in New York, naturally had used the French pronunciation. Decades later she described it as more of a choice than it may have been at the time: "I didn't like <u>Bernice</u>. *Burrnees*. So I put in another letter. Made it sound better." Possibly Elsa, who nevertheless always used the original American spelling, had some influence: Berenice found a poem tucked in an old book of hers, an open-ended declension: "BARONESS / BARE NIECE / BARE KNEES [/ BERENICE]."[5]

One afternoon in the Café Parnasse, musician Harrison Dowd, from

the Provincetown Players, introduced Bere-
nice and Helen Winner to the Welsh sculp-
tor Nina Hamnett. A minor Bloomsbury
figure, Hamnett had taken over Amedeo
Modigliani's studio after his tragic death
in 1920. She pointedly noted that Winner
was Jewish (a form of anti-Semitism hardly
unique to Hamnett in the 1920s) and Bere-
nice strange but extraordinary-looking,
with a whitish-green face, short ginger
hair like a boy's, beautiful large blue eyes, a
very long body, and rather short, fat legs—
altogether strikingly accurate observations.
Echoing Agnes Boulton's earlier assess-
ment, Hamnett too thought Berenice very
shy and only half-conscious. Recognizing
her skill as a draftsman—while dismiss-
ing her ambition to become a sculptor—
Hamnett introduced Berenice to her friend
the Russian sculptor Ossip Zadkine. Both
artists found promise in Berenice's work and
encouraged her, support she said was "more
important than air to breathe."[6]

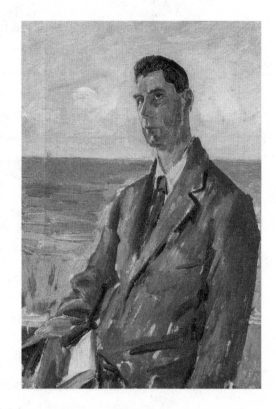

Thomas Earp, Meditation at Ischia, *ca. 1920.*
Augustus Edwin John

Through Hamnett, Berenice met a number of English expatriates,
people who spoke her language, or, as she joked, "at least the British
version." One was Thomas Wade Earp, a brewery-fortune heir, Oxford
graduate, and aspiring writer in the literary hostess Lady Ottoline Mor-
rell's circle. With his high-pitched quaver and his hair cropped close like
a convict's, Earp became "the flaming meteor" in Berenice's new world.
He spent freely to show her Paris, she said, "completely and magnifi-
cently, elegantly and poetically, and—expensively." He kept a room at
the Hôtel Foyot, in the Latin Quarter near the Luxembourg Gardens,

frequented by the English and by well-to-do Americans who thought its fine restaurant the best in Paris. At their first meeting Earp invited Berenice to dinner; with no evening clothes of her own, she borrowed an old opera coat from a new friend, Rachelle, whose hotel room she was sharing. Berenice and Tommy drank a great deal of champagne before their evening ended at 3:00 a.m. When Rachelle could not be awakened, gentlemanly Earp promised "not to take advantage" of her predicament and arranged for Berenice to stay overnight at his friend Nancy Cunard's room at L'Étoile hotel. The transatlantic shipping heiress always kept it booked, but that night it was conveniently unoccupied.[7]

Earp soon took Berenice to London. They crossed the Channel in a private suite. He did everything he could to show her a good time, providing box seats at the theater and taking her on a midnight drive outside London to view castles. They stayed in Earp's Savoy Hotel room, where they drank too much, including the powerful imitation absinthe and brandy cocktail Pernod Susie Fine, named for the bitter gentian Suze apéritif that was its third ingredient. Eventually, they tried, in Berenice's words, "a serious ménage," a sexual exploration that left them both feeling discouraged and monstrous: "It was almost a near miss—a near-something maybe, but I realized in London how much he drank. And, then also . . . I was Tommy's girl, you know . . . it wasn't my style." After each such extravagance, Berenice often spent the next days hungry, a situation she realized Earp couldn't imagine.[8]

Earp's offer of marriage and the couple's attempt at intercourse caused Berenice to ponder her true sexual identity. "One thing I am rather tired – rather embarrassed – at being a 'curio.' I want to appear – to feel human because god knows I am human, ordinary enuf." In a letter, Berenice told John Storrs to "rest your mind entirely of my 'homo'-possibilities," and by the following winter she wrote to him more expansively:

The two sides in me wage constant war – fight bloody battles and leave me aching; there is no attempt at apologies – I am too afire and do not spare myself when I suspect disagreeable things. It is necessary to see life as a whole,

to realize the inevitable laws of cause and effect. Just as a city weaves uncer-
emoniously its – design – as one form spins out of another, so a small life is
governed by impressions of environments according to the degree of sensitive
receptiveness. I have been held by a very strong – state of mind – due to just
such powerful early impressions – the life that surrounded me – it is simply
that nobody has broken thru this state of mind strong enuf to overcome it. You
can be – assured – I am assured – that it is a state of mind and not a physical
abnormality. The physical is not strong in me. Sometimes I suspect myself of
being a terribly maternal monogonistic – normal – spouse – actually. At least
some of that is in me. That I should at times disgust you is painful yet if it is
a physical distrust – I understand well – for one reason why I know I cannot
be – "abnormal" – to an alarming – degree – is that I feel this same distaste
– this same "abhorrence" – often toward homosexuals – and I feel quite as
uncomfortable with them as I do often in the presence of strictly normal peo-
ple. I believe truly if my general existence were not so distorted I should not
appear so hideous – perhaps.[9]

She was burdened with the belief that her family's broken history had robbed her of "normal" life and most convention, and her turmoil was aggravated by her personal style. All her life, she compartmentalized her associates and her activities hermetically, so that often one friend or group would not even know of another. She also seemed to simply drop friends or acquaintances and pick them up again when convenient or necessary.[10]

Berenice called herself "a little rebel from beginning to end. You see, with my childhood, what else could you be?" Having thrown aside convention at OSU and in the Village, she continued to pride herself on nonconformity, ostensibly indifferent to how she acted and dressed, "you know, really horrible." In New York it must have contributed to the openly negative feeling toward her that Agnes Boulton observed among the Provincetown women; and it was affirmed by her friendship with Dada's queen, Baroness Elsa, in Greenwich Village. However, in Paris, Berenice's unintentionally eccentric appearance actually caused

people to stare at her on the street. "I don't think I was a bohemian at heart at all," she said, "and Paris—the Quarter, that is—was pretty bohemian. And it was all right for the men to be very eccentric and different, but it was not all right for a girl."[11]

As a persistent outsider, Berenice observed that most artistic women she knew realized, consciously or not, that having a sense of style was part of their work, something they had to do, in addition to being talented, in order to succeed. Their flair for style enabled them to clothe themselves well regardless of wealth. "You have to give them a show," a dressed-to-the-hilt Margaret Bourke-White later counseled Berenice, advice she resisted as pandering to a false and unfair standard. Yet, slowly, in Paris, Berenice recognized the benefits of toning down her eccentricity by dressing a bit more conventionally, if not stylishly.[12]

Happily, another Parisian trend was women wearing masculine dress, which Berenice appreciated, recalling the baroness's saying that women looked extremely feminine in a tie and collar. Yet the fluidity of 1920s cross-dressing continued to emphasize women's second-class status. A female impersonator friend of dancer Josephine Baker offered the analysis that "women consider it a masculine quality simply to be yourself. But [instead] they end up being caricatures of themselves which makes them easy to mimic."[13]

Berenice had sailed with a letter of introduction from Marcel Duchamp written to his friend Henri-Pierre Roché, a tall and serious-looking journalist, art collector, and dealer later known for Francois Truffaut's mystical film of his semiautobiographical novel *Jules et Jim*. Roché was out of town when Berenice called, but his mother, perfectly charming in Berenice's eyes, welcomed her warmly. "The Rochés are an old, old family here – perhaps you know of them," she wrote to Storrs, "and they have – exclusively – the most exquisite collection – most rare – of paintings – sculpture – art – I have <u>ever</u> seen. [Mme Roché] calls me her daughter – makes me speak – French – and we go together to exhibitions. I hate exhibitions and we saw many thoroughly – rotten – painful ones – only yesterday we saw Picasso's, which was stimulat-

ing and interesting. She has a few Picasso drawings that are much finer than any in the exhibition. To-day we go to the opera. A few nights ago, the Russian-Ballet – very beautiful. The best scene was the Spanish one with a really good setting by Picasso." As generous as Mme Roché was to her son's young American friend, Berenice never mentioned her again.[14]

That spring, Berenice also met Romanian-born Tristan Tzara, a founder of Dada, the iconoclastic art movement whose humor so attracted Man Ray. He and Tzara had corresponded about the ambitious anthology *Dadaglobe*, then still in the planning stages (it never saw print). Berenice didn't like the Dadaists. "Insects," she called them. By 1921, Dada festivals and pranks intended to shock had been co-opted into drearily meaningless entertainment. Audiences arrived armed and ready to toss spoiled vegetables and raw eggs as part of the fun. Duchamp shared some of Berenice's distaste, observing how, from afar, "these movements take on a charm that they do not have close up."[15]

A happier discovery for Berenice was Parisian food. On the Left Bank, Michaud's restaurant was around the corner from the popular Hôtel Jacob, on the rue de Saints-Peres, a favorite of Greenwich Villagers. The publisher Harold Loeb found the food simple and unpretentious, "with a freshness and delicacy unknown in the United States." *New Yorker* correspondent Janet Flanner forever appreciated what she called the "new body experience" of eating in France. When Berenice was earning money, she went to the good but modest Rosalie's, in the heart of Montparnasse, which displayed a painting Maurice Utrillo had once traded for dinner. Another taste Berenice acquired in Paris, and enjoyed the rest of her life, was the combination of raw oysters and champagne, especially at Chez Baty. With its baskets of shellfish stacked outside and sawdust-covered tile floors, it rivaled Rosalie's in those early postwar years.[16]

Berenice became friendly with an American socialite she called Kiki, who was probably Anne Harriman Vanderbilt, confidante and companion of Anne Tracy Morgan, the youngest child of financier

J. P. Morgan. "Society gals" held no mystery for Berenice, and she was not in awe of them. She simply found them to be good company, and they could afford to treat her. Afternoons, for diversion, Vanderbilt fetched Berenice from her *croquis* class. Occasionally she entertained her at her home in Cannes. Once, Vanderbilt gave Berenice a fancy hat because she looked unladylike. Hatless women were not welcome in proper cafés—no doubt contributing to Berenice's perception as an eccentric. Later, she threw the gift off a bridge into the Seine. Another friend was writer Mary Butts, who once accompanied Berenice on a trip to Chartres Cathedral, one of the few landmarks she went out of her way to visit.[17]

Encounters with wealthy people fed Berenice's conviction, misguided though it was, that in Paris, as opposed to America, the lack of money made no difference whatsoever—people were accepted because they were interesting in their own right. Tommy Earp often treated Berenice and other friends to lavish nights out: dinner at the Café Parnasse, then on to Pigalle, the traditional girlie nightclub district on the Right Bank, or Jean Cocteau's hangout, Le Bœuf sur le Toit, for jazz, and finally Les Halles for breakfast and the Café du Dôme, where they could nap on a table, as Hamnett once claimed she did before going home to bed. In this way Berenice was able to mythologize French culture; based in Montparnasse, Paris's most cosmopolitan neighborhood, she rarely encountered its bourgeois aspects.[18]

"To help things along," Berenice told John Storrs, understating her need, she took odd jobs, as she had in New York. Sometimes these involved art, as when she cast figurine ornaments of fish for an English couple. Other employment seemed frivolous or servile, or both, such as three days of shepherding "a hideous old maid" from Boston. Young British and American women also worked as daytime babysitters or shopping escorts for such firms as Dixaid, an American-run tourist service. Viva King, an Englishwoman who was friends with Tommy Earp and another Englishwoman, Iris Tree, a free spirit and poet, married to the American photographer Curtis Moffat, earned money this way. But

in the evening King reported that she "led a very different life in the Café Vavin or the Rotonde," spending most of her time "with a bunch of American lesbians. This was not a sexual attraction," she wrote, "we were merely jolly girls together, without any tiresomeness." Nevertheless, in May, Berenice told Storrs that she had "quite entirely estranged myself from the boob Americans around. On the whole I am getting along beautifully – thanks – entirely – to you! I bought a little hat for 75 francs, which is very neat – very black – and very pretty. Had to." The hat cost five times what she received for a life drawing session, but she may have needed it to replace the one she had tossed into the river.[19]

She spent a fair amount of time at Le Bœuf sur le Toit; so did Nancy Cunard and Iris Tree, and there were no tourists at all in the early 1920s, when Tommy Earp was still rich "and gave us a wonderful time," as Hamnett wrote later. The walls were soon filled with Man Ray's portrait photographs of expatriates, including one of Berenice from August 1921, posing on a trunk in his hotel. Le Bœuf was known for its loud jazz, pretty women, and art-world gossip. The owner, Louis Moysès (Jewish, Hamnett noted, but "very tall and fair and I would not have known it if I had not known his name"), was a friend of pianist Jean Wiéner. By 1924 Wiéner was joined by Belgian pianist Clément Doucet. Berenice thought the club more fun than anything on earth and all her life loved the piano sounds of both men.[20]

At the Boeuf, Berenice met Robert McAlmon, an American writer and former artist's model in Greenwich Village who became one of her best friends. He was considered wild and daring and hard as nails, and sometimes wore a single turquoise earring as blue as his eyes. McAlmon enjoyed substantial financial freedom from his six-year marriage of convenience to Winifred Ellerman, called Bryher, the British shipping heiress and lover of the poet H.D.—Hilda Doolittle, whose former partner had been the poet Ezra Pound. The couple had divorced in 1927, with Bryher's father conferring a generous settlement. It led to the mean-spirited nickname "McAlimony." McAlmon's generosity led some to feel he was taken advantage of by spongers of all nationalities.

He started a publishing venture, Contact Editions, with American physician/poet William Carlos Williams, and supported artists, including Ernest Hemingway and James Joyce, for whom he typed occasionally and with whom he drank regularly.[21]

"Many was the time Bob and I dined and danced," Berenice wrote thirty years later. "I wish it were as simple and easy everywhere as it was then in Paris." After one late evening at La Rotonde during which McAlmon confided his story of working his way from his native Kansas to New York, where his lean muscularity led him to work as a nude model, he and Berenice were attacked by a couple of street toughs. They fought back and Berenice "got a bit socked around," injuring an ear. The police questioned her the next day, which she strangely regarded as antifeminist, as if such attacks were to be blamed on women. The thugs were subsequently arrested, armed and with criminal records.

Cafés and bars provided meeting places for the vagabond tourist hotel dwellers. The composer Erik Satie, an associate of modernist group Les Six, which loosely included her idol Jean Wiéner —and "a doll," in Berenice's eyes—treated her and friends to drinks at Le Bœuf. On the terrace of the Dôme she would encounter the painter Marsden Hartley, complete with homburg and cane, sipping aperitifs or café au lait with friends, including Ezra Pound and the painters Fernand Léger and Charles Demuth—people Berenice knew by sight, if not reputation. Sometimes Hartley would buy drinks for all, "*un bock*, coffee, even a glass of milk," and then chat. Berenice was unaware of his stature in the art world.[22]

Berenice liked Deux Magots for breakfast or lunch, and when she had money she also frequented the Select and the Coupole. Years later, Djuna Barnes lamented the absence of café life in New York. In Paris one encountered (or didn't encounter) people without plan or evasion, simply because everybody was there. Berenice worked hard during the day and went to cafés in the evening. She said she "brushed off" many expatriates' negative "attitude of *tant pis, on s'en fiche*"—screw it, what's the point?— which "ran counter to my own strong need to be positive and creative."[23]

Experimenting with living in different parts of the city, Berenice

briefly took a room in a small Montmartre hotel on the rue Lepic near Sacré-Coeur, but she never visited that famous church, or the Eiffel Tower, or most of the other conventional tourist monuments. Her early crowing to Storrs about her artwork was followed by a long lament about progress on her sculpture, another head cold, and loneliness. Kitty Cannell, whom Berenice knew from New York as "Rihani," the Provincetown performer of self-invented "static dances," found Berenice more than once during those early months sitting forlornly in her Paris hotel lobby, absentminded and withdrawn, vaguely asking passersby for help with crossword puzzles.[24]

Your bad little Berenice. —BA[25]

THERE WAS ALSO the matter of the baroness's letter of introduction to André Gide, another cultural giant of whom Berenice knew nothing. Berenice first tried to enlist famed bookseller Sylvia Beach as go-between. Beach had served in the French Red Cross during World War I, then remained in Paris to open a bookshop specializing in English-language and contemporary literature. She and other friends who read the baroness's letter were unsuccessful in dissuading Berenice from delivering it. Arriving at Gide's front gate in June, Berenice was greeted by his secretary, "la Petite Dame," an extraordinary-looking woman whose white hair complemented her customary outfit of black velvet jacket, tie, and collar. She was Maria van Rysselberghe, wife of a well-regarded Belgian painter. Finding Berenice a strange little figure who looked like a boy and spoke only horrible American English, she read the baroness's letter, immediately recognizable with its characteristic embellishments in yellow and red ink with occasional smears of gilt, and sympathetically assured Berenice of its delivery. She then sent Gide's young lover, the filmmaker Marc Allégret, to learn more about her. Glimpsing Elsa's distinctive style later, Gide was horrified by the reappearance of this ghost from the past and couldn't wait to tear the grotesque missive to pieces.[26]

The Rysselberghes' daughter, Élisabeth (called Beth, with whom Gide

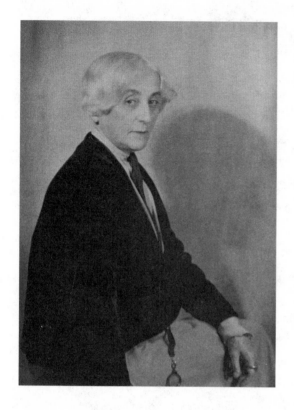

"La Petite Dame," Maria van Rysselberghe, Paris, 1926. Berenice Abbott

had a child the following year), had many English friends, including the memoirist Enid McLeod, who felt welcomed like an extra daughter and believed that Gide and his circle enjoyed the company of young people because they were unawed by him. Berenice soon shared McLeod's experience of warm welcome. Later she realized how exceptional had been her connection to the eminent Gide: how he might have found her interesting, a "funny kid" who brought him a strange letter from his past; but at the time she thought their encounter perfectly normal. In July, Gide invited Berenice to join Beth in the south of France. "I hope all this project [his effort to arrange a vacation for Berenice] will succeed and bring you a great deal of joy," he wrote in English. "Yet my friend [Élisabeth] recommends me to tell you again, and warn you: The cottage and the farm where she lives (a very pretty one indeed) is in a plain country without <u>distractions</u> at all. No casinos, no theatres; only fields and woods—with a delightful river to bathe in. Good food, healthy air, and immeasurable freedom. Quite sympathetic country people."[27]

With the summer even hotter than usual, Berenice seized the chance to spend six weeks out of town, like a real Parisian. Her destination was near the town of Brignoles in Provence, where Élisabeth, who studied agriculture, ran a beautiful old farm for a family friend. Berenice endured the five-hundred-mile overnight train trip south to Toulon, as McLeod had done, sitting up in a corner, getting grimier and grimier, but ending with a thrilling glimpse of the Mediterranean, "the pea-

cock sea," in the early morning sun. After a local train to Brignoles, a horse-drawn trap conveyed Berenice to the Domaine de Franco, or the Bastide, a two-story house standing alone at the foot of a mountain. Gide had promised her a well-furnished library with English, French, and German books and had assured her that Beth would help her learn French. "I feel immensely excited at the thought of your going thereto. Excuse my ridiculous english [sic]," he closed, "and believe me truly."[28]

Berenice had just turned twenty-three. She spent the summer reading French books, including Gide's, and resting. She would remain a prisoner all her life to the respiratory aftereffects of the influenza that had almost killed her in 1919. "It quite exceeds my expectations. There is beauty everywhere – comfort – freedom. Mind and body are at rest," she wrote John Storrs. "I hope you were not as depressed as I was in Paris. Everything is quite simple and well now." There was natural clay on the property, and Berenice worked from time to time at sculpting a life-size figure. One weekend she and Beth visited Gide's friend Jacques Copeau, founder and director of the *Théâtre du Vieux-Colombier*, a milieu familiar to Berenice from her time with the Provincetown Players. "Great time – many beautiful things," she reported.[29]

While in Brignoles, Berenice learned that Man Ray was coming to Paris. "Dada cannot live in New York. All New York is dada, and will not tolerate a rival," he wrote to Tristan Tzara. Page one of his now-famous letter has a running pun across the top margin, "MERDE-LAMERDELAMERDELAMER [etc.] // de l'Amerique!," where he formed the capital letter *A* from a photograph of the baroness's nude legs akimbo—a single frame from a now lost film depicting her shaving her pubic hair. Man Ray also thanked Tzara for "Mlle Bernice's sentiments!" Duchamp, already returned to France, wrote Man Ray that Berenice was "down South—I am writing her, so that she will come back soon."[30]

A refreshed Berenice returned to Paris at the start of September. She pointedly ignored the many Americans who had descended before she left town (Malcolm Cowley thought it like Greenwich Village, "only much more so"), and most were still there when she returned. The French pro-

July 19

There is little to be said for this place — it is so perfect. Nothing but praises. The heat is not at all bad and there is always good relief. It quite exceeds my expectations. There is beauty everywhere — comfort — freedom. Mind and body are at rest and I expect to be very much benefited by this. Rest your mind entirely of any "home" — possibilities. I hope you were not as depressed as I was in Paris. Everything is quite simple and well now.

Just received word from Duchamp that Man Ray is coming over — arriving the 32 nd.

Best of luck and wishes for you! Would be very glad to hear from you — here.

Yours

B. A.

Autograph letter to John Storrs, July 19 [1921, just after her twenty-third birthday]. Berenice Abbott

nunciation and spelling of her name made the simple change from Bernice to Bérénice virtually seamless. Though Duchamp had always used the French spelling, that third *e* took a few months to settle in—her letters to Storrs, for example, carry both versions. Malcolm Cowley used the new spelling in revisions of his never-finished *Hamlet*-based collaboration with Kenneth Burke. By mid-1922, when she applied for a passport extension in Berlin, she spelled her name "Berenice."[31]

Over the summer, Sylvia Beach, publisher of James Joyce's *Ulysses*, had relocated Shakespeare and Company to 12 rue de l'Odéon—probably the most famous expatriate address in Paris, after the cafés on the Boulevard Saint-Michel—right across the street from La Maison des Amis des Livres, the bookshop of her French partner, Adrienne Monnier. In addition to stocking American and British publications, including those of her customers, Beach ran a lending library, provided mail services, sponsored readings, and on occasion even lent money. Lacking disposable income, Berenice was not a registered member of the lending library or even a regular visitor. Over the years, Beach's shop wall came to hold scores of portrait photographs of authors and others known to her clientele. Berenice claimed not to know how Beach had obtained the small mounted and signed print of Man Ray's New York photograph of her, *Portrait of a Sculptor*.[32]

> I don't think I was a bohemian at heart at all, and Paris—the Quarter, that is—was pretty bohemian. And it was all right for the men to be very eccentric and different, but it was not all right for a girl; and I was an eccentric without knowing it. —BA[33]

BY MID-OCTOBER, financial help from Earp, who blithely reported Berenice to be "fat and jolly and healthy" from her summer in the countryside, enabled her to travel to Berlin. Fortified both by the baroness's enthusiasm for Teutonic culture and by Marsden Hartley's delight with his latest visit, she was confident that she could fend for herself

with her high school German, though the only person she knew there was Harrison Dowd, from the Provincetown circle. For income, Berenice planned to join him to teach American-style dancing—ragtime and especially the newly popular foxtrot. Edna St. Vincent Millay had already reported that Dowd was playing the piano in a jazz orchestra, inimitably well. Berenice felt that all she need do was advertise and wait for customers.

"Germany exceeds all my expectations," she wrote to Storrs. "It is a joy and I am enthusiastic beyond words. Everything seems to be developed more than anywhere. Energy – force – abounds in the air. The newer architecture excellent. Streets big and clean – shops handsome – original and all material advantages without any of the stamp of grossness or commerciality that spoils everything in USA. Theater – photography – music – years ahead. And there are signs of a most flourishing art – full swing . . . The place is clearly more healthy than Paris – dry – cold – fresh. One does not see a fifth or a hundredth of the number of Americans here." She also thought Germany looked prosperous, despite the resentment she felt about the inflationary currency exchange rate and a general assumption that all Americans were rich. "Everything's different. Women look 'dutchy' – on the whole – at first – one really must choke laughing sometimes. They look chic but they are much more independent and 'modern' than French women." She fretted about her vacant little Paris studio that Storrs had helped her find, a tiny space with a skylight and a loft bed in the rue Vercingétorix, opposite the Gare Montparnasse, but away from the tracks. Annual rent was 40 francs—about $80. Berenice slept on the balcony, which gave her the illusion of waking up and then going "downstairs" to work. Man Ray had the key in late 1921 and occasionally used it instead of his hotel room for his photography work.[34]

In Berlin as in Paris, Berenice found more of the destructive sexuality she disliked about the bohemian world: Young women flaunted their promiscuity and joked about their abortions and venereal disease, while men continued to take their primacy for granted. Lesbianism in

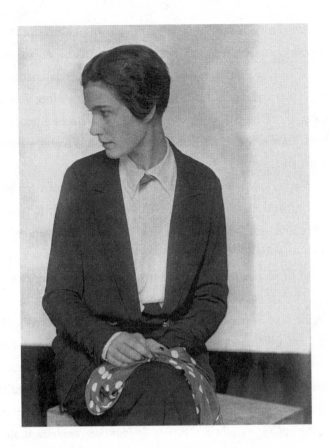

Thelma Wood, Paris, 1925–26. Berenice Abbott

Germany in the early 1920s was more open and the women there more organized and articulate than most anywhere else in the world. Some made a connection between lesbianism and feminism, but most identified with male homosexuals and saw themselves as a third sex. Sex researcher Magnus Hirschfeld's Wissenschaftlich-humanitäres Komitee (Scientific Humanitarian Committee), a leading gay rights organization, argued that all homosexuals were "born different." Another organization, Bund für Menschenrecht (Society for Human Rights), took the stand that sexual difference was no reason to curtail civil liberties. Though Berenice easily and intensely enjoyed several romantic friendships and lesbian relationships during these years, both in Berlin and

Paris, she was uninterested then (and in later life) in any sort of organization or action on behalf of gay rights.[35]

It was in Berlin that Berenice fell for the tall, dark, and boyishly handsome American artist Thelma Wood, sometime after Wood's summer fling with Edna St. Vincent Millay. Wood's generous allowance from her St. Louis, Missouri, family enabled her to live in modest security, though she spent her funds as fast as they arrived, treating friends to food and travel. Midwestern and athletic like Berenice, Thelma was widely recognized, by Djuna Barnes among others, for her bold, near-animal sexuality and promiscuity. Following Wood back to Paris in the flush of infatuation suited Berenice that winter; she could not find employment in Germany, despite Dowd's efforts and her own dancing prowess. "The reception a poor young artist or writer got in the European capitals was in no way comparable to the generosity with which Europeans are given jobs in the United States," Berenice wrote years later. They returned in time to visit Man Ray's first Paris exhibition, at Librairie Six, the tiny bookstore of Dadaist poet and critic Philippe Soupault, in December. Gertrude Stein, one of Man Ray's earliest Paris portrait subjects, reported that she had "never seen any space, not even a ship's cabin, with so many things in it" as Man Ray's hotel studio: a bed, three large cameras, several kinds of lighting, window screen backdrop, and a little closet where he did all his developing. It was while trying out a new lens in this room, Berenice recalled, that Man Ray captured her, happy and confident as she perched on a trunk, her chin flirtatiously in her hands.[36]

Berenice missed the December 1921 standing-room-only reading at Adrienne Monnier's bookshop from James Joyce's *Ulysses*, then being typeset for its first complete publication. Author Valery Larbaud presented his French translation first; then Berenice's old OSU mentor Jimmy Light, estranged from Susan Jenkins and visiting Paris before assuming the directorship of the Provincetown Players, rendered the Sirens passages, clearly benefiting from the coaching sessions Joyce himself provided. Though Berenice couldn't afford a copy of *Ulysses* when it was

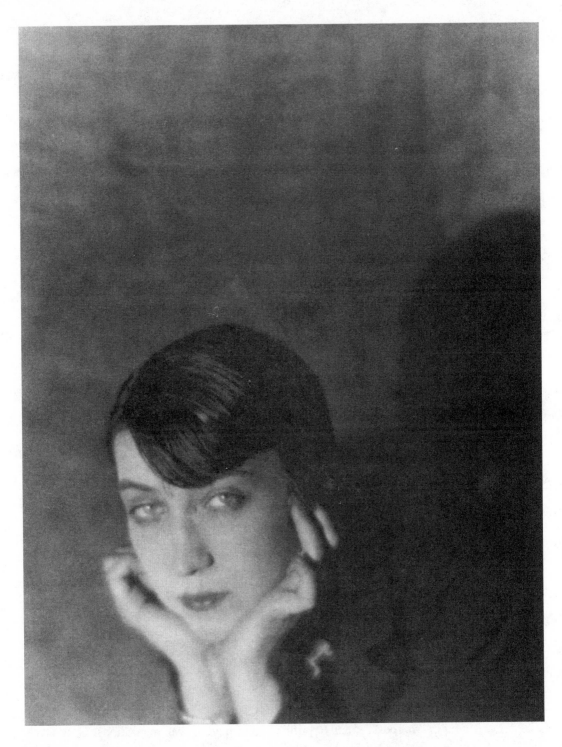

Berenice Abbott, *Paris, August–December 1921. She is perched on a trunk in Man Ray's hotel room while he tests a lens.* Man Ray

published a few months later, she soon got her hands on it (and claimed to have read it at least three times): "Why bother to read anything else?"[37]

In January 1922, she returned to Berlin intending to focus on sculpture. "Dear Storrs," she wrote,

> For once a wild fling of mine has seemed to lead strait [sic]. You could not finally imagine what miracles Berlin executes on me. I am really very happy. Germany was covered with snow when I entered – crossed over the border – and the air has played the very devil with my disposition and – energy – so that within this short time – I have been active every minute . . . I have bought a beautiful piece of whitish gray – coarse stone – for a head. Also I have acquired the best clay in the world here – entirely fine – and the sculpture tools that I have seen – (bought four) would definitely make you weep with joy. – Have the chisels and all – ablaze! I can very well work in my room – thank-heaven – I feel enuf now – to work anywhere. The place is too clean to be sordid. Everybody seems clean! To me the extremes are here. The appalling ugliness that also exists here – I simply don't see – look thru it – beyond it. Haven't seen one artist – and don't want to – after Montparnasse – for some time. And so – my dearest, dearest Storrs – I am cut quite off for a time from the world – I beg to hear all the news possible – of you – soon. Think of me now working – with an intensity that I have probably never before had. Remember – your little friend, who loves you very very much! B.A.

She later reported to Storrs: "It is glorious work – and even if I did take my thumb off several times with husky blows – I still insist that it is beautiful. I have made a small clay figure over which I was very much excited and then later thought it was a sad piece – so again – I dunno."[38]

As the Weimar Republic began paying war reparations, Germany's runaway monetary inflation meant that one US dollar bought as much in Berlin as ten or twenty elsewhere. Once while in transit between

Paris and Berlin, Berenice obviated a detail on her travel papers that would have cost her money by waving them high in the air and calling out "Américaine!" as she pushed through the border-crossing turnstile. When she traveled back and forth between Berlin and Paris, Thelma's weekly allowance supported a group of friends who carried currency around in satchels. Wood even sponsored side trips to Dresden and to Altdamm (now Dąbie, Poland)—"We had a ball."[39]

Such free spending made for wildness, at least in McAlmon's hard-bitten assessment. He wrote of the corrupting effect of economic imbalance within the party of friends, and of his own ambivalence when they visited "smart cabarets" and "one futuristic dance place for tea-dancing." The American critic and novelist Carl Van Vechten sought pleasure with prostitutes while his wife determinedly retired to her hotel. McAlmon found "joints and dives of every order, and there was no telling who one might encounter, anywhere." In addition to poverty-stricken Germans, there were displaced people drifting from everywhere. "Even hardened Berlin night-lifers could not tell with certainty what the tone or quality of any night-club might be from week to week," McAlmon marveled, as he gathered background for *Distinguished Air* (1925), his stories of Berlin gay subculture.[40]

In Berlin, Berenice also visited the national museums, where she especially admired work by Cézanne, and by Franz Marc and Wilhelm Lehmbruck—both Germans would appear in the Nazis' 1937 *Entartete Kunst* (*Degenerate Art*) exhibition. She had begun posing for local artists, including sculptors Milly Steger and Georg Kolbe and painter Max Pechstein. By February, though, Berenice's blazing chisels were too much for her German landlady, who made Berenice stop hammering away on a tabletop and work her stone figure sculpture directly on the floor. The fine stone she had ordered for a head she intended to carve was delayed by labor trouble that crippled Germany that winter. "Conditions are horrid here – now but I do my best not to notice them – no coal – no potatoes – railway-strike – tensions!" She kept to herself and saw "no American *Bekannten* – determinedly learning, speaking, reading, German." Her own lack of resources, her poverty, was visible in the society around her:

"Paris is too 'artistic' — for me — People here are very poor — It would not surprise me if a revolution were again to come," she wrote to John Storrs in February 1922. Planning to return to Paris in the spring when she could stand the weather, she wrote more about her sexual identity:

It is difficult to write the truth about myself when that one scarcely knows it — himself — herself — If you mean physically — I can truthfully say that, there — I "don't know where I stand" — that must work itself out — consciously —. No German men have interested me — but I know that also I am not now in the position to meet "interesting people" — It is also true that I have been interested in a German girl more than anybody here — but to say that it is complete — what I really want — no. She makes a good little friend for me — a companion — she is very droll — amusing — a very interestingly beautiful — exceptionally so — which is pleasant — but it is not a decisive appeal —. I know also that since I left America — or with time developed I have discovered new instincts — not yet realized — A vague account I am sure — "more mad than crazy" — but still these things may decide themselves very suddenly — or they may not. But I don't worry so much as formerly or think so much over it . . . Write me sooner if only to scold me a little bit . . . With lots of love — whole lot — your little friend Berenice.[41]

Berenice never belonged to the decades-long, semiofficial lesbian salon of the elegant and seductive American heiress Natalie Clifford Barney. In its 1920s prime, Barney's eclectic salon, thanks to her keen interest in women and her social and intellectual gifts, was a women-centric arena where a rich cross-section of academicians, thinkers and creators were welcomed and supported. T. S. Eliot, Ezra Pound, and Colette (an early lover, then a close friend of Barney) were among the visitors, as were women Berenice knew personally, such as Djuna Barnes and Mina Loy, and later, Janet Flanner and Elizabeth Eyre de Lanux (also a lover of Barney). But Berenice would become neither visitor nor lover; she was a bad fit, culturally and socially: cute but too desperate, too poor. Above all, Berenice was an armored loner, an inverse of rejection. She also recognized that many straight American men she knew, including Matthew Josephson and Wil-

liam Carlos Williams who both later wrote about it, disdained Barney's open lesbianism. Conversely, James Joyce, whose *Ulysses* Berenice so admired, was relatively indifferent, even fatalistic, deeming homosexuality, inconsequential to a woman, personally or socially.[42]

In Berlin, Berenice faced other difficulties. Behind on her rent and still making too much noise with her carving, she was "turned mercilessly out of my room by some common Germans who needed it. Last night had no place to sleep till the last minute and that under wretched circumstances – four in a room – no air – dirt – no money for a hotel. To find rooms yet – more than all for *Ausländern* is seemingly impossible." After several anxious days, Berenice moved into the family home of Fritzi Zimmermann, a pretty, slender, boyish, blond middle-class girl who befriended her in a Damenklub, a lesbian bar and gathering spot. The Zimmermann home was "a huge family where all the children are grown up – each has his or her partner – sit around the kitchen in couples and talk their plans – nice simple people." Berenice's "plans" were not so simple, she told Storrs, and to make things easier, she stopped making any. (Fritzi's mother soon thought that Berenice should return to France, alone, and refused to allow her daughter to leave with her.)[43]

Storrs tried to enlist Mrs. Payne Whitney as Berenice's sponsor when the wealthy collector, thinking Storrs had done the work, admired Berenice's *Lady in a Hoop Skirt* at his studio. He corrected her, but nothing further transpired; Berenice later allowed that Mrs. Whitney would support male artists but not women, and certainly not her. Other intellectuals and artists had found supporters—the composer George Antheil; James Joyce, whose patron was the wealthy Englishwoman Harriet Shaw Weaver; Hart Crane, subsidized by banker Otto Kahn; and Marsden Hartley, whose annual $2,000 came from a pool of American collectors in the United States. "But patrons were harder to find for young women than for young men," Berenice later told the authors of *Ladies Bountiful*, writing on famous female art patrons.[44]

In August 1922, she and Thelma Wood traveled back to the United States aboard the *Noordam*; at Ellis Island they registered with US

Immigration using Thelma's home address in St. Louis, though Thelma never went to visit her family. During this time, Wood arranged for Mary Mathers, a St. Louis art patron who had helped other young people, to support Berenice in her next attempt to study sculpture. Berenice understood that she "was to receive $12 a week, which went very far in those days," to support her for a year of art school in Berlin.[45]

Back in Paris, Thelma Wood abandoned Berenice for Djuna Barnes, leaving another Provincetown acquaintance, the ever-present and helpful Allan Ross Macdougall, to comfort her:

Fret not thyself Berenice,
nor redden thy lovely
orbs with weeping overmuch.
Kypnis[?] will return to ~~you~~ thee:
Roses shall bloom again.

Despite Berenice's sorrow, she was likely glad to remove herself from the couple's enveloping emotional turmoil. Barnes had been Berenice's mentor; she would later joke that in exchange for Thelma she gave Berenice her third *e*—but Barnes's joke is late by a year. With complete faith that the money would arrive from Mathers, Berenice gladly sublet her tiny studio at a big profit to an American couple eager to absorb Latin Quarter atmosphere, and headed back to Berlin, where she enrolled briefly at what she referred to as the Kunstschule-in-der-Kantstrasse (most likely the Kunstschule des Westens für freie Kunst und Kunstgewerbe), in the Charlottenburg district. She was still in town when Elsa arrived in April 1923, sprung from the United States by friends who paid her passage. When Berenice's landlady refused to let the baroness into the house, she would call up to Berenice from the street in the night; the neighbors cursed her, and Elsa cursed them back in German.[46]

The money from Mary Mathers never came; Thelma had no explanation. In desperation, Berenice penciled a note to Storrs on a scrap of paper.

"Today immediately – I try the American Red Cross – like going to my death. I am extremely worried and plagued – if you can help – let me know – <u>quickly</u> – yes?" In a previous note she considered and then abandoned asking Man Ray for help. "Nobody to advise or help me think!"

But Berenice had, in fact, been thinking, as she earlier wrote to Storrs:

Who can really analyze or account for an artist's queerness or adjust the motives that compel his work – that is the important thing – and it doesn't matter what those motives are so long as one is conscious of them and they <u>do</u> produce. A bigger understanding is yet waiting for us. . . . Ach – mein Gott! I feel better than ever in my life . . . my intensity is high and continual– new for me.[47]

Storrs again relieved Berenice's immediate financial emergency. His 20 francs brought her over 500 marks, but life in Germany wasn't free. Without a steady income, she could not take classes or indulge in self-directed sculpture—especially in stone, so difficult and costly. She had mostly modeled in clay before, but had chosen stone now, likely believing the medium to be a qualitative artistic advance.

She returned to Paris on a third-class train ticket. During the night, her car window was broken and glass flew everywhere, smashing bottles and dowsing her suitcase crammed with German books. Dragging this mess, Berenice boarded the wrong train and ended up in Charleroi, Belgium, the next evening. Rationalizing that she could not afford a porter, that the hour was late and her artwork heavy, she said good-bye near the tracks to a little statue and effectively to her career as a sculptor.

She spent her "last penny" to see a movie to shorten the overnight wait for the next Paris train. Returning to the deserted station at midnight, she dodged the stationmaster's advances ("one of those finks who start monkey business"), only to discover that her ticket was misdated. She talked her way onto the morning train, and when there were no seats in third class, snuck into first. Taxiing immediately to Wood's hotel, Berenice told Thelma that she'd "better pay for that cab, I haven't any money." And, of course, Thelma did.[48]

4

WHY NOT ME?

Paris (1923-26)

*A dollar would buy two thousand paper marks or an all-
wool overcoat. . . . it was an insane life for foreigners
in Berlin and nobody could be happy there.*
—MALCOLM COWLEY[1]

[M]en were really people and they were good. . . . Oh,
I think it was unconscious. Women were beautiful
objects. Same old myth, you see? I've only realized
this recently, I mean more recently. —BA (1975)[2]

In the two years since Berenice's Greenwich Village "buddy" Man Ray
had arrived in Paris, he had built a lucrative business photographing
wealthy tourists and fellow artists, including Berenice's friends Mal-
colm Cowley and Tommy Earp. Sylvia Beach had hired him to make
James Joyce's author portrait for her publication of *Ulysses* in early 1922.
Man Ray also accepted assignments to photograph artwork for dealers
and other commercial clients, such as Henri-Pierre Roché, who worked
privately for John Quinn, Joyce's American patron and a prolific collec-
tor of modern art.

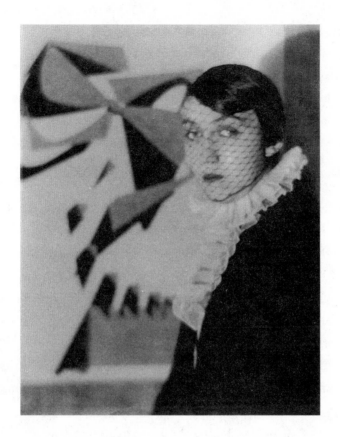

Harlequin Composition with Berenice Abbott, *Paris*
1922. Man Ray

Man Ray also practiced his own art, of course, now integrating pho-
tography into his image making by devising "Rayographs"—a process
he claimed to have discovered accidentally for making cameraless prints:
that is, photograms. The process was actually very old, dating to the ear-
liest work by photography's inventor William Henry Fox Talbot, in the
1840s, and simple, akin to children's "sunprints" of leaves and the like on
photosensitive paper. The sophistication lay in the selection and arrange-
ment of objects assembled directly on unexposed photographic paper.
Tristan Tzara called them "pure Dada creations" and wrote the preface to
Man Ray's portfolio of twelve Rayographs, *Les Champs délicieux* (1922).[3]

Although at twenty-four years old Berenice no longer posed nude for Man Ray, they "palled" around together in Paris. She accompanied him in November 1922 when he photographed the reclusive writer Marcel Proust on his deathbed. Though Berenice eked out a living, and decades later wouldn't say how she did it during this "terrible time in Paris," she insisted she "never became a whore. That was one thing I couldn't do." So in late spring 1923, when Man Ray complained to her across a Left Bank café table about his troubles with his latest know-it-all studio assistant, Berenice immediately sensed opportunity—she needed a job, and didn't care what it was. "If it had been a bricklayer, I would have said the same thing." She already knew Man Ray's business and belonged to his circle. It was a perfect fit. In her headstrong, independent way, she seized her chance for income, as well as a new direction, pointedly asking, "What about me? I don't know a thing." "Why not?" he replied. She started right away.[4]

Man Ray's was a modern studio, down the street from Rosalie's restaurant, at 31 bis rue Campagne Première, where he had moved in spring 1922—a "swell place," he called it in a quick postcard home, with plenty of natural light. The building had an elevator, central heat, gas, electricity, and private bathrooms—relatively luxurious amenities compared to the older apartment buildings nearby. The concept was to provide comfortable living quarters with working studios—some small, for single artists, and others large enough to accommodate families with children; each had a loggia leading into the living quarters that looked out over the studio below, connected by an internal staircase. Man Ray's was on the ground floor to the left of the entrance. The studio was 15 × 25 feet, with a window facing the street; a staircase at the back led up to the living area, 10 × 29 feet, with a toilet and sink and a round window at one end overlooking the street.[5]

Getting under way, Berenice told herself, "You've got to make this go, sister, you have to make this go," and with a bit of technical know-how from Man Ray, learned mostly by trial and error. He had long ago mastered the intricacies of darkroom practice, though he downplayed

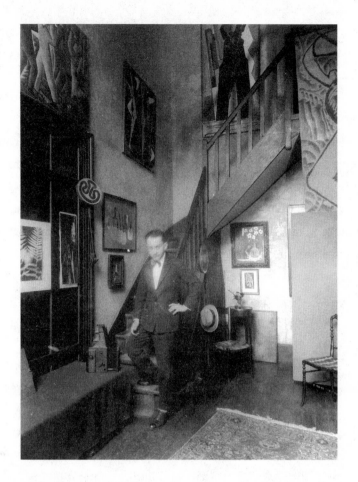

Self-portrait, 21 bis rue Campagne Première, *Paris*,
1922–23. Man Ray

his technical acumen, believing it largely beside the point if he had otherwise accomplished his artistic goals. Into this arcane and controlled realm, Berenice fell "like a duck to water." Timing, exposure intensity, chemical solutions, photo paper sensitivities, and enlarger framing and focus—they all offered a myriad of variables and combinations, always in near-darkness, illuminated only by the otherworldly dim glow of a red "safety light" that would not affect light-sensitive paper or film. Much later she wrote that "half the fun of photography is fooling around, mix-

ing solutions, playing with papers, exercising tangible authority over the silent partners of photography—film, paper, chemicals."[6]

Berenice worked hard, "like a dog," she said, in Man Ray's darkroom, willingly and happily, as step-by-step the photographic process unfolded. She quickly settled into a full-time routine that made her "heart sing. I liked photography. Photography liked me." The two old friends worked well together; left on her own, Berenice developed Man Ray's negatives, made the proofs, and composed finished prints in the enlarger. She believed that her experience with sculpture, drawing, dancing, and even writing had prepared her for this new art—"any work in different media helps," she argued. She lost herself in it, discovering that she had a great plastic sense, which amazed Man Ray, who thought her prints better than his. Within weeks, she was earning twenty-five francs a day (about $1.50), affirmation and cash that put her in "seventh heaven." Once "scorned, neglected, and slandered" by the art world, as Man Ray's friend Philippe Soupault said, photography had begun "to enjoy a vogue" as a modern medium. "Photographers began to believe themselves artists," wrote Soupault, "and everyone rushed to confirm them in that conviction."[7]

In May 1924, William Carlos Williams, winding down a six-month European sabbatical with his wife and family, came to Man Ray to be photographed. "Moving curiously across the back of the shop," he briefly spied Berenice, who "gave only one look, but it was a fine head, an impressive face, and the look was penetrating." He saw Berenice again at a party at the home of writer Ford Maddox Ford: "Almost before we had got our coats off, a woman had been knocked flat on her back on the floor by the man with whom she was dancing." Williams learned the couple was Berenice "and some English fairy." While the Maine lumber heir and artist Waldo Peirce glared at them, someone else told Williams to "Forget it, they're both of the same sex." Berenice's partner helped her to her feet and they continued dancing. In the drunken fall, Berenice cut her lip on her bracelet, a heavy silver one with dark stones that she

still wore in the early 1960s. Later, she was incensed at the description Williams published of her mishap, which she blamed on a broken heel.[8]

Like most conventional men, Williams found it difficult to accept the new independent women, regardless of their sexual orientation. Iris Tree and Nancy Cunard he thought "completely devoid of passion . . . completely empty"; he was unmoved by their "appealing and unassailable" youth. "Nancy, the perfect bitch if ever there was one, came out above it, unlying—and Iris, like Berenice Abbott, who had the same quality, affected one with the same elevated feeling, as of a religious experience . . . remote, childish, like the very first feelings of love, unassociated with sex . . . a depraved saintliness."[9]

While working at Man Ray's, Berenice met Ernest Hemingway, a client, whom she considered one of the most handsome men she ever knew. Djuna Barnes, who also sat for Man Ray during this time, thought Hemingway shallow, unimportant artistically, and even silly. Barnes complained about Man Ray's high fee and groused that no one but his mistress, the provincial bawdy free spirit and model Kiki de Montparnasse (Alice Prin), liked him. Berenice, who hated snobbery and pretension, considered Djuna a snob. She did, however, become friends with Hemingway's first wife, the boyish, redheaded Hadley, joining her for tennis and delighting in the couple's toddler Bumby. The two midwestern women had both been the babies of their families and had lost older siblings to stillbirth; Hadley's trust fund set her apart from Berenice. Once, the two friends were ejected from the famous Montmartre cabaret Bricktop's, named by Cole Porter for its owner, Ada Smith, the black American jazz singer with bright red hair. The renowned American jazzmen Louis Armstrong and Sidney Bechet routinely played at Bricktop's, and George Gershwin was a regular. Berenice dismissed Gershwin's 1924 *Rhapsody in Blue* as "piffle."[10]

She met her next favorite from this time, Tylia Perlmutter, in a lesbian bar. Tylia had been born to a Russian mother and a Polish father who was descended from a famous rabbi. The family had been exiled in

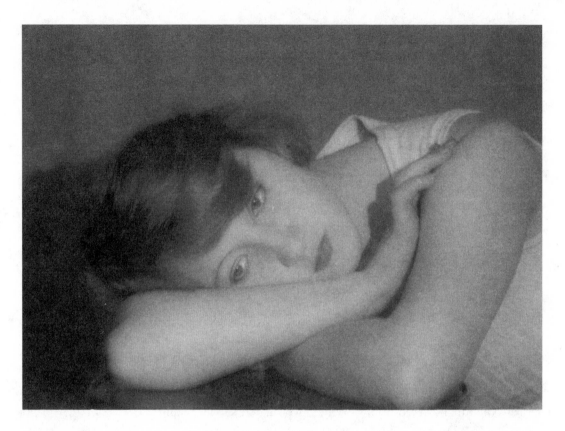

Tylia Perlmutter, Paris, 1925. Berenice Abbott

Amsterdam. At eighteen Tylia moved with her younger sister, Bronia, to Paris to continue her education. She wanted to be an actress. The graceful and petite Bronia, who eventually married the film director René Clair, described Berenice as "nice, attractive" but "odd, very odd," with a "slow way." Sixteen-year-old Bronia fell in love with Jean Cocteau's literary protégé, Raymond Radiguet, under Robert McAlmon's not-so-watchful eye. In the winter of 1923, Radiguet died of typhoid fever, and Bronia's grief and recovery became the source material for Djuna Barnes's short story "The Little Girl Continues," narrated by the central character's older sister. "It is different with me," the character based on Tylia explains, "I live more slowly, only women listen to me."[11]

Reporting on the Paris scene for the American fashion magazine *Charm*, Barnes captured a rather more flippant view of the Perlmutters and their modeling careers. The sisters "danced to the rhythm of the jungle beaten out by a 'dusky' on the drum," Barnes wrote, and "sat in their capes at the bar drinking *Yvette* and *Menthe* for its color, discussing Belgian poetry with the bartender." Barnes quoted Tylia, lighting her tenth cigarette: "America for me is the only *volupté*. Why? Because in all the pictures I have seen of your American life everything is arranged so symmetrically, the trains have space, the space is full of buildings and your buildings are full of money."[12]

The Perlmutters did not model in art schools, instead posing for artists—among them Moise Kisling and Marie Laurencin—in their studios. They tried to interest the latter in hiring Berenice, but Laurencin declined, confiding that Berenice's sad demeanor made her uncomfortable. Like many straight women of her era, Bronia thought that lesbianism was a distasteful choice and tried to ignore Tylia's activities and friends. Ever the artful dodger, Tylia later cautioned her young friend Dafna Allon to be careful with lesbians and avoid being alone in a car with one: "[I]f she gets her leg onto your lap, you're done for." (Fluent in several languages, Tylia would translate Anne Frank's diary from Dutch into French (1950), giving the historic memoir its first mass audience. In doing so, she memorialized a brother killed in the camps. Berenice had been long out of touch with Tylia, and never knew this history.)[13]

I had a tiny little room in a very small hotel and you
didn't need much money in those days. —BA[14]

MONEY IN HER POCKET from working with Man Ray allowed Berenice to resume going out to the cafés and bars that welcomed a growing American clientele and generally tolerated their unconventional public behavior. Alcohol consumption in France doubled as the party atmosphere of Americans escaping Prohibition became pervasive. "Me is

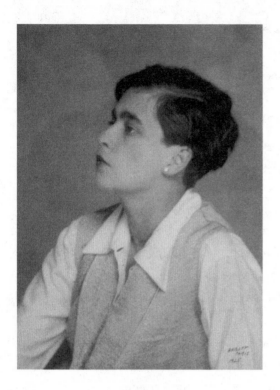

Gwen Le Gallienne, 1925. Berenice Abbott

sittin' pretty in the Café du Dôme just opposite the Rotonde and is writin' you a letter," Norma Millay, by now married to Berenice's former OSU classmate Charles Ellis, goofily wrote home. " ... We are having the time of our lives ... Think o[f] buying a big whiskey for 20 cents. I love Paris." Back home, Kenneth Burke (who never made the trip to France) parodied the alcohol-besotted travelers for his literary anthology *Aesthete: 1925.* "At last, I am in Paris! Great God, man, how I detest you back there among the Rotary Clubs and the grape juice!"[15]

On her off-hours, Berenice often consumed enough alcohol to be disorderly. Montparnasse barman Jimmy Charters said that during his time behind the counter at the Dingo, Berenice was the "great friend" of Gwen Le Gallienne, the struggling stepsister—Berenice later called her a "climber"—of the celebrated actress Eva Le Gallienne, founder of the Civic Repertory Theater. She tried painting and sculpture, but was memorable mostly for her sexual and social nonconformity, exceptional even in bohemian Paris. One night, Berenice and Gwen were carried off in a police raid on one of the gay-friendly dance halls on the rue de Lappe, near the Place de la Bastille. In these interwar years, the street was punningly called "rue de Loppe"—"Queer Street."[16]

Thelma Wood was also a great drinker, and Berenice continued to see her occasionally, with or without Djuna Barnes, and effectively dodged the melodrama of the pair's tormented alliance. Unlike women who cultivated steady and reliable groups of friends, Berenice made a conscious effort to "avoid little coteries, little cliques." She did not

identify herself exclusively with a lesbian sensibility or, for that matter, with a strictly female outlook. If anything, her sexuality—given the general social opprobrium and her lack of economic independence—became her nemesis and defined her great need for privacy. In her relationships, she set herself apart from notable female couples of the time—Janet Flanner and Solita Solano, and Margaret Anderson and Jane Heap—shunning deep romantic alliances, which she perceived as self-limiting entanglements. Though she usually had girlfriends in Paris, no great love appeared after Thelma Wood and Tylia Perlmutter. She came to accept loneliness as the by-product of her independent character, her tolerance for it a survival skill, a trade-off made unconsciously in her youth.[17]

My first pictures were pretty bad. Bad technically, underexposed.
I didn't think much about technique, but fortunately the
French didn't either. That made it almost even. —BA[18]

BERENICE WANTED TO do her darkroom job well enough to keep it, but it did not occur to her to take her own photographs. A year or so after she had started with Man Ray, he lent her a small box camera for her vacation in Amsterdam; she snapped some scenic views, but there was no magic moment when she squeezed the shutter. Rather, it was in his studio that Man Ray introduced Berenice to the uncomplicated operation of the view camera he used for portraits ("It's on a tripod and it stays there," Berenice quoted him), so that she could try to earn money on the side; he sensed her growing dissatisfaction with working ever harder without increased compensation. It was his way of giving her a raise at no cost to him, and she always insisted that he had never shown her how to take a picture: "Never once. Not with lighting or anything else. In fact, I didn't want him to show me. Somehow, this was a new adventure . . . something I was doing." Her ready aptitude continually surprised them both.[19]

Man Ray once said that men are more difficult to photograph than women. Men had "to have character, sex appeal, [and] look intelligent. Men were never satisfied with their portraits," he added, but women had only to be made pretty and young through retouching. Berenice recognized this objectification, eventually, much as Picasso's lover and model Dora Maar remarked: "All his portraits of me are lies. They're all Picassos, not one is Dora Maar."[20]

Berenice found a "twin" in one of Man Ray's clients, Peggy Guggenheim, the copper-mining heiress and future art collector. Both believed in astrology, and, born just weeks apart, they were age mates; both had lost their fathers during their formative teenage years (Guggenheim's went down with the *Titanic*). Both seemed aloof and standoffish, but were really deeply shy; even to Guggenheim's huge family and social circle, Peggy seemed a forlorn outsider, sitting back at her own parties and watching, seemingly out of place. Yet, with her first husband, the Greenwich Village artist and poet Laurence Vail, Guggenheim, still very much a young matron, was an informal social leader of the well-born Americans occupying Paris's Left Bank. Not considered a beauty, she was always beautifully dressed. Vail would often chide Guggenheim that her privilege should make her generous with the artists they drew into their circle, and grateful for their company. In Berenice's eyes, though, Guggenheim was never a phony, but rather a very real person with a serious bent, someone who stood out among the era's shallow eccentrics. Guggenheim adopted her contemporaries' wanton sexual mores—behavior Berenice considered destructive. As a free-living and solitary if penurious female, Berenice provided a window on a world of personal liberty that intrigued the always married Guggenheim.[21]

Man Ray had photographed an elegantly slim Guggenheim in a Poiret cloth-of-gold evening dress between the births of her two children, Sinbad in 1923 and Pegeen in 1925. Berenice produced all the finished prints, and the experience had helped launch their friendship. Later, when Guggenheim was pregnant with her daughter Pegeen, Berenice borrowed a camera from Man Ray and photographed Gug-

genheim nude, standing next to a cluttered dressing table, light streaming from a curtained window across her bulging torso. Guggenheim thought it looked as if a Brancusi egg sculpture had been superimposed on her slender figure.[22]

Pregnancy repelled and frightened Berenice; late in life she thanked God for not having children—"I wouldn't be too responsible." Though she believed from age ten that she was not the marrying kind, she could not escape the physical reality of her female body, which monthly reminded her of its potentially life-giving function. She felt motherhood would be as fatal to her independence as it had been to her mother's. From the onset, well before her health was compromised by her battle with influenza, Berenice endured painful menstrual periods that she felt always occurred exactly when there was important work ahead.[23]

Man Ray's flourishing art-minded photographic portrait business filled Berenice's days with developing, printing, drying, flattening, spotting, and mounting—it had become quite the touristic practice to bring home a suite of portraits by a fine Parisian photographer. Berenice also likely helped Man Ray and Duchamp in another collaboration, the assisted "Readymade" *Monte Carlo Bond*. Starting with a standard financial document, they added a Man Ray photograph of Duchamp with his face and scalp lathered up and his hair shaped into two devilish-looking horns, superimposed upon a roulette wheel drawn at the top. Berenice may have printed and trimmed the little photos for the thirty copies that Duchamp signed as himself and as his alter ego Rrose Sélavy, for sale at five hundred francs each, plus a projected high annual dividend! Marie Laurencin bought one, as did Duchamp's patron Jacques Doucet. Jane Heap in New York received another, and advertised sale of the Readymades in *The Little Review*.[24]

Berenice achieved a degree of autonomy in the studio. Once, when her boss was out of town, she agreed to rush the studio's largest order because the client was sailing soon. "Man Ray hadn't even seen the photographs!" she said years later; but she worked all night and went back into the darkroom the following day "as soon as I could lift my head."

The result was the biggest check that Man Ray had ever received. But when Berenice mentioned how much overtime she had put in, he didn't offer her "one franc extra" as a bonus, which disgusted her.[25]

Until then, Berenice had not been involved with studio finances. Now, the two photographers agreed that they should charge the same fee for a portrait session, reasoning that clients would respect Berenice more and ensuring that his business would not be undercut. Additionally, Berenice reimbursed Man Ray for consumables like paper, chemicals, and lightbulbs, while trying to keep their two operations separate. She photographed during her lunch hour and finished up her own work after-hours.[26]

Her first sitters came from Tommy Earp's English crowd. Flamboyant and beautiful author Paul Cross and sculptor Frank Dobson posed, as did Nina Hamnett's friend the painter Cedric Morris. Decades later, a friend found "very apt" Berenice's recall that "one of them told her she was like a fifteen-year-old boy, instead of a girl in her twenties."[27] But they were her friends, too, these young men; they often collected her after she had finished up the day's work. Another of her early lunch-hour subjects was Jean Cocteau, who "was more or less living on a stage all the time," she said, acknowledging that his stunning intellect provided half the artfulness of the resulting portraits. In one, he squinted down the barrel of the pistol that was a fixture in Man Ray's studio. For Bronia Perlmutter Clair, Man Ray's possession of the weapon was one of many reasons the American artist should have been considered untrustworthy.[28]

Berenice's other early sitters included art student and later gallerist Betty Parsons (also a *croquis* student), writer Janet Flanner and her American companion, Solita Solano, bookseller Sylvia Beach, and socialite Kiki Allen Preston and her young daughter. Thelma Wood soon posed for Berenice, and Djuna Barnes agreeably sat for a backlit profile to help build Berenice's portfolio, though she said Barnes never stopped considering her just a "funny kid," as she had imagined Gide may have. Barnes herself had used a camera in her pre–World War I

Jean Cocteau, Paris 1925. Berenice Abbott

police reporter days and may well have thought that the action of point-
ing and shooting was all there was to photography. Tylia Perlmutter
arranged for Marie Laurencin to pose for Berenice at the studio's
worktable, whose clutter Berenice cropped out of finished prints. For
her own portrait by Berenice, a close-up intimate view, Tylia rested
her head languidly on her bare arms. Bronia posed in street clothes,
demurely upright.[29]

Eventually, Berenice got so busy taking portraits at Man Ray's studio
that she was giving him back more money than he was paying her for

doing his work—an unintended consequence that created an increasingly untenable situation. When Peggy Guggenheim asked Berenice instead of Man Ray to take her portrait, he refused to allow it and made such a fuss she knew she'd have to quit. Guggenheim's patronage as a formal paying client provided validation and further emboldened Berenice to take the step. It was just as well, she rationalized later, for she could really be on her own—as she'd always wanted to be. She had come to Paris with neither resources nor direction; now, in 1926, she stood at another great turning point. Though the break took months to achieve, she never looked back.[30]

SEXLESS BIRD CATCHER

Paris (1926-29)

After being scorned, neglected, and slandered, around
1923 photography began to enjoy a vogue still difficult
to characterize. . . . What was really serious was that the
photographers began to believe themselves artists, and
everyone rushed to confirm them in that conviction.
—PHILIPPE SOUPAULT[1]

When I began to take photographs I was utterly unambitious,
in any worldly sense. Even when I was broke I wouldn't take
more than one sitter a day. Of course, there were hardly
any photographers in Paris then. . . . It wasn't like today,
when every other person is a photographer. —BA (1980)[2]

The stress of breaking with Man Ray was complicated by the logis-
tics of setting up a new studio on her own, at age twenty-eight,
and forgoing a steady income. Realizing that she needed her own
equipment, Berenice began acquiring lenses, cameras, and darkroom
apparatus. She purchased her first supplies in February 1926, continuing
into May. Among the equipment was a 5 × 7 inch camera with a Herma-
gis lens. Most sellers granted her a professional discount. Friends simply
also handed her money: When she complained of overwork and ner-

vous exhaustion, Bryher responded with an outright gift of at least 100 pounds. McAlmon tided Berenice over with additional small gifts and loans. Peggy Guggenheim offered a 500-franc loan, which Berenice later congratulated herself for having had the good sense to accept. Djuna Barnes lived on small subsidies from Guggenheim for decades, and wore her expensive hand-me-down mended lingerie.[3]

Sylvia Beach had been sending writers, including James Joyce, to Man Ray for publicity photographs, which she featured in her bookshop. Over time, Man Ray became unhappy with Beach's free distribution of his James Joyce prints and raised his fee to compensate for not being paid royalties for publication. When it was time for new pictures in 1926, Berenice, who loved *Ulysses* and believed it should be set to music, asked Joyce to pose for her.[4]

The writer's ailing eyes precluded his posing under bright studio lights. Hauling her photographic equipment, she went to his apartment at 2 Square Robiac and simply hoped for the best available light. "For God's sake, relax!" she admonished the long-suffering author as she began the session, oblivious to the stressfulness of her command. Joyce sat stoically in an armchair, changing only the position of his hands or the angle of his chin or eyes. He wore his distinctive bow tie and eye patch. Joyce subsequently immortalized the sitting in *Finnegans Wake*: "Talk about lowness! Any dog's quantity of it visibly oozed out thickly from this dirty little blacking beetle for the very fourth snap the Tulloch-Turnbull girl with coldblood kodak shotted the as yet unremuneranded national apostate, who was cowardly gun and camera shy."[5]

In late spring Berenice was offered a solo exhibition by Jan Slivinsky, a Polish musician who had been Iris Tree's partner when Berenice first came to Paris. Slivinsky had a gallery, Au Sacre du Printemps, on the Left Bank. While the exhibition was in preparation, the baroness moved to Paris. During three impoverished years in Germany, she had corresponded with her American friends, demanding and reproaching, and, once, apologizing—asking Djuna Barnes to "tell Bernice I am deeply humiliated before her now – because I have been harsh to her – when

she felt world scare – <u>I did not understand</u>! Also: she was <u>young</u> & <u>just</u> <u>starting</u> – <u>all creation before her youth</u> . . . May <u>you</u> and Bernice ever be saved from anything approaching – my condition – I pray." Reunited, Berenice spent a day with her and Djuna Barnes in Le Crotoy, a tourist spot on the Normandy coast, where they walked on the hard-pebbled beach in street shoes and city clothes and took ordinary snapshots.[6]

Berenice's exhibition flyer carried a witty poem by Cocteau, referring to her photographic work as a "chess game between light and shadow" and to her directly as a "sexless bird catcher."

> *Abbott porte un nom moitié ombre,*
> *moitié lumière: Bérénice. Elle expose*
> *sa mémoire délicieuse. Elle est le lieu*
> *d'une partie d'échecs entre 'a lumière*
> *et l'ombre.*
> *Elles d'oiseaux, oiseau des ils; Bérénice,*
> *oiseleur sans sexe, apprivoise l'ombre*
> *des oiseaux.*[7]

Berenice loved Cocteau's wordplay, and likely appreciated his remarkable phrase *oiseleur sans sexe*, for recognizing not only the varied and fluid sexual range of her sitters but also her own androgyny. Yet years later she downplayed this sophisticated celebratory verse, calling it a simple helpfulness to a young person, and saying that it merely meant that she caught both men and women with her camera. Cocteau soon expanded on this photographic theme in "Les Photographies de Bérénice," a poem that references the Roman emperor Titus's desertion of the historical Jewish princess Berenice. It begins, "Before Titus left, Berenice took a photograph."[8]

Exposition Bérénice Abbott: Portraits photographiques was on view June 8–20, presenting personages all expatriate Paris was sure to recognize: Djuna Barnes, Jean Cocteau, André Gide, Marie Laurencin, Sylvia Beach, James Joyce, journalist Sisley Huddleston, Alexander Berk-

Snapshot of Elsa von Freytag-Loringhoven and Djuna Barnes at Le Crotoy, June 1926. Berenice Abbott

man, celebrity author Princesse Bibesco, French statesmen Joseph Caillaux and André Tardieu, and Mme Paul Claudel, wife of the poet and diplomat.

Covering all bases, Berenice had slotted her few extant sculptures into the gallery. Until this exhibition, recalled Romeo Martinez, who would become editor in chief of *Camera*, the journal of the International Federation of Photographic Art, Berenice's ability to handle a sculptor's

tool or the camera had been largely unknown. Her role as Man Ray's assistant was much more widely known. But by not imitating the style of her celebrated employer, Berenice surprised viewers with her own artistic ability and won admiration for her individual aesthetic sense and secure technical knowledge. The *Paris Times* reproduced one of her James Joyce portraits, noting that the development of photography seemed to be in the hands of Left Bankers.[9]

Elsa attended the exhibition and commemorated her protégé's new art with a portrait in her unique assemblage style. Using foil, paint, glass jewels, and the brush of a typewriter eraser, among other materials, she fashioned an energetic head-and-shoulders portrait of Berenice hold-

Dada Portrait of Berenice Abbott, *Paris 1926.* Elsa von Freytag-Loringhoven

ing a lens cap in one hand; in the background the baroness's little dog, Pinky, sits on a rug next to a stylized crouching figure on a sculpting easel. A snow shovel leans against the wall (or, perhaps miniaturized, hangs from Berenice's ear), an esoteric homage perhaps to their mutual friend Duchamp and his 1915 Readymade *In Advance of the Broken Arm*. In turn, Elsa expected a formal portrait sitting from Berenice. Reminding Berenice that she had once hosted her in Greenwich Village, Elsa told her friend that she now wished to share her new studio. She needed just one small room, Elsa wheedled, and Berenice lived alone. Neither the portrait sitting nor the living arrangement came about.[10]

Man Ray resented the congratulatory press notices, some of which compared Berenice's straightforwardness to his stylization. "The frippery of lights, false and stimulating," Janet Flanner wrote in the *New Yorker*, "is not Miss Abbott's genre. Stolidly, as if almost accidentally, she arrives at a posturing of her subject so that mind and matter are clothed and balanced against a sensitive plate." Referring to Berenice as Man Ray's pupil, the *Herald* reported that critics "declared her not only a worthy follower of her teacher, but actually his serious rival." Though lacking his "spirit of fantasy," the article went on, Berenice's "strong and simple note of sincerity" does not strive for "effect or a pretty picture." The article quoted Berenice's opinion that "women, because of their native intuition and ability to give attention to details, make especially good portrait photographers." The review then delivered a coup de grace by asserting that, with the instant success of her own studio, Berenice had "come to be known as the best portrait photographer in Paris, which is to say in the world."[11]

The article also publicized her new location, 44 rue du Bac, a wide, fashionable street in Montparnasse near the Seine whose residents had included or would include other notable expatriates: sculptor Jo Davidson, journalist John Gunther, and writer Archibald MacLeish. Berenice's studio was up the second stairway to the left. She considered it "very elegant" and expected to be able to "swing it" financially, with her work becoming so popular. The landlord's restrictions

Peggy Guggenheim, Pramousquier, France, late June 1926.

Berenice Abbott

about water use, however, resulted in a "ridiculous" arrangement for a working darkroom.[12]

In July, she somehow forgot Elsa's birthday, her fifty-third. "I am personally convinced that you were secretly very pleased with this convenient memory slip," Elsa wrote, "for you like to spend your money only on yourself . . . slatternlyness – leaving it all to Thelma and Djuna – of course – as usual." Elsa did not confine her ranting to Berenice. Several pages of vitriol, comparing her three harsh years in Germany to

the relative wealth and freedom she saw all around in Paris, were sent to Berenice's friend George Antheil, the American composer: "You are no person you are nobody – you are a ghost – . . . you now are shitscared of me!" She told Antheil that Berenice was "immature" and a "soul-monster," living a "shallow meaningless puffed-up existence [called] 'success.'" To Peggy Guggenheim, she wrote that Berenice had become "inflated by inorganic prosperity – too newly gained – automatically with wobbly flop-poppyeyed vanity – idiotic flapperpout."[13]

To help repay Guggenheim's loan, Berenice arranged to photograph her and the children at their summer home in Normandy. Guggenheim financed yet another camera when Berenice complained about needing a specific one just for candid portraits. The photographs from the session comprise Berenice's earliest pictures of children and parents, as well as an animal—Lola, a wild sheepdog, probably adopted from neighbor Gabrièle Picabia. Guggenheim loved the portraits and felt her loan was well reimbursed. Berenice enjoyed her working visit and felt she could have used a rest, but Guggenheim did not extend an invitation to linger. Berenice also photographed McAlmon, in her studio, but never caught up with Bryher. As late as the winter of 1935, when Bryher visited the United States, Berenice tried to repay her generosity, but their schedules did not allow a portrait sitting.[14]

> Paris had a quality in those days that you can't have in an overcrowded place. People were more people. No one was rushed. There were no rubber stamps among us. We had the illusion that we could go ahead and do our work, and that nothing would ever come along to stop us. We were completely liberated. I don't mean that we were loose or promiscuous. We weren't, though sometimes people drank too much. —BA[15]

TOURISTS HAD SO THOROUGHLY invaded Paris that in certain neighborhoods only American-accented English could be heard. Picasso's Mont-

martre café, Au Lapin Agile—the last of the tree-shaded taverns—was out of business. Once-dim Left Bank cafés were "brilliantly illuminated, often with neon"; in place of wine and and brandy, they served powerful spirit-based cocktails to a "Prohibition-fired audience," wrote Matty Josephson. Ernest Hemingway's first novel, *The Sun Also Rises*, had been the talk of expatriate Paris the previous fall and served now as an informal guidebook to the Montparnasse scene.[16]

Berenice's Paris portraits from 1925 to 1930 comprise a visual legacy of strong women, many of them lesbian. Yet her sitters are not particularly fashionable or prominent figures; absent are Natalie Barney and her lover Romaine Brooks, Colette, Gertrude Stein, Alice B. Toklas, and Radclyffe Hall, author of *The Well of Loneliness*, the 1928 lesbian love story classic. (Nor does Berenice appear in any disguise in Djuna Barnes's illustrated satire of that year, *Ladies Almanack*; a wide-ranging group of artistic friends, including Berenice's old flame Tylia Perlmutter, helped hand-color fifty special copies.) What Berenice did record was a roster of self-assured individuals from different places, residing apart from their families, making their own way or earning their own living, in a city that was a haven for independent women and women of independent means. They were united, in the words of the novelist Bertha Harris, by "the more profound nationality of their lesbianism."[17]

Jane Heap posed in the rue du Bac studio, seated in Berenice's ever-present floral armchair as if upon a throne. Though still based in New York, Heap traveled frequently to Paris while organizing the groundbreaking 1927 *Machine-Age Exposition* in New York. Heap's preference for near-masculine attire was long appreciated by Berenice, who admired the look of a woman in a tie and collar—she shared the baroness's contention that the combination looked extremely feminine. Berenice required only two exposures to obtain a satisfactory portrait of Heap, though she pretended to take many more, to relax her sitter.[18]

Janet Flanner mentioned Berenice's photography often in her Letter from Paris column in the *New Yorker*. Berenice's much-reproduced 1925 portrait of Flanner captures the writer dressed for a costume ball

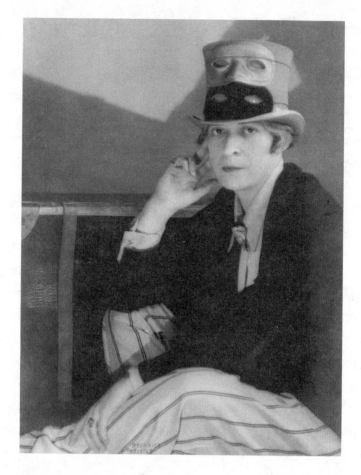

Janet Flanner, Paris, 1925. Berenice Abbott

in a top hat whose stovepipe crown was decorated with two face masks, effectively tripling the sets of eyes peering out at the viewer, and playfully suggesting a multiplicity of roles, identities, and realities. The hat came from Nancy Cunard's father. Berenice never said whether she, too, had been invited to the ball. Of Flanner's partner, journalist and novelist Solita Solano, Berenice rather snippily recalled, "[O]ne never saw what she wrote." Solano was close friends with Margaret Anderson and Cunard and also posed during Berenice's early studio career.[19]

Berenice photographed Sylvia Beach twice in 1926. One candid snap-

shot caught the publisher smiling, seated at her bookstore desk. Though Beach's print of this image is inscribed by Berenice and dated, the photographer decades later denied that she took it. In contrast, there is the elegance of Berenice's studio portrait of a seated, stern-faced Beach leaning forward slightly, dressed in a dramatically shiny dark leather trench coat. The full negative shows the long skirt of the coat, but the signed version in Beach's archive is cropped at the waist, giving full drama to the contrast of textures between the subject's crown of curly hair and the leather's slick reflective gleam. Beach also owned one of the two known signed and dated prints of Man Ray's prizewinning New York portrait of Berenice, *Portrait of a Sculptor, July 1920*. Decades later, Beach stressed that Man Ray and Berenice had been equals, the "official portraitists of 'the Crowd.' The walls of my bookshop were covered with their photographs. To be 'done' by Man Ray and Berenice Abbott meant," she emphasized, "you rated as somebody."[20]

Berenice photographed Adrienne Monnier, Beach's companion, in a rare full-length standing pose in order to capture the effect of the bookseller's customary ankle-length skirts. Next to Monnier, on Berenice's mirror-topped marble mantel, was perched *Lady in a Hoop Skirt*, which John Storrs had evidently returned.[21]

The enthusiasm of early influential friends is discernible in the personalities appearing in portraits at her Sacre du Printemps exhibition and in commissions in the months after: André Gide (despite a debilitating headache on the day of the shoot), Mme Rysselberghe (though not daughter Élisabeth) and Cocteau (in the playful Antigone white mask series). Absent, however, were her old New York friends Man Ray and Duchamp and new friends in Paris such as John Storrs, H.-P. Roché, and Nina Hamnett. Marsden Hartley wanted a sitting at a bargain price. Some friends encouraged Berenice to charge less money and schedule more sitters, but one person a day was enough. She explained her deliberately unhurried schedule: "Five or six exposures, [it's] exhausting to take a portrait of somebody you have to sort of turn yourself inside out to get through to. You can't just snap one after another, you'd be doing it mechanically." Long after Paris, Bere-

nice overheard a man say he'd just taken a thousand pictures, which made her wonder, *Did you get* <u>*one good one?*</u>[22]

Aiming for a relaxed and informal atmosphere, she relied "on the instincts of the moment," a gesture in which the person "would reveal something about herself." She used as little artificial light as she could, content that this simple approach comprised a manageable studio system. Her backgrounds were equally minimal, allowing the wall—with striped wallpaper, light switches, shelves, and all—to show. Sometimes she used draped fabric or an old printed map that, out of focus, blurred into an abstract variegated pattern. Not realizing, at first, how large the background had to be to fill the image area behind the sitter, she found that she often had to trim fairly close to the sitter's face when printing enlargements or cropping to eliminate an intrusive wall object.[23]

Many important women came to be photographed, among them English architect Eileen Gray, who designed luxurious handcrafted modern furnishings. The American artist Elizabeth Eyre de Lanux, who stole Evelyn Wyld, Gray's design partner and lover, from her, posed for Man Ray during Berenice's darkroom period but not for Berenice herself, though they became friendly. Lanux despised Berenice's trusted horoscopes and ridiculed astrology, but Berenice never ceased to be charmed by her. Djuna Barnes sat for a second portrait, wearing a plaid suit and a striking turban of metallic fabric. Berenice also photographed the English poet Anna Wickham and her teenage sons, who earlier had sat for painted portraits by Nina Hamnett.[24]

McAlmon wrote to Sylvia Beach that instead of visiting his relatives he would send them the portrait that Berenice had done of him. "I don't like family and that is that," he said—a not uncommon theme of Paris expatriates. At the rue du Bac studio Berenice also photographed Jamaican-born poet and novelist Claude McKay, a *Little Review* acquaintance from New York, who was becoming a leading figure of the Harlem Renaissance.[25]

Future Resistance hero Jean Prévost and his wife, Marcelle, were

publishers and booksellers. Like Sylvia Beach, they featured author portrait photographs in their store's show windows. From them came new clients André Maurois, Paul Morand, and Jean Guérin and his family, pictured snuggling their enormous bulldog. Surrealists and ex-surrealists included a favorite of Berenice's, poet Pierre de Massot, "a roaring Communist," Janet Flanner called him, who expressed his passion for America by drinking Coca-Cola instead of coffee for breakfast. Massot posed as a swaggering tough guy for the frontispiece of his 1926 limited edition *Portrait d'un bull-dog; ou, Prolégomènes à une critique de la sensibilité*. He inscribed a copy to "Bérénice ABBOTT, little pixie," adding, "between women and men she prefers dogs."[26]

One of Berenice's favorite portraits was of the American drummer Buddy Gilmore; she was simply crazy about his playing. Gilmore had toured Europe before the First World War with dancers Vernon and Irene Castle, and never returned. He was the regular drummer at Au Zelli's in Pigalle, and Frank Dobson introduced him to Berenice. Gilmore posed in action at his drum set, which he brought with him to the rue du Bac at Berenice's request. Now almost a cliché—a grinning black musician holding up drumsticks at his drum set—the picture was a powerful reference to the exhilarating new American music, jazz. The cultural monthly *Jazz: l'actualité intellectuelle* would feature Abbott's image in its first issue in December 1928.[27]

Toying with soliciting additional French public figures to sit for her, Berenice recruited newsman Sisley Huddleston to help draft an all-purpose letter in French to go along with his accompanying letter of recommendation. Joseph Caillaux posed again and though nearly blind wrote Berenice that the new prints were extremely beautiful. The *Paris Times* raved about the number of sitters flocking to her studio, though plans for an exhibition of portrait photographs at Lyons eventually collapsed. Berenice hoped to visit New York in the coming summer. Her query to Cleveland's Korner & Wood Co. book and print shop about a possible exhibition, however, went unanswered.[28]

I never tried to take portraits that used the whole negative. I
was more interested in spontaneity and expression and I didn't
want to fool around too much with mechanics that might
make a sitter uneasy or bored. I always attempted to make a
sitting as relaxed and informal as possible, using as little light
as I could get by with. This was my whole system. —BA[29]

EXPOSURE TO NEW AUDIENCES was opening additional doors and spreading the word to fashionable expatriates. Sophie Victor and her husband, Stephen Greene, dabbled in painting, made movies, and "never claimed to do anything in particular but did live graciously," in Berenice's view. Boston painter Margarett Sargent came to her studio "a stranger out of the blue," just one of the artistically engaged American circle of socially connected women whose eye was caught by Berenice and her work. Berenice photographed Sargent in at least six poses and two outfits, including a painter's dark smock and striped polo shirt. Others went to Man Ray for their portraits. Evelyn Pratt, born in New York and raised in Kalamazoo, Michigan, was a typical American client: coolly cosmopolitan, traveling and living abroad in the late 1920s. Her teenage daughter Virginia, sent to Berenice for her portrait, believed that the choice of Abbott over Man Ray had been made for propriety's sake. Perhaps Berenice's midwestern "Pie Belt" origins, as Virginia later put it, had endeared her in some way. Her signed portrait carries the further inscription: "taken by crazy Bernice [sic] Abbott when we lived in Paris at 20 rue Quentin Bauchart."[30]

Even from artists such as Man Ray and Berenice, the tourists and temporary expatriates usually expected conventional, warm-toned, softly delineated, flattering images on matte-surfaced, cream-colored paper. To meet expectations Berenice used a paper called "Antique" or a special ivory-colored Belgian paper. From Man Ray's practice, she had learned to mount prints on heavier stock, cream single-weight board as

well as dark tan, and to sign her work in block letters on the mounts in ink or pencil, often adding the place and/or date.[31]

Less demanding was the shy and introspective Leo Stein, Gertrude Stein's estranged older brother. Stein's neediness and iconoclastic temperament appealed to Berenice; she credited him with great influence over her thinking about art, science, and culture, absorbed in long hours of conversation at various cafés. Stein's 1927 book *The A-B-C of Aesthetics* does not touch upon photography, but the theories heightened Berenice's dawning awareness of the cerebral and aesthetic components of photographic practice. Pre-envisioning the composition and tonal balance of the final image, observing all the details within the viewfinder, and selecting a precise moment of exposure: All were qualities she drew upon the rest of her artistic career.

That summer, she published a sardonically aphoristic poem in the new international expatriate journal *transition*: "Don't discuss life, people, problems. Don't voice poverty." Although she is mimicking the sort of well-meant advice many ambitious novices receive as they move into the wider world of opportunity, the word "poverty" tugs plaintively, belying an ironic or flippant reading of the line. The contributors' notes report that Berenice's "writings are brief and uncompromising, with brusque staccato rhythms and acid philosophic content"; disappointingly, only one other was published.[32]

She had attended what she called the "electric" opening night of the African American *Revue Nègre* at the Théâtre des Champs-Élysées in October 1925, when a teenage Josephine Baker, with only "feathers on her tail and this beautiful little body," drove the tired, decadent French audience wild. "Everybody just wanted to leap over the balcony," continued Berenice, who later sought to photograph the star, but Baker's management company turned her down. She was more successful with George Antheil; in June 1926, she had attended his uproarious *Ballet Mécanique* performance—scored for sixteen player pianos, various percussion instruments, a siren, and three kinds of airplane propellers. Unlike with Dada spectacles a few years earlier, however, the audience

neither stormed out in disgust nor came to blows but good-naturedly took in the work's spirited celebration of modernity's chaos, cementing Antheil's self-assigned reputation as the "bad boy of music." As fellow American composer Virgil Thomson would snipe, when Antheil became a conventional Hollywood film composer, the bad boy "simply grew up to be a good boy."[33]

Berenice visited Germany briefly in early 1927. (Elsa had again asked to use the studio and was again turned down.) She told fans and the press that she planned to study experimental photography in Berlin and Dresden, but in fact she traveled principally for business. She visited Ullstein Verlag, the largest, most modern illustrated press publisher in Europe, where she explored selling photos to their magazines: the large-format *Die Dame*, which covered fashion and culture; the middlebrow cultural journal *Der Querschnitt*; and the independent *UHU*. All three made prolific use of contemporary personality photographs from a mix of agency and other professional photographers. Berenice's early portrait of Cocteau pointing a gun soon appeared in *Der Querschnitt*. An interesting feature of photographic publishing at this time was the interchangeability of art images, journalism, and commercial application; for example, André Kertész's now-famous 1928 still life of a dinner fork resting tines-down on the edge of a plate also illustrated a silverware ad in *Die Dame*.[34]

Berenice was gone four months in all, traveling back and forth between France and Germany with Dora Omankowsky, a German dancer of dark, animated beauty. Hearing Berenice describe Dora thirty years later, one friend summed up her impression of their relationship: "extreme high spirits, young, running through the streets together, laughing wonderfully." Dora spoke fluent German, of course, but was also Jewish, which Berenice in her typical provincial midwestern parochialism thought helped with the Jewish staffs of the big publishing houses they visited. Berenice loved Omankowsky's slender, supple figure—years later, at a loss for words to describe her, she resorted to making a curve in the air with her hands. Dora sat for Berenice in the

studio and appears, far right, in André Kertész's often reproduced snapshot of friends around a table at the Café du Dôme.[35]

Berenice celebrated her thirtieth birthday as one of several photographers who gathered regularly at the Les Deux Magots, calling themselves L'Avant Garde. The group included Man Ray and René Clair, André Kertész, Germaine Krull, and Eli Lotar. Kertész had arrived from Hungary in 1925, quickly placing his city-scene images in illustrated magazines. He took Berenice's portrait and exhibited it in his own solo exhibition at Au Sacre du Printemps in March 1927. But Berenice resented Kertész's cavalier divorce from his adoring first wife, soon after the couple arrived in Paris. She was the painter Rozsa (Rogi) André, who took up photography simply to earn a living and eventually became Lisette Model's first and only teacher. Polish-born Krull had studied professional photography in Munich and arrived mid-decade in Paris with a substantial portfolio that included some privately photographed female couples and sex play. Krull became, in Berenice's words, "sort of the Bourke-White of France," for her photographs of iron machinery and steel construction in the streets of Paris and Amsterdam, collected in her 1928 printed portfolio, *Métal*. By also offering a business model that combined remuneration with artistic pursuits, which was possible in the early years of documentary photography, Krull helped Berenice get started with photo agencies. Lotar, Krull's lover and financial partner, also provided contacts to the magazine world.[36]

The German-born surrealist Max Ernst and his second wife, Marie-Berthe Aurenche, brought Berenice another kind of opportunity. The couple's scandalous elopement in 1927 induced Marie-Berthe's father, a close friend of the head of the French equivalent of the FBI, to charge Ernst with abduction. Along the way, Marie-Berthe's older brother, Jean, who was also a friend of Cocteau, became Berenice's good friend, too. After the family recovered from the turmoil of their daughter's escapade, the senior Aurenches often welcomed the four young people at their large lakeside suburban home. Jean took

Berenice to French boxing matches, which she thought more sporting than the American ones, as well as for workouts in a gymnasium weight room. His "parents begged me to marry him, but I loved them more than I did him," Berenice recalled. "He was a lovely person, and I was fond of him; but not enough to marry him." Bronia Clair, who knew Aurenche from the French film world, later expressed surprise that Jean had wanted to marry Berenice, observing delicately that he was "interested in boys," while Berenice, she said, was "interested in her work." A marriage of convenience would have provided the social convention Jean's parents sought, plus the financial security Jean believed Berenice needed. Looking back, Max Ernst's son, Jimmy, observed that despite the spirit of rebellion in his father's artistic circle against the mores of the "hated bourgeoisie," straight male prerogatives remained largely unchallenged, while homosexuality, notwithstanding verbal attacks on the hypocrisy of sexual convention, was not even broached.[37]

Painter Josef Sima was the leading member of a Paris-based circle of Czech and French surrealist artists and writers calling themselves Le Grand Jeu, also the title of the journal they published. In 1928 Berenice posed for Sima's portrait series L'Énigme de la face. Most of the life-size oil-on-canvas portraits in the series depict individual friends and family members in everyday dress. Often derived from photographs taken by Grand Jeu member Artür Harfaux, these subjects face conventionally forward in an indeterminate space, but Berenice's portrait defies anatomy. With her back to the viewer, her head is rotated 180 degrees, her carrot-topped hair and ice-blue eyes contrasting sharply with the ivory of her bare back. The portrait subsequently traveled for exhibition in Czechoslovakia, where it has been on display intermittently after its 1963 purchase by the National Gallery in Prague.[38]

Gotthard Jedlicka, a young Swiss journalist and self-taught art historian who wrote sympathetically of the great number of his generation's lesser artistic aspirants crowding the cafés and boulevards, sat for a smiling three-quarter-length portrait at the rue du Bac. The result was

Portrait of Berenice Abbott, *Paris, 1928.* Josef Sima; © 2018
Artists Rights Society (ARS), New York / ADAGP, Paris

an image of impish good looks and vitality that Berenice enjoyed view-
ing for the rest of her life. The sitting spurred jealous Elsa, who received
no portrait sitting from Berenice, to break into Berenice's studio and
retrieve her proffered assemblage portrait. She subsequently presented
it, in a ferocious public display, to Marcel Duchamp's lover, the aristo-
cratic and dependable American war widow Mary Reynolds. Years later

Berenice learned that the purloined work had entered the Museum of Modern Art in New York with the gift of Reynolds's collection.[39]

Sometime in 1927, Elsa moved into a relatively comfortable hotel with her pet dog. She had fresh prospects, including a school and agency for artists' models. On December 14, 1927, she died from gas asphyxiation—an accident, most likely, when a flame was extinguished but the jet not closed; suicide was unlikely in light of her recent stability. Learning the sad news from Jan Slivinsky, Berenice, barely believing "such a vital creature" as Elsa was really gone, went to view her friend's body. A plaster death mask of the baroness wound up in Djuna Barnes's possession. Though Berenice had once been designated Elsa's heir and executor, her letters, manuscripts, and drawings also went to Barnes, who oversaw their publication in *transition* the following year.[40]

In early 1928 Berenice moved her studio to 18 rue Servandoni, where her rent was lower. Typically, after economizing on rent and location, she paid a small fortune (6,050 francs) for custom-built furniture from art deco cabinetmaker Dennery. The new studio had beautiful north light, though it took months to install the electricity and phone. One of her first subjects was James Joyce, her favorite sitter and her best work, she said in 1981. Though Sylvia Beach once told Janet Flanner that there was "always something a little shabby about Mr. Joyce," his distinctive striped tie, jeweled stickpin, and multiple gemstone finger rings offered a different picture, that of a dandy. Photographing under artificial lights was still out of the question because of eye problems he suffered, though seven surgeries in three years allowed him to submit briefly to the soft daylight of Berenice's studio. Still, to protect his eyes he donned a hat, producing a decidedly rakish effect. Berenice found Joyce "sort of a sweetheart"—patient, amusing, and animated; he lingered to look through her Atget photographs and especially enjoyed the view of headless clothing store dummies in a show window. The Paris edition of the *Chicago Tribune* gushed that her new portrait of Joyce "justifies the belief that this young American photographer is one of the outstanding photographers of the day."[41]

Joyce's wife, Nora, often called the real Molly Bloom, posed for Berenice, who especially admired Molly Bloom's insolent and unrelenting mockery of the male species in *Ulysses*. Berenice was certain that Joyce fell in love with Nora because the sound of her voice must have "sent him really high." Like Berenice, Nora had been a free-roaming teenager who on occasion dressed in trousers; Berenice relished the way Nora so openly revealed herself to the camera. Their daughter, Lucia, also sat in the rue Servandoni studio's distinctive curved-arm wooden chair. "Poor ill-fated little daughter," Berenice called her—the increasingly mad but beloved Lucia was institutionalized by her thirties. The portraits are somber, even grim. In some, Lucia turned nearly to profile in order to minimize the appearance of her wandering eye, the result of an uncorrected strabismus. A good student of modern dance, Berenice thought, Lucia gladly performed at family gatherings. For Berenice's camera, she donned charmingly creative handcrafted costumes to strike performance poses in advance of competing, unsuccessfully, in late May 1929 at Paris's largest dance hall, the Bal Bullier, in the heart of Montparnasse.[42]

A movement to demonstrate that photography was a separate art— "neither the slave of reality nor of painting," as one contemporary review put it—was well under way by 1928. In the spring, the directors of the Premier Salon Indépendant de la Photographie sent an official invitation to "the most distinguished photographers of the entire world," as Berenice would later quote on her resume. Editors Lucien Vogel and Florent Fels, filmmaker René Clair, critic Georges Charensol, and publisher Jean Prévost invited nine international artists, including Man Ray, Germaine Krull, André Kertész, and *Vogue* photographers Paul Outerbridge and George Hoyningen-Huene, to exhibit. Berenice volunteered to loan Atget prints from her collection, while the organizers also requested a dozen of her most characteristic works, reminding her that any prints sold earned a commission. On the back of the first invitation letter, Berenice penciled a list of subjects that included recent tourist portraits plus writers Clotilde Vail (sister-in-law of Peggy

Guggenheim), Djuna Barnes, Gide, and Jules Romains, and the economist André Siegfried. On the committee's second communication she revised the selection to: "Atget, writers André Maurois, Gide, François Mauriac, plus Thelma Wood, Comtesse C.L./I., Portrait d'enfant [not further identified], George Antheil, James Joyce, Buddie [Buddy Gilmore], and Mains de Cocteau." The portraits Berenice finally submitted included Mme Rysselberghe, Princesse Bibesco (a recent magazine assignment), and Sophie Victor.[43]

The exhibition, from May 24 to June 7, 1928, was dubbed the *Salon de l'Escalier* because it was installed on the walls of the twin staircases of the Théâtre de la Comédie des Champs-Élysées. This premier contemporary performance space had hosted such events as a ballet by American painter Gerald Murphy and his former Yale roommate Cole Porter, Josephine Baker's astonishing Charleston, George Antheil's *Ballet Mécanique*, and George Gershwin's *Rhapsody in Blue* played by Paul Whitman's orchestra. Unhappy with her fellow portrait exhibitors, Berenice complained about Austrian Madame D'Ora's theatrical lighting tricks and the mere inclusion of George Hoyningen-Huene, who had been her constant nemesis when Lucien Vogel (encroaching on Man Ray's territory, too) contracted with Berenice to photograph accessories and portraits for *Vogue*. "Most of the really good photographers were foreign and they wanted to include someone French," Berenice rationalized, "so they showed [Laure] Albin-Guillot . . . very second-rate . . . I don't remember one picture she took."[44]

Critics again praised Berenice's studio portraits extravagantly, which "flabbergasted" her and angered Man Ray. Florent Fels, in *L'Art vivant*, called Berenice's portraits "precious and living documents of elegant style and of the most beautiful faces in the world." He also intimated that the picturesque style of conventional amateur photographic salon submissions was trumped by the new blend of commerce and art, all but calling for a larger, more comprehensive show.[45]

Berenice had begun a small scrapbook and kept every review: *Paris-Midi* published a full-length portrait of her, serious in a Chanel-style

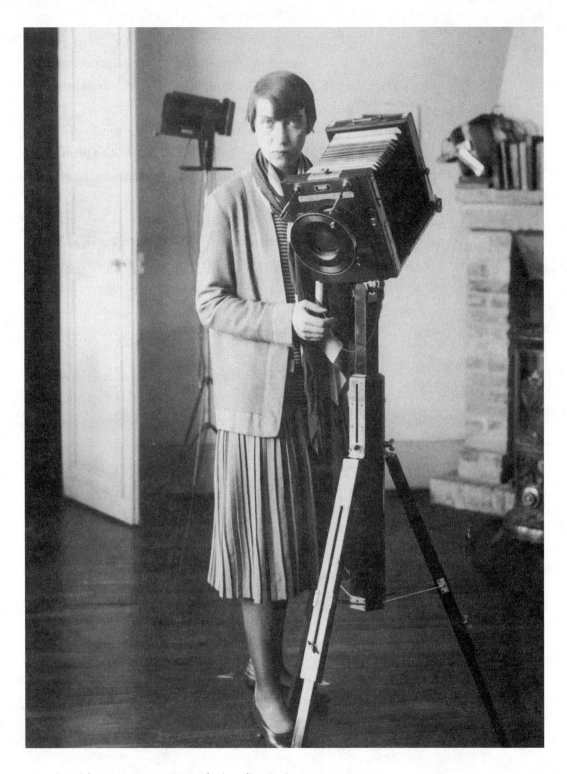

Berenice with a camera, rue Servandoni studio, Paris, 1928. Keystone-France

suit, standing with an imposing studio camera on a large wooden tripod. *Paris Phare* praised her "very sure taste and an exact knowledge of the play of light and shade upon the human countenance." The little magazine *Chantecler* raved: "Her simple portrait descends from Holbein, I want to say with the most naked truth, the most modest, the least pretentious. This human representation evokes a religious emotion. It is a bare countenance, bathed in the morning light. . . . Berenice Abbott knows perfectly how to let her emotions go in order to present her characters according to their own actions." The collector, critic, and anti-surrealist Pierre Mac Orlan wrote, in *Les Nouvelles Littéraires*, translated imperfectly by Berenice, "Those who look for details often subtle in the fantastic social actualities will find photography an incomparable revelation. Berenice Abbott in her portraits has given an absolutely new significance to the interpretation of the lens."[46]

Berenice's success led to more magazine contacts. Lucien Vogel's new illustrated general-interest *Vu* used a proof print of her startling close-up of Cocteau's hands crossed over a felt hat. Agent Katia Hirshman, representing Condé Nast's *Vanity Fair*, arranged for the same image to appear in the stylish American monthly's pages, introducing Berenice's work to editor Frank Crowninshield. Berenice continued to furnish *Vanity Fair* with portraits; in the Condé Nast files today is a representative selection of her vintage Paris prints.

She tried to maintain high standards while marketing images intermingling the worlds of commerce and fine art. Though it was a common French practice, she told one magazine that it was "against her principle to provide publicity prints of her portraits . . . the picture is a very accurate and unretouched character study . . . that would satisfy the most critical taste. It could be 24 × 30 cm if you choose and well-mounted." She also offered a substantial discount for print purchases, evidencing the confusion between licensing an image for reproduction in a publication and producing a fine original print for a collector or an exhibition. The first decades of the photography art market, the 1970s and 1980s, saw opportunity (as Berenice would later join in) in the con-

tents of early twentieth-century file drawers of non-master prints that came to be considered "vintage" artifacts in their own right. "I may safely say," Berenice subsequently (if unsuccessfully) reminded another agency dickering over her commission, "that as a portrait photographer I rank the highest here, and do very exclusive work."[47]

Berenice joined a small group of regular contributors to the new Belgian illustrated journal *Variétés*. Her first picture appeared in a double spread opposite Man Ray's, with Berenice's portrait of the Cuban dancer Caridad de Laberdesque facing his of writer and *Jazz* editor Titaÿna. Berenice liked Laberdesque but criticized her for her indolence and her impatience—Laberdesque felt she deserved instant music hall fame. Eventually, she became addicted to drugs, which "finished her," in Berenice's words. Drugs held no attraction for Berenice, although they were semilegal then and available in Montparnasse. Decades later she denied even knowing "anyone who took drugs. . . . They can really take you." She also photographed the American dancer and choreographer Helen Tamiris, capturing the dancer's renowned animation, her flaming red hair and outsize glamour—drama that was the antithesis of what *Chantecler* had called Berenice's "Holbeinian" studio work. Later in New York, Berenice would continue to be fascinated by dance.[48]

Variétés next printed a double-page spread of Berenice's portraits of Thelma Wood and Marie Laurencin facing similar portraits of lesser figures by her and Man Ray, a foursquare layout that emphasizes the images' stylistic correspondence. A later issue featured portraits of various photographers themselves, the celebrities of the moment. Berenice was also negotiating with German firms to establish outlets for her portraits of public figures and artists. "If it is inconvenient that I write in English, please inform me and I shall write in French or my bad German," she offered. Her business correspondence was prepared by Vassar graduate Julia (called Julie) Oppenheim Reiner, a sturdily built, dark-haired divorcee who had taken Dora's place as Berenice's companion and who acted as secretary and business manager and soon, more significantly, as banker.[49]

In the winter and the spring of 1929, two large contemporary international photography exhibitions were organized in Germany: *Fotografie der Gegenwart*, in Essen, and *Film und Foto*, popularly called *FiFo*, in Stuttgart. At Germaine Krull's suggestion, Berenice sent her own work and Atget's to both, but it was the *FiFo* that effectively launched contemporary photography into international art consciousness, by featuring a roundup of all nationalities and expressions in creative photography—from photograms by Man Ray and Moholy-Nagy and collage by Hannah Höch, to examples of applied and industrial imagery, from x-rays and photomicrography to aerial and astronomical camera work.[50]

SHOCK OF RECOGNITION

Atget: Balzac of the Camera

Paris (1925-28)

*The artist is not distinguished either by the quality
or the amount of his feeling, but by the intensity and
comprehensiveness of his unifying perception. He must be able
to look long and hard. His seeing must also be cumulative.
He learns to see just as other persons learn any other subject.*
—LEO STEIN[1]

Atget had no personal life. He lived entirely for his work, his
art. . . . Light was his medium. . . . He was the most important
forerunner of the whole modern photographic art. —BA (1929)[2]

The Surrealists claimed the photographer Eugène Atget as one
of their own. Man Ray was his neighbor on the rue Campagne
Première. Early in the 1920s, the aging commercial photographer
had sold much of his abundant archive, consisting of photographs of old
Parisian architecture and monuments, to French government agencies.
On his own initiative, he said, he had completed this collection of "artis-
tic documents of beautiful urban architecture from the 6th to the 19th
centuries." Now he was turning to modern urban subjects.

As de facto picture editor of *La Révolution surréaliste,* which began

publishing soon after André Breton's first *Surrealist Manifesto* in 1924, for a brief interlude Man Ray sang Atget's praises, hung his photographs on his studio walls, and even emulated his street scenes in a rare series of neighborhood snapshots. He put Atget's *Eclipse 1912* on the cover of *La Révolution surréaliste*'s summer 1926 issue, with the provocative title *Les Dernières Conversions (The Last Conversions)*; an engaging image of an informal public gathering was thus repurposed as a jab at religion. More Atget photographs appeared in the journal before it folded in December 1929.

To the early surrealists, Atget's new images—turned backs, crowded shop windows, advertisements, vacant public venues, and marginal urbanites such as rag pickers and street vendors—were fascinating, for all the wrong reasons. The surrealists championed the accidental and the automatic; bent on seeing the exotic in the everyday and the unfamiliar in the commonplace, they misinterpreted Atget's reflections and accidental multiple or blurred images of motion as otherworldly explorations. They were especially taken with a recent commissioned series of Parisian prostitutes, unusual for Atget, whom they considered artistically naive and ignorant of his own exceptional visual achievement. Within a year of his death, in August 1927 at age seventy, his work was taken up by a cultural world that misread the authentic optical artifacts of his photographic practice as deliberately fantastic, disquieting inventions. Adopting the late photographer into the surrealist canon, journalist and poet Robert Desnos compared Atget to the "primitive" painter Henri Rousseau, observing that his straightforward photographs of apartment interiors suggested crime scenes.[3]

Berenice found the surrealists' ideas meaningless. When Man Ray first showed Atget's images to her in 1925, they sparked in her "a sudden flash of recognition—the shock of realism unadorned." She never forgot the first one she saw—*Boutique d'articles pour hommes, 16 rue du Petit-Thouars (3e arr.)*. It showed a crowded storefront with graceless signage over the windows and wares arrayed on the sidewalk; top-hatted mannequins flanked the doorway, while a dozing woman in the lower center

nodded slightly during the exposure, leaving a ghostly trace. Berenice had never seen the everyday world so visually sequestered, its features isolated and elevated for her consideration.[4]

Atget was not "aesthetic," she wrote early on. "With the marvelous lens of dream and surprise, he 'saw' (that is to say, photographed) practically everything about him, inside and outside Paris, with the vision of a poet. As an artist he saw abstractly, and I believe he succeeded in making us feel what he saw." Atget's "subjects were not sensational, but nevertheless shocking in their very familiarity," she allowed. "The real world, seen with wonderment and surprise, was mirrored in each print. Whatever means Atget used to project the image did not intrude between subject and observer."[5]

For Berenice, Atget's images were not unconscious but hyperreal; to her they meant "photography." Their specific depictions of the visible world—reflections, isolated subjects, and the dross of the everyday—exemplified the true purposes of camera optics. "Sure taste and an artistic audacity" possessed Atget, said another admirer. In this spirit, Berenice welcomed his juxtapositions, blurred figures, and odd angles on curious subjects like tree forms as necessary collateral aspects of his intentional photographic decisions.

Atget's photographs helped Berenice solidify her artistic philosophy. Her belief that there is nothing so compelling as reality, no fiction so exciting as "the ordinary things about us if only one has the eyes to behold them," was bookended a lifetime later by her corollary claim that the photographer's role is to select "what is worthwhile to take the trouble about." Berenice thought that in miscategorizing Atget as a primitive, Man Ray and other artists overlooked his sophisticated accomplishment—for the simple reason that he neither intellectualized his work nor socialized in cafés like a bohemian. Atget was equally dismissive of them: When his photographs were reproduced in *Révolution surréaliste,* he declined even to be credited.[6]

"How tall was he?" Berenice mused on the occasion of Atget's centenary. "Perhaps five feet nine or ten inches. He was very thin, as well

he might be after twenty years of sugar, bread, and milk. The wisps of hair were gray. What color were his eyes? Gray? Blue? I am not sure."[7]

Berenice knew little of Atget's biography: He had gone to sea as a teenager, like her older brother Frank; as a young man, he had acted in minor roles with traveling theater companies; and he had worked briefly for a humor magazine called, improbably, *Flâneur*—one who freely but purposefully wanders the streets. In his thirties, Atget took up landscape painting in an undistinguished post-Impressionist style, and then view-camera photography as a profession.

The medium was barely a half-century old when he mastered the simple equipment that became his mainstay. His camera was a heavy light-tight wooden box, more than a foot square, with a brass barrel lens fixed on one side and a flexible leather bellows connected to a frosted-glass focusing screen on the other. For stability the camera required a stand, a tripod—in Atget's case, a folding three-legged contraption attached to the camera body. To make a photograph—once the scene or subject was selected and the image framed precisely—the operator focused a view, closed the lens (or shutter), switched out the frosted-glass for an unexposed glass negative (a sheet of clear glass about 8 × 10 inches, coated with a dried thin film of light-sensitive silver salt emulsion), and reopened the lens for a fraction of a second or longer, depending on the light and the subject. All of this activity took place under a dark cloth, a heavy, tablecloth-sized black drape that completely covered photographer and camera, leaving only the lens protruding. Controls for focus and exposure were few and depended on features of the lenses employed; the bellows allowed latitude in angle of view, functioning somewhat like a modern zoom lens, from wide-angle to telephoto. Light admitted through the lens would record a selected view in reverse tonalities on the glass negative, which would be developed and fixed later in the darkroom by means of chemicals in solution. Contact printing from the negative was the last step to produce positive photographic prints. Into the 1920s Atget used an old-style wooden printing frame to hold his preferred nineteenth-century type of photographic paper, coated with

albumen (egg white) and light-sensitive chemicals, against the glass negative. The print "developed-out"—that is, the image emerged as it sat in sunlight—and then Atget "fixed" it by rinsing it in plain water.

After settling in Paris in the 1890s, Atget began to photograph the city and its surroundings systematically. Clad in shabby work clothes, stooped from carrying his heavy equipment, he became a familiar figure in all quarters. His clients were artists, designers, and antiquarians who sought documentary photographic records rather than scenic views. The Montmartre painter Maurice Utrillo is especially known for having drawn upon Atget's cityscapes. In his candid small-trades series, Atget photographed everyday Parisians: an organ grinder, a child singer. He photographed a crowd of people observing an eclipse. It was all a form of documentary street photography.

In 1920, after thirty years of taking pictures, Atget sold many of his glass-plate negatives to the French government; previously he had sold only prints, not negatives, the basis of his livelihood. After the deaths of his stepson and wife he was entirely alone. Frugal, independent, opinionated, and strong-willed, he was single-minded about his work, and unconcerned with material success or new technology. He resumed photographing old locations and new, and did the rare commissioned portraits, his style becoming more personal and introspective. Man Ray had tried to interest him in modern handheld cameras, but he said that they worked faster than he could think.[8]

Berenice visited Atget's atelier three or four times after her first solo exhibition in June 1926. This "beautiful old man," as she called him, left her in his austere workroom to look through his topical albums and make selections. Like a picture agency or library—because he needed to retrieve images quickly, by subject—Atget scratched a unique identifying number into the emulsion of his thousands of glass negatives, a standard practice dating to the earliest topographical photography of the Near East and American West. He also classified his work by theme, or generic subject: landscape documents, Old Paris, picturesque Paris, environs, and street-by-street topography.[9]

Berenice never saw Atget's comfortable middle-class apartment and imagined he was even poorer than she. She set aside her image selections and paid for prints when she could afford the five or ten francs Atget charged for making a new one. She was drawn particularly to the touching eccentricities of his *Ragpickers' Hut* of 1910, the first print she purchased from him. She expected others to be equally impressed by this remarkable figure right out of Balzac's Paris stories—she called Atget "a Balzac of the camera"—and encouraged Cocteau, Robert McAlmon, and James Joyce, among others, to buy from him.[10]

Over time, the two solitary and self-reliant personalities warmed to each other as Berenice absorbed Atget's stories of the difficulties he had encountered in photographing locations as far away as Amiens. His calm and purposeful tenacity in the face of hardship and indifference impressed her; his near-ascetic example of uncompromising solitude and unwavering commitment would become a steady if tacit source of inspiration and courage through her decades-long struggle as an independent photographic artist. Remarkably, she said she never showed him her own photographs, perhaps because they were portraits, a genre Atget never on his own indulged in—and which Berenice was increasingly, if unconsciously, finding artistically unsatisfying.[11]

She would take the only known formal portrait of Atget, persuading him to pose at rue du Bac in the spring of 1927. If she pigeonholed him as an unworldly romantic, he refused to be patronized, and to her surprise, he accepted her overture as a fellow artist, donning a suit and handsome overcoat for the sitting instead of his usual work clothes. The lack of a "costume" did not keep Berenice from capturing his slumped shoulders, symbolizing for her his thirty years' labor "tugging about his bulky 18 × 24 cm view camera and heavy glass plates." Along with these profile angles, Atget positioned himself facing her camera and, evidencing his long-ago theatrical flair, gave Berenice the barest hint of a skeptical smile, which she captured.[12]

Months later, "after a delay due to the rush of life," which involved grappling with fractured relations between Djuna Barnes and the bar-

Eugène Atget, Paris, 1927. Berenice Abbott

oness, plus trying to sustain her portrait business, Berenice went to Atget's building to deliver her portrait proofs. She walked up the stairs and, not seeing his familiar studio door sign, *Documents pour artistes*, thought she had climbed too high.

> So I walked down the stairs, and still I did not see the sign. I went to find the concierge.
> "Where is M. Atget?"
> "M. Atget is dead."

He had died on August 4, with no public announcement. Berenice was shocked to realize how frail the seventy-year-old must have been at their last meeting. Her next thoughts concerned Atget's archive and camera. The concierge had only an incomplete address for his executor, André Calmettes, a film director and theatrical colleague. With a girlfriend's help, Berenice rang doorbells on both sides of his street, the nearby rue Saint-Guillaume, until she learned that he was now in Strasbourg, serving as artistic director of the municipal theater.[13]

She wrote immediately to Calmettes about the disposition of Atget's studio contents. Anxious to dispel any notion that she was merely an idle rich American with time and money to spend on a whim, she enlisted Jean Aurenche to help convey her sincerity in proper French. Calmettes answered that Atget's remaining archive was available but that his big wooden camera was gone with the furniture. He came to Paris to meet Berenice in the winter of 1928 and she photographed him flashing a grand, relaxed smile in her rue du Bac studio. Relations with Calmettes expanded afterward to include his wife, Suzanne; the couple began spending time with Berenice and Julie Reiner.[14]

Berenice would later contend that her passion and youth had won Calmettes over, that he considered her not only a champion of his late friend's work but also energetic and young enough for the task of keeping his legacy alive. In addition, she could afford to buy it, though not with her own funds. Rather, Berenice was able to purchase Atget's

Julie Oppenheim Reiner, New York, 1929–30. De Hirsh Margules

archive, for 10,000 francs (just under $10,000 today), with Reiner's money—a loan kept secret all their lives. She did so in June 1928.

Man Ray would later claim wrongly that Berenice's brother Frank had provided the funds; decades following the sale, he was still piqued that she had had the perspicacity to acquire the archive. The siblings had indeed managed a hasty reunion in Cherbourg, but only because Frank's ship was in port (he died the following spring in a New Orle-

ans naval hospital, with their mother at his side). It took Berenice a long time to realize how resentful Man Ray was of her acquisition; in 1975, she called his assertion that it was he who had discovered Atget "nuts." Reiner and Berenice would drift apart within a few years, only to reconnect decades later when Atget's profile rose with publication of Berenice's *The World of Atget* (1964).[15]

Parisian art critic and writer Florent Fels, who had also bought photographs from Atget, was the sole Frenchman seriously interested in the future of his archive. Fels had proclaimed, "[A] good photograph is, above all, a good document"—an echo of the sign on Atget's studio door. By the spring of 1928, with the matter settling in Berenice's favor, she lent Fels, one of the organizers of the *Salon de l'Escalier*, several Atget photographs, along with a dozen of her own. She realized only much later that this was the first flowering of serious interest in photography in France, which she found particularly striking since it was "the land of Daguerre," one of the early nineteenth-century inventors of photography.[16]

Arts journalist Georges Charensol addressed the attraction of realism and truthfulness, and the role of Nadar (Gaspard-Félix Tournachon), the pioneering French portraitist, whose forthright portrayals of well-known French public figures led off the exhibition at the Comédie des Champs-Élysées. "In the case of Berenice Abbott," Charensol wrote, "it is the human face reduced to its essential lines, with due regard for character." It was only Berenice's second time (after her 1926 exhibition) on so grand a stage, yet her generous enterprise and well-intentioned efforts on behalf of Atget required her to share it with him.[17]

Pierre Mac Orlan, who would later write the introduction to Berenice's 1930 Atget book (*Atget: Photographe de Paris*), divided photography into two streams, artistic and documentary. The latter, he claimed, with its capacity for narrative, mood, and specificity—exemplified by Atget—was unconsciously artistic in a way that pertained more to literary than to visual art. Mac Orlan also brought a sociological understanding to the postwar experience of "*inquiétude*" (unease or anxiety). He called it "*le fantastique social*" and saw one type of new photography

as its logical visual expression. "For those who look for the often subtle details of modern society, photography is an incomparable revelation," he wrote. Berenice echoed this thought in her later writing on Atget: "The photographer's punctilio is his recognition of the *now*—to see it so clearly that he looks through to the past and senses the future . . . the photographer is the contemporary being par excellence; through his eyes the now becomes past." For many more viewers, as critic Roland Barthes's 1980 *Camera Lucida* conveyed so affectingly, the particularity of photographic imagery is among its most compelling features.[18]

What Mac Orlan saw as unease pervading Atget's streetscapes and empty views struck Berenice as a tender and subtle emotion felt, by Atget, for his subjects. This quality connected her to the old photographer, and resonated with her dawning aesthetic of realism as a representation of the photographer him- or herself. Berenice's own cityscapes, as Rosa Reilly commented a decade later in *Popular Photography*, would "portray detail with simplicity, clarity, and tenderness," an undertone that never touched on (unwelcome) sentimentality.[19]

Berenice once explained to a newspaperman—who said that she loved cities the way other women love fur coats—that she was "sort of sensitive" to them. "They mean something to me. They have a personality. Not the people in them, but the buildings, the little odd corners." In a profile for the popular magazine *Coronet*, Berenice's fellow New School instructor Robert W. Marks compared her to Marcel Proust: Both, he said, had inseparable links with the past, and both lived with "obsessing memories of streets and buildings, old scenes and places." Though Marks implied that Berenice's tenderness toward the built environment served as a highly selective substitution for human emotional contact, he let her off with a gentle accusation of "nostalgia recurrent as hay fever." Years later, teaching the unbroken relationship of today's photography to yesterday's, Berenice would explain how Atget "simply and tenderly" used "luminosity to show that streets have mood and personality as much as people."[20]

She loved Atget's unmediated perception of reality—an expressive directness she would soon discover in photographs from the medium's

Rue de l'Hôtel de Ville, *Paris, 1921.* Eugène Atget

earliest decades. From this "stylelessness" she would forge her own philosophy of photographic expression. Atget's greatness lay in his "conscious intent in permitting the subject photographed to live by virtue of its own form and life," Berenice wrote, "rather than by the false endowment of memory and association."[21]

A photographer's cerebration, she believed, is explicit in unadulterated images: "Every motion, line, area in a picture denotes the greatness, or pettiness, thought or lack of thought, of the photographer. The photographer himself is written all over the picture." Indeed, Atget's closest practitioner in our time—after the literary Walker Evans, Berenice's contemporary—is arguably Robert Adams. Adams's direct compositions and optically pure images, though highly intellectualized, evoke the instinctive sensibility of Atget without the overlay of nostal-

Broad Street Looking Toward Wall Street,
Manhattan, *July 16, 1936.* Berenice Abbott

gia that, despite Berenice's disclaimer, can cloud contemporary appreci-
ation of the Frenchman's work.[22]

> This acquisition represents something more than
> the purchase by a wealthy person of a well-known collection,
> since at that time I was very poor and struggling to
> establish myself in Paris, and the work of Atget was
> comparatively unknown and unrecognized. —BA[23]

BERENICE TOOK PHYSICAL possession of the Atget archive at about the
same time she relocated to the rue Servandoni. Her shelves and mantel
were stacked with folders and binders comprising the collection—more

Many scenes of Paris life, including that of the pre-war street
singers (below), photographed by the late Eugene Atget (upper
right), are being preserved by an American girl photographer, Bere-
nice Abbott (upper left), as "works of art."

*Newspapers throughout the United States picked up
the syndicated story about the enterprising American
girl and her French discovery, October 1928.*

than 1,500 glass negatives and 8,000 original prints—visible in the full
negative backgrounds of several portrait sittings from this time. Some
prints escaped Berenice's scrutiny for decades because they were curled
into tight cylinders that she had never risked damaging by trying to
unroll. An Associated Press release, "American Girl Finds Photogra-
pher's Plates Showing French Life," was published as far away as Idaho.

"Critics say [he] was a forerunner of most that is good and nearly all that is new in modern photographic art," read the text, which dismissed French interest in the work and made Berenice sound like a rescuing angel, albeit a heavily mascaraed flapper, to judge from her accompanying portrait photograph. When Albert Valentin published a long article in *Variétés*, articulating Atget's lyrical contemporary vision, Berenice sent a copy to André Calmettes to demonstrate the reach of his friend's reputation and to confirm his faith in her stewardship of the work.[24]

Berenice recognized that the French were simply too familiar with Atget's subjects to be further interested, and she planned to promote the archive in the United States. Julie Reiner also wanted to start recouping her silent-partner investment, so the pair made a quick visit to New York in January 1929. Berenice returned to France alone in early April and hired a fledgling Dutch photographer, Lood van Bennekom, to help her ready the collection for transatlantic shipment. For two laborious weeks, they cleaned Atget's glass negatives and placed them in new envelopes. (Likely they did not realize or consider that their action might destroy Atget's original documentation or other historical features.) Berenice installed van Bennekom in her studio as an assistant and returned to the United States aboard the speed-record-holding RMS *Mauretania*. Her twenty-one pieces of baggage included seventeen professionally packed crates of Atget's archive. Anticipating the treasure's arrival, the *New Yorker* and the *New York Times*, which valued the collection at $200,000 (nearly $3 million today), both intimated that there would be upcoming Atget exhibitions.[25]

Berenice expected to capitalize the archive readily by selling individual prints and ultimately the entire holding, as her 1930s price lists show. She believed "it would go quickly instead of taking forty years!" And she had no inkling that its ownership at the start of her creative career would make it so difficult for critics and fellow photographers to separate her from Atget. Her city-sized ego would wind up carrying the creative burden of two artists, a sacred trust that also became an encumbrance. When, four decades later, the Atget collection was finally sold

to the Museum of Modern Art, Berenice was relieved. Pestered about having "sublimated" and "really sacrificed" herself, she wearily replied that she hadn't meant to and didn't want to. "It is always easier to admire the dead than the living . . . I sold what I could of myself, but people wanted Atgets."[26]

The nineteenth and the twentieth centuries are very different periods; and the work done by artists in the two centuries is very different, too. . . . I live in a world where the basic facts are contradictions, conflict, insecurity. My work is, I hope, realistic and expressive of the time's critical spirit. —BA[27]

BEGINNING IN THE 1930S, as the work of Atget became better known, Berenice and others who photographed urban subjects in a straight documentary style were deemed his disciples. Though she would eventually resent the comparison, in these early years she could not disavow the parallel; indeed, when discussing her work, she was often the first to mention Atget. Temperamentally, she naturally sided with the underdog. Her life partner, the writer and critic Elizabeth McCausland, quipped that Berenice was always rescuing some stray—such as Atget in Paris, anarchist Havel, and, soon, photographer Lewis Hine—from whom she then needed rescuing.[28]

At the time, acquiring Atget's archive was personally empowering and aesthetically validating, spurring a new phase of Berenice's own artistic career. Moreover, the art of photographing and mastering her subjects was becoming as essential to her (as she had said of Atget) as writing was to James Joyce or flying to Lindbergh. Yet the emotional commitment to Atget's memory detracted from the considerable self-interest a growing artist needs to muster, sustain, and exercise constantly. As she grew creatively, simplistic comparisons between her and Atget made her livid.[29]

Highlighting Atget whenever the opportunity arose alarmed sup-

porters who knew what a psychic toll the comparison cost. "I think it is bats to drag in Atget here," McCausland said in the 1950s, chiding Berenice as she revised a manuscript, "especially as you are so super-sensitive about any creative relation between your work and his." At the end of her teaching career, Berenice claimed that her own style was "difficult to imitate" and took pride in those of her students "who could stand on their own two feet." Yet, at that mature date, she was also more willing to concede that Atget "is fairly easy to imitate and there are occasions when it cannot be avoided."[30]

In truth, her commitment to Atget's archive was fused with her artistic discovery of New York as subject matter. Atget's independence, persistence, and scale of operation provided an eager and impulsive thirty-year-old Berenice with a new goal: not to replicate his work in New York but to emulate his self-direction. As she grew, she became clearer about the differences between them. "Atget," she said, "lived in the nineteenth century and I live in the twentieth." Paris and New York "are vastly different in almost every respect . . . being a half-century apart, the interpretations differ qualitatively. . . . Atget was a poet, romantic, tender. But . . . I live in a world where the basic facts are contradictions, conflict, insecurity."[31]

Berenice asked West Coast photographer and teacher Ansel Adams, who was organizing an exhibition for the 1939–40 San Francisco Golden Gate International Exposition that would include both her and Atget, to install a wall label pointing out their differences. She was delighted when the Swiss cultural historian Sigfried Giedion, pointedly referencing the title of her New York series *Changing New York*, called it "not an imitation of Atget . . . in the U.S.A., but the real 'Changing' world so characteristic or typical for your country."[32]

As late as her "rediscovery" in the photography boom of the 1970s, Berenice still had to correct the record of her artistic independence. Revising the manuscript for Anne Wilkes Tucker's survey *The Woman's Eye* (1973), she scratched out the young photo historian's innocently penned phrase about Berenice's photographing New York "in much the

same way that Atget had so patiently and lovingly photographed Paris" and scrawled "no!" in the margin.[33]

New York Times reviewer Gene Thornton recognized the difference. Paris was vast and monumental but also orderly and composed, already a work of art; New York City had appeared as a "happening of monstrous proportions without any visible order or human scale." And those were the qualities, alone and juxtaposed, new and old, that had captured Berenice's imagination. As she told a Chicago newspaperman, "I wasn't in love with Atget. I was in love with New York. And that's very, very different." Unlike Atget, who spent three decades photographing Paris, Berenice would wrap up her New York photographic passion in a few years and move on to make another compelling new subject her own, science.[34]

Yet the practical burden of caring for the Atget collection remained, as did the investment Berenice expected to recover. Stubbornly ignorant financially all her life, Berenice priced the collection at $50,000, a ridiculous sum in the Great Depression and still wildly high for a photo archive years later. Not until the 1960s would serious institutional acquisition occur. In the decades between, Berenice exhibited, published, and sold Atget reprints from his negatives at various prices, and barely broke even.[35]

Her near-daughterly attachment to Atget was deeply rooted. Her own father's failings left her hungry for a father figure to rescue and cherish, and be cherished by. In Greenwich Village, three grizzled mentors had adopted the teenaged Berenice, but she was the needy one then. Atget had responded warmly to Berenice's youthful energy and androgynous charm, but offered a more mature fulfillment of filial rapport. His sudden death sealed her perception of him as a forlorn figure whose legacy she would ensure.

She told publisher Leslie Katz that she'd once run "away from home to get away from my father and there in Paris I'd found I'd taken on another." To MoMA staffer Barbara Michaels, she said that stewarding the archive had been like caring for an aged father. In the early 1970s,

she gave photographer John Goodman a cold reception until he won her over by saying that in her front-facing portrait of Atget, he seemed to be regarding Berenice as if she were his daughter. With that, she showed Goodman box after box of Atget prints in her studio.[36]

Astute observers understood all this. Robert Marks called Atget's rescue "a clue to wellsprings in Miss Abbott," a psychological knot that "hits deep, dark, Freudian things." A quarter-century later, a less patient witness, longtime photographer friend Irene Shwachman, wondered if Berenice, who disdainfully mocked photographer and patron Dorothy Norman for using Alfred Stieglitz as a father image, had any self-awareness at all.[37]

Even at the end of her life, Berenice's cultural contribution on behalf of Atget would be celebrated alongside almost an obliging recognition of her own creativity. Curator Beaumont Newhall selected Berenice's 1929 *Creative Art* essay on Atget for his anthology *Photography: Essays & Images*, ignoring her mature photographic writing entirely. The French government's Legion of Honor in 1988 and the Skowhegan School's posthumous service to the field award in 1992 commemorate Berenice's Atget rescue. Grace Mayer, the Museum of the City of New York's emeritus curator, memorialized Berenice in 1992 by claiming that she wanted to document New York "the same way Atget did Paris"; Leslie Katz compared her preservation of and dedication to Atget's lifework to Mendelssohn's rediscovery of Johann Sebastian Bach, "except Berenice was poor."[38]

NO SCRUPLES

New York (1929–30)

*One belongs to New York instantly, one belongs
to it as much in five minutes as in five years.*
—THOMAS WOLFE[1]

Finally I am quite certain of going to the U.S.A. the beginning
of the year . . . debating between New York and Cleveland. The
latter attracts me because it is my home city. —BA (1928)[2]

I n 1928 *transition* asked, "Why Do Americans Live in Europe?" Reply-
ing to a series of related questions submitted to them by the maga-
zine, expatriate writers including Gertrude Stein, Kay Boyle, Robert
McAlmon, Kathleen Cannell, and Harry Crosby cited tolerance, pri-
vacy, and freedom from commercialism, but to the first question, Why
do you prefer to live outside America?, Berenice scrawled, "I don't."[3]

Now thirty, Berenice, who had once loathed America and run away
from it, was ready to return home. A "nostalgic sap" had been rising for
some time, bringing with it homesick longings for American common-
places. She told Dot Whitney, one of her "society gal" friends, how she

hungered for pancakes at Childs, a modest national chain restaurant. With tea dancing in some of its locations, Childs was one of the few acceptable public places for gay women to meet. Intellectually, Berenice had been impressed by industrialist Henry Ford's book *Today and Tomorrow* (1926) and André Siegfried's *Les États-Unis d'aujourd'hui* (1927; published in English as *America Comes of Age*). Both made the nation's soaring industrialism—"the dynamic force of the human impulse," Siegfried called it—sound spiritually transformative. But when he added that "America has no national art and does not even feel the need of one," Berenice did not agree.[4]

She had renewed her US passport, telling the State Department that she planned to return for an exhibition of her photographs. Although she tried to elicit interest in showing her work at Chicago's Marshall Field's—and in Toledo, New York, and Cleveland—in the end, no offers were forthcoming. Her European publishing contacts, however, were quite interested in American life. *Variétés* editor Paul-Gustave van Hecke specifically suggested that she find authors John dos Passos, Ernest Hemingway, and Sherwood Anderson to photograph; Edouard Léon Théodore Mesens of Galerie L'Époque expressed interest in city views, mechanical constructions, and *"photos de reportage."* Gustav Stotz, organizer of the *Film und Foto* exhibition, asked Berenice's help in contacting American photographers who specialized in industrial subjects, especially Ralph Steiner. Berenice offered also to try to contact Edward Steichen and Charles Sheeler on his behalf. Eugène Jolas of *transition* simply asked her to keep them in mind should she "come across anything startling." Ernst Mayer of Mauritius-Verlag was specifically interested in pictures of factories, Chinatown, New York's working-class neighborhoods, and store display windows, and in theater shots.[5]

For Thanksgiving in Paris, on November 29, 1928, Berenice and Julie Reiner arranged to have a local bakery roast a turkey for them. On January 16, 1929, they sailed for New York. The main enterprise was to create interest in Atget's archive on the American side of the Atlantic by finding venues for exhibitions of his photographs and her own and

Self-portrait [?], renewed U.S. passport, March 1929. Berenice Abbott

promoting her Atget book, already under contract with the French publisher Henri Jonquières. Berenice planned for this exploratory return to last just six weeks. From Reiner's parents' home across the Hudson River, in Orange, New Jersey, the winter commute to the city was quick and safe via the new Holland Tunnel.[6]

> When I saw New York again, and stood in the dirty slush, I felt
> that here was the thing I had been wanting to do all my life. —BA[7]

FROM ATOP THE open-air Fifth Avenue bus in brutal winter weather, Berenice reveled in "all these awful buildings and the good build-

ings. . . . The new things that had cropped up in eight years, the sights of the city, the human gesture here sent me mad with joy." As Manhattan churned all around her, she felt "keenly the neglect of American material by American artists . . . America to be interpreted honestly must be approached with love devoid of sentimentality, and not solely with criticism and irony."[8]

She claimed she "always had this 'instinctive feeling' about cities," and now photographing New York—its buildings and infrastructure changed so enormously in the Roaring Twenties—became her new passion. With the American economic boom appearing to go on forever, and with it transatlantic life, Berenice opened a second front, a branch portrait studio in New York City, building on the international reputation that preceded her. She chose the elegant Hotel des Artistes, Manhattan's largest studio apartment building when it opened in 1917. There, at 1 West Sixty-Seventh Street, next to Central Park, she could continue her bread-and-butter portrait work while photographing the city and promoting Atget.[9]

The crucial changes in Berenice's life, like this one, had come almost always on impulse; her initial aims were vague and speculative, her choices unfolded slowly, and her course of action rambled. For a year, her new "Portrait Photography" stationery carried two addresses, one for each side of the Atlantic. At $200 a month, Berenice's small apartment was not cheap; but she expected growth for her portrait business and licensing fees for her and Atget's photographs. Janet Flanner had written of an imminent exhibition of Berenice's portraits, which didn't happen, and many months passed before the city glimpsed any of her signature portraits—or her New York City views.[10]

Her working method for capturing New York evolved slowly, as she tried out a variety of styles of seeing, informed by Atget's photographs and those of her contemporaries in Europe. The city revealed its character in increasingly nuanced ways. Initially, she gave free rein to the formal modernist vocabulary, the "*Vertikal-Tendenz*" of angle views and skewed perspective, to tackle subjects unique to New York City—the tight fit of

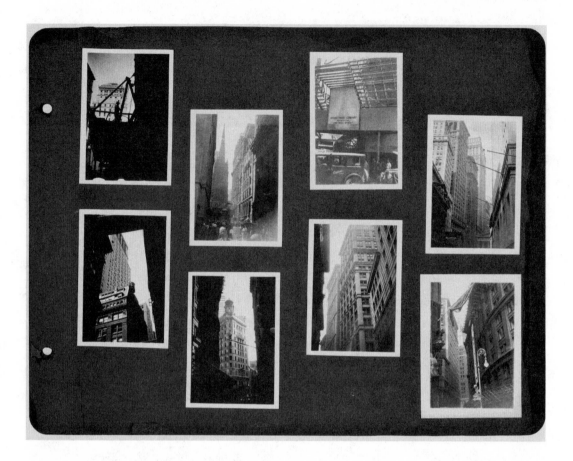

Typical layout page from Berenice Abbott's snapshot album, New York, 1929.

buildings and streets that allowed no overview, the stark contrast between sun and shadow at any time of day, the discordant arrangements of shapes and subjects. She kept her little contact prints in a conventional black-paper photo album grouped by location, topic, or interpretation.[11]

Her layouts mimicked illustrated magazines; she tried to present the work in arrangements such as Lucien Vogel's photography-dependent *Vu* used. The album's only captions appear with parade images taken on Decoration Day, May 30. Early on, Berenice encountered the total disappearance of a desired subject—gone, torn down—between the time she discovered it and returned to the location weeks later. The experi-

ence instilled a sense of urgency; she felt compelled to be more strategic whenever she saw something interesting, to "hurry up and do it because the newer things I could do later." Berenice, one journalist observed, had been "in the right frame of mind to discover New York. . . . Paris lived in the past. London was static. New York was of the present; changing, growing before her eyes."[12]

Using both of her cameras—her 13 × 18 cm view camera (similar to a 5 × 7 inch portrait camera), with a reducing back to make the size 12 × 9 cm, and the Graflex she'd acquired for shooting the Guggenheim children—Berenice had a small body of work to take back with her in March, processed and contact-printed at local nonprofessional labs. After her initial haphazard search for the subjects requested by her European publishing contacts—"walking around with a little camera to take notes of what I wanted to see"—she began to devise a method that "started with the waterfront and worked northward," paying special attention to buildings coming down or going up. She relied on a record of "tiny photographic notes," concentrating on the light in order "to figure out the time of day that it would be right, and then go back." She kept her small enlarger from Paris until some years later, when she acquired a high-quality Saltzman model.[13]

"How can anybody but a photographer hope to-day to fix for posterity the image of the modern city?" Berenice wrote that fall in *Creative Art*. Ostensibly the question pertained to Atget, but she was also describing her own evolving goals. "It is not profitable to discuss whether or not photography may be an art," she argued. "Results will speak in due time . . . Atget was not 'aesthetic.' With the marvelous lens of dream and surprise, he 'saw' (that is to say, photographed) . . . with the vision of a poet. As an artist he saw abstractly, and I believe he succeeded in making us feel what he saw."[14]

The June 1929 issue of *transition* carried Berenice's first published New York photograph—a vertical view down Hester Street showing a pair of trousers hanging sideways like a flag in front of a shop's stone steps. The image echoed Atget's subject matter, but captured it

with a modernist's formal interest in off-balance perspective. Though Berenice felt she was floundering around that summer, she placed other speculative New York pictures in European journals where she had connections. The issue of *Variétés* dated August 15, 1929, printed four skyscraper views, two to a page, titled "Photos Berenice Abbott." The December 15 issue printed her disorienting view looking down from the platform, *El at Columbus Avenue and Broadway*, in a section called "Mélancolie des villes" alongside more city photographs by Herbert Bayer, Germaine Krull, Ewald Hoinkis, and Lux Feininger; another section, "Paysages méconnus," included work by her friends Lood van Bennekom and Eli Lotar.[15]

Later, she would say that her early photographs of New York were sentimentally motivated by childhood memories of Ohio, "and when I saw similar things in New York, they seemed so American to me." Nostalgia lingered for almost a year, as she worked through the issue philosophically and aesthetically. Other "truly American" subjects that struck Berenice's fresh eyes were gas station pumps, for they looked "very Indian . . . like totem poles." She also made some of her earliest pictures of American subjects like cigar-store figures representing American Indians, and antiquated lighting fixtures, feeling later that though the pictures "weren't really very good . . . I was so excited that I just kept at it."[16]

Unconsciously, Berenice was partaking in a general rediscovery of Americana—the restoration of Williamsburg, Virginia, for example, and the promotion of folk art by her old friend Holger Cahill at the Newark Museum. She was drawn to modern feats of engineering construction, such as the George Washington Bridge, a suspension span with 600-foot-high towers connecting northern Manhattan and New Jersey, then just going up.

Her contemporary Margaret Bourke-White's alluring femininity inspired solicitude and cooperation in such all-male preserves; Berenice's independent and tomboyish manner encouraged pranks and teasing. Wanting to shoot the bridge from above, she persuaded con-

Hudson River (later, George Washington) Bridge tower nearing completion, New York 1930–31.

Berenice Abbott

struction workers to put her in the pan of their crane, but once she was high in the air, they swung the crane back and forth. Terrified, she managed to get several fine photographs of the bridge's anchorage and span, which appeared simultaneously the following year in two competing architecture magazines.[17]

But her first goal in the United States had been to promote Atget. In March she visited Alfred Stieglitz's Intimate Gallery, expecting "the old Stieglitz" to receive her "with open arms" as Man Ray's young friend, an expatriate bringing home a treasure. On view were photographs by Stieglitz's former protégé Paul Strand. Upon overhearing Stieglitz crit-

icize Strand's work to another visitor, Berenice decided protectively to drop the matter of an Atget exhibition, but waited anyway to speak with him. Stieglitz viewed Atget's prints indifferently, and then offered Berenice a glimpse of his own Equivalents series. She was appalled by these "mystical hocus-pocusy" cloud images and felt he didn't deserve Atget. Her enmity toward the éminence grise of American photography would grow; finally, she dismissed Stieglitz as a pompous egotist and hairy-eared cult leader who "took about five good pictures in his whole life." Stieglitz later said he regretted not knowing about Atget when he was publishing *Camera Work* (1903–1917).[18]

> I remembered Greek fish markets in Columbus, Ohio,
> where I grew up and when I saw similar things in
> New York, they seemed so American to me. —BA[19]

IT HAD BEEN MORE than eleven years since Berenice had seen her family. Finally traveling to Cleveland in late spring 1929, she arrived at the house where her sister, Hazel, was boarding while in the process of divorcing, and found no one there, as had occurred so often in her childhood. Hazel eventually returned from her shift at a commercial laundry; their mother soon followed from a nearby rented home she shared with Hazel's estranged husband, Otto C. Ross, and their teenage daughter, Alice—"homeliest thing you ever saw," said Berenice. She and Hazel clung to each other and cried, "making a fuss," while Hazel chided their mother: "Well, you never loved us anyway." Their brother Frank, the merchant seaman who was his mother's favorite, had died in New Orleans that January and was buried in Frankfort, Ohio; their mother, as Alice Wilson, would share a headstone with him in 1943. Berenice's favorite brother, Earl Stanley, had begun his dissolute, drug-addled life and was nowhere to be seen.[20]

Berenice drily termed all her subsequent visits to Ohio as "traumatic," although on that trip she spent one happy day with her Bunn

relatives near Chillicothe, including cousin Mary Virginia, a high school senior. The girl knew Berenice's mother as "Aunt Alice" (she was her grandmother's younger sister) and thought it odd that she spoke of Berenice only when asked directly and said only how nice a child she had been, as if Berenice the grown woman did not exist. Mary Virginia drove her around Ross County, stopping at covered bridges and at "the May Place," a favorite old house in Frankfort, where Berenice set up her tripod and camera on the roadside to take pictures. It would be her last contact with any of the Bunns outside her immediate family for more than five decades.[21]

> I would not feel right, commercializing sculpture. With
>
> photography, though, I have no scruples. —BA[22]

WHILE IN CLEVELAND, Berenice looked up Margaret Bourke-White, an eastern transplant and almost an interloper in territory where Berenice had once toyed with the idea of returning to open a portrait studio. The newly divorced twenty-five-year-old, whose steel mill documentation had been featured recently in the *New York Sun*, had set up a studio in Cleveland's tallest modern building to specialize in industrial photography. She'd chosen her widowed mother's adopted city over New York to avoid the cutthroat competition she feared would force her to accept hackwork just to survive. Berenice openly admired Bourke-White and her photography but also begrudged her "good luck"—an attentive father, a college education, and, as a young divorcee, a seductively feminine sense of fashion and regal helplessness that gave her a head start with male clients. Naively, Berenice expected the immediate artistic camaraderie she had known in Montparnasse, not to mention the worldly professionalism 1920s women enjoyed throughout the western world. Bourke-White, sensing less Berenice's gayness and more a potential business rival, was wary of Berenice's motives in seeking her out. Berenice left, "disgusted" by the overriding ethos of American competition.[23]

Nevertheless, when Bourke-White soon became the star photographer for the new *Fortune* magazine in New York, she recommended Berenice for portrait work, a standing assignment that helped provide income and cemented a mutual professional respect. Their work for illustrated magazines provided this common ground. For example, the illustrated avant-garde *Jazz* debuted in Paris in late 1928, with Berenice credited on the masthead, and featured her portraits throughout 1929. But none appeared in the special Portraits issue of January 1930. At last, the fifteenth (and final) issue, for March 1930, reproduced her photograph of an air shaft with fire escapes and hanging laundry from the very early Chinatown pages in her little black photo album, titled *Une Cour à New-York*.[24]

If you are not well off, you better not throw your
health away, because when you need a doctor
or sanitarium or something . . . —BA[25]

WHEN SHE GOT BACK from Ohio, Berenice was hospitalized in New York with pneumonia, a recurrent aftermath of her decade-old bout with influenza. With Julie Reiner looking after the Hotel des Artistes studio, Berenice was still recovering when the bottom fell out of the stock market and the economy spiraled downward. Black Thursday (October 24) and then Black Tuesday (the 29th) hit, plunging the Dow more than 11 percent, sending the nation, in tandem with an international, preglobal economy, into the Great Depression. President Herbert Hoover's term for what most assumed would be a temporary decline, "Depression" was softer than the traditional alarm of "panic" and "crisis." The economic effects were felt slowly. Wall Street recovered somewhat in the spring of 1930, only to slump by summer. Berenice and her clients were not yet badly affected by unemployment and drastic loss of income; rather, through 1930, domestic news was dominated by Prohibition and its lawlessness and by a deep drought in the nation's agricultural heartland.[26]

Berenice's flippant remark about having no scruples when commercializing photography, made well before the Depression hit, became pertinent as economic conditions worsened. In a 1930 interview, she insisted on the validity of her medium's remunerative role as time-honored and said that "the notion that artists must starve is nonsense." Her portraits and growing body of New York images helped feed the presses of Europe and America.[27]

Fortune, "the Tycoon's own magazine," as publisher Henry Luce called it, debuted in February 1930, combining the elegance of an art magazine with the fresh graphic spirit of the new European picture press. A monthly newsstand issue of *Fortune* cost four times the established business magazines, such as *Forbes* and *Business Week*. Feature photographs, including Bourke-White's, were showcased in large gravure reproductions; the back of the book held its own in design and picture editing. Berenice's shadowy study of RCA chairman David Sarnoff appeared deep inside the first issue of *Fortune*. Despite her later mastery, Berenice said that when she started photographing tycoons she hadn't yet learned any tricks for photographing "stinky little men."[28]

For the next three years, *Fortune* assignments were a reliable source of income. "There's nothing wrong with good, honest, commercial work," Berenice claimed, though "shooting magnates" was her ready answer when asked decades later about her least favorite job. When she photographed leading American businessmen in their offices, she found that she was unable to establish the kind of rapport she usually had with cultural clients in her studio. The businessmen were "vain nobodies [who] would sit there like a bag of sawdust," she told Joseph Mitchell, then a fledgling journalist, in 1932. " . . . A man with a weak face wanted to look like the Prince of Wales. I make portraits of authors and poets . . . and railroad executives." Decades later she told collector Arnold Crane, "The pictures were very bad because they looked too much like these people. . . . I love ugly people, but . . . they must have compensated by simply concentrating on money."[29]

In winter 1930, a wonderfully stylized and expressive bronze head

Portrait of Berenice Abbott, *New York,*
1929–30. Isamu Noguchi

of Berenice, emphasizing her deep-set, wide-open eyes and distinctive shock of hair over her forehead, was featured in a show by the young Japanese American sculptor Isamu Noguchi at the Marie Sterner Gallery. Noguchi had returned to New York following his Guggenheim years in Paris, where he began his abstract work, and resumed portraiture to earn a living, sculpting heads of friends and fellow artists to show potential patrons his range of styles. From his top-floor space in the Carnegie Hall Studios, casting first in plaster and then in metal, Noguchi completed more than two dozen heads within a year. In return, Berenice photographed Noguchi at the Hotel des Artistes. Later, when Noguchi lived briefly at the hotel and Berenice had left for cheaper quarters, he hired her to photograph sculpture because she was taking any photographs simply to earn a living. Though Berenice never really liked the Noguchi head, it eventually wound up in her possession, until the National Portrait Gallery in Washington, DC, bought it for its permanent collection in 1986.[30]

On the Sunday after Black Thursday, Berenice and Robert McAlmon took in the fall scenery of Sussex County, New Jersey, fifty miles west of Manhattan, with William Carlos Williams and his wife, Floss. At "a fine country inn with a bar in the basement," they drank apple brandy at Prohibition prices—fifty cents a glass—and played a penny gambling machine for cigars. After twenty tries Berenice and Williams each had won a five-cent prize, which they pooled to upgrade to a single ten-cent stogie for Williams to enjoy.[31]

Berenice and McAlmon went to New York clubs, hoping to re-create the nightlife of Paris, but "everybody sat in the dark," she said,

"being entertained by frenetic people who were overdoing everything and pounding on your nerves." McAlmon's usual reply: "Oh, my God, at least we got up and danced." Eventually, he "spoiled his health" by drinking too much. Berenice could hardly ignore the lingering effects of her bout with Spanish influenza a decade earlier. But it was only much later in life that she vowed not to "let drink get me." Even then, she indulged in champagne and beer, often while driving.[32]

The "dollar chasing and all that kind of stuff," as Berenice called her work for hire, was balanced by her ongoing photographic exploration of New York City. She set aside Wednesday afternoons for scouting locations, often accompanied, protected, and entertained by De Hirsh Margules, known affectionately as "The Baron." A Romanian-born poet and painter, he earned his living as a night police reporter with the New York City News Association, the legendary cooperative agency covering Manhattan and the Bronx, whose anonymous staff included many reporters who became literary figures. Shortly after Berenice settled in New York, Margules got behind the camera and took a handsomely pouty portrait of her and another, a double-exposure study, of Julie Reiner. Margules, like Berenice, was also a habitué of Romany Marie's Greenwich Village cafés. So, too, was Isamu Noguchi, who began a lifelong friendship in the Village with future visionary designer Buckminster Fuller, whom Marie had charitably hired as a "professional talker." A decade later, they joined Berenice and scores of others to stage a three-day benefit reunion for the beloved restaurateur, who read tea leaves and, though married, never got over her crush on Eugene O'Neill, also an early customer.[33]

As Man Ray's assistant in Paris, Berenice had first caught the eye of Princess Eugène Murat (Violette Jacqueline Charlotte Ney d'Elchingen) when she delivered a finished print to her home; because a taxi and more work were waiting, Berenice regretfully declined an invitation to linger. Murat was a granddaughter of Michel Ney, one of Napoleon's marshals, and the widow of a grandson of Napoleon III, the source of her title. She had been a patron of Nina Hamnett. Marcel Proust once

Berenice Abbott, *New York, 1929–30.*

De Hirsh Margules

said that, despite her given name, her figure made her look "more like a truffle than a violet." Harlem Renaissance poet Countee Cullen called her "Princess Muskrat" for her stocky, robust body, the type Berenice was increasingly drawn to.[34]

When Murat visited New York, Berenice fell hard for the older Frenchwoman, as love-struck as a teenager. Murat "lived to have fun," Berenice said, and took her to parties and treated her to frivolous enjoyments, like traveling along Fifth Avenue in a hansom cab. Janet Flanner noted that Murat enjoyed "smoking opium intemperately," though only when Berenice was not at her side. Berenice once saw Murat "go into a ten-cent store and buy the place out and have a fling doing it." The French, and Murat in particular, "made more of the art of living than anybody," Berenice insisted. "More important than any work of art, she

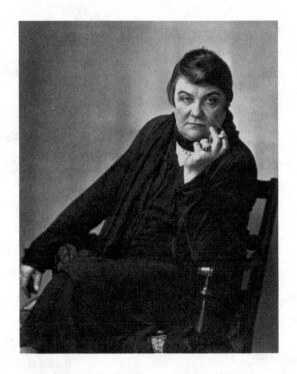

Violette, Princess Murat, New York,
1929–30. Berenice Abbott

was a work of art. She knew how to live and how to enjoy the simplest things in life by having a cup of tea . . . or down on the waterfront or having Coca Cola for breakfast," pleasures, in Berenice's view, unappreciated by materialistic Americans.[35]

Berenice photographed Murat twice, but one of the negatives was lost and the much-reproduced level-eyed gaze is the only portrait known today. Berenice thought it did not depict Murat's "wide and humane" character, as an "aristocrat with no creative outlet, three children." On July 27, Berenice jumped on a nationwide fad to make scratchy two-minute Speak-O-Phone "personal phonograph" sound recordings. Her collaborators were Ohio-born musician and photographer Max Ewing and his cousin Doris, friends from Paris amused by her friendship with Murat and Max's mentor, the author Carl Van Vechten. In a dialogue

that they called "Isn't It Awful," Berenice plays Murat, decrying East Coast summering conditions (the Berkshires and Carrie Stettheimer are among the few decipherable proper names); another recording, "Êtes-Vous Polygame?" ("Are You Polygamous?"), is charmingly vague.[36]

Late in November 1929 an English acquaintance and fellow photographer, Olivia Wyndham, appeared in New York in pursuit of Edna Lewis Thomas, an African American actress more than ten years her senior with whom she had fallen in love while Thomas was touring in London. (Wyndham had been the partner of Iris Tree's ex-husband, photographer Curtis Moffat, and established her own London studio, with Barbara Ker-Seymer as assistant.) Thomas's Broadway career had begun with *Emperor Jones* in 1925 and included a role in Orson Welles's pioneering "Negro *Macbeth*" (1936). Before her theater career, she'd served as social secretary to Madam C. J. Walker, the self-made, internationally renowned millionaire African American beauty-care entrepreneur and philanthropist. Wyndham and Thomas lived with Edna's husband, Lloyd Thomas, in Harlem and Brooklyn for the rest of their lives. After Murat, they continued to serve as Berenice's connection to Harlem culture.[37]

Going to Harlem had become customary for white New Yorkers and tourists out on the town. The lure of people thought to be exotic; the titillating sense of transgression—real or by proxy; the new music, jazz; and dancing were powerful draws. Berenice had been introduced to Harlem earlier that summer by Violette. She later described how a young male friend, Max Ewing or Jimmy Stern, assisted with her earliest attempts with flash powder to photograph the Savoy Ballroom, one of the first Harlem clubs to welcome white and black customers together. The explosion of the powder frightened them both, though Berenice eventually obtained successful pictures after the development of more reliable flash photography. But for all her photographic efforts in Harlem, Berenice was nevertheless unsuccessful in placing her photographs of its scenes in European journals.[38]

Murat was attracted to the salon of heiress and impresario A'Lelia Walker, C. J. Walker's only child. The Dark Tower, as the salon was

called, was staged in A'Lelia's palatial, gilt-wallpapered pied-à-terre on Edgecombe Avenue, Harlem's gold coast, Sugar Hill. (Her suburban mansion overlooking the Hudson River has since been landmarked.) Poet Langston Hughes memorialized her as "queen of the night." Six feet tall and very dark, A'Lelia was a warm-hearted cultural maverick who provided the model for Carl Van Vechten's Adora Boniface in his pioneering if condescending novel *Nigger Heaven* (1926). (Unlike certain of his fellow American avant-gardists, Van Vechten genuinely and deeply appreciated African American culture.) Some Harlemites believed that A'Lelia was more interested in presenting authentic Negro culture for the benefit of her white acquaintances than in lending it needed financial support. And her tolerance of gays—of any color—set her at odds with some of Harlem's more socially conservative hierarchy. The Depression closed the salon in 1930, but not before Berenice had photographed a "delightful" Walker there, quickly "snatching [her expression] out of the air." Walker's high living took its toll, and she died the following summer. To Hughes, her funeral, attended by thousands, signaled "the end of the gay times of the New Negro era in Harlem."[39]

In 1929 and 1930 Berenice photographed stars of various Negro reviews including the second New York run of the Theatre Guild's (pre-Gershwins, nonmusical play) *Porgy*, which included Georgette Harvey and Edna Thomas. She was a near-regular at mixed gatherings like those Van Vechten recorded in his diary—beginning with drinks at bootlegger McCleary Stinnett's, followed by a party "where are A'Lelia Walker, Taylor Gordon, Blair Niels, Heywood Broun, Ruth Hale, Bernice [*sic*] Abbott, Olivia Wyndham . . . etc." She'd also begun hosting her own Saturday afternoon gatherings, which Bob McAlmon described, in his 1938 memoir, *Being Geniuses Together*, as "a remarkable conglomeration of types, races and sexes." Afterward, "the hardier members of the party explored the town, generally Harlem. Those who have seen one of the negro 'drag' balls knows what they are like," he warned, concluding fastidiously, "and those who have not have either

been told or are the kind of people who had better not know, so there will be no description of them."[40]

The young aesthetes associated with the new Museum of Modern Art, as well as their friends from Paul Sachs's legendary museum course at Harvard, were also drawn to Harlem, often heading uptown around midnight from the East Fifty-Seventh Street home of art dealer R. Kirk Askew and his wife, Constance Atwood Askew. In a variety of ways, these people would continue to be involved with Berenice: architectural historian Henry-Russell Hitchcock, museum pioneer Chick Austen, architect Philip Johnson, musician Virgil Thomson, and the young photographer Ruth Bernhard. Bernhard was especially taken by the famed Cotton Club, with its Prohibition-required password at the little window to open the door; by the fabrics and bright colors of the evening dresses; the tuxedoed men; the crowd's sophisticated taste for the music. Like Berenice, she felt that the city itself had "so much excitement . . . a jazz rhythm to it."[41]

With Berenice, Bernhard also socialized in Greenwich Village. During the 1920s, prosperity and Prohibition had driven away many of the old-style cafés where people would sit around and talk, old-timer Holger Cahill said. "The virtue went out of the Village," he added, and "it began to become just a good time place." Various establishments tried to serve alcohol as a normal, if illicit, component of a restaurant meal. The Lebanon Restaurant, which Berenice photographed in 1936, had served aquavit in coffee cups during Prohibition. But the Village was still a refuge for gay people, where specific clubs, bars, cafés, and speakeasies welcomed, in contemporary guidebook language, "fairies and lady lovers." MacDougal Street in particular was lined with speakeasies and tea rooms, becoming "the best-known locus of gay and lesbian commercial institutions." Eve Addams' Tearoom, at 129 MacDougal Street, was run by Eva Kotchever, the so-called queen of the third sex; the Black Rabbit, at 111 MacDougal, shut down in 1929; the Howdy Club was around the corner on West Third Street, later *the* street for lesbian bars. Still, the enduring genteel meeting places

for women before the end of Prohibition in 1933 were tea dances, and "dancing clubs for women who don't wish to dance with gentlemen," as Bernhard reminisced coyly, "just little places where people met" without necessarily exchanging names.[42]

Ruth Bernhard was introduced to what she called "tea dancing for girls in the afternoon" by a sales clerk at the dime store notions counter where she bought objects for her advertising still life photographs. They went to the respectable, modest Childs restaurant in Times Square, filled with people "in snappy clothes, dressed up, even sophisticated," Bernhard recalled, with a band that played the best tunes of the day. "Everyone danced," she said, recalling her first meeting with Berenice there. The two discovered much in common—including student experiences in Berlin and their sideways slide into photography—and a lifelong friendship grew.[43]

As Berenice's social circles widened in New York, she became friendly with the young people around the Harvard Society for Contemporary Art, which overlapped with the Museum of Modern Art, a set that included homosexual and bisexual men whose social position and expectations led to double lives of varying secrecy. Lincoln Kirstein was simply asexual; Philip Johnson was openly gay; and men such as Chick Austin, then the Hartford, Connecticut, Wadsworth Atheneum's modernist director, were largely closeted—his wife did not know, until the very end of his life in the 1950s, of his sexual activity with men.[44]

When Berenice met poet Hart Crane, she was unaware of his literary reputation and stature, appreciating him primarily as a mutual friend and Ohio contemporary; he worried her by falling "in with the worst people," the rough-trade waterfront characters he sought out. She was also sensitive to the treatment he received from homophobic New York friends, especially Malcolm Cowley, who "belittled Crane chiefly because he chased men" and baited him about it.[45]

Captivated by Joseph Stella's 1922 paintings of the Brooklyn Bridge, Crane had been trying to persuade the American artist to illustrate his

epic poem *The Bridge*. Insurmountable technical difficulties required an alternative—the photographs taken earlier that year by a young Walker Evans as he walked across the bridge to his Wall Street job. Crane's father and Evans's were Cleveland acquaintances, and the sons lived near each other in Brooklyn Heights.[46]

Evans had spent a year in Europe and became interested in photography only after moving to Brooklyn in October 1928. A year later Berenice shared Atget's work with him at the Hotel des Artistes, as was her wont with anyone who might be interested. On Olivia Wyndham's first night in New York, Berenice showed Atget photographs to her and her young shipboard companion James Stern. Long afterward, Stern claimed to have seen in them the origins of the style of Walker Evans, who later became his good friend.[47]

The short-lived little magazine *Alhambra* had published a New York City view of Evans's in the European modernist style when he and Berenice met. Like the young Englishmen who waited to pick her up after work at Man Ray's, he was charmed by her tomboy manner and told his best friend, Hans Skolle, that Skolle would like Berenice, "with her hair brushed forward and her woozy eyes." That winter of 1929–30, Evans made a series of traditional straight and experimental portraits of Berenice, and the two photographed similar New York subjects.[48]

The Black Sun Press printed a limited edition of Crane's *The Bridge* in January 1930, with silver prints, and put out two subsequent photogravure trade editions. The book was well received; the poet even hired a clipping service to keep track of his reviews. Crane worked the whole year for *Fortune,* where he was assigned to write on the new Hudson River Bridge (George Washington Bridge) because everyone liked the idea of the successful author of *The Bridge* tackling the new one. Given Berenice's previous photography of the new bridge for architectural magazines, Crane's article might have provided an opportunity for her to break out of the portrait pigeonhole at the magazine (assuming Bourke-White would have been willing to share the "industrial" spotlight), but Crane could not complete his piece.[49]

Crane wanted Berenice to do his portrait, but she declined when he couldn't even reimburse her for materials, because, "it cost a lot . . . to make a photograph, about twenty-five dollars a shot . . . So you might love your friends but you could only work for some situation that could pay you or else gave you a reasonable chance" to license the image. After reading Crane's poems years later, she contrarily said that she would have taken his picture regardless of payment, especially if she had known he was going to be famous. (Berenice had likewise declined to photograph painter Marsden Hartley, who also wouldn't pay her.) It was Walker Evans who did photograph Crane around the time the latter sailed off to Mexico in 1931 on a Guggenheim fellowship with Berenice's old Village friend Peggy Johns Cowley. On their return trip, Crane threw himself overboard and was quickly lost, according to the frightening tale Berenice soon heard directly from Peggy.[50]

I still love New York! (Abstractly speaking). —BA[51]

HARRY CROSBY, BOSTON SCION of the Morgan banking family, had long been photographing and had begun to make his use of the medium more public. Evans, who began photographing earnestly in the fall of 1928, had reached an artistic stage where he "couldn't think about anything else." Berenice had an international reputation as a portrait photographer; her city scenes had been published abroad, and her Atget collection was already well publicized. The time was right, at the end of 1929, for the United States to apprehend Europe's explosive development of photography as a medium of new expressive power and as a vehicle of modern consciousness. The transformation in the kinds of photographs emerging from Europe was being perceived and welcomed by the sensitive antennae of American aesthetes. "For a good many years now," reviewer Katherine Grant Sterne wrote in late 1931, "an interest in photography has been the hall-mark of the *chic*. Young men, who twenty years ago might have collected Hoku-

sai prints and Whistler etchings go about with camera taking angle-shots of smokestacks, stairways and giant turbines."[52]

Crosby had quit his position with the French branch of J. P. Morgan & Co. to devote himself to poetry and the encouragement and publishing of other writers. With his wife, Caresse, he founded Black Sun, underwritten by his trust fund. The magazine *transition*, where he was on the editorial board, not only published his writings but also reproduced his pictures, as did *Variétés*. All were posthumous, if not memorial, publications: On December 10, 1929, three days after a party that Crane threw for his publishers, Crosby shot himself and his lover, the newly married young socialite Josephine (Rotch) Bigelow, in the Hotel des Artistes. The murder-suicide was carried out in a studio that Crosby had temporarily commandeered; it belonged to his portrait painter friend and prep school classmate Stanley Mortimer Jr., an heir to the Standard Oil fortune.[53]

The scandal was soon gone from the newspapers, and Berenice never mentioned this sad, symbolic event that took place in her own building. A few years later, in *Exile's Return* (1934), Malcolm Cowley used Crosby's brief biography, rather than Crane's, whose death he found still too painful, to represent, and moralize on, the trajectory of the Roaring Twenties. Robert McAlmon was still in New York when "Crozby suicided," though he held his tongue with reporters. Later, he said that he regretted not having portrayed Crosby as a "spoiled and pretentious rich boy, trying to be Rimbaud or something passionate." In his view, Crosby was, he wrote Sylvia Beach, a "hanger-on, with connections only because he had wealth and bought his way in." Though Berenice valued McAlmon's honesty and friendship that winter, he must have been depressing company: Apart from his comments on Crosby, he complained that Bryher called him a "dope fiend, etc. and things I am definitely not. . . . I haven't written four books in three years on dope or drink or anything but work. It riles me that she can't be sporting."[54]

Most of my life, when there was a time for change, I thought
I used to make the right turn . . . either you go there or
you go here. And that turn is pretty important. —BA[55]

DESPITE THE FREELANCE WORK for *Fortune*, Berenice's portrait studio was not producing enough income. As they had done in Paris, her friends pointed out that if she charged less and took more sitters, she could make more money, but Berenice was firm about not doing "a portrait for under $150.00." Her competition was the then faddish dollar portrait; "the idea of paying any money for a portrait was astonishing," she said. Moreover, licensing reproductions to magazines was failing to pull in the expected revenue and was enormously time-consuming before photo agencies could do the work. The occasional use, in places like *Town & Country*, of one of her workhorse Paris portraits, such as of Gide, required her to chase down payment, answer biographical questions about the sitter, and then beg for the return of the print.[56]

Editors who bought stock portraits sometimes commissioned other subjects. Ruth Pickering, editor of *Theatre Guild* magazine, published *Buddy Gilmore* as *The Jazz Player* and "the hat picture of Mr. Atget" in April 1929. They also commissioned photographs of apartments in the Beaux Arts Building, on East Forty-Fourth Street (paying Berenice $10) and another of the Woolworth Building ($5), but published none of them. Still, Pickering tried to help Berenice connect with the New York photography-publishing world by enlisting Arnold Genthe, a previous generation's master theatrical portraitist. Regarding her as a newly arrived foreigner, Genthe offered Berenice suggestions about American publishers. She was more impressed with Genthe's documentation of the 1906 San Francisco earthquake (and included it a decade later in her book *A Guide to Better Photography*). At a different dead end, Berenice received a kill fee from the J. Walter Thompson advertising agency,

which did not run pictures she had photographed on request. Accordingly, she shied away from ad agency work for decades.[57]

Berenice's few private portrait clients included her Hotel des Artistes neighbor Sergei Soudeikine, a Ballets Russes designer, and his latest wife, "one of those beautiful fat ladies," Berenice said. Another sitter was the writer Evelyn Scott, who wrote Berenice of the "vast difference between being 'taken' by someone with an artist's feeling, and merely being asked to 'sit.'" Possibly Berenice knew of Scott from a debate the latter had engaged in ten years earlier with Jane Heap, published in *The Little Review*. Other subjects included the novelist Marjorie Muir Worthington, who had posed for Man Ray in Paris, and her husband, William B. Seabrook, a journalist and occultist; the Harlem Renaissance spiritual singer and poet Taylor Gordon; the publisher Pascal Covici and his young son; editor Samuel Putnam; writer and editor Elliot Paul; and socialite and philanthropist Anne Tracy Morgan, the youngest child of financier J. P. Morgan. "Here I am, the poorest girl in the world, taking the richest," recalled Berenice.[58]

> I was obliged to sell a part interest in this collection to a young
> man who on the strength of the Atget photographs is opening
> a photographic gallery which will make accessible collections
> of both old and new photographs, and generally stimulate
> the recognition of photography as an art. —BA[59]

BERENICE FIRST MET and photographed Julien Levy, the young Harvard dropout and future photography and surrealist art dealer mentored by Marcel Duchamp, in Paris in 1927. Shortly after, Levy fell in love with and married Joella Haweis, the twenty-year-old daughter of poet Mina Loy, who managed her mother's small crafts business ventures. The couple and another daughter of Loy's, Fabi Cravan Lloyd, still a child, posed for portraits. (Berenice's much-reproduced photograph of Levy with his head shaved in admiring imitation of Loy's deceased

husband, the Dadaist Arthur Cravan, was done later.) In Paris, young Levy learned from Robert McAlmon about Atget and purchased some of his photographs.[60]

In New York, Julien worked for his father, Edgar, a successful developer of West Side luxury apartment buildings, before leaving his employ to work at the Weyhe bookstore and gallery, which specialized in art books and fine illustrated editions. Carl Zigrosser, the legendary print historian and connoisseur (later print curator at the Philadelphia Museum of Art), trained Levy at Weyhe. The Mexican muralist José Clemente Orozco, who showed his prints there, described the place as not a gallery but "a kind of Volador [the Mexico City flea market] in miniature, because it has a little of everything, even knickknacks."[61]

Enthusiasm for Atget made Levy a natural ally when Berenice's financial situation deteriorated in early 1930 and she sold him a half-interest in her Atget collection for $1,000. With the idea that he would promote the archive, they executed a formal sale contract on May 2, 1930, that named Levy's best friend and Harvard classmate R. Kirk Askew as arbiter in any future disagreements. Besides Berenice's outright payment of $1,000, the contract stipulated advances up to $500 against her future profits for any expenses "necessary to the utilization and exploitation of such plates and prints," which included making to-order reprints from Atget's original negatives; there was a sliding scale for dividing profits, should there be any.[62]

With the zeal of a convert, Levy had big plans for promoting their Atget collection and expected "two years of fun at least." He and Berenice sifted through the print portion together, sorting duplicates, and marked their personal selections with their initials as they went, each choosing fifty to keep. If successful, Levy wrote to his mother-in-law in Paris, it would make his reputation "as a person, a connoisseur, an art dealer, man in public life, etc." He also thought that he was helping Berenice with more than money, believing that her association with him would further boost her reputation as a photographer. But he was alternately irritated by and elated about his new prize. He condemned

customers who balked at his prices for believing "that any photograph is just a snapshot and only worth its association value." Yet he could cheer himself, too: "There is nothing I could ask for better than to roll myself between sheets of Atgets, each new one . . . a revelation."[63]

Meanwhile, the infusion of cash enabled Berenice to square her finances temporarily and allow the immediate purchase of a longed-for view camera—an instrument, like Atget's, that produced a large negative image with great detail, as a contact print or enlarged. One of her first view-camera photographs depicts boats permanently docked under the Manhattan Bridge, converted to floating oyster bars. She didn't yet know how to use the camera's optical tools, its swings or lens filters, but learned by experience. View-camera photographer Edward Weston, who organized the American section of *Film und Foto*, described the visual discovery process of pivoting "the camera slowly around watching the image change on the ground glass . . . seeing a new world through the lens."[64]

Trading her smaller cameras' speed and flexibility for the large format's greater detail and control had forced a change in shy Berenice's street photography practice, from nimble anonymity to awkward conspicuousness. The whole procedure—erecting the tripod, deploying the camera, assembling plates for exposures, ducking her head in and out from under the huge black focusing drape—could not help but attract passersby. The first time she tried, she packed up and left. "But I knew I had to do it and I made myself come back." Soon, she "went into the streets and snapped people unawares . . . and climbed up on 'L' platforms. . . . Crowds gathered and stared at me." At first, she felt that she had to forgo comfort for a conventional skirt, because trousers were considered improper on the street—truck drivers yelled at her when she tried wearing pants. But she had never gone in for the "hat and gloves routine," and eventually abandoned any pretense of ladylike attire while working in public, almost always wearing pants out in the field. She greeted kibitzers with polite explanations. One man, whom she invited to keep in touch about interesting events on the South Street pier, later

pursued her to the Hotel des Artistes, and she realized that he thought she was "a pick-up." When the doorman wouldn't let him in, he snuck around and used the service entrance, forcing Berenice to throw him out herself. Quickly, with steely nonchalance, she learned how to tell curious children to "beat it." Soon she could set up her "camera in the middle of Times Square," she boasted, citing the busiest streets in New York, "and never notice the people crowding around."[65]

Such incremental successes allowed Berenice to sustain her undaunted enthusiasm largely without compensation, though she would sell an early image, taken looking west on Forty-Second Street, with the Daily News Building on the left and the Chrysler Building to the right—two landmark skyscrapers then still under construction. The purchaser was Henri Jonquières, publisher of the projected Atget volume, who was also editing *L'art moderne primitif*, a survey by Belgian art critic Maurice Casteels of the first three decades of twentieth-century architecture in Europe and, secondarily, the United States. Most of the 144 plates in Casteels's book reproduce straightforward agency and professional architectural photographs, but three are by newcomers Berenice and her friend Walker Evans. She must have thought that she was doing Evans a favor by circulating his New York pictures to Jonquières for publication, though she did so without his knowledge or permission. When he learned about the use of his photographs, Evans was "furious," he said, over losing of some of his "best photographs": of the Chrysler Building under construction and of a midtown Manhattan view looking down onto the roofs of office buildings in the West Forties, a siuation he found "very tough on Knerves." [66]

Berenice sailed to France on May 9, 1930, with her new selection of her and Evans's New York photographs in hand, to work with Jonquières and, more specifically, to join Princess Eugène Murat, who had paid her passage. Her business in Paris included the final production details for Jonquières's *Atget: Photographe de Paris*. Pierre Mac Orlan, champion of the new documentary style of photography, provided the preface. His essay, today considered a defining statement on modern urban photog-

raphy, identified five qualities that capture a city's "social fantastic," in images that he described as "entirely free of vanity." The photographic prescriptives were: avoid official monuments; include everyday commonplaces; use full daylight; show the underbelly of modern life as "a highly contagious romantic perversity"; and avoid experimental pictorialism such as the moderns he admired were falling prey to: Man Ray, Kertész, Maurice Tabard, Krull, László Moholy-Nagy, and Berenice.[67]

Ralph Barton, the flapper caricaturist and illustrator of Anita Loos's *Gentlemen Prefer Blondes* (1925), had tried to help Berenice promote Atget in early 1929, pitching publisher Alfred Knopf on an English-language edition of the upcoming Jonquières title, which was declined. However, Levy's employer, Erhard Weyhe, agreed in March 1930 to publish a thousand copies of the French edition for sale in America under his imprint, and to mount an exclusive exhibition. As with other Jonquières titles, the publisher also produced an edition in Germany, using the same printing plates prepared from Berenice's collection, but with a new introduction by translator and author Oscar Camille Recht. The reproduction quality of all editions was disappointing, and Levy "raised hell about it," Berenice recalled, "but it didn't do any good."[68]

Jonquières had hired Berenice to do research for an illustrated volume of historical photography, *Die Alte Photographie*. In selecting images, she drew appreciatively on the artless simplicity of the early portrait work of Nadar, Mathew Brady's portraits and Civil War documentation, and Atget's entire oeuvre. She did photo research for another book, a German translation by Camille Recht of Firmin Roz's 1930 *Histoire des États-Unis* (as *Geschichte der Vereinigten Staaten*), adding thirty historical illustrations and two of her own New York photographs, taken with her new view camera. They were used as the concluding plates: *Old New York* and *New York of Today*.[69]

At the Hôtel des Saints-Pères, she turned her room into a studio to photograph Margaret Anderson. Anderson had ended publication of *The Little Review* in April 1929, using many of Berenice's portraits—of Anthiel, Barnes, Cocteau, René Crevel, Joyce, Romains, Heap,

Massot—to accompany responses to a questionnaire intended to elicit truths about artistic practice. Berenice, who declined to participate, called it the "tell-the-truth-about-yourself" questionnaire; sent to James Joyce, among others, it was widely derided. In a particularly petty gesture, Anderson credited Berenice's portraits using the original spelling of her name, "Bernice."[70]

That summer, Berenice participated in the eleventh *Salon de l'Araignée*, an exhibition "resuscitated" by its new inclusion of photographs, organized by *Jazz* editor Carlo Rim. On the street, Berenice went almost unrecognized by Nina Hamnett, who later wrote how the photographer, with her "tremendous success in New York," looked "so beautiful and well-dressed" behind the wheel of "a smart motor-car." Perhaps others also saw her as a living art deco icon, mirroring the fashionable self-portraits of painter Tamara de Lempicka driving her Bugatti. None of this notability protected her from heartbreak. Murat rescinded what Berenice thought was a special invitation to be a summer houseguest; worse, she also declined to finalize what Berenice had believed was an offer of ongoing financial support.[71]

Wounded at being "dumped," Berenice also felt duped. Her dire financial situation pushed her past concern about personal problems and forced her to think earnestly again about making a living. She abandoned her plan for a transatlantic photography business and gave up her rue Servandoni studio, trading her custom-built "nice modern furniture" with Max Ernst for four of his small paintings—"easier to take to the US and a good deal for both." She left Europe on June 11, 1930, not to return for nearly forty years.[72]

Berenice would later conflate the three Parisian leave-takings of 1929–30, the compact, dynamic narrative of rediscovering America shielding a more convoluted truth of professional indecision, financial peril, and deep emotional hurt. Murat's abandonment broke her heart— thirty years later, the memory still brought melancholy. The story of those deeply closeted days was simply one that Berenice chose not to share even decades later with journalists or historians.[73]

REALIZING NEW YORK

New York City (1930–32)

*The "well-dressed" room in the year 1931 is decorated
with plates by Moholy-Nagy, Strand and Atget. They
harmonize with the aluminum furniture, for one thing; and
they express the state of mind that substitutes the shingle
for the pompadour, the vitamin for the viand, gin for
Burgundy, and Ernest Hemingway for Henry James.*
—KATHERINE GRANT STERNE[1]

Here we don't seem to know what we have—tremendous
possibilities and material. . . . [Americans] should do their
own work and not borrow from Europe. —BA (1931)[2]

A joint Atget and Abbott show was scheduled for the Weyhe gallery at the end of what had been a very discouraging 1930. As half-owner of the Atget archive, Julien Levy, 25, played publicist, salesman, and archivist as he bossily besieged Berenice, eight years his senior, with various demands. "The Atgets are NEWS," he insisted, instructing her to contact publications ranging from the upscale *Town & Country* to the practical *Pencil Points*. Bluntly, he told her to "charge $5.00 or nothing" for prints to reproduce with their write-ups because "the publicity is worth money to us." As if she were his clerk, he also

ordered her to organize the Atget prints not yet inventoried—so that "we can tell without too much delay which ones we may have duplicates of in good condition."[3]

Levy said that Julie Reiner had told him that she had agreed to the sale price of $5 and to the need for an inventory. Quite possibly he was holding Berenice hostage with the details of her private financial arrangement with Julie for the purchase of the Atget archive in 1928, knowing that she would never publicly divulge Reiner's loan. Berenice's silence on the matter, and her refusal to dissemble, enabled Levy to conflate his purchase of a share of the archive into the fable he later told of coming to the collection's rescue in Paris with an emergency loan to Berenice.[4]

The Atget-Abbott show ran for two weeks, beginning November 24, 1930, to showcase the Jonquières book. Reviewing the book in Lincoln Kirstein's cultural review *Hound & Horn*, Walker Evans praised the poetry of the images but complained that the production looked like a "pirated edition of some other book." The *New York Times*'s Ruth Green Harris, who had approached Berenice in Paris about Atget, praised him now for being "everything, in short, but 'arty'"; she was silent about Berenice's role and the small installation of her portraits. Ruth Morris, in the *Brooklyn Eagle*, noted that Berenice's New York photographs (though not on view) reflected America's mass production, in contrast with Atget's old-world cultural details. At the same time, perpetuating the conflation of the two photographers that the show itself suggested, she added that Berenice now aimed "to do for New York what Atget did for Paris."[5]

Lincoln Kirstein, in addition to coediting *Hound & Horn*, founded the Harvard Society for Contemporary Art in late 1928, when he was still an undergraduate. Son of the head of Boston's Filene's department store, he collected student allies who became important figures in American museums, in particular Alfred H. Barr and Jere Abbott, soon codirectors of the Museum of Modern Art. In 1930, the year Kirstein graduated, the Harvard Society's eclectic exhibition program ranged from Noguchi's busts to American folk art.[6]

As an adolescent, Kirstein confronted a key distinction between himself and the artists who attracted him. "Coming down to it, money was all: I had it and [they] didn't." It was a difference that separated Berenice from him and his class throughout her life. Decades later Walker Evans complained about artists with "private income[s] of unearned money," as well as the frustrating lack of attention to the effects, simply, of penury on creative people. Walker and Berenice dined with Kirstein after the two men returned from taking photographs in Boston; Kirstein observed afterward that Berenice was "nice in a way, a face with no edges, boy's cut hair and enormous kewpie eyes." The three discussed Cocteau's recent addiction memoir in which he wrote of opium mixing "the past and future, making them a *present of One*. . . . the photographic negative of passion." Knowing herself to be a source of Cocteau's photographic metaphors, Berenice was fascinated, admitting that his description made her want to try the drug.[7]

In November 1930, the Harvard Society mounted an ambitious exhibition mirroring the encyclopedic scope of Europe's *Film und Foto*. Kirstein's introduction sought "to prove that the mechanism of the photograph is worthy and capable of producing creative work entirely outside the limits of reproduction or imitation, equal in importance to original effort in painting and sculpture"—essentially, what photography had come to mean to Berenice. The exhibition labels offered snobbishly canted recitations of photographers' family pedigree, schooling, and personal details. Berenice's name was not on the formal exhibition list, and her tiny, dismissive biography omitted her affiliation with Man Ray, her work for *Fortune*, and her nearly two years of New York photography. The omissions signaled her near-interloper standing in this status-conscious new modern art world in New York.[8]

The Atgets on view were lent by the Weyhe gallery, and credited to Berenice's collection, but she was represented only by her portrait work. Kirstein later said that he searched New York galleries for emerging portrait painters but never found any comparable to photographers "Man Ray, Berenice Abbott, or George Platt Lynes." Perhaps she was

included in the show only to secure the Atget loans. Maybe her New York work was *refused* by Kirstein in favor of Evans's, in the wake of pique at Berenice for unauthorized publication of the latter that fall in Casteels's *L'art moderne primitif.* The Harvard Society show traveled to the Wadsworth Atheneum, where prints, including Berenice's portraits, were offered for sale at around $15 each, but none sold. In any event, Kirstein and Berenice's mutual acquaintance Leonie (Mrs. Harold) Sterner would soon photograph him holding aloft a possible new purchase from Berenice, her early sculpture *Lady in a Hoop Skirt.*[9]

At the end of 1930, editor Samuel Putnam launched *The New Review*, a magazine "going in heavy for photography." He asked Berenice about possible writers "to play you up in the N.R., not for your sake, but for our own; because I look upon your work as the most important in contemporary photography." Berenice suggested—if Putnam thought it "good enuf"—an essay about her already written by Dorothy Todd, the mid-1920s feminist *Vogue* "highbrow editress," whose lesbian lifestyle had gotten her fired personally by publisher Condé Nast. In her cover letter to Putnam with the essay draft, Todd claimed she had argued for Berenice's point of view, while eliminating what she called "Berry's grosser aesthetic heresies." But Putnam did not think Todd's essay "good enough" to publish and, unfortunately, it is now lost, leaving all the "heresies" unknown. Berenice told him that Bob McAlmon was "too good" a friend to ask to write a critical essay on her, and that Pierre Mac Orlan, "perhaps the only man who understands" photography, intended once to write one on her, but did not. (He did write on their mutual photographer friend Germaine Krull.)[10]

Putnam commissioned Berenice to photograph life-size caricature sculptures of Herbert Hoover, Mary Pickford, and Greta Garbo, meant to be sold in fashionable Madison Avenue gift stores (no one bought, and they are today lost). The works had been created by a young Russel Wright, the industrial designer who soon came to define American style in manufactured ceramics and metalware. Receiving the photos from consulting editor Ezra Pound, Putnam said he was "crazy about

them" and published them all in *The New Review*'s second issue. An erratic publication schedule saw three more issues and reproduction of a few folk-sculpture photographs by Berenice, among them a view of a cigar-store figure representing an American Indian. Though he was only thirteen years older than Berenice, Pound maintained that she probably was "too young to remember" this fixture of most American Main Streets. *The New Review* folded in April 1932.[11]

The national mood in 1931 was severe as the Depression worsened. Every large city had shantytowns, occupied by the poor and the homeless and popularly called "Hoovervilles." Berenice placed a photograph of a Central Park shantytown with the Acme News Photos agency. The following year, farm prices reached such extraordinary lows that surplus corn was burned for fuel, while foreclosed farms were rescued by "penny auctions," in which fellow farmers disrupted the sale by deterring potential buyers and allowing only one bidder, who then offered one cent, paid, and returned the property to its previous owner. Hoover was still president and Prohibition was still in effect. The market for high-end portrait photography had vanished. Artists increasingly felt that their patron class had deserted them. Potential clients either could no longer afford to buy luxuries or considered it unethical or in poor taste to do so. Painter George Biddle explained their quandary: "[I]f collectors bought they sometimes bought anonymously, not to conceal an act of generosity but rather a self-indulgence!"[12]

Berenice learned from Sylvia Beach that Joyce had described a photography session with her in the third fragment of his "Work in Progress" (published in May 1930 as "Haveth Childers Everywhere"). Beach listed the available editions, with prices, and did not quote the pertinent text itself—but Berenice was in no position now to buy anything. Lucia Joyce also inquired about the "fish-costume" pictures Berenice had taken in Paris. In April, Julien Levy advanced Berenice another $175 against future Atget reprints, among other photographic work; though she decided not to buy a Leica she'd been eyeing, she was still in the hole to the gallery by year's end.[13]

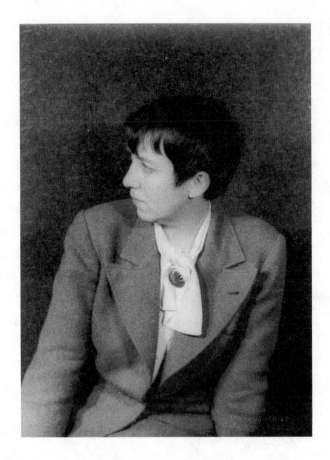

Berenice Abbott, New York, November 1937.

Carl Van Vechten

Helpfully, Carl Van Vechten came to pose for Berenice, about the same time that he took up portrait photography. His wife, Fania Marinoff, called the result "better than anything done" recently. He ordered a dozen prints, assuring Berenice, "I can't begin to tell you how people rave." Van Vechten's poor attempt to reciprocate with a daylight portrait of Berenice led him to plead for a second chance. Five years later, with a steady assistant for studio lighting, he succeeded.[14]

Berenice earned ten dollars for photographing Edna St. Vincent Millay for *Town & Country* magazine. Millay called the occasion "fun" and

liked the photographs well enough to plan on ordering them "forever." That meant, she said, "Don't let the cat play with the negatives." (Berenice seemed always to have had a cat in her New York apartments. A very curious image in her files from this time is a staged shot of a kitten ensconced in a suite of miniature rattan furniture.) Reserving the right to approve the poses that she would let Berenice license, Millay singled out two: one "in the striped tie that you always said looked about twelve years old, and the one in the dress that we called the crazy one."[15]

From France, Robert McAlmon offered to assemble reproductions of photographs and paintings for another new review, *Pagany*, explaining that "they touch up the magazine and as regards photography . . . it is becoming a type of visual document or literature." *Pagany* published four of Berenice's New York photographs in spring 1931, suggesting her "portrait of a city." They depict views and subjects she returned to over the next decade: the waterfront, the Squibb Building balustrade, and commercial signage such as cigar-store Indians, billboards, and barber shop poles.[16]

These were Berenice's first New York pictures to appear in print in the United States since her transition to a large view camera: its sophisticated optical capacity allowed her to correct distortions of perspective, and to render parallel the vertical elements of architecture and construction otherwise distorted by vantage. This tool effectively ended her reliance on a slanting and tilting visual vocabulary—*Vertikal-Tendenz*, to use her European contemporaries' term—freeing her to choose an angled view or not as her subjects and her aesthetic wishes warranted. This versatility carried through the rest of her 1930s photographs of New York.

In August 1931, an article on Berenice appeared in the Girl Scouts of America magazine *American Girl*. It was written by Sarah Carlton, one of many female freelance writers who promoted Berenice. Carlton seized on the connection with Berenice's work and that of her historical predecessors in straight photography. To the magazine's young all-female readership, Berenice confided that "you really *feel* more than you

think about it. That's where a 'woman's intuition' comes in, and why women may be better fitted to do portrait photography than men." She felt the same way about her nonportrait photography, declaring in her nineties, "I was a natural photographer; I had confidence in my selectivity." *American Girl* was hardly the critical forum Berenice's art friends sought, but it gave her a platform and, as with Ruth Harris's *Brooklyn Eagle* piece the year before, a chance to articulate her attraction to the medium and New York City. About rediscovering the city through her view camera, Berenice explained that there was nothing so romantic as reality, no fiction so exciting as the ordinary things, if only one had the eyes to behold them. "A photograph is a document which may stand as testimony of a period whose folk, architecture, fashions and modes of transportation have been supplanted. And it may be something more— it may be an interpretation as well as a record."[17]

One important image reproduced in *American Girl* was the new gleaming tower of the Daily News Building. Berenice said that her work "looks as though it were taken by someone who loved standing on ledges," but she had always been afraid of heights and was initially scared to look down to photograph. She once fled from the top of the Chrysler Building, but talked herself into going back. "You sissy . . . you've got to get over it . . . you damn idiot. Get back up there." She had the building guard hold her while she held the big 8 × 10 inch view camera in her hands "out the window [Margaret Bourke-White's, perhaps], which took all the daring I was capable of." The result was her view from above of the Chanin Building, a fifty-six-story skyscraper built in record time in 1927–29. Conquering her own fear was one battle, but Berenice had no patience with how much "red tape . . . [and] time-consuming energy" it took "just getting into a building, getting on the roof," because, she said, "they think you want to jump off it." When she wasn't shooting city scenes in Manhattan, she ventured out to the beach, as a height-of-the-summer 1931 photograph of a crowded Coney Island attests.[18]

In September, Paris friends Stephen and Sophie Victor Greene, in the grip of a fleeting enthusiasm to film New York, asked Berenice to

help their hired cinematographer, already embarked from Paris; poet Countee Cullen was to shepherd their cameraman in Harlem. Berenice identified the appropriate police officer (Edward Mulrooney) at Centre Street headquarters for necessary permits and offered to let the couple use her car. "Will need some cash. Await details." There is no further hint of follow-through or indication that footage was ever shot.[19]

Berenice continued trying to raise funds and support for her own photography of New York. Her friend Anne Tracy Morgan, founder of the Working Girls Vacation Association and the Colony Club, New York's first social club for women, was a prime candidate. Berenice budgeted $5,000 to complete her project, a sum Morgan agreed to match if Berenice could raise half. The goal proved impossible. In retrospect, Berenice, whose grasp of business and money was always tenuous, believed that she should have asked for more. She applied to the Guggenheim Foundation for a fellowship, which then only supported independent work and study abroad, and was deemed ineligible because she intended to stay in the United States.[20]

Her New York project did pique the interest of real estate developer and historian Isaac Newton Phelps Stokes, who had recently finished his six-volume *Iconography of Manhattan Island, 1498–1909*, a compendium based largely on his own collection. He had hopes once of "zigzagging . . . from the Battery to Spuyten Duyvil" to photograph landmarks, and his enthusiastic endorsement provided moral support, but Berenice rejected his desire to regiment her intuitive working method. Moreover, he wasn't terribly helpful for fund-raising.[21]

Undaunted, Berenice also approached Hardinge Scholle, director of the Museum of the City of New York. Founded in 1923, the museum focused on urbanism and the built environment of old New York, in contrast to the upper-crust, first-families emphasis of the New-York Historical Society. Berenice hoped Scholle could help identify "interesting landmarks bearing on the development and nature of the city that are about to be destroyed." Although sympathetic, Scholle was not in a position to seek special support while the museum was urgently fund-

raising to complete its new building, on upper Fifth Avenue. However, he did offer Berenice exposure in the museum's January 1932 debut exhibition. The plan was to include Atget prints as a possible source of revenue, but in the end these were excluded, and only four Abbotts were exhibited, marking the first New York presentation of the pictures she had been making for twenty months.[22]

Berenice had become friendly with Grace Mayer, then the museum's iconography curator. Mayer, financially independent and Swiss-educated, belonged to the circle of wealthy New York German Jews memorialized in Stephen Birmingham's *Our Crowd*. She performed her work for the Museum of the City of New York on a volunteer basis. In 1936, she sat for a portrait. The image harks back to Berenice's commercial Parisian style, of cream paper and soft warm tones. Despite the women's friendship, and although Berenice liked Scholle and appreciated his attention, she came to believe that the young institution "was like a hobby for a few people . . . just rich Jews," who, she felt, were not really interested in her work.[23]

In November Berenice loaned three Max Ernst paintings to the first American museum exhibition of surrealist art, *Newer Super-Realism*, organized for the Wadsworth Atheneum by Chick Austin. The catalog quoted Samuel Putnam's essay "The After-War Spirit in Literature," adapted from his anthology *European Caravan*, for which Berenice provided Putnam's portrait photograph. Berenice subsequently sold most of her Ernsts during the Depression and had only one left in 1961—it, too, was sold in the following decade.[24]

With luxury businesses struggling by late 1931, the *New Yorker* featured portrait photographs along with custom luggage and intimate lingerie in its Christmas shopping roundup. Described as "sensationally good at photographs with simplicity, drama, and character," Berenice and her "straightforward, down-to-earth" portraits headed a list of studios that included such well-known names as Alfred Cheney Johnston, Nickolas Muray, Charles Sheeler, and Florence Vandamm. The most threatening competition that season came from a trick self-portraiture

process called PhotoReflex, also described in the magazine, which department stores such as Bloomingdale's and Wanamaker's made available: Sitters posed in front of multiple mirrors, pressing the shutter themselves to capture their most pleasing expressions. Prices began at one dollar, and the rush for appointments was said to be terrific.[25]

Berenice had wanted to start a photography gallery "from the moment I struck these shores," but had never found support to do so. In November 1931, Julien Levy used money inherited from his mother, and an excellent location secured through his father's real estate connections, to open a commodious Madison Avenue gallery. His goal was to offer photography and film, and all that was new in Europe, especially surrealism, in other mediums. To ease his artists' increasing economic stress, including Berenice's, the gallery also displayed portfolios to help them obtain commissions. The debut exhibition, designed with Alfred Stieglitz, was a brief retrospective survey of American photography ranging from Mathew Brady to Paul Strand.[26]

Levy's next photography show, during the holidays, was Berenice's idea—prints by Atget in conjunction with portraits by Nadar she'd purchased in Paris from his son, "who couldn't understand why in the world she wanted them." Despite her years-long association with Levy, and their Atget partnership, Berenice was jealous of Levy's financial wherewithal and felt her entrepreneurial contributions to his gallery ventures were taken for granted.[27]

Strand recommended this exhibition to his friend Elizabeth McCausland, a feature writer and cultural reporter for the *Springfield* (Mass.) *Sunday Union and Republican*. She was unimpressed and, after meeting Berenice in 1934, still held, as she told Berenice often throughout their thirty-year relationship, that Atget was not "so almighty wonderful." She also remembered vividly that Levy had implied that Atget was his discovery.[28]

Berenice made prints for "something else Julien cooked up," a line of photo-image-based knickknacks and household goods for sale in

the gallery. Their inclusion was the suggestion of Joella Levy, whose mother had sold lampshades in galleries, the sales generating income for artists. Agreeably witty in retrospect, these "surrealist" goods included lampshades with photo images of leaves, and containers covered with photographic images of their proposed contents—for example, cigarette boxes wrapped with pictures of cigarettes and wastepaper baskets bearing photographic enlargements of crumbled sheets of paper. Berenice later remembered pictures of "wood shavings. . . . Oh!" The old memory made her throw her hands up in exasperation. Though she received a credit of $4.50 for providing the enlargements (two per item, Joella Levy stated in a hasty gallery reorder), she still owed Levy nearly $100.00 against advances made in 1931. More objects sold the following year, but Berenice was still in the red.[29]

One of the earliest regular visitors to Levy's gallery was Joseph Cornell, the genteel, self-reliant, and introverted American surrealist artist from Flushing, Queens, whom the gallery staff recalled as "one of the great social bores of all time." Cornell responded deeply to Atget's photographs and biography and, on the heels of his own first solo exhibition, devised a handmade book, *Monsieur Phot (Seen Through the Stereoscope): Scenario for a Film* (1933). The limited-edition, handcrafted work is illustrated with original nineteenth-century half-stereographs, which tell of an urban photographer who is moved to tears by tenderness for the images he sees in the world before him. A decade later, Cornell gave the name Berenice to a fictitious little girl about whose taste and sensibility he corresponded in letters with poet Marianne Moore. Just as Susan Glaspell's 1919 play was entitled *Bernice*, a seven-page photo collage of Cornell's called *The Crystal Cage (Portrait of Berenice)* suggests more than a biographical coincidence. Something about Berenice Abbott—her life, her temperament—seems to have touched Cornell enough for him to give her name to the character, who visits France and returns home with treasured objects, and speaking of constellations, balloons, and her own scientific interests.[30]

> Next to golf and bridge, I loathe people who try to make
>
> photographs look like paintings or engravings. —BA[31]

BRIDGE, THE CARD GAME, was Julie Reiner's métier—she played competitively for decades—and Berenice's derision signals their parting of ways. Thelma Wood had broken with Djuna Barnes in Paris and returned to New York, settling on East Tenth Street. She and Berenice ran around with society girls interested in having a good time, including a niece of a "guy on Wall Street," Berenice recalled, probably Anne Tracy Morgan. *The New Review* reproduced Wood's silverpoint drawings; perhaps Berenice was able to help her old friend continue to place her work. The two attended readings by the Russian mystic-philosopher George I. Gurdjieff, esteemed by Left Bank friends and, to a lesser extent, by Lincoln Kirstein. Berenice and Thelma just giggled through his presentations. Berenice had encountered the English occultist and self-taught painter Aleister Crowley. His small circle included Nina Hamnett and Man Ray; Crowley claimed to have performed "sex magick" with Berenice in November 1926—to help him travel to Egypt.[32]

In February 1932, Harding Scholle helped Berenice gain access to the massive two-year-old Rockefeller Center construction site in the heart of midtown Manhattan, the largest private building project undertaken in modern times. Landmarked today, the complex of more than a dozen art deco buildings is still home to the skyscraper "30 Rock" and to Radio City Music Hall. Berenice was fascinated by the engineering feat of steel anchored to bedrock but noted that "mostly men are interested in those things." To the end of her life she equivocated about enjoying the center's "grandeur of industry"—the monumentality of its architecture and human achievement—and its embodiment of a single family's enormous wealth and power. Her pictures of the riveted steel girders are in some sense a continuation of her work photographing the George Washington Bridge. "The marks of the compressed air drill on Manhat-

tan's basic granite are as much a fact as the marks of wind and rain in the western landscape," she wrote of one favorite view taken inside an excavation, looking up to the sky from deep in bare bedrock.[33]

Alfred Stieglitz also photographed Rockefeller Center, but was unwilling to have his art used for mere documentation; to prevent any second-quality prints reaching the public eye, he disdainfully refused director Scholle's request to donate his rejects for the Museum of the City of New York's reference collection. Berenice, who held that the best art, by capturing reality, produced superior records, also never donated prints, rejects or otherwise, to the museum.[34]

Unable to afford the "overhead troubles" of the Hotel des Artistes "or a big 'front,'" she had decamped to a new space, at 44 West Ninth Street, around the corner from Walker Evans's shabby apartment, which had made Lincoln Kirstein uncomfortably self-conscious of his wealth. De Hirsh Margules arranged for Berenice to photograph the mystical romantic American painter Louis M. Eilshemius, self-styled as "the Mahatma . . . Mightiest Mind, Supreme Parnassian and Grand Transcendent Eagle," said his letterhead. Duchamp had been his champion, and Mina Loy wrote about him in the Dada journal *The Blind Man* in 1917; Berenice may have even met him before she went to Paris. She took her camera to his family home, the last unmodernized brownstone on East Fifty-Seventh Street (no. 118), and still lit by gaslight; Eilshemius posed, shaking with palsy and too deaf to hear her directions. In March Scholle offered Berenice a job printing old negatives for a collector; a portrait sitting in May with novelist Valentine Thomson earned a fee of thirty dollars.[35]

The spring 1932 issue of Lincoln Kirstein's *Hound & Horn* contained a suite of four of Berenice's most recent New York City photographs, praised by one reviewer for combining "the artistic flair of the greatest of Atget's disciples . . . with the timeliness of a tabloid." Many of the 1932 exhibitions Berenice participated in further raised the level of public awareness of contemporary photography. *Modern Photography: At Home and Abroad*, at the photography-friendly Albright Art Gal-

lery in Buffalo, New York, reprised the Harvard Society's 1930 exhibition. *International Photographers*, the Brooklyn Museum's 185-print survey, included four of Berenice's New York photographs, prints labeled only No. 1, No. 2, etc., all "Loaned by the Artist." In Philadelphia she participated in the *International Salon of Photography*, as well as the second annual exhibition of American photography at the gallery of N. W. Ayer, the oldest American advertising agency. She also loaned several Atget photographs (and one Brady) to Ayer for a month-long show called *Ancestors: An Exhibition of the Photography of Mathew Brady and Eugène Atget*. The popular traveling photography exhibition *A Showing of Hands*, organized by San Francisco's M. H. de Young Memorial Museum, introduced her elegant *Hands of Cocteau* to a national audience.[36]

> What more vital medium can this age
>
> offer than photography? —BA[37]

BERENICE'S FIRST IMPORTANT exhibition of 1932 was the Museum of Modern Art's showcase *Murals by American Painters and Photographers*, intended to spur commissions for corporate and private interior decoration and explore wall adornment for the Rockefeller Center complex. Lincoln Kirstein developed the concept, adding photographs at the last minute. In three weeks, Julien Levy rounded up twelve of his favorite photographers, asking them, like the painters, to work on "some aspect of 'The Post-War World.'" Somehow Levy misunderstood that there was a prize of several thousand dollars to install a mural in Rockefeller Center. He said he advanced $300 to Berenice and others for materials, and claimed to have jointly produced Berenice's maquette, based on an idea of his.[38]

All the artists were asked to devise projects for a space 7 × 12 feet and to execute one section full-size. Berenice's was a four-part montage, *New York*, framed and subdivided by images of steel girders and

New York *[photo mural maquette], spring 1932.* Berenice Abbott

structural plates. For a newspaper piece announcing the exhibition's inclusion of a photography section, Kirstein described how the portraitist Berenice was fabricating her design by cutting away the areas framed by the girder images and inserting small, trimmed prints from her past three years of New York scenes. These included a back view of the Statue of Liberty, a traffic-police officer, the view from the El at Columbus Avenue and Broadway, and others that comprise her most distinctive images from 1929–30. After assembly, the pieced work was photographed—hence the 8 × 10 inch prints known of it today. A commercial lab fabricated the middle-right panel full-size, 7 × 3 feet. The structural steel girders and plates were supposed to be done in sculptural relief. At the museum, some of the sample full-size panels were displayed above explanatory labels and illustrations of the final compositions. Notably, the participation of so many female artists sent a syndicated news article around the country, with portraits: "Six American Women Win Places in Exhibit of Modern Murals."[39]

Berenice's mural was a critical success when the show opened in May. "The girders of Berenice Abbott's 'New York,'" *ARTnews* said, "speak

SIX AMERICAN WOMEN WIN PLACES
IN EXHIBIT OF MODERN MURALS

Their work won critical acclaim in the current mural exhibition in the Museum of Art, New York. Above, left to right: Georgia O'Keeffe, Berenice Abbott and Mrs. Joella Levy. Below, left to right: Mrs. Stella Simon, Jane Berlandina, and Mrs. Emma H. Little.

Berenice Abbott, top center; syndicated article on women muralists that ran nationally, May–August 1932.

for themselves as freshly patterned evocations of this day and age." "The 'montage' technique achieves something as impressive as it is novel," wrote the *New York Times*. "The vision of New York tantalized me," Berenice said at the end of the decade, "fragments of the antiquity breaking through the city's steel frame—they fascinated me." By the 1970s, however, Berenice dismissed her 1932 mural image as something Levy had "cooked up" and claimed never to have seen it exhibited. The mural exhibition did launch an important association: Berenice exhibited more work at the Modern in the decades that followed than any other photographer, said curator John Szarkowski in 1973.[40]

Berenice's 1932 montage also reflected her interest in the expressions of *unanimism*. Based on concepts of collective consciousness and group

behavior, especially the collective spirit or personality of a larger, complex entity such as a city, it was a theory developed by Jules Romains, whom Berenice had photographed in Paris—though she never did finish reading his "awfully good" novel *Death of a Nobody*. She even tried to persuade Samuel Putnam to devote *New Review* attention to the phenomenon of "orchestral literature"—the simultaneous and coordinated recitation of poetry by multiple voices—as aesthetically appropriate to the tumult of the modern world.[41]

Levy's gallery exhibition in May, *Photographs of New York by New York Photographers*, included the entire stable of American modernists—Kurt Baasch, Margaret Bourke-White, Maurice Brattner, Anton Bruehl, Walker Evans, Arthur Gerlach, Samuel Gottscho, Lester Johnson, George Platt Lynes, Wendell McRae, Ira Martin, Mortimer Ottner, Thurman Rotan, Sherrill Schell, Stella Simon, and Ralph Steiner—many of them also in MoMA's mural show. Levy's exhibition "should be sealed in cellophane and bequeathed to the future as a document of our time," argued the *New York Times*, which singled out Stieglitz's midtown skyscrapers and praised Berenice, "too often dismissed as a portraitist or 'a New York Atget' . . . as a photographer of perhaps equal stature. Her *Village Houses*, quiet and clear under a grey sky, is as perfect in its way as Vermeer's *View of Delft*." From Paris portraits rivaling Holbein to cityscapes suggesting Vermeer in just four years was quite a trajectory.[42]

At long last, for three weeks beginning September 26, 1932, Levy's gallery hosted Berenice's first solo exhibition in six years and her first ever in America. William Carlos Williams pinned the gallery announcement among other memorabilia on the wall of his attic study. The opening of *Photographs by Berenice Abbott* was a welcome occasion to greet old friends and show off her "New York shops and skyscrapers, James Joyce, Joe Gould, and other foreign parts," as Lewis Mumford noted in the *New Yorker*. Though citing her "discipleship" of Atget, Mumford nevertheless praised Berenice's view-camera skyscraper depictions as photographs "of another order." Around this time, the American edition

of Nina Hamnett's Montparnasse memoir appeared, with its account of Berenice as an oddity in 1921, redeemed by her artistic success.[43]

The *New York Evening Post* wrote, "Miss Abbott's work registers strongly, for most of her effects depend on the clarity and incisiveness of her pattern. . . . It is the unfamiliar aspect of the familiar which gives piquancy to much of the work." The *New York Times* also called Berenice a disciple of Atget but once again praised her, acknowledging that "particularly in views of skyscraper developments, the American photographer succeeds in asserting her own personality, her own artistic credo." Poet Melvin Geer Shelley, who reviewed the show for *Creative Art*, was charmed by the "slightly Parisian" air of Berenice's pictures of old New York, which fell "midway between fantasy and fact," he wrote, effectively paraphrasing Pierre Mac Orlan; he also felt that her ambition exceeded her execution. The show prompted Hardinge Scholle to remove himself (temporarily, it turned out) from further promotion of Berenice's New York photography project; he expected that Levy's gallery would function as a new channel of potential support. As Scholle explained to Berenice, in fall 1932, the city museum's friends "are in worse condition than ever." The bottom line, though, was that nothing of Berenice's in Levy's show sold.[44]

Levy's next exhibition, *Portrait Photography, Old and New*, included Berenice among more than thirty photographers from the nineteenth century to the present. She had helped devise the historical concept and researched the selection of photographers, drawing on Alvin Langdon Coburn's 1915 *Old Masters of Photography*. For a while after receiving her final financial statement from Levy's gallery, for 1932, Berenice sent him his share of income from Atget print sales, but she eventually stopped, feeling he had been adequately repaid. She had always disliked Levy's arrogance, his womanizing, and his presumptuous reliance on efficient and hardworking Joella, who ran the gallery while he was away in Europe each summer (or was too hungover to work). Levy's few subsequent business communications to Berenice begin with a formal "Dear Miss Abbott." They remained estranged until his death, in 1981.[45]

Franklin Delano Roosevelt was elected president in November and hope was in the air. The week before Christmas, Berenice submitted an ambitious proposal to the New-York Historical Society with a plaintive cover letter that asked librarian Alexander J. Wall to "please read it through even though it does seem lengthy." Emphasizing that her photographs would render the city "crystallized in permanent form," Berenice argued that the only record of contemporary "social and human aspects, types of people, manner of dress, architecture and interiors" now was "poorly reproduced and inferior photographs in yellowing and crumbling files of newspapers. The camera alone can catch the swift surfaces of cities today and speaks a language intelligible to all." As if anticipating today's necessary digital backups and redundancies, she explained that duplicate sets of her prints would make "obliteration by fire or accident almost impossible."[46]

Berenice assured the society that her straightforward photographs of specifically selected subjects would be "without tricks, retouching," and not "of the pretty picture type," and that they would have "the utmost clinical precision of details." Promising to devote a whole year and to employ full-time lab and field assistants, she offered to deliver two sets of 350–500 prints and negatives, reserving the exclusive right to make new prints as well as receive royalties from all subsequent uses. The weekly budget she submitted—including assistants, $60; materials, $75; second-hand car payment, $5; car maintenance, $10; and the catchall "personal maintenance, including rent, food, workroom, maintenance, and incessant and inevitable gratuities to janitors, truckmen, elevatormen, caretakers, watchmen, etc.," $175—came to almost $20,000 a year, four times the figure she had earlier proposed to Anne Tracy Morgan and to Phelps Stokes. Clearly she had learned how to account for the seemingly random inevitabilities of a large-scale project. The board met the next day, discussed her "plan to photograph the passing phases in life of New York City at an estimated cost of $375 per week," and declined the request, noting that they were "unable to suggest the sources for securing the funds at this time."[47]

The *New Yorker* again featured Berenice's studio in its luxury Christmas gift roundup, and the *New York World-Telegram* ran a spirited personality piece on her (absent a byline) by Joseph Mitchell, the future *New Yorker* mainstay. Describing Berenice as "slim, direct, realistic, and efficient," it quoted her at length. "I didn't want to do art photographs," she told Mitchell. "If I caught myself making a picture arty I ripped it to pieces. Any one of those newspaper cameramen is worth more than ten arty photographers."[48]

Mitchell's piece reproduced one of Berenice's few unidentified portraits, a Jewish man playing cards, as "A Portrait by Miss Abbott"; it also appeared in that year's French annual *Photographie* with no title, and has since become know as "East Side Portrait." Her friend the author Nathan Asch had directed her to the Lower East Side when asked for "the worst of all possible slums." She chatted in German with Yiddish-speaking residents to gain access to a second-floor window in order to photograph from above the pushcart activity at the corner of Orchard and Stanton Streets. Turning away from the window in the room's semidarkness, she asked a "beautiful" man passing time playing solitaire to hold still, closing the shutter after about ten seconds when he started to move. The hominess of the electrical outlet in the picture's upper right is an early example of Berenice's tolerant inclusion of mundane, humanizing details.[49]

A month before FDR's March 1933 inauguration, during the coldest winter in years, Berenice made one last effort to raise funds privately from a list of one hundred names of prominent New Yorkers provided by the ever-sympathetic Hardinge Scholle. Her new ammunition was a letter of support from him and a rave endorsement from Philip Johnson, the architect who founded the architecture department at the Museum of Modern Art. Berenice and he had met about the time Johnson and Alfred Barr staged their *Salon des Refuses*—young architects' work rejected from the mainstream 1931 Architectural League annual. The salon was held in one of Edgar Levy's vacant midtown storefront properties. Johnson called it the "first shot across the bow for international

style architecture," as it anticipated the revolutionizing show he and Henry-Russell Hitchcock organized the following year, which solidified the label "International Style." On museum letterhead, Johnson extolled Berenice and her project. "Photography is the art of making permanent the temporary but fundamental aspect of things. To capture the essence of New York today an artist must be behind the lens," he wrote. "You are uniquely equipped to accomplish this important task. You have a deep love for New York. You are an excellent photographic technician, and you have the artistic power of selecting the essential."[50]

Both Cleveland natives (albeit from opposite ends of the socioeconomic spectrum), Johnson and Berenice hit it off as professional friends. They didn't discuss their sex lives, he said, but shared excitement about plans for an exhibition to be called *America Deserta*: photographs of empty Depression-era streets, with suspended construction, half-built shells, and subdivisions where no one lived. Wealthy from his father's investments in Alcoa, Johnson could well have simply written Berenice a check outright for the project; he felt she had a wonderful sense of buildings and architecture lacking in most photographers. (Johnson had acquired a custom-built, velvet-lined wooden camera in Berlin for documenting architecture; what Berenice thought of it is not known.) The two friends later parted ways over Johnson's political views and his enthusiasm for the Third Reich.[51]

9

REALIZING AMERICA

New York and Eastern Seaboard (1933–34)

Good photography, then, is one of the best educations
toward a rounded sense of reality. . . . If photography has
become popular again in our own day . . . it is perhaps
because, like an invalid returning to health, we are finding
new delight in being, seeing, touching, feeling . . .

—LEWIS MUMFORD[1]

The object seen imposes itself upon your eye; the eye imposes
itself upon your will. You call on your technical ability to carry
out the idea to the final effect that you desire. —BA (1939)[2]

FDR declared a "bank holiday" for the five days following his
inauguration. The US Treasury and the nation's banking system
were in dire straits, and cities and businesses defaulted on payrolls
and bills. Berenice's old suitor Jean Aurenche, now active in France's
film industry, even traveled from Paris to ensure her well-being. Her
fund-raising goal, to secure seventy-five patrons contributing $250
each for a total of $18,750, could not be realized. Save one $50 contribu-
tion, all of the thirty-odd replies from Scholle's list of prospects were
negative. In turning her down, the potential donors cited diminished

resources for their own favorite charities, the plight of the city's people, or the near folly of her request. Wall Street lawyer Samuel Untermyer wrote, "[W]ith a large part of the population of this City almost starving [her project] can await more auspicious times." Museum of the City of New York founding patron and real estate developer J. Clarence Davies, whose gift of thousands of New York views formed the basis of the museum's iconography collection, and who had supported a previous, different, photographic documentation, was simply furious at her request for money.[3]

Despite these setbacks, Berenice was making what would prove to be her signature early New York view-camera images. Resisting the "slavery" imposed on the eye by the fixed aspect ratios of film formats, and contradicting the full-frame fetish of some (including Atget), two of these are heavily cropped. For *Exchange Place* (1933), she set up her camera in July, when the sun was high over the tenth-floor window ledge of a Broadway building in the heart of the Financial District. Her view is straight east, down the narrow vestigial slit of a seventeenth-century lane. The full width of the 8 × 10 inch negative includes much of the "irrelevant" facades of the two buildings flanking the opening of Exchange Place, which Berenice readily cropped out. The resulting insistently vertical image mirrors the eye's path down the narrow street, a tour de force of selection for vantage, tonal range, and movement, all facets of compositional control best achieved with a view camera. "Only the modern unplanned American city," she said, "can offer these deep architectural vistas as a theme.

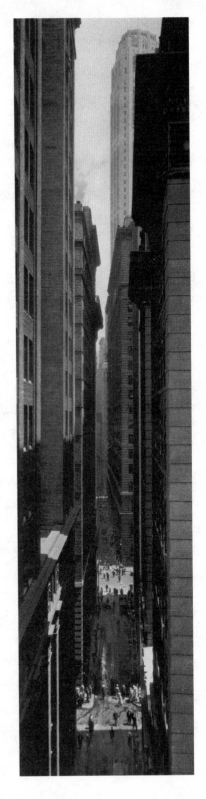

Exchange Place, *New York, July 1933.* Berenice Abbott

The narrowness of the street . . . the overpowering fashion in which the tall buildings crowd in from either side, the occasional interruptions of patches of bright sunlight, the crowds hurrying antlike about, express a concentration of life and human activity."[4]

The Museum of Modern Art chose the image for its 1939 New York World's Fair exhibition *Art in Our Time*. (Berenice thought a contact print 9½ inches high and 2¼ inches wide was a ridiculous size to display, though decades of just such contact prints have found their way into public and private collections.) Her full-frame *Hoboken Ferry*, one of her favorites, was made at the same time. Her narrow window of opportunity required advance planning to access the tall building opposite the pier in time to mesh the morning's raking light with the last disembarking crowds.[5]

She made her most famous photograph, *Night View, New York*, which captures Manhattan's unique skyscraper landscape, in December 1932. We are high over midtown, facing north on one of the shortest days of the year, in the half-hour between winter's earliest sunsets and the end of the nine-to-five working day, when electric lights blaze indoors and out. The city's rectilinear street grid, with the now-demolished Sixth Avenue El in the foreground, is sliced by the ancient path that endures as Broadway. After trying a balcony ledge and finding it too windy (despite her heavy tripod, the camera moved), Berenice took the photograph through a dirty window, which may have diffused the lights, heightening their glow. The building swayed slightly but that was all right.[6]

Focusing her view camera on the city below for the fifteen-minute exposure, Berenice seized upon electricity as both symbol and expression of the role of modern science in contemporary life, perhaps remembering the introduction of nighttime street illumination in the Cleveland of her girlhood. Though she derided "arty" photographs, *Night View* is perhaps her most sublimely artful image. Unrepentant in its direct realism, the image relies on the abstract beauty of the city's design to achieve formal rigor and simultaneously convey the magical ethereal-

ity of loftiness and light. The expansive view illustrates her metaphor of a city's unceremonious design, one form spinning out of another. Demonstrating the contradictions that most creative people harbor so productively, Berenice's triumphant image of a fleeting winter quarter hour in *Night View, New York* shows us the receptive mind behind her lens, making us feel, as she said of Atget, what she saw.[7]

The image was one of the very few New York City scenes Berenice was vague, if not evasive, in dating (when pressed, she'd occasionally cite 1933 rather than 1932), and perhaps with reason. On May 1, 1931, despite her proclaimed fear of heights, she had been among the earliest visitors to the opening of public observation areas of the Empire State Building. She photographed fellow sightseers on the sunny outdoor terrace and the skyscraper's shadow on the cityscape below. But a fellow photographer, likely one of her favored newspaper cameramen, had beaten Berenice, albeit flatfootedly, to this glittering nocturnal image that became her signature. He was Arthur Sasse, a Bronx-born son of German and Swedish immigrants, best known today for his 1951 candid portrait of Albert Einstein sticking out his tongue. Beginning as a newspaper illustrator, he joined International News Photos, and won awards throughout the 1930s for his specialty, night photography. In December 1930, from the northeast corner of the unfinished Empire State Building, Sasse made a panoramic night scene to fill the wraparound dust jacket of the boosterish handbook *New York, the Wonder City*, which promoted his company's photography.[8]

Berenice transformed Sasse's conventional horizontal view two years later by framing her exposure vertically, to convey the dizzying sense of leaning over from a great height. Her photograph's diamond jewelry–like radiance, at once, unmistakably communicates an optimistic "modernity" to our cynical twenty-first-century eyes as surely as it did to her Depression-weary contemporaries. Berenice usually presented the sparkling image in a near-square format, eliminating the black sky above and the window ledge in the lower left of the full frame. Discuss-

ing "swings" and "tilts"—the mechanisms that enable horizontal and vertical image correction and alignment—she described internalizing and mastering these view-camera features to achieve "solutions which require on your side . . . a creative emotion. Unless you see the subject first, you won't be able to force the camera (no matter how subtle and complex) to see the picture for you. But if you have seen the picture with your flexible human vision, then you will be on the road to creating with the camera a vision equivalent to your own."[9]

In Paris, the Galerie des Quatre-Chemins showed Berenice's "astonishingly picturesque" New York photographs, which *Beaux-arts* called "intelligent" and the annual *Photographie 1933–1934* featured. A continent away, Berenice followed cityscapists Thurman Rotan and Ira W. Martin exhibiting at 683 Brockhurst, the Oakland, California, gallery where view-camera devotees Ansel Adams, Willard Van Dyke, and Edward Weston founded Group *f*.64.[10]

Berenice's most successful commercial photograph of 1933 was her orchestrated view of the New York Stock Exchange, an assignment for the *New York Times* completed while she was also exhibiting in a midtown gallery to benefit the anticapitalist *New Masses*. She wanted her stock exchange image to contain three elements: the US flag flying from the pediment, a band of direct sunshine, and the normal weekday flow of humanity in the streets. The flag flew only on holidays, when there were no crowds. However, there were only twenty minutes of direct sun each day. Exchange president Richard Whitney was persuaded to arrange for the flag to fly briefly on a regular weekday.[11]

She positioned her camera under the portico of the Sub-Treasury building at the foot of the standing George Washington sculpture, which occupies the right side of her image. The left captures the corner, including the window of J. P. Morgan Jr.'s "splendid, beautiful" office overlooking the exchange. On her first attempt, she missed the light by the time the flag was installed; her second try became the institution's semiofficial portrait, the frontispiece for its annual reports for the next five years. She did another exposure, with the flag moving, but consid-

Stock Exchange, *New York, fall 1933.* Berenice Abbott

ered it a failure, because the negative was so thin. Nonetheless, in the 1980s it was successfully printed, and she "was smitten with it."[12]

Her old friend the writer John Cowper Powys came from upstate New York with his partner, Phyllis Playter, for a November afternoon portrait session in Berenice's studio. "Phyllis and I were so excited by these photos. . . . [Your] stalks of straw are better than the full grain of all the rest!" he wrote her on Christmas Eve, predicting that "1934 will be a lucky year for you & for your work." Berenice had moved again, to the south side of West Fifty-Third Street, right across from the fledgling Museum of Modern Art. The rents were especially cheap because the brownstone buildings were to be demolished soon to make way for a new subway line.[13]

I remember doing the Mohawk Valley, and Savannah.
We went through Williamsburg. He tore his hair out
there. He was a very temperamental guy. —BA[14]

DURING THE SUMMER of 1934, Berenice was driver-photographer for
Henry-Russell Hitchcock, the Wesleyan University architectural histo-
rian from her MoMA circle. He was investigating two topics: the build-
ings of H. H. Richardson as America's first "modern" architect, and
the anonymous pre–Civil War structures in America's oldest cities—
ordinary warehouses, factories, business blocks and row houses—that
Hitchcock called "urban vernacular." His goal was to establish the now-
canonical historical progression (Richardson, Louis Sullivan, Frank
Lloyd Wright) that led to the International Style in the United States.
Funding from the Carnegie Corporation provided a modest stipend
plus expenses for their six-week venture.[15]

Rather than feel demeaned by working for Hitchcock (as Walker
Evans had by photographing American architecture for Lincoln
Kirstein), Berenice dutifully took pictures of the subjects he wanted.
However, she subsequently distinguished between these two projects
in terms of her own contributions. Taking photographs of Richardson's
architecture was largely a paying job—the only image she really liked
was her Fenway Stone Bridge. For decades, Richardson's transitional
role was illustrated largely through Berenice's austere and workman-
like photographs reproduced in his 1936 monograph. Photographing
Hitchcock's urban vernacular subjects, however, gave Berenice greater
freedom of vantage and composition, as she took specific buildings and
streetscapes and made them her own.[16]

The pair drove from Boston to Savannah in three separate trips, doc-
umenting nineteenth-century buildings chosen for their architectural
excellence and because they were in pristine condition. From visiting

her Paris acquaintance Marjorie Crocker Fairbanks in suburban Harvard, Massachusetts, Berenice already knew Boston. She had even been run out of Christ Church's historic graveyard by a rector after setting up her camera and lying flat on her belly to photograph a tombstone. They swung west to Buffalo, New York, and circled back around to Philadelphia, Baltimore, Charleston, and Savannah, with stops in New York and detours to smaller cities. Along the way, Berenice photographed buildings not in Hitchcock's agenda, such as a Saratoga Springs, New York, summer home on Main Street.[17]

Hitchcock communicated what forms and qualities Berenice was to portray; she made the photographic decisions for vantage, or angle, and framing. This personal tutorial in American architectural history was an effective education in connoisseurship: It furthered Berenice's intuitive historical perceptions and provided fresh subjects for her evolving vision and technical skills. Compositionally rigorous, her images, exhibited in 1934 as *The Urban Vernacular of the Thirties, Forties, and Fifties: American Cities Before the Civil War*, offer examples of strong patterning, vivid graphics and signage, and various modes of transportation, increasingly her signature pictorial prerequisites. She especially liked the intrusions of contemporary elements—"new, contrasted with old." Mostly, the assignment helped hone Berenice's artistic discernment that "many [historically] interesting things aren't photogenic at all; [the subject] has to have shapes, and forms, and lights and darks."[18]

She prepared fifty contact 8 × 10 inch prints on card mounts with red-ink signatures for a November opening at Yale University. The show went on to travel for years to East Coast colleges from Dartmouth to the College of William & Mary. The experience helped Hitchcock appreciate the essential individualism inherent in documentary-style photography. "The photographer may well be so important a collaborator that, when the work is completed, the original initiator must retire as gracefully as may be, recognizing that the quality of the achievement is ultimately wholly due to the photographs."[19]

Nineteen thirty-four also saw Berenice lead the count with twelve images in a slender volume, *This Is New York: The First Modern Photographic Book of New York*, of pictures selected and arranged by the young female photographer Leigh Irwin. Captions were by critic and popular arts champion Gilbert Seldes, who had worked with caricaturists Al Hirschfeld and George Grosz under humorist Alexander King on the short-lived satirical magazine *Americana*. It reproduced Berenice's New York photographs in several issues, as well as at least one Atget. King's circle included Romany Marie restaurant regulars R. Buckminster Fuller and De Hirsh Margules. Editor King wrote, without irony, that Berenice and staffer Robert Disraeli, as documentary workers, were "the only two conscious photographic artists" because they "record things as they are," rather than create self-conscious "aesthetic piffle."[20]

This Is New York showcased Berenice's recognizable landmarks—from the stock exchange to Rockefeller Center under construction, to St. Patrick's Cathedral, Hester Street, and Exchange Place—and the first publication of her glittering scene from the Empire State Building, titled as *Skyscrapers at Night* [*Night View, New York*]. Intended as a "souvenir book for tourists," its content was editorially more like an art book despite Seldes's belief that photography was not a serious or high art. But to her now-grown niece in Ohio, Berenice groused dourly when she signed a copy for her: "My darling Alice, Wish this were a better book." Her name was misspelled throughout as Bernice.

Nevertheless, photographic art books were becoming popular with the same middlebrow audience that would make *Life* magazine, launched in 1936, such a hit. *Metropolis: An American City in Photographs*, by Agnes Rogers and Frederick Lewis Allen, a "day in the life" compendium published in 1934, followed their *The American Procession: American Life Since 1860 in Photographs* (1933), whose success effectively trumped the vague plans Berenice had for her own book featuring US pioneers of straight photography.[21]

To photograph with passion – overcome technique

– assimilate it – master it – forget it. —BA[22]

IN THE FALL OF 1934, Berenice began teaching photography at The New School for Social Research in Greenwich Village, a commitment that lasted a quarter century. The New School was founded in 1918 by ostracized antiwar Columbia University faculty and served as a progressive intellectual haven specializing in adult education and the arts. In 1933, it added the University in Exile, an alternative interdisciplinary graduate school primarily employing eminent refugee scholars fleeing Hitler's Germany. The art department hired largely Americans, such as historian Lewis Mumford (a fan of Berenice's), painter Stuart Davis, and dancer Doris Humphrey. Berenice always credited her friend Marchal Landgren, an art historian, educator, and independent curator, for helping her secure her position by showcasing her photographs with other media in a well-reviewed exhibition. Frank Lloyd Wright saw those images and told her that it was the first time he thought there was "anything to photography." Wondrously, he asked her to photograph all his work, which she "was crazy about." She told him that she "would love nothing better." Though Wright offered to pay all the expenses of a car and assistants if Berenice came out to his Wisconsin headquarters, she balked because the offer did not include a salary or the upkeep of her New York studio.[23]

The New School job came about while Berenice was taking a portrait of Ecuadorian painter Camilo Egas, who headed the art workshop program; she accepted his offer to teach a new class in photography, just to "bring in groceries." She had never aspired to teach, and felt unqualified because she lacked formal photographic instruction and had learned darkroom practice bilingually; moreover, her working procedure differed from others, as she set up her materials from right to left rather than from the conventional left to right. Teaching was "[t]he hardest

thing I ever did in my life," she said decades later, recalling her terror that she'd "probably faint" and have to "be carried out" after her first class.[24]

Before classes began, she was referred by the New School to a twenty-five-year-old Mississippi writer and photographer named Eudora Welty, who was seeking a suitable class in printing and enlarging. In a tightly spaced letter, Welty laid out her accomplishments, which included a semester spent studying advertising at Columbia University's business school. She explained that she had "been taking pictures to suit myself artistically" for the past three years, photographing "everything within reason or unreason around here," including "studies of negroes, with an idea of making a book, since I do not like Doris Ulmann's pictures." (Ulmann's pictorial style, most notably of Gullah culture in her 1933 *Roll, Jordan, Roll*, was the stylistic opposite of Welty's equally sympathetic candid street photography.) Welty also sought "entree into the business world of photography," poignantly asking Berenice in a handwritten postscript for ways to "make money with photographs while attending school." There is no record that Berenice replied, or that Welty enrolled in this or any subsequent New School class. The fledgling writer continued to work and photograph in Mississippi for the WPA.[25]

Like all New School course instructors, Berenice was paid according to the number of students enrolled each semester in her weekly two-hour evening classes. In addition to "theory and practice of elementary photography," her course description offered "discussion of the function of modern photography as an independent medium, divorced from the purely pictorial . . . and deriving its approach rather from the social, psychological, aesthetic and commercial values of the medium as an individual expression." For her first class, on October 4, 1934, and for many more after, Berenice wrote out the whole lesson and read it straight through. "Really a lousy teacher," said her early student assistant, documentarian Sol Libsohn, who felt he "could get more instruction from reading the directions" on the containers of darkroom chemicals. It took her two years to feel at ease.[26]

She began every semester by demonstrating exposure and development as Man Ray might well have taught her, using photogram technique. She took objects from various students, placed them on black-and-white sheet film, made an exposure, developed it, and then discussed the various opacities in the resulting negative. She cared about darkroom procedure because it ensured beautiful, controlled prints. She believed photographers should know their equipment "the way you know your own hands . . . intimately . . . easily." Her style of cultivating her students' self-sufficiency disappointed those who wanted metaphysical secrets, but she encouraged independence: "I tell students that you have to learn the way a flower evolves. It is a seed, a nothing in the ground; it germinates and grows a little bit and—boom! The whole plant." Some teachers, Berenice held, turn students into pale copies. "You have to evolve on your own."[27]

All her life, Berenice remained equivocal about her classroom success and ambivalent about the rewards. What particularly distressed her were promising female students who abandoned their ambitions because "they always have to go home and make supper for somebody."[28]

10

FANTASTIC PASSION

New York (1934–36)

Any city may have one period of magnificence, like Boston
or New Orleans or San Francisco, but it takes a real one to
keep renewing itself until the past is perennially forgotten.

—A. J. LIEBLING[1]

To put it mildly, I have and have had a fantastic passion for

New York, photographically speaking. —BA (1934)[2]

Berenice's solo exhibition of forty-six New York City photographs
opened in October 1934 at the Museum of the City of New York
and was so popular that it was extended into the following Feb-
ruary. Lewis Mumford, writing in the *New Yorker*, "wanted miles and
miles of such pictures, with even more emphasis on the human side."
Berenice was praised elsewhere as a more authentic recorder of the
American scene than such painters as Reginald Marsh, or any of the
Soyers. The *New York Times* commended her for turning "to humble
dwellers in the crowded city regions" but found "rather terrifying" her

four-foot-high enlargement of Exchange Place, her sliver-shaped look down into the canyon.[3]

Another reviewer praised the honesty of Berenice's straightforward execution of prints as "the essential spirit of [the photographic] medium," as well as her choice of subjects: The "ability to see the life of one's time clearly and coolly capable of being molded to art's eternal intentions is the hope of art in any age, not only of American art in 1934."[4]

The author of those words, published in the progressive Massachusetts *Springfield Sunday Union and Republican,* was Berenice's contemporary and a fellow midwesterner, the Kansas-born journalist Elizabeth McCausland. After studying sociology at Smith College, McCausland graduated with a master's degree in medieval literature in 1922. She then joined the Springfield newspaper and reported compassionately on the Sacco and Vanzetti case and local labor issues, as well as book censorship and blacklisting through the 1920s. She followed contemporary arts, including photography, closely. While visiting her sister's dude ranch in Taos, New Mexico, she met Paul Strand and his wife, Rebecca, and reviewed their 1932 New York shows, arguing that photography was an art form, produced by an "unflinching integrity of artistic perception and conception." She printed this essay on the large hand press she had installed in the basement of the Springfield house where she lived with a cat named Jigger, a nod to her fondness for drink. The following year, she printed a denim-bound book, *Hot Nights & Other Poems,* about the Depression travails of the American heartland and her own life, and wrote an analytical essay, "Stieglitz and the American Tradition," for the 1934 anthology *America and Alfred Stieglitz.*[5]

Elizabeth was stocky, with close-cropped light brown hair. Her piercing look, keen mind, and razor-sharp tongue "could really lay people low," a young friend of Berenice's said later. This same friend, a femme blonde, joined Berenice's fellow photographer Ralph Steiner in recalling Elizabeth as "mannish." At home, she dressed casually and comfortably in men's socks, boxer shorts, and tee shirts. When Elizabeth, the young-

est of three siblings, was still a toddler, her immediate family lived doubled up in a big house in Wichita, Kansas, with her well-off maternal in-laws. Her grandfather John Noble's occupation was "capitalist" in the 1900 US Census, while her young uncle John was an artist with a gallery; Elizabeth's father was a bookkeeper. She was a sensitive child who felt rejected when her own parents resettled with her two siblings in a new home nearby, leaving Elizabeth temporarily with the old folks. Though she was soon back home, and her father on his way to establishing a successful seed business in the prominent farm center, the trauma never left.[6]

For her Smith College tenth-year class reunion (her older sister Helen led the way east, graduating from Simmons College in Boston), Elizabeth described her interests as "Prohibition, politics, poetry, art, shake[n] in a kaleidoscope which has no pattern or else a pattern so protean as to be undecipherable." In November 1934, she gave a post-Prohibition party at her Springfield home in a big Victorian at 63 Mulberry Street, with Eileen Paradis, a young Mount Holyoke graduate she had met on vacation the previous year. Their playful invitation was printed on Elizabeth's press in a variety of typefaces: "Perhaps it will be tea / perhaps it won't / any way come and see . . . Receiving friends & foes / brickbats & contributions from 4 to 6."[7]

On October 14, 1934, on one of Elizabeth's biweekly visits to New York to keep up with new performances and exhibitions, she was introduced to Berenice in the lobby of the Museum of the City of New York, according to curator Grace Mayer. Berenice later described Elizabeth as "one of those bright young things . . . with a beautiful brain . . . [who] sort of sparkled." A few days later, Elizabeth sent Berenice a clipping of her *Springfield Republican* review. "My dear Miss Abbott," she wrote, "I enjoyed very much seeing your prints at the Museum of the City of New York, though perhaps my 17th-century metaphysical style does not make that fact clear." She apologized for the rhetorical excess that perennially plagued her writing. Berenice replied in the same formal but

good-natured vein, on elegant onionskin stationery, the envelope lined in a velvety midnight blue:

My Dear Miss McCausland,

It is truly with a deep sense of gratification that one finds, ever rarely an intelligent understanding of one's work from one's own countrymen, of all things! Your article [is] the first intelligent one on my work that has appeared in this country.

To put it mildly, I have and have had a fantastic passion for New York, photographically speaking. These present pictures are, I hope, a slight beginning of what could be done with the city if one were not thwarted by financial handicap. The museum is trying to raise money for such a project – for a full time concentrated year – at least, but I have been waiting – hoping now for five years – meanwhile doing what I could.

Again, I thank you for your appreciative article and sincerely hope that I may have the pleasure of meeting you sometime when you are in New York. Your approach to my pictures has been most encouraging.[8]

Elizabeth responded immediately, repeating Berenice's use of the word "passion" eleven times in her increasingly giddy letter. Flirtatiously, she signed off, "[T]remendously glad if anything I wrote has helped a little someone who has a fantastic passion of her own." Elizabeth added that she would soon see Berenice's *Urban Vernacular* show at Yale. Their mutual friend Henry-Russell Hitchcock was amazed, he told Elizabeth, at how accurately she had written about Berenice's attitudes and methods of work without knowing her.[9]

Marchal Landgren, then an advisory editor for the new cultural quarterly *Trend*, was also impressed by Elizabeth's newspaper review. He asked her to contribute (literally—the short-lived *Trend* did not pay for articles) "a critical biography on Miss Abbott" for the magazine's American artists' series, just expanding to include photographers, and he brought her to Berenice's place for an interview. Her finished

essay included such infatuated phrases as: The oblique angle of vision of *Chanin Building: 1931* created "the emotional effect of a world about to fall over from its own sheer lack of balance." A left-leaner herself, Elizabeth emphasized Berenice's political sympathies: "It is fantastic that the Chrysler Building, the Daily News Building, Rockefeller Center, the Stock Exchange, and any other of a hundred similar displays of ostentatious and vulgar wealth should exist side by side with those Central Park shanties of the unemployed which she has also photographed."[10]

On May 6, 1935, President Roosevelt had added the Works Progress Administration to the New Deal, the latest in an alphabet soup of federal programs to provide economic relief to the unemployed in exchange for public improvements. Its Federal Project Number One aided out-of-work "cultural workers"—from graphic designers, actors, musicians, writers, and stagehands to historians, editors, photo-finishers and archivists— to tour small towns, teach in community centers, or work for the agency itself. Products of Federal Project Number One were a series of still-useful guidebooks to American states and cities by top-drawer writers, the popular "Living Newspaper" of staged documentaries about current events, as well as prints, posters, public murals, and smaller individual paintings for allocation to public buildings, schools, libraries, and hospitals.[11]

The Federal Art Project (FAP) was the visual arts division. In anticipation of FAP support, a new version of Berenice's New York City project proposal emerged from Elizabeth's typewriter. The purpose of Berenice's "photographic enterprise," Elizabeth wrote, was "to preserve for the future an accurate and faithful chronicle in photographs of the changing aspect of the world's greatest metropolis. . . . To photograph New York City means to catch in the sensitive photographic emulsion the spirit of the metropolis, while remaining true to its essential fact, its hurrying tempo, its congested streets, the past jostling the present." Berenice often claimed that Landgren, as director of art activities for the New York City Municipal Art Committee from 1935 to 1939, got her the WPA job. She downplayed Elizabeth's key role as proposal doctor, and for decades, Elizabeth tried to correct the omission. The new text for what became *Changing*

New York, reflecting Elizabeth's professional familiarity with previous art-related government relief efforts, argued the civic and programmatic reasons to act rather than pitch aid for starving artists. Meanwhile, Berenice was reaching out to appropriate local bureaucrats: Frances M. Pollak, director of Art Projects for the New York Emergency Relief Bureau, and Audrey McMahon, of the College Art Association. McMahon, editor of *Parnassus*, was soon to head the New York region of the FAP, which included New Jersey and Philadelphia. In May, Pollak told Berenice that "Miss Gosselin and Mr. Langsdorf . . . were tremendously interested," which led Pollak to believe Berenice's project would likely be approved, pending new congressional appropriations.[12]

With federal funding anticipated, Berenice and Elizabeth designed a four-week road trip through the central eastern half of the United States to develop "a portrait in words and photographs" of the state of the country. They left New York in late May, drove through the Holland Tunnel, and parked on an elevated roadway so Berenice could take an establishing view across the Jersey City train yards with the towers of lower Manhattan in the distance. In her trip log, Elizabeth noted: "No beer." It was Berenice's favorite refreshment behind the wheel.[13]

The standard truck route, US 22, took them to eastern Pennsylvania, where they stayed overnight in Chapman and Berenice photographed two old stone barns outside Allentown. They next swung southwest through Harrisburg, crossing the Mason-Dixon Line near Hagerstown, where "Bunny [one of Berenice's rarer nicknames] danced with a little Maryland girl" that evening, Elizabeth recorded. They spent four days on a southwesterly course through West Virginia, where Berenice photographed a few farm and mining families and their settlements, a connection with her father's background. Her uncredited photograph *Home from the Mine* accompanied Elizabeth's unsigned Springfield newspaper article on the coal industry; a strike was imminent. Berenice's credited picture of a miner's home ran in the *New York Times*.[14]

In Jenkins, Kentucky, Elizabeth noted in her journal that they booked "twin beds" at the Clubhouse motel. While Berenice was circumspect

in public about her sexual orientation, in her immediate, intimate circle she was free to be herself. She thought lesbian lovemaking was beautiful, but would shudder at the mention of male homosexuality, with its anal intercourse and sexual violence. As Berenice's confidence grew and her work became better, she gave up on sex, but not affection, one straight friend believed. Male genitalia she found simply funny: Alexander Calder's explicitly naked male bent-wire *Circus* figures reminded Berenice, who laughed out loud, of the floppy men she had once seen diving at a nudist colony swimming pool. Speaking of the famed 1920s female impersonator performer and aerialist Barbette, Berenice said in 1960, "People should LIVE their sex." As a woman, Berenice experienced perennial sexism, yet she seems never to have engaged in what she recognized as the fluidity of gender identity to impersonate a man.[15]

In Tennessee, Berenice photographed and Elizabeth took notes on Norris Dam, the first in the series constructed by the Tennessee Valley Authority, the New Deal agency for regional economic development and flood control. They stayed at Maccabee's Tourist Camp at Coal Creek photographing around Pulaski, whose "dusty, sunny lazy" town square, like others they passed through, struck Elizabeth as an eerie childhood memory. After a stop in Memphis for car repairs, they zipped through Jonesboro, Arkansas, photographing old houses and shantytowns outside St. Louis before heading east into Illinois and Indiana. One view turned up in the *Daily Worker* files: "Part of 6 miles of Hoovervilles along the Mississippi at St. Louis, Mo."[16]

At the end of the third week they came through Springfield, Ohio—"baby's birthplace," Elizabeth called it—and spent two days in Chillicothe, where Berenice's mother now lived. Heading north through Columbus, Berenice photographed icons of economic failure, including *Abandoned Fox Farm, near Colfax*. Driving leisurely on US 30, the old Lincoln Highway, and through Philadelphia's Main Line, they arrived home in New York on Friday, June 14. Berenice learned on the trip that Elizabeth "was not one of those flag waving what-do-you-call-it, but . . . somebody who really loved America and would also fight about it."[17]

Norris Dam, *May 27, 1935.* Berenice Abbott

The 3,200-mile drive was Elizabeth's first opportunity to observe the routine practice of large-format photography. It enabled her to describe the process with insight and sympathy, if also wearying exactitude, for that fall's joint Guggenheim Foundation application:

> We could only travel a certain number of miles a day, if we were to take any photographs at all. For taking a photograph is not just a matter of pressing a button as fast as you can. It involves setting up the tripod, setting up the camera, deciding which one of several combinations of lenses shall be used, deciding on what angle the picture should be taken from, what exposure and aperture shall be

used, what filter if any, and then sometimes waiting as much as an hour for the sun to come out from under a cloud.[18]

From Audrey McMahon, Berenice learned that her project had been given the official go-ahead for one year. Like the rest of the nation in the fall of 1935, the women enjoyed a hopeful interlude, as the WPA alleviated earlier fears "of falling into utter destitution," Malcolm Cowley wrote later, of what turned out to be a short-lived sense of restored prosperity. In mid-September, Berenice allowed Walker Evans the use of her well-equipped, fastidiously maintained darkroom to print enlargements of his photographs of African artwork for the Museum of Modern Art. Evans was assisted by her New School student Peter Sekaer. She found the Danish native's outlook refreshing and became friendly with him and his wife-to-be, Elizabeth Hitchings, a bit of a rebel herself from Ohio who assisted McMahon at *Parnassus*.[19]

[Elizabeth McCausland] wouldn't let anybody push her around.

If somebody gave her a job to do and wanted it their way,

and she didn't think it right, she wouldn't do it. —BA[20]

WITH THE GUGGENHEIM FOUNDATION now considering domestic projects, Elizabeth began preparing an application for a joint photographer-writer American survey the following summer. Didactic and disciplined, she had found a willing and hungry pupil in Berenice, and an artist she could call her own; in Elizabeth, Berenice found a soul mate who embraced her talents, intelligence, and unconventionality. Berenice had made possible Elizabeth's transformation from an astute provincial reporter to an urbane cultural critic; Elizabeth helped give Berenice a more articulate and nuanced understanding of her art. Yet their thirty-year relationship would take a toll: Berenice was an enthusiastic friend who eagerly sought social company when she wished it (she was certainly no loner in the popular sense), but she never craved constant com-

panionship and shunned its obligations, prizing above all her autonomy and independence. Elizabeth, so reliant professionally on contacts for assignments, would come to feel isolated as her enthusiasms and writing style fell out of fashion; it was a loneliness Berenice was temperamentally ill-suited to counter, no matter how it would later pain her.[21]

In December, Elizabeth left her newspaper staff job in Springfield to live with Berenice and freelance in New York. She was tired, she wrote her mother, "of the constant frustrations, tired of the lack of appreciation and recognition, tired of feeling that I am up a blind alley." It was "silly for me to hang on here till I die. I don't know what I shall do about earning a living. Perhaps I shall starve in the gutter. . . . So there you are. Your timid, ever-cautious child starting out at 36½ to conquer the world. I get frightened at the idea of crawling out of my little hole, for I am like a cat, attached to a place."[22]

Before Elizabeth dismantled her print shop in Springfield, Berenice photographed her standing at her press in her printer's apron, an image Elizabeth preferred to a casual, friendly portrait Berenice had taken earlier in the spring. Elizabeth had stored her furniture and books with her newspaper colleague Madeleine Ball and sent other things down to Berenice's apartment on West Fifty-Third Street. Uprooted and liberated, she wrote her mother that she wanted no "possessions at all. Just a roof over my head and a few clothes, preferably blue jeans and red cowboy shirts, and a car which will run and a little cash," the fantasy she hoped to fulfill by winning a Guggenheim. Her *Springfield Republican* colleagues gave her a farewell party and a "beautiful new dictionary, unabridged," which Berenice soon adopted, spending "all her time sitting on a cushion reading . . . says she is learning the English language. I love it too."[23]

Upcoming subway construction forced Berenice and Elizabeth to find new housing in early 1936, not in the midtown neighborhood Berenice preferred but downtown in the Village, where rents were lower. Driving around with a New School student, she found the space she and Elizabeth would occupy for the next three decades—adjacent studio apartments on the fourth floor of a modern (built in 1929), recently con-

Elizabeth McCausland standing at her printing press, Springfield, Massachusetts, 1935. Berenice Abbott

verted small manufacturing building with an elevator, at 50 Commerce Street, a curious L-shaped conduit connecting Seventh Avenue to Barrow Street (hence the building's alternate address, 75 Barrow Street). Later, the Portuguese American landlord, Alcino Neves, ran the popular Blue Mill Tavern on the ground floor.[24]

Berenice called the space a loft because of its high ceilings and the communal way she and Elizabeth used their two open-plan studio apartments and a large storeroom. Each was the tenant of record of a one-room apartment (Berenice in apartment 4-B and Elizabeth in 4-A), which permitted a modicum of privacy and withdrawal, though visitors saw that they occupied one apartment as a living room and the other for sleeping. Berenice's space retained a kitchenette, while Elizabeth took her kitchen out to accommodate their big double bed. They took over the common hallway whenever they had a party, which was often. With no shower or tub, they managed sponge baths in a small sink, with towels on the floor, for their entire thirty-year tenancy.[25]

For her studio and darkroom, Berenice claimed the storeroom, 4-D, whose small, high window opening onto an airway made it illegal for living, for a low monthly rent of $15, plus improvements. One of these was a partition with a Greek-key doorway at one end of the big room to keep light out of the darkroom but allow air in and fumes to escape.[26]

The FAP apparently paid the $200 cost of painting, wiring, darkroom plumbing, and straw matting to cover the concrete floor in the studio, which doubled as an office. Berenice also used the space as a portrait studio but its poor natural light forced her "to stand on [her] head to take a decent portrait," utilizing a wide variety of lamps. She curtailed her chain-smoking in the areas that were predominantly Elizabeth's, but not in the relatively airless studio/darkroom. The furnishings were sparse, partly Bauhaus influence, partly simple humbleness and austerity: butterfly chairs, for example, as both women had exquisite taste. Berenice's floor was painted deep blue, while Elizabeth's was gunmetal-gray, like a battleship.[27]

In February, Julien Levy mounted an Atget exhibition for the Junior

League of Boston, though nothing sold. By now, Elizabeth felt that she was living with *two* artists. She recognized the toll Berenice's commitment to Atget had exacted, and its effect upon her career. Only once, however, and calmly, Berenice said, did Elizabeth wish out loud that Berenice had never heard of the old French photographer.[28]

In that first Guggenheim application with Elizabeth, Berenice described the difference between working with a small, handheld camera and a view camera. "Any moment you can catch on an unguarded human face the fleeting instant of surprise, or fear, or ennui . . . [but] . . . for a towering mountain of coal or the texture of a stone barn, you work with care for precision." For references, she tapped acquaintances old and new. Many turned out to be less supportive than she had assumed and needed. Smith College art museum director Jere Abbott, from the Harvard Society for Contemporary Art circle, wrote lukewarmly that Berenice was "probably capable of excellent work on the technical side"; Hardinge Scholle repeated that opinion but warned that "Miss Abbott is possibly temperamentally difficult." I. N. Phelps Stokes praised her ability to select subjects artistically but faulted her lack of formal historical background, concerns exacerbated by Elizabeth's proposed role as "creative reporter." They did get raves from former Guggenheim fellow George Antheil; and Francis Henry Taylor, of the Worcester Art Museum, who had known Berenice in Paris, said that she represented "the best in the photographic tradition without all the helium which surrounds Stieglitz and the photographic gang," but that he supported Elizabeth only because of Berenice's involvement.[29]

> It was a miracle to get anything done on
> the Federal Art Project. —BA[30]

BERENICE JOINED THE Photographic Division of the WPA/FAP right after Labor Day 1935. She was thirty-seven and served as a project supervisor, a managerial category of nonrelief workers hired, so the

relief workers believed, "on their reputation." At the beginning, however, Berenice did not even know that her old Village pal Holger Cahill led the agency. Dining with him and others that fall, she complained about the FAP's shortcomings, singling out Ralph Gutieri, the overall photographic supervisor, for neglecting her requests for supplies. While she ranted, amused glances and under-the-table kicking ensued; in the end, Cahill confessed his role as national director of all art projects. Subsequently, Berenice believed, he sent down a directive that ended the delays.[31]

Her salary—$143 a month (more than $2,500 in 2017)—was a third more than the regular staff artists and her assistants received. Having a steady income after her feast-or-famine self-employed, freelance existence—her first since Man Ray's darkroom stint—meant "all the difference in the world." Her WPA classification as "nonrelief" (since Berenice had not been a wage or salary earner, she could not now be considered "unemployed") allowed her to continue teaching at the New School, where her fall 1935 course catalog biography dropped a mention of Man Ray that had been included before. Efficiently, Berenice scheduled her beginning and (new) advanced New School workshops back-to-back on the same (Thursday) evening. Her friendship with the New School's assistant director, Clara W. Mayer, who was especially interested in the arts and their role at the school, lasted for decades, Mayer looking out for Berenice like a watchful big sister. Audrey McMahon often played the same role at the FAP.[32]

Oblivious to the politics and personal relations of organizational administration, Berenice complained that the highly structured FAP was "full of red tape." She possessed few skills to circumvent this; her sincerity and blunt artistic ambition rendered her incapable of bureaucratic scheming and calculation. She resented the office routine required of any supervisor—approving time sheets, formalizing requisitions, and managing work flow, for example—and moaned about having to forgo a good day for photography just to check in with the main office "and sign a paper!" She found her subordinates, generally willing workers in

need of direction, to be troublesome "people in my hair" and the staffers she was assigned to oversee intrusive. At times she had as many as a dozen to assist with recording, filing, and research. One young friend summed up Berenice in this managerial capacity as a "well-organized marshmallow."[33]

Her darkroom chief, Boris Stackcliff, thought her fussy and demanding. In bad weather, Berenice would stay in and print with him, whether at FAP headquarters in midtown or at 50 Commerce Street is unclear. Tending the files at Berenice's studio and later overseeing the print spotters (staff who touched up the inevitable dust flecks and other flaws that appeared on prints fresh from the darkroom) was an eighteen-year-old clerk-typist named May Malkin, whose full-time wage, $18 a week, provided her family's only income. Berenice's "little kingdom" and the "odd . . . art people" she encountered were a new world. Eventually, Malkin was transferred permanently from Berenice's studio back to headquarters on Thirty-Ninth Street, where she found the rest of the "creative" photographers as aloof as Berenice had been in her studio: "If I walked in stark naked, they wouldn't have noticed."[34]

Berenice began shooting in October. Her first numbered image, *Broome Street #512–514*, in the West Village, shows a warehouse looming over two small old brick houses about which she "felt very intimate." She headed next due east to the Bowery for its lively signage and density. Returning to headquarters she encountered a protective bureaucrat who advised her that nice girls didn't go to such rough places. "Buddy," Berenice told him in a story she loved to repeat, "I'm not a nice girl. I'm a photographer. . . . I go anywhere." The incident caused at least one sleepless night of worry, needless it turned out, that as a female, her territory and subjects would be limited.[35]

While she was photographing *Blossom Restaurant, 103 Bowery*, "a man came out when he saw me setting up the camera," and so she included him, which she thought made the picture much better. Blocks away, she captured *Tri-boro Barber School, 264 Bowery*, one of her favorite images because its straightforward storefront subject also contained compound

Blossom Restaurant, 103 Bowery, Manhattan, *October 3, 1935.* Berenice Abbott

shadows mixing with the patterns on the building. In the Spuyten Duyvil waterfront neighborhood of the southwest Bronx she photographed two old-fashioned businesses and a wood-frame house, the first of several "gam-crack" examples, she said, of Victorian buildings from another era she called "her monsters" for their size and ornateness. Her field assistant that day balked at having to walk through poison ivy to reach the camera position Berenice wanted. "Poison ivy or not, we are going in there," she told him, then had him transferred. Days later, a new assistant was "incidentally" photographed in *Waterfront South Street*, walking in

the middle distance of the view, the first of his many appearances in the project, rarely without his light-colored fedora. This was ex-chauffeur Mack Young, a naturalized Austrian Jew who later became a professional photographer. He appeared in two Village images from November 21, standing outside *Mori's Restaurant, 144 Bleecker Street* and descending the stairs in *Minetta Street, Nos. 2, 4, 6*; his last appearance, on May 18, 1938, was in *Rothman's Pawn Shop, 149 Eighth Avenue*.[36]

The sixty images Berenice took that first year included: A row of shanties and their occupants on a vacant lot in what is now the heart of Manhattan's high-rent SoHo. A typical midtown newsstand, full of what she called "escape" literature (she liked the idea of blowing up her negative to read the newspaper headlines and magazine teasers). The Murray Hill Hotel, whose wrought-iron filigree spiral staircase she thought "very American." *Gasoline Station Tenth Avenue and 29th Street*, another completely modern American subject that had long interested her. A view of the Daily News Building, though not as earlier from the roof of the Chanin Building a block away, but out an office window on a high floor, accounting for the photograph's tilt.[37]

One view is not architectural but environmental: the length of Seventh Avenue from midtown to show the harsh glare-and-shadows effect typical of high-rise Manhattan in winter's low-angle sunlight. Perching her view camera on a little balcony outside an office located on a high floor, on December 5, 1935, she photographed to the left (*Seventh Avenue Looking North from 35th Street*) and then the right (*Seventh Avenue Looking South from 35th Street*) along the building-lined avenue, creating twin canyon views. This was the view from outside the office of fellow Ohioan and attorney Roy H. Ellison. He held onto her legs to keep her from tumbling over a balustrade whose shadow, including Berenice at her camera, is visible in the northerly shot. A champion of civil liberties and labor organizing, Ellison had represented Berenice several times in low-level nonpolitical scrapes with the police. With Prohibition's end, she did more socializing in lesbian bars, drinking harder than ever. As

Fifth Avenue, Nos. 4, 6, 8, Manhattan, *March 20, 1936.* Berenice Abbott

in Paris, she was on occasion ejected from the premises, and more than once arrested, charged with disorderly conduct, resisting arrest, and, even, assaulting a police officer.[38]

The Federal Art Gallery debuted in midtown in March 1936, showcasing work by every FAP program. The *New York Herald Tribune* zeroed in on the few of Berenice's *Changing New York* photographs on view, in particular some handsome buildings in an isolated cluster of townhouses on lower Fifth Avenue basking in the morning sun, an

image that would become known popularly as *Fifth Avenue Houses*. The reviewer likened the style of the image to that of painter Edward Hopper, but Berenice disagreed: "[Y]ou don't even think of anybody when you take a photograph; you simply see the subject and you take it or you don't. People read all kinds of things into my work, and what they say makes me laugh. I like Hopper's work very much . . . But so what?" she challenged, "I can't help it if it looks like Hopper."[39]

Though she generally responded to specific subject matter, what we might call an "American Silences" aesthetic exemplified by Walker Evans and Edward Hopper resonated with her, as Germaine Krull's industrial images had in the late 1920s. It may have been disingenuous of her to disavow any conscious connection to Hopper's art, when she, like Evans, shared his sensibility. In truth, however, the connection was coincidence rather than influence, as Evans himself said, when similarly charged: "It just happens. It's one of the wonders of the art world."[40]

CREATIVE DOCUMENTARY

New York (1936-37)

*Documentary photography as a creative art has
been given a place of high distinction in the work
achieved by the Photography Division.*

—WPA[1]

I'm sort of sensitive to cities. . . . They have a personality. Not the
people in them, but the buildings, the little odd corners. . . . Why,
when I walk around I seem to be looking in all directions and when I
find a little street or something that's different . . . gee. —BA (1937)[2]

With her long-anticipated project fully under way, Berenice at
last felt her passion for New York becoming artistically ful-
filled, her years of self-imposed view-camera apprenticeship
resulting in a fully matured ability to express deep feeling through tech-
nical mastery. In March and April 1936, she photographed the patterns
of track and shadow created by the elevated railroads of lower Manhat-
tan, which had so intrigued her earlier in the decade. She then captured
a stretch of elegant town houses at Sutton Place and East Fifty-Seventh

"El," Second and Third Avenue Lines, Hanover Square and Pearl Street,
Manhattan, *April 24, 1936*.

Street, an almost disreputable neighborhood transformed in the early 1920s by Anne Tracy Morgan and three friends, including society interior decorator Elsie de Wolfe. In May, she photographed Department of Docks and Police Station Pier A, North River, "a very American building . . . the kind that harks back to Columbus, Ohio." The same day, she shot a large frame building in the heart of the Village and an old firehouse on the waterfront; both seemed to demonstrate a nostalgia for her Midwest childhood. She photographed another section of her five-image series West Street Row, begun that April. She then made a bold experimental image along Exchange Place, for subsequent presentation in a vertical diptych, exaggerating the "canyon" effect she sought to capture both in lower Manhattan and in midtown.[3]

Turning to Brooklyn on May 14, she took almost half that year's total Brooklyn output in the Willow Street neighborhood in Brooklyn Heights. When Paul Strand questioned her out-of-focus iron grille in the near foreground of *Willow Street, No. 104*, she realized that he did not understand her deliberate arrangement of elements to structure a meaningful document. She explained that she used the effect to bring attention to the house across the street and simultaneously hide the dull house next door. The following week, she photographed *Traveling Tin Shop*; *Brooklyn Bridge, Water and Dock Streets, Looking Southwest*; and *Warehouse, Water and Dock Streets*.[4]

With FAP funding renewed for another year, Berenice devoted much of the summer of 1936 to transportation, a subject to which she would return in the 1970s. July also saw a beautiful series inside Pennsylvania Station, which she inexplicably deleted from the project's final images, though she retained the single image of the nearby Greyhound Bus Station taken on the same day. An earlier Penn Station photograph appeared in Seldes's *This Is New York* (1934). She "had to obtain all sorts of permission to make these photographs, but I knew I had to capture this magnificent building"; she would later call its demolition "wicked." On the waterfront, she avoided the smothering summer heat of city streets, though she photographed one ethnic eatery, *Restaurant (Syrian)*,

where she'd enjoyed aquavit in coffee cups during Prohibition. The artist Eilshemius refused her request to photograph the interior of his unmodernized brownstone with a terse letter ornamented with a cartouche reading "Art is Bluff."[5]

In October, Berenice sought out subjects slated for demolition and firetraps poised for potential self-destruction. The sidewalk jumble of goods in front of an antique shop, a type of business fast disappearing from Third Avenue, caught her attention, as did the nearby mansard-roofed, soon-to-be-demolished streetcar barn. Just in the nick of time, on October 8, Berenice photographed Chrysler Building architect William Van Alen's temporary experimental steel house, nestled among midtown office buildings and open for the previous three months to visitors at ten cents each. Later in the month, old wooden structures in rustic precincts of Brooklyn would seem especially urgent.[6]

"Many parts of the city cannot be reached by so-called rapid transit lines," she argued, as if she had even considered traveling by such means with her view-camera outfit, let alone on foot like Atget. When she was finally upgraded to "Project Supervisor Grade 311 with Car for 39 Hrs. Wkly at $183.33/mo," in November, she bought the 1930 Ford Sport Roadster she'd been borrowing from a friend. After New Year's, in February 1937 her name headed the member list of the Citizens Committee for Support of the WPA. The program had diverse support; others on the list ranged from ACLU cofounder Roger Baldwin to Rabbi Stephen Wise.[7]

Berenice photographed the exterior of old St. Mark's in the Bouwerie Church comprehensively in March 1937 and included nearly all the exposures in her final project selection, especially the lovely view contrasting the eighteenth-century church's steeple against up-to-the-minute skywriting. Her images of the Brooklyn Bridge avoid the now-clichéd modernist angle views of cables. Feeling obliged to revisit the Lower East Side, she found it especially difficult to make its facades and what she called "general" views, those taken from on high looking out over city rooftops, "artistically" interesting. With her next general

view—shot through the lacy curves of an old-fashioned wrought-iron chair on the terrace of Austrian expatriate designer Frederick Kiesler's penthouse apartment in Greenwich Village—she achieved the visually engaging quality she had found so elusive.[8]

On April 1, she recaptured *Sailor's Bethel* and *Oyster Houses*, subjects from the early 1930s. Skipping Broadway theaters, she made a singular image in Times Square, of a full-figure portrait sculpture of the heroic World War I army chaplain Father Francis Duffy temporarily bound in cloth prior to its unveiling. When the inevitable crowd gathered, a police officer accused her of creating a nuisance. "I should have insisted on staying" to try other angles and include different details, Berenice said, but after one exposure, she just packed up and left. At the new Triborough Bridge (now Robert F. Kennedy Bridge) connecting upper Manhattan and Queens to highways leading to New England, Brooklyn, and eastern Long Island, she failed on her first attempt, from a moving boat, to capture the sinewy complex. She and Mack Young signed a legal release absolving the bridge authority of responsibility for any personal or property losses in order to situate themselves in the middle of the bridge roadway, surrounded by red flags to divert traffic.[9]

When a newly elected Congress voted, in early 1937, to cut the FAP's funding, Elizabeth wrote in the *Nation*: "[T]he Renaissance lasted three centuries, the Age of Pericles and the Augustan Age each a half century; for the 'cultural birth of a nation' our government allows less than two years." Her unsanctioned article earned a reprimand from administrator Audrey McMahon, who had been otherwise indifferent to Elizabeth's previous bylined advocacy in the *Springfield Republican*; she would soon adopt the pseudonym Elizabeth Noble.[10]

The funding cuts cost Berenice two key staffers, including the project's mapmaker, Everett Gratama, but she nevertheless sought to expand the scope of *Changing New York* to include the entire state. She approached McMahon with the idea, and tried to enlist Charles C. Adams, director of the State Museum in Albany and a staunch supporter of hers. Her photographic interest in wooden Victorian relics—already plentiful in

Changing New York—was intended to record "surviving vestiges of past eras which afford clues to our immediate ancestors' esthetic and cultural thinking." She proposed scheduling part-time WPA workers to travel statewide in a series of short treks and to maintain her darkroom in her absence. McMahon responded that lack of funds made it impossible to undertake "this interesting work," adding, "Perhaps later."[11]

Still, Berenice looked forward to more city photography. "Climbing up buildings. Leaning over roofs. Hanging on rickety fire escapes. Boy, I loved it! I'm going to keep doing it as long as I can," she said. In November she photographed 14 Gay Street, made famous as the basement apartment home in Ruth McKenney's *New Yorker* short stories *My Sister Eileen*.[12]

Jefferson Market Court, scene of some of Berenice's run-ins with the law, and since repurposed as a branch library, was photographed several times by her. In November 1937 it loomed in the background of her image of Patchin Place, a tiny private lane where author Djuna Barnes would soon make her last home. Barnes's 1936 novel *Nightwood*, based on her eight years with Thelma Wood and other characters and events recognizable to those involved, was greeted upon its US publication by a screed from young critic Alfred Kazin, who called the characters "freaks" in a world of grotesquerie and self-torture. That is actually what Berenice found disagreeably uninviting about the fashionable lesbian subculture she stood outside. For many years, she claimed not to have read Barnes's book, and her friends urged her not to. Later, when she did (or acknowledged it), she said that *Nightwood* was far above *The Well of Loneliness* in quality. [13]

On her only visit to photograph Staten Island, Berenice targeted a handful of subjects including a monument to Garibaldi she found personally distasteful. She regarded him as "a big fake . . . a terrible person . . . a little Fascist . . . peacock."[14]

That fall, more than one hundred *Changing New York* images appeared in a huge solo exhibition, Berenice's second at the Museum

of the City of New York, which opened on October 20, 1937. As in her show there three years earlier, prints were mounted in groups and ranged from 8 × 10 inch contacts to 14 × 17 and 20 × 24 inch enlargements. New for this installation, at the entrance was an 8-foot-tall mural reproducing Berenice's *DePeyster Statue, Bowling Green*, an "old time figure" against modern buildings. The image amused Berenice, and she was disappointed that few others saw the humor she did.[15]

The show's draft brochure featured a quotation from Honoré de Balzac's *Ferragus*: "Monstrous marvel . . . astounding assemblage of brains and machinery in motion . . . City of a Hundred Thousand Romances." Editor George Parsons's note that Balzac's "vast plan involved the *photographing*, the analysis, the classification, of every social element," spoke to the heart of Elizabeth's, if not precisely Berenice's, intellectual motivation. He was an author claimed by "everybody," Berenice said, "from the communists to the fascists," for presenting "society in a light that could be used either way, from all angles."[16]

Repeatedly misspelling her name as "Bernice," the *New York Times* produced a banner article that announced the photographs' placement in the collections of the Museum of the City of New York and (erroneously) the Library of Congress. An Associated Press story of the intrepid urban girl photographer appeared in newspapers as far-flung as Fort Worth, Texas, and Little Rock, Arkansas, often illustrated by a jaunty portrait of her in a beanie beret adjusting her big camera. The picture was taken by Consuelo Kanaga, a *New Masses* journalist and fellow WPA photographer.[17]

On the back of the printed invitation to the press opening on Tuesday afternoon, October 19, Berenice wrote to an unidentified friend, "Do come, my dear, and wear violets – Berri." The violets Berenice requested were a symbol of women's romantic affection. Her personal guest list had names from all facets of her life in Paris and New York, and Elizabeth's as well, including artists, writers, and other friends, most notably Thelma Wood and Marjorie Fairbanks, feminists Rosika

Berenice Abbott photographing on South Street,
New York, 1937. Consuelo Kanaga

and Franziska Schwimmer, and project supporter I. N. Phelps Stokes. Also included were WPA officials Frances Pollak, Ruth Reeves, and Clarence Weinstock, the latter also editor of *Art Front* and assistant editor of *New Masses.*[18]

Hippolyte Havel, living in a Stelton, New Jersey, anarchist colony, near New Brunswick, arrived wearing spats and carrying a cane, his hair in a bob. He had gotten so drunk before her 1934 Museum of the City of New York exhibition that Berenice had prevented him from actually attending the event. A friend would tease her about Havel, noting that as she had once looked out for Atget, now "it's an old, ex-bomb-throwing Bulgarian anarchist." Perhaps atoning, Havel helped Berenice gain entrance to photograph the antique male-only McSorley's Old Ale House in the East Village. FAP filmmaker Leo Seltzer helped

McSorley's Ale House, 15 East 7th Street, Manhattan, *November 1, 1937.*

Berenice Abbott

light two invasive photographs of amused and horrified patrons—all intruder Berenice's nerves could stand. (Women sued successfully for admittance in 1970.) She felt she got only "lousy" pictures.[19]

The Museum of the City of New York exhibition's huge press coverage was due in part to Berenice's independent contract with a husband-and-wife public relations firm, Torrey-Hohoff, Fine & Decorative Arts Publicity. (Therese von Hohoff, as Tay Hohoff, later

worked for decades as an editor, notably helping Harper Lee finish *To Kill a Mockingbird*, the 1961 Pulitzer Prize winner for fiction.) People were reading about Berenice Abbott everywhere: in a *Town & Country* news note; a feature in *Arts & Decoration*, "Which Do You Like Best . . . New York Now or Then?"; a piece in *The Bible in New York*. *The Spur*, a high-end monthly devoted to hunting and horses, ran a personality piece by Bertha A. Houck, a writer seemingly new to art photography, who praised Berenice's artistry—"any dub can click a shutter"; Houck had visited Berenice's studio expecting "artistic disarray" but found instead a "large workman-like place, where one would expect to find such a workman-like person as Miss Abbott, dressed in corduroy slacks and a sweater."[20]

Inevitably, Houck also equated Berenice's artistic effort on behalf of New York to Atget's for Paris, a comparison still impossible to shake off. Even in *U.S. Camera Annual*, where *Vanity Fair* editor Frank Crowninshield lauded the ascendance of American women photographers, he called Berenice "the veritable Eugène Atget of our time." When Julien Levy moved to a new location on East Fifty-Seventh Street, he featured Berenice's photographs in a huge exhibition of the entire gallery stable, followed by *Pioneers in Modern French Photography*, featuring Atget. In the *New Yorker*, former Paris expatriate Robert Coates sounded the only discordant note, saying that Berenice lacked Atget's feel for textures. In a radio interview, Berenice answered that she tried "to photograph the city without sentimentality or illusions. . . . [My pictures] must have content, they must be realistic in the best sense, the sort of realism which transcends reality by what the artists have added in their vision of the external world."[21]

Berenice's leftist political alliances guaranteed coverage in *The New Masses* by Elizabeth (writing pseudonymously as Elizabeth Noble, after the *Nation* episode). Under her own byline, she did a piece for the *Daily Worker*, an article notable for citing by name the project's supporting staff members. The Jewish socialist daily the *Forward* gave the show a huge rotogravure spread. Simultaneously, the *U.S. Camera Salon Annual* at Rockefeller Center included Berenice's recent portrait

of Orozco, lauded by the *Daily Worker* as the best in the show, by "one of the best photographers in the country."[22]

Genevieve Naylor, a friend and former student of Berenice's, jointly reviewed the *U.S. Camera* exhibition and Berenice's museum show for *Art Front*. She began by comparing what she considered the vacuous technical achievement of conventional photography as evidenced in the *U.S. Camera* display with the triumph of the conceptual richness of Berenice's pictures. Intending to champion continuation of the FAP, Naylor focused on the success of government sponsorship in fostering artistic and intellectual freedom versus the corrupting pressure of commercial photography. While the rigid control of fascist governments over official art was well recognized in leftist circles, the irony of the Soviet Union's increasingly totalitarian behavior toward artists was less clearly perceived. Elizabeth provided another favorable review for the *Springfield Republican*. Discussing the *U.S. Camera* show, she found documentary work by "sensitive, sincere workers . . . a welcome relief after saccharine beauties on magazine covers and fashion ads."[23]

When Berenice's Museum of the City of New York exhibition was held over into January 1938, *Life* magazine gave her a portfolio layout. Her brief text explained her focus on the built environment, harking back to her lessons from Hitchcock's "urban vernacular" expedition: What people are really like, she had decided, is shown by what they build. "Their houses tell more about a people than their noses," she claimed, and she didn't "care whether" her pictures were "called art or not." This national exposure drew praise in the magazine's letters column—"Orchids to Berenice Abbott of course—but also to *Life* for bringing her work to an unsuspecting public." The elderly Cleveland pictorialist photographer Carle Semon congratulated a hometown talent for providing relief from "bad photography." Defensively, the FAP public relations office saw fit to remind *Life* readers—lest they be misled into thinking that the federal government was indulging individual art projects—that Berenice's "photographs were all taken . . . as part of her" WPA-sponsored job.[24]

Reining in their high-flying art celebrity, the FAP then sent Berenice—like any other regular relief worker—to photograph the activities of a WPA day-care center. These pictures ran without a credit in *Hearst's International Cosmopolitan* and later, with Berenice's name, in *Parents* magazine, a leader in its use of editorial photography. While Berenice had been willing earlier in the 1930s to take photographic jobs of all sorts for income, such a humbling assignment with its photojournalistic subjects and style were the antithesis of nearly every other photograph she made for *Changing New York*.[25]

By late January 1938, when the Museum of the City of New York show finally closed, Berenice gave Grace Mayer a personal gift of a new FAP photograph, *Snuff Shop, 113 Division Street*, which had taken seven different views to get without reflections in the glass windows. It was "much admired by jealous members of the staff," Mayer wrote when thanking her. Photographically, Berenice was concentrating on townhouse contrasts for *Brownstone Front and Skyscraper, 4 East 78th Street* and *Glass Brick and Brownstone Fronts, 209 and 211 East 48th Street*. She also photographed town houses individually: *James B. Duke Town House, 1 East 78th Street* and *Fifth Avenue, No. 8 (Marble House)*—one of the unusual doors in the Hopperesque *Fifth Avenue Houses*—but she discarded her image of the Carnegie mansion at Ninety-First Street and Fifth Avenue. The winter's low-angle sun provided the "decent light" Berenice sought to capture a "marvelous spread" of everyday tools in *Hardware Store, 316 Bowery*. In February she photographed the familiar ornament-encrusted facade of the Stettheimer sisters' Alwyn Court, a building of vast apartments (twelve to thirty-four rooms each) that had been subdivided into more modestly sized layouts.[26]

One day in March, Berenice rephotographed *Starrett-Lehigh Building II: 601 West 26th Street*, along with a subject from 1930 (then under construction), *John Watts Statue from Trinity Churchyard Looking Toward One Wall Street*. She ended the day with an artistically adventurous documentation of a now-decimated New York industry, *Steam + Felt = Hats, 65 West 39th Street*. At the end of the month, she continued her

record of Hudson River piers and ferry terminals as well as the facing blocks of West Street.[27]

> We cannot go on just looking at things on the surface – we
> must go deeper. This means getting at things as they really are
> – which is not always pretty; in fact, almost never pretty. —BA[28]

FREELANCE FEATURE WRITER Rosa Reilly went along on a day's shooting in May 1938 as Berenice inaugurated her new model medium-format Linhof camera. She fretted about the gray, flat light but then kept all of the day's work in the project. Starting out, assistant Mack Young pacified some drunks outside the East River pier caretaker's shack ("they dragged these alcoholics out of the river every day," Berenice recalled), and she set up her tripod and photographed the action against the city's skyline. River barges used to tie up at Coenties Slip in lower Manhattan for the winter but in the Depression, with no business, they were tying "up for life—at approximately one dollar a year." Berenice briefly explored acquiring a barge for her personal use, an adventurous if unrealistic alternative, and was dissuaded only by the need for such practicalities as dry-docking and routine painting.[29]

The *L* in *Changing New York* image file codes stands for Linhof camera, to which she added a Rolleiflex (*R*). She was soon smitten with the new, even smaller 35mms, suitable for 5 × 7 prints, and got a Contax with special FAP funds. Later, she bought a Leica and another Rolleiflex from Lisette Model, her opposite in sophistication and artistry. The two shared an interest in astrology. During the war, Model later said, Berenice would phone her to borrow five dollars. Instead she would invite Berenice and Elizabeth to come over to eat and stop at the grocer, where she had credit. It was hand-to-mouth for all of them, she implied.[30]

Berenice later had a winter coat made with a pocket for the small camera "always" by her side, decrying how their early black inconspicuousness gave way to fancy chrome-trimmed prettiness, "visible a mile

off, scaring away possible victims." She advised new photographers to start slowly and work up to speed, as in practicing scales. "Tempo is a far more important part of photography than people realize. The speed of reaction time, the speed of perception, the speed of working, all affect the result. . . . Do not use it just now and then. Take pictures by the hundreds, nay, thousands, practicing to make perfect," she wrote in 1941, after *Changing New York* was a closed chapter.[31]

Reilly's *Popular Photography* article, based on her day with Berenice, carried obligatory details about equipment, lenses, and exposure times, "a little technical fluff to impress the boys," she told Berenice. Regarding light meters, Berenice carried a Weston model but found the "zone business . . . much too complicated," and often relied on her judgment. She even did a test once with a colleague who subsequently pursued two light-meter manufacturers for their responses to the test results; when their divergent technical explanations canceled each other out, Berenice felt vindicated in her intuitive artist's ad hoc practice. She also complained that her tripod was the "most inadequate equipment of all . . . They aren't flexible and they all shake. They aren't high enough, they aren't low enough, and they don't have enough arms."[32]

On the Lower East Side, she again talked her way into an obliging tenant's apartment in order to look down on the pushcarts and shops of Hester Street. The cleanliness of the third-floor tenement in the middle of such poverty impressed Berenice. Down at street level again, she photographed a food vendor before rain drove everyone indoors. The next day, Berenice climbed to the roof of One Wall Street, the 55-story Irving Trust Building, under construction when she first photographed it in early 1929. She took a half-dozen views sweeping across the harbor and looking down upon the rooftops of the financial district's smaller skyscrapers, handholding her Linhof. For one composition, she waited for the *Île de France* to line up with a rooftop and then made her precise exposure: "bingo!" Along with "shoving trucks out of the way" on the Triborough Bridge, the most exciting experience of the project had been "hanging over the edge" of One Wall Street. A month later she

Broadway to the Battery, from Roof of Irving Trust Building, Manhattan, *May 4, 1938.* Berenice Abbott

ascended the taller Cities Service Building, at 70 Pine Street, shooting above and below the rooftop grille and then right through it for an even more lyrical effect. In at least one of these ascents, she was accompanied again by Leo Seltzer, who helped hold the camera steady.[33]

In mid-May, Berenice visited three small businesses with interesting windows and names: Flam and Flam, attorneys, on East 121st Street in Harlem; Rothman's Pawn Shop, on Eighth Avenue, where Mack Young posed in the entrance as a window shopper; and Pingpank Barber Shop, on Bleecker Street. They stopped at Twenty-Third Street near where Broadway crosses Fifth Avenue to take a second photograph of the Flat-iron Building from street level, looking up, which Berenice vastly pre-ferred over her first, conventional view.[34]

She had hit her stride with steady if modest federal support, but in June 1938 a bill to provide a permanent Bureau of Fine Arts was defeated in Congress. Still, she kept on. Using the Linhof, she captured *Normandie, North River, Manhattan, from Pier 88, French Line*. She had set her van-tage when, unexpectedly, the ship turned in the opposite direction, "up the river and . . . out on the other side." *Charles Lane Between West and Washington Streets* was kept in the final *Changing New York* archive; such alleys, rare in New York, were for Berenice sentimentally reminiscent of similar ones in Columbus, Ohio, though she quipped later that it was another one of her "dismal subjects. Talk about the Ashcan School!"[35]

As 1938 closed, with a total of seventy images made, Berenice ven-tured above Fourteenth Street for a wood-frame curiosity on Cathedral Parkway (West 110th Street), midtown's Con Ed massive powerhouse, and a stark architectural contrast view of old housing framed by new skyscrapers. She acquiesced to Grace Mayer's pleas to capture the Fifth Avenue Theatre, at Twenty-Eighth Street, photographing its exte-rior and interior just prior to its conversion to a movie house. A week later, staying close to home, with view camera and Linhof, she made three images, the last of the project's official pictures. In December she was reclassified downward from project supervisor to assistant project supervisor, with a 10 percent pay cut.[36]

"Contrary to popular superstition which says that photography is a simple mechanical affair, it is actually the least mechanical of mediums," she told an interviewer in January 1939. If El Greco and Brueghel had had photography in their day, she believed, they might have been photographers. "Being a good photographer depends on the individual's talent and discipline; it doesn't matter in the slightest whether that person is a man or a woman . . . if you want to do this all your life, realize it is as hard as any worthwhile creative activity. You must master the medium. You must understand your machine. You must understand your own purposes and the world around you."[37]

It is your job to make photographs; let
the future look at them. —BA[38]

THE MUSEUM OF THE City of New York—Berenice's institutional sponsor, as required by FAP regulations—agreed to purchase her *Changing New York* negatives for the cost of materials. Hardinge Scholle asked FAP administrator Holger Cahill in February 1936 to let them remain at the museum rather than go to Washington, which Cahill agreed they could, "ultimately." The matter was still unsettled three years later, when the project wound down, and Berenice worried about maintaining control over printing. She appealed to Audrey McMahon to be consulted about future prints because "the skill and intelligence of the photographer" provided "further creative addition." However, the negatives stayed in project offices before passing, incompletely (if along with a full series of mounted and signed prints), to the Museum of the City of New York after the project closed in 1940. In accordance with FAP regulations, the museum paid only the original cost of materials ($106.75)—to the project, not to Berenice. But their ownership as intellectual property was initially unaddressed, and the issue remained contentious for decades.[39]

As precedent, the public relations unit of the US Agriculture Depart-

ment's Resettlement Administration and its successor, the Farm Security Administration, owned all the negatives taken on assignment by its many photographers, including Walker Evans. Evans had obtained leave from his government assignment to shoot Alabama sharecroppers for *Fortune* magazine only by agreeing that his negatives would remain the property of the federal government. With the exception of supervisors, the WPA pay level was subsistence, while the FSA was far above, so there was a clear-cut understanding that the negatives belonged to the federal government. Further clouding the issue was the interest of individual citizens as well as institutions in Berenice's photographs. When collectors sought to purchase specific *Changing New York* images printed by Berenice, she had to decline, explaining that they were not hers to sell.[40]

Throughout the FAP, several organizational factors blurred the lines of authority and responsibility for tasks in support of the project's research functions as its methodology evolved. Rather than a rigid timetable, Berenice used her established, instinctive method of scouting locations, reviewing light conditions, obtaining permissions, and returning later for the actual photography. The research workers over the four-year existence of Berenice's project rotated often, and their reporting hierarchy shifted in a fluid administrative environment. At its high point, the photography section employed its full quota of thirty-seven people. Their "Outline for Photographing New York City" asked, "How shall the two-dimensional print in black and white suggest the flux of activity of the metropolis, the interaction of human beings and solid architectural constructions, all impinging upon each other in time?" The answer was a taxonomy based on three broad topical themes—"Material Aspect," "Means of Life," and "The People and How They Live"—categories traceable to Lewis Mumford's *Sticks and Stones* (1924). These topics were broken down further and assigned alphanumeric classification codes. Each of the project's final three-hundred-plus images received a code, some more than one. Cross-indexed, these classifications perform—imperfectly, as data—the analytical function their creators envisioned.[41]

Berenice respected Mumford's concepts, but the project's sophisticated, taxonomic framework reflects Elizabeth's education, enthusiasms, sympathies, and vocabulary. "What a vast subject the metropolis is and how the work of photographing it could go on forever," Berenice wrote; indeed, over the project's four-year run, she photographed only a portion of the specific subjects in the outline, giving many short shrift and neglecting others outright: Of six subjects named in the subcategory "historical buildings," she photographed only three—Civic Repertory and 45 Grove once each, and Murray Hill Hotel five times.[42]

The third theme, "The People and How They Live," called for topical social images of such subjects as "night," "Demonstrations," and "Harlem nightlife." Adhering to action-filled subjects ran contrary to Berenice's previous practice and lifelong belief that, without including a single person in the composition, "you're photographing *people* when you're photographing a city." Her small-format Rollei and Linhof cameras allowed her to capture action, but she virtually ignored most of the theme, and complained of "lots of things I could have taken in the last five years, if I only had had better cameras. . . . You want to get a crowd of people really protesting something. If you try to get the expression on their faces, you are stuck. . . . Suppose you want to catch a seething mass of people from a bus top." She did capture *Tempo of the City: I*, in name only, for the people are not seething, but simply walking briskly and confidently, as city people do. In truth, she was dissatisfied artistically with the small, less detailed images produced by her small cameras and kept trying, well into the 1970s, to take action shots with view cameras, 8 × 10 inch and larger.[43]

Asked by the project researchers to clarify their tasks, Berenice responded: "[My] photographs are to be documentary, as well as artistic, the original plan. This means that they will have elements of formal organization and style; they will use the devices of abstract art if these devices best fit the given subject; they will aim at realism, but not at the cost of sacrificing all esthetic factors. They will tell facts . . . [but] these

Tempo of the City: I, Manhattan, *May 13, 1938.* Berenice Abbott

facts will be set forth as organic parts of the whole picture, as living and functioning details of the entire complex social scene."[44]

As an example, she had photographed the Manhattan Bridge first in a horizontal view, focusing straight down the walkway along the entire span, and then turned her camera 90 degrees up to foreshorten the rectilinear bridge's ornamented pier into a dramatic visual exercise in vanishing point perspective. The feat, on a blustery Veterans Day, required two assistants to hold their overcoats as a windbreak to keep the camera from blowing away; "falling off anything was always a problem." They had to be always on the lookout for "innocent-looking bystanders."[45]

> Photography is both visual and intellectual, because
> you work with your eye and your mind. —BA[46]

New Horizons in American Art had opened at the Museum of Modern Art in September 1936, marking Congress's recent reauthorization of the Federal Art Project. Of more than four hundred works on view, Berenice's were the only photographs, and the first draft of her catalog statement exceeded the five-hundred-word limit threefold. She neglected to mention the existence, let alone the efforts, of her project's support workers, leading editor Emanuel M. Benson to write: "To judge from your article, one would assume that the project is a one-man job." Acknowledging the project's darkroom, field, and research assistance, Berenice replied defensively, "All the creative photographic work is done by myself."[47]

Nineteen thirty-seven marked the centennial of the invention of photography. MoMA's librarian, photographer Beaumont Newhall, launched an enormous commemorative exhibition in March. His research for the eight hundred objects on view—prints, cameras, albums, and books—led him to the prehistory and early history of the medium, explored earlier in the decade by Berenice and Lincoln Kirstein, among others.

Newhall paid homage to photographic technology, while his chronological presentation and subsequent catalog editions codified the aesthetic history of the medium for decades. Exhibition visitors entered through a huge camera obscura that presented their images inverted on a framed panel of ground glass and effectively demonstrated the basic principle of photography—a focused image from reality captured on a flat plane. Newhall showed that while the desire to make pictures is creative and photography allows people lacking skill to make photographs, the medium is not merely mechanical but also cerebral and artistic. Berenice loaned five New York prints, from her earliest work to FAP images, as well as Atget prints and albums from her collection.[48]

Elizabeth reviewed the show, extolling its inclusiveness and focusing on the medium's history. But Berenice produced a terser assessment in *Art Front* of Newhall's failure to acknowledge documentarians' subtle expressions of individual esthetics. "To be documentary creatively implies that the photographer has a point of view and an objective. If his purpose is communication in a wide popular sense, he is obviously communicating content and subject matter." The photographer's achievement grew, as critic Ben Lifson said decades later, "from the reconciliation, often within single pictures, of documentation and lyricism, of objective fact and personal perception." As one of the most cerebral of documentary photographers, Berenice challenged her viewers by asserting that her own highly rigorous formal work was also socially conscious, putting her closer than she wished to acknowledge to Paul Strand's position on an artist's autonomy. In *Art Front*, Strand rebutted the conclusion of French author Louis Aragon that the fruitful path for contemporary photography lay in social and political struggle. "I believe that the choice of medium in itself bespeaks a particular inner need and a particular form of perceiving reality," Strand wrote of the deeply personal choices made by all artists. "Whether the artist chooses words or music, stone or paint, or the photographic image will condition absolutely not the content but the form of his work."[49]

Real things today are conflict, contradictions,

warfare, unbalance, lack of order, lack of reason—

contrasts in a rapidly changing civilization. —BA[50]

THE SUCCESS OF BERENICE'S exhibition at the Museum of the City of New York enticed publisher E. P. Dutton, who contracted for a book with the Federal Writers' Project rather than with Berenice and Elizabeth as individual creators. Layers of bureaucracy and anxiety lay ahead.[51]

As project editor, Elizabeth aimed for the antithesis of a conventional guidebook, proposing, instead, "an adventure in form . . . to reproduce faithfully the spirit and the intention of [Berenice's] work." She envisioned a book of one hundred photographs organized into eight topical sections, including "Obvious marvels," "Old and picturesque buildings," "Movement," "Unplanned and helter-skelter effect of juxtapositions of activities and operations"—all held together by her own "Documentary commentary."[52]

Her sample text was as turgid and banal as Berenice's pictures are direct and rigorous: "The city changes. Men die. Memory fails. / How may we know the city of a hundred years ago—or even ten?" For all her hard work and professional profile, Elizabeth was regarded by peers as a distinct liability in this effort, as she had been in the unsuccessful Guggenheim proposals. Berenice, of course, loved her and always defended her. Still, Elizabeth's (ultimately ignored) ideas about the design of *Changing New York* were good ones. She proposed a large page trim (10 × 12 inches) so that Berenice's 8 × 10 inch contact prints could be reproduced full-size in their proper orientation, obviating the annoying need to turn the volume 90 degrees for horizontal images. Her concept for the book paralleled the form of a documentary film "in which commentary accompanies the visual image seen on screen, the spoken word complementing and accenting the pictured fact."[53]

Together she and Berenice created a full-size mock-up on sheets of brown wrapping paper. Some pages were full-image, some all text, and others a combination, offering lively visual variety. Photographs were centered with margins, placed off-center, or bled to the margins. The last page contained seven small photographs of New York's bridges, arranged along the left edge of the page like a strip of 35mm film. Elizabeth's tendency to verbiage was even clearer in this visual draft, whose text after the title on the first sheet read, "The photographic excavation of the archaeology of contemporary life / The New York few people see / Giving eyes to seven million New Yorkers / Their experience of the metropolis / its visual impact / its hurried tempo / the vibrations of / its hidden life." Berenice had initially compiled an alphabetical index of photograph titles, integrating her FAP New York images with some from before, and Elizabeth's editorial choices did not distinguish between them, but the final book would contain only photographs made under the auspices of the FAP.[54]

Meanwhile, the concept and format of the *Changing New York* book had continued to evolve. Although Dutton initially thought its principal audience was architects, they decided that they wanted more of a guidebook. Elizabeth wrote a long memo defending Berenice and addressing "several misconceptions of fact, due to the unfortunate circumstance that the artist was not permitted to work more closely with the publisher." She and Berenice had researched existing New York City guidebooks and investigated styles and formats of recent photographic books, to no avail. They felt powerless—and believed their commercial and government collaborators to be obtuse. Elizabeth explained the absence of "action" photographs. In exasperation, she wrote: "This series is not literal press photography!" She patiently explained the unique attraction of Berenice's images and the rationales behind the photographer's subject selection, and explained, too, why there were few landmark monuments or other guidebook fare. Underlying her frustration was a commitment as a creative citizen worker to something other than "profit."[55]

Ultimately, Dutton wanted a more conventional work, organized geographically, with one captioned image per page. The final result was a hybrid—neither an illustrated guidebook like the Federal Writers' Project's *New York Panorama* (1938) nor a writerly collaboration like Erskine Caldwell and Margaret Bourke-White's crusading *You Have Seen Their Faces* (1937). It would emphatically not be a monograph, such as Walker Evans's *American Photographs* (1938), then in development as well. (Gilbert Seldes, who used so many of Berenice's New York pictures just four years earlier in *This Is New York*, admired *American Photographs* and wrote about Evans's show for *Esquire*, but seems not to have publicly noticed Berenice's *Changing New York* work at all.) In a discarded draft of acknowledgments for his pioneering book, Evans expansively wrote: "To Berenice Abbott for having been an honest and uncompromising artist from her beginning."[56]

With Dutton's editorial reconfiguration of *Changing New York*, Elizabeth was assigned to edit the captions written by the same research staff—Charles White, Sally Sands, and James F. Broughton—that had failed earlier to complete the 1937 exhibition labels, a team now augmented by eight newcomers. She annotated their manuscripts and badgered them for facts and analysis: "Are [coal elevators] strictly functional? And does their beauty of form derive from the fact that their structure precisely fulfills their function? . . . In event of a nationwide coal strike would the city be seriously crippled for fuel?" Her sheer verbosity had to be reined in to meet Dutton's July deadline; nevertheless, the publisher rejected the first draft of captions. Elizabeth's "literary" text, which Berenice had approved, lacked the cool detachment that Elizabeth most admired in the photographs; a new, strictly factual program for text went forward.[57]

Picture selection was not left to Berenice and Elizabeth, either. The final cut shows a strong shift away from Berenice's more idiosyncratic subjects toward midtown Manhattan, including Rockefeller Center and other office skyscrapers. Reducing the book at the last minute from one hundred to ninety-seven plates lost three of the most inter-

Father Duffy, Times Square, Manhattan, *April 14, 1937.* Berenice Abbott

esting images—*Church of God*, depicting a Harlem Pentecostal minister springing down the storefront's stairs; *Father Duffy*, showing the commemorative statue of the Irish American priest wrapped and bound before its Times Square unveiling; and *Construction Old and New*, contrasting tenements and cleared lots with the towers of Wall Street (a detail of exposed brick wall provided the graphic for the book's dust jacket, a design Berenice was allowed to provide).[58]

For the book's foreword, Berenice first approached her early supporter I. N. Phelps Stokes, who declined after a month's hesitation. She next asked Lewis Mumford. When that didn't work out, she followed up a hasty telephone conversation with Henry-Russell Hitchcock by sending him proofs with an immediate deadline of October 1. Cautioning him that the audience was not "architectural," Berenice affirmed her "belief that things, forms, objects, buildings" in her pictures "tell us as much about a civilization as people themselves." She also wanted him to make clear that the Federal Art Project was to "get credit for supporting [her] idea, not for originating it."[59]

Along with Hitchcock's completed essay, Elizabeth sent McMahon a cover memo addressing plagiarism of Berenice's photographs by other FAP participants. A main offender was Alexander Alland Sr., who had been named supervisor of the "Photo Mural" section in order to execute a three-panel series for the Newark (N.J.) Public Library. The publication of the Federal Writers' Project's own book, *New York Panorama; A Comprehensive View of the Metropolis,* in summer 1938, included pictures that were truly reminiscent of key angles Berenice had been stalking for years. She followed up with her own memo to McMahon a day later: "The reckless and unintelligent imitation of my work included in *New York Panorama,*" she wrote,

is an intolerable injury to my reputation as an artist. For fifteen years I have worked to present the integrity and honesty of "straight" photography and to promote the values of the docu-

mentary method. My work is internationally known, and my signature is valued because I have been true to my standards.

To have my ideas and themes stolen and presented to the world in a corrupt and bastard form — let alone the disgraceful quality of reproduction — is a negation of my lifework, as well as a tangible blow to my position as a photographer.[60]

Meanwhile, Hitchcock's rambling historical essay graciously acknowledged the high quality of Berenice's photographs, concluding, "[P]hotography will prove its artistic maturity not by the single print, the isolated purple passage of incredible style, but by the execution of large-scale documentation, with all the thoughts the photographer has behind it." Nevertheless, the essay was rejected by the publisher as esoteric and irrelevant to the photographs. In its place, a perfunctory appreciation written by McMahon savvily commended the federal government's ability to support a collaborative effort as it did one artist's creative result. "Berenice Abbott does not wish to be called artistic. She hates everything that is sentimental, tricky or devious. Her photographs are not dressed up with trailing clouds nor dramatized with superficial tricks or angle shots, soft lighting or oversimplification."[61]

Berenice again taught her two New School workshops that fall; Eliot Elisofon taught a class called Photo Reportage, and Jay Leyda and Irving Lerner ran a filmmaking workshop. A fiscal year-end FAP report announced the overall creation of 355,126 photographs—mostly records of works of art made on the project and for reference by the Index of American Design. The report said that the photography unit's main legacy was the numerous settlement-house courses taught by its staff. Berenice's final FAP pictures, of children at work in community art centers in Harlem and Queens, were made in late April and early May 1939 and continue the numbering and coding used for *Changing New York*. Their content approaches the overt social aspects of Berenice's (or Elizabeth's) vision for the entire project, but none appear in the project's final images. A decade passed before Berenice photographed New York City again.[62]

Changing New York was one of several New York City books appearing in time for the April 1939 opening of the New York World's Fair. The *New York Times* said that it "brings out aspects of the city that few natives, let alone visitors, ever take the time to notice," and called the pictures "eloquent and honest." *Time* magazine observed that "photographs . . . become poignant to most people only gradually, as years pass and streets vanish," and went on to describe Berenice as "a direct girl who still talks harsh Ohio, still wears a Left Bank haircut and beret, [and] confesses to being scared of heights and crowds until she gets her head under the black cloth. Her dizziest shots are nevertheless sharp, hard, and sense-making, though her best are meditative portraits of comely, chapfallen facades selected from the vast 19th-century underbrush among Manhattan's skyscrapers." Fellow Paris expatriate Swiss photographer and cultural critic Sigfried Giedion, then teaching at Harvard, congratulated her as an artist and as a historian—"a vivid creature!"[63]

None of the praise seemed to capture the implicit critique that underlay her work. Compared to the Paris of Atget, as she told Ansel Adams, "New York is the face of the modern city, bred of industrial centralization. Our age is ruthless, hard, competitive, tense, greedy. It shows as much in the faces of buildings as in the faces of people. That character I have sought to recreate in my photographs." When Berenice asked if she thought photography was an art, Lisette Model—who became Berenice's "best buddy" when the two photographers met soon after Model emigrated to the United States in October 1938—answered, "I couldn't care less, but what else can it be?" Only she seemed to understand, as she told Elizabeth a decade later: "When people see Berenice's pictures of the city, they say 'so what? We have seen this a thousand times.' They <u>have</u> seen it a thousand times, but not this way. Yet they can't see the difference . . . There is no distortion, no hysteria. She is the healthiest photographer I know." On the other hand, Lisette found Atget's pictures the "most boring thing" she'd ever seen, which Berenice didn't understand at all.[64]

In May the Museum of Modern Art celebrated its tenth anniversary with an expansive contemporary exhibition, *Art in Our Time*. Berenice was the only woman among seven photographers. Filmmaker Irving Browning photographed her determinedly scrambling around on a tugboat to get any angle of view, footage later incorporated in his *Women in Photography* (1941).[65]

Federal Art Project members and cultural leaders petitioned Congress unsuccessfully in June 1939 to continue the program's funding. Supervisor Ralph Gutieri left and was replaced by staff photographer Anton Grubman, who tried to run the place like a communist cell, said clerk May Malkin, saving the choicest assignments for his comrades. On September 25, a month after Berenice and Grubman addressed the Photo League on "The Government Sponsors Photography," she and many others received a pink-slip termination notice as a "non-essential non-relief recipient." The Photographic Division had generated 40,388 negatives, 170,254 prints (including four exhibition-quality sets of *Changing New York*), and 3 motion pictures. The unit also produced photomurals for the New York World's Fair and the dining room of Rikers Island jail. Berenice tried to remain employed, as New York City's official photographer, but by November the transition was complete as FAP staff was cut nearly in half to 1,000.[66]

In December, Berenice applied for a passport, intending to embark from New Orleans in February for "one year's travel to Mexico and the West Indies for purpose of rest and travel." She gave the State Department the FAP's 112 Leroy Street address as her own. There is no indication, however, that she took the trip. "The WPA," she said, "knocked New York out of me."[67]

FRIENDLY INTERPRETER

New York, California, Chicago (1939–51)

> *Certainly progress in photography is not going to stop. . . . It*
> *would be a brave man who would predict that such a process*
> *will always remain clumsy, slow, and faulty in detail.*
>
> —VANNEVAR BUSH[1]

See, my idea for doing that was too early. They weren't ready for

it. And things have to be timed at the right time. —BA (1968)[2]

At forty, Berenice felt it was time for "another turn," a different subject. Making a logical intellectual leap, she proposed a new artistic role for herself as "a friendly interpreter between science and the layman." Even as a young and fashionable American portrait photographer in Paris, she had been impatient with her artistic contemporaries' ignorance of the cultural and technological transformations revolutionizing modern life. "What about the engineers, the architects, Antheil, the comic movies, *Gentlemen Prefer Blondes?* What about our Scientists, in fact?" she had asked in 1928. "Microbes! . . . the biggest movements are not named."[3]

Long after she left Paris, Berenice quoted Leo Stein's belief that "essentially ours is a 'scientific age' rather than an artistic one." Lewis Mumford had argued that perhaps photography alone "is capable of coping with and adequately presenting the complicated, inter-related aspects of our modern environment." He thought that the world was at the dawn of a new science and machine age serving freedom and social community. They were all aware of the embrace by Marxist economics of the rational authority of science and its presumed certainty. On Berenice's reading list was *Science at the Cross Roads*, Boris Hessen's 1931 classical statement of Marxist historiography, which concluded: "Only in socialist society will science genuinely belong to all mankind. New paths of development are opening up before it, and its victorious march has no bounds either in infinite space or in eternal time." A few years later, the new *Science & Society: An Independent Journal of Marxism* specifically took an openly non-Stalinist stance, and Elizabeth anticipated contributing American art scholarship. In *The New Masses*, Berenice's old OSU friend Louis Lozowick explicitly united this certainty with photography, referring to "the camera as an instrument of scientific precision."[4]

Berenice was at a crossroads. Asked by *Popular Photography* to cite her favorite photograph, she proposed a symbolic tableau, illustrated by her 1932 photomural of New York:

> Suppose we took a thousand negatives and made a gigantic montage; a myriad-faceted picture combining the elegances, the squalor, the curiosities, the monuments, the sad faces, the triumphant faces, the power, the irony, the strength, the decay, the past, the present, the future of a city—that would be my favorite picture. . . . My favorite picture will be made in the future![5]

Berenice's interest in "science" was also in keeping with a more general, between-the-wars, twentieth-century belief that technological

development led to social and material advancement. This "technological optimism" fed popular expectations of progress through discovery and innovation. A mass-market roundup such as 1935's *Eyes on the World: A Photographic Record of History in the Making* typically included discoveries that were going to solve problems and innovations that would lead to a better life for all. In addition, attention to science education was also expected to enhance critical thinking on the part of ordinary citizens in service of democracy.[6]

> [T]his function of photography seems
> extraordinarily urgent and exciting. —BA[7]

HER ENTHUSIASM FOR "all electrical and industrial processes" helped Berenice attract commercial assignments in order to investigate "science" through its industrial manifestations and applications. For *Fortune*, she shot Ballantine's operation in nearby Newark, New Jersey, where "America's Largest Selling Ale" was brewed. Her visual perspective, reminiscent of her late 1920s *Vertikal-Tendenz* imagery, captured delivery trucks at the loading dock and foaming vats during the brewing process; only her candids of workmen in a bar did not appear in the article. At Rutgers University in New Brunswick she photographed plant research and hydroponic agriculture. At RCA's facility in Camden she documented television equipment as well as the team led by scientist-inventor Vladimir Zworykin.[8]

Another Time Inc. assignment at a mechanized poultry slaughterhouse caused the writer to faint, and Berenice "didn't eat chicken for a year." Though she pleaded for more science jobs, she "was not going to work cheap . . . being splattered with blood and I don't know what all, I should do that for little money?" She claimed that she wasn't hired more often because the publisher already had one prima donna—Margaret Bourke-White, a full-time salaried staffer—and didn't "want two!" (Notably,

Berenice had submitted to Wilson Hicks, Time Inc.'s legendary picture editor, an expense account for "porters for eight pieces of equipment.")[9]

The late 1930s arrival of European artist-photographer refugees from Hitler's Germany further thwarted her career on the science beat, Berenice believed. When Fritz Goro became Time Inc.'s science photographer, she felt she "was just thrown out"; publications got the newcomers "cheaper" and "American photographers could go fly a kite." She groused that Time Inc. would employ her students, who would then call asking for help with their assignments: "I'd help them, but—." A few years later, however, in 1944, *Time*'s science consultant, the popular lecturer Gerald Wendt, would hire Berenice for *Science Illustrated*, a digest-sized, general-audience monthly.[10]

But in 1939, her overarching goal as she started on her earnest but undeveloped effort to "photograph science" was to educate average people, including her artistic contemporaries. She considered them all "woefully ignorant" in their dependence on sophisticated technology in everyday life. Exploring funding possibilities, Berenice was guided by Dr. Charles C. Adams, of the New York State Museum, who encouraged her to produce a manifesto:

> We live in a world made by science. But we – the millions of laymen – do not understand or appreciate the knowledge [that] thus controls daily life.
>
> To obtain wide popular support for science, to that end that we may explore this vast subject even further and bring as yet unexplored areas under control, there needs to be a friendly interpreter between science and the layman.
>
> I believe that photography can be this spokesman, as no other form of expression can be; for photography, the art of our time, the mechanical, scientific medium which matches the pace and character of our era, is attuned to the function. There is an essential unity between photography, science's child, and science, the parent.

Yet so far the task of photographing scientific subjects and endowing them with popular appeal and scientific correctness has not been mastered. The function of the artist is needed here, as well as the function of the recorder. The artist through history has been the spokesman and conservator of human and spiritual energies and ideas. Today science needs <u>its</u> voice. It needs the vivification of the visual image, the warm human quality of imagination added to its austere and stern disciplines. It needs to speak to the people in terms they will understand.[11]

The Carnegie Corporation brusquely turned down her naively vague proposal to bring "science to the public by means of photography," explaining that "neither science nor photography is at the point where the two can work together to common advantage." The Bronx High School of Science, newly founded to further education in the sciences, told her that existing science illustrations were quite adequate. Berenice characterized her fledgling efforts to communicate as being something "[l]ike a flea attacking a giant."[12]

In this quest, she had good historical company. English scientist James Clerk Maxwell had argued, three-quarters of a century earlier, "For the sake of persons of different types, scientific truth should be presented in different forms, and should be regarded as equally scientific, whether it appears in the robust form and vivid coloring of a physical illustration, or in the tenuity and paleness of a symbolic expression"—that is, an equation. Critic and art historian Charles H. Caffin had written, in 1907, that photography is "a new art, as electricity is a new science," and should be concerned "not with allegories and old-world myths, but with actualities of the present."[13]

Berenice explicitly also sought to "understand why artists don't understand scientists and scientists don't understand artists." J. Robert Oppenheimer, who developed the atomic bomb, allowed that artists and scientists, by living at the "edge of mystery," had a special bond, "with the balance between novelty and synthesis, with the struggle to

make partial order in total chaos." In 1959 the same challenge would be addressed by British scientist and novelist C. P. Snow, whose "Two Cultures" lecture drew attention to the persistent divide between the sciences and the humanities.[14]

Berenice encountered the Biological Photographic Association, in existence since 1931, in time to attend its annual conference in fall 1939. (Possibly her connection was the botanist and photographer Wanda K. Farr, who, Berenice recalled incidentally, had discovered the wetting agent that was the basis for the darkroom aid Photo-Flo—"the water became much wetter and the ducks would sink"; they both exhibited in a group photography show at the Hudson Park Branch Library in 1940.) Of three hundred association members, only forty-one were women, and since not all members attended the conference, Berenice stood out, underdressed at a black-tie dinner in Pittsburgh. At this event, she met Robert C. Cook, a vocal champion of improved photography in scientific communications and editor of the heavily illustrated *Journal of Heredity*. "Scolding about ignorance, indifference, and lack of imagination," and "bawling out [his colleagues] for the lousy pictures they had," Cook urged more consideration of the importance of quality photography as an educational force in advancing the scientific method. When an associate of Science News Service, to whom Berenice had sent her science manifesto, offered her thoughts as his own, she mentioned the plagiarism to Cook, who was sympathetic; she and he became fast friends.[15]

Berenice had immediately focused on electricity for its ubiquity and familiarity. "My God, we only had electric light while I've been alive," she marveled in her eighth decade; "most of us don't even know what makes the light go on." From 1920, Duchamp's electric motor–driven Rotoreliefs and other optical constructions surely made an impression. She also likely knew of May Ray's 1931 gravure portfolio *Électricité*, commissioned by La Compagnie Parisienne de Distribution d'Électricité. Her own 1935 photographs of TVA construction illustrated the corporation's goal of providing power throughout the South.[16]

Ambitiously, Berenice aimed to produce a popular monograph on

electricity, from magnets to dynamos, sketching out a book idea and identifying a potential coauthor in Laurence Sanford Critchell Jr. He had written to her about *Changing New York*, claiming that she was "not altogether American" because her photographs possessed "a curious antique iron darkness . . . Paris on a grey-dark afternoon in autumn when the ironwork on the balconies looks black, and so does the future." But in October 1941, Macmillan Publishers turned down her idea, and Critchell's army enlistment in early 1942 ended the possible collaboration. Berenice kept at the topic until the mid-1950s, routinely encountering opposition for security and liability reasons when she tried to gain entrance to dynamos and transmission stations.[17]

For the war effort, Berenice investigated a civilian position with the National Roster of Scientific and Specialized Personnel, while Elizabeth (despite extreme farsightedness) studied photogrammetry for aerial mapping; in the end, neither found employment in these areas. With wartime dim-out mandatory in 1943, Berenice's *Night View* ran in *Harper's Bazaar* across two pages promoting war bonds as Christmas gifts; "New York as it was, as it will be, and as New Yorkers have never ceased to think of it—in its glory by night," read the copy. Loyalties from the 1920s colored Berenice's feelings during the war; she loved France but disdained England's empire of colonial domination and smug Victorian ways. She was conflicted about Germany, whose culture she enjoyed and respected artistically. Elizabeth's stalwart antifascism made her anti-German, as if the entire nation was responsible for Hitler, a not uncommon attitude in New York. But Berenice did not share this depth of feeling, and openly admired many aspects of historical Germanic culture, possibly to the point of being misinterpreted as sympathetic to the enemy. After the war, from 1949 to 1951, Berenice served on the advisory board of Volunteer Service Photography Inc. along with Ansel Adams and Margaret Bourke-White, among others. Believing that the practice of photography sped the healing process by easing the pain of mind and body, they helped raise money for veterans' hospital services to provide cameras and darkroom equipment.[18]

In March 1942, as Berenice lay in bed musing, she imagined a totally new photographic method—an ingenious and deceptively simple system of direct image capture, which she wrote down:

> I had previously projected objects in my enlarger, but only transparent objects can be so treated. While considering how to make photographs which possess greater definition and roundness and so are more faithful to their real appearance, I suddenly thought: Can I not project opaque objects if they are lit from the front? I immediately made an experiment with my assistant, Miss Wilkinson, to test the idea.

Pat Wilkinson, Solita Solano's niece and a photography student, witnessed the statement, which Berenice sent by registered mail to herself in order to prove and date her invention. It continued:

> I sat her in back of my 8" × 10" camera, the ground glass first having been removed – this in the darkroom. Then I took two portable lights and lighted her face, draping the focusing cloth, etc., over her head, the camera and lights to shut out light from everything except her face. Thus I was able to project her image through the camera's lens onto a white cardboard on the wall. The image thus projected was startlingly vivid, real and exciting. I then placed a sheet of normal sensitive projection paper over the cardboard and, exposing it, got a very interesting negative photograph . . .
>
> Since March 9 I have carried out experiments with paper negatives, autopositive paper, super speed positive paper, etc. As strong lights cannot come near a person's eyes, all of these were discarded because of their slowness.
>
> The method I evolved experimentally is to project the image of the object behind the camera onto 16" × 20" film in a totally dark room, the object being lighted from the front. This setup creates

a new kind of photography, Projection Photography. Its prime advantage is greater realism, the raison d'être of photography.

This is possible because the object itself is enlarged instead of a negative. A greater range of tones results; for the real object has more tones than film registers, and paper registers even fewer tones than film. Loss of tones — by which we mean shapes, forms and hence facts — means loss of truth to the real object. This, I am certain, makes an important addition to photography.[19]

The genius of Berenice's invention resides in her clear understanding of camera optics and her conceptual leap to the mechanics of image enlargement. Basically, the image of any three-dimensional object, when illuminated inside a closed dark box, in a darkened room, is transmitted or projected via an enlarging lens mounted on the side of that box. When received by a photosensitive surface outside the box, that transmission creates an enlarged image of the thing itself, with no intervening "noisy" medium to filter or dilute the image, as does, for example, grain in a negative. By reversing the operation of a camera obscura, Berenice's process allowed a greatly enlarged and detailed image of a real object to be captured directly for "greater realism in pictures," which she felt her scientific subjects needed and by which any subject, big or small, could be better communicated. Eventually she devised a dark-box contraption nearly five feet tall and three feet square in which to position her subject and lights for optimal illumination and image projection, leading to a better capture.

Over time the invention's name evolved, as Berenice played with branding in her notebook: "Ultra-Sight/ Super-Sight/ Prior Sight/ Precision Sight/ Syco Sight/ Pre-Sight/ Tri-Sight/ Tru-Sight/ Sur-Sight/ Sycosight/ Telesight/ Kro-Sight/ Macro-Sight/ Show-Sight." As photographic materials were rationed during the war years, she experimented by piecing together 8 × 10 inch sheet film and paper until she was able to obtain full-size 16 × 20 inch supplies. With these she could create large

negatives and contact prints, offering a beautifully realistic image of the thing photographed, with its most salient qualities and dimensionality in startling detail. Among her first subjects was the works of a pocket watch, which she showed to others as evidence of her process's capabilities.[20]

Austen Crocker Fairbanks, son of her Boston friend Marge Fairbanks, offered to approach his Swarthmore College physics professor, a Dr. Johnson, with a print of "Berry's" Super-Sight photography for endorsement. For comparison, Berenice provided a conventional enlarged photograph of the same subject. A previous prospect had dismissed the effort as pointless, claiming she needed to get within ten angstroms' magnification to be helpful to him as a scientist. This distinction—between scientific photography that tolerated imperfections incidental to cutting-edge research imaging and Berenice's humanistic goals of facilitating communication among nonspecialists via beautiful images—caused misunderstanding and delayed appreciation of her ingenuity.[21]

While Marge Fairbanks tried to identify a trustworthy patent attorney, Robert Cook introduced Berenice to Milton E. Lowry, in Washington, DC, who advised, futilely, that he needed full disclosure of the process to proceed with a patent search. Three years later, Berenice's old legal savior, Roy H. Ellison, introduced her to one of his partners, Samuel A. Shacter, who advised her to flaunt her photographic reputation to command attention and respect from manufacturers. Shacter was also concerned lest Berenice injudiciously disclose her idea, feeling that its very simplicity and obviousness might render it unprotectable by a patent. On the advice of lighting specialists at GE in the mid-1940s, she reached out to Harold Edgerton, MIT's pioneer in stroboscopic photography, whose path she had crossed several times; he warned that her required lighting was at least five years and many thousands of dollars away. But Berenice did not give up, horse-trading for bulbs and other small supplies with less egoistical entrepreneurs such as Milton J. Schwartz, whose business, Electronics for Photographers, counted Edgerton among its clients.[22]

Berenice applied again to the Guggenheim Foundation, in the fall of 1941, this time to "study photographically the applications to everyday life of modern science" using "imaginative camera interpretation" to "visualize and vivify scientific knowledge. To photograph scientific subject matter with accuracy yet also with art demands a new kind of photography." She wrote, "The photographs which are to interpret science to the layman must be realistic, they must represent the physical actuality, yet at the same time they must be imbued with the poetry of the new life created by science. This is a task for the artist-photographer." Briefly describing her project's "Contribution to Culture," Berenice asserted that the "democratic life can only be maintained and developed where the whole citizenry is alert to problems of social existence and informed as to their nature." Her purpose as a creative photographer would be to "widen the usefulness of the medium as a means of communication. . . . Photography['s] . . . greatest strength is that it only functions in the highest esthetic and expressive sense when it deals with reality. Science is the great reality of our time. The union of photography with science will evolve the new art."[23]

Willard Morgan was interested in science subjects during his two years as photo editor of *Life* magazine and served as an enthusiastic reference, calling Berenice the one photographer who could "swing into action" on what she had proposed. Berenice also received support from Time Inc.'s Gerald Wendt, who had been science advisor for the New York World's Fair. Wendt acknowledged that Berenice possessed an amateur's familiarity with science but was concerned "always with the advancement of society by way of science," basically "tracing social phenomena to the source and revealing the creative role of science."[24]

Another Guggenheim reference, Sigfried Giedion, wrote that "the new forms revealed by scientific research are beginning to enter into the realm of our feelings. . . . Scientists concerned with research have little understanding that their discoveries may have aesthetic as well as scientific significance." Dr. Charles Adams's recommendation championed Berenice's "mastery of technique" and "courage to undertake explora-

tion in this field, which she discovered on her own." Less supportive was Professor Lyman Bryson, of Teachers College, Columbia University, who doubted the "efficiency" of her plans. Even worse, Alvin Johnson, director of the New School for Social Research and Berenice's employer since 1934, had "grave reservations" that isolated moments could be selected in a technical process and "still illuminate the process as a whole." Such conditional endorsements signal the perceptual obstacles Berenice faced. She was turned down and applied the following year; no awards were made to photographers.[25]

Berenice continued photographing industrial subjects, with Charles Rotkin as assistant. A postal worker who "wanted out," Rotkin was a for-credit New School student who exchanged classes for lab and field assistance and traded his mechanical know-how and home workshop for instruction in meticulous darkroom practice. Berenice had one assignment from McAllister Towing, one of the big family-run firms in the tugboat field, though, Rotkin said, she didn't know one end of a boat from the other. Another involved a $100-per-day job to photograph the new Grand Central Terminal offices of the Minnesota-based Red River Lumber Co. It was the family firm of Hudson D. Walker, who, while continuing as an executive there, from 1936 to 1940 operated, with his wife, Ione, the Hudson D. Walker Gallery on Fifty-Seventh Street. Berenice exhibited at the gallery, and Elizabeth authored exhibition texts.[26]

The goal of the Red River job was not only to obtain high-quality professional photographs but also to garner support within the firm for additional assignments for Berenice. Walker art-directed the shoot, while Rotkin assisted to get the right afternoon light and city view through the office windows. Even with Berenice's widest-angle lens on her 8 × 10 camera, they still had to jam into the back of the elevator to get far enough away for an all-encompassing view of the reception area.[27]

Rotkin found Berenice a "tough, tough woman" and felt that her demanding nature and humorlessness came from having to work so hard. Her stifling discretion about being a lesbian was more for Elizabeth's sake than her own, he felt, an unacknowledged secret life detri-

Berenice Abbott Playing the Concertina, *New York, 1940.*
Dressed for a costume party, she posed for a student from the family
of the well-known photographic equipment firm Simmon Omega.

Kay Simmon Blumberg

mental to Berenice's "career, her manner, everything." She encountered a wider discrimination for who she was, regardless of her discretion—her feminism, her politics, her brusque, intemperate personality. Another young New School friend, Kay Simmon, captured a glamorous Berenice costumed in May 1940 for a *danse Apache* and playing a concertina, her ever-present cigarette clenched dashingly in a long holder. Not long after, *Popular Photography* published Berenice's sloe-eyed, flirtatious self-portrait in full lipstick and eye makeup.[28]

Atget's archive was never far from Berenice's attention. As France fell to Germany, Americans raised money to support French refugees

Berenice Abbott, lower left, in "Self Portraits," Popular Photography *(May 1941).* Berenice Abbott

and exiled institutions and to keep the occupied country in the nation's consciousness. *Harper's Bazaar* ran several pages on Atget, including an explanation of how he had inspired Berenice to become a documentarian. She contacted expatriate French actor Charles Boyer at RKO Pictures. He was then establishing the French Research Foundation as a Hollywood resource for French history and culture. Boyer eventually acquired two dozen prints, whose proceeds Berenice split with Julien Levy.[29]

However, Berenice rebuffed Funds for France Inc., which sought to sell "reprints" of Atget photographs, and instead offered to lend fifty original prints for a paid-admission exhibition, with proceeds going to the organization. A month before Pearl Harbor, she loaned a group of Atget prints to an exhibition organized by the Coordinating Council of French Relief Societies. In 1942, with the United States officially at war, she and Levy were back in communication concerning MoMA's inter-

est in acquiring a selection of a hundred originals from their cache of duplicate Atget prints. Berenice urged her old partner to act quickly, "as Newhall may go into the Army very soon and [this] could mean years of delay." As she had feared, the curator soon entered the military and the Atget question fell dormant.[30]

At a party for Irving Browning's *Women in Photography*, Berenice learned that "male hostility" had driven child portraitist Ruth Nichols, another subject, from the field. Of her own appearance in the film, Berenice later said she was "going through a difficult time or something" and thought she "looked like hell" leaping around tugboats for the FAP. Browning is best known today for his 1931 film *City of Contrasts*, set in Manhattan, which cuts from rooftop luxury to street-level hard knocks, and for his antiquarian interest in old cameras and photographs; he also screened documentary films at the New School for the Film and Photo League. *Women in Photography* included Margaret Bourke-White and fashion photographer Toni Frissell, whom Berenice denied ever knowing. The film was seen on Army bases by many of Berenice's contemporaries, including William C. Estler, Elizabeth's WPA friend with the Army Air Forces in Gulfport, Mississippi; their grocery delivery boy in the South Pacific; and their doctor at Camp Edwards on Cape Cod.[31]

Berenice's portrait commissions during the war included a study of her science booster Gerald Wendt and the Austrian author Hans Habe, born in Hungary, on the occasion of the translation of his book on the fall of France. She captured uniformed servicemen, taking "a very handsome photograph of a very unhandsome" medievalist, Rossell Hope Robbins, he said, as a new second lieutenant; Robbins and his wife, teachers' union activist Helen Robbins, and their friend Nan Pendrel were among Berenice's most committed leftist friends outside her photographic circle.[32]

In 1942, Berenice was out of town when publishers H. W. Wilson prepared a profile of her for their new reference series, *Current Biography*, so Elizabeth fielded their inquiries and helped with the rewrite:

Berenice Abbott works in a huge studio in Greenwich Village, New York, furnished completely in modern pieces by Artek. Her working procedure in the darkroom differs from others as she sets up her materials from right to left rather than from the conventional left to right. Active, restless, she is likely to be found playing a vicious game of ping-pong, if she is not prowling around the city taking photographs. She is blue-eyed, five feet five and one-half inches tall, weighs 135 pounds, wears her brown hair cut short, and likes striking but comfortable clothes. Her hobbies, she says, are traveling and playing the concertina.[33]

In 1944, *Science Illustrated*, newly acquired by publisher Jacques Cattell, hired Berenice at $25 a week as both a photographer and the publication's photography editor. She was assigned to enliven the magazine with illustrations, and saw it as a venue for her efforts with Super-Sight. (She even tried to interest the Hamilton Watch Company in her photographs for advertising purposes; the company was located in Lancaster, Pennsylvania, where the magazine was published.) One of her ideas for a Super-Sight series was "Eyes"—that is, "whose/what eye is this?" Specific animals to photograph included frog, owl, reptile, bird, horse, cat, human, rat, cow, and bat; she also envisioned a series of seeds such as "grape, avocado, peach, grapefruit," and one of plant "buds."[34]

Intending to use Super-Sight to photograph machine components and to do portraits, she proposed a series of murals to decorate offices and record the history of IBM, whose chairman and CEO, Thomas J. Watson, she had photographed a decade earlier for *Fortune*. IBM's Marinoble Smith, director of the Fine Arts Department, contracted with her for $1,200 plus travel and lodging expenses; Berenice provided all film and paper, while IBM provided then-scarce flashbulbs. Berenice went to Binghamton and in mid-May to Endicott, New York, to photograph at the IBM plants there, foregoing for the latter an invitation to a party for Ansel Adams thrown by photography critic Nancy Newhall, the wife of Beaumont Newhall.[35]

In another effort to break into industrial-science photography, when the miracle antibacterial drug penicillin was released for limited civilian use, Berenice approached its primary manufacturer, Charles Pfizer & Co., about a photography job. While the Pfizer archives have no record, she claimed to have "just borrowed" at least one inch-wide *Penicillium* mold to photograph in Super-Sight; it was reproduced in *Science Illustrated* for January 1945. (In July 1946, another "ripe penicillin mold turned up," and the fact that it had to be photographed immediately nearly caused Berenice to miss her train to Chicago to teach at the Institute of Design, founded by Moholy-Nagy.)[36]

Berenice's general theme for *Science Illustrated* was to be "Adventure in Seeing." From the start, she hoped for help with book projects, but she ended up being unhappy with the pay scale. In mid-July 1945, McGraw-Hill bought the magazine and transformed it into a large-format publication with lots of color. The redesign debuted in April 1946, with Gerald Wendt still editor in chief but without Berenice on the masthead. The first revamped issue featured her anomalous images, taken at her Commerce Street studio, of fashion models wearing clothing made of polymer fabrics. (One of the images shows the framed elephant folio-size print of Audubon's bald eagle that hung in the studio, evidence of Berenice's interest in Americana.) For this shoot, she was joined by a new assistant, forty-year-old Edward Schwartz, from the Lower East Side, a communist member of the Photo League from before the war and a returning Navy Seabee (Construction Battalion) vet. Not seeing himself as a "hot air" type, he had studied mechanical engineering before the war.[37]

In June 1945, *Tricolor*, a French-American magazine coedited by Audrey McMahon, had reproduced Berenice's *Termite House*, a Super-Sight image of insect-channeled wood in an article on contemporary photography. Beaumont Newhall also viewed what he called Berenice's "macro photographs"—16 × 20 inch images of watch works, a shelled walnut and a knot in a piece of wood—in her studio. Worried about being held responsible for knowledge of the secret process if she were to

disclose it to him, he declined to provide an endorsement for the process, claiming insufficient expertise in the history of photographic science.[38]

Using two sheets of 16 × 20 inch film end-to-end, she created an impressive Super-Sight diptych of a fish, for which she had shopped exhaustively on Bleecker Street, frustrated by the fact that "none of them looked like fish. They were all dead you know." After Berenice found her specimen, she came up with a singsong near-rhyme—"I want to marry a barracuda"—whose drunken repetition resulted in her ejection from a Valentine's Day party. Her escort home was teenaged Leticia Kent, a family friend of the hosts. After viewing Berenice's *Changing New York* photographs the next day, Kent, who was studying at Cooper Union, signed up for her New School class and became a good friend and dancing partner.[39]

A few years later, MoMA photography director Edward Steichen included several Super-Sight images in *In and Out of Focus*, his first big MoMA show "surveying contemporary photography." The museum's label for Berenice's work proclaimed that her "passion for realism goes beneath the surface appearance of things, places and people. . . . With the large portrait of the fish she aims at a curious intensification of reality." The only other showcase of Super-Sight pictures would be in an illustration-rich 1948 biology textbook.[40]

Over the years, Berenice's friends tried to guess the Super-Sight process; in the 1960s Irene Shwachman understood that its operation required two people and believed, correctly, that only poet Muriel Rukeyser, who shared Berenice's interest in science, had been let in on the secret. In 1968, Berenice bemoaned Super-Sight's commercial dead end and admitted to being "down at everything. Down at the mouth, down at the heel, and down in spirit" about it; at the same time, she remained amazed that a process her patent attorney had told her "to keep . . . secret" hadn't been deciphered. In the 1970s, Polaroid developed its similar "museum camera" independently of Berenice's unheralded work.[41]

Her experience with photomurals and her enthusiasm for enlarging

Installation view of the exhibition In and Out of Focus: A Survey of Today's Photography, *April 6, 1948, through July 11, 1948, the Museum of Modern Art, New York. BA's panel of photographs (*from left, clockwise*):* Termite Architecture, *right half of diptych* Fish, Beetle, Bud and Leaf, *Abbott Distorter self-portrait, and* Penicillin Mold. Soichi Sunami

her New York City images to 11 × 14 and bigger was informed by a desire for intensity of detail and the greater realism to be achieved by larger scale. But she was not a fan of what she saw as simple gigantism that "might startle you for a moment; but . . . for what? It doesn't mean art to me." Then, thinking less of photography and perhaps more of Claes Oldenburg's pop sculpture, she continued, "Just because you blow up a faucet . . . and make it big . . . doesn't mean it's a good thing. Whatever art is, I don't think it's that. . . . It's simply pretentious idiocy."[42]

Ed Schwartz assisted on one of Berenice's most exuberantly artful 8 × 10 inch photographs, *Soap Bubbles* (1946), for *Science Illustrated*. Declining to feature a glamour girl in a bubble bath for an article on surface tension—another photographer obliged with that subject— Berenice focused on the foam. Her lush, gleaming close-up image

resulted from a three-day marathon of photo styling using glycerin-spiked tiny suds, a small Pyrex dish balanced over a flashbulb, rubber tubing, and an air pump.

PM, a liberal New York City daily newspaper published briefly by Ralph Ingersoll and bankrolled by the eccentric Chicago millionaire Marshall Field III, recounted the shoot in its Camera Eye photo column. Though Berenice said she "wasn't after beauty," by photographing the bubbles "for what they were, they couldn't help but be beautiful."

Science Illustrated superimposed a diagram on Berenice's *Soap Bubbles*, intending to ensure that readers understood their structure, but the effect was simply to obscure the beautiful photograph beneath. In the same issue, the magazine, which had been gender-neutral in its appeal to readers, started a trend of featuring a pretty, leggy young woman on the cover, aiming to appeal to a young male audience. Though Wendt remained in charge, Berenice no longer worked on the regular photography section and after 1946 had no role at all in the magazine, which folded three years later.[43]

During the *Bubbles* shoot, Schwartz "wanted to wring her neck" when Berenice directed him, one more time, to move the precariously arranged equipment, tripod and all, but he allowed that she was "ultimately right." There were six prints of the final image and Berenice gave him one, which he gratefully accepted for helping engineer the setups. Sandra Weiner, a postwar Photo League member, later posited that Schwartz, who she believed suffered from low self-esteem, enjoyed a special companionability with Berenice for precisely this reason—both were prickly personalities who would rather have their own way than get along with others. Weiner also recalled Schwartz's exceptional Stalinist fervor, which, like Berenice's less blatantly expressed sympathy, contrasted sharply with the more congenial "Trotskyite" tenor of the majority of left-wing Photo Leaguers.[44]

For one of Schwartz's birthdays, Berenice treated him to a performance of violinist Jascha Heifetz at Carnegie Hall. Before the performance, they dined at a nearby favorite French restaurant. A house

photographer snapped a picture of the pair at their table and at the end of dinner brought back a finished 5 × 7 inch glossy for them to buy. Berenice raised her eyebrows, because the harsh flash lighting made it look "like a sack of flour had been put in our faces," but paid the camerawoman her dollar and gave Schwartz the print.[45]

Berenice had joined the American Society of Magazine Photographers (ASMP), a group of freelancers tired of being "underpaid, ripped off, and ignored" by magazine editors. She found the other members "especially alert and alive" compared to the painters in the Artists Union. She believed in unions for freelancers, citing her work at IBM as one instance in which she "really got the dirty end of it" in terms of compensation and subtle discrimination against women. As the war ended, Berenice signed on with Frank A. Lavaty, a Madison Avenue agent, as his sole "photography" specialist among art directors, cartoonists, and fashion illustrators. Her listing in the 1945 New York Art Directors Club *Annual* featured her classic *Night View, New York* in their "Atmosphere, Mood" category, a promotional selection of art that was also exhibited in Rockefeller Center.[46]

For The Old Print Shop on Lexington Avenue, where Marchal Landgren and Elizabeth's friend Mary Bartlett Cowdrey were both employed, Berenice took some interior photographs. A very young staff member observed that she was a "nicer lady" socially than when photographing. Berenice did the work on a barter basis, trading a mid-nineteenth-century marine painting then in her possession, *Constellation*, by the American artist James Henry Wright, for a farm scene. She came to regret the trade. The dramatic storm-tossed *U. S. Ship "Constellation"* is now in the permanent collection of Boston's Museum of Fine Arts.[47]

A meeting with Vienna-born director Fritz Lang led to a commission for location shots for *Scarlet Street*, Lang's 1945 Greenwich Village adaptation of Georges de La Fouchardière's novel *La Chienne*, about a low-life couple who take over the paintings of a henpecked amateur and succeed in the art world. Berenice photographed the Lafayette Hotel banquet hall, on Ninth Street, and the Village's famed open-air art

show, in bad light and small format. Strangely, she congratulated Lang for making films that are the "mass art democracy needs," an endorsement at odds with the conventional view that *Scarlet Street* led the cynical trend of Hollywood film criminals escaping consequences.[48]

Berenice's Super-Sight subjects ranged from portraits—Elizabeth was also in the earliest tests, and painters Philip Evergood and Reuven Rubin sat for her later—to natural objects such as plants, birds, and insects. In her journal, Berenice noted commercial possibilities for advertisements: "Hamburger; Oranges; Phonograph Needles; Cigarettes; Soap; Bacon; Tie (cravat)." On another page, "Uses for Super-Sight" include "Scientific Murals!, Bill Board Advertising, Visual Education Series, e.g. Biology, Mineralogy, Chemical, Physics, Electrical, Board of Education sets of pictures on approved list; Science books—hundreds; Bureau of Standards; Crime Detection; Metallurgy; Many industrial uses—Textiles, Jewels, Manufacturers, Movie Murals (Ben Schlenger); Colleges of Design; Medical Schools; Teachers training (Lyman Bryson); Museum of Natural History, a brochure of prices and where obtainable; Training Schools, technical and industrial; Exhibitions; Museum of Science and Industry; Museum of Natural History; Science museums; Flower shows."[49]

Berenice was planning a Super-Sight book in collaboration with Muriel Rukeyser, who had briefly been her Greenwich Village neighbor, and who shared her politics and interest in science. The two met at a party in fall 1939 and likely had an affair, as alluded to in Berenice's early 1950s FBI report. Rukeyser had impressionistically labeled Berenice's Super-Sight process "Certain Ways of Seeing" when, in May 1946, she first saw the photographs and was taken into Berenice's confidence. "There is a very important place in my heart for you that I doubt very much another could fill," Berenice wrote two years later to Muriel, by then a new single mother in California, "a focus of articulation and recognition of sorts—a much needed support, communication, call it what you will. . . . I hope we can do some work together someday."[50]

The overextended Rukeyser intended to write what Berenice called "poetic captions" for their planned (but ultimately never realized) Super-Sight collaboration. She had already published a biography of the pioneering nineteenth-century American mathematician-chemist Josiah Willard Gibbs, and followed it with *The Life of Poetry*, inscribing Berenice's copy in December 1949, "For Berenice and the life of pictures. With Love." Initially Rukeyser titled their proposed Super-Sight collaboration "Seeing Things," but eventually she settled on "So Easy to See," based on her distinction between *seeing* and *vision*, which she likened to the perceptual and psychological difference between listening and hearing. At the end of her life Rukeyser resurrected her Super-Sight impressions for one of her last poems.[51]

Berenice's forty-eighth birthday fell during a week that found her teaching at the summer seminar New Vision in Photography, organized by Moholy-Nagy in Chicago. She didn't know the Bauhaus giant personally, had initially disdained his imposition of European methods on American art education, and declined his first offer to teach when her unreasonable requirement of a five-year, $10,000 annual contract was not accepted. At the seminar, Berenice again pleaded for improved equipment "adjustable to the human will and intelligence" of its users in the service of "greater realism," but she never mentioned science or her Super-Sight process. Her seven sessions comprised print critiques, the techniques and personalities of her Paris portraits, and field trips around the city for streetscape and night photography. When photographing, she instructed, "You must keep cool, work accurately and above all know your equipment," mindful of the "essential dignity" of humanity. Moholy-Nagy, who underwent radiation treatment for leukemia throughout the summer, managed to teach a daily photo class and explicate the 1920s modernist films he screened in the evenings. Berenice was in "her home territory," the Midwest—so foreign to many New York Photo League members, mostly "Jewish boys from the Lower East Side and Brooklyn with the New York accents."[52]

Moholy-Nagy recommended Berenice's Super-Sight images to Rukeyser's publisher, Doubleday, as "represent[ing] the highest level and aspiration of a documentary photographer today." Doubleday editor John T. Sargent agreed to publish their collaboration if Edward Steichen, the Museum of Modern Art's new curator of photographs, would exhibit the photographs to help boost book sales, but Steichen could not promise to do so. When Sargent stopped communicating with her, Berenice determined to get the photographs back and try other publishers. In fact, Doubleday's production staff had early on determined that printing difficulties made the book commercially impractical, and had suggested fine-art methods of limited edition printing, all of which Sargent was slow to let her know. Berenice never did pursue the suggestions, or other publishers. Over time, Berenice and Rukeyser continued to exchange ideas about subject matter and about photography as a means of communicating elemental truths and as a metaphor for reality.[53]

Soon after returning from Chicago, Berenice underwent a long-anticipated hysterectomy for fibroids, which Elizabeth told Rukeyser "should have a good effect on her general health and well-being. . . . She has complained a good deal, but that is not out of character." Morphine, the "perfect sedation" Berenice received in the hospital, "was so powerful, it did such wonders—I said don't give me any more!" Berenice had seen a dancer friend in Paris succumb to opiate addiction in the 1920s. Two decades later, her surviving brother, Earl Stanley, the sibling to whom she felt closest, turned up in New York, addicted to cocaine and heroin. He hustled her and stole from both her and Elizabeth when he couldn't wheedle loans and gifts. When he telephoned once during a party asking for money, Berenice told the guests not to help him: "Do not give him money. I have no brother."

A year after her surgery, Berenice won a "signal moral victory" at ASMP for single women's health care when the group's insurance company removed its limit on the amount of coverage female members—generally expected to be sicker, and more often than men—could purchase. In truth, the victory was economic, not moral, for the insur-

ance company acquiesced only because ASMP women, uncharacteristically, earned as much as the group's men and there were so few of them.[54]

After a two-week "interlude of emptiness" in the hospital, Berenice, who told Rukeyser it was "much more fun to die at the barricades than safely in bed," was discharged. Elizabeth had reserved "the only drawing room on the only Pullman car" out of Grand Central Terminal. Their destination was Amagansett, New York, on the eastern end of Long Island. The town's cheap property and low summer rents had attracted art expatriates and collectors during the war. They stayed in the cottage of Ruth Lindsay, a "ravishing" friend of Elizabeth's from Jamaica, Queens, who had paid a visit to Commerce Street that had sent Berenice into "a tizzy," according to her assistant Ed Schwartz. A photo of Lindsay and Elizabeth together shows them as virtual twins in stature and haircuts. A cat called March Lion shared the beach house with them (a later gray one was dubbed Juan Gris), and the walls were hung with a dozen artworks they owned, plus one piece by each woman. Lindsay, a public high school principal and art teacher, contributed a watercolor, *Railroad Station, 1942*, and Berenice a Super-Sight photograph, *Grass Roots, 1946*; both hung in the kitchen. In the bathroom was a woodcut of Elizabeth's, *Nude, 1933*. The women prepared a card-mounted typescript guide to all the works for visitors. They felt at home in the Hamptons, in those days an inexpensive, less stylish, and traditionally visual arts–oriented haven in eastern Long Island—more so than among the upscale, historically lesbian Cherry Grove set on Fire Island, successors of the Paris circles of Natalie Barney, Gertrude Stein, and Radclyffe Hall, none of which had included Berenice.[55]

Photographers Sandra Weiner and Rosalie Gwathmey and their husbands also had summer homes in Amagansett and sometimes shared the car ride out from the city. Weiner said that razor-sharp Elizabeth could be a nasty tease when she'd been drinking, and had once chased Rosalie's husband, Robert, around the kitchen with a butcher knife. Occasionally, Robert would cuddle Berenice, Weiner added, and she would

Berenice Abbott photographing an electroscope, New York, 1938–1939. The resulting photograph illustrated a flyer for "Some Military and Political Aspects of Atomic Energy," an October 1947 lecture by Dr. Manson Benedict to the Organized Reserve Signal Groups in New York. Photographer unknown

wriggle away but stand aside nearby and look at him cutely. Mostly Berenice seemed glum to Weiner; to Muriel Rukeyser, around this same time, Berenice said that she felt "loose & slow, tumbling without much order," like a movie running backwards in slow motion.[56]

Science historian I. Bernard Cohen, who had been infatuated with his contemporary Muriel Rukeyser and her leftist fervor in the 1930s, had known Berenice since 1940. In 1941, he edited an anthology on Benjamin Franklin's experiments in electricity and became the first PhD in Harvard's history of science program. He believed, with his mentor, George Sarton, that the intellectual underpinnings of science could serve as a bridge to the humanities. During the war, he and Bere-

nice had communicated as kindred spirits about cyclotrons, magnets, and the coarsenesses of iron filings. Berenice was trying to use this last item to illustrate the magnetic force in photographs—when spread on a sheet of paper placed over a bar magnet, for example, the little iron particles would line up along the field of magnetism. Berenice and Cohen talked about various methods (such as sifting the filings through cheesecloth) to distribute them evenly. Early on, Cohen thought that Berenice's "book on electricity sound[ed] like fun," and he invited her to consider helping him with a publication on the fundamental nature of science for the National Academy of Sciences. The audience for Cohen's first postwar title, *Science, Servant of Man: A Layman's Primer for the Age of Science* (1948) were the educated nonspecialists Berenice also sought to reach. Cohen came several times a year for dinner on Commerce Street, prepared by Elizabeth, a very able cook, and over time offered Berenice practical information on equipment (and occasional deals at camera stores in New York and Boston). In 1949 he bought Berenice's hardworking 9 × 12 cm Linhof for $225. With ready access to Harvard's physics and optics labs and staff, Cohen also put them at her service.[57]

In the summer of 1947, Berenice spotted an announcement for a new science photography competition at the Smithsonian Institution sponsored by *The Scientific Monthly* under the aegis of the American Association for the Advancement of Science (AAAS). She submitted four pictures, of which only her Super-Sight *Corn* was rejected. The show hung at the Smithsonian in November and at the AAAS winter meeting in Chicago. However, the modified rules of subsequent years' competitions called for participants to be working scientists, which effectively disqualified Berenice from future participation.[58]

PHOTOGRAPHY COMMUNITY

New York (1937–58)

. . . [I]f a new technology extends one or more of our senses outside us into the social world, then new ratios among all of our senses will occur in that particular culture. . . . And when the sense ratios alter in any culture then what had appeared lucid before may suddenly become opaque, and what had been vague or opaque will become translucent.

—MARSHALL MCLUHAN[1]

Art is a crystallization of integrated—mind—organization—personality. Art is never so easy that it can be handed to the beholder on a platter without any effort on his part. . . . [A]rt is an exchange—donor and recipient, and vice versa. The beholder is the receptacle, the union gives birth to recognition—both are enriched. —BA (1956)[2]

B erenice did not abandon the larger world of art photography when she took on *Changing New York*. In 1937, Frederick Kiesler engaged her to photograph a work of art she'd seen a lifetime ago—Duchamp's *The Large Glass (La Mariée mise à nu par ses célibataires, même, or The Bride Stripped Bare by Her Bachelors, Even)*. Newly restored by the artist himself and installed at collector Katherine Dreier's

West Redding, Connecticut, home, the work was hailed by Kiesler as "the first x-ray painting of space." Duchamp liked best Berenice's view of the lower portion of the glass, reproduced on a sturdy sheet of transparent cellophane. Though he had originally tried to schedule Man Ray to rephotograph the work, Duchamp expected to use Berenice's image for his *Boîte-en-valise*, the exacting reproduction "album" of his life work that he was devising. He tried to obtain additional head-on shots of *The Large Glass* by Berenice, through her or Kiesler, but "evidently she couldn't, or wouldn't" do the work. In October, Duchamp thanked Dreier for sending prints of the images Berenice had taken, adding, "I am sorry you had to suffer from Berenice Abbott's attitude—Don't ask her any more. I don't know whether I can use her photos because they are not 'full face.' But we will see." With the package of photographs, Dreier evidently included Berenice's bill.[3]

Many months later, Berenice told Duchamp in dismay that the "matter of the photographs of 'La Mariée' needs explanation between friends." Dreier reneged on their original purchase agreement, she said, and destroyed any sale value the photographs might have had by sending them through the mail too often. Reflections and inhospitable backgrounds had also made it difficult to photograph the work head-on, she continued, adding "extreme cold weather" to the list of hardships she had endured on the job at Dreier's home. To end the matter, Duchamp offered to pay for materials and time; Berenice proposed half the fee she had originally negotiated with Dreier. Once again, Berenice's financial precariousness had evoked a disagreeable nickel-and-dime negotiation. Though Duchamp and Berenice remained on civil terms, Dreier subsequently hired a commercial photographer to take the "full-face" pictures Duchamp wanted.[4]

Berenice and Elizabeth again applied for a Guggenheim, in fall 1937, encouraged by the awarding of a domestic grant the previous year to Edward Weston, the first photographer ever to receive one. While the social purpose of documentary was never a rationale for the Guggenheim grants, Elizabeth cited it among her primary motivations: "It

is the contrasts, the paradoxes, the anomalies, the illogicalities of life today which contain the most vital and interesting material for future historians to examine." Revising their American project to emphasize cities, the women resubmitted it with a new batch of reviewers. Economist Roy E. Stryker, the moving force behind the snowballing FSA photography effort, endorsed the collaboration, adding that if he could afford it, the FSA would always partner its photographers with writers. "Miss Abbott certainly stands at the top of the little group which we like to call documentary photographers," he wrote, but he balked at the project's overly ambitious scale. Holger Cahill praised Berenice as "one of the most brilliant of contemporary photographers," assuring the committee that she and Elizabeth were together well suited to test the possibilities "of writing that is more than captioning and of photography that is more than illustration." Edward Weston qualified his praise of Berenice's "very fine" work by admitting that he knew it only from reproductions. In any event, the application was turned down— old friend and rival Walker Evans was that year's awardee.[5]

Berenice also had two magazine encounters that spring. *Vogue* ran a photomontage of America that included images by Bourke-White and sixteen others, with a variant of Berenice's *Manhattan Bridge Walkway*. She had agreed to contribute to the surrealist-in-exile art and literary magazine *View* being developed by the young American writer Charles Henri Ford, brother of actress Ruth Ford and a friend of Djuna Barnes, but backed out for lack of time long before it launched.[6]

She met the pioneering nineteenth-century western expeditionary landscape photographer and entrepreneurial publisher William Henry Jackson—a "lovely old man," frail and slim, with "no tinsel about him"—at his ninety-fifth birthday celebration at MoMA. His recently published autobiography, *Time Exposure*, brought western photography to life, she felt, and she acquired one of his mammoth landscape prints, which she favored over Californian Ansel Adams's views, work she dismissed as pictures of "sticks and rocks."[7]

After she scrambled to provide photographs for an exhibition

of portraits for Mount Holyoke College, whose former president, Mary E. Woolley, was Elizabeth's friend, she prepared for a special section ("Murals") in the *First International Photographic Exposition* at Grand Central Palace, in midtown Manhattan. Willard Morgan, the organizer, a transplanted Californian, had been the publicist for the 35mm Leica camera in America. The show featured commercial and pictorial work, augmented by photographs from the New York City WPA, amateurs, and schools. It included nineteenth-century prints loaned by Berenice and Julien Levy, among others, while "Murals" contained Berenice's work, along with that of Barbara Morgan, Margaret Bourke-White, Paul J. Woolf, Drix Duryea, and the FSA.[8]

Her first solo art gallery show in years was in April 1938, at the Hudson D. Walker Gallery, on East Fifty-Seventh Street. A peripheral member of Levy and Kirstein's Harvard circle, Walker had opened the gallery in 1936 with Elizabeth as his researcher and presented work by Käthe Kollwitz, Alfred Maurer, and Marsden Hartley, all interests of hers. Berenice's exhibition was totally different from her Museum of the City of New York show, containing more than fifty photographs from the last decade (except the FAP work) of American cities and portraits, at prices that ranged from $7.50 to $25. Among them was a portrait that was not for sale, exhibited as *Woman's Eyes*. The subject was FAP administrator McMahon, unidentified; the picture had been cropped horizontally to show only her eyes.[9]

Also in April 1938, under Lewis Mumford's guidance, the liberal, decade-old American Group, Inc., presented an exhibition, *Roofs for 40 Million*, at Rockefeller Center's La Maison Française. The show advocated for better housing and more socially responsible urban planning: light, air, parkland, and transportation for city dwellers. Joining twelve of Berenice's prints from all her urban projects were models and drawings, and photographs by a wide range of contemporaries, all selected by novice curator Elizabeth Hitchings (later Mrs. Peter Sekaer), who relied gratefully on Mumford's critical guidance.[10]

An international show of documentary photographs in Rotterdam

from May to July 1938, along with a Museum of Modern Art exhibition sent to the Musée du Jeu de Paume in Paris at the same time, led Berenice to devise a new method for preparing enlargements (often up to 20 × 24 inches) by mounting them "on Masonite, bled to the edges, and sprayed with a matte lacquer by air-brush." The prints stood up "very well" to crating and installation, while the lacquering enriched their tones and added luminosity, she claimed. The backs of the Masonite sheets were usually fitted with spacers recessed from the edges, which made wall-hung prints appear to float off the surface for a definitively modern look.[11]

MoMA's Paris show, *Trois siècles d'art aux États-Unis*, with sixty photographs, drew little interest. The galleries were always empty, but Max Ernst's teenage son Jimmy visited the exhibition repeatedly in preparation for his emigration to the United States. (His mother was Jewish.) The photographs, he recalled, were especially revealing and frightening, and caused him to realize how lost he would feel in the hot summer crowds of New York City.[12]

Nineteen thirty-eight also saw the publication, in England, of Berenice's old booster Robert McAlmon's *Being Geniuses Together*, which she called the best and most truthful of all the Paris 1920s memoirs. Completed in 1934, the manuscript could not find an American publisher, largely because the period was out of fashion and the text, Malcolm Cowley peevishly reported, fell short of "its brilliant title." Nina Hamnett surfaced briefly and approached Elizabeth about a possible editorial collaboration for a memoir of Modigliani, but nothing developed.[13]

That summer, adding to Elizabeth's oil by Arthur Dove, purchased in 1934 with proceeds from her essay in *America and Alfred Stieglitz*, Berenice acquired her own Dove, a watercolor that they were waiting for the framer Edward Landon to finish so they could hang "in our little white room," she wrote the painter, whose sister-in-law Mary Torr Rehm Berenice had photographed in Paris. She reminded Arthur that she hoped he would relocate to Long Island from upstate, a discussion

she and he had had earlier. "I want you close for biscuits," she wrote now. In fact, after a serious illness in the spring, he and his second wife, the painter Helen Torr, had indeed moved—to Centreport, on Long Island's North Shore. Berenice was unaware of the move when she wrote. For her summer vacation, Berenice went no farther than the country place of friends in nearby New City, in Rockland County, New York, where she posed for striking snapshots playing checkers, a cigarette in hand, and for silly ones dressed in a Victorian dress and bonnet, snuggling a cat.[14]

Back in 1936, Berenice joined octogenarian Arnold Genthe as the photography specialists on the advisory board of the Hobby Guild of America, a popular organization of enthusiasts. Advisors ranged from pioneering ethnographer Franz Boas for "anthropology" and John Sloan for "painting" to notables in categories ranging from drama to tropical fish. With Genthe, Berenice judged the World's Fair Hobby Olympics, a national contest that ended in June 1938. The Hobby Guild also served as an agent or speaker's bureau for its advisors. Berenice earned money this way, judging school and union amateur photography contests, which separated her from the highbrow preoccupations of many other photographers in her artistic circle—a sign of the continuing gulf between photography's aesthetic elite and the ranks of camera enthusiasts who found it so attractively accessible. In August 1938, she judged the contest subject "Waterfront" for the Manhattan Camera Club, evidencing a cozy willingness to engage with amateurs.[15]

Simultaneously, she became involved with the Art Adventure League, an idealistic adult-education enterprise run by Nathaniel Pousette-Dart, adman, teacher, artist, and father of abstract expressionist painter Richard Pousette-Dart. Other artist teachers were sculptor William Zorach and FAP decorative arts specialist Ruth Reeves. Aline Kistler, art writer and wife of painter Warren Chase Merritt, was general manager. Berenice's course was designed to encourage fine photography and stress the "esthetic of the documentary trend." Elizabeth worked on the text for course materials while Berenice visited Roch-

ester to select product and action photographs from Eastman Kodak. Alfred Stieglitz agreed to let her use his *Steerage*. Berenice also obtained photographs from Edward Weston and Roy Stryker, though something resulted in the latter's regression from his friendly "Dear Berenice" to a standoffish "Dear Miss Abbott" in his communication a month later.[16]

Art Adventure produced six lessons of a projected series of thirty-two, begun with an energetic introductory essay by Berenice, boiled down from a typically digressive manuscript drafted by Elizabeth. It reproduced photographs by Berenice, as well as her students Sol Libsohn, Peter Sekaer, Charlotte Post, and Gay Dillon (from her first class—one of those who had to go home and make dinner). Despite a celebratory launch in September 1938 at the Museum of Science and Industry in Rockefeller Center, the Art Adventure League fizzled.[17]

In December, she ended her arrangement with agent Therese von Hohoff, who was unable to interest World's Fair architects in engaging Berenice. Having "worked like nailers" on the Art Adventure League, and having peddled book ideas and contacted *Esquire*, Hohoff and her assistant, Jane Wise, had come up with nothing. They also tried to start Berenice in advertising photography, where their cut would be a comfortable 25 percent. The big problem in any commercial arena, Hohoff claimed, was the limited repertoire and high cost of Berenice's prints. They had a point—Harriet Monroe's book *A Poet's Life* reproduced a James Joyce portrait by Berenice without permission or fee. *Vanity Fair* also used a print; she tried unsuccessfully to collect $15 in payment from the magazine.[18]

Most of 1939 was devoted to winding down *Changing New York* and developing "science." In February 1940, Berenice exhibited portraits and New York views in response to a request from Tucson, Arizona, photographer Faurest Davis for her "most advanced seeing" for his contemporary gallery Sternberg-Davis Photography. These included prints mounted flush on Masonite, a practice she would carry into the 1960s. She hoped that the exposure would lead to portrait sittings, at $100 each, but the show, unfortunately, generated no sales, let alone a

sitting. More productively, she spoke at a one-day conference in New York, "Photography: Profession, Adjunct, Recreation," organized by the Institute of Women's Professional Relations. Her talk, "Civic Documentary History," marked the last time for many years that she publicly discussed *Changing New York*. Berenice's panel included the head of the New York Public Library's Picture Collection, Romana Javitz, who had been acquiring contemporary and historical documentary photographs for the library since 1930. Over the years, "when Miss Abbott was very hard up," Javitz said later, the library bought Berenice's Paris portraits, non–*Changing New York* views, and Atgets, for five or ten dollars each.[19]

In late 1940, the Museum of Modern Art engaged Beaumont Newhall as curator, with Ansel Adams as consultant, for its new department of photography. Simultaneously, the museum tried selling, for under $10 each, original contemporary photographs, especially printed by their creators, to "encourage collecting . . . for decoration and pleasure." Berenice's *Night View, New York* was one of nine images offered. But sales were poor and the experiment was not tried again for years.[20]

If you expect to make millions out of photography easily
or in a short time, I feel very sorry for you. —BA[21]

CROWN PUBLISHERS, one of the first book packagers, approached Berenice in early 1941 to write a how-to photography book, for a $500 advance plus reproduction fees. An important antecedent was Ansel Adams's 1935 *Making a Photograph*. Aiming for publication in June, Berenice drew upon her seven years of New School class preparation, plus the abortive Art Adventure League lessons coauthored with Elizabeth, who assisted with "punctuation and the smoothing up" and would share the book's modest but reliable royalties. *A Guide to Better Photography* (1941) mixed practical advice with informal insights—and occasional obscure vocabulary, thanks to Elizabeth. Reviews varied, but Berenice's friend Allan Ross Macdougall, from the Provincetown Play-

ers days, called it "swell." Young photography mystic Minor White, still an unknown WPA employee in Oregon, raved that Berenice's *Guide* contained "more about real photography" than any other book and welcomed its "very human and very honest instead of pompous" authority.[22]

Berenice also began writing for Henry M. Lester and his business partner, Willard Morgan, who published authoritative books on photographic practice. For Morgan's ambitious *Complete Photographer* series, Berenice produced essays on Atget, city documentation, and Nadar, while Elizabeth surveyed more general topics, such as contemporary photographic book design and printing. The pair often welcomed Willard and his wife, the photographer Barbara Morgan, at their Commerce Street "cider bust" parties. Mostly female, these gatherings were the locus of at least one encounter with the young writer Patricia Highsmith, then in her "communist period" but not yet a published author, who took an immediate if flighty interest in "ABBOTT," as she wrote in her diary.[23]

World War II drove old friends back to the United States. Among them were Peggy Guggenheim and Max Ernst, who soon married, only to divorce five years later. Along with other European art and intellectual refugees, they internationalized the cultural scene and laid the groundwork for American postwar dominance in the arts. Berenice was the first person Max looked up when he got to New York. The Guggenheim-Ernst household settled into a Fifty-First Street town house overlooking the East River. There, at a party, Berenice spoke with Charles Henri Ford. Unaware that she never photographed anyone who didn't pay, the handsome Ford was disappointed when she declined to do his portrait gratis. She did, however, shoot Max Ernst on assignment for Ford's surrealist *View*, perching like a matinee idol in an ornate Victorian thronelike chair. Berenice thought Ernst corrupted by marriage to Guggenheim; when he betrayed Peggy for Leonora Carrington a few years later, Berenice dropped him.[24]

In 1942 Berenice joined fellow artists at Guggenheim's house to pose

Artists in Exile *[exiles and Americans at Peggy Guggenheim's house], New York, 1942.* Back row, L–R: *Jimmy Ernst, Peggy Guggenheim, John Ferren, Marcel Duchamp, Piet Mondrian.* Middle row: *Max Ernst, Amédée Ozenfant, André Breton, Fernand Léger, Berenice Abbott.* Front row: *Stanley William Hayter, Leonora Carrington, Frederick Kiesler, Kurt Seligmann.*

Hermann Landshoff

in two different and now widely published photographs credited at different times to refugee Hermann Landshoff, a snobbish and stylish commercial freelance photographer, and George Platt Lynes, an American known for his fashionable work outside this circle. While the big artist egos jockeyed for advantageous adjacency, Marcel Duchamp stood

aside quietly. In late November 1942, Berenice visited Chillicothe, Ohio, where her mother, who had succumbed to Parkinson's, was being cared for by Bunn relatives. Alice Bunn Abbott Wilson died a year later, but Berenice was ill again and did not travel for the funeral.[25]

It was after celebrating Elizabeth's forty-fourth birthday, in April 1943, with restaurateur Romany Marie, that Berenice began what she called "the lumber job"—photographing at Red River Logging Co., in Westwood, California, another one of Hudson D. Walker's family interests. It was her first trip this far west; her schedule cost a chance to visit Elizabeth's mother in Kansas, as she'd hoped to. In Reno, Nevada, she shopped at Tait's Shoe Store, where her wartime leather shoe ration coupon, airmailed by Elizabeth, awaited her. In Westwood Berenice toured the Red River mill with publicity chief William B. Laughead, a Minnesota advertising man who popularized the Paul Bunyan stories in the 1920s. The local press played up the professional photographer from New York, noting that she consistently wore slacks. Years later, she recalled how the good weather made every negative on the job "perfect," because "in the California light," one "can't miss."[26]

Walker and Laughead added a traveling exhibition of 16 × 20 inch prints to their plan to distribute Berenice's high-quality photographs for editorial purposes. Flu in January 1944 made Berenice miss the deadline for starting the tour at San Francisco's De Young Memorial Museum. After the last venue, the Seattle Art Museum, in 1946, the prints went missing, only to surface in the 1970s at the Walkers' New York home.[27]

Willard Morgan was subbing as MoMA photography department director for a mobilized Captain Beaumont Newhall when he invited photographers, critics, and other picture professionals to form an advisory committee. At the April 1944 meeting, Paul Strand mentioned Atget as an influence on Berenice; reflexively, she angrily inferred his implication of "something second rate, merely imitative," which he fruitlessly later tried to clarify. The next day she phoned Strand, berating him as an imitator of Stieglitz who overemphasized print quality—using "double coated platinum . . . You couldn't miss," she said later—and lived

off his inherited income, and that of his wives. With the epithet "wind-bag," Berenice hung up on him. Strand immediately wrote asking for an apology, lecturing about Americans having a "democratic right to their own reactions, their own evaluations" without receiving abuse and personal condemnation in return. His request for mutual respect "as fellow workers and as democratically minded people" seemed intended to squelch Berenice's right to *her* opinion of him. It was typical of Strand's hypocrisy about competition, she felt, recalling how he once played "dirty" Ping-Pong at her West Fifty-Third Street apartment, skewing each ball to ace his opponent instead of carrying "on a nice, clean, friendly volley." Elizabeth felt insulted on Berenice's behalf and ended her long friendship with Strand.[28]

Berenice may have been particularly defensive at the time: A recent article on Atget in *Harper's Bazaar* said that she had been inspired by him to become a documentarian; and she had just contracted for a commercial job packaged by Crown's Robert Simon to photograph nudes, at which Strand excelled. Berenice's nudes were for *Drawing the Human Figure* (1944), a how-to book by NYU instructor, illustrator, and muralist Arthur Zaidenberg, who provided the models and posed them in Berenice's studio. Berenice said that Ruth Bernhard's nudes were "always in good taste" but Stieglitz's were vulgar and Weston's "too suggestive—too stimulating." Pondering photographer Eliot Porter's spending all his time doing birds, Berenice wondered if he too photographed other subjects, such as nudes that his public had never seen, and joked about doing nudes again someday.[29]

> Style alone is egotistical, limited, introspective, expression of
> self – unless highly integrated. To interpret the thing, outside
> yourself, with truth and proximity is more important. —BA[30]

IN SPRING 1945, Berenice made her curatorial debut with *The Instant in Photography* at the New School. She chaired and chose the jury, a

mix of photographers and New School supporters and students. Potential exhibitors were to submit photographs that evidenced what Berenice called "peak interest" in the subjects portrayed, by which she meant something akin to Henri Cartier-Bresson's later, near-magical concept "decisive moment"—the split-second poise of compositional elements that animate an individual photograph's subject. The end of World War II and Allied victory was just weeks away. Elizabeth wrote a hope-filled catalog essay, while the *vernissage*, as Berenice called the opening, included a symposium that was as intentionally "non-controversial" and optimistic as the subjects of most of the photographs, such as Gjon Mili's Asian girl reaching to grasp a soap bubble and Gene Smith's leaping dog in training. Berenice hoped to enlist a varied contemporary group that included photographers whose work she admired, from Dorothea Lange and André Kertész to Edward Steichen, Weegee, and Genevieve Naylor. She considered Kertész "a prick" for the way he had treated his first wife in Paris in the 1920s but insisted she could be "critical" and judge photographs without regard to personal involvement. Others could not ignore the personal: MoMA curator John Szarkowski apparently enjoyed passing along a snarky story about Berenice and Kertész in 1920s Paris sharing a girlfriend who became pregnant; friends, he said, joked that Berenice was the father.[31]

Weegee's prints were unavailable for loan. Lange was ill but later thanked Berenice for being "a great encouragement and [reminding] me that I am a photographer." Black Star picture agency head Kurt Safranski was one of the jurors, along with Elizabeth and author Norris Harkness, head of the Photographic Society of America. Their final roster was Dorothy Meigs Eidlitz, Rosalie Gwathmey, Andre Kertesz, Gjon Mili, Lisette Model, Barbara Morgan, Martin Munkacsi, Genevieve Naylor, Walter Rosenblum, W. Eugene Smith, Nettie Smith (W. E.'s mother), Elizabeth Timberman, and Ylla. At the reception combat photographer Joe Rosenthal spoke about his famous *Flag Raising on Iwo Jima*, taken that February. Berenice would forever resent Edward Steichen for copycat-titling his 1949 MoMA blockbuster news photography survey *The Exact Instant*.[32]

Young postwar *Life* photographer Todd Webb, another midwesterner, became friendly with Berenice. They had lunch at Café Royal on Second Avenue on Sunday, November 3, 1946, joined by Bertolt Brecht's close associate Ferdinand Reyher, who would soon figure in much of Berenice's next efforts to promote Atget (see chapter 20). Afterward they all went back to Berenice's to look at Atget prints. Webb photographed both friends there, deploying only one of Berenice's many portrait lights, which made her stern expression look haggard.[33]

Ed Schwartz had worked nearly a year for Berenice, three days a week at five dollars a day, which got him back on his feet during a rocky time. In late 1946, after a hiatus of a few weeks, he arrived at her studio only to discover her with a new assistant, Photo League member Lida Moser. She was helping Berenice photograph the Delta blues singer Huddie Ledbetter, known as Lead Belly (his preferred styling of the name) or Leadbelly. The shoot was arranged by Berenice's old friend Marge Fairbanks, who was launching an international tour for the popular "people's artist" singer; assisted by her son Austin Fairbanks, Lead Belly did play venues in the United States and France before his death, in 1949, cut short their ambitious plans.[34]

Though he helped with the lighting—Berenice found Lead Belly's dark face a challenge to photograph—Schwartz felt he was being asked to move on. Moser stayed long enough to help Berenice organize her Atget archive, then left for a career in magazine photography. She was succeeded by war veteran Elizabeth L. Russ, studying at Moholy-Nagy's Institute of Design on the GI bill. This successful hire encouraged Berenice to formalize an apprenticeship program with the New York State Education Department.[35]

Berenice had used the earliest models of a thumb camera she invented to shoot Whitney Museum openings on Eighth Street; she proposed a book of those and many other Village subjects to Harper & Brothers. The publisher insisted on pairing her with writer Henry Wysham Lanier, whose own Village book was already under consideration. Lanier, the eccentric son of the southern poet Sidney Lanier,

Lead Belly [Leadbelly] (Huddie Ledbetter) in performance attire,
New York, late 1946. The photograph illustrated his posthumously
released record; with Berenice Abbott portrait credit, New York,
1950. Berenice Abbott

had derived a series, *Photographing the Civil War*, from the ten-volume
production edited by Francis Trevelyan Miller and Robert S. Lanier
before World War I. Berenice didn't know Henry Lanier and thought
him a terrible match, but likely knew of his Civil War photography his-
tory. Together, they interviewed Hippolyte Havel in New Jersey, but
Berenice had to fight off Lanier's bossy photographic direction. When
their collaboration, *Greenwich Village: Today & Yesterday* (1949), was
about to appear, the *New York Times* reported the book as Lanier's,
failing to mention Berenice. The omission engendered an apologetic

publisher's confirmation that the title page and everything else would credit her appropriately.[36]

Berenice's *Greenwich Village* photographs are a combination of locations and portraits of old and new artist friends. She photographed half a dozen characteristic businesses through their shop fronts, including McSorley's Old Ale House, where she spotted a man sitting in the window in "great light . . . and just took it" from outside, through the glass, not attempting a reprise of her invasion a decade earlier. John Sloan, "a sweet darling, lovely person," known from her earliest Village days, was posed in his Chelsea Hotel studio, her floodlight hidden inside his fireplace. The shoot of Edward Hopper went well after his wife, the painter Jo Hopper, "quit interfering." The subject sat beside the couple's wood-burning stove in his studio at 3 Washington Square North, in the Village. The Hoppers liked the result and traded prints of Berenice's portraits for a copy of Edward's 1921 etching *Night Shadows*. (After wood-burning stoves were outlawed for heating in New York City in the 1960s, the Hoppers gave theirs to Berenice for her Maine house, see chapter 17.) Other artist friends and Village-specific artisans photographed for the volume include Isamu Noguchi, captured at work with his power tools, and jeweler Sam Kramer.[37]

Berenice was recovering from yet another bout of pneumonia when Grace Mayer proposed an exhibition of these Greenwich Village photographs at the Museum of the City of New York. Harper & Brothers gladly considered the show part of the book's advertising budget, spurred by a $200 contribution from an anonymous fan—Robert Charles Weinberg. A wealthy civic booster and New York City Parks Department administrator, Weinberg had clashed with Robert Moses over local neighborhood control and had been asked by a private concern to prepare a master plan for Washington Square. In the end, Museum of the City of New York director Harding Scholle scotched the proposed show, explaining unpersuasively that the cash-strapped museum couldn't accept donations for new ventures.[38]

Brown & Delhi, a bookstore on lower Fifth Avenue, held a signing.

Eleanor Roosevelt, long a Village resident, welcomed the book in her syndicated "My Day" newspaper column for the photographs' portrayal of the "flavor of this part of New York City." Grace Mayer congratulated Berenice as "New York's official photographer" for lavishing "loving understanding and care" on the Village. Reviewer Lewis Gannett preferred another text on the Village, *Here Is God's Plenty*, by Mary K. Simkhovitch, founder of Greenwich House, to the "cold" Lanier's, but liked the contemporary look of Berenice's "evocative" photographs. Lew Ney praised the architecture, saying that "only an Abbott could get the best shot." Berenice and Simkhovitch both presented autographed copies to the library of neighborhood PS 8. Another local book that year, *Greenwich Village Gourmet*, also featured celebrity Berenice (though Elizabeth was the better cook), along with such Village residents as civil liberties attorneys Roger Baldwin and Philip Wittenberg and art critic Clement Greenberg. Published in mimeograph from typescripts, the recipes were signed in facsimile; to her "Bouillabaisse formidable" Berenice added this handwritten recommendation: Serve "with white wine of the Pouilly (fusé) [*sic*] type."[39]

All through the war and early House of Photography years (see chapter 14), she continued to teach at the New School and occasionally elsewhere. In 1943—largely for the $15 per session plus travel fee—she joined Muriel Rukeyser and Elizabeth at suburban Sarah Lawrence, a women's college noted for its creative and performing arts programs. She genially told Dean Constance Warren that the undergraduates enjoyed her weekly photography class and did well, though she would later recall only "disagreeable lab arrangements" and no serious students, likely because the college failed in early 1944 to renew Elizabeth's contract. That same year, she taught in Brooklyn College's art department, founded by artists fleeing Europe on the eve of World War II. Though she thought it was "absolutely marvelous," with "a wonderful bunch of kids," she claimed the college cheated her on pay ("Not this girl you can't"); when department head Serge Chermayeff wouldn't back her up, she quit and sent an assistant to finish the term.[40]

BOUILLABAISSE FORMIDABLE

BERENICE ABBOTT
photographer

Buy a good pile of fish, 3 or more kinds with white flesh and 1 red, totalling about 3 lbs. Choose sea perch, bass, whiting, eel, slice of cod, red snapper, mullet, salmon--whatever is in the market. Add 2 small live lobsters, each cut in 3 segments.

Into a deep pot put the following seasonings:

2 onions, chopped	1 bay leaf
2 cloves garlic, crushed	envelope of saffron
1 tomato, cut up	thyme, savory, fennel--
4 sprigs parsley, cut	big pinch of each
salt and pepper	$\frac{1}{4}$ cup olive oil

Cook seasonings gently in the oil for 5 minutes. Cut fish into serving pieces (bones left in) and put into the pot the lobster and all fish except delicate varieties (sea perch, whiting, cod, etc.) Boil vigorously for 5 minutes. Add the rest of the fish and boil another 7 or 8 minutes.

Serve in soup plates. A thick slice of French bread should be in the center, broth poured over it, the pieces of fish and lobster arranged around. A meal for 6.

—with White wine of the Pouilly (fusé) type.

Berenice Abbott

Miss Abbott's new book of photographs is "Greenwich Village Today and Yesterday." Her traditional bouillabaisse is quick, easy, delicious.

Bouillabaisse formidable recipe, printed with her annotation, in Greenwich Village Gourmet *(1949).* Berenice Abbott

After the war, the college again approached her to teach, but she declined (as did Lisette Model, then also teaching at the New School). As a replacement, Berenice (and Model, too) recommended the young Photo League member Walter Rosenblum, who had photographed the D-Day invasion of Normandy. On occasion, Rosenblum had served as an emergency substitute in Berenice's classes at the Photo League and the New School. She respected his talent; she also felt that, once idealistic, he had come back from the war calculating and ambitious, and she resented his infatuation with Paul Strand. Rosenblum referred to the Berenice-Elizabeth pair as "The McCauslands."

At Brooklyn College, as at the New School, Berenice saw what she considered undue influence being exerted by a preponderance of European instructors, many of whom she viewed as pretentious. Among the offenders at the New School, in her eyes, was *Harper's Bazaar* art director Alexey Brodovitch. Russian-born, Brodovitch had made his way to the United States after years as an émigré in Paris, where, among other work, he painted scenery for the Ballets Russes. By the late 1940s, Brodovitch's New School classes were meeting in the studio of fashion photographer Richard Avedon, who had been both his and Berenice's pupil.

The inferiority complex Berenice thought instructors like Brodovitch gave American students broke her heart. Into the 1970s, with undiminished animus, she criticized him for teaching what she vaguely called "shock appeal" without ever specifying her objections. In 1945, Brodovitch published a book of dance images called *Ballet*. Lisette Model watched Berenice look at it, page after page, and say, "missed photograph, another missed photograph, another missed photograph," until she came to an empty page and declared, "That's the best."[41]

The GI bill exploded Berenice's first postwar New School photography class enrollment into what she called "a circus," even if she was paid by the number of students. Photographer Clem Kalischer, then a student of Berenice's, called her a wonderful person but a "lousy teacher" who put students "immediately to sleep." His classmates would gradually sit farther in the back and then vanish, meeting later at the corner

Berenice photographing with Rolleiflex camera,
Washington Square, New York, mid- to late 1940s.

Photographer unknown

drugstore luncheonette. Kalischer stayed, however, thinking it "rude to
just leave the woman standing there." By fall 1947, class size was capped
at thirty-five, half the enrollment of the previous year.[42]

With the French print and graphic art historian Marcel Valotaire,
Berenice briefly entertained a global publishing project, *Revue Inter-
nationale de Photographie*, to feature the "best photographers – Lisette
– Mili – Lange – Engels [Morris Engel and his wife, Ruth Orkin] –
Evans – ABBOTT – Rosskam," her friends and associates of the hour.
Her notes for possible articles included "Trends in America – EMCC

[Elizabeth McCausland]; The Effect of the War on Photography – B. Newhall; Cheesecake in America – Reyher" (after her experience with the new direction of *Science Illustrated*). Valotaire was also involved with the new Groupe XV, called the Quinze, a postwar European photographers' fraternity (the only female member was Thérèse Le Prat) that included Robert Doisneau and Willy Ronis, both identified with French postwar documentary style. Spokesman-photographer Marcel Bovis offered Berenice a solo exhibition in Paris's newly opened Galerie KODAK, partly in homage to her effort to save the archive of Atget. She sent one hundred prints from all facets of her work, including Super-Sight images, which, Bovis said, the French photo community found most intriguing.[43]

[I]n the 1940s I did so much experimenting . . .

it was ridiculous. —BA[44]

BERENICE'S STOP-ACTION wave images were a self-assignment. "Moholy-Nagy and Man Ray had done pictures by putting objects on sensitized paper but I wanted to do the same thing in motion," she said, explaining how she "put a piece of sensitized paper in . . . the bottom of the developing tray . . . just raw paper, flashed the light and there was a beautiful wave" captured in "negative" form. Every darkroom worker sees these waves and their shadows when gently rocking the flat shallow trays of chemical solutions to distribute them evenly over a developing photographic print. It was Berenice's genius to use the photogram method to capture and freeze the action with a stop-action lighting technique. With the idea of producing a photogram in motion, Berenice had experimented since the 1940s with images of waves, as reproduced in her 1953 *New Guide to Better Photography*.[45]

Berenice knew of MIT professor Harold Edgerton's high-speed photography from reproductions in *Life* and his 1940 book *Flash!*; they had also shared an exhibition at MoMA. Soon after, when she deliv-

ered prints for an exhibition at MIT's Photographic Services Department, she had tried to meet him in Cambridge to discuss high-speed photography, but he hadn't replied to an inquiry sent in advance. That MIT show had been generated by photographer Richard Elwes Pope, a midwestern transplant who knew both Elizabeth and Henry-Russell Hitchcock. Pope had told MIT about Berenice and made sure her prints were properly mounted on Masonite for display. Berenice also visited the Boston Camera Club and gave a talk on Atget there—"an unexpected pleasure," she called it, and a chance to rest "a bit from the hectic turmoil of New York."[46]

She also went to New England to photograph Arabian hunting dogs, or salukis, for her friend Anna Marie Paterno, a handler and breeder. (Berenice had invited Paterno to her 1937 Museum of the City of New York exhibition; they may have known each other through Margarett Sargent, whose husband bred Afghan hounds, a saluki relative.) Berenice even included three unexceptional images from Paterno's commission in *New Guide to Better Photography*. Instead of cash, Paterno paid for the work with a saluki puppy named Queen Haturu. The exotic breed attracted attention whenever Berenice walked the dog, but she was soon overwhelmed and gave it to her friend Sally Valentine Nerber, who lived in a farmhouse outside Hartford, Connecticut. A local farmer eventually killed the dog for poaching chickens.[47]

In 1954, Helen Gee opened the Limelight, a photography gallery and coffeehouse on Seventh Avenue South in the Village. As in a European café, there was no music, and there were no poetry readings. "Nothing to take away from the photography." The exhibition space was separated from the two-hundred-seat coffeehouse with panels hung from the ceiling; there were formal openings and press releases. On Saturday the café stayed open until 2:00 a.m. and a line would form outside, with patrons lingering for hours, talking and table-hopping. Gee's theater friends Peggy and Jerry Tallmer would later help a new weekly newspaper, the *Village Voice*, institute the Off-Broadway theater awards called Obies, whose first ceremonies were held at the Limelight.[48]

Berenice did not attend the opening of Gee's first show in May 1954, but exhibited in what Gee called her first "important" exhibition, December's *Great Photographs*. Gee invited a number of prominent photographers, whom she hadn't met, to be in the holiday show. Dorothea Lange and Walker Evans didn't respond; Steichen politely declined. Lisette Model, an early Limelight customer, sent one print to the show; Berenice sent three classics: *Exchange Place*, *Night View*, and a portrait of James Joyce.[49]

In June 1955 Marchal Landgren, now in Washington, DC, to be near his elderly mother, came up with a dazzling offer, a collaboration, photographing Chandigarh, the new capital of Punjab, "the most exciting thing that has happened in the 20th century!" "Dear Berri," he wrote, "the only person in the world today that could do it justice with a camera." Berenice immediately telegraphed an enthusiastic reply, and they posited an underwriting budget of $6,000 (of which 40 percent was airfare)—for a magazine article, exhibition and/or collection—in order to capitalize on the big Le Corbusier retrospective MoMA planned for late 1956. Clara Mayer's brother Albert was involved in Chandigarh's development, and they also hoped to exploit a connection to India's prime minister, Jawaharlal Nehru, for a Fulbright grant. However, no funding was forthcoming, and, moreover, Landgren was tied down caring for his mother.[50]

Soon after this futile excitement, Yale University Art Gallery opened a small exhibition of Atget and Berenice photographs, including unusual electricity and science pictures as well as her recent U.S. Route 1 images (see chapter 17). Simultaneously, one of Elizabeth's friends, Charles E. Buckley, the new director of the Currier Museum of Art in Manchester, New Hampshire, offered "Mme Abbott" a month-long exhibition. Buckley believed strongly in offering the same high quality as a museum in a major metropolitan area. He met with Berenice over Labor Day weekend before she went to Sag Harbor for September, to arrange what she called her "most important show yet." One hundred pictures—he asked for more U.S. 1 scenes and fewer (only five) Super-Sights—were ready for the opening, on Saturday, November 5.

Stressing her New England photography along U.S. 1, the exhibition flyer reproduced a most uncharacteristic image by Berenice of a seagull. Elizabeth's network continued its beneficial efforts as another friend, Joe Fulton, director of the Pasadena Art Museum, considered touring the show on the West Coast.[51]

The *Village Voice* launched on October 26, 1955, with backing from Norman Mailer and Dan Wolf; Berenice arranged with the editors to keep a file of her prints on hand and pay her whenever one was published. These included her portraits taken in the 1920s and 30s (*Joe Gould* among them) and her Greenwich Village pictures of 1947–1949, as well as more recent photographs, such as the demolition of Mark Twain's home just north of Washington Square, and the adjacent Hotel Brevoort, with its memorable Café Lafayette. Berenice's view of Louis Sullivan's Bayard Building in the *Voice*'s long-established rival local paper, *The Villager*, engendered an enthusiastic response from her big fan (and Robert Moses nemesis) Robert Weinberg. Otherwise, except for the occasional use of file pictures of twenty-year-old New York locations and even older Paris portraits, Berenice was out of the circuit for commercial work, falling deeper into the valley between out-of-date and nostalgia.[52]

Even darkroom work had become problematic. After the death, in 1955, of Dr. Ernst P. Boas, an early proponent of national health insurance and Elizabeth's physician, as well as doctor to Karl Menninger and Felix Adler, his son Norman ordered prints of a portrait of him that Berenice had done. A new assistant, Harold Plotkin, was likely responsible for filling the order; he was also supposed to help with the Atget portfolios (see chapter 20). Frustrated with her pace, and disappointed by the finished prints' poor quality, Norman Boas returned them in mystified exasperation. In June 1957 she showed a self-portrait in A. Hyatt Mayor's sweep of contemporary artists' portraits, *Faces in American Art*, at the Metropolitan Museum of Art. She had created it using a proprietary tool that she called the Abbott Distorter (see chapter 14).[53]

HOUSE OF PHOTOGRAPHY

New York (1946-59)

*Nineteen forty-six was a good time—perhaps the best
time—in the twentieth century. The war was over and there
was a terrific sense of coming back, of repossessing life.*
—ANATOLE BROYARD[1]

"Gadfly" . . . is incorrect; for my objections to present-day

equipment and materials are of a grave nature,

based on mature professional experience, and

not to be dismissed with a word. —BA (1942)[2]

Berenice had consistently argued for more industry attention to professional photographers' needs since embarking on *Changing New York*. She disdained the huge retail photography market for encouraging amateurs to believe that "the camera makes the photograph," and she blamed America's "faith in the instrument, in the machine," for consumers' gullibility—people failed to learn how to see, she felt. Serious photographers were at the mercy of "very commercial backward equipment and materials," she believed, causing

many to obsess in the darkroom with "sterile perfection at saying nothing," or to fling "technique overboard entirely." Berenice found historical precedent for these perennial complaints in the struggles of her forebears. David Octavius Hill, the prolific Scottish portraitist of the 1840s, seemed "determined to torture himself with the limitations of his machine," while "Atget worked within the limits of his . . . transmuting [them] into positive esthetic virtues."[3]

"Photography," she insisted, "isn't an art in the old sense. It's a language. A powerful, living, dynamic, vivid speech" that requires suitable new tools. In March of 1947 she created a company called House of Photography to funnel investments and provide capital to develop products to address these needs. She was president and majority stockholder; Hudson Walker, treasurer; and Muriel Rukeyser, despite being in California and expecting a child that fall, secretary. (Rukeyser later asked a patent attorney they hired, "When do we go to jail?") Designers and fabricators hired by the company would be "associates" receiving thirty-five shares apiece. Share #1 went to Ferdinand Reyher, then newly working on Atget. Other, more solvent, investors included Robert Gwathmey, Philip Evergood, and Symeon Shimin.[4]

Of the products that Berenice would develop, her favorite was perhaps the first: the darkroom distorter with which she had created the self-portrait she loaned to the Met. Called the Abbott Distorter, it was a flexible printing easel, a fun "gadget for making controlled caricatures," and had once been called, jokingly, "the Corrector." Others she especially liked were a picture composer, a one-legged camera stand, and her thumb camera. As she had done with her Super-Sight process in 1942, she wrote out formal descriptions of each invention, had them witnessed by Elizabeth and notarized, and then mailed them individually, registered, to herself, officially recording and date-stamping her ideas—the so-called poor man's copyright—in preparation for patenting them.[5]

Berenice publicly credited her New School students' interest in caricature for having inspired the Distorter, but she told Muriel Rukey-

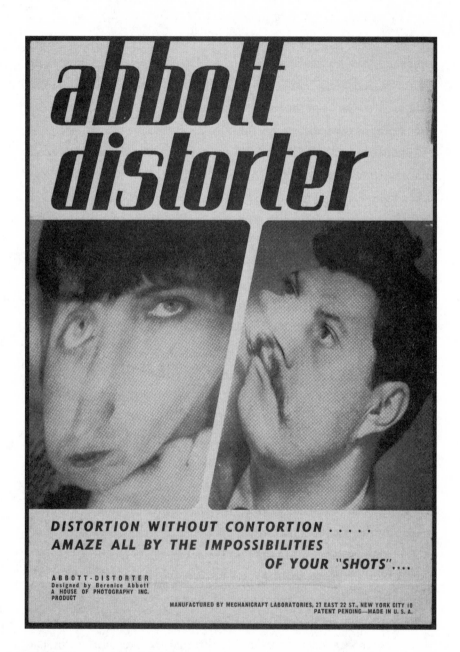

Abbott Distorter advertising flyer. Berenice Abbott

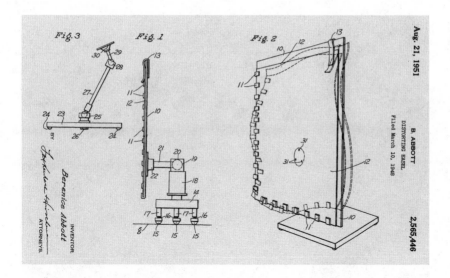

"B. Abbott Distorting Easel," U.S. patent, filed March 10, 1948; granted August 21, 1951.

ser that she had thought of it while pondering her thumb camera. She experimented first with pliable copper sheeting edged with little teeth to secure unexposed photo paper under the enlarger. However, it lost flexibility after a few bends, so she more successfully tried out a weave of copper wire, material used during the war to teach pilots about aerodynamic stresses on their aircraft; the material could be bent and twisted repeatedly to generate different effects. Because of this flexibility, however, no two images, even from the same negative, could be exactly alike: Witness the several different versions of the self-portrait Berenice made with the device, using the image that accompanied a 1931 *Abel's Photographic Weekly* profile. *Modern Photography* noted the irony that a photographer best known for making "straight prints" was the inventor of the Distorter.[6]

House of Photography's attorneys, Lackenbach & Hirschman, liked the Distorter best of Berenice's ideas, because it was simplest to explain and manufacture; they were able to make seven claims for its uniqueness, resulting in the first of her four patents. The device went into

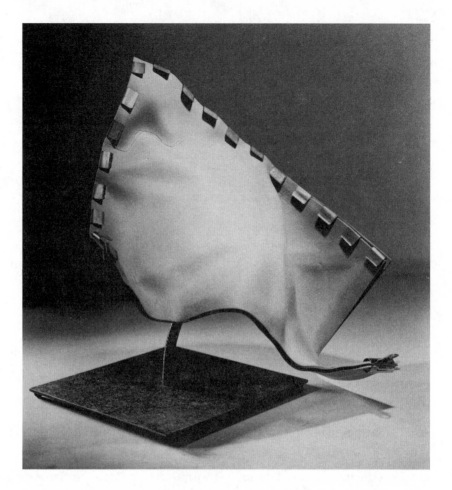

Abbott Distorter, showing its use, and placement of unexposed photo paper, New York, 1948. Berenice Abbott

production in 1948 at Mechanicraft Laboratories, with promotion and distribution being carried out by Caradell Products Company, both of New York. Ads for the $9.95 Abbott Distorter (over $100 today, a pricey hobby item) appeared in photography magazines when it went on sale in Fotoshop Stores in midtown Manhattan. Newspapers all over the country quoted the flippant press release, as if Berenice herself were claiming that "it's a good way to lose friends and get even with your mother-

in-law." But in December, Hudson Walker reined in further promotional spending and House of Photography showed a loss of $9.08 for the tax year. As late as 1956 Berenice was trying to interest manufacturers in the device.[7]

One of Berenice's Distorter portraits appeared in the May 1948 exhibition *Photography Pioneers*, at the Addison Gallery of American Art at Phillips Academy, in Andover, Massachusetts, with two Super-Sight prints, *Ear of Corn* and *Half-Apple*. Alongside the *Pioneers* show was a huge Atget exhibition, 250 prints on 23 panels, organized in topical categories by Ferdinand Reyher, who also wrote the commentary. Perhaps provoked by the then all-male privilege of Phillips Academy, Berenice at this time conceived an idea for a school of arts and sciences for "women of all ages, regardless of Race or Color," with

Berenice Abbott, Brooklyn, 1930. Charles Abel (attributed)

first-rate teachers and equipment, that would also teach engineering and mechanics, navigation, chemistry, physics, math, and photography—both the science of the discipline and "as a high form of art." It built on Berenice's brief 1946 ambition for a "Photographic School and Center," with wide-ranging courses, complemented by eclectic exhibitions and lectures. But when a poll of former students generated no interest, she annotated her journal entry for the plans "discontinued."[8]

Another invention, the picture composer, patented in 1952, was to be a manufactured version of two homemade cardboard right angles that Berenice used routinely in the studio, to try out different options for trimming prints and cutting mats, and in the field, to frame a view before positioning her camera. The only manufacturer that Berenice approached declined to take it on, with reason; there was so little call

for a similar item priced at one dollar that Willoughby's, the "World's Largest Camera Store," bought the inventory for 5 cents each.[9]

Berenice's Hi-Shot Shoulder-Pod, or monopod, was basically a one-legged tripod, a lightweight telescoping metal pole with an interchangeable base—either a rubber ball, allowing a photographer to tilt it without slippage, or a very small three-footed swivel pad, for vertical stability. A photo in Berenice's archive shows her dapper friend and Photo League president W. Eugene Smith deploying the ball version on a sidewalk. The device could also be lifted straight up to shoot over crowds and other obstacles. Margaret Bourke-White enthusiastically expected that news photographers shooting 35mm, and her Time Inc. bosses, would seize on the device's utility, and she even tried to help Berenice round up more financial angels, to no avail. (Its use as "selfie" stick did not occur to anyone.)[10]

The Kit-Jak, or "carry-all" jacket, was another near miss. Berenice compared its simple and functional utility to a painter's overalls or a printer's apron, "primarily for small camera users, though valuable for all photographers." Its design presaged the multipocketed safari/military jacket now universally recognized as the field uniform of working photographers. In one test, Berenice listed the items her jacket could hold—a "dozen #5 flashbulbs, Weston exposure meter, four 4x5 film packs, filter, cable release, booklet of lens tissue, handkerchief, lipstick, compact, pack of cigarettes, wallet, keys, alternate lens shade, notebook"—and noted that it "could have been loaded up much more." She collaborated with Romana Javitz's mother, Malvina, a skilled milliner and designer, to make a muslin prototype; due to a Jewish holiday, however, Javitz failed to keep an appointment with potential manufacturing and financial partners, Berenice said, putting "the kibosh on that!" Eventually, she had two examples tailored in blue duck, the same fabric used for French work jackets, and wore them for years.[11]

Her candid, or thumb, camera combined the image detail superiority of 4 × 5 inch medium format with the ease and unobtrusiveness of point-and-shoot. She fabricated prototypes and researched the theory

behind her empirical observation that people can usually point accurately at a target (or photographic subject) with their thumbs. Friends in Brookline, Massachusetts, Philip Walker and his wife, Ruth, who became a House of Photography stockholder, provided neurological sources for the theory of being able to accurately aim with the thumb—especially the top two segments, the "center of all activities of fingers, hand & forearm."[12]

Years earlier, Berenice had jotted down her basis for the invention: "See and immediately click. No focusing. No viewing. No lost motions. No lost time. No ground glass. Is manipulative with one hand only. Has a four way electrical shutter—for smoother working and thumb-aiming/ right hand aiming/ left hand aiming or from camera bottom or remote control . . . Built-in Synchroflash. Could take roll film, film pack, or sheet film. Can be any size—4 × 5 or 3-1/4 × 4-1/4 (I prefer 4 × 5). At same time it is 'much smaller' (more compact) and 'lighter' than any camera of similar size." A big problem with the thumb camera was how to push or release the shutter without disturbing the aim.[13]

Designing the holder and thumb grip to ensure immovable aim was eventually tasked to award-winning industrial designer George Farkas, based in Miami, Florida. Berenice had visited Miami in 1949 to convalesce from another bout with pneumonia and may have heard of Farkas, or even met him, through Peter and Ruth Salt, her old friends there. Farkas's 1952 contract with House of Photography also called for help, in exchange for stock, with redesigning her picture composer and a later item, a picture-hanger device. Berenice photographed Farkas in his office for $3 per print, which he never paid, believing them to be free. She consigned her own photographs to his interior decorating business; ubiquitous today, it was not common then for black-and-white photographs to hang in private homes as wall art. But the relationship soon soured.[14]

Berenice's most disappointing invention, Catch-Pole, was a spring-loaded floor-to-ceiling tube; she used it mostly to hold and position photofloods with clamps but envisioned it holding much heavier things, like

portable televisions. A patent search was under way when she showed it in early 1950 to photographer David Eisendrath, an advisor to Kodak who also headed ASMP's technical committee. Bernice expected Eisendrath to help her find a manufacturer. (She said that she tried to join the ASMP committee but that they didn't want a woman.) A year and a half later, Eisendrath was marketing his own version. Attorney Hirschman didn't think the device could be patented and advised Berenice to manufacture her own version anyway, hoping Eisendrath's company might sue her. However, George Farkas, who thought he was owed payment for prior work, refused "to hustle up a thousand units" to match her competitor in the marketplace. Berenice later saw Eisendrath and controlled herself enough to ask, "How is 'your' pole doing?," to which he replied, "You know you can't patent that thing," and walked away.[15]

Peter Salt in Miami tried to intervene with Farkas in 1953, after which House of Photography bought back Farkas's stock for $500. Two years later, Berenice sold Farkas the negatives from her portrait shoot in his Miami Beach office on the condition that he never credit her. Replacing Farkas as House of Photography designer was Iranian-born Alexander J. Kostellow, a leader in American industrial design education. He joined the faculty of Pratt Institute in the 1930s and established its Experimental Design Laboratory in 1952, while his own firm was the major consultant to Frigidaire, General Motors's home products division. Kostellow's fatal heart attack in August 1954 stalled further product development by the financially strapped House of Photography.[16]

Berenice's other photo product ideas included "small lamps for 'table top' [photography] . . . with flexible joints and extensions to place in any odd position"; "metallic [printing] paper . . . for richness & luminosity"; wall display mounts; and a half-tone or "repro" screen inside a camera. In the post–World War II marketplace, House of Photography was no competition, said Fred Spira, founder of a prominent photography accessories company (and one of the first photo-supply companies to import Japanese accessories into the United States); moreover,

he emphasized, photographers commonly developed products or built custom equipment.[17]

Berenice also recorded ingenious nonphotographic ideas, such as a down-filled kidney-bean-shaped pillow for long-distance travelers; buoyant waterproof shoes, molded or inflated; raised mesh or gridded sidewalks to allow water runoff and keep walkers' shoes dry; a paperless "writing pad of white washable material"; a toilet seat and bidet combo, and "protection from assassination" such as checkpoint metal detectors (X-ray or magnetic)—most of them long since developed by others.[18]

A decade later, Berenice showed a model of her thumb camera to Polaroid cofounder Edwin Land, who was uninterested in developing the product; he also cautioned her against making radical technical improvements in consumer products, advising her to release them slowly into the marketplace to avoid being seen as "crackpot." A Morgan Guaranty Trust banker sent Berenice to two of his customers, but one wasn't interested and the other was Eastman Kodak. "My heart sank," said Berenice, relieved when the banker told her not to sign Kodak's releases. The Deardorff view-camera people were interested but unhelpful. As late as 1958, Berenice hired the small St. Louis, Missouri, firm National Service Bureau, "Commercial Service for the Inventor and Manufacturer," to place her invention. Notably, many camera companies addressed their letters to *Mr.* Abbott, even after Berenice pointedly asked them to correct the spelling of her name from Bernice to Berenice. It appeared that no one at the firms, including the female secretaries, could fathom a woman inventor. Henry Lester of Graflex sought to prove the practicality of Berenice's "thumb pointing" and arranged for the development of three different handles for her to try out. US patent #2,860,556 was finally awarded for the camera on November 18, 1958, well into Berenice's association with the Physical Science Study Committee in Cambridge, Massachusetts, while New York State finalized its requirements for dissolving the House of Photography corporation, leaving just accounting details through the end of the year (see chapter 18).[19]

During its twelve-year existence, House of Photography raised and spent $20,000 developing items, but Berenice always felt that Hudson Walker wouldn't invest enough money to make it succeed. Long out of steam for the effort, and years after the House of Photography experience, she lamented the shift of skilled American camera and accessory manufacture to Japan in the 1960s, and roundly blamed American companies for "cutting out our own people of course," seeking cheaper overseas labor to the sure detriment of US workers.[20]

PHOTO LEAGUE

New York (1932–55)

It is our century, which is pre-eminently the century of
men throughout the world claiming the right of equality,
it is our own history that makes it inevitable that we can
only make sense of art if we judge it by the criterion of
whether or not it helps men to claim their social rights.

—JOHN BERGER[1]

The McCarthyites began putting them on the . . . subversive list.
So everybody got scared as hell . . . but I was fed up with the
League long before that . . . they weren't doing what they were
supposed to do; making you feel pity for something isn't it. —BA (1975)[2]

In June 1946, the New School asked Berenice to confirm that she had taken the loyalty oath required by the New York State Education Department. Again that fall, Dean Clara Mayer asked her to meet the requirement for teachers, but it is not certain that Berenice ever did.[3]

All her life, Berenice enjoyed the intrigue of being a political outsider, but she was hardly doctrinaire. During the Depression, many creative people had been idealistic Communist Party of the United States of America (CPUSA) members, a "tearful type of Red," informer Louis

F. Budenz called them, attracted as much by sentiment and injustice as by economics. Elizabeth, shrewder and better educated about political science, economics, and history, had been involved with progressive causes since the early 1920s, but she was a sympathizer without membership. Berenice's young friend Leticia Kent, who worked alongside preservationist Jane Jacobs in the 1950s and introduced Jacobs to Berenice, said Berenice "wasn't political but thought she was."[4]

Unlike the more practical WPA efforts that built and maintained bridges, schools, and parks, the New Deal Federal Art Project drew resentment as a haven for idlers and left-wingers, a perception shared not only by some members of Congress but by a segment of the public. Moreover, the New York office had more than the national share of trade union sympathizers: art workers following recent precedents set by industrial workers demanding hours, wages, and freedom from union busters. Some, like stagehands and printers, came from industries that were already organized. The official bargaining agent between the Federal Art Project and its 5,300 participants over a period of nearly eight years was the Artists' Union; Berenice endorsed its principles, if not always its effect on her activities.[5]

Her name had led the alphabetical list of signatories to a 1936 "call" for the creation of the American Artists' Congress, part of the CPUSA's "Popular Front" initiative, to encompass the entire Western Hemisphere, and she served on the welcoming committee. Its first meeting, chaired by Lewis Mumford, was held at New York's Town Hall. Margaret Bourke-White, fresh from a trip to the Soviet Union, represented photography at this assembly. Her short paper praised the Communist Party for supporting art in Russia, which gave artists the "freedom to think" and where, she said, there was an educated, receptive audience. José Orozco attended with his national delegation and sat for the portrait by Berenice that was so lauded by the *Daily Worker*, and later by Orozco himself, from Guadalajara. This portrait and one of Stuart Davis and other attending artists illustrated Elizabeth's *Springfield Republican* arti-

cle about this first meeting. The event also led Berenice to a friendly acquaintance with Gilbert Wilson, a painter from Terre Haute, Indiana. Wilson's murals in the local high school had been attacked by the American Legion as un-American. [6]

The resurgent Photo League, a reborn organization following the 1935 dissolution of the original Film and Photo League, started a formal school in the summer of 1938. Filmmakers and still photographers in the Film and Photo League had parted company over aesthetics and ideology. Now, leaving the filmmakers to combat Hollywood's official and commercial themes, the still photographers retained the original headquarters up a rickety stairway to the second floor of 31 East Twenty-First Street; with or without credit line, the Photo League continued to provide occasional photographs to leftist publications, including the *Daily Worker*. The club's loft was high-ceilinged, with gray walls, long tables, and plenty of wooden camp chairs. Its semester-long evening classes, at a minimal cost of $6, led young, artistically inclined, socially conscious men and women such as Morris Engel and Lucy Ashjian into photography and life-changing encounters with older members such as Paul Strand and public school teacher Aaron Siskind.[7]

Building on this enthusiasm, League members Sol Libsohn and the young WPA photographer Sid Grossman launched a formal curriculum for documentary photography, proclaiming their intent "to express their interest in the life of their city and its people in excellent and exciting pictures." They recruited Berenice, Elizabeth, Strand, filmmaker Leo Hurwitz, and photographer Lionel Berman to serve on the school's small advisory board (Berman was soon replaced by Beaumont Newhall). In an eminently practical gesture, and perhaps as a skewed nod toward Popular Front efforts to identify and incorporate American elements, a designated course text was the US Army Air Corps 1930 photography manual *Basic Photography*, which Berenice praised at every opportunity. The weekly print critiques, where students' photographs of a pre-assigned subject were reviewed as part of class

instruction, were followed by lectures by leading members and invited guests; Berenice's was the first. The classes and atmosphere of the Photo League were, for her, "very characteristic of New York—talk all night, talk their heads off."[8]

Paralleling the launch of the school, the group's newsletter called for a League of American Photographers to further the social value of photography and support the responsibility of "the photographer to record the truth about life as it is today." They posited themselves as a third stream between pictorialists who never made it into the twentieth century and "so-called modernists, who retired into a cult of red filters and confusing angles much beloved by the manufacturers of photographic materials," echoing Berenice's opinion about the photographic equipment industry, if not about her fellow modernists.[9]

One of these modernists was Lotte Jacobi, who had taken over her family's photographic business in Berlin and had sold work to Ullstein-Verlag before immigrating to New York in 1935. Berenice and she had in common not only Berlin but attitudes toward portrait photography: Jacobi's claim that her "style is the style of the people I photograph. . . . I refuse to photograph *myself*," echoes Berenice. Moreover, both women insisted that their students learn to see their subjects by focusing on the ground glass of large-format cameras, sharing the belief that technique is to be thoroughly absorbed. Students had to have technique in their fingers, Jacobi said, not their heads.[10]

Reviewing the first *U.S. Camera Annual* salon in fall 1936, Elizabeth praised the trend toward social and documentary themes, calling Berenice's work "as fine and honest as her previous photographs of the metropolis." She also commented on the scientific imagery in the show, and concluded: "With such a broad base of usefulness in diverse scientific and social ways, the medium has splendid chances of surviving also as art." At the same time, the American Contemporary Art Gallery (ACA) showed two hundred works by almost as many American Artists' Congress members to benefit the democratic struggle against fascism in Spain, where a brutal civil war between leftists supported by the

Soviet Union and totalitarian forces supported by Hitler's Nazi regime had begun. Berenice's contributions were included in the "Prints" section, along with those of Charles Sheeler and Paul Strand.[11]

To raise the profile of photography among her peers, Berenice composed a historical overview of her medium for the leftist Artists' Union magazine, *Art Front*. Touching on the early interest in photography of both scientists and artists, she contended that contemporary documentary "values are a relentless fidelity to fact, a deep love of the subject for its own sake, [and] a profound feeling for materials and surfaces and textures." In the same issue of *Art Front*, Elizabeth reviewed MoMA's *New Horizons* exhibition, concluding with her remonstration—learned directly from Berenice's experience and struggle—that an artist's freedom to create entails also "economic security and permanence of jobs, freedom from needless interruption and diversions of energy."[12]

Later that fall, Man Ray visited New York for the Museum of Modern Art's *Fantastic Art* exhibition but, avoiding politics, dodged Louis Lozowick's invitation to address the American Artists' Congress by claiming that he feared public speaking. Unlike the Artists' Union, the Congress was intended for "artists of standing" and was comparatively free of Communist Party involvement. The organization's exhibition and monograph of one hundred socially conscious prints, *America Today* (on view in thirty cities in December 1936), specifically excluded photographs, an issue further debated in the pages of *Art Front*. "Why the discrimination?" one correspondent named Isabel Cooper asked in a letter the magazine published in November. "The Artists' Congress has among its members a number of photographers including Berenice Abbott, Margaret Bourke-White, Barbara Morgan, Ralph Steiner and Paul Strand, not to mention Rockwell Kent, who has recently added the camera to his conquests. And presumably these photographers were admitted to membership as artists. . . . If photographers are artists, is not photography art? . . . In fact this seems not only discrimination, but a serious error of judgment, to omit what is one of the most popular

media of the day. In fighting fascism, the congress's avowed objective, the camera is a very handy weapon."[13]

The American Artists' Congress again took up the matter of photographer members in May 1937, at a symposium that included Berenice, Barbara Morgan, New School instructor Ralph Pearson, and printmaker Alexander Stavenitz. Pearson, the only detractor, held that photography relied solely on "accidents," while Stavenitz argued that photography was a new artist's tool. Berenice added that "the fundamental difference between painting and photography is that the artistic contribution of the photographer must be completed before his technical work begins. . . . Is not the crucial greatness of art in the artist's conception and ability to present that conception, whatever his medium? What more vital medium can this age offer than photography?" Whatever the membership thought, photographers continued to participate, as in the Congress's December *Exhibition in Defense of World Democracy, Dedicated to the Peoples of Spain and China*, where Berenice's portrait of Orozco led the alphabetical checklist of works on view. In early March, Berenice exhibited portrait photographs and gave a talk, "Photography—A Challenge," at the Art Students League. In 1939, the year of the 100th anniversary of the medium, the question of photography's role as an art at the Congress still went unresolved, while Photo League members implored the New York World's Fair Art Committee to host an art photography exhibition rather than a trade show of products. The League's Max Yavno asked Berenice for permission to use her name in the effort, another example, she felt, of the Photo League taking advantage of her public profile to gain notice and credibility. At the Congress's annual membership exhibition in 1939 Berenice showed *Gunsmith and Police Headquarters* from *Changing New York* as a political comment.[14]

That same year, the powerful images of twentieth-century American child laborers and other workers taken by the now-revered pioneering visual sociologist Lewis Wickes Hine drew Berenice, as with Atget years before, to seek out their creator. She was shocked to find the sixty-five-year-old Hine and his family on relief, their modest suburban

Gunsmith and Police Department, 6 Centre Market Place, Manhattan, *February 4, 1937.* Berenice Abbott

bungalow in preforeclosure. Together she and Elizabeth tried to help, introducing him to photography publisher Willard Morgan and *Life* picture editor Alexander King, as well as the Photo League, where an admiring young generation welcomed him. A prickly beneficiary, Hine believed the attention long overdue and took umbrage when Berenice's patronizing solicitude "toward the old, the helpless, the people stepped on by life" appeared in a popular magazine personality interview.[15]

She turned him over to Elizabeth, who soon organized a Hine ret-

Italian mother, Lower East Side, New York City, ca. 1910. *Abbott published the image as* Taking Home Work: East Side, 1909, *in her* Guide to Better Photography *(1941)*. Lewis Wickes Hine

rospective at New York's Riverside Museum. Berenice lent her well-equipped darkroom, with its high-end Saltzman enlarger, to make exhibition prints, and even made some herself: "Hine wasn't too good a printer." Volunteering as "number one assistant," fixing, washing, and drying prints with Hine, was Walter Rosenblum, who recalled Hine as a "master craftsman, extraordinarily familiar with darkroom technique." Berenice used Hine's *An Italian mother, Lower East Side, New York City* ever after to teach how a great photograph can break rules compositionally "if you express the reality of your subject." Decades later, Hine's child labor images still moved her: "The outrage . . . they are just children."[16]

In 1941 Berenice and Elizabeth were "sponsors" of the dinner dance—its Second Annual Salute to Spring—held by the recently formed Artists League of America, a merger of the Artists Union and the American Artists' Congress. The Photo League and other Popular Front organizations often held fund-raisers that featured progressive folk musicians such as Sis Cunningham and Pete Seeger. The connection only partly explains Berenice's role as wedding photographer for Seeger and Toshi Aline Ōta [Ohta] in 1943. Berenice also knew Toshi's mother, Virginia Harper Berry, from the Provincetown Players. But Berenice was not among the family friends, Toshi said, whom she would have called by the respectfully familiar honorific "aunt," and wondered whether anyone would have been that intimate with the stern photographer.[17]

Following Germany's defeat in 1945, the antifascist union between America and the Russian Soviet Union, America's opportunistic ally in

defeating Nazi Germany, quickly frayed. Growing fear of the totalitarian country, for its control of postwar governments in Eastern Europe and progress on an atomic bomb, brought individual Americans' political associations and suspected potential for communist sabotage under scrutiny. Berenice was "unusually nervous all day," she wrote, after President Harry Truman effectively declared the Cold War in his March 1947 "Truman Doctrine" speech against Soviet expansionism. His Executive Order 9835 led US Attorney General Tom C. Clark to issue a categorized list of communist, fascist, and subversive organizations believed active in the United States, ranging from the Ku Klux Klan and neo-Nazis to labor unions and the Communist Party. Suspected membership in a listed organization was to be reported to the Justice Department and loyalty boards. Within months, the Photo League was on the list, already identified in a 1934 compendium of left-wing and social justice organizations by Nazi apologist Elizabeth Dilling, *The Red Network*: "WORKERS FILM AND PHOTO LEAGUE: *A section of the communist Workers International Relief; secures photos for the Communist Party of U.S.A.*"[18]

Unknown to many post–World War II Photo League members, the original Depression-era Workers Film and Photo League (USA) dated back to 1930, with deep communist roots. It had been part of the *Internationale Arbeiterhilfe*, or Workers International Relief (WIR), founded in Berlin in 1921 by the Comintern, or Communist International, which advocated world communism between the two world wars. The Film and Photo League's primary function in the United States was as a picture agency, providing visual documentation of the workers' side of contemporary news stories and other topics on the American Communist Party's agenda, such as labor organizing and racial equality. Still photography was mainly for the party's newspaper, the *Daily Worker*, but newsreel footage shot by members was also available to movie theatres. In 1934, Nancy Cunard, who had become a communist, issued her monumental anthology *Negro*, using many images credited to the Workers Film and Photo League. This was a connection that Berenice,

too, could trace back to the early 1930s; Cunard's book also reproduced Berenice's portraits of saloniste A'Lelia Walker, drummer Buddy Gilmore, and singer Taylor Gordon. Berenice had participated, as advocate and advisor, in a 1935 fissure that found members of the Film and Photo League splitting off from the group to create Nykino, a moviemakers group. Nykino then became Frontier Films, under Paul Strand. The Photo League remained as the still photography organization and opened a school; the war found many members in military service, but the League resurged in 1946 with peacetime.[19]

Berenice claimed that "politics," more than any other issue, drove a wedge between her and Walker Evans as early as the 1930s. By the next decade Evans had become a snob, affecting the mannerisms and dress of an upper-class aesthete and writing anti-Stalinist film reviews for *Time* magazine. He admired Henry Luce's protégé and communist informer Whittaker Chambers, taking his side in the Hiss-Chambers case in the late 1940s.[20]

During its brief postwar heyday, the Photo League offered entertainments at Café Society, a Greenwich Village nightclub owned and operated by Barney Josephson, a communist. It was a principal venue for black performers including Josh White and Billie Holiday and, unlike most in New York City and the rest of the country, welcomed racially integrated audiences. Berenice's record collection of 78s (as it stood after her death) contained such requisite communist fare as the Soviet Army men's chorus, *American Folksay*, *Songs for John Doe*, and *Ballad for Americans*—a selection that mirrors the CPUSA's twisting party line through the war years. (Morris Engel, whose postwar livelihood derived from photojournalism for mainstream magazines, said he threw his similar record collection in the trash to avoid possible discovery.) Others in the creative community simply steered clear of the leftist pitfall. Painter Barnett Newman, an expert on New York City history and buildings, never consulted with Berenice, a fellow artist/historian of New York's built environment, specifically, he allowed, because she was a communist and he didn't want to get into trouble by being associated with her.[21]

New York Photo League "Photo Hunt" judging. New York, August 1947. L–R:
Weegee, Berenice Abbott, Eugene Smith. George Gilbert

Berenice and Elizabeth championed Sid Grossman, a charismatic
League teacher, but felt that he, like Walter Rosenblum, who had also
joined before World War II, became ambitious and doctrinaire. Lisette
Model found especially odious Grossman's power-hungry expectation
that the communists would soon prevail in the United States and reward
loyalists such as himself. Grossman conducted all-night at-home pho-
tography seminars that Berenice considered cultish; they were a trial for
adult students such as future gallerist Helen Gee, who had to get home
to babysitters or go to work the next day. Berenice was also appalled
by Grossman's treatment of his adoring first wife and assistant Marion
Hille: "like dirt," she said.[22]

While many photographers had been drawn to the original Photo
League's commitment to social justice and progressive politics, post–

World War II members were just as likely to be interested in its photography education and the camaraderie among like-minded, young cosmopolitan people. Lisette Model said she never before encountered people who talked so much about photography. New York is "the talkingest city that ever existed," concurred Berenice, who regarded the constant palaver as a form of evasion: "[P]eople who do things don't talk . . . they go out and do it." In the late 1940s, the Photo League's original function as a leftist picture agency was haltingly revived; there was a picture library, and use fees were to be paid to members should their photographs appear in mainstream publications (though not when they were used for free in the *Daily Worker*).[23]

The 1947 update to the attorney general's list that included the Photo League shocked many new, post–World War II members who simply didn't know the communist origins of their organization. The listing and the front-page newspaper articles it elicited cast a pall on members who were being denied clearances, passports, or other forms of access to their livelihoods, and on those who feared their loss. In response, the Photo League held a full membership meeting in January 1948 and produced a public statement and action plan crafted by the executive committee under Walter Rosenblum. The counterblast began with plans for a nonthreatening exhibition to showcase the organization's good intentions. Berenice was sympathetic to the fears Rosenblum and Grossman felt by being labeled subversive, but continued to disdain the League in general for its "male chauvinism" and what she insisted was their "same old rut of worship of Stieglitz and Strand."[24]

Rosalie Gwathmey, who headed the committee organizing the exhibition *This Is the Photo League*, called Berenice's submission—her Super-Sight *Half-Apple*—"a poor choice" for its failure to "demonstrate the class struggle." Berenice was "fed up with the League long before" the listing by the attorney general. In her view, they weren't exploiting the uniquely communicative capacity of photography's realistic imagery to inform or enlighten, but rather selecting or constructing what she called "crying pictures," pitiable scenes with maudlin elements. She eventually loaned her

portrait of James Joyce, deemed an acceptable substitute, only to have it and her other pictures relegated to the far reaches of the gallery, while the "more socially aware" pictures were hung out front. Though her name continued to appear on the Photo League's letterhead, where she was listed as a member of its advisory committee, younger leaders resented Berenice's overbearing manner, as well as her perennial failure to pay dues.[25]

The exhibition opened in December 1948, simultaneous with the effort to take the Photo League magazine, *Photo Notes*, to a higher, more professional level by including illustrations and a slicker cover. The first issue ambitiously featured a badly reproduced Atget, which Berenice made them reprint, only to discover their omission of credit to her for the collection. "As for Berenice——!" Nancy Newhall wrote Gwathmey from Rochester. "No loss, in my opinion, though letting her stew in her own cantankerous juice is a sad state to wish even on her!" Further sympathy wasn't "worth it, even for her real abilities and the Atgets, too."[26]

The Photo League's listing as a subversive organization has been blamed on a young lesbian member, Angela Calomiris, whom the FBI finally succeeded in recruiting in 1942 (after an earlier prewar attempt) to join the CPUSA and report back. Already "out" as a gay woman, she denied being blackmailed into cooperating and instead viewed her wartime and postwar spy assignments as patriotic contributions. Calomiris's actions were also lucrative, her real attraction to being a spy, enabling her to outfit a Greenwich Village studio and live securely. Her book *Red Masquerade* (1950) briefly recounts her House Un-American Activities Committee (HUAC) testimony about Photo League members reporting to "higher-ups" in the CPUSA.[27]

Berenice did not actually catch the attention of the FBI until June 19, 1951, when Louis F. Budenz, who had been the managing editor of the *Daily Worker* before renouncing communism, identified her as one of four hundred prominent people he called "concealed Communists." He recalled Berenice as an "outstanding professional photographer" whom he met briefly "in the early 1940s when she contributed some photographic work" to the paper and who was thereafter identified to him

as a Communist Party member. The FBI launched a thorough search for her in previous informers' reports, *Daily Worker* files, mainstream newspapers, voter registrations, and passport applications.[28]

Their resulting record of communist-affiliated activity began with Berenice's 1934 sponsorship of a "motion picture costume ball" by the Film and Photo League at Webster Hall in the East Village and her January 1935 support of the Political Prisoners Bail Fund. Around this time she led a protest march during which she grabbed an apolitical writer and sculptor named Chenoweth Hall from the sidelines to "be part of this." The FBI also noted her activity after the WPA: signatory to a 1946 *New York Times* ad for Citizens United to Abolish the Wood-Rankin Committee (that is, the House Un-American Activities Committee [HUAC]); member of the Greenwich Village chapter of the Civil Rights Congress in 1947; attendance at a Photo League party in 1949 at the Village Vanguard nightclub (thirty attendees were all allegedly members of the cultural division of the CPUSA); and sympathy for the New York City Teachers Union, then assumed to be a hotbed of communists.[29]

Berenice never learned of Budenz's disclosure to the FBI, however, and believed her biggest exposure to have been the publication in March 1949 of an alphabetical list—headed by her name—of a thousand sponsors of a three-day international conference for world peace at New York's Waldorf Astoria. The conference was organized by the Independent Citizens Committee of the Arts, Sciences, and Professions (ICCASP), identified by HUAC as a well-established communist front. The FBI's decision to create a Security Index Card for Berenice generated a fuller search of public records and a report that concluded in January 1953 with a physical description:

> Berenice Abbott (HQ 100-383988; NY 100-96405) SECURITY MATTER – C [that is, communist]. Age—40–50; Hair—Blonde ("dirty"), straight with bangs; Build—Rounded figure; Characteristics—Wears slacks constantly.

Washington FBI headquarters chided the zealous New York agents for relying on guilt by association, arguing that another perceived infraction that had been reported—Berenice's October 1950 signing of the Stockholm Peace Appeal, a petition to outlaw the hydrogen bomb signed by two million Americans—was not in itself a communist activity.[30]

It's unlikely that Angela Calomiris gave the FBI "information concerning homosexual tendencies" on Berenice's part, but someone did, repeatedly advising that during 1939 and 1940, "[obscured name] was carrying on a homosexual affair with a Miss BERNICE ABBOTT, whom the informant alleges to be a member of the Communist Party. Informant described ABBOTT as having previously carried on a homosexual affair with Miss ELIZABETH MCCAUSLAND . . . a fellow traveler." Several pages of Berenice's initial FBI report were devoted to Elizabeth's political affiliations and activities. Washington told New York to rewrite the report with less detail about Elizabeth, but all future reports continued to contain references to Berenice's homosexual associations. The New York FBI office submitted its revised report in March 1953 and asked to interview her. Washington said no, arguing that Berenice was unsuitable as a potential informant (presumably due to her open sexuality, and insusceptibility to blackmail), but retained her Security Index listing.[31]

The FBI then launched into an exploration of Elizabeth's political engagement, going back to her defense of Sacco and Vanzetti in the 1920s through her participation in the American Labor Party in the late 1940s. Elizabeth had signed petitions with greater frequency than Berenice and spoken out at many forums, all duly noted in her FBI report, completed in January 1954. The file identifies her as a self-employed writer and art critic who "shares apartment with Berenice Abbott, a CP member" and further refers to their "homo-sexual affair for a number of years" (the phrase is underlined and in capital letters). Washington told New York to interview Elizabeth before assigning her a Security Index Card. On May 17, 1954—just after Berenice left town to photograph U.S. Route 1 (see chapter 17)—two male agents interviewed

Elizabeth alone in the Commerce Street apartment. Disingenuously, she told them that she was "a simple working woman" with "no knowledge of Communism." The agents recorded that she "has always manifested an interest in the civil liberties of her fellow man." Elizabeth argued that the Communist Party's relatively small membership presented no threat to the country. When asked about "information indicating that BERNICE ABBOTT was a Communist," Elizabeth "appeared noticeably upset," the agents noted, and suggested they "ask ABBOTT."[32]

On August 2, an informant told the FBI that Berenice had "toured the southern United States obtaining material relative to conditions of the Negro people" there. The unidentified informant further claimed that Berenice planned to use this material in her New School classes, supposed evidence of communist affiliation that the FBI would dismiss the following year. FBI director J. Edgar Hoover saw subversion in civil rights activity, which likely explains the informant's action.[33]

Decades earlier, for *Changing New York*, Berenice had photographed a Brooklyn waterfront neighborhood in transition around the Manhattan Bridge; a black family on Jay Street had told her that "a dog shouldn't live in this place." Around the corner, she set up her camera on a poorly paved street lined with small, dilapidated frame houses, which she found difficult to photograph because the poverty so distressed her: "The poor colored people, they have had all the dirty old places to live in New York." Conversely, she had also photographed bustling Lenox Avenue in Harlem for the project.[34]

Berenice and Elizabeth had long supported civil rights for African Americans. Elizabeth endorsed a 1951 "Call to a Conference for Equal Rights for Negroes in Arts, Sciences and Professions." Berenice was vehement about the century-old "treachery of Buchanan's cabinet" and felt that the Civil War had never been won. To her last days, she despised the South and wanted never again "to witness the degradation imposed upon the Negroes" there. In the 1940s, in the spirit of Nancy Cunard's illustrated anthology, Berenice had envisioned a photo book on "American Negro Genius." It would contain historical images and her portraits—

Jay Street, No. 115, Brooklyn, *May 22, 1936.* Berenice Abbott

some from her files, and others taken for the purpose: of prominent black politicians, performers, writers, composers, and athletes.[35]

Berenice's FBI Security Index Card was updated as more biographical information surfaced, but in August 1955 the New York office recommended removing her from the "Index," because her activities no longer met the inclusion criteria; by the end of October, Berenice's name was deleted from the FBI's "Program for Apprehension and Detention of Persons Considered Potentially Dangerous to the National Defense and Public Safety of the United States."[36]

For years afterward Berenice feared reinvestigation and would go silent during phone calls when certain topics arose, in case her phone was tapped. She stood by the ideals of the Russian Revolution to the end of her life, and was fondly recalled for dragging friends to any Soviet film that was playing, memorably those about tractors and healthy farmworkers. Among her very favorite films was the 1943 American-made *Boy from Stalingrad*, in which the lone girl in a pack of orphan partisans decries as "reactionary" her exclusion from a mission, "Girls are just as good as boys!"[37]

IT HAS TO WALK ALONE

Aspen and New York (1951–54)

> *Naturalism and anecdotalism are required to be as*
> *original in photography as in any other art.*
> —CLEMENT GREENBERG[1]

What the human eye observes casually and incuriously, the eye

of the camera. . . notes with relentless fidelity. —BA (1941)[2]

As Berenice was coming to the attention of the FBI in 1951, the new Aspen Institute for Humanistic Studies was organizing a conference on the state of American photography. The institute was the postwar brainchild of Chicago businessman Walter Paepcke, president of the Container Corporation of America, noted for its uplifting public service advertising and modern graphics by leading artists, including Man Ray and Fernand Léger. Paepcke envisioned a retreat where thinkers, artists, and businesspeople would gather to freely consider values and progress across the spectrum of human endeavor. (Others would later view it as the co-opting of high culture by capitalism.)

Paepcke's design consultant was Herbert Bayer, the former Bauhaus artist and architect (and second husband of Joella Levy), who helped plan the institute community in the former mining town of Aspen, Colorado, which aimed to reinvent itself as a European-style ski resort.[3]

Berenice, enjoying a small professional revival, and eager to see Colorado, accepted the invitation to take part in the conference. She had just published a fervent essay, "Photography at the Crossroads," incorporating ideas she'd been reworking since 1946, defending photography as a realistic medium. The essay appeared in the *Universal Photo Almanac*, a camera annual for amateurs and professionals, newly aiming editorially for an audience "of maturity and distinction" with articles by other notables, such as Ansel Adams, Minor White, and Beaumont Newhall. En route to Aspen at the end of September 1951, Berenice stopped in Chicago, where the ambitious and innovative director of the Art Institute of Chicago, Daniel Catton Rich, had offered her a solo exhibition, under the auspices of adman Peter Pollack, a photographer and WPA community art center veteran.[4]

Pollack also offered to help find a manufacturer for Berenice's picture-hanging invention, and tried to enlist the *Chicago Tribune* and local advertising men for support, but the effort evidently foundered on Berenice's unfocused ambition, which by August extended to photographing the entire Midwest as part of an unspecified "big plan." Pollack vetoed her use of a Distorter self-portrait in her exhibition publicity to help market the device, so she provided the usual one by Consuelo Kanaga. She sent instructions and detailed sketches for installing her Masonite-mounted prints with their little hidden blocks to make them float over the wall surface. The two-month show comprised forty-four works hung topically per Berenice's stipulation, plus "her latest experimental work called modestly the Abbott Process"—i.e. Super-Sight. In Pollack's office she let him snap her portrait—she was wearing a prim hat and suit and an ensemble of modernistic silver jewelry—and they discussed an Atget exhibition. She completed the train trip to Col-

orado without mishap but was terrified by a sightseeing drive she took with Ansel Adams over the local Elk Mountains range of the Rockies around Aspen.[5]

> They fell in line with the general illness in photography,
>
> which is the Strand, Weston, Stieglitz group. —BA[6]

THE ASPEN CONFERENCE opened on Wednesday, September 26, with a slide lecture on "Great Photographic Surveys of America" by Paul Vanderbilt, the Library of Congress's consultant in iconography. Ten too-long days later, she said, it closed. In between were informal late-afternoon meetings in the lounge of the 1889 landmark Hotel Jerome, after-dinner panels in the Wheeler Opera House, and field trips, around town or to nearby mountaintops or abandoned mines. She characterized the "whole thing [as] sort of a party." The giddy atmosphere reflected the participants' preemption of the tiresome question, "Is photography art?" Rather, the conference addressed what kind of art and the photographer's place in the modern world.[7]

Life picture editor John Morris met Berenice there. "With her bobbed hair and feline eyes, she wasn't about to be taken in by the American photo establishment," he said. Minor White, teaching at the San Francisco School of Fine Arts, headed the first night's panel, "Evolution of a New Photographic Vision," with Berenice, Walker Evans, Aspen photographer Patrick Henry, and Paul Vanderbilt. Though Berenice disagreed with everything White said and later resented his mystical aesthetic, she still liked him personally, describing him as a "nice guy with a caricature of a face, Joe E. Brown mouth." That evening she openly challenged White and his group of aesthetes "to look around them and see what life was like." From the audience, a "pink in the face" Frederick Sommer argued back, "We're not postage stamps. We're not trying to communicate. We don't care if people understand us. We

Attendees, Aspen Institute for Humanistic Studies Conference on Photography,
Hotel Jerome lobby, Aspen, Colorado, September–October 1951. Back
row, L–R: *Herbert Bayer, Eliot Porter, Joella Bayer, Marian Vanderbilt,*
Connie Steele, John Morris, Ferenc Berko, Laura Gilpin, Fritz Kaeser, Paul
Vanderbilt. Middle row: *Aline Porter, Minor White.* Front row: *Milly*
Kaeser, Ansel Adams, Dorothea Lange, Walter Paepcke, Berenice Abbott,
Frederick Sommer, Nancy Newhall, Beaumont Newhall. On floor: *Will*
Connell, Wayne Miller. Robert C. Bishop

are expressing ourselves." Berenice asked him if he didn't think it was
"rather arrogant for artists to expect people to come and sit at their feet
and try to figure out and wonder what on earth it is they mean? . . . <u>You</u>
should communicate."[8]

"It's all spirit and emotion! . . . You could photograph a little spit on

the sidewalk; you can make a design of anything"—as Sommer, in her view, did, with "little pieces of 'ordure' and . . . decayed stuff and took it seriously! . . . We didn't get along at all."[9]

" 'Look, I've heard about the spirit here . . . I haven't heard one thing about the intelligence.' It's as though intelligence didn't come into art," she recalled. Herbert Bayer, fortunately, took the floor and addressed the importance of intellect and intelligence in the arts.[10]

Just prior to the conference, Berenice had published "What the Camera and I See" in *ARTnews*, with the latest pictures taken for her "electricity" series, *Van de Graaff Generator* and *Magnet with Key*. "While reality is the subject matter of the photographer," she wrote, "it follows that the knowledge of how far the camera can go, and the choice of subject, lead the photographer into the subjective. He cannot help equating the objective world with his self."[11]

This stern, sublimating attitude toward her subject matter cost Berenice all sympathy for photographers who make their "vision" the center of their artistic focus, especially those whose subject matter she found insignificant or insipid. Further, Steichen and the Museum of Modern Art had earlier that year earned her opprobrium with *Abstraction in Photography*, a design-oriented exhibition that included scientific imagery with unrecognizable subjects and "purely inventive" photographs, such as leaf outlines by Berenice's future friend Irene Shwachman. Abstractionism, Elizabeth moralized in sympathetic response, was "the artist's flight from reality and from responsibility. . . . artists have been captured by a false propaganda, to fight the battles of the enemies of creativity, to destroy man's soul, to poison his hope, to prepare him for surrender, as works of art of non-hopeful quality will surely enervate men in general." More pointedly, Berenice aphorized decades later: "In the search for art the subject gets lost. In the search for a subject one finds art."[12]

On the last conference day, Berenice led "Objectives for Photography," with panelists Walker Evans and Dorothea Lange. Her formal talk aimed to summarize goals for the field. She felt it was a huge responsibility, the first time she had the "guts," as she said, to attack

Stieglitz as part of what she viewed as the persistent historical succession of pictorialists, poisoning photography's elemental nature, its realism. Stieglitz had been dead only five years, and she realized that her stance against his "cult" provoked many, including Elizabeth. Others might have thought her simply ignorant or stubborn, but Berenice said what she thought should be said, knowing it would be unpopular and controversial. "My knees were sort of quaking. I thought God might descend from the sky and strike me dead!" She quoted Goethe on the "general sickness of the present day—subjectivity." A poet returning to his hometown of Hamburg, Goethe said, discussed his feelings for his parents, relations, and friends, but not the particularities of Hamburg, the physical place. (Months later, Dorothea Lange told Berenice that she was still reading Goethe because of this reference.)[13]

Right after her talk, Berenice took the train east, believing her impact to have been "Hit and run; but not intentionally." She was not among the panelists at MoMA for "What Is Modern Photography?," organized by Steichen, and broadcast by Voice of America, on the heels of the Aspen conference. It included her friends Lisette Model, Bourke-White, and Aaron Siskind. Nor did she join the largely West Coast–based participants who followed up the conference's consensus that creative photography needed a serious journal, though Ansel Adams's biographer credited this outcome of the Aspen conference to Berenice, who had stressed the poor state of photography publishing. Her focus on the subject was likely related to her short-lived coeditorship of *American Photography* with a young Byron Dobell; she "had fun unearthing new and interesting photographers. Some old ones too." In 1952, Adams, the Newhalls, White, and Lange formed the core that launched *Aperture*, a dignified publication, Newhall said, that would avoid the editorial inconsistencies experienced by every ambitious photography magazine dependent on industry advertising.[14]

Berenice herself long felt that the *Aperture* group had "put thumbs down on" her after she bashed Stieglitz, and she realized that she had criticized Eastman Kodak's mass-market approach to their face—company

managers had been among the conference invitees. November's ASMP *Bulletin* printed a condensed version of Berenice's talk as "It Has to Walk Alone." In it she concisely cited all three stages of pictorialism as she saw them, from Henry Peach Robinson's nineteenth-century staged narratives, through Stieglitz's work, "spiked with mystical and subjective overtones," to his present-day inheritors, imitators of the nonfigurative painters Jackson Pollock and Mondrian. "The only relationship is that of a two-dimensional image on a flat surface within a certain area, but the natures of those two images are worlds apart. Photography can never grow up and stand on its own two feet if it imitates primarily some other medium. It has to walk alone. It has to be itself."[15]

> If the copyright law fails to protect the creative artist,
>
> whether photographer, painter, author, or songwriter, is there
>
> not another protection, the common law property right? . . .
>
> the Authors League has worked for improvement in the
>
> copyright law, at least as regards authors. It seems about time
>
> that the ASMP does the same for photographers. —BA[16]

THE BOWERY FIGURED large for Berenice in fall 1951. She did a somber but youthful portrait of her long-ago Village acquaintance Dorothy Day for the dust jacket of *The Long Loneliness*, the radical Catholic social reformer's autobiography. She photographed Mina Loy's rag sculptures at her Bowery studio and home but not Loy herself, who may have demurred; Berenice told Loy's biographer, "[W]hen a beautiful woman becomes older and loses her beauty, it's a tragedy for her." Berenice spent an evening exploring the Bowery with filmmaker John Arvonio, who had once helped Berenice analyze light meters. She still preferred intuition and judgment, eschewing Ansel Adams's "zone system"—a strict method for determining the light and dark values of a visualized image, and exposing film to optimize them—as too complicated to be effective. Neither Day's humanitarian Catholic Worker movement nor

Loy's compassionate rag sculptures seemed to sway hard-nosed Berenice, who described her night with Arvonio on the Bowery as "like wandering around in Hell" among loners who all felt "they had been done wrong . . . They never did any wrong." Among them could have been Berenice's lost brother, Earl Stanley. In the early 1960s, long after Berenice had washed her hands of him, refusing to bail him out one last time, Earl died, reportedly a suicide, in the old Manhattan municipal jail called the Tombs.[17]

In February 1952, Berenice drew an overflow audience at the Village Camera Club with a rework of her Aspen talk, advertised as "The Dark Ages of Photography." She explained her opposition to using the word *documentary* to indicate "a particular category, especially since a foolish cliché" dismisses the form as "preoccupied with only the drab, or with the things that many people prefer to close their eyes to." Former Bauhaus artist Josef Albers, head of Yale University's Department of Design, read about the talk in the *New York Times* and sympathized with Berenice's argument that "Living photography builds up, does not tear down. . . . Living photography is positive in its approach." Berenice's "attitude and philosophy give important directions for all the arts and should enlighten many artists today," Albers wrote. "Bravo."[18]

Berenice contracted with Crown Publishers at roughly this time to provide an update to her 1941 book as *New Guide to Better Photography*, for which she chose eighty-six plates of mostly new pictures. Man Ray declined permission to reproduce his time-lapse, multiple-exposure portrait of Marquise Casati, explaining that the picture was "too complicated" for Berenice to meet his reproduction requirements and fee. "It is not a question of good or bad company," he continued, "the photo you refer to is . . . very bad . . . from a technical standard. . . . I prefer having my 'rayographs' used; and they have the least to do with photography." For sentimental reasons and because Berenice wanted something of the American West by someone other than "slick, self satisfied" Ansel Adams, she asked Laura Gilpin for a photograph, only to be disappointed by a very "ordinary" image. Other photographers Berenice

included reflected strong personal connections. The Lewis Hine image of a child behind a glass door came from a negative then in Berenice's possession. In May, Dorothea Lange sent two prints, one of them her only copy of what Berenice reproduced as plate 52, "Field Worker . . . Cotton Rows, Eloy, Arizona"; for identification, Lange had called it "Cotton picker with hand across face," noting that the negative is "buried somewhere in Washington," not in the Library of Congress, "which is not such a problem. In short, keep your eye on the prints, for as you know I don't own my negatives."[19]

To work on *New Guide*, Berenice took a long summer vacation in Miami Beach, by herself, and visited her friends Ruth and Peter Salt in their old Florida home on Emathla Street in Coconut Grove. Elizabeth stayed in New York. Working independently on various individual projects after their Federal Art Project collaboration in 1939, the two women had become accustomed to separation, and to other friends.[20]

Berenice apparently received an advance of $250 for a children's title, which she provisionally referred to as "Baby Monkey Book," with Lothrop, Lee and Shepard Books, owned by Crown Publishers. The unfulfilled shooting script called for a dozen morning-to-night narrative pictures, but evidently the publisher could not find an author for the project. She also tried furthering her collaboration with Muriel Rukeyser on "Discovery," the working title for their book of Super-Sight pictures; the project was turned down by Long Island University Press. After sending her corrected *New Guide* manuscript back to Crown in August, Berenice prepared to return to New School classes. Sometime after New Year's 1954 she became a "cat mother," Holger Cahill said, having adopted a little kitten she named Gigi.[21]

> Briefly, photography is very young. Writing is very
> old. Everybody writes but they know they are not
> writers. Everybody photographs but they don't
> realize that they are not photographers. —BA[22]

CRITIC JACOB DESCHIN, himself the author of two successful photography handbooks, raved about *New Guide* for conveying "the unbroken relationship of today's photography to yesterday's." Lisette Model, whose pictures appear in the book, said it was "the finest thing she ever read" about photography and found herself underlining throughout the first chapter. Hearing this from her artistic peer, Berenice artlessly responded that she "couldn't even remember what was in it."[23]

Out west, Elizabeth's friend Bill Estler arranged for a show of Berenice's photographs at the Stanford Research Institute. It was "a smash," he reported and then employed his formidable public relations skills to move the exhibition to the San Francisco Museum of Modern Art for February. Berenice's prints next hung for several weeks in the showroom of Bill Brewer Associates Inc., a national contemporary designer and wholesaler, in the Jackson Square neighborhood of the city, where Estler called their decorative importance the equal of any painting. By May the prints were moved to the Skylight Gallery, in Palo Alto. Estler also tried to obtain scientific assignments for Berenice at Stanford despite its four-member permanent photo staff.[24]

Harvey V. Fondiller, the photographer and editor of the twenty-volume *Encyclopedia of Photography*, interviewed Berenice for a new feature called "I Wish I'd Taken That" in *Brief*, a pocket-sized bimonthly for men that strove for a socially useful role before devolving into another "girlie" magazine. The conversation moved from a then relatively new "thrilling" photograph from space called *Rocket-Eye View of the Earth*, courtesy the US Defense Department (Berenice said that she wished she had been aboard the rocket), to her own *Night View, New York* ("it re-creates for me some of the feeling I got from the original scene—and that is the real test of any picture"). Both photos were reproduced in the magazine.[25]

In November 1951, Berenice transcribed or translated into her journal Proust's famous lines, from *Within a Budding Grove*, on genius, which "comes less from intellectuality and superior social refinement than from the faculty to transform – transpose." Later, Berenice copied

into her journal a passage on creation from Freud's *Civilization and Its Discontents* that echoes her favorite from Nathaniel Hawthorne about taking pleasure in the making, in the creating, not in the final object, and also unites art with science. "This kind of satisfaction, such as the artist's joy in creation, in embodying his fantasies, or the scientist's in solving problems or discovering truth, has a *special quality* which we shall certainly one day be able to define metapsychologically." From critic Van Wyck Brooks, she learned the George Santayana maxim: "Nothing is really so poor and melancholy as art that is interested in itself and not in its subject." Brooks's decade-old *Opinions of Oliver Allston* cited the work of Assyrian archaeologists who considered the cuneiform writing found on the royal palace at Calah to constitute an early example of art and science united. Berenice paraphrased those lines into her journal and wrote to Brooks as "one American (battered by the things we live by to-day)," thanking him "for the great lift and fun you have made possible."[26]

In fall 1953, a Frank Lloyd Wright retrospective exhibition, *Sixty Years of Living Architecture*, included a fully furnished contemporary Usonian house. Erected on Fifth Avenue at Eighty-Ninth Street before construction began on Wright's tapering cylindrical Solomon R. Guggenheim Museum, the Usonian occupied a temporary plywood pavilion. Berenice photographed the pavilion and its interior, and also made a portrait of the octogenarian architect. He was sad about the way New York looked and had forgotten his long-ago offer to hire Berenice to photograph his buildings—having employed, since 1939, the young Arizona-born view-camera master Pedro Guerrero.[27]

Berenice had participated in the summer of 1953 in a group photography show at Caravan House—the Upper East Side home and gallery of Julie Olin Benkard Chanler and her second husband, politician Lewis S. Chanler. The Chanlers had founded a splinter Baha'i group in 1929, retaining its main principles of universal unity and evolution toward peace. In the 1930s, their town house hosted world peace groups including the Fellowship of Reconciliation, the War Resisters League, and the

Women's Peace Society. The gallery within the Chanlers' house was professionalized and given an American focus by Berenice's old painter friend De Hirsh Margules. It branched out into photography under a connection of Elizabeth's, Katherine Young, a wealthy portrait photographer Berenice thought not very good.[28]

The 1953 show awarded cash prizes to exhibitors who ranged from amateurs to professionals. Hoping for remuneration, Berenice resented that her "masterly precise work" (in the words of Jacob Deschin, one of the judges) didn't win. She deplored the Caravan organizers' excuse that someone of her standing didn't need a prize. Regardless, a year later she had a solo exhibition there. The new director, Mirza Ahmad Sohrab, head of the American reform Baha'i movement, seemed to be angling for Berenice's endorsement of the organization's ideals. Berenice's own goal was likely to secure a public venue for her work. This show was her first big survey in years, with many new pictures, organized topically. Portraits ranged from *James Joyce* to the *New Guide*'s *Mother and Child*, depicting Eva Shimin, the wife of the Russian-born illustrator Symeon Shimin, with their toddler; the "New York" section offered scenes taken with Berenice's new thumb camera and other photographs for *Greenwich Village*; "Science" contained 1930s industrials as well as botanical images used in the textbook *American High School Biology* (1948) and others for her electricity project; "Experiments" featured prints "Made by the Abbott Process"—that is, Super-Sight images.[29]

I have had the experience which is a healthy part of every artist's growth: The more you do, the more you realize how much there is to do, what a vast subject the metropolis is and how the work of photographing it could go on forever. —BA[30]

FOR THE 300TH ANNIVERSARY of the City of New York, more than a dozen of Berenice's pictures appeared in John A. Kouwenhoven's monumental book *The Columbia Historical Portrait of New York* (1953). But

the author drew upon the Museum of the City of New York's *Changing New York* holdings rather than Berenice's files directly, resulting in some antagonism between the two. The book reawakened Berenice's interest in the city, and she applied to the Architectural League for a fellowship to work on a photographic documentation, "Metropolis Old and New," comparing 1929 and 1954. The quarter century would bracket the earliest pictures she had made in the city—work that was in her personal archive and under her control, unlike the work in *Changing New York*—with new pictures she would take in the coming year. She expected to exploit the qualities of her thumb camera for candid and stop-action work. And she envisioned a panorama of the Manhattan shoreline, made by taking a view-camera photograph every five hundred feet along the island's entire circumference to convey a volumetric "roundness" of the components of the built environment and "the correct relations of objects in deep space." Though the professional references she offered ranged from architectural (Philip Johnson and historian Talbot Hamlin) to pictorial (artist Paul Grotz and librarian Romana Javitz), no fellowship was awarded her.[31]

As critic John Russell once emphasized, Berenice had "an armored ego—how else could she have got the work done." He erred, however, in adding that she had "no vanity."[32]

LITTLE OLD AMERICA

Florida and Maine (1954–58)

When the artist rose high enough to achieve the Beautiful,
the symbol by which he made it perceptible to mortal
senses became of little value in his eyes, while his spirit
possessed itself in the enjoyment of the Reality.

—NATHANIEL HAWTHORNE[1]

When I got to Maine it was "little old America" the way it
used to be . . . down to earth and unpretentious. —BA[2]

In January 1954 Berenice spent a week in central Maine vacationing
with her Harvard physics photography lab friend Margaret Bennett,
a Maine native, and scouting locations for Elizabeth's further study of
painter Marsden Hartley. Berenice's youthful Paris acquaintance with
Hartley inspired Elizabeth to tease out of Berenice, after twenty years'
intimacy, an autobiographical narrative of her early years there, which
they committed to paper. Successive manuscript revisions reflect Eliza-
beth's efforts to refine Berenice's cruder expressions and to clarify her
awkward attempts at a literary style.[3]

Both out West and up and down the East Coast, Berenice had seen

two decades of changes in the American built environment, and she had experienced the cultural contrasts between North and South. The American interstate highway system was in the planning stage; upgrading the U.S. 1 Eastern Seaboard corridor, the most heavily traveled territory in the country, was the first priority. The New Jersey Turnpike, which opened in 1952, ran parallel to, when not over, old U.S. 1. Perhaps Muriel Rukeyser's *U.S. 1* (1938), a book of poems, helped spur Berenice to consider photographing the fast-transforming highway, but it was an encounter at the New School that turned it into a reality.

A young couple, Sara (née Rohm) and L. Damon Gadd, had been touring the world as fledgling journalists—Sara took writing classes at Columbia and Damon studied photography at the New School. They sought out Berenice for her European background. Over lunches, a plan for traveling U.S. 1 together percolated: "Go with me on this trip—you pay for it—and you'll learn photography," Berenice said.[4]

May 1954 found the trio, and the Gadds' shih tzu, heaving south in a Mercury station wagon, with no itinerary beyond the full length of the highway itself. After overnighting in Princeton, New Jersey, the Gadds invested in a small pea-green trailer to save on lodging. They dubbed it Alma—perhaps after Berenice's trusted cleaner, Alma Richards, who introduced her and Elizabeth to rum and Coca-Cola, the Cuba Libre. The couple occupied the bedroom in the front; the kitchen and living room in the back became a darkroom that also held Berenice's cot, tucked below the lines used to hold dripping-wet processed film to dry.[5]

They stopped when they saw a subject to photograph and waited for the light, or for anything else to make it right. Damon was unfamiliar with the practice of large-format photography, and impatient with the preparations necessary for one shot. He also thought that Berenice was extravagant with film (costs he was absorbing). But she didn't direct his photography, and there was no formal understanding between them about the instruction he was to receive. "Some places we'd see a shot and we'd wait until the next day," he recalled. They would stop in a motel or pull the trailer into a field. Berenice tried to get action shots

with her view camera, "and it took us a long time to convince her" to abandon it. She "finally succumbed to the Rollei," but did not adopt a 35mm camera, which is what Damon used for the purpose.[6]

After Princeton, they photographed with the view camera in Trenton, Philadelphia, Baltimore, and Washington, moving on to Alexandria, Richmond, Fredericksburg, and elsewhere in Virginia. By June 9 they were flying through the Carolinas. They stopped at two farms—Brewster Stables, in South Pines, and with Mr. and Mrs. A. J. Taylor, in Leesville, South Carolina. From the eleventh to the fifteenth Berenice took pictures through the car window around Augusta, Georgia (likely those view-camera action shots Damon disparaged), plus locations identified in the log as "Colored" and the slave market in Louisville. They tried to stick to U.S. 1 in Georgia; Berenice saw many other scenes of segregation and subjects she "would have liked to take but didn't have the nerve." The group recorded the signs of religious exhortations in $2\frac{1}{4} \times 2\frac{1}{4}$. One "dreadful" night, their trailer camp was next to a preacher with a loudspeaker "shouting about God and get right with your sins and everything," which made Berenice "very nervous and miserable and I got out of there just as fast as I could."[7]

In Vero Beach, she had a friend who owned "a wonderful old Florida house with a huge, huge tree, not a banyan." As mosquitoes swarmed, they meticulously photographed "all the old furniture and bric-a-brac" and interior details of the extraordinary place, called Driftwood Manor. Berenice also photographed the shrewd and eccentric owner, Waldo E. Sexton, on the front steps. They got to Key West on July 9 and turned around, dawdling through Miami—and Berenice's fifty-sixth birthday on the 17th—but moving faster north. They detoured briefly in Maryland to visit Robert C. Cook and his new wife and photograph their farm just south of the Pennsylvania state line on July 29, and captured scenes of New Jersey traffic before arriving back in town on July 30.[8]

In mid-August, they were back on U.S. 1, heading north. They lingered in Connecticut and then skipped through the rest of New England to reach Maine, where they photographed potato farms in the town of

Old Florida Oak, *July 1954, in* Beauty and the Camera *(Whitestone series 21),*
1957. Berenice Abbott and Damon Gadd

Houlton on the twenty-first and Caribou and Fort Kent on the Canadian border the next day. Then they began a leisurely return, stopping at Rubenstein's Antiques in Rockland, but on August 31 they ran into Hurricane Carol, the most destructive to strike the area since 1938. Berenice was "scared to death," she told Elizabeth, and reported that Salem's historical monuments were wrecked, though they took a few photographs there, too. Traveling through Rhode Island and Connecticut, they finished the trip on September 9. At the end of October, Berenice went out again to photograph U.S. 1's New York approaches, making a dozen pictures of the Pulaski Skyway and the George Washington Bridge.[9]

American Shops, New Jersey, *July 30, 1954.* Berenice Abbott

Berenice and Damon, who had no darkroom training, worked steadily to print all the black-and-white negatives. "A fantastic experience," he later called his opportunity to work with a master printer. There were color images, but Berenice felt that color "crowds the picture and affects the composition. Color is secondary. The primary thing is the subject." That fall, the Gadds acquired the Vermont property that launched their Sugarbush ski resort; the next summer, they resumed touring as travel photojournalists, leaving the marketing of the project, by then called *U.S. 1 U.S.A.*, to Berenice—typically, Elizabeth helped with the book proposal.[10]

Literary agent Mary Squire Abbot, of McIntosh & Otis, Inc., was lukewarm about *U.S. 1*'s prospects, based on Simon & Schuster's doubt about public interest in the subject and concern that the text be "superlative" (novice Sara Gadd was the proposed author). Margaret Bourke-White's editor there, Maria Leiper, suggested Carson McCullers or Carl Carmer as strong and well-known narrative writers, and believed that "Abbott work shouldn't have trouble finding a publisher." At the same time she opined, correctly, that the project might not be sufficiently commercial to make it into print, and ultimately publisher Dick Simon agreed. At Random House, Bennett Cerf had "a violent thumbs-down attitude toward expensive collections of photographs." Mary Abbot also suggested that Berenice approach her former agent Tay Hohoff, now an editor at Lippincott, to no avail; on her own, Berenice asked her old Paris acquaintance Kay Boyle, newly settled in Connecticut, to consider taking over as writer or advocate for the project, unsuccessfully. Finally, in January 1961, after months of consideration, Harvard University Press rejected her eccentric and selective record of the pre-interstate I-95 corridor and it would not appear in her lifetime.[11]

Mary Squire Abbot also explored remnants of Berenice's Architectural League proposal for "Metropolis Old and New" as "Our Changing City," possibly involving Meyer Berger, the great local-color reporter for the *New York Times*, who was also an avid photographer. Berenice's Paris book projects rose and died just as quickly. Expatriate Hilaire Hiler told her of revisiting Paris, where "the Quarter is peopled with a fine collection of personal ghosts." In 1957, Kay Boyle discussed a Paris portrait book with Janet Flanner and felt that it could be "an historical document, actually, with the right people" (such as Marie Jolas or herself) "putting their hearts into it," but Harper senior editor Michael Bessie turned it down. Boyle's next suggestion, William Raney, of McGraw-Hill, made a studio visit and with genuine regret explained that the subject seemed too fragmented; moreover, an electricity title, the topic Berenice and Elizabeth had expected since the 1940s to collaborate on, was already in the pipeline with their young adult division. A

husband-and-wife team who had done previous books with them had been signed on. Berenice's unique imagery was almost beside the point.[12]

The failure of so many publishing projects mid-decade led Berenice to the unhappy conclusion that she was not a "go-getter" who could sell herself and "keep running around all the time." Though she licensed the U.S. 1 pictures to the Gamma Agency, employer of her friend Edna "Bennie" Bennett, she realized that people had begun to treat her like an old person. When publishers' young receptionists who didn't recognize her name treated her dismissively, Berenice simply stopped visiting their offices.[13]

I was never sorry I moved here. Never. —BA[14]

BERENICE SAID MORE than once that discovering Maine had been "almost like seeing home." Midcentury Maine evoked the streets and buildings of Berenice's Ohio childhood without that state's depressing family entanglements, demands, and memories. Her awareness of the state likely began in her early Greenwich Village days with the freedom-loving Millays, the first Maine natives she knew. Perhaps Berenice was also aware that while she was in the south of France in the summer of 1921, Kenneth Burke had lived briefly in Monson, Maine, visited by their mutual friends the Matthew Josephsons. And Berenice's long-ago Paris dance critic, the lumber-fortune heir Waldo Peirce, had returned to Maine, where he was happily raising a family in Bangor. Another precedent, which Berenice thought crazy at the time, was the 1939 relocation of her friend Chenoweth Hall to the family home of her partner, Miriam Colwell, in coastal Prospect Harbor; working as the town's co-postmistresses, they continued to make art and to write.[15]

After years of vacationing on Long Island's South Shore, which Elizabeth loved, it was the north inland that captivated Berenice, following financial reversals in 1945 that quashed the couple's plan to buy a New Hampshire farm. At times she wondered what on earth she was doing in Maine. But being there made her feel happier, an effect she partly

attributed to the physical and aesthetic sensations of the clean, clear air. One whiff could bring her "back to life." Ever the photographic technologist, Berenice had also noticed how very black the shadows were in upland Maine with no polluting particles to diffuse or reflect light. "Straight photography is a clean breath of fresh air," she had written, in *Guide to Better Photography*.[16]

During her U.S. 1 trip, Berenice again visited Margaret Bennett, a woman she considered the most "New Englandish" of anyone she knew. Bennett told her about an abandoned hundred-year-old inn in Blanchard, Maine, sixty miles northwest of Bangor, near Moosehead Lake in the Highlands, the state's year-round inland vacation destination. She had considered buying it, but soon spent a small inheritance on other things. Seeing Bennett's slide of the rundown building, Berenice loved its dilapidation and said *she'd* buy it, sight unseen, for the asking price of $400, if Margaret thought that an outsider would be welcome. By the time Margaret got around to asking a local cousin of hers the question Berenice had put to her, the property was gone, bought by a Massachusetts man, and Berenice forgot about it.[17]

That purchaser got back in touch, offering it for $600. Berenice convinced Bennett, who rarely went to Maine in the winter, to drive her up between semesters. They made the trip in February 1956, and Berenice jumped on the sale because "it was so cheap . . . even I can afford that." Moreover, the little hamlet of Blanchard was within the larger town of Abbot, further capturing Berenice's imagination. Elizabeth would later tease about "Miss Abbot [*sic*] . . . in . . . Abbot Village Maine."[18]

The weathered clapboard inn, situated on less than an acre of land along the Piscataquis River, had fourteen rooms and gingerbread trim. Henry David Thoreau had traversed the area in the 1850s and written about the "fork in the road between Abbot and Monson about twenty miles from Moosehead Lake," where he "saw a guide-post surmounted by a pair of moose horns, spreading four or five feet, with the word 'Monson' painted on one blade, and the name of some other town on the other"—indicating the Blanchard Road. Thoreau also noted that Maine

was then seeking to banish "bar rooms from its highways," which may have helped spur the demise of the inn. Improbably, a communist friend of Berenice's from the Photo League, Joe Reynolds, who had served as the league's darkroom manager, was a native of the area and knew the building right away. Before the house was ready to be inhabited (it remained unrenovated for the first years of Berenice's ownership), she stayed with her neighbor Flora Garon, who remained a supportive friend: She would feed her and her husband, Ernest, would win money from her at poker (20 cents was typical), though she could beat him at checkers. It was also her game with Bernard Langlais, "an old French-Canadian lumberjack and his wife," more neighbors with whom she later spent evenings.[19]

"I like it up here," said Berenice to a visitor in 1982. She found Maine "different from other states. It's poorer. . . . Vermont is too pretty, too arty, terrible, can't stand it. Here, it's more rugged and wild. New Hampshire has too much money." She would claim after moving that she was healthy because she lived "near the wilderness. 'Civilization' you can have!" In her tiny town, however, Berenice stood out as a person of some means, simply by being able to pay other people to do work that most of her neighbors had to do themselves.[20]

To welcome her friend to Maine, Chenoweth Hall approached Vincent A. Hartgen, head of the art department at the University of Maine in Orono, about an Abbott exhibition in January 1957. Hartgen proposed that it be held in the Louis Oakes Room of the library and assured Berenice that previous photography exhibitions—for Sam Falk, Aubrey Bodine, Ansel Adams, Andreas Feininger, and Alfred Eisenstaedt—had gotten good press coverage throughout northern New England. (Minor White and Clarence Laughlin shows would follow.) Berenice sent her prints at the end of December, apologizing for not having typed a list of them. "I have been involved in the mad New York rat race with pressure beyond description," she wrote, adding that she was hoping to come to Maine for the show and to "[absorb] some of your good air."[21]

Berenice Abbott's Town of Abbot inn after a decade of repair and modernization,
Blanchard, Maine, 1966. Edward Schwartz

Before buying the old inn, Berenice had noted in her journal, "Maine: Shrewd – poor or rich – soak you in summer – could have good photo school." With profit from the Atget portfolios (see chapter 20), she bought a Willys Jeep to replace the 1950 Buick she had picked up to drive back and forth to Maine, which she often did by herself in the pre–I-95 days. In June 1957 she explored the possibility of opening a photography division at the Haystack Mountain School of Crafts, in Liberty—renowned for its weaving, ceramics, wood and dimensional

design, and textile graphics—and received a warm reception from director Francis S. Merritt. The school had actually considered photography earlier and rejected it, Merritt said, while graciously welcoming Berenice's further thoughts on integrating photography into the existing program. Over the summer, Berenice had roof and chimney work done on her new home.[22]

While Berenice attended to the new property, Elizabeth suffered a protracted period of illness in New York. On one return to the city, Berenice found her partner in a diabetic coma. "Two more hours and I wouldn't be alive today," Elizabeth said. Her doctor was out of the country, and Berenice frantically arranged for a substitute. Elizabeth subsequently endured several weeklong Brooklyn hospital admissions. Her diabetes needed further regulating, which seems to have both frightened and repelled Berenice, who left. A new young doctor friend, Shirley Kaufman, helped Elizabeth obtain insulin, which was then expensive. It was only years later, after Elizabeth's death, that Berenice admitted that buying the Maine house—at a time when she also gave up heavy drinking—had enabled her to distance herself from her New York life and from Elizabeth's health troubles and financial insecurities. Leticia Kent had derided Berenice's near-nightly visits to Helen Gee's Limelight coffeehouse as some holdover Parisian fetish, but Berenice likely found its alcohol-free environment a welcome proscription. The ritual supported Berenice's slow transformation from a heavy drinker to a more moderate one.[23]

Jo Hopper, who knew the state well, endorsed Berenice's move to Maine, "the perfect place for you after the darkroom to give you new life." The Hoppers spent summers in Maine, on the coast, and Jo Hopper had posed for a portrait with Berenice's cat, Gigi. "Damned good!" Jo reported her husband exclaiming upon receiving the photos. He later showed the portraits to a handful of painters at a party, whereupon "our host leaned in and whispered to me, 'Which is the cat?' So maybe I haven't ceased to be photogenique," Jo wrote to Berenice, "when handled by a master of the art." [24]

Berenice did an hour-long portrait session in her New York studio with Djuna Barnes, photographing her repeatedly passing through the doorway next to the mural-sized *Exchange Place*—eighteen different exposures, capturing three separate entry sequences. Barnes changed outfits at least once. Many years later, she characterized the shoot as an act of spontaneity: "that little number [Berenice] was always full of tricks and one day when I went to visit her, she snapped her camera just as I walked through the door."[25]

In 1957, Berenice again lent her name in support of a national cultural effort, her first since the 1950 Stockholm Peace Appeal (see chapter 15), as a member of the National Council on the Arts and Government; she and W. Eugene Smith were the only photographers on the group's letterhead. Chaired by Lloyd Goodrich, director of the Whitney Museum of American Art, the council enlisted four hundred supporters of legislation to establish a second body, a federal-level Advisory Council on the Arts, the precursor to the National Endowment for the Arts.[26] Among the signatories to this appeal, which was submitted to Congress, were photographers Richard Avedon, Arnold Newman, and Roman Vishniac.

Thanks to Lisette Model's prodding, Berenice had a solo show at Helen Gee's Limelight over the year's-end holidays. Lisette had to overcome Berenice's reluctance to exhibit, suggesting she might "make some money." She likely meant sales of prints, but Berenice hoped that the show might generate new commissions. She declined to show her *Changing New York* photos, which she worried people might find "old hat," instead trying to "foist Route One" on Gee. Gee felt that the work was inferior, and decided that a bad review would badly affect Berenice, who struck her as somber and worn-down. To Gee, Berenice didn't fit anywhere: not in photojournalism, not working for magazines. She was someone doing her "private scientific stuff." On a studio visit, however, Berenice brought out a box of 1920s Paris portraits. Laboriously, one box at a time, "she would go into the next room, a bedroom, and get a ladder and go up into the closet and bring down a box." She also

brought out recent portraits, of servicemen from the 1940s, which Gee thought looked like "department store studio" work. But Gee had hit upon the theme for Berenice's show, *Portraits of the Twenties*. Though it was nicely reviewed in the *Times* as a surprise to those who knew only her New York work, the lack of sales was disappointing. Berenice also appeared in MoMA's holiday roundup, *70 Photographers Look at New York*, which Grace Mayer helped Steichen organize.[27]

Berenice had stopped accepting portrait work in New York. Rare exceptions included the smiling face of Leslie Katz, a Black Mountain College graduate. He later sold his father's collection of Thomas Eakins paintings to finance the Eakins Press. Katz wrote and directed experimentalist plays in a Brooklyn community center, wrote for Classic Comics, the *Nation*, and the Democratic National Committee, and was a speechwriter for Democratic presidential candidate Adlai Stevenson. He was also the publisher of *Arts* magazine in the 1950s and a long-time board member of the Yaddo artists' colony, in Saratoga Springs, New York.[28]

At *Arts*, Katz met James Mellow, then the young editorial assistant to Hilton Kramer, and arranged a meeting at Berenice's studio. As a high school student interested in photography, Mellow had discovered Berenice and Atget in her *A Guide to Better Photography*, and had even posed his grandfather in emulation of Berenice's Atget portrait. At their only meeting, she showed him her front-facing version of Atget, "the photographer, not the weary man." Mellow referred Berenice to a graphic designer friend seeking an industrial photographer for Miles Laboratories, the Elkhart, Indiana, manufacturers of Alka-Seltzer and Bactine antiseptic. Mellow's friend, surprised that Berenice was still active or even alive, gave her the job, which entailed photographing caged lab mice, among other subjects used in a promotional booklet, "Behind the Label."[29]

PSSC

Cambridge and Maine (1958-60)

It is our duty not least to help create a world in which
despair and cynicism are complemented and partly replaced,
not by optimism, but by a courage and by hope.

—J. ROBERT OPPENHEIMER[1]

After I got the science job, everything began to turn for me. —BA (1975)[2]

B y the late 1950s, science—and the scientific principles of "Obser-
vation, Evidence, the Basis for Belief," laid out by Massachusetts
Institute of Technology physicist Jerrold R. Zacharias—was
gaining a popular foothold as a rational way of viewing the world,
in contrast to the irrationality of the McCarthy era. When the Soviet
Union took the lead in the Cold War space race in October 1957, by
orbiting *Sputnik I*, Earth's first artificial satellite, fifty-nine-year-old
Berenice phoned Robert C. Cook, her longtime Washington booster.
"Maybe these birds would be interested in science now," she said.[3]

"Cookie" made some calls and in January 1958 Berenice met with
science editor Richard K. Winslow of Doubleday & Company, one of

the publishers affiliated with the Physical Science Study Committee (PSSC), a federally supported effort to modernize American science education. The PSSC's goal was to transform "the physics of pulleys and levers, refrigeration, and internal combustion engines"—practical everyday applications—into one of "waves, atomic energy levels, and the photoelectric effect": a more theoretical approach. The PSSC was administered by the President's Science Advisory Committee (PSAC), whose creation had been overseen by the head of MIT, Dr. James R. Killian Jr., President Dwight Eisenhower's Special Assistant for Science and Technology from 1957 to 1959. PSSC's members were America's top theoretical and experimental physicists, including politically progressive veterans of the Manhattan Project at Los Alamos, New Mexico; under J. Robert Oppenheimer they had been responsible for creating the first atomic bomb, in 1945. To varying degrees the PSSC team members felt that modernizing science education was their "important public duty," said Philip Morrison, Oppenheimer's principal assistant at Los Alamos, formerly on the government's blacklist, who drafted the first, thematic PSSC textbooks.[4]

At Doubleday, Berenice showed Winslow her two decades' worth of independent science photography. In turn, he sought her feedback on illustrations for the first units of PSSC curriculum materials. Accompanying artwork was being overseen by George H. Waltz Jr., an associate editor of *Popular Science* magazine. Through Waltz, Winslow put her in touch with Elbert Payson Little, the PSSC's first director, at MIT.[5]

Dr. Little, who had specialized in optics at Harvard, where he led the undergraduate photography club in the 1930s, surprised Berenice by knowing her reputation—he even knew about her nudes for the Zaidenberg drawing book. Making an appointment for February 15, Berenice traveled up to Boston just ahead of a blizzard. Next day, with Little temporarily snowed in, she fretted, in his office opposite the MIT campus at 94 Massachusetts Avenue, that he would consider her too old. Once they were face-to-face, she "talked turkey to him more than I ever talked with anybody. I never was able to sell myself but . . . this one

time! I just put it on the board . . . I thought, 'My God, he must really think you are a pretty shameless hussy.' I told him that the scientists were the <u>worst</u> photographers in the world. They needed the <u>best</u> . . . I bragged; I was ridiculous; I said, look . . . nobody else can do it. I am the only one." To her relief, Dr. Little read her 1939 science manifesto, studied her photographs, and, on the spot, offered her the job of project photographer, at an annual salary of $12,500, about $106,000 in today's dollars. Berenice asked for a week to decide and accepted; it was her first salaried position in twenty years.[6]

> Most scientists still thought you could do
>
> these things with a Brownie. —BA[7]

ALTHOUGH LITTLE WAS YOUNGER than Berenice, he became even more of a mentor and father figure than had been his contemporary, her long-time Harvard mentor I. Bernard Cohen, coincidentally the PSSC's historical consultant. Both men felt that the PSSC curriculum needed compelling, indelible images to convey principles anew and anticipate actual laboratory demonstrations. The goal was not "arty design" but "good proportion, balance, and lighting." Her images would elevate the curriculum's visual components, Cohen held, and ultimately he considered Berenice on a par with the project's Nobel Prize–winning physicists for the value of their contributions to the project.[8]

Berenice started commuting weekly between New York and Cambridge on March 1, 1958. At first, she stayed at the Hotel Continental, then with Katherine Byrne Edsall, a divorced friend of Margaret Bennett's, and finally in Somerville with Bennett, whose modest means soon tamed spendthrift Berenice into conserving her new income to fix up her Maine property. She kept her Commerce Street studio stocked and used the darkroom when in New York, leaving Elizabeth effectively tasked with fielding her business matters. (Elizabeth's diabetes sent her to the hospital every six weeks or so during the first half of this year—

mail piled up and phone calls went unanswered.) As early as possible in May, following a valedictory student exhibition, Berenice dismissed her final New School class, glad to be rid of teaching. A scramble ensued to replace her: Lisette Model, who had earlier quit over low pay, could not be wooed back, so Arnold Eagle stepped in, to be followed by newcomer Marion Palfi, whom Model respected.[9]

Over the summer, Berenice's pulmonary health continued to deteriorate, and she suffered from increasingly severe episodes of flulike symptoms. In October, she was admitted to Mount Auburn Hospital in Cambridge and given tetracycline, then a new antibiotic. She convalesced at Bennett's, where Elizabeth joined her for their first visit since Berenice's sixtieth birthday, in July. Berenice then decamped to Sally Nerber's home in nearby Weston, Massachusetts, for more rest. After a happy Thanksgiving with Joe Fulton and Elizabeth, Berenice brought her doctor more complaints and tested positive for exposure to TB, an alarming result subsequently deemed false.[10]

Long-planned organizational changes were under way at the PSSC. A newly created not-for-profit entity, Educational Services, Inc. (ESI), took over production and distribution of the envisioned curriculum materials. ESI was headed by James E. Webb, who went on to lead NASA during the Apollo program. Berenice relocated to the PSSC's spacious new headquarters in nearby Watertown, where studios and workshop spaces occupied a former Main Street supermarket she called "the plant."[11]

ESI personnel rapidly grew to about 150 staffers, consultants, and freelancers. Berenice was assigned to the Text & Laboratory Materials team under another Manhattan Project veteran, Francis L. Friedman, a mix of young postdocs, experienced teachers, and leaders in midcentury American physics research and education. The other two production teams, Studio and Films, were headed by nonscientist outliers—CBS-TV cameraman Kevin Smith and versatile journalist Stephen White, respectively. Jerrold Zacharias welcomed these men into the operation, as he did Berenice, for bringing unique skills

and strong personalities. Himself a Manhattan Project veteran, Zach-arias was really the driving force behind the PSSC curriculum. After a decade of mentoring a few top doctoral candidates at MIT's nuclear science lab, he was ready for a larger public role. He also believed that hands-on, trial-and-error classroom participation, including the false starts and mishaps that characterize the real-life pace of experimental science, was key for learning. That belief spoke directly to Berenice's early experience of drab and dull science classes at OSU.[12]

A new scientist assigned to Films was Albert V. Baez, the Redlands University, California, co-inventor of the X-ray reflection microscope and more generally known as the father of folk musicians Joan Baez and Mimi Fariña. He had phoned Berenice while she was ill in October 1958 to talk about "dreaming up visual treatments in physics." He fol-lowed up with an exuberant letter: "You know, from the minute we are born—we have to push to get out into the world (we are extruded into existence)—to the last rites when pall bearers let us down into the hole in the ground, forces are exerted on us and we exert forces throughout our lives." The PSSC goal "to show the different kinds of forces we meet in nature" and explain them "intuitively and scientifically" was, he acknowledged, "a big order."[13]

Berenice relished these collaborations; each partner, artist, and sci-entist provided crucial guidance or expertise. "I had to see that [the set-ups] were working . . . visually well, but they had to see that they were working scientifically correctly." Ever appreciative of the attention of accomplished men, she found the scientists "really living," their work both interesting and "fun." Such teamwork was a creative elixir for Ber-enice, "excitement and the way it should be," she later crowed, "art . . . united with science" to produce something meaningful to all. Echoing her sentiments from Aspen, she dismissed painters "just splashing their emotions on canvas" as "for the birds."[14]

Though Berenice was "filled with joy" to be working there, she soon "got the score" about her second-class status as a woman. She felt that the PSSC male lab assistants were treated with more respect, while

her request to upgrade the first little basement studio and amateurishly equipped darkroom was ignored as the demand of a difficult woman, a troublemaker. "Some colleagues couldn't understand," as she said, "what an old woman was doing taking pictures of their equipment" with the huge 8 × 10 camera she had brought up from New York. "They thought they could do it better themselves."[15]

The scientist responsible for the "lousy little amateur horrible snapshots" of waves that Berenice first saw in Dr. Little's office was James S. Strickland, a new young MIT PhD. She was convinced he "hated [her] guts." He became her "worst enemy," because Little (and Cohen, conspiring, she later said) had recruited and elevated *her*—"this outsider <u>and</u> a woman"—while the other PSSC females were mere editorial or clerical support staff. Berenice held that Strickland—"this little idiot"—was unaware of his "deeply rooted pure male chauvinism of the worst sort."[16] Strickland was also "very penny pinching," causing Berenice to feel constant pressure about funds despite Bert Little's assurance that she could spend what she needed. Unlike Strickland, Little was not a chauvinist; he could have "walked right over me," Berenice said, "and it would have been O.K. because that was the way [mutually respectful] people should work together."[17]

Some on the PSSC team had old-fashioned ideas about photography and didn't appreciate "an arty New York photographer," as Bernard Cohen said. When Strickland belittlingly told her to "do your arty stuff," Berenice answered, "Jim, if you knew anything about photography, you would know I'm the least arty photographer in America; I hate artiness." Strickland's mediocre photographic efforts served to reaffirm Berenice's analogy of photography to literacy: "Everybody writes, but they know they are not 'writers.' Everybody photographs, but they don't realize they are not photographers." Her first tasks at PSSC involved redoing the subjects that others had photographed unsatisfactorily.[18]

In spite of illness, commuting, and trouble with coworkers, by April 1959 Berenice miraculously managed to create many of the PSSC's signature images. These included the series on transformation of energy

and conservation of momentum: stroboscopic views of moving balls (golf balls or ball bearings) representing potential and kinetic energy, and her many water "wave" images about wave-particle duality.[19]

For *Multiple Exposure of Bouncing Golf Ball*, which introduced concepts of force and motion by showing decrease of energy in a moving object, a golf ball was rolled off a six-foot-high platform and bounced on a marble surface. Berenice was well centered and the camera was low, almost on the floor. She lit the subject from the side to enhance the ball's roundness, ensuring the presence of defining shadows in the image. Berenice felt that MIT's high-speed specialist, Harold Edgerton, was interested in showing only evidence of motion, not the physicality of moving objects. Her goal in every photograph was to reinforce the expressive roundness of the realistic, illustrative balls. To that end she used painted gray parts, not white or metallic, to reduce contrast and capture shadow gradations. To illustrate vectors and projectile motion, her new young assistant, Frank Genovese (with whom she remained friends after PSSC), made the setup to be photographed: it dropped one ball straight and sent an identical one outward at the same instant. The stroboscopic exposure illustrated their parallel descents and how they reached the ground together, a result that would occur with any two identical objects.[20]

Berenice's PSSC wave images were used to illustrate tenets of quantum mechanics for high-school comprehension. Refining techniques she'd explored much earlier, she staged at least a dozen wave photographs in ripple tanks—shallow, flat, glass-bottomed three-foot-square trays filled with water. Various objects, as required, would change the shape, direction, and intensity of waves generated by a tap on the side or a drip from above. Now, "if I got the paper far enough away from the tray the waves would focus themselves, much like a lens . . . I finally devised a system of putting a pinhole over the light source."[21]

Lighting presented a problem, and Edgerton's strobe lights were no help. Many trials led Berenice to discover that the waves would focus themselves when projected onto a white surface by means of an overhead

light through a pinhole, much like a lens. Using the point light source and moving the sensitized paper further away from the tray solved the basic problems. However, the open tank allowed dust, bubbles, and a host of other impurities that the waves magnified. Even when the water was changed often, the resulting photographs still required meticulous retouching. "Then there was the question of whether to use a positive or a negative for the illustrations," she "chose negatives because they were easier to read." Notably, she kept no records of the individual setups or the darkroom specs she used to obtain prints to her liking.[22]

Philip Morrison called Berenice's sequence of images of a spinning wrench *the* most important picture in physics. It demonstrates Newton's law of constant velocity by showing how an object's center of gravity moves at uniform speed in a straight line, even though the object itself appears, at first glance, to tumble erratically. That is, the handle and jaw rotate, while the center travels in a straight line. To create this illustrative photograph, an everyday asymmetrical object—the adjustable wrench—was painted white so its movement would show readily in the photograph. It was suspended from a length of piano wire at the point marking its center of gravity, indicated by a dark *X*. Berenice stood on a tall ladder, looking down on the horizontal wrench. The wrench, suspended from its hanging wire, was twisted around so that it would spin when released. An assistant bathed the wrench in light as it traveled without illuminating the background. The setup required many practice runs before Berenice could make the exposure. The principle bore importantly "on predicting the course of a missile," with implications for both warfare and space exploration—a key international metric through the 1960s.[23]

Publisher Angus Cameron had found her a room in the leafy Boston village of Newton Centre on the second floor of a big colonial house owned by a recent widow. She continued to see Margaret Bennett and Joe Fulton and visited New York often to see Elizabeth and use her own studio. The Atget collection was still there, along with her negatives, providing additional income for picture reproduction. Work contin-

ued on a volume that had been under way since 1956—Leonard Louis Levinson's *Wall Street: A Pictorial History*, for which she used her Rolleiflex and benighted thumb camera.[24]

Many friends stayed in touch by mail. Jo Hopper commiserated with her over "that wicked attack of pneumonia" just "when the sky opened for you—! Oh, dear, how well *je comprend*." She also reported that the potbellied cast-iron stove in the Hoppers' Washington Square North quarters was ready for its promised transfer to Berenice's home in Maine.[25]

A new publication, *Who's Who Among American Women*, included Berenice among six New School faculty members recognized. Clara Mayer arranged with Bert Little for an exhibition of Berenice's PSSC work to inaugurate the gallery space of the New School's new buildings, and launched a hoped-for ongoing institutional collaboration with MIT. The building-naming ceremony, on May 15, included a tour of Berenice's exhibition, the first to hang in the bridge connecting the Twelfth and Eleventh Street buildings, naturally lighted from a glass wall to the west. The chief architect of the new buildings was Berenice's friend William J. Conklin, best known for codesigning the planned community of Reston, Virginia. Berenice felt he'd designed the best show she'd ever had.[26]

Up to the last minute, Mayer had implored Berenice to proofread the label captions for the show's twenty-seven prints, probably written by Little. They were edited for nonscientists, possibly by Elizabeth, in more general language for the public, but at PSSC there was concern that outside the classroom the photographs' scientific meaning was being deemphasized. The exhibition panel included a quote attributed, by whom it wasn't clear, to Pythagoras: "Order marks the works of Divinity." (It's hard to imagine Berenice accepting reference to any god.) The unsigned panel continues, noting that "Pythagoras" used the maxim to "convey the perennial wonder of those to whom it is given to observe the harmonious perfection of natural laws. Thus the universe becomes a masterpiece transcending mortal dreams."[27]

Helen Gee hosted the after-party at the Limelight. Unknown to Berenice, Mayer had arranged a two-page article in the Sunday *New York Times Magazine*. The unsigned text echoed Baez's sentiment: "Man lives and moves at every moment amid forces that are both subtle and gross . . . to study these forces he often has difficulty visualizing their effects." The paper's arts section asserted that Berenice's ingenuity and skill made the subject of physics interesting and clear even for the layman.[28]

Berenice had her Maine house painted red that summer and installed a bathroom and an oil furnace. At PSSC, seventeen-year-old college student Ben Fairbank signed on temporarily as a darkroom and background setup person. They began by working on the *Train* photograph (also known as *Multiple Exposure Showing the Path of a Steel Ball Ejected Vertically from a Moving Object*), which took well over a week to execute. Nathaniel C. Burwash, a sculptor who, along with his wife, Ida, became Berenice's friends, ran the workshop that fabricated her apparatus. Borrowing a toy train from Bert Little's children, he and Fairbank painted the ball and wheels white and built the setup; the ball was to first bounce 20 inches high. Berenice exposed the train at rest and then let it roll down the track; as the ball was ejected she opened the shutter, closing it after several bounces when she felt the composition worked.[29]

Finally, Berenice "got two good exposures and was glad to be through with it. Develop them," she ordered Fairbank, handing him the sheet film carriers with the exposed negatives. (The fast film she used for PSSC photographs to compensate for low illumination, Royal-X Pan, had "an awful lot of funny spots on it" due to inconsistent grain.) Fairbank was experienced with prints but he had never before developed sheet film negatives. When the slimy materials stuck together, he pried them apart with his pocketknife and heard a noise like tearing canvas. Berenice heard it as well, and was utterly relieved that the negatives were not ruined.[30]

Freelance publicist Harriet H. Gibney was hired by ESI to help handle the growing interest in Berenice's photographs; the office team seemed

oblivious that it was their compelling appearance, their visual impact, as much as the physics they portrayed, that mattered. Gibney complained of "writing about Berenice all day" and, lacking experience with image-licensing practice, managed to offend Berenice's long-suffering Gamma Agency by dealing directly with its clients. ESI's initial reproduction fee was $25 per picture; that was updated to "free"—that is, not Berenice's to license at all.[31]

Far from science, Janet Flanner's "Letter from Paris" in the *New Yorker* reported on the many 1920s portraits by Berenice, drawn from Sylvia Beach's archives, in an exhibition in the French capital held at the new US Information Service's American Cultural Center. The exhibition came to New York's Gotham Book Mart. Berenice was deeply moved at the opening party, as she told the poet Marianne Moore, whom she met there and described as looking "like a 'lovely, little cloud.'"[32]

"I was very serious about wanting to photograph you," Berenice wrote in a note to Moore. At year's end, she used three rolls of film in her Rolleiflex to photograph a very self-conscious Moore in her Brooklyn home, and feared even those weren't enough. For a year, she told Moore not to despair of ever seeing any prints. "First attend to the science work," Moore soothed, asking if Berenice would make her look like the published PSSC "trajectories."[33]

Poor health continued to plague Berenice. Ineffective cycles of various antibiotics led to a general feeling of hopelessness, while her doctor performed at least two invasive and painful bronchoscopies. Daily, Berenice downed diluted vinegar, a tonic she had found in a modern book of folk remedies. Margaret Bourke-White's recent diagnosis of Parkinson's disease, a sure death sentence, weighed on her. Later that summer when asked about a big Atget show, sixty-one-year-old Berenice had snapped, "<u>No.</u>" What Berenice really wanted, it was thought, was a "big <u>Abbott</u> show . . . while she lives."[34]

That insight came from Irene Shwachman, a new friend and the wife of a prominent Boston pediatrician who had aspired to be a photographer since childhood. In 1959, with her three children nearly grown, the

Barnard College graduate was seeking to reapply her artistic voice when she saw Berenice's *New York Times* spread. Irene invited her to visit their nearby Newton Centre lakeside house, where Berenice arrived "walking through the garden, like a figure rising out of the lake" in a brown "taffeta afternoon dress, crystal necklace, slender gold bracelet [a partial payment for product photographs for jeweler Phyllis Sklar], brown chiffon scarf, [and] brown Scandinavian wool jacket."[35]

Berenice seemed slightly confused and unsteady, and as they moved indoors, she briefly discussed her health with Irene's husband, Dr. Harry Shwachman. A graduate of MIT and Johns Hopkins, he headed the cystic fibrosis center at Boston's Children's Hospital. Shwachman diagnosed bronchiectasis. During Berenice's two-hour visit, all three Shwachman children listened as she patiently explained the PSSC photographs in the *Times*. Later, when she knew the family better, she analyzed their signs of the zodiac and read their horoscopes. They soon took to calling her Grandma Abby, and she taught them to drive her stick-shift jeep when they were ready to get their licenses.[36]

For almost fifteen years, Irene kept a detailed log of Berenice's activities and thoughts, as if by studying this remarkable, self-contained artist, she could break the code and become one herself. She assisted Berenice with photography, typed her letters and manuscripts, and encouraged a businesslike approach to her affairs, including the Atget collection. It tired Berenice to reciprocate with career advice and print critiques, while Irene found Berenice's disregard of social convention disorienting: During Irene's first visit to Berenice's rented room, the freezing, feverish hostess crawled under blankets on her bed to keep warm. Contrasts between the two often caused misunderstanding and unhappiness. But early on, Berenice kindly advised Irene to keep photographing, if only just for herself.[37]

Six weeks after their first meeting, Harry Shwachman became Berenice's doctor; she was his *only* adult patient. He advised her former physician that she has "many of the characteristics of our artistic individuals. In spite of her deep interest in science, she still has a number of

hocus-pocus ideas and a great deal of skepticism about the science of medicine. . . . It will be a difficult job to manage her complicated pulmonary problem but I am prepared to do this." Though Elizabeth had long forbade smoking in their common areas at Commerce Street, Berenice finally quit her four-decades habit that summer, as a condition of her treatment.[38]

That fall at PSSC, twenty-seven-year-old George Cope, described by Irene as serious, intelligent, and quiet, joined the Watertown staff as a workshop assistant. Berenice had interviewed at length a "girl from Polaroid," and railed helplessly against the nepotism of Cope's appointment: He was a relative by marriage of her nemesis, Strickland. While Berenice trained Cope in the PSSC darkroom, fastidious Irene was barred from assisting. In August she had found the place "dirty & disorganized," with New School exhibition prints helter-skelter on any available flat surfaces and new prints drying on the floor. Berenice generously took Cope to the opening of the Hopper exhibition at the Currier Museum in Manchester, where Jo and Edward happily introduced Berenice to everyone.[39]

Cope's first job was to prepare to photograph a rolling disk with lights, the "cycloid." Two exposures were required for detail, as the lights, moving at different speeds, had different densities, a problem Berenice solved with cellophane filters. In one more nourishing interaction with scientists, the legendary mathematician and philosopher Norbert Wiener, originator of cybernetics (the study of scientific control and communication), told Berenice that "it was not a perfect cycloid because the light was not exactly at the edge"; she countered that it had been impossible for her to execute a photographable model any other way. Other assignments included photographing a modern lab at MIT, to contrast with that used by the nineteenth-century physics pioneer Michael Faraday; a giant crystal at the Peabody; and an outdoor steel tower to illustrate parallax. Resenting Strickland's direction, Berenice balked at his choice of the two-year-old WBZ-TV tower in Needham, but did not provide a substitute.[40]

When, in 1958, word had gotten out that Berenice was coming to Boston, Walter Muir Whitehill, director of the Boston Athenæum, welcomed her with a note inquiring about her 1930s Boston photographs, which he subsequently acquired as prints for the modern collection at $3 each. Someone at PSSC later spotted their mention in an "expensive Boston book"—Whitehill's 1959 *Boston: A Topographical History*—adding to the arty mystery of their project photographer. But it was another fifteen months before Berenice joined the contemporary Boston photography community. Gallerist Carl Siembab, whose questions about the 1955 Atget exhibition in Cambridge had been deftly dodged by Berenice, was shepherding a photographers' collaborative on fashionable Newberry Street; it included Irene, but Berenice thought him an ignorant brainpicker.[41]

"Sorry to hear that photography is not rampant in Boston," Grace Mayer wrote from MoMA, where she had become a personal assistant to Edward Steichen, "it always was a backward city!" Berenice predicted, and Harry Shwachman concurred, that Irene would be pushed out of Siembab's as she herself had been from Julien Levy's decades earlier. Among Boston photographers, Berenice felt slighted—"boycotted," she said—by Minor White and the *Aperture* group, and agreed to exhibit at Siembab's. Preceding hers was a show by Aaron Siskind; the old Photo Leaguer had greeted her with noisy affection at the only gallery membership meeting she deigned to attend. When Siskind mentioned Ansel Adams's rich wife, Berenice said, "Too bad we have to earn our own money."[42]

In late September, Irene drove Berenice to New York to meet Lisette Model, who was solicitous of Berenice and her welfare. Berenice seemed uneasy, anxious to get to Commerce Street and Elizabeth, yet the three women ran errands and passed by Commerce Street on the way to the Limelight. In the gallery, they found Gee's reliable helper, editor and photographer Lew Parella, installing a show, badly: fuzzy *Images of Love*. Asked to name an image of love, Berenice offered French filmmaker Albert Lamorisse's short, *White Mane*, which preceded his popular *Red Balloon* (1956)—both films about children that speak to adult

audiences as well. The painter Evsa Model, Lisette's husband, arrived when Berenice left, and together the Models and Irene all agreed about Berenice's innate seriousness and lack of humor, plus the tremendous pressure exerted by Elizabeth.[43]

The next day Irene, "boiling over" from her dispiriting meeting with Grace Mayer at MoMA that morning, visited Berenice and Elizabeth. Barred from Berenice's studio, she spied the enormous 1934 exhibition print of *Exchange Place* inside. Elizabeth sat immobile before a Parcheesi game: "Short, fat, close cropped reddish hair, round face—pathological looking." But when she finally "rose to shake hands she was chatty and friendly" and genuinely amused at Irene's anger. They had lunch at a favorite restaurant, Chez Vous, on Carmine Street, where Elizabeth spoke knowledgeably about Boston galleries, while Berenice, as usual around Elizabeth, sat silently, "like a mouse." Berenice's "fine mind," friends agreed, was not equal to Elizabeth's educated erudition, which Berenice enjoyed deflating; once, when Elizabeth quoted Cicero in Latin, Berenice only half teasing her, asked "Who's Cicero; was that a photographer?"[44]

Back at Commerce Street to select prints for Berenice's upcoming Siembab show, Elizabeth "changed into jeans and jersey, came in for a word, and then fell asleep on her bed. We went over pictures, with all doors open!" a startled Irene observed, her exacting sense of domestic propriety genuinely shocked by the couple's relaxed intimacy. Poring over photographs and making selections was "hot, grimy, wearing work," but Berenice declined Irene's invitation to rest at her family's Park Avenue apartment, for there was in fact a "place to lie down"— with Elizabeth. Berenice and Elizabeth met Irene at the curb the following day. The couple kissed good-bye and talked about not writing letters because of Elizabeth's writing obligations. On the drive back to Boston, Berenice chatted "about Buckminster Fuller, her camera, the movie business . . . the changing city, her enormous desire to photograph." She "seemed rested, eager, talked a mile a minute . . . almost high—what had happened?" Irene wondered at the transformation. "[W]as she just thrilled to get away?"[45]

During the Siembab show that October, Berenice appeared on an evening broadcast on Boston University radio station WBUR; in her journal the next day, she wrote: "The Art of Photography consists of probing a subject with an all-embracing eye while avoiding all self-consciousness of A-R-T." A local photographer, Nicholas Dean, flatfootedly reviewed her show for the *Boston Herald*, predictably comparing Berenice to Atget while strangely lauding "the Man Ray tradition" of her Super-Sight *Half-Apple*, Irene's selection as the Siembab show's signature image. In the *Christian Science Monitor*, a critic friend of Elizabeth's, Dorothy Adlow, singled out the PSSC enlargements, which had needed Dr. Little's permission to be exhibited. They were initially priced at $150 apiece, but ESI's financial advisor, Gilbert Oakley Jr., decided that no PSSC images would be for sale for now.[46]

By this time, word was circulating that with the textbook's publication in June 1960, PSSC would disband. Berenice was discouraged from thinking about additional images for future books, as there were still unused ones in the files. She nonetheless approached Harold Edgerton "for a new point source light, a minute one" when he appeared at the MIT faculty lounge, where Albert Baez was helping her select PSSC photographs for a mid-November exhibition there. Publicist Harriet Gibney thought that the PSSC photographs should be shown away from science venues to attract new audiences.[47]

During the installation, Berenice became spellbound by Norbert Wiener, who "talked on like the rolling light—illuminating more and more my abject ignorance. He was also 'photogenic'—which merely means that he was alive—human—warm and simple," she wrote to Irene. "So I have a new project—to photograph him and some of these physicists who are floating around or bobbing about in the midst of our televised human sea. I feel like having my ignorance appreciated for its subterranean and rebelling effect. Zacharias came in later and was very funny and cute too." He might have told Berenice his often repeated definition of physics research—"like chemistry, but it doesn't smell as bad."[48]

Earlier, young Julia Newman (later Scully, a future *Modern Photogra-*

Berenice Abbott With Exhibit of Her Scientific Pictures, MIT Faculty Club,
Cambridge, Massachusetts, in Christian Science Monitor, *Friday, December 18,*
1959. Lyman W. Fisher

phy editor) had flown up to Cambridge to select pictures for a *U.S. Camera* piece when Gibney was too flustered to help. Gibney also complained about the "overworked" ESI staff's effort on the "lengthy and difficult job" of "captioning these pictures, so that they can be properly understood by the layman." Newman looked through Berenice's own "crop file" but found Berenice herself gruff and uncommunicative. George Waltz also assured Gibney that a piece would run in *Popular Science*.[49]

Gibney had devised a standard reply to public inquiries: PSSC prints were "not available for individual purchase except for publication in appropriate magazines and textbooks." Berenice argued that her PSSC photographs were intended as textbook illustrations and must not be presented as meaningless designs.[50]

The week before Thanksgiving, Berenice's old friend Ed Schwartz and his third wife, Pearl, came up from New York to see Berenice's concurrent exhibitions and buy one of the 1956 Atget portfolios (see chapter 20) that, with Irene's help, were on offer again. Ed had reunited with Berenice three years earlier during her Atget show at the Limelight, in December 1956. He remained a staunch CPUSA member—photographing the Rosenberg boys for a clemency flyer and the parents, Julius and Ethel, in their coffins following their execution for conspiracy in 1953. He spent the rest of his working life in architectural engineering and remained on prickly but admiring terms with Berenice until her death. Elizabeth joined Berenice for Thanksgiving eve with the Shwachmans; the next day Berenice drove the children around in her jeep—she had just obtained a new license after failing two tests to reinstate the one she let lapse—while their mother took Elizabeth to see Berenice's shows. Next weekend Berenice went to Maine by herself.[51]

By early January 1960 most of the PSSC photographs were done, each different in its own peculiar way. For *Parabolic Mirror*, Berenice arranged small flat mirrors on a concave surface so that the rays of light reflected from an object in front of the apparatus (a cropped photo of a woman's eye—Muriel Rukeyser's left eye; see chapter 22) fall in each mirror, and then focus to the same point (the camera).[52]

Multiple Beams of Light (Light Through a Prism), *Cambridge, Massachusetts, 1960.* Berenice Abbott

Her long interest in the use of prisms in photography stood her in good stead for *Multiple Beams of Light*, one of the last PSSC photographs. The prism for this image was a specially built, sturdy trapezoidal box of clear plastic, filled with water to minimize "little blobs and lights which would distract and be ugly." Depending on the angle of incidence, beams of light shining through slits in an assembly below the prism are reflected or refracted by the box's plastic walls. Typically, Berenice managed to involve "nearly the whole place" to execute it.[53]

With *Candle* (anywhere the viewer moves, the candle lines up with the candle in back of the mirror), she touched on her old electricity project, in which she had hoped to include Michael Faraday, inventor of the generator and the electric motor. "If you can understand what makes a candle burn," she paraphrased him, "you can understand the universe."[54]

In Boston, through Leticia Kent, Berenice made new lifelong friends: Sue Buckingham, a medical researcher with a Johns Hopkins fellowship, and Mignon Shepard, an aspiring if directionless writer on whom Berenice soon developed a minor crush. In a pinch, Margaret Bennett provided access to her old Elwood enlarger at Harvard, but Berenice also relied on other new friends, the photographic team of Louise Young and her partner, Jean Squittieri. In business for a dozen years, their Duette Photography, on Joy Street in Boston (and later in the suburb of Arlington), provided darkroom facilities when Berenice could not get to her own New York studio. She already had to sneak around to use the Watertown studio for finishing up portrait work, dodging Strickland, who had criticized her for having female friends visit the lab and eventually forbade her to work nights and weekends there. Irene offered her own darkroom, only to get into a name-calling exchange; her experience with Berenice's utter lack of social grace seems typical, though only she recorded the instances with such specificity. Early in their friendship, Berenice had asked Irene what she thought she would be like, based on her work. "Harsh, aggressive, domineering, terrifying," Irene said. Berenice replied that she considered herself a softy and expected to be terrified of Irene but had been proven wrong.

Berenice had also begun to consider renting a studio in the area with a younger assistant or partner. Jean and Louise had pointed out a vacant storefront among the new technical industries popping up on Route 128. Quick, impatient, and not used to meticulous if repetitive work, Louise Young did not aspire to be a photographer, while US Army–trained Squittieri relished the darkroom routine. Under Berenice's supervision, the two produced Atget prints for exhibition and more portfolios, and were paid in-kind.[55]

The lesbian-couples culture so familiar to Berenice in New York suited her in Boston. There, and later at Jean and Louise's Arlington home, there might be dancing on the weekends. Chenoweth Hall and Miriam Colwell occasionally joined them, coming down from Prospect

Harbor. Elizabeth had received a grant to continue work on Hartley, and Berenice felt that she had a secure future, too: "thrilled to death that she can work the way she does at her age," Irene reported. Within months, however, Berenice was again worried about Elizabeth being alone in New York.[56]

At PSSC's request, she made large prints in New York to send to ESI's Washington, DC, headquarters for display, and tried (and failed) to figure out how to bring her big studio enlarger up to Watertown in the jeep; PSSC would not invest in one. George Cope became so excited about the challenges of the PSSC photographs that he wanted to do original photography himself. As he and Berenice worked less and less as a team, he brought in his own new 8 × 10 Deardorff camera to photograph other assignments, but she kept him busy mounting the prints demanded "by Washington." By March, he was assisting again for images that needed reprinting or rephotographing, such as one of a beam of light in a blacked-out studio.

When Strickland's involvement led Berenice to believe that the film-strip division (another small subdivision of the Text & Laboratory Materials section) was taking over responsibility for her painstakingly executed wave pictures, she feigned inability to recall her procedures, saying that she had not kept technical records. She tried her hand at color when Strickland requested shots of a number of items, such as lights, that the publisher then wanted included in color, for which she decided to use 4 × 5 Ektachrome with outside processing. Meanwhile, she was "thrilled" by a small, "beautiful" show of her photos at the new Watertown public library.[57]

With PSSC deadlines looming in late January 1960, Berenice still accepted portrait assignments and kept trying to promote her inventions. To photograph Norbert Wiener, she hauled her 8 × 10 and two lights for an early-morning unassisted shoot at his home in Belmont. Exhausted, she left work early the next day to read his autobiography, *Ex-Prodigy*, annotating as she read. Ever-helpful, Irene arranged a sixtieth birthday portrait shoot of a family friend, Boston hematologist Wil-

liam Dameshek. The $300 job took two sittings and involved unhappy haggling. Berenice used Duette to fulfill Dameshek's second print order, despite her constant disappointment that no one was ever as meticulous as she, nor as willing to ploddingly accomplish the job. When Dameshek later ordered one hundred ordinary glossies, Berenice simply printed them herself, at $2.50 each, with Irene on the production line. Unaccustomed to dull, repetitive work, Irene faltered at exposing each print via a foot-pedal light switch; Berenice finished on her own, working at the rate of fifty prints an hour. Conversely, Irene observed Berenice's meticulousness at PSSC when printing *V Trail of Light Made by a Bouncing Ball*. Irene thought that a 90-second exposure was fine, but Berenice "thought it was a trifle 'heavy,' increased the exposure imperceptibly, and decreased the development and the print was SHINING and beautiful. Anyone else would have accepted the previous one."[58]

As Irene saw it, the episode demonstrated Berenice's contradictions:

> Always patient and attentive, unless completely detached, or raving against injustices like poorly made equipment, nylons, burdensome taxes and women's lack of independence. . . . Crazy attitude toward cash and debts. . . . She reads widely, continuously, and somewhat crazily, latching onto all kinds of crackpot autobiographies and scientific tracts.[59]

The first deadline for PSSC textbook photographs was February 15, and overtime work was expected. Dr. Little told Berenice that he was not making any plans for himself for the near term, leading her to feel that "everything is breaking at once." They were still shooting in the second half of February—a white ball rolling down a black platform against a black background, requiring four people: one on the camera, one to set the ball rolling, two to light it. Meanwhile, plans continued for a traveling show of Berenice's PSSC work, for which she examined new packing cases. Elizabeth's art history friend, Currier Gallery director Charles Buckley, wanted his second Abbott show there, in April—of

her science photographs; she managed to push it back to the fall. Artist Yonny Segel, a former New School instructor then at Bronx Community College, also sought to host an exhibition of her PSSC work, *Portraits from Physics*, but the project was unrealized. The United States Information Agency was interested in an international exhibition with text by Berenice based on her 1939 manifesto, but requested only twenty-five small photomechanical reproductions.[60]

She was to learn by mid-March if her PSSC job would continue, but the date came and went; by April 6, only one more photograph remained to be done. Everyone was anxious about the future, which depended on funding. Whatever happened with her job, Berenice intended to take away complete sets of exhibition and contact prints. For the laboratory manual, she continued to photograph instruments and apparatus, sometimes from high on a ladder. At the end of April, buoyed by a good horoscope, she shopped for new summer clothes at Best & Company. In mid-May, rumors flew about PSSC funding for six more months; Dr. Little even said that there was enough for a year. On the nineteenth, however, he announced that only a skeleton staff would remain at ESI; Berenice's job was ending, though there might be occasional days of consulting.[61]

When my job ended I was almost suicidal.

I was just heartbroken. —BA[62]

BERENICE LEFT AS PLANNED for a week in New York, where she kept the grim news to herself. She hoped to see Dick Winslow at Doubleday about the book of PSSC photographs he had invited her to consider after raving about them during the New School show, and she wanted to pursue other book ideas, including some with Dr. Little. She did briefly work with him on a portfolio-type publication, but none of these projects went further than very rough ideas. Returning to PSSC, she was dismayed to learn that George Cope was being retained because he was also useful in the shop. She would be paid through September, with

PSCC. Physics *(Boston: Heath 1960). Decorated cloth binding.*

a month's vacation in July. There were still new photographs and large prints to be made.

Her first evening back, Berenice had a complete emotional breakdown while driving to dinner with the Shwachmans and wept inconsolably in their car. Unable to face dining in public, she asked that they sit by Hammond Pond in Newton for a long while. Eventually they bought sandwiches from Howard Johnson.[63]

It was clear that the PSSC photographs had taken on a life of their own beyond their role in the curriculum. Berenice expected that the rights to them, except for reproduction in textbooks, would be hers. The first spin-off books in Doubleday's Science Study Series failed to credit her photos, a slight she attributed to ESI staffer Bruce F. Kingsbury, who had constantly objected to her photo studio costs. Jealousy lingered about her high public profile. Irene sympathized with her, saying that "only Little and Zacharias are big enough to accept this, and be glad about it."[64]

With the textbook manuscript complete, Gibney turned over to Berenice a thick file of ESI materials to use as a source of potential business contacts; Little planned to publicize her work privately among scientists and manufacturers; and Zacharias encouraged her to find more portrait work in the scientific community. While Berenice went to Maine for her mandated July vacation, Webb's staff cleaned out ESI's stash of large prints for more office displays in Washington. Back in April, Berenice had vowed to leave in possession of a complete set of contact prints of her images and another of exhibition enlargements. In August, she rushed to build up three new complete sets of PSSC enlargements for ESI's files, plus her own complete set, as well as prints for the Currier show. The last PSCC work in September, her final month, involved photographing equipment such as the ripple tank for the lab book.[65]

When the textbook was finally published, Berenice was appalled by the reproduction quality, layout, and scale of her images. "I really had to laugh," she said. "It wasn't even painful; it was just so bad . . . after all that work, who could care less?" Berenice told Baez that her pictures were unrecognizable; she even found fault with the bouncing-ball cover image. Credit for the book's photographs—to her and Strickland, and half a dozen other cameramen—was buried deep in the long acknowledgments at the book's end. Used to working collaboratively from their Los Alamos days, the scientists had a culture of shared credit; as with the WPA, solitary artist Berenice could not accept being one on a team of many.[66]

September 30 was her last day. A month later, visiting the Watertown "plant," she was stunned to find George Cope at work there on new photographs. She forever blamed Strickland for encouraging Cope to "connive to get my job," a machination she had been "too dumb . . . too naive" to see.[67]

ELIZABETH

New York and Maine (1945-65)

You can't help knowing you are the only
critic around the artists respect.
—RUTH GREEN HARRIS[1]

Elizabeth should have stayed in Springfield—we
were two separate people. —BA (1965)[2]

In May 1945, Hudson Walker had hastily organized a public dinner at the Village's Hotel Brevoort to honor forty-six-year-old Elizabeth. Despite the short notice, nearly one hundred guests—curators, publishers, writers, collectors, and artists—paid tribute. Whitney Museum director Juliana Force said she "admired [Elizabeth's] honesty" and her "capacity for cocktails," for she could not be bought, "not even by ten cocktails!" (Later recounting the evening, the honoree insisted that she had skipped predinner drinks.) Elizabeth closed the evening "especially happy," she said, because her many friendships with artists and curators grew from their work. "Then I came to know and value and love its

makers, in their own right as human beings." ACA director Herman Baron called it "a very rare and warm occasion" in the art world.[3]

Elizabeth and Berenice's relationship was somewhat novel—a collaborative symbiosis, both as life partners and coworkers. Those who knew them assumed that Berenice spoke up to Elizabeth only "if she could get a word in edgewise," but it was Berenice's nonchalance and independence that kept Elizabeth emotionally in thrall. Meeting them the first time, Ruth Bernhard had expected a cosmopolitan couple who knew everyone in the photo world and beyond, and found only homebodies with house cats. Ralph Steiner met Berenice "at parties" where she seemed "kind of shy" but also "looked sort of forbidding, and that lady who dressed mannishly [Elizabeth] was always sort of guarding her."[4]

Berenice's assistant in 1946, Ed Schwartz, described them behaving "like wildcats" when Elizabeth would stop in the studio at the end of a workday only to be greeted by a snarled "Don't bother me!" from Berenice. Elizabeth would then whimper "like an injured kitten, MEE-MEE, MEEMEE!" (Berenice was nicknamed "MiMi," while Elizabeth was "Mickey.") Schwartz had heard Elizabeth's "robust proud presentations at the Photo League," but in this intimate setting, "Berenice reacted like a cat under attack, arched back, giving off a hiss and tail straight up ready to spring." He thought Berenice "must have been embarrassed, but she calmly said [of Elizabeth], 'She doesn't take her medicine!' "[5]

Elizabeth's good fortune meanwhile continued: In the years since the WPA and *Changing New York*, she finished her work on the tragic American painter Alfred H. Maurer, begun on her wartime Guggenheim; completed a monograph on landscapist George Inness (1946); edited a survey, *Work for Artists* (1947); authored *Art Professions in the United States* (1950); launched her American art survey *American Processional, 1492–1900* (1950), for the Corcoran Gallery of Art in Washington; and began her Marsden Hartley research. Berenice and their high-school art teacher friend Ruth Lindsay both lent artwork to Elizabeth's big 1949

Maurer retrospective, a detail that *New York Times* reviewer and New School art department head Howard Devree made a point to note.[6]

Throughout the early 1950s, Berenice grew more distant from Elizabeth. She felt increasing guilt, but no constraint against drifting away. Elizabeth had worn herself out working sixteen-hour days in Washington, DC, with a dozen young art historians to complete the *American Processional* exhibition at the Corcoran as well as its catalog for the National Capital Sesquicentennial Commission. Berenice felt that the project took an enormous personal toll on Elizabeth, who was already in poor physical condition—overweight and nonathletic. Elizabeth's ill-health was exacerbated by her perfectionism, evidenced once more by *American Processional*'s meticulous but exhausting citations and baroque text. Elizabeth's upbeat paragraph to young *Processional* project friends in summer 1951 was nonetheless charmingly typical: "I don't know what Berenice told you. But whatever it was, was probably nuts. The only thing wrong with me is over-weight, age (52), long drawn-out menopause, blood pressure a little too high (160 over 90), myopia and astigmatism, a hole in my right patella, some arthritis of the joints, a neurotic personality, and an occlusion which does not please me. Otherwise, I am fine. All I need is a couple of years rest and a million dollars."[7]

By the spring of 1953, however, Elizabeth, ailing from the onset of diabetes, was saying that her will to live was at a very low ebb, saved only by working on Hartley. Less than a year later, she was required to regularly inject insulin, in her thighs, and by January she felt in no condition to travel with Berenice to visit Margaret Bennett in central Maine, where Hartley had worked in the 1930s and 1940s. Elizabeth hated physical inconvenience and the absence of modernity, conditions that fairly defined such a wintry wilderness car trip. Although Berenice went no further north than Mount Katahdin, Elizabeth called it "the Canadian border."[8]

Berenice had partly justified the occasions when she left town in the late 1940s and early 1950s as affording Elizabeth a chance to focus on her own work—the two women readily accepted such separations as a nec-

essary by-product of their independent ambitions and work ethic. Elizabeth lacked funds to travel on her own. While Berenice traversed U.S. 1 in 1954, Elizabeth, home alone, had attacked Berenice's office and studio and recategorized files, melodramatically likening the tidying effort to "a lifework almost as appalling in its extent" as her Hartley opus. She was also cat-sitting (as she would for the next ten years) for "mother" Berenice's "planned" cat, the sixteen-month-old Gigi—borrowing Berenice's own parody of the birth control term. When Berenice arrived back early on Commerce Street, Elizabeth went "crazy because" she wasn't finished with her reorganization work, and instead offloaded her anxiety by writing to three different friends on September 9: "Gigi's eyebrows are per[purr]ennially raised." Regardless, by decade's end Berenice's archive had reverted to its former "helter-skelter" state. For good or ill, Elizabeth never got to Berenice's darkroom.[9]

Before acquiring her Maine property, Berenice often came to the Limelight early in the evening to huddle with Lisette at a little table. Helen Gee believed that the two were commiserating about their partners—Lisette lamenting the fact that her husband, Evsa, had a roving eye (he had pursued Gee), and Berenice discussing "separating from Elizabeth." Her constant hunt for new projects and landscapes outside New York advanced without Elizabeth's participation.[10]

To Irene, a straight woman, Berenice once explained that she had never been unfaithful while still sharing intimacies with Elizabeth and considered such behavior unacceptable. She further discussed the privacy that she and her female-couple friends, such as Margaret Anderson and her serial companions, "practiced when with each other—opportunities to be alone rather than with each other" as constant companions. In other words, breathing room. Since 1956, Berenice had spent spare time and money on her Maine property, a tacit manifestation of her growing ambivalence, yet inclusion of Elizabeth-related news when writing to mutual acquaintances was also typical, such as when the Newhalls in Rochester learned, in summer 1957, that Elizabeth, who had been hospitalized again, was in "fair" condition, and

that Berenice had no idea of her release date. Since she was stuck in the city indefinitely, Berenice taught her first and only summer class (Basic Workshop) at the New School.[11]

> A woman is like a sponge. She soaks up everything
> around her. Until you do what you want to do
> you do not know your own identity. —BA[12]

FOR BERENICE'S SIXTY-FIRST birthday, in July 1959, she and a well-rested Elizabeth got together in a New Haven, Connecticut, hotel; Berenice's landlady forbade overnight guests, and Elizabeth was again researching Marsden Hartley at Yale. Occupied intellectually by PSSC, and reserving her money for expenses in Maine, Berenice had slowed her consumption of alcohol even further, but Elizabeth, with little professional success in the eight years after her blazing activities early in the decade, had threatened to resume drinking upon turning sixty in April 1959—deadly in her diabetic condition.[13]

Berenice poured every spare dollar—about $11,000—into fixing up her Maine house and expanding the property, but she did not yet have a telephone. "Hi – Ho – Rome was never like this – nor N.Y. nor Boston," she crowed. Holger Cahill's death, at age sixty-seven, crashed any hope that he would resolve the issue of printing her *Changing New York* negatives with the Museum of the City of New York, however, and she then sprained her back and spent the days before her sixty-second birthday in pain exacerbated by rainy weather. It was more reason for Berenice to avoid New York, as she did by continuing to live and work in Massachusetts after her PSSC role ended.[14]

She was overwhelmed by "dirty housework . . . A pile here, a pile there . . . a washer and dryer to install—a gas stove so I can <u>eat</u>. I have been <u>starving</u> – eating is such a chore." Friends noted her complete indifference to meal planning and preparation, part of her "haphazard"

care of herself. A typical lunch while driving straight through to New York from Blanchard might be cheese, crackers, and sherry at Irene's.[15]

By summer's end, Berenice's *Image of Physics* exhibition was in full preparation at the Currier Museum. With few ESI administrative staff members left and shipping cases ready, Charles Buckley collected the four crates of exhibition prints in his own car. Elizabeth was tasked with writing the label copy but found Berenice "vague, as usual" and asked Buckley to specify either "beautiful, literary, poetic remarks" or "mysterious, analytical, scientific data." The result was a series of "free verse captions" that she termed "clear and informative but human": *A BOUNCING BALL / traces parabolas / in diminishing height / as the initial impetus decreases*. Ultimately, Elizabeth's labels were long and verbose and Berenice's thirty-two PSSC enlargements occupied a large, poorly lit room displaying silver and china objects.[16]

As early as 1959, Berenice had given friends the serious impression that she was seeking to avoid returning to New York so that she could separate from Elizabeth. She thought she could work in Irene Shwachman's barn darkroom, promote Atget, and even set up a studio business in Boston. Now, Elizabeth was neglecting herself physically, Berenice realized, and should have a nurse or constant companion. A woman came in once a week to do her typing and filing, but it was not enough. Berenice believed that if she undertook this care of Elizabeth, "she would be dragged down and destroyed with her; her work, her friends, her life, would be taken over."[17]

Yet when Elizabeth arrived in Boston on September 30, 1960, for their long-postponed photographic tour of Marsden Hartley's Maine, Berenice welcomed the two-week car trip as a diversion. It would help her put PSSC in the past, and it was a chance to reconnect. If not a romantic rekindling, there was a gentle reconciliation as their relationship resumed its affectionate tone. Newly caring for each other, they accommodated each other emotionally.[18]

They took the Great Northern Paper Company road to Mount Katah-

din, which proved too foggy to photograph. Unwilling to hike five miles to Hartley's exact vantage point, and unable to find the site of his *Backwaters Up Millinocket Way*, they headed down the coast to his studio, a chicken coop in Corea, Maine, and to Schoodic Point's massive rocks, where they found calm seas rather than the rough waves he painted. In Ellsworth, Berenice photographed the hospital building where Hartley had died and, in Vinalhaven, the view from his window at the inn, The Moors, as well as Clam Shell Alley and fish houses along the waterfront. By the shore in Camden State Park, they could not identify his Baker's Island.

Farther south, looking for Robin Hood Cove and Fox Island, they stumbled on the remote summer cottage of William and Marguerite Zorach, their longtime artist friends and Hartley's, too; the Zorachs "saved our lives," Elizabeth wrote, "by giving us lunch." Unable to identify any landmarks at Five Islands, Reid State Park, or Bay Point, Berenice photographed the summer home owned by Hartley's friend the sculptor Gaston Lachaise in the 1920s and early 1930s to have something to show for their effort. At Popham Beach she recorded Seguin Light in the far distance, before turning inland to the public library in Lewiston to photograph its early Hartley landscape painting. Heading south to Massachusetts, they traversed dirt roads in Dogtown Commons before luck and good directions took them to a fifteen-foot-high rock formation called Whale's Jaw, against which Berenice photographed Elizabeth—"5 feet, 4 inches high in low heels"—for scale.[19]

"Few people after thirty-five years of work in their medium have shown such a capacity for growth," Elizabeth wrote in an essay for the jazz magazine *Metronome* that fall. Noting that she had been "overcome by [Berenice's] consummate realism" in 1934, she said that she found the science photographs "amazingly and beautifully abstract, but they are the most real pictures imaginable. They look like fantasies, but actually they are visualizations of reality." Not everyone agreed or understood. When Grace Mayer sought to borrow prints for Steichen's show on abstraction, Berenice said that she had none: "I'm a realist through

and through. I don't approve of abstractions as such. I think they are a terrible bore . . . just pretentious, phony stuff."[20]

Berenice lamented her fruitless job search in New York that fall, surprised how "awful and terrifying" the city now seemed; it sent her back to New England, which, she told Muriel Rukeyser, was "easier on the psychy [*sic*]." Harriet Gibney had introduced Berenice to Olive Pierce, who became a private student. The $40/session fee got her a first lesson in Berenice's clothes closet: She sat on the floor in the dark to load exposed roll film into developing tanks. Berenice also joined Gibney and another ESI colleague, John H. Durston, in planning a public relations business serving the region's new technology companies, but it never got off the ground. She continued to pursue contacts and small jobs in New York with Grace Mayer, *Look* magazine, and Herb Snitzer, of *Metronome*. Contract Interiors, which had been trying to license *Exchange Place* for the Howard Johnson motels it was remodeling, failed to conclude an agreement, and so did Chase Manhattan Bank's proposed mural commission. Fortunately, reproduction fees from her portraits of James Joyce, Lead Belly, and others— Philippe Soupault in Matthew Josephson's *Life Among the Surrealists*, for instance—continued to help pay bills.[21]

Happily, she began a $50/day contract (grossing nearly her PSSC salary) to photograph equipment and matériel at Hanscom Air Force Base in Bedford, Massachusetts, for the Air Force Cambridge Research Laboratory Sensors Research Directorate. "Bedford" occasionally provided the kind of teamwork that Berenice had found so satisfying at ESI. She also picked up specialized assignments for consultants Arthur D. Little in Cambridge and electronics firms in Waltham, including, thrillingly, the interior of a nuclear reactor.[22]

In March, Elizabeth and Berenice saw *Gypsy* on Broadway with Ethel Merman, a performer they loved. Attracted to the concept of burlesque and striptease, Berenice never saw Gypsy Rose Lee perform, but long ago, she'd taken Djuna Barnes, then newly back in America, to Minsky's Burlesque—"to show her NY!!," Irene recorded. Louise

and Jean gave her a beloved Lili Marlene record as a birthday gift, and planned to take her to see a surprisingly tawdry show involving "a girl contortionist with dollar bills." Elizabeth and Berenice also attended Steichen's big retirement exhibition opening at the Modern, where Berenice's demeanor was "stiff and unbending" for she still considered the honoree her nemesis. But she was back in "high key" by week's end in Boston, alone, kissing and hugging everyone at Siembab's opening for photographer and Vanderbilt heir Shirley Carter Burden. She fussed over prominent local photographer John Brooks, whose work she later called "lousy" when his portrait of her "made her look fey" and ten years older.[23]

In May 1961, editor and book designer Abe Lerner held a sixty-second birthday party for Elizabeth, his longtime friend. She had injured her hand again and was now assisted by a young graduate art historian, Ilene Forsyth. After a quarter century of informal finances, Elizabeth added Berenice to her checking account and provided a life interest for her in her family's fund, the John Noble Trust. A year later, Berenice made her first will, leaving everything to Elizabeth. They were living together peacefully in New York, playing Parcheesi and shopping for clothes, but Elizabeth balked at visiting Maine: "I can't go up to that old dead place when all I love is the ocean."[24]

> [Elizabeth] should have been given a much bigger
> place, and she wasn't. It's a case of a brilliant
> woman being denied her potentiality. —BA[25]

ELIZABETH "WASN'T A GRIPER," Berenice said, though her "absolute integrity" made her exacting and unrelenting. She "was sort of argumentative," she elaborated, and wouldn't "let anybody push her around. . . . She wasn't that kind of obliging, sweet little . . . pushover. She wouldn't play somebody up big when she wouldn't think they were," and would never "write about anybody as a favor." Elizabeth, Berenice continued,

was "a complex person, contradictory . . . stubborn." Walter Rosenblum recalled that during his editorship of the Photo League's *Photo Notes*, if something was out of order in anything Elizabeth published— even a comma—"the phone rang the next day, and . . . she really gave it to you. She was hellfire."[26]

In late August 1961 Elizabeth flew to Portland to participate in a symposium on Marsden Hartley. Berenice arrived from what Elizabeth had teasingly called the "manorial splendor" of "Abbotthall," her fourteen-room mansion. Berenice thought Elizabeth "looked wonderful . . . in nice clothes" like the becoming summer dress she chose; she was the best of the presenters, said Portland Museum of Art director Donelson F. Hoopes. Afterward, Elizabeth flew right back to the stifling heat of New York, while Joe Fulton and his houseguest, Bob Wiles, a young painting conservator, joined Berenice in Blanchard.[27]

Berenice finished work on her ground-floor study and avoided looking "at a camera all summer—thank god." Country life took over; she observed swallows and a hornet's nest on her porch, and the grass in the front yard grew high as hay and was full of wildflowers; impractically, she planned to cut the grass with a scythe. Elizabeth's friend Abe Lerner came to visit, bringing Kurt Weill recordings and Peter Freuchen's book on Eskimos, issued by World Publishing, where he then worked as head of production. It made Berenice want to drive to the Hudson Bay to see the aurora borealis.[28]

For Thanksgiving 1961, Berenice invited a big group to Maine that included Mig Shepard; Shirley Kaufman; architects Peter Strauss, Louise Dees-Porche, and her partner Read Weber, a Frank Lloyd Wright devotee; ex-PSSC staffer Muriel B. Kennedy, who was Berenice's friend and landlady in Lexington, Massachusetts, where she still kept a room; and Elizabeth, who did not like the architects. Berenice planned to get one whole chicken, and when reminded how many people she was hosting, offered to buy two. In self-protection, the friends arranged to bring the food themselves and agreed that "spoiled" Berenice passive-aggressively enlisted help by "portraying herself as a nin-

compoop." At the semi-renovated house, one guest accidentally closed a dripping water faucet and the pipe froze, leaving them without toilet and running water until local help arrived. Another Thanksgiving, Berenice's miserliness caused a long-unmaintained water pump to fail, which cost her $10 to fix.[29]

Berenice spent Christmas in New York with Elizabeth, staying through the end of January 1962. The pair likely hosted their traditional January 8, end-of-Christmas cocktail party, with friends new and old, such as the Raphael Soyers. They set out Elizabeth's family china, with music, and dancing, if Berenice had her way. She also saw the long-awaited publication of Leonard Louis Levinson's *Wall Street: A Pictorial History*. Her newest photographs, commissioned specially for the book, were undistinguished, even those taken with her thumb camera. But Levinson helped her obtain a huge rolltop desk from the last private house on Wall Street and had it trucked up to Maine.[30]

Back in New England for the spring, Berenice was losing weight and her health was poor. Dr. Harry Shwachman referred her to Dr. James A. Bougas, a young surgeon and one of the first doctors to publicly link smoking to lung cancer. Harry described Berenice as "an extremely strong girl" relatively unconcerned about her own health: "For example, she would drive a jeep and get all knocked out but make as long as a 275 mile trip in one day" from Maine, "as she did yesterday." Berenice had "a lot of crazy ideas about medicines and doctors," he continued, and could well believe that Harry's referral meant "I recommend surgery; far be it!" But, after performing a scan and bloodwork, Dr. Bougas immediately scheduled Berenice for surgery at New England Deaconess Hospital to remove a section of her right lung.[31]

Ed and Pearl Schwartz and Joe Reynolds with his wife, Nella, visited Berenice in the hospital and Ed donated blood for her surgery; he saw her again at the Shwachmans', where she recuperated. Upon her discharge she paid her remaining $200 bill with funds that arrived that very day, a reproduction fee from the magazine *Photo Methods for Industry*. (Ed had loaned money to pay for her operation, which she never repaid.)

Elizabeth visited "during that time of unavoidable anxiety," staying with the Shwachmans. Grace Mayer sent James Baldwin's new novel, *Another Country*, set in New York City with contemporary social themes, but Berenice was absorbed in André Malraux's *Voices of Silence* (1953), which she found provocative on the aesthetics of photography.[32]

Despite Elizabeth's misgivings, Joe Fulton drove Berenice up to Blanchard and stayed a few days to see her settled in at home. Both had exorbitant "Abbott-oriented" phone bills that summer; Elizabeth protested that Maine was "no place for a convalescent—eight miles from groceries, thirty miles from a doctor (of what qualifications?), five hundred miles from civilization—and GiGi," as Elizabeth wrote to Joe, using her private styling of the cat's name. Although Berenice readily left Gigi in Elizabeth's care, Berenice missed her pet and felt guilty— their own mothers had left young Berenice and Elizabeth with relatives for weeks at a time. Berenice and Elizabeth and their circle enjoyed sharing cat imagery: Romana Javitz sent a Rubens cat postcard from the National Gallery in London to Elizabeth; Irene complained of receiving one of Berenice's customary "old cat" postcards in reply to her own personally crafted cut-paper work. Elizabeth, too, received from Berenice a deluge of "those same cat cards," printed in Belgium for an Italian firm, and mysteriously for sale in a Greenville, Maine, gift shop. It was Berenice's way of keeping close without personal contact.[33]

For her sixty-fourth birthday, Berenice's neighbors toasted her around her kitchen table with a nice bottle of wine she had on hand. "No news here," Berenice reported, "just a sleepy little-less-than-village. Lung seems to improve—I take a deep breath and no more pain but I have no more energy than a flea . . . I need energy and go-go-."[34]

In August, Irene seized the chance to swing by Blanchard after picking up her son Alan in Bar Harbor, arriving at Berenice's remote but "elegant perfect place" one night at ten:

> House lit up in hollow of road, red and cheery; BA welcoming and pleasant . . . old clock, on floor of kitchen, from demolished

church, which BA gave to Alan. Beautiful Piranesi on sitting room wall; Kitchen: large light and beautiful, table near street windows; wire ice cream chairs around, fruit and cloth napkins in bone holders; large grey woodstove and refridge. . . . Study along back and right side of house: one window overlooking rocky stream, with small cot at window; another window overlooking crossroads. . . . Bookcases of beveled planks, handsome, many different heights to accommodate magazines and books, tall and short. . . . Elizabeth Olds silkscreen print of cocks in kitchen. Stoves in house: sitting room and kitchen; her bedroom, and best guest bedroom. Carved eagle, black and white, over kitchen door, photos of Sputnik in another guestroom; cushions from Design Research in sitting room and some bedrooms; her clothes hung neatly, and shoes arranged in shoe bags, in every closet. Claims she feels crowded already. Huge coffee cups in kitchen, with special phrases like "Remember Me;" over her bedroom door, a plaster eye, purchased on Eighth Street; machete and snowshoes on study wall.

Berenice took only the local Greenville newspaper; she wouldn't have the *New York Times* in her house, not even when a friend gave her a gift subscription, because it had published her name at the top of the alphabetical list of endorsers of the Scientific and Cultural Conference for World Peace in 1949 (which she would mistakenly call the Stockholm Peace Accord, a different effort around the same time).[35]

With her overall health restored, it was a time of expansiveness. After much excitement, a possible job with the PSSC's Albert Baez for UNESCO in Paris sadly came to naught, and Berenice set about resolving various projects. Mig Shepard brought a girlfriend to spend two weeks in August, worrying Berenice with her drinking and Dexedrine. Irene, soon to visit Europe, returned for two days and Berenice hastily listed Paris cafés, restaurants (onion soup at Les Halles) and people to visit—Jean Aurenche, Marc Allegret, Sylvia Beach, and jealous Dora Omankowsky (advising caution because of her outspokenness). Bere-

nice wanted to travel, too, and made fantastical, fruitless plans to go to Mexico with a friend from Chelsea, the sculptor Concetta Scaravaglione, who did visit in Maine.[36]

Elizabeth, despite the previous disastrous Thanksgiving, agreed to return to Maine for Christmas 1962, but forbade any other visitors. The jeep ride to Maine was hard on her and on Gigi, caged in her hated blanket-lined carrier. For ten days, the two women coped with extreme weather and cold, using up all their firewood, and considering burning furniture. Berenice got stuck outside in her snowshoes, thinking, "I'm going to die here, and what a ridiculous way to go." A neighbor came to her rescue, but she never put on the snowshoes again. Exhausted, the two women headed back to New York after New Year's.[37]

> In photography the thing that appeals to me personally is the subject. . . . Not to just go out and take a picture here and a picture there, who cares? . . . I want a subject. —BA[38]

SINCE 1961, BERENICE had wanted to do books for young adults. Independently, she and Muriel Rukeyser had each approached World Publishing, where Abe Lerner worked, about a science book project. (The two communicated erratically for years—Berenice wasn't even sure Muriel had seen her 1959 New School show of PSSC photographs.) Muriel specifically requested Berenice as photographer, so the children's book editor, Velma Varner, envisioned a series based on Berenice's earlier work on magnets and electricity. Then things went awry—perhaps Rukeyser was distracted or overcommitted—and World editor Bill Targ (who would later publish Mario Puzo's 1969 blockbuster *The Godfather* at G. P. Putnam) brought in science popularizer Evans G. "Red" Valens to replace her. The project became *Magnet* (1964). Muriel could neither afford to return World's advance nor understand Targ's displeasure, and collaborated later with other artists on her own science books for children, *Bubbles* and *Mazes*. In 1971 she published a biography of

sixteenth-century scientist Thomas Harriot, with Berenice's Super-Sight photo of her left eye serving as author portrait; the image filled the entire back of the dust jacket.[39]

A sixty-fifth birthday phone call from Berenice's sister and niece in Ohio brought on anxiety and stomach cramps. In New York, Elizabeth took Berenice to hear Martha Schlamme's Off-Broadway *World of Kurt Weill* revue, shortly before eye surgery at Lenox Hill Hospital kept her admitted for ten days. With the Commerce Street apartment sublet until the following March, Berenice returned to Maine by July 20 for the total eclipse of the sun, for which she was joined by Sidney Cowell and Margaret Bennett. Rain obscured the event, though Sidney used her Rolleiflex to capture Berenice huddling under her raincoat at the edge of a slate quarry in Monson, plastic sheeting down to the ground protecting her big camera. At home in Blanchard, Berenice luxuriated in her bed, built on a raised platform and dubbed her "throne" by Elizabeth, and lovingly tended a garden of "natural" tomatoes in the front yard; her back hurt, however, and she had no plans to expand the effort. Berenice never particularly cared about other horticultural aspects of her Maine property, but a visit to Lotte Jacobi in New Hampshire led to acquaintance with Jacobi's daughter-in-law, Beatrice Trum Hunter, the author of *The Natural Foods Cookbook* (1961), who lived with Jacobi. Apparently, the tomato patch flourished without much attention into the 1970s.[40]

She had read Red Valens's latest title, *Viruses and the Nature of Life*, while recovering from lung surgery. In August 1963, he visited Maine to collaborate on several problematic photographs for *Magnet*; light leaks in the attic studio forced them to work at night. Berenice felt ill but read guests' horoscopes at breakfast—the Shwachman clan was also visiting. Valens departed, leaving setups for Berenice to complete alone. Irene tried to help after her family had left, staple-gunning plastic sheeting to the north window. Over the next two days the women struggled to stage the magnets, filings, and disks to make good exposures. For reward, they went to Greenville for lunch and antiquing; back home, Berenice polished off a nearly full bottle of wine after dinner.[41]

Around this time Berenice read Evelyn Waugh's *Brideshead Revisited* and also Marguerite Yourcenar's *Memoirs of Hadrian*, which shocked her; she had traded the volume with a young Blanchard man for Simone de Beauvoir's *Second Sex*. She had high praise for *As I Pass, O Manhattan* (1956), an anthology of New York writings compiled by Esther Morgan McCullough, another member of her wide circle of lesbian friends. Eyre de Lanux, a superb cook, visited for several days, as she had in earlier summers. Berenice then made a two-day trip with a local guide to the upper reaches of Maine in Aroostook County, where the schools close for three weeks to harvest potatoes—"quite a sight." Arthur Trottenberg, a Harvard assistant dean and author of a book that paired Atget's photographs and Marcel Proust's writings (Berenice had supplied the idea), offered a $10,000 teaching assignment at the college. Not for her at any price, was the response.[42]

Elizabeth in front of ornamented architectural exterior, early 1960s. Sidney J. Waintrob (Budd Studio, New York City)

Elizabeth refused to come to Maine again, fearing she might need medical attention. She endlessly discussed her own health and had taken to anxiously wondering how she would cope with the burden of disposing of all of Berenice's property if left with the task. She even took out a policy with a local insurance agency against loss on the Maine house and all of Berenice's possessions that fell into the category of fine art. Berenice, in turn, seemed terrified at the thought of losing Elizabeth, and left Maine for New York upon finishing the last magnet photograph.[43]

But she was already thinking about her next big subject, Maine. Her architect friends Read Weber and Peter Strauss lent her a 4 × 5 Linhof

for aerial photography of Moosehead Lake. In November, she stopped in Boston to join the Shwachmans for a performance of the Moscow Circus, then continued on to New York, where she spent a fortune on a Christmas cactus "growing all kinds of pink babies" that required constant fluorescent and tungsten light. She went skating with Eddie Schwartz and Joe Reynolds, borrowing Joe's daughter Barbara's figure skates, whose unfamiliar "picks" caused her to fall. The Schwartzes gave her a Christmas check for $50 toward a piano.[44]

Simultaneous with development of Berenice's next science titles for World Publishing (*Motion* would appear in 1965 and *Attractive Universe* in 1969), Horizon Press's Ben Raeburn was working up a book of her 1920s Paris portraits. Janet Flanner, resurrected as possible coauthor, dropped out, and Raeburn eliminated Malcolm Cowley and Cocteau biographer Francis Steegmuller as possible writers. (Steegmuller later told Berenice he regretted that an Atget book they had briefly considered had not worked out, calling Trottenberg's "gimmicky.") Ben then approached Kay Boyle, sharing thirty of Berenice's portraits for inspiration. Months later, a behind-schedule Boyle apologetically declined and suggested Djuna Barnes or even Peggy Guggenheim. Berenice also did one of her last successful portrait sittings, of poet Jane Mayhall at home in Brooklyn, charging a friendly $200 instead of $300. She used her small Rolleiflex, though she had lugged her 8 × 10 along; prints were now a minimum of $25 because she found the darkroom a chore.[45]

In May 1964, for Elizabeth's sixty-fifth birthday, Abe Lerner and the painter Frank Kleinholz gave a testimonial cocktail party in the Commerce Street hallway, where the women had entertained for decades. Berenice served champagne wearing custom-fit "space shoes"—like her Accutron electronic watch, evidence of her early-adopter philosophy for new technology. Elizabeth seemed happy and wore "her tartan," a long skirt of green-and-yellow plaid wool, the colors of the clan from which her family descended. Redhead Ella Jaffe, an attractive divorcée and art dealer nicknamed Ivory, had researched Elizabeth's ancestors and hunted down the fabric. Elizabeth needed further eye surgery but had

put it off. When an infected finger required only the removal of the nail, she bemoaned the potential likelihood of her entire arm's amputation. This exaggeration, though typical, worried Berenice, but not enough to keep her in New York.[46]

It was Raeburn who had eventually commissioned an Atget book for Horizon, with an essay by Berenice. The piece was due, and the book's title, *The World of Atget*, had been settled upon. Mention of Berenice's silent partner Julia Reiner, included earlier, had been excised. *Magnet* received good notices—Grace Mayer called it splendid—and Berenice started on her second book with Valens, *Motion*. Both had hesitated signing for more books because World paid "coolie rates," as Berenice called her advance. Intending to finish all the new photographs by fall, the pair met briefly in Maine, but Berenice was "ready to throw it [the project] out the window" when he left her on her own. She especially missed Valens's input, for example, when executing such photographs as the "ball going around on a Victrola." A pendulum swung above, and the complex timing of the shoot was difficult to execute, though everything eventually "worked like clockwork." Ed Schwartz accompanied Berenice to photograph at Coney Island and the circus; for other subjects Valens wanted, Elizabeth and Velma Varner tried to buy fireworks before realizing the extent of the black market in New York City.[47]

When Berenice stopped in Newton on her way to New York in October 1964, thinking she might not go back to Maine for the winter, Irene thought she seemed "tired, older . . . lonesome. Too long without guests." She was frail and vulnerable, having had minor varicose vein surgery that spring. Elizabeth was to have escorted her home from the hospital, but she instead had to get there herself, and arrived to find her partner drunk.[48]

In late November Berenice drove down from Maine with a local man she found in a bar, collected Ed and Pearl Schwartz in Queens, and took them all on a crazy ride across the Brooklyn Bridge, around Wall Street, onto the Staten Island Ferry, and then around the island to cross the new Verrazano Bridge back to Brooklyn. Soon after Thanksgiv-

ing dinner at a favorite Village restaurant, The Leopard, Elizabeth had her long-postponed eye surgery, and Berenice's Christmas cards to her were elaborate confections of lace and Victorian engravings.[49]

The year 1965 was the saddest year of my life. —BA[50]

ELIZABETH HAD LOST WEIGHT. She needed nursing care, but defied instructions and fell often. By January 1965, a few people who had been helping out on Commerce Street had moved on, and Elizabeth's health needs had become overwhelming for Berenice, physically and psychologically. One day, she found Elizabeth on the floor, unconscious in a pool of blood from a scalp wound. There was a long wait for the ambulance, and then an argument between the police and the ambulance driver, before she was taken to the hospital for treatment. Elizabeth's eye was not healing well; she neglected her insulin and was tricking friends into bringing her miniature bottles of liquor. She canceled a commitment to teach at the University of Southern California that summer. When Berenice, unable to stand New York any longer, offered to nurse Elizabeth in Maine and was turned down, she simply left. Elizabeth scolded Berenice for running up long-distance phone charges just to say she was lonesome. In fact, the calls were her way of checking in with Elizabeth.[51]

For the next few weeks, Elizabeth dissuaded Berenice from returning to New York, saying that her own problems were merely psychological. The two spoke often by phone, but on Thursday, May 13, Berenice left to run errands and instructed her assistant, Cathleen Bingham, not to pick up the telephone, aiming to avoid friction between Cathleen and Elizabeth, who was sometimes jealous. Berenice had hired Cathleen, her first assistant in years, through Marion Palfi at the New School. Cathleen was the former girlfriend of Alan Ribback (Moses Moon), whose interest in recording the sounds of the civil rights movement led him to the Student Non-Violent Coordinating Committee (SNCC). A strapping, quiet-mannered blonde who worked without pay for the privilege of learning from Berenice and living in Maine, Cathleen thought her the

"only old person" who understood young people. The phone rang that afternoon for a long, long time as Cathleen followed Berenice's direction to not answer it. The following morning, Commerce Street elevator operator and superintendent Georgia, the towering black woman whom Berenice called when she got no response at Elizabeth's number, told her that she had found Elizabeth dead at 8:30 a.m.[52]

From Bangor, Berenice was just in time for the next plane to Boston. She wandered Logan's restricted airfield distractedly, waiting for her connecting flight to New York, until an official chased her away. In New York Elizabeth was still in the apartment, on the floor under a blanket; her feet stuck out. Berenice did not look at her face. Elizabeth had willed her body to science but too much time had passed, so executor Abe Lerner arranged for her cremation. The police had removed papers and other property from the apartment, as well as from Berenice's studio, which the attorney Philip Wittenberg fought to retrieve. Mig Shepard stayed with Berenice on Commerce Street through the weekend, but by Monday Berenice felt she could be alone. Cathleen came down, having had no luck making nature photographs for Berenice's final book for World, 1969's *The Attractive Universe*, which had the provisional title "Mechanics of Nature."[53]

Cathleen planned to stay in Maine through August, and had already sublet her East Village apartment. Elizabeth's siblings placed a death notice in Sunday's *New York Times*, Irene's first hint of the news, though Berenice had tried to call her during the Boston layover. The American Federation of Arts (AFA) notice on Monday was laudatory, addressing "NYC colleagues, friends, and those whom she inspired and helped," who mourn "the passing of this pioneer spirit, art critic, historian and newspaperwoman. She dedicated her life to the appreciation of American art and pioneered in the recognition of photography as an art." A *Times* news obituary appearing the same day cited Elizabeth's survivors, though not Berenice, a customary omission. Four years earlier, Berenice had asked Irene whether an obituary for H.D. had mentioned the poet's decades-long lesbian partner. She was referring to her long-ago benefactor, Bryher. But she

was also surely calling attention to the heartless convention that decreed public acknowledgment of same-sex relationships an impropriety.[54]

In the week after Elizabeth's death, Berenice invited friends to select books from her library. Elizabeth's clothes went to Alma Richards, their housekeeper. In Elizabeth's papers, Berenice found a package labeled "Photography," which she brought to Maine to consider for possible publication. On the phone with Elizabeth's long-widowed sister, Helen Kentnor, Berenice was heartbroken that she wanted the amethyst ring Elizabeth always wore, then let it pass; Helen did not want the family china, which Berenice promptly packed up for Maine. Lisette dropped by for a private half hour and told Berenice that she was really better off without Elizabeth. "A harsh thing to put into words," Irene observed. Condolence letters came from Jere Abbott, weekending in Dexter, Maine (he was grateful for Elizabeth's sympathetic reviews of his Smith College work), and from Grace Mayer, who respected Elizabeth but had resented her interference at the Museum of the City of New York.[55]

The general tenor was of guilt, but Elizabeth had also tried many of Berenice's friends' patience. Despite the dangers posed by diabetes, Elizabeth had kept doing as she pleased—drinking, neglecting medication, and eating proscribed food—and seemed to not really want to live.[56]

Even more so than Berenice, Elizabeth had no smooth edges. Her unfashionable physicality, queer sexuality, acerbic tongue, razor-sharp intellect, and overbearing temperament all fed discrimination. It had angered Berenice to see "tenth-rate people" rewarded while Elizabeth was ignored. "She should have been a big critic on the *Times* or one of the big critics in the country, but it didn't happen"—a failure that made both heartsick. When Irene observed that Elizabeth had never even seen her exhibitions at the Athenæum in Boston, Berenice explained that she had simply tired of the art world (had "tired of everything," Irene added). Berenice believed that her weak friends survived but the strong ones did not, because they wouldn't take care of themselves. At some point she determined that she would live to be 100.[57]

The AFA scheduled a memorial service for Monday, June 7; neither Elizabeth nor Abe Lerner believed in the "tribal" custom of a funeral. In the interim, Berenice returned twice to Maine. On May 28, she finally took with her the stove offered years before by the Hoppers, the one beside which she had photographed Edward. Cathleen came down from Maine with two young men to help get it out of the Hoppers' apartment and into Berenice's jeep for the drive north. Cathleen was joined for company in the Maine remoteness by a new friend, Terry, whose boyfriend was a photographer; they drove straight through and moved the stove into the house so that, following Elizabeth's memorial, the jeep could retrieve more Commerce Street possessions. Berenice dined with Abe Lerner and met the next morning with Bert Little and Ben Raeburn. Rose Hass, Ben's secretary, sent a letter of intent about their planned book of Berenice's Super-Sight and other science photographs. Strangely, Raeburn had not known Elizabeth, though Berenice had earlier told him she was worried about a close friend; when Elizabeth died and she revealed the friendship, Raeburn spoke of how much he had admired Elizabeth's work. Berenice's plan was to leave Cathleen in charge of the Maine house and of Gigi, relocated there.[58]

Berenice returned to New York on June 3, stopping overnight with the Shwachmans. Irene, as usual, noted Berenice's appearance in her journal: favorite L.L. Bean olive corduroy slacks, too long though cuffed, and a burgundy turtleneck, "plus tan poplin jacket and yellow bandana." Berenice seemed quieter, "reflective, puzzled and subdued" as she burrowed in bed, her turtleneck over pink silk pajamas, Irene's orange cashmere over that, and an extra yellow blanket—rainbow colors Irene found "quite a sight." Her hair was now gray, and she looked healthy. Having arrived a day sooner than expected, she went right upstairs with issues of *Scientific American* and the *New York Review of Books* to avoid a party downstairs; Harry's medical colleagues were in the house. Irene apologized for her obligation to her husband's guests, and Berenice urged her to appreciate their companionable marriage.[59]

For Elizabeth's late-afternoon memorial service, Berenice was almost

unrecognizable in an uncharacteristic black silk skirt suit with a black-and-beige turban, pearls, her narrow gold bracelet, a new heavy metal cuff, and a gold ring that had been Elizabeth's. Jane Jacobs and Leticia Kent sat with her in the second row of the small room at the American Federation of Arts building on East Sixty-Fifth Street. Also present was Ella Jaffe. In gratitude for Ella's finding the tartan fabric for her sixty-fifth birthday outfit, Elizabeth had made Ella her first-ever martini at the party. Their friendship dated from the late 1950s, when Ella had hired Elizabeth as a researcher/writer for her catalog on the Russian émigré painter David Burliuk.

Elizabeth had exquisite taste and would save up for luxuries, such as clothes from Women's Haberdashers, the exclusive Madison Avenue shop; when they wore out, she had them copied in Chinatown. She brewed coffee in a Chemex, then exotic. With Elizabeth gone, Ella felt that she "inherited" Berenice, who had seemed timid and dependent in the company of her domineering partner. Irene had the same impression years earlier when she first overheard Elizabeth sounding "querulous, tentative [and] masculine" on the phone with an anxious, "almost afraid," Berenice.[60]

Some thought the short memorial service perfunctory and lacking in praise of Elizabeth. Newcomer Irene recorded her impression of these friends of Berenice who attended: abstract artist I. Rice Pereira; illustrator Jean Purcell, a "frizzy blonde"; sleek, dark-haired Pat Wilkinson and Betty Main, the "tailored" mouse, with her; and Dr. Shirley Kaufman, who had helped Elizabeth obtain insulin, with her German friend, Wally. Eyre de Lanux and Romana Javitz were not present. Berenice had managed to visit the New York Public Library Picture Collection looking for images of shark jaws for her projected "Mechanics of Nature" book, and had noted a display. Javitz, out of her office at the time, had seemingly created a silent memorial of her own that included Berenice's enlarged photograph of the view toward Commerce Street through Elizabeth's rain-streaked window. Also absent from the memorial service were Leslie Katz and his wife, Jane Mayhall, who

were probably out of town. Ben Raeburn had to be at a scheduled Frank Lloyd Wright event. He and Horizon Press copublisher, the poet Coby Britton, met Berenice later for a sad breakfast. Unable to comfort her, they invited her to visit Coby's Blue Hill, Maine, place later in July.[61]

Before heading back to Maine, Berenice bought a gold chain for another piece of Elizabeth's jewelry, a cameo, and brown rice and tofu— then unusual foodstuffs—at an Asian shop for Cathleen, and picked up the Hoppers' gift of a print. She also reviewed a boxful of Elizabeth's juvenilia, including early poems that reminded her that Elizabeth had always been unhappy. She wept the entire drive up from New York.[62]

Berenice initially thought she'd give up Commerce Street completely, but Sidney Cowell and a young male photographer rented the studio setup and made the darkroom available to Berenice when she was in town. Sidney would also perform the little services that Elizabeth had done for Berenice, such as take phone messages, handle mail, and retrieve items from files. In Maine, she had boarded up the front-door sidelights to discourage break-ins. She opened up the house but slept outdoors on the terrace. Her jeep was not running well; the hot water was out, again; and Gigi was catching mice everywhere indoors. Berenice, who was in high spirits except when she wasn't, asked Harry Shwachman how to "keep damp air in your lungs and out of your joints." Abe Lerner's daughter Judy brought Berenice's new will for her signature; it made her niece, Alice Ross, sole heir.[63]

Elizabeth had left Berenice some money outright, plus a share in a small Kansas real estate trust. The family contested this, but Philip Wittenberg resolved the matter. "From Elizabeth" became Berenice's shorthand explanation for her large purchases in 1965—new furniture and upgrades on the Blanchard house, plus a modest rental-income "camp" on Moosehead Lake that she sold in 1980 at a small profit. It would be decades before Elizabeth received public acknowledgment for her role in Berenice's life.[64]

SELL ATGET!

New York and Maine (1956–68)

For Berenice Abbott.
—JOHN SZARKOWSKI AND MARIA MORRIS HAMBOURG[1]

There was some part of the game I didn't play, not because I
didn't want to, but I didn't know how apparently. —BA (1968)[2]

A telegram awaited Berenice when she reached Blanchard on the
Saturday after Elizabeth's memorial in June 1965. It followed
up an unacknowledged engraved invitation, one of 102, to the
White House Festival of the Arts in just two days, Monday, June 14. The
event commemorated President Lyndon B. Johnson's reestablishment
of federal government support for the arts, a huge goal of Elizabeth's.
"Photography" was specifically among the seven arts to be celebrated.
Berenice immediately telegraphed Marchal Landgren to make overnight
arrangements in Washington, uninterested in the protest that some
event invitees, such as Robert Lowell and Edmund Wilson, were lodg-

ing against the war in Vietnam. Though Berenice attended the antiwar march on Washington that fall with friends of Jane Jacobs, she evidently shared Walker Evans's sentiment that, if the White House Festival was good enough for Duke Ellington to attend, there was no reason for her not to go. Berenice had a good time, saw many old friends, and left early to visit with Marchal.[3]

In early August, she focused on getting photographs ready for a September show in the remodeled Squaw Mountain Inn on Moosehead Lake. Red Valens wrote from the West Coast to say that an obligation to complete the biography of Olympic skier Jill Kinmont, famously paralyzed in an accident, was holding up their gravity book, finally published as *The Attractive Universe* (1969). "*Motion* looked so nice," he acknowledged. "Your frustrating hour with my pendulums and silly little cars etc. did pay off."[4]

Right before Christmas, Diane Arbus visited Berenice on Commerce Street. Berenice found her personally interesting but, perhaps anticipating a fashion plate from Russek's, her family's stylish Fifth Avenue emporium, also older than expected and bizarre, especially her clothing. (Unremarked was the fact that Arbus, as a newlywed teenager, had attended Berenice's beginner's class at the New School in 1941.) Berenice liked Arbus's work despite its shock value, and wanted to buy some prints, though she never got around to it. After Arbus's 1971 suicide, she called her a great, misunderstood photographer who had let her health go for her career. Later, refusing to succumb to the romanticization of illness, Berenice claimed that she "knew that girl was going to kill herself. I tried to get her up here to visit me, but it was too late." Another December visitor was photographer Bruce Davidson, whom Cathleen knew through SNCC. He bought a few Atget reprints.[5]

Back in September, Berenice had dodged her sister's invitation to visit Ohio, but she did go for Christmas, only to come back to New York ahead of schedule and depressed. More happily, she spent New Year's Eve with her old friends the Schwartzes and the Reynoldses.[6]

A *Springfield Union* colleague of Elizabeth's named William G. Rog-

ers began corresponding with Berenice about helping her to complete an illustrated autobiography. The work, commissioned by Harcourt editor Margaret Marshall, was based on the drafts of her life story that Berenice had composed in the 1950s, and which Elizabeth had subsequently revised. Along with his wife, Mildred, a poet, Rogers had met Berenice at Sylvia Beach's 1959 party at the Gotham Book Mart (he subsequently wrote *Wise Men Fish Here*, about proprietor Frances Steloff). Ultimately, Berenice's photographs made the autobiography too expensive to print, Rogers said; another editor believed it too similar to a recent work by photographer Gisèle Freund. Berenice served as a source for Rogers's *Ladies Bountiful: A Colorful Gallery of Patrons of the Arts* (1968), which quoted her observation about the lack of support by women for female artists; the British edition is subtitled *And the Men They Helped.*[7]

A year after Elizabeth's death, Berenice used her bequest to return to Paris for the first time since 1930. From her dude ranch in Taos, Elizabeth's sister, Helen, urged her to go—"You miss Elizabeth and so do I, but I know it is harder on you . . . the trip will do you good and give you another perspective and new faces and sights." Berenice had invited her old friend Dora Omankowsky, now working for NATO, to come to the United States, and Dora had countered with an invitation to the south of France. Abe Lerner and Ed Schwartz saw Berenice off at the airport, where she boarded an overnight discount flight on Saturn Airways, which stopped in Iceland before landing in Luxembourg. When she found the Paris hotel Dora recommended uncomfortable, she decamped to Marge Fairbanks's house; illness there and son Austin's presence sent her to the historic Hotel Continental.[8]

Atget's photographs had made her "so familiar with Paris, it was better than seeing Paris itself." She had not studied the city with her photographer's eye when she lived there in the 1920s, but now that she had had years to study his work, she explored some of the places depicted, and also took a quick Rolleiflex photograph of Atget's doorway. At some point she met with a representative from the office of André Malraux, the country's minister of cultural affairs, about her Atget collection.

She found Man Ray in the phone book, but when she called and no one answered she hung up readily—hardly surprising given that his 1963 autobiography, *Self Portrait*, omitted any mention of Berenice's three years as his darkroom assistant in Paris. It was "rather dirty" and "bitchy" of him, she thought, to leave out her studio role; she believed that he was still angry at her for her early success, not to mention her acquisition of the Atget collection. She also complained that the food was no longer good and cheap, even at old familiar Rosalie's or now-Hemingway-renowned Closerie des Lilas, on the boulevard du Montparnasse, where the cheese and bread passed muster but not the onion soup. The traffic and pollution were unbearable, and the women— "little mini-skirt mannequins"—made her mad. "Nothing was any good anymore as far as I could see; not one thing."[9]

She was extra grouchy because she was getting sick again, which spoiled her time in Nice with Dora, who'd had no idea Berenice was still in mourning for her partner of three decades. Rather, Dora seemed devoted to her emotional memory of 1920s Berenice. As old women they expressed no affection, not even giving each other a peck on the cheek—though a year later, Berenice was still raving about Dora's "over 70!" physical fitness. Departing from the Paris airport, Berenice waved from the tarmac without a proper good-bye.

Flying first class on a fast, direct plane was a salvation, though her seatmate smoked the entire transatlantic flight. On doctor's orders, Berenice went right from the New York airport to the hospital, where pneumonia was diagnosed. With taxis on strike, Ed Schwartz left work early to drive Berenice home upon her discharge. Meanwhile, a long-planned exhibition of her work had opened at Long Island University.[10]

Paris had cost $1,000, "from Elizabeth." Back in New York, Berenice was "much taken" with her reading of what she called "Somerset Maugham's confessions"—possibly his evocative memoir of interwar Paris and London, called "Looking Back," in *Show*, the lavish arts magazine edited by the A & P mogul, Huntington Hartford, if not Maugham's earlier books. She continued spending almost defiantly,

enjoying the money as something deliciously unexpected. She bought more Design Research accessories, plus furniture, and a case of expensive wine ($12 a bottle, over ninety dollars in 2017) that Lincoln Kirstein introduced her to. Berenice was still wearing Elizabeth's rings, but mentioned her now only in passing.[11]

Berenice's final topical photo book, *A Portrait of Maine* (1968), was born by chance at a dinner where she met the poet Arthur Gregor, then a senior editor at Macmillan. He suggested that she photograph New York City again, and she said that she was only interested in photographing Maine. Agreeing about Maine, Gregor surprised her with a ready offer of a $5,000 advance, which she accepted. Cathleen Bingham returned to assist Berenice, exchanging room and board for housekeeping, but she wanted to be paid for her photographic work. Together they began on the Maine book by building a platform on top of Berenice's jeep from which to photograph from up high or looking down onto her subjects. It could accommodate even the huge 11 × 14 inch camera, but mostly Berenice photographed in formats smaller than 8 × 10. Happily, all of the photographs were to be in black-and-white—the publisher specifically didn't want color. Macmillan accepted Berenice's proposed coauthor, her old friend Chenoweth Hall, who had been a local newspaper feature writer as well as a novelist of Maine.[12]

The challenge of the book, in Berenice's view, was to select only "very Maine" subjects, rather than those also found in other states. With subjects also limited due to cost, she used the title *A Portrait of Maine* rather than *The Portrait of Maine*. She even photographed hunting, which she hated, as it was an activity typical of the state. When she went north to Aroostook County for potato harvesting, she hired small planes for aerial shots of coastlines and inland terrain. The Great Northern Paper Company arranged for her to photograph their deep-woods lumber camps, including a modern one to help with employee recruitment; the work is hard enough in the best of circumstances. Though she usually balked at oversight, Berenice was glad for the firm's escort, fearing she'd get lost on her own in the forest and never be found again.[13]

Berenice reclining, conducting along with record player, Blanchard, Maine, 1960s.

Irene Shwachman

The book features the state's lobstermen, lumbermen, farmers, and hunters and their families—"just quiet, modest stuff . . . the way Maine is . . . terribly simple and down to earth." It received a lukewarm reception. The last chapter tries to capture the built environment. Berenice omitted the Maine work entirely from her first retrospective book and exhibition, in 1970. A decade later, advancing age and declining energy led her to abandon a project on Maine's distinctive country stores.[14]

Berenice's well-traveled Smithsonian Institution exhibition, *Image of Physics*, ended its five-year run, and the forty Masonite-mounted prints, still in fine condition in their custom shipping crates, became her property. In November she drove down to New York to close up 4B at 50 Commerce Street and disconnect her New York phone number. For two

days, she and two helpers stacked the contents of the studio, where they remained on hold till February. She met up with Djuna Barnes, and they splurged on bottles of the perfume L'Heure Bleue, Guerlain's Belle Époque classic. Berenice drove straight back to Maine, exhausted.[15]

Christmas found her in low spirits. Cathleen came and went, and they continued to work despite growing tension, sometimes playing Ping-Pong on the porch, protected from the winter by tarpaulins. In late January 1967, Berenice attended the opening of MoMA's *New Document* photography exhibition, so busy drinking and visiting that she completely overlooked Diane Arbus's work. For years she'd been thinking of a huge retrospective exhibition for herself—Photography Department director Szarkowski was an admirer, Lincoln Kirstein told her, though she couldn't see it and never knew what to say to him at openings; Irene, after her first meeting, agreed that the curator was "a putz." The publication date of the long-anticipated Horizon Press monograph on Berenice kept slipping due to costs.[16]

On March 1, 1967, the move out of 50 Commerce Street was finally completed. She saw Lincoln Kirstein for lunch, while all her goods, including new luggage from Ben Raeburn, sat guarded on the sidewalk. The Reynoldeses and the Schwartzes, who had helped her pack, took her for a snack at Katz's Deli and then a farewell tour over to Staten Island on the Verrazano Bridge. Berenice seemed fatigued, though not visibly upset by anything, except her progress on the Maine book.[17]

A month after the move, relieved of the obligation of Commerce Street and any pressure to be in New York at all, she was feeling very well, restored by Maine living and fresh, clean air. "What do you get up here? You get plenty, honey. You get fresh air. And water. Good sleep. All the things you can't get in New York. All the things you need for a healthy basis for life," she told Gretchen Berg, in an unpublished interview. She praised her move to Maine by thanking "God—I don't believe in any god—thank God for that, but I go out there and I just praise God anyway because . . . I take in a beautiful big breath and it is a luxury, you know."[18]

Two weeks later, Gigi died on the way to the vet. Berenice tried a new pet, a little female beagle called BoBo; dogs, however, as she failed to recall from her experience with the saluki puppy, required more attention than she was willing to spend even on herself. Happily, BoBo found a new home and Berenice got an orange tabby kitten she ironically named Butch, insider slang for a stereotypically male-acting woman. He grew large and stocky, thanks to his routine treat of Schlitz beer, poured right into his bowl.[19]

In early April, Berenice flew to Cleveland for her fiftieth high school reunion; she also saw what remained of her family (sister Hazel and niece Alice) and met with the Cleveland Museum of Art regarding Atget. The imperative to dispose of the collection was becoming increasingly central. Hazel, now over eighty, still resembled Berenice, slender with gray hair, while Alice, only fifty-four, was heavy and looked older than her years. Berenice fell ill with a hard cold upon her return. Though Cathleen took good care of her, Berenice was finding her less and less helpful in the darkroom and more and more irritating. Increasingly concerned about the disposition of her property—not only the Atgets but her own work—she made a plan, unfulfilled, to train Alice regarding "creative property."[20]

Cathleen Bingham eventually departed for good, "to work with Indians" out west. The deaths of friends Edward Hopper and Willard Morgan, along with Henry Cowell and Dorothea Lange the previous year, weighed heavily on Berenice. She tended her flower beds, fixed up her house, and tried to bring order to the "studio mess from N.Y."[21]

She continued to battle ESI for access to her PSSC negatives, consulting Bert Little, to "keep the niceties in order," he explained. He in turn would contact George Cope, who was still working there. "I know and sympathize with your feelings about the whole business of the ESI pictures," the fatherly Little wrote, "but the details of life are sometimes hard on all of us. . . . the tremendous significance of your work is reflected in the eyes and minds of all the students who have learned and will learn about the world through your eyes and your camera."[22]

Berenice had earlier contacted the US Copyright Office about the

status of the 1939 *Changing New York* title published by Dutton; now she learned with finality that the copyright had not been renewed; hence any claim of exclusivity was unenforceable. In effect, the rights to most of Berenice's life work—New York and PSSC, and soon Atget's archive—belonged to others or to everyone. Atget's archive was perhaps the most complex property—from both legal and personal standpoints.[23]

Hoping the proposition I have in mind may

go through, for Atget's sake. —BA[24]

EVER SINCE ITS ACQUISITION in 1928, the archive had created a separate, parallel universe—one in which Berenice saw herself as Atget's famous headless, white-smocked store mannequin. That self-image had helped fuel her attack on contemporary abstraction during her presentation at the 1951 Aspen Institute; current fascination with abstraction thwarted hope of a big solo museum exhibition of Atget. She felt that curator Edward Steichen had virtually extorted fifty original Atget prints from her two years earlier, in 1949, by insisting—while "just riffling through" them—that she sell them to MoMA at five dollars each, prior to any exhibition there. She let them go, "with tears in her eyes," and acceded to Steichen's plan to pair them with a group of Stieglitz prints newly acquired from Georgia O'Keeffe, rationalizing that Atget could only benefit from the comparison. Berenice still honored her 1930 contract and shared these sad sale proceeds with Julien Levy.[25]

She had lost an early Atget champion with the death of *Times* art critic Edwin Alden Jewell, who had argued in 1932 with Stieglitz associate Herbert J. Seligmann about the primacy of the straight documentary tradition, of which Atget was the ultimate practitioner. Reviewing MoMA's March 1950 exhibition of Atget and Stieglitz, however, the *Times* dispiritingly saw an "objective and monosyllabic" Atget and a "subjective and highly articulate" Stieglitz. A quarter-century later, Berenice still railed against the responsible MoMA department head

Mannequin, *Paris, ca. 1926.* Eugène Atget

Edward Steichen, calling his own photographs "nothing." She liked only his portrait of Willa Cather—he couldn't "ruin Cather. She wouldn't let him." She recorded the whole experience as a low point in her journal under 'Self-Esteem': "Don't be so damned accommodating – a pushover – a sucker. // Say no."[26]

To redress this unhappy situation, Berenice spent much of 1951 printing for two other New York Atget shows—at the New School in December and the Metropolitan Museum of Art in March 1952. The New School show had two hundred prints by Berenice, copies of which could be ordered, and a smattering of sequestered originals, retrieved from Weyhe's twenty-year-old holdings. The *New York Times Magazine*

reproduced a selection of Atget photographs, "rescued from oblivion" by Berenice's efforts; they later attracted national attention when published in *Time* magazine. Elizabeth's exhibition text reminded viewers, "[H]owever stark[,] however direct and realistic[,] was his work . . . all the more sensitivity is needed, the deep love and understanding of the subject is required. This is objectivity and subjectivity balanced nicely like two poles of a magnet": a tidy reference to Berenice's ongoing efforts to image magnetism and electricity.[27]

Berenice loaned more than one hundred prints plus her portrait of Atget for the Met show. Curator A. Hyatt Mayor, a longtime acquaintance and once an aspiring photographer, offered the manuscript of his essay for the museum's bulletin for her vetting, and she specially noted his observation that former actor Atget "always saw his surroundings as a stage." She "almost fainted" when she saw Mayor's installation, however, because the pictures were up near the ceiling and the glass was full of glare. Despite her pleading and offer to "stay up all night" to rehang the show, Mayor declined.[28]

Robert Offergeld, a writer and editor for the style magazine *Flair*, had helped Berenice choose the prints for the Met show "with great and selfless devotion." He had been involved in *Flair*'s April 1950 Paris issue, and had encouraged Berenice to pen remembrances to accompany her Paris portraits reproduced there. Berenice felt it would be more effective to build a larger project around the personalities themselves, anticipating her unrequited desire for a book of her Paris portraits.[29]

Earlier, she had given Atget admirer Ferdinand Reyher "unlimited time and unlimited everything," she said, happy to have a collaborator as sympathetically interested in Atget as she. Reyher's familiarity with 1920s Berlin and friendship with Bertolt Brecht, plus his success as a Hollywood producer and scriptwriter, including Berenice's beloved *Boy of Stalingrad*, were additional imprimaturs. They'd go out to dinner and have fun together—catching up on their many shared acquaintances, from William Carlos Williams in World War I Greenwich Village to

Beaumont Newhall, whose youthful WPA photography assistant in Massachusetts, Ernst Halberstadt, was Reyher's cousin. (A decade later, the Halberstadt family introduced Berenice to Katherine Edsall, who housed Berenice briefly at the start of her PSSC job in spring 1958.) In May 1947 Reyher wittily wrote Newhall that he'd been "Atgeting 5-6-7 brutal hours at a stretch, day after day, at Abbott's. I close each hitch exhaustedly but exhaustively cursing the old bastard. I looked for 5½ hours the other afternoon. . . . 51 prints!"[30]

Finally, Berenice let him take some of the originals to his place in the Chelsea Hotel, toward his help organizing a show in Paris; he also shared the prints with Brecht, then back in East Germany. Upon his return to the United States months later, Berenice felt Reyher acted guilty for having "swiped some of the[m]." "Where is the little man in the boat?" she asked him. Others were missing from a clutch that had been rolled up, and for which there were no negatives. Berenice felt particularly betrayed because only Reyher had taken the trouble to look at her entire Atget collection; had Newhall done so, she believed, he could have corroborated the existence of specific images. Lisette Model later told her that Brecht was a "notorious thief" who "would steal anything." Berenice never revealed these thoughts to Newhall. Later she learned that it was Reyher who facilitated Newhall's 1952 acquisition of Man Ray's album of choice Atget originals for the George Eastman Museum, thereby discouraging, she believed, the museum's acquisition of her Atget archive. She was still mad in the 1970s and spitefully judged that "Reyher got what he damned well deserved. He died on a train or something and all his manuscripts were lost."[31]

In 1951, Sally Nerber's husband, John, became Berenice's agent, and through him she outlined her vision of sequencing the photographs for Stanford University Press, where Bill Estler had connections. They were to be in Atget's own topical and thematic series, with "lots of white space to give them room to breathe," and her own introduction would

lead the book off. Seeking endorsements, editor Donald M. Stewart spoke about the project to Walker Evans, who liked it.[32]

However, the proposal to Stanford soured when Beaumont Newhall, consulted in his capacity as curator of the George Eastman House, informed Stanford that Ferdinand Reyher had a manuscript under way and had "accumulated more materials on Atget than anyone else." A surprised Berenice replied that she had not seen Reyher's manuscript: "After almost a quarter of a century of conserving the Atget collection single handed, and with no help from the professed friends of photography, I am beginning to lose my naive willingness to give Atget away," she told Newhall. No Atget book by Reyher ever appeared.[33]

Beyond Berenice's emotional and artistic attachment to the Atget collection, it also continued to be a source of income. In March 1955 (eighteen months after an unfruitful deal with Boston's Swetzoff Gallery to showcase modern Atget prints), she provided originals to the Boylston Street Print Gallery in Cambridge, Massachusetts, run by Andrew Oates, a 1950 Black Mountain College photography graduate. Berenice made $84, the payment of which finally required a lawyer's letter. The young James R. Mellow, a huge Atget fan, reviewed the show, saying that Atget should be better known. Soon after, Berenice futilely wrote to Irving S. Olds, a trustee of the New York Public Library, regarding possible interest in purchasing her Atget collection.[34]

Nothing else had been done in the four years since the 1951 Aspen discussion of a committee to help place it. Now, two of the original conceivers, Beaumont Newhall and Minor White, both contacted Berenice about the George Eastman House's small Atget holdings; they also alerted her to a new Kodak paper being tested—with a tonal range "far greater than anything that is now available"—that could perhaps be used to print more modern Atgets. Persuaded that Eastman House was loaning some of its own rare, nineteenth-century wet-collodion glass negatives for Kodak's trials, she released a small selection of Atget negatives to Rochester—preparation, in part, for an exhibition.[35]

Plan on health & time for more action organized without so
much pressure and worry. Action – "the one thing in the world is
the active soul" – "Action is the chief end of existence." —BA[36]

BERENICE FELT SHE was on the way to fulfilling the objectives she
had recorded for 1956: "Sell Atgets – Complete Electric Book / US 1
layouts, captions, etc. 20's. Atget Book – line up more work for more
income." She also noted "Teeth" in this entry, but it was not until sum-
mer 1972 that she could afford to have all her teeth extracted and buy a
full set of perfect dentures.[37]

In April 1956—the year of the centenary of Atget's birth, as far as
she then knew—she sent out a flyer addressed "To Museums, Librar-
ies, and Collectors," offering a portfolio by subscription of twenty mod-
ern Atget prints from original negatives in her collection. Elizabeth,
as Berenice's self-described factotum for this promotion, had surveyed
recent circulars and form letters for similar productions to create the
mailing, and then had fielded correspondence, while Berenice fulfilled
orders in the darkroom. Berenice had portfolio models dating from
the 1930s—by Ansel Adams, Paul Strand, and the Photo League on
Lewis Hine—and went for a high-end finish. All twenty images were
contact-printed and gold-toned for permanency and placed on 10 × 13
inch all-rag mounts. A descriptive insert with an introductory statement
by Berenice, folded in four, was included in a slipcase.[38]

Abe Lerner had helped obtain paper samples. The cloth-covered
portfolios were made by Spink & Gabor, a classic purveyor of bind-
ings and cases. Ed Schwartz's sister-in-law, who worked there, said
that Berenice's order cost a "fortune"; Pearl Schwartz was astonished
at the sums Berenice had been willing to spend. The subscription offer
was $120 and, upon publication, $150—over $1,300 today. Seed money
was the 18,000 francs (about $500) from licensing use of her Atgets
to the French photo agency Roger-Viollet. It took Berenice until

November to print the thirty portfolios sold through the initial solicitation. Another dozen of the projected edition of one hundred sold though the late 1950s.[39]

The Royal Ontario Museum in Toronto ordered one portfolio and surprised Berenice by hosting a joint Abbott-Atget exhibition that was well reviewed in the *Globe and Mail* by Rex Frost, photographer and host of the national radio show *Camera Club of the Air*. In addition to other expected institutional subscribers—the George Eastman House, the Library of Congress, and MoMA—orders came from art museums in Michigan and Colorado as well as public libraries in Texas and Maine. Art book dealer George Wittenborn asked for a 20 percent courtesy discount on his personal copy in exchange for a mention in his catalog; Berenice put him down for five copies outright for his business, at $96 each.[40]

A. Hyatt Mayor at the Metropolitan Museum of Art gladly ordered a portfolio at full price, praising Berenice's "admirable selection [and] wonderful printing of these all but impossible plates." He hatched a plan to elicit a sponsor for the Met to acquire the entire Atget collection, though something went wrong with this connection. Later in the decade, when Mayor's name arose as a possible contact for placing the collection, Berenice vehemently announced, Irene recorded, "that no one who had refused to buy it would get any [Atgets] after her death. . . . and called them ghouls."[41]

Individuals such as collector David McAlpin bought and helped reach others who might be interested; Ansel Adams cautioned Berenice that it would be "no good to mention me" to purchaser Shirley C. Burden in Los Angeles. Hollywood film writer Ben Maddow asked Berenice to "wait till I get my veteran's bonus (WW 2!) to pay for it." He and Berenice had known each other at the Film and Photo League; since then, he had written a number of screenplays, including John Huston's *The Asphalt Jungle*; under HUAC scrutiny, however, he'd been forced to write pseudonymously. "So many foolish, monumental things are done," poet Marianne Moore said to Berenice. "This really matters." Research by MoMA film

librarian Christopher Bishop helpfully compiled a short list of possible purchasers in the photography and film worlds. Berenice already knew many, but the filmmakers, except for René Clair and Jean Benoit-Levy, were likely new: Cesare Zavattini, Vittorio De Sica, Edward G. Robinson, Fred Zinnemann, and Thorold Dickinson.[42]

The strangest order came from Paul Strand, living in the south of France. As if making a peace overture since their 1944 blowup, he reported he had "at last a real dark room" making it "possible to work and at the same time take a bath." Berenice was grateful for his check and encouraging letter, for "the going here is rough," and promised that Elizabeth, too, would soon write. Upon receiving his portfolio in December, Strand posited the idea to Berenice of more such albums in the future, as twenty prints did not offer a complete sense of the variety of Atget's work—a reminder, to her, of the topical presentations that had occurred to her years earlier. He also commented on the grim state of affairs on the continent, likely alluding to the suppression by Soviet troops of November's Eastern European uprisings, among other conflicts of 1956. More happily, he recounted to Berenice that Jean Cocteau had recently mentioned her while "speaking of America."[43]

In December, Helen Gee held an Atget show at Limelight. Months before, she had approached Berenice in the café about a show of her work, but before Helen could open her mouth, Berenice chimed in about an Atget exhibition. Gee assented, though she knew his work only from reproductions in the 1930 Weyhe book that Sid Grossman had passed around in class. Gee had a fascination with everything French, and both women thought it would be a very salable show. Gee was only later disappointed with the quality of Berenice's portfolio prints (finding them far less rich than the Atget originals she subsequently glimpsed hanging at Commerce Street), while Minor White backhandedly complimented the portfolio's range of subjects only to decry the inadequacy of contemporary printing materials and the eulogistic tone of Berenice's preface. Regardless, from opening day, the modern prints sold briskly at fifteen and twenty dollars each.[44]

In May 1957 the art library of New York's Queens College held a centenary Atget exhibition; in her tribute introducing it, Berenice said, "Paris with *ses misères et ses trésors* lives for us and for the future" through Atget's photographs. However, as usual, she had to chase down various people to be reimbursed for expenses. At a low ebb with her own work, she also approached the college, to no avail, about possible employment. Later that summer, she wrote cordially, if disingenuously, to Beaumont Newhall, following up an earlier proposal to have the George Eastman House buy her Atget collection. "Many people seem to think that is the logical place. I wish we could talk it over. Can that not be soon when you come to New York?" Newhall annotated this letter, "Not ansr'd / filed 7/19/57."[45]

For Crisake – try to sell Atget. —BA[46]

ATGET TOOK A BACKSEAT during Berenice's PSSC years—spring 1958 through 1960. Months after New Year's 1960, Irene and the Duette team independently began helping Berenice print for Atget exhibitions and further portfolios. Berenice tried, unsuccessfully, to recruit photographer Bert Stern as a promoter after he bought an original Atget for $200. An old book idea of Berenice's from 1946, pairing Atget images with text from Marcel Proust, resurfaced when Arthur Trottenberg, then a young Harvard administrator and amateur photographer whose Proust-Atget book had not as yet been conceived, lined up a female graduate student to assist with reviewing the entire collection. She and Trottenberg "will have to move in with me," Berenice said, recalling her experience with Ferdinand Reyher and vowing to "never let the Atgets out again!!"[47]

With second thoughts, she considered transferring the whole collection to Trottenberg's Cambridge home, going so far as to examine the suitability of its third floor for archival storage. Trottenberg accompanied Berenice to New York to pick up more prints, in addition to those already in hand and at Siembab's; Irene had offered to inventory those—to create a proper record but equally to hear Berenice's running

narrative on their subjects, such as "Kitty Cannell's night in a brothel after a fight with her companions." After dealing with Proust heirs, who expected royalties, they signed a contract with Cecil Scott, a contact of Berenice's at Macmillan, in January 1961.[48]

Both Irene and Trottenberg blamed Berenice's emotional attachment for her procrastination in settling the future of her collection. As Robert Marx had decades earlier, they suspected Freudian underpinnings in her rescue and protection of the work. Berenice was starting to let go—incrementally. MoMA in the 1940s and the Met in the 1950s had turned the collection down for lack of facilities and money. Now she was also looking to recoup her investment, for somehow she always owed taxes: "the more income you have to pay taxes on—the higher the tax rate," her taxman wrote in explanation. "Sorry to have to disappoint you, but these are the cold facts."[49]

She was horrified by Trottenberg's suggestion that private funds be found to purchase the Atget collection in honor of Steichen or Stieglitz, or both, for the Museum of Modern Art. The price was set at $50,000 as the Smithsonian Museum of American History began exploring its purchase, though Irene agreed that its representative, Eugene Ostroff, who asked if the Atgets had historical significance, was "a dope, after all." Smithsonian negotiations had fallen through by summer 1962, while Berenice was recovering from lung surgery, despite Marchal Landgren's pursuit of Paul Mellon's Old Dominion Foundation for funding to enable the collection's purchase from Berenice. "The photographic field is a very strange one," Marchal told his friend "Berri" when planning a September visit to Maine. "It certainly needs some new blood in the critical and historical field." Berenice also feared scaring away potential acquirers and warned Landgren against mentioning "deterioration" of the collection. (She was known to drink beer all evening and go to bed with Atget prints spread around her living room.) Their new plan was to deliver an informational package to Lisa Sergio, the WQXR radio commentator, who was to give it to David Schoenbrun, the CBS Paris correspondent, to enlist aid in raising purchase funds; it went nowhere.[50]

Joe Reynolds led young photographer-filmmaker Harold Becker to Berenice about an Atget short film, and in February 1962, they signed a contract. After a screening that November, Berenice questioned Becker's inclusion of so many pictures of prostitutes, though she later toyed with doing an Atget book called *For Sale*, since he photographed so many things for sale, "including the women." John Szarkowski, who had replaced Edward Steichen as director of MoMA's Photography Department, suggested an Atget printing project to place more work in museums, with Dorothea Kehaya of the Association of Heliographers as assistant. Along with Leticia Kent, Kehaya was not quite a formal assistant to Berenice but one of the young women whom David Vestal, a young former Photo League member, called "strong young camera-carriers." Beaumont Newhall quashed the project; Berenice, correspondingly, nixed Newhall's plan to revive Ferdinand Reyher's Atget book.[51]

She'd begun writing her own general Atget book, her first book in a decade, for a Czech publisher's international monographic series, Umělecká fotografie (Art Photography). Her essay had been polished with Elizabeth's considerable help, Berenice said, to "get 'into' it at the beginning and out again at the end." Building on her 1940 extended Atget essay for *U.S. Camera*, she considered the new text a valid statement about photography generally, and a good base on which to build a future longer work. She soon had an opportunity, with the help of Ben Raeburn, whom she'd first met in the 1950s through longtime Village friends Paul and Dorothy Grotz. He had published extensively on Frank Lloyd Wright, and even owned Berenice's portrait of him. She said she never knew "a person with less evil in him" who had made a success of "doing very decent things . . . not junk . . . and he's fun." Berenice was so pleased with Raeburn that she ignored an entrée to Viking offered by the Schwartzes. Ben was happy with their possible joint projects—Paris in the 1920s, science with Bert Little as coauthor, and a redo of New York City (the special interest of Leslie Katz and his friend Hilton Kramer). In 1963, Raeburn began paying Berenice a small monthly stipend against any future royalties.[52]

With the Horizon Press manuscript of 20,000 words due in June 1964, Berenice planned to build on her Czech essay for the introduction to *The World of Atget*. (The format Berenice had outlined a decade earlier to Stanford University Press was essentially the one Ben Raeburn produced.) Elizabeth refused to help, wishing, as she often did, that Berenice had never met Atget, on whom she'd spent too much time already. Though Elizabeth was already quite frail, Berenice insisted she could take care of herself, and took off for Maine to work on a text that became "strictly and entirely" hers. On the way back to New York a month later, Berenice made Irene take the unusual precaution of locking up her house while they went out briefly, to ensure the security of her draft Atget manuscript inside.[53]

For years, whenever Berenice sold any Atget prints, she usually sent Julien Levy his share of the proceeds as per their 1930 contract, and filed away his canceled checks; they were not otherwise in contact. Then, one May afternoon, Levy and his second wife, Jean, surprised Berenice at home. "Levy mess," she noted tersely in her log; former news reporter Elizabeth typed up a play-by-play account after Berenice left home to attend an ASMP event:

> Levy and his wife called on Berenice Abbott early in the afternoon of May 27. They returned later and made a disturbance, which attracted my attention . . . It was Mrs. Levy screaming and waving a piece of paper at Miss Abbott, demanding that she sign it. . . . I casually (and I think ill-advisedly) suggested calling the police to eject them . . . the police came and advised the Levys that if they had any legal grounds, it was for a civil action. Meanwhile, Mrs. Levy kept threatening to call the reporters and make a scandal.

Berenice's lawyer, Philip Wittenberg, cautioned Levy against "a further intrusion." Berenice scrambled to find the 1930 contract along with Levy's cashed checks.[54]

Fearing that Levy would return with "some goons" and take part

of the Atget collection, she enlisted Ed Schwartz and Joe Reynolds to remove the "principal treasure"—the eight thousand "original beautiful prints"—from her Commerce Street studio. The Friday before Memorial Day weekend, they packed prints into random grocery store cartons and loaded them inside Berenice's jeep, displacing some new kitchen chairs destined for Maine. Atget's fragile glass plates stayed behind in their steel cabinet. Driving alone, Berenice arrived around midnight at the Shwachmans' empty house in Newton; she slept until the returning family woke her, in her clothes and not quite sober, Irene thought, on Saturday afternoon.[55]

Berenice and Alan Shwachman completely repacked the cartons of precious Atgets to fit into the jeep with a new kitchen table that Berenice was swapping with one from Irene, along with her large cameras, which had been stored there as well. Early on Sunday, the thirty-first, Berenice drove to Maine, where a local teenager helped her transfer the prints into her house. With the prints thus secured, Berenice headed back down to New York, stopping at Irene's, where she danced to Alan's Louis Armstrong records while Irene read her Horizon Atget manuscript. Months later, Julien Levy tried to schedule the division of their Atgets while he and Berenice were both "still living" and ensure the preservation of his half of the collection, which he assumed was still on Commerce Street "without adequate fire protection."[56]

They pay more for paintings. Don't they? —BA[57]

MONTHS AFTER HER Horizon Press monograph on Atget was published, Chicago educational TV producer Roger Smith asked Berenice to do a show on the French photographer for his *Creative Person* feature. After quashing Smith's plan to include Andre Kertész as well, Berenice flew on June 13, 1966, to Chicago and the Drake Hotel, where she worked six hours straight on her script. Audio taping and filming took place the next day, using photographs Berenice had brought with her. Her interview was authoritative and personable; though she was anxious about

her clothes, a "white wool suit with navy turban and navy silk topcoat," they photographed well under the television studio lights on black-and-white film. After a night plane back to Boston, she stayed over with the Shwachmans, then flew on to Bangor.[58]

Local NET stations throughout the United States broadcast the half-hour Atget program for over a year. Interest in photography history was on the rise. In 1966, George Eastman House curator Nathan Lyons edited an influential anthology of twentieth-century photographers' writings that included Berenice's 1951 Aspen talk. In October 1967, Berenice welcomed Lyons in Blanchard—driving him back and forth to the Bangor airport in heavy rain with broken windshield wipers. There was no further word about Eastman House acquiring the Atget collection.[59]

The University of Texas in Austin had invited Berenice to lecture and open an Atget exhibition in early November. "Hope something comes of it," she wrote to Ed and Pearl. "But good news," she continued, "I found your print and it is so marvelous with the original it goes with that I am obliged to send you both & before 'they' get it." Berenice had never been to the state but had a fan in Texas native John Howard Griffin, the white author of *Black Like Me* (1961), his best-selling account of masquerading as a black man in the Deep South, which civil rights sympathizer Berenice told him she lent to "everybody I could." The Catholic convert and photographer admired her *World of Atget*.[60]

Two days before her Texas flight, Berenice, unwell and restless, came to Newton Center. Irene was out of town, and Harry cared for her, making dinner every night. She left her sickbed to watch a film on TV about the late Dorothea Lange, but gave up because it made her too sad. In Austin, she had a full weekend: an interview for the campus *Men and Ideas* television show and a cocktail and barbeque buffet, hosted by FSA photographer Russell Lee, at which she met many of the university's key art staff. On hand was her old friend Jean Purcell, whose husband was an art preparator for the university.[61]

Once home, Berenice wrote to Donald B. Goodall, founding direc-

tor of the university's art museum, offering the Atget collection—which she would mostly donate to offset the "exorbitant" income tax she would owe—for $117,750. Warren Roberts, director of the university's Humanities Research Center, visited Maine to assess the collection in its entirety. Berenice had toured the center's Gernsheim Collection and believed that the university was mainly interested in the history of photo technology; she said she liked the idea that Atget's "monumental work of art" would join it. Surprised she'd liked Texas so much, she called the Schwartzes and the Reynoldses "you-all" when inviting them for Thanksgiving in Maine, where they ambitiously fixed stuffed goose with turnips. When Marchal Landgren arrived for Christmas, Berenice tasked him with chasing model releases for *A Portrait of Maine*, whose writing had not been going well. Texas, however, bowed out shortly after New Year's.[62]

Many aborted efforts and much energy

have gone unnoticed. —BA[63]

MEANWHILE, THE MUSEUM of Modern Art, through the efforts of Berenice's friend Leslie Katz, had stepped in regarding the Atget collection. Berenice and Philip Wittenberg met in New York with John Szarkowski, offering it for $80,000. Leslie had urged her not to bargain—to accept the museum's counteroffer, sell, and be free. Szarkowski was set to visit Maine in the spring with his wife to review the collection and arrange for its removal after the sale. "Then the research will begin," Irene laughed with Berenice. "And everyone will come consult . . . and they'll send famous people like Diane Arbus to make terrible pictures." Berenice admitted that the time for sale was ripe. Driving down from Maine for one of the MoMA Atget meetings, she'd had to hold the stick shift of the VW in place the whole way, and so bought a new green one in New York to drive back up.[64]

An early draft agreement for the Atget sale dated April 8, 1968, for

$80,000, does not mention Julien Levy's involvement (though back in 1951, to the Library of Congress, Berenice was forthright about his half-ownership) and includes Berenice's future use of the negatives. The final contract, on May 7, 1968, however, was between three parties—MoMA, Berenice, and Levy, whose ancient partnership with Berenice came to light at the museum despite her deliberate silence. The $80,000 purchase funds were provided by Shirley Carter Burden; his older brother, William A. M. Burden, had been president of the museum in the 1950s and was an Aperture trustee, a member of MoMA's photography committee, and a mentee of Edward Steichen and Minor White.

Since 1960, Berenice had thought that Shirley Carter Burden, who had purchased one of her early Atget portfolios, would make a good middleman for acquiring the collection for some institution, because he was rich. The collection would be packed and delivered to MoMA with a first payment of $10,000 to Wittenberg, as attorney, with most subsequent annual installments of $12,000 divided in Berenice's favor. A fourth clause said: "In all announcements or other matter of any kind issued to the public by the Museum wherever the name of Berenice Abbott is referred to, you will refer to the name in equal prominence of Julien S. Levy."[65]

That last point galled Berenice: "Levy and I agreed at the beginning that credit would continue in my name," she wrote to Wittenberg. "Verbally, however. Nor was there any mention in the original contract as to joint credit. . . . If Levy had lived up to his part of the contract and done most of the work which fell upon me, I would not object." Later, she would explain that Levy had come in after the fact, both times; "in exchange for the $1,000 he had lent me in 1930, he gets a big chunk of this. He's already a rich man, you know. It's all very amusing."[66]

After an unsatisfactory phone conversation with Szarkowski about publicity, and lost mail from MoMA containing a draft press release, news of the Atget acquisition ran in late September 1968 without Berenice's input. Implicit in the deal were exhibitions for both Atget and, begrudgingly, Berenice fumed, her. The acquisition news reanimated

Julia Reiner, who had been pursuing Berenice since publication of *The World of Atget* in 1964 to recoup her decades-old investment. In July 1969 Berenice sent Reiner a token check, which Julie accepted, although she still wanted a written agreement to "clarify my interest in the collection . . . which will be fair to both of us. . . . Your memory is as good as mine. . . . I could well insist on an amount equal to what Julien Levy is getting." Eventually, Reiner was "willing to settle for half of what you have to pay him, namely $10,000 or 12½% which is a small enough return. . . . Neither of us are spring chickens." Berenice paid an agreed-upon share, annually every April, for several years.[67]

After the Museum of Modern Art purchase, Berenice admitted that she had neglected her own work to boost Atget. "I am not a self-sacrificing person . . . but it just happened. People would look at the Atgets and they would be exhausted and pleased and happy about it, and I was glad they were. And there wouldn't be anything left over for me . . . What could I do about it? Nothing." The one action Berenice could have taken—to get rid of the collection sooner, on terms other than her own—was unthinkable; to her, the archive embodied its creator, and she felt beholden. "I couldn't just throw [Atget] out the way the Photo League threw out Lew Hine," she said, referring to the group's treatment of the pioneering social documentarian's archive. "They threw him out and left him out on a balcony" at League headquarters; "I'd have taken much better care."[68]

The sale proceeds allowed Berenice to improve her Moosehead Lake camp—with a dock, a furnace, and new wiring—and to buy two Nikon camera bodies and a Mamiyaflex, with three lenses for each brand. She experimented with tape-recording random voices and sounds such as rain showers, and enjoyed listening to a "new love," Charles Ives, on LP. For her second full winter in Maine, Berenice was assisted by a young Canadian, Lionel Stevenson, and his skier wife, Sue.[69]

There was no news from former assistant Cathleen Bingham, but Berenice's social life was nonetheless busy. Margaret Bennett and Conchetta Scaravaglione visited separately; the latter and Berenice con-

sidered plans to work and live in each other's studios and homes and even collaborate. Other friends at this time of exuberance were Jean Garrigue; Jean Purcell and her husband, Nierendorf; Jack Lewis; Kay Harris; David Vestal and his wife; Dennis Traub, from Philadelphia; Addison Metcalf, with whose family Berenice spent the Thanksgiving of 1968; and also Ed Fountain, whose octogenarian mother, Henriette, was the wealthy woman in *Nightwood* who had supported and then rejected Thelma Wood.[70]

Berenice may have initiated, in Maine, a modified version of the open, happy lesbian life that shut down so dramatically when she returned to the United States in 1930. "I haven't seen so much fun since the roaring 20s," she wrote to Marchal Landgren, "only this is more roaring and primitive.... there has been some mighty friggin dancing going on. I'm not sure what friggin means but the word around here is legion.... The Charleston did not compare with this goof — Anyway, it is vital and if I weren't so darned old, I'd get up more.... But only in Maine could this be." Her three post-PSSC science books had paid for long-needed house modernization and an updated darkroom with powered ventilation. The five lean years between the end of PSSC and Elizabeth's death were definitely history.[71]

HOTCAKES

New York and Maine (1962–75)

If you are still startled or discomfited in hearing
photographers spoken of [as great artists] you are simply
late—historically, esthetically, late—in recognizing
one of the artistic glories of our own epoch.

—HILTON KRAMER[1]

Watch out for photography dealers. They expect a whole new
turnover every three years because most of their customers are rank
amateurs who think the camera makes the photograph. —BA (1971)[2]

In 1962 Beaumont Newhall, A. Hyatt Mayor, and Ivan Dmitri, of Photography in the Fine Arts (PFA), an eccentric organization to promote fine-art photography via eclectic juried exhibitions, persuaded Berenice to send four science prints for their competition. The following year, her long association with Atget admirer Henry Holmes Smith, a photographer-educator at the University of Illinois at Urbana-Champaign, led her to exhibit as part of the school's 1963 Festival of Contemporary Arts, where she was the sole woman photographer.[3]

That year she also acquired a private dealer, one of her last New

School students, Jerome S. Miller. He worked directly with collectors and interior decorators, and suggested—unsuccessfully—that Berenice lower her prices. She first gave him Atget reprints and portfolios for his inventory, but soon added her own Paris portraits and New York scenes. He quickly placed portfolios in several institutional collections and was working on a mural commission for a government building using science photographs; the bid involved much red tape but went nowhere. Berenice also tried to place portfolios with photographer Richard Jaquish's fine-photograph lending service in Madison, Wisconsin. By February 1964, Miller gave up being a dealer to take a salaried job, leaving his assistants to sell Atget prints; they last placed a portfolio in early 1965.[4]

In late 1968 an enterprising young couple, ASMP member Bob Greger and Laura Greger, sought to represent Berenice in their Miami-based contemporary fine-art photographs business. Younger photographers saw opportunity in Bob Greger's "dream plan" for gallery sales of their contemporary prints, but he got off on the wrong foot with Berenice by touting a cache of original *Changing New York* prints, supposedly picked from the abandoned effects of an elderly Abbott relative.[5]

Simultaneously, another young photographer, New Jersey–based Lee Witkin, started what became an art world revolution, by planning a first for the Upper East Side art scene, a gallery devoted solely to photography. He approached Berenice right after New Year's 1969. When she accepted Witkin's proposal to exhibit and sell modern prints, her own and Atget's, she became one of the most established photographers in Witkin's stable and, with the Atget boon topping all sales, effectively launched today's still-ascendant art photography market. She was able to provide Atget prints despite sale of the collection to MoMA for several reasons: She had held back some originals; she had printed others herself over the decades; and she generated more from copy negatives she had made from the glass originals. The first consignment of Atget prints sold so well—"like hotcakes," Witkin said—that he lifted their retail price ten dollars, to $50. The 1922 *Cour, 7 rue de Valence*, picturing a snazzy parked auto, sold as fast as Berenice could make prints, some

Lee Witkin and gallery artists at home of collector Dan Berley, Long Island, New York, July 9, 1981. L–R: *André Kertész, Berenice Abbott, Lee Witkin, Manuel Alvarez Bravo, and Lisette Model.* Dr. Isidore M. Samuels

fetching $100 each. The success of Berenice's Atget prints, "sales wise," Witkin said a decade later, "set the pace for the gallery's future."[6]

Within weeks, Witkin paid her $1,000.00 for thirty Atget prints and $333.33 for the sale of an Atget portfolio, with orders on hand for three more. Understanding that darkroom printing was burdensome for her, he warned clients about possible delays. After she supplied "slews" of her Paris portraits and Atget's popular *Street Singer*, she asked Witkin to raise her prices for 11 × 14s to $100 ("—each" she clarified), because her old negatives "scuffed from all the moving around . . . are <u>hard</u> to print!!!" He agreed.[7]

She was also busy preparing for a solo retrospective at the Smithsonian Institution's Hall of Photography, *Women, Cameras, and Images III*; it opened on her seventy-first birthday and ran through mid-October 1969. (It was also the summer of *Apollo 11*, the first moon landing: "I think we all went to the moon," Berenice said of this powerful collective monument.) The *Washington Post* sent young Style Page writer Meryle

Secrest to Maine to interview a seemingly visitor-starved Berenice. It was some five years before the first of Secrest's many published biographies. Berenice clearly warmed to her, even showing her how to use her own Mamiyaflex for a candid portrait to illustrate the article.[8]

Berenice visited her sister and niece in Cleveland in September. Despite a wide female circle of friends and visitors, she was often lonely in isolated central Maine, but found New York overstimulating. Aging and the deaths of a few neighbors left houses standing empty or derelict in tiny Blanchard and made her gloomy. She had become a local character, known for such imperious behavior as honking her car horn a block from the general store, so that someone would be ready to pump gas the moment she pulled in, or terrorizing a grocery cashier during checkout. In a state that still voted predominantly Republican, she was generally assumed to be one of the few Abbot town residents to vote Democrat; she acquired a like-thinking friend when aspiring writer Jack Sullivan moved into his family's summer cabin. He called her the "Bad Baroness Berenice of Blanchard."[9]

When the Museum of Modern Art's debut Atget show finally opened in December 1969, Szarkowski emphasized Berenice's rescue of the collection in labels and press materials. (Levy's portion of MoMA's scheduled payout still made her incensed.) MoMA offered one hundred duplicate Atget originals (not prints by Berenice) for sale through the Robert Schoelkopf Gallery on Madison Avenue; simultaneously, Atget prints made by Berenice were on sale at Tom Halstead's new gallery in Birmingham, Michigan, north of Detroit. Her income for 1969 also included the trust share left by Elizabeth.[10]

Though financial hardship had forced a Spartan lifestyle for decades, Berenice had always welcomed luxuries and small comforts. She did not spare them when they could be afforded and particularly enjoyed practical, quality things—Design Research, L.L. Bean, and Eddie Bauer (both then still made-in-America expedition suppliers)—but also some antique pieces. Her work ethic and unwavering commitment to her art precluded planning meals or seeing to finances, and she didn't spend

much time on fashion and jewelry, though she enjoyed them all. Soon she would be able to have them.[11]

Berenice's new income enabled long-desired improvements at Blanchard, such as a new woodshed, a kitchen with a big ceramic stove and sink, and a terrace paved with tree trunk slices instead of slate over fine gravel spread on the ground. She took a course on navigation. After her first solid year out of New York City, she had sought Joe Reynolds's advice on buying a boat. Sol Libsohn, her former colleague at the Photo League, had brought a little Boston Whaler with him on one of his Maine student trips and launched it at her Moosehead Lake property. She then finally got her own boat, but almost drowned when she forgot to put the plug in the bottom. The craft was knocked to pieces on lakeside rocks. Now she bought another.[12]

Always interested in antiques, she sold her big Wall Street rolltop desk and replaced it with a smaller one, adding a horsehair-upholstered chair. Additional filing cabinets in her office still left papers and photographs spread all over. She bought an old slate school blackboard for her Greenville cottage terrace, where she also added a back bedroom and hung a nineteenth-century mammoth-plate albumen print travel view of the Colosseum.[13]

She had enlisted the Schwartzes' help in the summer of 1968, when it had seemed she would have power of selection for the retrospective promised by MoMA. Ed washed and dried prints and helped her choose the few that met her high exhibition standards; all others were ruthlessly ripped to pieces and thrown into a soon overflowing darkroom trash bin. After her retrospective was delayed, she borrowed ten of her original *Changing New York* negatives from the Museum of the City of New York in March 1970, to make additional prints; this started a contentious saga that would last for years.[14]

In late October Berenice finally saw her finished Horizon Press monograph. Muriel Rukeyser wrote the appreciative essay that Grace Mayer wouldn't. David Vestal, a colleague at the New School, provided the back matter: As a young man in 1949, respect for Berenice had

led him "to put on a suit and tie to visit her at Commerce Street." The choice of Vestal had been Lisette Model's "inspired idea." For thirty years, Lisette had championed Berenice, so much so that a student shared his memory of her once lecturing how "Berenice Abbott is the most impressive American I have met. In fact, she is the only impressive American I have met."[15]

Ben Raeburn sent Model a copy, saying that he wished he could see Berenice's face as she read her own; she was unwell again and unable to come to New York. She sent a copy to a dying Margaret Bourke-White and by November was well enough to visit Thelma Wood in Madison, Connecticut, a month before Thelma died of cancer. It had been a long road from Wood's daylong, alcohol-fueled "dinner parties," which often saw guests quite drunk in bed by the time Thelma began at the stove, only to finally cry out, "Dinner's ready!" at 3:00 a.m.[16]

> What impresses me greatly is the vast amount of creativity
> that could have been added to the store of human well
> being and development – but instead has been wasted
> and ignored – defeated by the super dreadnought of
> a vicious society, vicious in its destruction of what
> in man is its most precious possession. —BA[17]

BERENICE'S MOMA RETROSPECTIVE opened on December 10 in the third-floor Steichen Gallery, with a separate reception for the Horizon Press book in the Founders Room. "Disgusting" was Berenice's word for tall, lanky Szarkowski's "Aubrey Beardsley" act with trustees, as she described his having draped his long arms over their shoulders. She was appalled by his eccentric and unrepresentative selection of her sixty-two prints, and wondered if he was trying to destroy her reputation. Or perhaps sabotage it by scheduling within weeks a huge Walker Evans show on the main floor. Hilton Kramer called her work "precise, complex, poignant and strong," and singled out her PSSC pictures for their "daz-

zling synthesis of art, nature and photographic technology." A month after the opening, though, it was still necessary for Irene Shwachman to plead: "For Heaven's sake, for Miss Abbott's sake, for the sake of science, and even to lend variety to a display that needs it, please re-hang the photograph of the flying wrench. . . . The image should be horizontal, not vertical."[18]

The Horizon Press book and MoMA exhibition prompted *Harper's Bazaar* to place Berenice on its list of one hundred outstanding women, a gossipy honor she found less than impressive. Meanwhile, money kept pouring in from gallery sales, and Berenice took depreciation deductions for her studio and the cottage to offset her burgeoning income, which still included an annual Atget collection payment. Home improvements included a new roof, siding, paint, and slate steps. She replaced her old moth-eaten piano with a brand-new spinet, claiming she was meant to be not a photographer at all but a musician. Jack Sullivan had studied piano seriously and admired the pianist Myra Hess: "Shades of Myra Hess. (Ah, how I loved that woman!) But I have not the heart to remind Berenice that she is not Jewish." When Sullivan loaned Berenice Hess's 1966 memoir, he mused, "I suppose Bun will ask me if Myra was a Lesbian, and I will reply that never was there a breath of scandal attached to that good woman's name. Bun will ask me if I think it is scandalous to be a Lesbian, and I shall say, 'Of course it is,' and then oh dear."[19]

For $6 a week, Berenice took weekly piano lessons with Michael Burgess, a teacher from Skowhegan; in the spring, Ed Schwartz, himself a solid amateur, and Pearl encouraged Berenice, "among friends," to show them her musical progress. Slowly but rhythmically she played the carnival part of Offenbach's *Orpheus in Hades*, the can-can theme, thrilled to make recognizable, cadenced music.[20]

When she saw the new *Ms.* magazine, she seemed surprised, and a bit encroached upon in her defiant isolation as a feminist, to learn of the uprising of baby-boomer women. "I love to see young people's work, see where they're at, see what they're up to . . . America [is] . . . in a state of transition, and if young artist-photographers can photograph it, their

work will be true and important." But when Cornell Capa, founder of the International Center of Photography, talked Berenice into lecturing in the NYU series "The Concerned Photographer III," she immediately regretted it and advised him to tell young people "to go out and work and take pictures, and stop talking. . . . I hate it."[21]

The Metropolitan Museum of Art brought out her *Night View* as a 20-cent card for Christmas; Berenice faulted every aspect—size, cropping, format, and paper stock. Nonetheless, she used her supply, received in lieu of a fee, for correspondence. Her work also appeared in *Ten New England Women Photographers*, at Wellesley College, as she kept printing photographs and signing mount boards for Witkin. Ineffectually, she asked Solita Solano for a way to contact "wonderful" *Second Sex* author Simone de Beauvoir, hoping to photograph her in Paris for better portraits than those she'd seen. Nearing the five-year mark as a year-round Maine resident, she received a Skowhegan Fair blue ribbon for a solo show.[22]

When Carlton Willers, a former NYPL Picture Collection assistant under Romana Javitz and a confidant of Andy Warhol, approached Berenice about exhibiting in his two-year-old Upper East Side gallery, starting with Atgets and Paris portraits, she told him delightedly that it would pay her winter fuel bill. Berenice's income was almost more than she knew what to do with. It afforded additional Blanchard amenities such as an automatic garage door opener and heating upgrades. It also fueled her growing passion for real estate; she bought three large adjacent waterfront lots a few miles east on Lake Hebron in Monson from her neighbor Howard Thompson. She first called the property Stark Hollow, concocting a chart for its numerological values, then changed it to Inglenook.[23]

She appeared in Anne Tucker's *The Woman's Eye* (1973), disparaging the book's thesis as only biological. "I don't care if you are a mathematician or a scientist," she said, "there are a great many social factors that guide women in one direction, but this is . . . not human nature. . . . a good psychiatrist like Adler will tell you that. They're cooked by the

age of four. . . . They didn't even get to first base to find out who they were. . . . There is good and bad of everything. It has nothing to do with their sex. Competition or prejudice is ridiculous with one's own species. There is no species of animals that discriminates against half of itself." She added, "It doesn't mean we're inferior." She also noted that she appreciated men's superior lifting capacity. For Berenice's portrait photograph in Tucker's book, Irene had copied her sultry 1921 Man Ray portrait using a 35mm camera. Berenice was still a portrait photographer with no suitable pictures of herself.[24]

In September 1973, she finally had her long-promised solo exhibition at Witkin Gallery, a show of "impeccable" prints better, she thought, than MoMA's in 1970. Hilton Kramer called her, at seventy-five, "one of the truly remarkable figures in the history of 20th-century photography." Following the opening, Witkin took Berenice for an evening at Maxwell's Plum, the flamboyant singles bar and trendy Upper East Side restaurant that symbolized two social revolutions of the era—in sex and food. Berenice, rarely satisfied with the latter, scribbled recipes for Moroccan Chicken and Shrimp à la Grotz, crediting them to her Village friends Dorothy and Paul Grotz, who had introduced her to Ben Raeburn and who soon visited Blanchard.[25]

> He's a high flying live wire . . . grass doesn't grow under his
> feet . . . thinks in big terms, moves around in big ways. —BA[26]

IN SPRING 1973, a major financial opportunity came "out of the blue from a stranger"—Robert Feldman, a former SEC enforcement attorney who had become an entrepreneurial print dealer. In 1970, his Parasol Press had issued Ansel Adams's *Portfolio V*, which helped launch the modern market for editioned photographs—a limited and numbered series of prints. Feldman asked Berenice about making forty-six more Atget portfolios, completing her projected edition of 100. He offered cash up front, as opposed to following Witkin's consignment practice.[27]

Executing the portfolios was a problem. Berenice's work on them for Witkin had stalled because she had been printing on an India paper, an old Ansco product no longer manufactured. Serendipitously, a solution arrived in the form of the multitalented Hank O'Neal. An aspiring photographer and former army intelligence officer working with the CIA, he met Berenice just months earlier while researching jazzman Eddie Condon, whom her former student Genevieve Naylor had photographed in the 1940s. Berenice told O'Neal that if he ever got "a real camera" she'd teach him how to use it. (When apprised later by Hank of Walker Evans's use of a Polaroid SX-70, Berenice said to tell Walker "not to play with toys.") Hank soon returned to Maine with an 8 × 10 Deardorff view camera. She demonstrated tilts and swings, sketched a diagram of lenses and light to show how the image appears reversed on the ground class, and then abruptly said, "That's enough of that." He called her "a barrelhouse girl."[28]

For the CIA, O'Neal had worked with organic chemist Juliette Moran at the giant materials manufacturer GAF, Ansco's corporate and photographic successor. Moran had risen through the administrative ranks to become one of the most powerful American female executives at the time, a senior vice president and the executive assistant to president Jesse Werner. She had discovered photography at MoMA as a college student and owned an Atget portfolio print depicting the Paris street where she had lived as a toddler with her expatriate family. Moran contacted a responsive GAF lab manager in Binghamton, New York, explaining that not only did they all share an animosity toward Kodak, but that only the rare Ansco paper gave Atget reprints the right look. A grateful Berenice soon began printing from a stash of the precious archived India paper.[29]

Bob Feldman's ambition expanded beyond Berenice's Atget portfolio edition. He supported her wish to photograph New York City street traffic and imagined a Parasol Press edition. Twice, Feldman provided his convertible Porsche and a young artist he admired, Todd Watts, to chauffeur Berenice among the city traffic. She wanted to recapture over-

head views of crowds, as she had at Herald Square and at Fifth Avenue and Forty-Second Street in the 1930s but now thought traffic less jammed and crowds uninspiring. As earlier, fear of suicide jumpers kept her from readily accessing tall rooftops to photograph from on high. The ordeal was unsuccessful whether she photographed from the car or the street with her familiar Rolleiflex cameras or a new 4 × 5 inch hand-held; Berenice blamed blurred pictures on a faulty cable release or an unfocussed film pack.[30]

A neighbor of Berenice's, a retired army supply officer and Maine native named Doane Eaton, who shared a fascination with electricity, rekindled her interest in photographing the state. She tried to get Macmillan to account for sales of *A Portrait of Maine*—reportedly out of print, but actually lost in the warehouse—and place it in local stores. Eaton also inquired on her behalf for the possible purchase of a used telephone company repair truck as a suitable expeditionary vehicle.[31]

Berenice's small exhibitions in 1973 and 1974 included a solo one at the University of Massachusetts (Boston) Art Gallery in its "Photographic Perspectives" series. In advance, fledgling journalist Kay Larson drove with friends to interview Berenice in snowy Maine for Boston's alternative *Real Paper*. The seventy-five-year-old photographer with "startling glacial turquoise" eyes seemed decades younger. Larson's boyfriend, a Maine-born photographer, couldn't believe that Berenice wasn't also a native. Opposite her big Portland stove hung a *National Geographic* map of the moon, on which was pasted a magazine photo of a long-haired blonde holding a sign that read, "Eve was framed." They polished off two bottles of sherry before "the BU kids," as Berenice misidentified them, headed back. In Boston that May, Berenice opened her series lecture by saying, "I'm a photographer. I don't talk." Then she sat back down, entertaining questions and speaking extemporaneously for her $400 fee. She'd earlier skipped a Maria Callas concert as too pricey.[32]

Witkin raised Berenice's prices again in 1974: 8 × 10 for $150, 11 × 14 for $200, and 16 × 20 for $250—as orders kept "rolling in" from individuals and institutions. Weekly print orders were typically a one- or two-

page list keyed to images in the Horizon Press monograph, with best sellers starred to indicate those needing back stock: portraits of Joyce, St. Vincent Millay, and Atget; *Changing New York* images *Warehouse*, *Fifth Avenue Houses*, *Hardware Store*, and *Newsstand*; and *Transformation of Energy*. Everyone wanted a *Night View (New York at Night)* print, but as Witkin pleaded, "We can't sell them if we don't have them." There were two big institutional acquisitions in 1974, by the Hallmark Collection (in Kansas) and the High Museum (Atlanta). That spring Berenice's "crazy attitude" toward finances caught up with her again, Irene later recalled, as the IRS charged her an underpayment penalty. Berenice realized that she would have to attend more closely to her steadily rising documented income.[33]

In early January 1974, she accepted an invitation from Chicago lawyer and amateur photographer Arnold Crane to fly to Washington for an exhibition of his. Crane had interviewed and photographed Berenice five years earlier. His show was being held simultaneously with one by Man Ray, and Berenice hoped that Man Ray might attend. She was shocked by Crane's "simply ghastly . . . terrible portrait" of her. He had secured a surprise portrait photograph commission for her in Paris, but flu kept her from traveling.[34]

While in Washington, Berenice met Harry H. Lunn Jr., another ex-CIA man. Finding photography "fertile ground and not that expensive," he'd begun a print dealership that operated more like a conventional retail gallery. The two hit it off, Berenice trading a few of her prints for a large view of Rome by the mid-nineteenth-century Bisson Frères; she accepted Lunn's tentative offer of a gallery show early the following year. In July 1975, Lunn traveled to Maine, where he selected one hundred vintage prints for his gallery; she "always liked round numbers," and likely his cash-up-front deal as well. For $200, he also bought her *Cocteau's Hands* as a valentine gift for his Parisian wife; he kept his gay life a secret from her, but not his art photography world, for decades.[35]

Meanwhile, Berenice was juggling terms for a formal portfolio of her work with Lee Witkin and Daniel Berley, a collector. She complained

that her $3,000 advance against $15,000 was too low, and wanted Hilton Kramer to write the text. They were ready to begin printing by May, but Berenice, who relished enlarging her old negatives to scrutinize their rich detail, had been struggling simply to keep up with the high volume of gallery orders. In her mid-seventies, she found darkroom work both physically and mentally exhausting.[36]

When the abortive traffic-photographing attempt in New York ended, a frustrated Berenice recruited Watts to print multiples of near-identical, high-quality enlargements. She had been trying to make half a dozen prints of an image in one exhausting darkroom session—"the popular ones [went] so fast," and she felt "less and less capable of standing in the darkroom all day long." Todd's streamlined, highly organized system began with Berenice selecting her best print of a specific image and telling him what she still didn't like about it; he would then address those concerns until she was satisfied, creating a model print for further production.[37]

Dan Berley, a successful builder of postwar housing in Queens and Long Island, had enjoyed photography as a teenager and began collecting in the mid-1960s. In June 1974, he sent Berenice his list of image selections and promised processing chemicals as well: one ounce of gold chloride and one pound of sodium thiocyonate (which Berenice knew as rhodanide); his, he noted, would double the Kodak GPI formula.[38]

Mounting boards and production supplies arrived almost daily for portfolio and other prints. Berenice favored Brovira paper made by Agfa and blamed the mid-1970s silver shortage for the generally poor, thin quality of photo paper emulsion, which she felt lacked intensity. Boston suppliers agreed to ship paper on account, but she could no longer get her favorite German Ilford Fabobrom developer, hoarded as far back as the PSSC days. She was using Ilford's Pro Micro now, which, though faster, was also very expensive: Berenice always bought the best materials; the work was "difficult enough" without the sabotage of "inferior stupid materials." Two years later, she complained to a French

manufacturer "that your decision [to cease production] is not yet irrevocable. I have depended on this material since the 1920s." After she sent the portfolio prints, Dan Berley, while mindful to praise her quality standards, sent back a few for "spotting," that is, routine touch-ups of normal, random surface-mark issues.[39]

Lisette Model had recommended a friend, Lynn Davis, who spent the summer of 1974 as Berenice's unpaid darkroom apprentice, occupying the Moosehead Lake camp with her painter-teacher husband and their young son. Davis was responsible for washing prints, the water piped in from the Piscataquis River, which ran behind Berenice's house. She appreciated Todd's darkroom professionalism, especially given the circumstances. At the same time, she reviewed every detail, down to the gold toning, and found him rushed and careless on occasion. Berenice liked Lynn but grew impatient with "teaching and answering all the time"; she didn't even thank her at summer's end. When Berenice and Todd later once fought, she chased him out with a broom, and he vowed never to work in her darkroom again. (They subsequently reconciled and he went on to become an independent, internationally successful artist-photographer, based in Blanchard.)

Art historian Anne Tucker visited that summer, too, to interview Berenice about the New York Photo League. Like other assistants and guests, Tucker and Davis sometimes prepared meals as requested; the kitchen was chronically undersupplied, and finicky Berenice would sometimes reject the food. Since the early 1970s she had entertained the idea of hiring a housekeeper. Doane Eaton even offered to vet local candidates from the Maine state employment office, but the primary obstacle was Berenice's reluctance to "have somebody around all the time" getting on her nerves. As a result, visitors and photography assistants picked up the slack ad hoc.[41]

Lida Moser, who had been Berenice's assistant in 1947, next came to help print. She found the experience "both exhilarating and grueling" and setting up in the darkroom almost a "purification rite." Prints had

to be kept faceup in developer, rather than turned over in the tray, to avoid creating or trapping air bubbles that might cause uneven development. Before air-drying, prints were propped on a smooth waterproof surface (angled at 60 degrees) to drain, then gently wiped with a clean towel; Berenice eschewed the more common heat dryer and thought blotter books would contaminate prints. A fourth assistant, a Frenchwoman named Brigitte Monrot, worked briefly on the portfolio prints. The Witkin-Berley portfolio was finally issued in April 1976, a full tumultuous year later.[42]

As the market for Berenice's work had expanded in the early 1970s, her relations with the Museum of the City of New York over use of *Changing New York* negatives became more strained. Arrangements with photography curator Albert K. Baragwanath had been informal; at one point Berenice may have had as many as fifty original vintage negatives in her studio. In September 1974, the Witkin-Berley portfolio prospectus cited three images from the series—*Fifth Ave at 8th Street* (that is, *Fifth Avenue, nos. 4, 6, 8*); *Blossom Restaurant*; and *Factory Warehouse, Brooklyn*. A memorable screaming fight followed, with Berenice calling Baragwanath her worst epithet, "a male chauvinist pig." A formal agreement was reached, with original negatives released in exchange for her return of others on a rotating basis. The deal nonetheless saddened Berenice. "It's a wicked, wicked thing. . . . They have no right. . . . It's like cutting my arm off, my whole livelihood, now when I'm selling prints," she said in the summer of 1975. She also received no reproduction fees from the museum when they licensed a *Changing New York* image directly; "it's my capital and it's taken right from under me." The next curator, Steve Miller, tried to meet Berenice halfway and took charge of the collection's disused records and storage.[43]

Nineteen seventy-three had seen the death of Berenice's sister, Hazel, and her friend Marc Allegret; 1974 saw the death of Dora Omankowsky. The year also marked the final installment payment for the Atget collection and the liquidation of Berenice's share in the John Noble Trust,

Elizabeth's legacy, for nearly $16,000. Just for the fee, she said, Berenice did her first teaching in more than a decade at summer's end—a week at the Apeiron Workshops in Millerton, New York; she declined their invitation to return the following year.[44]

Her new objective was to fund new wells and electrify the log cottages under construction since spring on her Lake Hebron lots. One was big and well winterized, with a basement and second-story bedroom, the other more modest. Though the bathrooms in each included a bidet, the exotic fixtures were a nod to her Paris years and decades of makeshift facilities at Commerce Street and Blanchard. They were "the wonder of the county," Jack Sullivan observed, "referred to far and wide as 'Berenice's bugwasher.'" A local carpenter mistook one for a toilet. After sharing a six-pack of malt liquor one afternoon, Berenice and Jack toured the property. Stopping at one of the bidets, she cheerfully explained its purpose, Jack wrote to Coby Britton: "See? You set your little poosy over this spray, get the water going like this, and presto! You have a nice, clean little twattie."[45]

At Thanksgiving, Berenice received the Maine State Award from the Commission on the Arts and Humanities. Governor Kenneth M. Curtis commented at the presentation dinner, "When her camera meets subject, something like a pistol shot confrontation occurs. A straight-on style is her unmistakable hallmark." The metaphor fell unintentionally close to home. Berenice kept two handguns in Maine, an automatic and a pistol, originally in fear of an attack on the Atget collection. She'd brought them with her when she moved permanently to her isolated property in Monson, and always slept with one under her pillow. She once asked a visiting Ed Schwartz to load them for her. He was struck by the contrast inherent in a woman who couldn't bear suffering or hurt animals—Berenice had to have him unhook the little fish she caught on their Sheepshead Bay, Brooklyn, fishing excursion—but would use deadly force against another person. She still had the guns in 1984 when her soon-to-be companion, Susan Blatchford, fearing Berenice would shoot herself or a visitor, made her get them out of the house.[46]

Berenice in her new Lake Hebron home with her cat Butch, Monson, Maine, ca. 1975. George Daniell

You can make millions of pictures but if they don't get printed
what good are they? Printing is all your life is worth. —BA[47]

THE MAY–JUNE 1975 ISSUE of *Museum News*, with Berenice's *Night View* on the cover, focused on photography collecting, reflecting its art-marketplace ascent and the institutional implications. In September, a public symposium, "Collecting the Photograph," took place in New York, with panelists representing the worlds of museums, collectors, and dealers. Among them was Harry Lunn, with more than half his overall volume comprising photographs. His Graphics International Ltd. partnered with the well-established Marlborough Gallery on New York's West Fifty-Seventh Street, and Berenice began realigning her

business interests toward him. Lunn felt that Witkin's unwillingness to invest up front had cost him representation, first of Ansel Adams and later of Berenice—though, indeed, she mocked the "hurry up and buy them!" fire-sale urgency of Lunn's promotion of Adams.[48]

The increase in sales did not prompt Berenice to put down her camera. Corcoran Gallery curator Jane Livingston phoned about participation in the museum's bicentennial series, *The Nation's Capital in Photographs, 1976*. As was her practice, Berenice jotted details on a handy sheet of paper (in this case Ben Raeburn's solicitous letter inquiring about her new business settlements). She hoped to leverage the assignment: "a new enlarger, all materials incl gold and mounting, an asst, a new lens, one pix to Hank O'Neal if I use his camera, otherwise a new camera, some adjustment in case of inflation." In the end, however, only younger photographers participated in the show's documentation of Washington.[49]

Lunn arranged with Bob Feldman to split the remainder of Berenice's 1956 Atget portfolio edition and, bringing in the Marlborough Gallery, sent staffer Paul Katz to Maine; he wanted to reassure Berenice that the gallery, despite a recent Mark Rothko estate scandal, was financially sound. The two had a history: A decade earlier, as a City College student and Guggenheim Museum photographer, Katz had been inspired by Harold Becker's Atget film to visit Berenice. He was unprepared for her mannish outfit of trousers and oxfords, and hoped that their mutual admiration of Frank Lloyd Wright helped endear him. There had been talk of the Guggenheim's acquiring her Atget collection, but it went nowhere with the administration; Berenice and Paul had also discussed a plan to fill the museum's individual bays with Atget enlargements so that viewers could meander down the ramp as if through his Paris. In the end Berenice agreed to accept monthly payments from Lunn and Marlborough, based on changes in the consumer price index, for 1,300 extant single Atget images printed by her, and to cease printing from negatives she still owned.[50]

Berenice was interviewed in July 1975 as the pilot subject for an oral

history project on senior American photographers. Encouraged by Beaumont Newhall, the effort grew out of the research conducted by James McQuaid, David Tait, and Steven Lewis—three young photography MFAs with social sciences backgrounds—for their 1973 handbook *Photography: Source & Resource*. Berenice was chosen first because she was older than their other "targets." She also lived conveniently on the East Coast, provided a good cross section of history (1920s Paris and 1930s documentary), and produced work they liked. Her Atget association was another source of appeal.[51]

Tait and McQuaid had compiled a detailed chronology, helped by Ben Raeburn, Grace Mayer, and John Szarkowski, among others. (McQuaid felt that Szarkowski homophobically belabored Berenice's relationship with Elizabeth, as if to disparage her.) The pair were en route to Maine when Berenice got cold feet and, too late, tried to cancel. She nonetheless received them, McQuaid said, as "two nice young men." They asked no favors during the three-day interview, except for a request that she sign a friend's copy of PSSC's *Physics*, and seemed to hang on her every word. She had ignored their long chronology, however, fearful it would "rile her up too much." Later, its detail shocked her and led to depressing musings of her lost "potentialities." Two years later Berenice approved the very lightly edited typed transcript.[52]

BARRELHOUSE GIRL

New York and Maine (1975-83)

*It seemed, at first, a shaky business. But now, a decade
after taking its first tentative steps, the collecting
of photography is as safely ensconced a cultural
phenomenon as the collecting of other art forms.*

—JOHN DUKA[1]

Since last summer I have been in discussion . . . regarding
sale of my personal collection of prints and long-term
relations for the sale of future work. —BA (1976)[2]

Elizabeth had begun placing her papers with the Archives of
American Art in 1956, a decade before her death, a fact that Bere-
nice had barely acknowledged. The death of friends—including
Walker Evans's, in 1975—signaled that the time had come for seventy-
seven-year-old Berenice to think about settling her affairs. On the heels
of the Atget archive sale, she had recognized that her own life's work,
with no rescuer in view, would be threatened with oblivion after her
death. The new Center for Creative Photography at the University of
Arizona in Tucson, with Ansel Adams and others of their generation on

board, offered to buy Berenice's papers and a robust selection of vintage prints. They could not come to terms.[3]

In July 1975 Berenice drafted a letter of commitment to Paul Katz, representing Marlborough Gallery, and to Harry Lunn to continue discussion of her "existing prints, negatives, papers, publishing rights during my lifetime, and posthumous publishing rights in a way which will permit my financial security during my lifetime and the preservation of the artistic integrity of my work after my death." Harry considered this a "deal to buy everything in Berenice's files"—though as he soon acknowledged, "not getting it all." As Paul Katz had said, "With Berenice, you don't get everything." The disposition of Berenice's archive would take another nine years.[4]

Berenice's secluded log house on Fire Lane 2 off the Blanchard Road in Monson was ready by fall. Its monumental stone fireplace, which Berenice designed to hold four-foot logs, was now unmanageable by her, so she installed a small cast-iron woodstove inside it. She soon acquired adjacent acreage, nearly doubling her Monson property. She and neighbor Howard Thompson also bought a snowmobile, but she crashed it into his garage door and questioned her ability ever to control such a machine.[5]

In November 1975, Marlborough held an exhibition entitled *Three Photographers—Three Cities: Bill Brandt, Berenice Abbott and Brassaï*. Each of the three had done a city book. Gene Thornton observed that all were now "enshrined . . . in the pantheon of modern photography" along with Atget, who was on view simultaneously at Witkin; somehow, he misstated that Berenice was Man Ray's niece. (The following year, a canard was traveling around Berenice's Maine neighborhood that she was Jack Sullivan's illegitimate mother.) In San Francisco, the Focus Gallery featured Lisette's new portfolio prints alongside photographs by Berenice. Like a barnacle, a show of Atget images was around the corner at the Highland Gallery.[6]

In December Berenice finished writing the short introduction to her

own portfolio, condensing the arc of her artistic development in her first two sentences:

> There is far too much talk about photography . . . It is something you do, if you do it, not something to talk about. . . .
>
> I took to photography like a duck to water. I never wanted to do anything else. Excitement about the subject is the voltage which pushes me over the mountain of drudgery necessary to produce the final photograph. . . .
>
> The challenge for me has first been to see things as they are, whether a portrait, a city street, or a bouncing ball. In a word, I have tried to be objective. What I mean by objectivity is not the objectivity of a machine, but of a sensible human being with the mystery of personal selection at the heart of it. The second challenge has been to impose order onto the things seen and to supply the visual context and the intellectual framework—that to me is the art of photography.[7]

Months after the first draft contract of the Marlborough-Lunn deal had been sent to her, Berenice was still consulting her local lawyer about it. Harry promised big money, but his payments were often slow. With Marlborough's great solo exhibition coming in January 1976, Berenice wanted to finalize the deal when all parties (Marlborough, Harry, and she) were together in New York. Outright purchase meant providing the bulk of the nearly two hundred vintage prints on view—mostly New York, but some portraits and Super-Sight as well; also to be displayed, though not offered for sale, was her first New York album from 1929. Lee Witkin marveled at her $300 prices—"can you imagine that only 6½ years ago you let me sell them for $50.00 each"—and worried that sellers' greed might kill "the goose that lays the golden egg."[8]

In 1976, Harry Lunn published a portfolio of Lisette Model's classic images. Generally unhappy with the new photography market, she

was severely upset with Lunn's work, particularly the printing, and confronted an innocent Mrs. Lunn in public: "How can you possibly be married to that horrible person?" Writing the portfolio introduction for her "best buddy" Lisette, Berenice memorialized Model's dictum "Don't shoot until the subject hits you in the pit of the stomach." Berenice's own portfolio project attracted interest from Ralph Steiner, who noted, "Photography has turned Wall Street, but it's a bit crazy." He asked about her experience printing large quantities of prints and put out a feeler to rent her full darkroom setup for production.[9]

Simultaneously, Lunn's breakthrough designation of "vintage" photographic prints sparked a thorough search behind file cabinets and under drawers in the Blanchard workroom for old strays. The designation was an art-marketing coup particularly about photographers' work (like Berenice's) that had had much iteration over time. As with "states" or "editions" in traditional printmaking, photographers could issue various versions of a photographic print over the lifetime of a particular negative—paper stock and enlargement size were the basic options. A print made soon after the negative was photographed could be termed "vintage"; one printed a decade or so after that time could be called a "later" print; and one made recently from an old negative a "recent" or "modern" print. Into the 1980s, living photographers routinely made fresh photographic prints from existing negatives as required for exhibitions. It was still assumed that these prints, perhaps in a size designated by the exhibiting gallery or museum, would be an improvement and best represent the photographer's vision: for example, Berenice made "new" prints for her 1950s shows at the Limelight Gallery and elsewhere and for the 1969 Smithsonian and 1970 MoMA retrospectives, plus others. Moreover, in that pre-digital era, new prints might be required for reproduction licensing if a photographer had no existing prints in his or her archive file of the specific images ordered. What Harry Lunn and the rest of the industry did was elevate "old" into a desirable aesthetic quality, worth a higher price, by positing that a print that had been made at or close to the time of its negative best reflected the intention of the photographer.[10]

The Marlborough opening of Berenice's solo exhibition, on January 5, was followed by a genteel buffet dinner at the home of the Anthony Smiths in the Upper West Side's landmark Apthorp, one of the city's grand nineteenth-century apartment buildings. Tony Smith was a former CIA agent and an investor in Harry's company; in exchange for hosting the party, he had his pick from the show. Berenice's flowing cape somehow disappeared during the long evening's hubbub.[11]

The next day, Berenice signed a contract with Marlborough International Fine Art AG and Lunn's Graphics International Ltd.: $120,000 for "all of the prints owned by you as of this date of photographic images created by you (hereinafter referred to as the 'Abbott Collection')."—approximately 2,000 exhibition prints and 3,000 working prints. She reciprocated for all the times the Schwartzes had treated her, taking them to dinner at one of Leslie Katz's favorites, the Chateau Henri IV in her tony East Side hotel (today's Plaza Athénée). Berenice, who carried no handbag, had to lift her elegant blouse to reach for her money belt to pay.[12]

Reviewers of the exhibition struggled to characterize Berenice's work; in a field still lacking critical nuance, they were clearly seeing it through the lens of recent history. Hilton Kramer, for example, dismissed her pictures' nostalgic elements to better appreciate their unadorned statement—a clarifying, plainspoken directness he saw as central to American culture in the twentieth century. Gene Thornton, conversely, saw "an exercise in nostalgia," with Berenice's "stark and realistic" New York photographs having "a kind of picturesque charm"; he allowed that her 1920s Paris portraits served as a bridge between old and new eras.[13]

Marlborough also took on the role of agent, policing the use of Berenice's pictures in reproduction, notably requiring the Bettmann Archive to cease licensing her James Joyce portraits and forward any fees already received. One of the most important sales Harry made at this time was to Phyllis Lambert—"one of everything we had in vintage," he said, for her future Canadian Centre for Architecture in Montreal. Though

Berenice's work was not yet that popular, Lambert and her curator, Richard Pare, Harry said, "had the smarts to know what to do. Paul and I knew what we were doing, too," he added, explaining how Paul Katz arranged for the purchase of Berenice's little 1929–1930 New York reference snapshot album for donation to the Metropolitan Museum of Art; its four-figure price astonished its creator.[14]

In Washington for the April opening of her show at Harry's gallery, Berenice met the *Washington Post*'s Tom Zito, an aspiring photographer and culture critic. Harry had warned him not to ask about Atget, but, while lunching at La Nicoise, with Berenice sipping Wild Turkey, Zito looked up brightly and asked, "When did you first meet Atget?" It was downhill from there, said Harry. Syndicated, Zito's article appeared elsewhere in the United States with fewer edits and more flavor; he recounted how Berenice, driving in her new VW on I-95 from Maine, overshot Washington and wound up in Richmond, and how she lost her glasses and drank too much at lunch: "The only way to do interviews is to get drunk," she said, raising an after-lunch snifter of Calvados.[15]

Hank O'Neal had finished his book on 1930s Farm Security Administration photography, and was ready to embark on a book about (and with) Berenice. History was on the move, apparently: Art historian Marlene Park had also recently sought to interview her about the Federal Art Project. Hank had earlier ingratiated himself by arranging for the great jazz pianist Mary Lou Williams to give Berenice a lesson in Maine. Berenice had admired Williams for decades, not least for alerting her interest in astrology with the 1945 *Zodiac Suite*. Likely she'd seen Williams perform in the 1940s in the integrated Greenwich Village nightclub Café Society, where the Photo League held fund-raisers. In the 1960s, Berenice had tried to buy Mary Lou Williams records from her New York record dealer, James Ringo, who supplied Julian Bream, Stravinsky, Mozart and also "dance music (as per your request, not too rock & rollish)," he once replied, apologizing that they didn't carry Williams. The pianist wasn't particularly interested in Berenice

or photography, but her manager, Fr. Peter F. O'Brien, S. J., was, and they came for a weekend. Graciously, the antireligious Berenice drove the pair to Greenville Holy Family Church for Sunday Mass (Williams had converted to Roman Catholicism in the 1950s, and O'Brien was a Jesuit priest). She waited, scowling, Hank said, in the car outside for the Mass to end.[16]

> I need a secretary and a housekeeper and an
> assistant . . . to keep your house halfway clean. You
> can't get up and live on dirty dishes. —BA[17]

THE SUMMER OF 1976 also saw the arrival of Cheryl Greaney, a University of Southern Maine photography student who had contacted Berenice the previous summer on the suggestion of one of her professors, Juris Ubans. She wound up as studio assistant for the next two years. Joined for a while by Julie Motherwell, a friend who did household and yard chores, Greaney found the period "life changing" for giving her a "global view of the art world."[18]

Most weekdays, Berenice drove the 4.6 miles from her Monson lakeside log home to Blanchard for breakfast with Cheryl; she'd print in the morning, break for lunch, and then print some more, before returning to Monson for the rest of the afternoon. Cheryl finished up—trimming, mounting and matting prints, and shutting down the huge new enlarger. Then she and often Julie would join Berenice in Monson to make dinner, play Ping-Pong, and watch the evening TV news. It was a welcome rhythmic and steady pattern for Berenice, as she approached eighty, the kind of care and work support she had longed for. Cheryl stayed on after Motherwell left, and the two got out into the world for wonderful adventures that taught Cheryl about lifelong "spunk and energy." In the same way Berenice had said, "Let's go dancing, Tish," to her young New York friend Leticia Kent, she now invited Cheryl to local lumbermen's bars, where they fed quarters in the jukeboxes and danced up a

Forehand Smash, Monson, Maine, *winter 1977*.

Hank O'Neal

storm, leaving the regulars to wonder what that "young thing and that older woman were up to."[19]

To Maine native Cheryl, these years saw an acceleration of increasingly presumptuous visitors from New York, Boston, and the entire Northeast. Berenice was flattered by the attention but also felt distracted and interrupted. Many expected to be welcomed with their entourages and appreciative tokens, and usually wanted something in return. Deigning to review a portfolio, Berenice was abrupt in her corrections—pointing out compositional shortcomings with a "Listen, buster"—and merely nodded approval without comment.[20]

She noted the deaths of two old acquaintances in 1976—New York gallerist Hudson D. Walker and Paris friend Margot Schuyler. About

this time a literary historian, Frances Doughty, reached out to Berenice in one of the earliest efforts to link her publicly with the word "lesbian"; in Margaret Anderson's papers at the Library of Congress, Doughty had come across Solita Solano's mention of Berenice's lifelong friendship. The potential violation of Berenice's deep public reticence about her sexuality might have helped discourage further consideration of placing her own papers in any institution, regardless of their promises of restrictions on access. (With close gay associates, female and male, no such reserve existed.)[21]

Hank O'Neal was ready to start on their book, and his editor gave the go-ahead. Berenice had sent Paul Katz ahead to scout; he reported to Berenice that "pleasant and charming" Hank really liked her and would write factually about her artistic achievement but omit anything personal. Paul then helped Berenice prepare for her October exhibition of New York images at the Allan Frumkin Gallery in Chicago, where her presence at the opening was expected to increase collector interest. To the *Chicago Tribune*, Berenice offered the idealistic, almost exhortatory tone she had begun to adopt as a historical and cultural sage. "The photographer is the contemporary man par excellence, because he has to understand the present. But the past is necessary for that understanding," she was quoted, mindful of Chicago's role as the cradle of American architectural modernism. "Buildings are being torn down . . . but continuity, cause and effect, evolution—this is all a part of our heritage, our roots. If you have no roots, what then?" To Margaretta Mitchell, working on her anthology of women photographers, *Recollections*, Berenice aphorized: "Photography can only represent the present. Once photographed, the subject becomes part of the past."[22]

In December, Berenice traded photographs with FSA photographer Arthur Rothstein, receiving one of his 1930s FSA prints for her contemporaneous *Blossom Restaurant*. She continued to update and improve her Blanchard house while living in the new one in Monson. In Ohio, niece Alice had surgery but Berenice did not go there or to Mexico, which she had again contemplated. In April 1977, she accepted a Deborah Morton

award—given to prominent Maine women—at Westbrook College. She didn't prepare a talk, though she made notes on the invitation letter from president James F. Dickinson: "confidence—aim high; dedication to work that really interests you, not just a job; independent women in the long run most satisfaction; compensation; all kinds of people, but what interest you & the courage to be yourself." Standing to speak, she bypassed the "I am delighted to be here" opening and simply asked, somewhat more graciously than in Boston three years earlier, "Well, what do you want me to talk about?" Someone in the audience had the presence of mind to reply, "Tell us why you came to Maine," and she did, conveying her now-codified biography, an observer noted, "underlying it all with her love for the state."[23]

At the college, she met Dorothy Healy, cofounder and curator of the Maine Women Writers Collection, which aimed to preserve and promote the state's female literary heritage. The two women were well matched—both open-minded and liberal—and eager for companionship. Proposing a two-year course in biophotography for Westbrook, Berenice also provided a sympathetic ear for Dorothy's troubles with her ailing husband, while Dorothy, her children grown and welcomingly accustomed to creative artists, sought nothing more from Berenice than friendship and exposure to what Healy called Berenice's "remarkable talent for expressing . . . forthright and original" ideas. Soon after they met, they made the first of their "precious and vivid little excursions into the Old Port"—Portland's waterfront bars. Cheryl often joined them, even after she had left Berenice's studio. The older women would march in wearing their fur coats; men at the bar wore their fishing boots. Fighting with Dorothy to pay their bill, Berenice would open her wallet with hundred-dollar bills all lined up. "You got to put that away—do you have any idea where we are?" Healy would say. Berenice didn't care.[24]

Healy showed her understanding of Berenice's need for time in the studio by bringing her ready-to-eat lobsters, chicken, and "more fresh stuff." To no avail, she also encouraged Berenice to write about her

1920s life, arguing that her original perspective would equal her photographs stylistically, and "carry the kind of intellectual wallop that good honest writing achieves." Possibly this encouragement prompted Berenice's 1977 journal musing, "Can it be true that people who are the product of broken families and hurt emotionally, that if they survive the crush, can become the most independent of all and become steeled against emotional hurts?" After Healy's husband died in 1979, Berenice spent the next few New Year's Eves in Portland with her, bringing her big cat Butch along in his carrier.[25]

When Dorothy first visited in Blanchard, Berenice's unmarried niece Alice Ross, then in her midsixties, was there with two friends. By the following summer, Alice had moved in, with the expectation that she would assist aging Berenice in exchange for a comfortable home. That November, Berenice interviewed Rochester Institute of Technology student Julia Dean, and chose her to be the next photographic apprentice in exchange for room and board in the Blanchard house upon graduation.[26]

During the winter Berenice received encouragement from Marius B. Péladeau, director of the William A. Farnsworth Library and Art Museum in Rockland, about a state Arts and Humanities Commission grant to photograph Maine. In preparation for an exhibition, Berenice entertained Norma Boom Marin, the America painter John Marin's daughter-in-law, by playing 1920s jazz records and teaching her to build a fire. George Mason University American studies professor Michael Sundell interviewed her about *Changing New York*, the project's first scholarly investigation. Paris memoirist Morrill Cody interviewed her by phone for his 1984 book with Hugh Ford, *The Women of Montparnasse*. She entertained a scheme of Djuna Barnes's first biographer, Australian Andrew Field, for her to travel as a Fulbright scholar to his university, but dismissed it as impractical.[27]

Talk of Djuna Barnes led Berenice, who considered her old mentor a boring "literary snob," to dispatch Hank O'Neal to check up on her. He characterized Barnes's situation as "desperate." Her papers and business

affairs were in disarray. It was an area in which he felt he could assist. The two women retained their rivalry. Barnes still dismissed Berenice as "that little number" but asked about her current circumstances. Hank thought Barnes might fall out of bed with shock if she learned of the $25,000 advance he and Berenice had received for their planned book, ten times Barnes's most recent one.[28]

In early April 1978, Berenice was part of a luncheon discussion at the Rutgers University Conference "Women and the Arts in the 1920s in Paris and New York." The other "'20s gals," as Berenice called them, were Janet Flanner, Lillian Hellman, and Kay Boyle. Berenice read her aphoristic remarks from a clutch of 3 × 5 inch paper slips: dance is "the best of all exercise": "physical exercise and state of mind—pleasure combined." Composer Ned Rorem, acknowledging that there had been unfairness, argued that women shouldn't complain about not taking chances, because "in the arts, there is no rule beyond everyone for himself." Berenice reportedly replied, "I see no difference between men and women; the only difference is biological. I would never have anything to do with a man who showed a bit of chauvinism around me; I resented it!" She also dismissed nostalgia: "It's useless to think about the '20s, the '30s, the '40s, the '50s or the '60s too much. There is only our time now."[29]

Berenice's fortresslike walls around the subject of homosexuality were still strong. She was stunned at this conference, and at another later in Washington, to hear the younger audience discuss lesbianism so publicly. Incredulous, she repeatedly asked herself what Elizabeth would have thought or said.[30]

Photography history continued on the rise. She met with Lotte Jacobi and German photo historian Ute Eskildsen about recreating the 1929 *Film und Foto* show in spring 1979 at the Württembergischer Kunstverein, in Stuttgart; Berenice's career scrapbooks were anticipated as a resource. Anne Tucker's first historical look at the New York Photo League took place in a symposium, without Berenice. "I won't have anything to do with it. They're male chauvinists," she told Ed

Schwartz, himself a former League member who could not get Tucker's attention. In May, Paul Theroux's *Picture Palace*, about an elderly spinster photographer based very loosely on Berenice and on Imogen Cunningham, appeared; it's not known if Berenice commented on it, or even knew of its existence. At Kertész's MoMA opening in 1964, she had been introduced as Cunningham, and the misidentification possibly still rankled. She prepared generous remarks for the Witkin Gallery's tenth anniversary, calling it the first "to be born at the right time, in the right place and with the right person." Her words indirectly addressed her unrealized ambition more than three decades earlier to open such a gallery herself. In June she attended a cocktail party staged by Burt Britton, a partner in the new, eclectic Books & Co. store next door to the Whitney Museum of American Art, then on Madison Avenue, as a surprise for Ben Raeburn, because he wouldn't have shown up if he'd known about it.[31]

A month later, on July 17, Berenice celebrated her eightieth birthday with an open-house blowout at her Monson lakeside home. The crowd included old friends such as Marchal Landgren, the Shwachmans, and Mignon Shepard, and new photo-world people, among them Witkin, O'Neal, and a young art historian, Susan Dodge Peters, who was working on Elizabeth McCausland's criticism. Jack Sullivan got drunk, went skinny-dipping, and was seen rolling on the ground to pull his trousers back on. Berenice was done with his shenanigans and called the police to take him off her property. She told her guests that she hoped to live to be 102 and see the next millennium, and that she wanted to start out her eighties "with a bang." She and niece Alice would buy a van and travel cross-country. Alice considered herself, at sixty-six, and Berenice, at eighty, both too old to follow up on this plan. The septic tank backed up, and the guests formed a shovel brigade that helped direct the flood through the grassy yard down to the lake.[32]

In early June, Julia Dean, 23, had set out from Rochester to begin her apprenticeship. She was averse to making the long solo drive to central Maine, but Berenice told her bluntly, "Honey, it's about time

you did!" Replacing Cheryl Greaney as the printer of special orders, Dean warmed to Hank, who shared his Abbott manuscript and "electrified" her mind. The three socialized occasionally, with Berenice once teaching the Charleston to Dean after dinner. When they ran out of fuel for the oil heater in Blanchard, darkroom water temperatures went awry, test prints languished, plants died, wood stoves smoked, and Alice was in her cups. "Berenice came through the door and all hell broke loose!!" apprentice Dean wrote. Everyone got yelled at, except her dog. "What a day!!"[33]

Berenice was working on a new portfolio for Parasol Press, printing from negatives loaned in the rotating arrangement with the Museum of the City of New York. Two darkroom assistants in their early twenties joined the enterprise specifically to carry out this work—Crissie Haft and her assistant, Kevin Brown. Both were part of a larger contingent of photographically minded young people who had bought land or rented houses in the vicinity and freely visited Berenice's Blanchard property. Maine in the mid- to late 1970s was a "photographer's paradise" for the many who found their way there. Haft was a School of Visual Arts graduate and former student of Todd Watts; Brown, a photographer, lived nearby with his wife, who was possibly the latest object of Berenice's scorn directed at women who "get married and start a family before they know what they are doing. . . . Do you see many people happy as couples, as parents?" she asked a *Down East* interviewer that summer. "I am appalled at seeing people foul up their lives by getting married casually. No thank you." Berenice told Anne Tucker that she felt the sixties protesters, whose dishevelment and long hair had made her nervous, had given up too easily.[34]

In midsummer, Berenice and Bob Feldman agreed to refrain from selling the new portfolio prints until she had terminated her current contract with Marlborough and Harry Lunn's Graphics International. Just under the wire that September, a typical huge order came from Harry for forty 8 × 10 prints of various subjects: in one morning

alone, Berenice and Dean made two dozen contact prints of *Manhattan Bridge, Looking Up*. He also sent several sizes of four-ply board for dry-mounting and signing the prints, plus fifty-one "examples of 'New York at Night' . . . numbered on verso, 3120.5, 3120.12 through 3120.61" from Todd Watts's New York studio. Berenice's cut of 40 percent of retail, cited in one undated but typical list from Marlborough, totaled more than $13,000 (more than $50,000 in 2017).[35]

All year Berenice had swollen ankles and what she thought was an unshakable cold, for which her local doctors were cautious about pre-scribing antibiotics. Harry Shwachman, though "pleased with Berenice's general appearance, behavior and activity" (she weighed 139 pounds and stood five foot three and a half), advised that she be treated with antibiot-ics for pneumonia. She could not keep up in the darkroom when Parasol Press contracted for three more New York portfolios; they were printed under Todd Watts's direction in his New York darkroom, first by Cris-sie Haft and then others, including the gifted Nina Chernik. In all, four New York portfolios, and more, including individual prints were pro-duced in this manner.[36]

I would do almost anything to honor Muriel Rukeyser.[37]

FOR SARAH LAWRENCE COLLEGE's "Day in Honor of Muriel Rukey-ser," December 9, 1978, Berenice lent New York photographs and her set of mounted PSSC prints. *Parabolic Mirror*, featuring Rukeyser's eye, served to illustrate the event's official mailing. Rukeyser's new, uncol-lected poem "An Unborn Poet" cited Berenice for their long-shared efforts to unite art and science:

Peddler, drowned pier, birdcage—images
caught in your lens forever, Berenice.
You said, "I need a light
great as the sun. No. Greater than the sun."[38]

Parabolic Mirror, *1959. Referencing a long-standing surrealist trope, Berenice chose the image of an eye, Muriel Rukeyser's, to illustrate compellingly how a parabolic mirror focuses a light beam, such as a car headlight, 1946.* Berenice Abbott

Despite a minor travel arrangement mishap on the big day, Berenice appeared on a panel, with Hortense Calisher and Frank Oppenheimer. The latter, a physicist and the brother of the late Manhattan Project director, had founded, in 1969, the San Francisco Exploratorium. Berenice spoke earnestly about Muriel as a fellow artist who alone shared her understanding of the modern need to combine art with science. She then traveled to Harvard for their "Learning from Performers" series at the Carpenter Center, where she spoke to an overflow student group, using slides. Davis Pratt, the Fogg Museum's first curator of photography, ferried down an accompanying exhibition from Colby College, where it had opened in October.[39]

"Much work on trees and Portfolios for Feldman" dominated 1979. The arrangement with Alice had become a disaster. Often drunk, Alice became maudlin and aggressive. "Gawd—that woman—she'd be unhappy if she were happy," said Julia Dean. She returned to Cleveland in late January. Virginia Junk, a cousin, said simply of the failed experiment in family support, "They didn't have ways alike."[40]

In late May, Berenice flew to Europe on the occasion of two exhibitions. The first was a retrospective of her 1920s portraits, held at gallerist Virginia Zabriskie's two-year-old outpost devoted to photography near Paris's new Centre National d'Art et de Culture Georges Pompidou. Young French photographers and writers crowded the opening, eager to meet a living relic of the generation photographed a half-century earlier. Speaking in French, Berenice enchanted this audience in an impromptu and enthusiastic hours-long question-and-answer session, the personality of the young rebel who had quit Ohio to seek her artistic fortune still very evident. She was eventually rescued for a quiet dinner nearby with friends, including the photographer Ilse Bing. (Berenice wore a new black rain hat described by Jane Mayhall as "so becoming and zingy.") Berenice found Paris even more crowded than it had been on her 1966 trip; cars parked on the sidewalk made walking difficult. "Atget was lucky he worked when he did," she said. "He wouldn't have been able to do a damned thing with Paris today."[41]

The seond exhibition of Berenice's work was in London, at the Robert Self Gallery, but the only reason Berenice had agreed on the overseas trip at all was to fly on the Concorde, the short-lived Anglo-French supersonic transport. She loved the plane "the way Melville fell in love with Moby Dick" and later hung a photo of it on her bedroom wall. "I wouldn't mind dying up there. I wouldn't mind if it flopped down in the water. It's just what a plane ought to be. It's small. It's well run. I could take it every day." Harry Lunn accompanied her on the outbound flight—he had his martini and Berenice her bourbon—and together they managed to pocket a Lalique glass as a souvenir. Berenice's excursion had been arranged by Jacqueline Kennedy Onassis, whose Doubleday book *Atget's Gardens* was being celebrated in London at the Royal Institute of British Architects. As a trustee of the International Center of Photography in New York, Onassis enabled the Atget show to later travel there. Berenice flew home without Harry on a Concorde operated by British Airways; the experience, she thought, was not as good as on the Air France flight.[42]

Shortly before Berenice left on this trip, she and Hank had chosen Ben Raeburn's Horizon Press over Knopf to publish their book; she was dismayed, however, by Hank's first draft. Following Ben's advice to formalize her objections via registered letter with a return receipt, she typed out a draft on a half sheet of foolscap threatening to cancel the project, without saying what she objected to. Ben advised Hank to consult Berenice, "one of the great artists of the twentieth century," for "the privilege, not only of benefitting from her corrections and from her knowledge of her own work, but of getting the advice of the most deeply perceptive and sympathetic person you are ever likely to meet." Few people, he went on, "mean as much to me as she—as a person, as a friend, and as an artist." Regarding the struggle to rewrite, he idealistically continued, "there should be no limit to how long an inadequate manuscript should be delayed, no limit to how much work should go into it to make it worthy." Proceeding to re-edit the manuscript, Ben

told Berenice, "I often wish you were as impressed with yourself as I am with you."

By early 1980, however, money and personal troubles took Ben and Horizon Press out of the picture. Jackie Onassis, hoping to bring the work to Doubleday, dropped in on Berenice via private plane and sent her Harry & David fruit gifts, but in the end Onassis was unable to persuade Doubleday to take on the project. The book was ultimately published by McGraw-Hill, in a unique imprint, Artpress.[43]

In San Francisco that July for a weekend conference called "Mothers of Us All: American Women in the Arts in Paris in the 1920s," Berenice gave a slightly revised version of her Rutgers talk, idealizing the noncompetitive nature of her peer artists back then. The visit also offered a chance to visit with Ruth Bernhard, who'd been living in the Bay area since the 1940s. Bernhard was shocked that the conference organizers put Berenice up in a quaint but inconvenient old Victorian house converted to a hotel, where she had to walk up five flights of stairs and share a bathroom. To Ruth, Berenice was not a "fun person," but rather very serious about everything. During lunch at the home of a local photographer, Berenice viewed the host's photographs of nudes, only to insist that Ruth alone "can truly photograph the nude." On the pretense of needing to wash her hands, Bernhard fled the room to compose herself.[44]

Old friends alerted by press coverage of her Paris and London shows had left greetings: Helen Ann and Ross Robbins congratulated her as "an old Village friend from years gone by"; from Paris, Stephen and Sophie Victor Greene invited her to join them outside Marrakech in the hideaway where they had spent the past half century, offering "plenty of room, lots of what Man Ray used to call 'hair on the face of nature' and a nice big swimming pool + 3 cats." Taking up their offer to chew "the fat about old times and old friends, most of whom are no longer around to defend themselves," Berenice cabled her plans to visit in February, as part of a Mediterranean loop through Venice in 1980 to see Peggy Gug-

genheim. Paris friends were on her mind as she signed a contract with Bob Feldman for her fifth portfolio with Parasol Press, of twelve half-century-old portraits in an edition of sixty, like the others, with five artist's proofs; similar to her previous arrangements with him, she received a flat fee and agreed not to make or sell any of the same images for two years after the portfolio was released.[45]

ICP's *Atget's Gardens* New York exhibition was celebrated at a champagne benefit preview with the French ambassador and Jackie Onassis, Berenice resplendent in her chic sable jacket, purchased with cash at Saks Fifth Avenue for the event. This exquisite garment, along with a few pieces of David Webb jewelry, were the sorts of luxuries Berenice considered essential now that she was really making money. She met Phyllis Lambert, soon to launch the Canadian Centre for Architecture in Montreal with stellar photograph holdings assembled by her curator, Richard Pare; its Abbott photographs came mostly from Harry's and Marlborough's earliest, choicest acquisitions. During an evening at the Stanhope Hotel of "treasured . . . straight talk," Lambert wrote to Berenice, the women became trusted friends.[46]

Having been "poor as a church mouse" all her life, Berenice barely knew what to do with all the money she was making. Having seen runaway inflation in Germany in the 1920s and bank failures in the Great Depression in the 1930s, she retained a "money-under-the-mattress" attitude toward wealth. Even Juliette Moran, who was probably responsible for Berenice's otherwise anomalous subscription to *Moneysworth* magazine, had given up in frustration at Berenice's willful resistance to sound modern personal finance. In 1977 Berenice began converting her cash to gold, off the books, buying Krugerrands, the South African coin minted as a means of private gold ownership. She felt bolstered by the approval of Jackie Onassis, who seconded her judgment, and even quoted financial wizard Felix Rohatyn on the subject.[47]

Driving an Audi sedan, Berenice made at least four overnight buying trips to Montreal, staying in a fancy French hotel and in the morning

presenting "wads of cash" at various banks. She and a trusted assistant put the coins into the especially large pockets of pants they wore for the purpose. They were never searched or suspected at border crossings. Berenice's Montreal excursions were occasionally enlivened by visits with Phyllis Lambert at her home. Berenice kept her gold in a basement safe at home in Maine, though she explored having a safe-deposit box in New York and the eventuality of liquidating her gold outside the United States. "If bank moves or folds what happens to bricks?" she noted in a small 1979 notebook devoted, sparsely, to money.[48]

Her "twin," Peggy Guggenheim, had died right before New Year's; Berenice wept at the news and abandoned her planned Mediterranean trip. Attending MoMA's fiftieth anniversary exhibition, she was name-checked on a *New York Times* social page for holding "quiet court" at the opening; she returned to the city for a dual exhibition (with Imogen Cunningham) in Helen Serger's *Pioneering Women Artists, 1900–1940*, held at La Boetie, alerting Muriel Rukeyser of her arrival.[49]

Though glad to have had no assistant after Julia Dean left in fall 1978, Berenice soon welcomed Robert Lyon, an established MIT staff photographer, who helped with her files as well as in the darkroom. After he died of cancer in spring 1979, she took on his protégé, Algis Thomas Kemezys, a Maine native who also had the much-appreciated ability, and willingness, to cook; his specialties included curries he had learned to make in India. In turn, Berenice introduced him to arugula, which grew in a patch near the door, a remnant of the organic kitchen garden whose maintenance requirements had long ago outpaced her interest and motivation. Kemezys stayed through much of the completion of the five Parasol Press portfolios and almost fell in love with Berenice, he said, so eager was he for both the intellectual compatibility her friendship offered and the ready opportunity to be useful as she aged.[50]

On March 15, 1981, the year-old newsletter *Photograph Collector* boldly announced Berenice's $100,000 Parasol Press *Retrospective Portfolio*, containing fifty 20 × 24 inch prints in an edition of forty. Berenice

Berenice Abbott at airport, Montreal, Quebec, 1984. Algis Kemezys

continued to sell prints separately, too. Bob Feldman bought a smatter-
ing of vintage prints, including some science images, for $14,000, a pur-
chase made on the occasion of Berenice's signing a letter of agreement
for a "science" portfolio. It did not sell as well as her others.[51]

On her eighty-second birthday, she and Kemezys drew up a price
list of specific images for direct individual sale to collectors, carefully
skirting the print sizes embargoed by Parasol's portfolio contracts.
The list advised that her iconic *New York at Night* was available in
16 × 20 inches through "Mr. Joseph French, PO Box 638, West Red-
ding CT 06896 Ph: 203-775-3828"; astonishingly, Berenice had sepa-
rately licensed the future rights to him (he was likely the mysterious
buyer who flew in privately with $100,000 in cash to exchange for one
hundred *Night View* prints). Old friends were sending in personal print
orders—I. Bernard Cohen, for instance, who regretted having put off
buying for decades.[52]

The Berlin-born filmmaker Erwin Leiser discovered Berenice's work
at Marlborough Gallery and wanted to make a film about her. Having
fled the Nazis as a teenager, Leiser emigrated from Switzerland to the
United States and after specializing in Nazi history as a documentary
subject turned to making films about artists. Berenice called him crazy,
but accepted him as "an artist," and agreed to his project. Unlike ear-
lier, unfinished films on Berenice (Bob Greger's in 1969 and another in
the early 1970s by James Ringo), Leiser's was the product of an expe-
rienced documentarian. In May 1980, with Hank O'Neal assisting, he
filmed Berenice at a windy New York harbor, reenacting her use of the
8 × 10 inch view camera. "Ridiculous," she said of the effort, using one
of her favored words of the time. The wind couldn't budge the heavy
double dark cloth that was used—a tent, Berenice called it; it pulled on
her clothes as she demonstrated the cerebral acts of framing and posi-
tioning. "Listen. Take it off a minute," she said at one point, ending the
session abruptly.

Leiser also captured Berenice at Zito's Bakery on Bleecker Street,
where she reminisced with the current generation about the two pho-

tographs she had made of the shop front decades earlier. She remained conflicted about the city's commercial architecture, including the "sort of glorious and sort of awful" World Trade Center's twin "monuments to commerce, power, and greed . . . the wrong things," she told Leiser's camera, echoing her 1930s feeling about Rockefeller Center. In November, Leiser filmed Berenice in her Maine darkroom, where she deftly processed a large print (a task she could barely repeat); all the while, she complained about ignorant apprentices and incapable printers. Berenice also walked her Maine property for Leiser's camera, calling herself a city girl in the country. After a financial struggle, the film, *The Restless Eye*, was released in 1984.[53]

In November 1980, Berenice drove from Maine to New York through an early Connecticut snowstorm, worried less about the weather than about getting a third speeding ticket, which would jeopardize her license. She danced in her sable jacket at the last automat in New York, a fund-raiser for the Writers Room, the nation's first nonprofit, shared writing work space. Attendee Malcolm Cowley was shamed by "her vigor," he wrote Kenneth Burke, whose absence disappointed Berenice. She had recently agreed to produce with Bob Feldman a second, smaller portfolio of portraits, in an edition of sixty; some of the images later illustrated a Limited Editions Club republication of Cowley's *Exile's Return*, whose numbered copies both she and Cowley signed. Before departing for Maine, Berenice posed in the Flatiron district studio of photographer Michael Halsband, in a pixie-cut ash-blond wig she owned, and wearing a David Webb bracelet, for the portrait on the cover of January 1981's *ARTnews*.[54]

John Russell, successor to Hilton Kramer as the *Times* art reviewer, had learned that Berenice's 1921–22 letters to her old Paris mentor John Storrs were held by the Archives of American Art and asked her whether he should read them. Given her reticence about both her personal life and her new cultural eminence, Berenice could not have been pleased to learn that her youthful ramblings and frank discussion about same-sex turmoil were so readily available. History also pursued her in

the shape of a graduate student at Ohio State University named Mary Ann Anderson, who quoted liberally from Berenice's 1975 oral history in drafting her master's thesis. Berenice anxiously telegraphed a response to the manuscript Anderson sent for her comment: "too many errors . . . assumptions . . . impossible to endorse." The result was a new focus on "biographical facts directly related to" Berenice's "professional development and career," for which Anderson interviewed the photographer in Maine.[55]

Oh, so much of what happened to me happened by
chance. . . . Life is such a ridiculous gamble, so hit or miss.
We take it all too seriously . . . I certainly did. —BA[56]

BERENICE HAD ENGAGED a professionally trained secretary, Jean C. DeIeso, the wife of a local handyman. DeIeso, a native of Worcester, Massachusetts, felt Berenice welcomed her as a fellow outsider. A light, flexible schedule and Berenice's willingness to let her bring her youngest child along worked well for nearly three years; her secretarial code "BA:jcd" on Berenice's correspondence from this period attests to the order she brought to some of her employer's multifaceted business affairs.[57]

Berenice, now eighty-three, often felt ill and sought help, only to mix up directions for new medicines or abandon them altogether. "And to think we thought she was so sick that we ought to go up there!" Irene wrote, vowing, "No More Wolf Cries." Nevertheless, the stress was real, exacerbated by pressure about upcoming shows and Hank O'Neal's monograph. Another source of stress was an on-again/off-again plan, masterminded by Gordon Bowman, director of Corporate Creative Programs for United Technologies, for elderly Berenice to be filmed in action photographing in Paris and Marseilles. She stood to earn $17,000 (almost $48,000 today)—for a book, a film, and an exhibition—and flew over in fall 1981; illness and the cold, damp weather cut the trip short, however.[58]

She had been showered with awards and exhibitions in these years. The New School gave her (and Lisette Model) honorary Doctor of Fine Arts degrees, prompting congratulatory telegrams from President Ronald Reagan—hypocritical, she felt, considering his politicization of the National Endowment for the Arts. A new organization, the Association of International Photography Art Dealers (AIPAD), prepared to fete Berenice with its first Annual Award for Significant Contributions to Photography. Leslie Katz said that Berenice's photographs had about them "an air of a world being born" and quoted Walt Whitman's poem "Beginners." Even with young Marlborough dealer Lee Marks as go-between for AIPAD with Berenice, the November 6 award program managed to misspell her name as "Bernice."[59]

Virginia Zabriskie held a small exhibition in New York, and the following week Berenice flew to Chicago for the opening of Edwin Houk's show of her vintage prints. Back in New York at ICP, she spoke at "Photography Stands on Its Own," with Cornell Capa moderating, to help inaugurate the exhibition *Berenice Abbott: The 20s and 30s*; Jackie Onassis and modern art curator Henry Geldzahler, then commissioner of cultural affairs for New York City, served as co-chairs. A dinner at Windows on the World, the restaurant atop the World Trade Center, followed the exhibition's champagne reception. Capa congratulated Berenice the next day: "What a week! You have spun us around, keeping up with you. Last night on the dance floor in particular."[60]

Even with these lifetime accolades and attention, including advertisements for her ICP show on the sides of city buses, Berenice could not escape Atget. The Museum of Modern Art had just launched its grand four-volume survey of the Abbott-Atget archive; the first volume was dedicated to Berenice. The editors of the *Saturday Review* titled a personality piece "The Woman Who Rescued Atget's Work," while *New York* magazine paired "Abbott and Atget" in a review. The press release for Marcuse Pfeifer's concurrent gallery show, *Eugene Atget: A Tribute to Julien Levy*, repeated a false story of a pleading telegram to Levy said to have been written by Berenice in 1927. From

Berenice's lifetime of writing, critic and historian Vicki Goldberg chose only the *World of Atget* essay for her 1981 anthology *Photography in Print: Writings from 1816 to the Present.* Last, there was art historian Richard Whelan's *ARTnews* article, "Are Women Better Photographers Than Men?" Interviewed by phone, Berenice told Whelan that the "fuss about women photographers" did "more harm than good. Count me out." She told Whelan about "always getting all the tough jobs that the men refused and getting paid half what any beginning man would have gotten." (In a less public gesture of feminist solidarity, that same month, photographer and Democratic Party activist Diana Mara Henry presented Berenice with Caroline Bird's 1979 polemic, *What Women Want.*)[61]

Nineteen eighty-two, which *Times* reviewer Andy Grundberg called a "crowning year" for Berenice, began with hernia surgery followed by a strained back. While recovering at home, she received the results of the Ohio public-record search she had hired a Springfield genealogist to conduct and at last learned the scant legal details of her parents' troubled marriage and nondivorce. The year was full of more awards and exhibitions, including an honorary degree from Bowdoin College, another show at Westbrook College, and the Women's Caucus for Art's Award for Outstanding Achievement in the Visual Arts. Berenice was well enough by late February to attend the award ceremony at the New York Cultural Center on Columbus Circle, where an exhibition by the honorees, to which she had loaned photographs, was on public view. However, she had to miss the Jeb Gallery opening in Providence, Rhode Island, which sold only one print, *City Arabesque*, anyway, due to the "soft photographic market." Berenice joined Lisette Model in skipping inclusion in yet another "women in photography" book, Dianora Niccolini's 1982 *Women of Vision.* She also declined an on-camera interview in Nina Rosenblum's film about Lewis Hine.[62]

Ed and Pearl Schwartz, visiting Maine in April, were surprised by Berenice's gray hair, which she had always colored; she did still wear her blond wig occasionally. While surveying construction progress

on the guest cottage adjacent to her main log house, they stubbornly argued about a foundation flaw and parted on rocky terms. The old friends didn't reconcile until 1991, when Ed sent Berenice an announcement of an exhibition of his work at the Littoral Society in New Jersey, and she phoned him. In the interim, Ed had beseeched Hank that "photographers and art lovers the world over" should know the full story of Berenice and the Atget collection; Hank assured him that Berenice "would have the last word" in their upcoming monograph.[63]

That spring, photographer Willa Percival invited Berenice to attend the Washington, DC, opening of a show of contemporary landscape photographs from what was still known as Red China. Berenice was already planning to be in the capital city in June for the National Museum of American Art's iteration of her ICP show; an accompanying panel, "Creative Women in Paris and New York in the '20s and '30s," moderated by Meryle Secrest, would also include playwright Lillian Hellman and *New Yorker* journalist Emily Hahn. A glimpse of Berenice's prickliness emerges in the quick, challenging responses she notated on the preliminary schedule, which she found overly detailed and full. Berenice had accompanied Irene Shwachman to a Hellman diary reading in Boston in 1960, where the playwright seemed half tipsy; they'd also appeared together, not entirely happily, at the Rutgers panel in 1978. Luckily, they hit it off this time. Hellman volunteered to fly to Maine on a friend's private plane in August, go fly-fishing, and sit for a portrait by Berenice. Illness forced her to cancel that shoot, but Berenice later flew privately to Hellman's home on the coast and tried to make the desired portraits. Using her Rolleiflex, she had as much difficulty with Hellman as she'd had in her camera demonstrations for Leiser's film, and the results were unusable.[64]

Hellman also asked Berenice's permission to nominate her for honorary membership "in that half silly joint," the American Academy and Institute of Arts and Letters. "You are one of the few people in the world, I guess, where the person fulfills the work," she wrote. In addition to photographers Berenice and Ansel Adams, the academy that year

also honored choreographers Martha Graham and George Balanchine and actor-director Orson Welles.[65]

In Ohio, Kevin Kampman, an Ohio University graduate in photography, had generated the idea of a hometown welcome, enlisting the Springfield Art Association and a trustee, Carleton Bauer, especially interested in Berenice's work. In September 1982, Berenice drove with her assistant Elaine Christiansen for a celebratory exhibition of her work there. However, Christiansen crashed Berenice's uninsured Audi (she didn't "believe" in insurance) while driving on her own. Alice Ross had attended the opening, but the accident prevented Berenice from visiting with her cousin Mary Virginia Junk, whom she phoned instead. "You will never know the shock that I had when I answered the phone and you said Bernice Abbott," Junk wrote her afterward; her last letter had gone unanswered, and she had assumed Berenice was dead. With Ohio ASMP colleague Bill McCuddy, Berenice visited Cincinnati, which she found inspiring but took no photographs.[66]

Design, production, and editorial details for Berenice's Artpress monograph were finalized, with retired *New York Times* reviewer John Canaday writing an introduction. Hank's narrative focused on the story Berenice wanted told, her photographic history. Accepting Ben Raeburn's advice to engage Berenice more fully, Hank had tape-recorded her as they looked through the picture selection together, and her comments became the book's captions. Design was well under way by April, with the decision to print in Japan. Berenice crowed to Irene about the book's "beautiful layout," the work of Kornelia Kurbjuhn— her first book design in the seventeen years since she had become an anthropologist. Kurbjuhn urged Berenice to fight for the quality of printing she deserved, reminding her that she knew "more about [it] than the production manager." She buttressed her urging with references to Simone de Beauvoir, women's complex relationship to male authority, and the power of women's solidarity. The American edition's dust jacket, disappointingly, had one of Berenice's least characteristic or notable photographs, an old Maine lobsterman in a rocking chair on his

porch—chosen, Hank said, to appeal to older readers. The UK edition, picturing James Joyce, was better.[67]

A deluxe limited edition of the folio-size book was available in time for Christmas 1982; it including one original 11 × 14 inch mounted print, of the purchaser's selection—*James Joyce, Penn Station, Deer in Show Window,* or *Belfast House, Maine.* Jackie Onassis, insisting that if Berenice's "superb" book didn't "win every prize, something is wrong," chose the Penn Station print. The book's plates disappointed Berenice, however; she blamed the production supervisor, Ray F. Patient, humiliatingly criticizing his work at Witkin's December celebration. Patient countered that the "source prints" provided to him were of poor and uneven quality.[68]

Reviews were not particularly good. Andy Grundberg in the *New York Times* dismissed the scientific work as "soulless." A most unflattering photograph accompanied Jerry Talmer's review in the *New York Post,* which focused largely on Berenice's solitary life. It prompted commiseration from Witkin Gallery director Evelyne Daitz, who tried to cheer Berenice with news that sales were "going fairly well considering nobody has any money." When Berenice could not be available due to illness, Paul Katz or Hank filled in at book-related events.[69]

Time, place, and circumstance. They are like three balls
that you toss in the air, and they control your life. —BA[70]

BERENICE WAS ANTICIPATING a big eighty-fifth birthday celebration the following year, as well as continued high earnings from her visual legacy. Negotiations for images in her huge, final Parasol Press *Retrospective* portfolio were finalized when the Museum of the City of New York again agreed to loan original negatives. Discussions continued into February with Joseph C. French, licensor of *Night View* in 16 × 20 inch, which had earlier appeared in smaller form in the Witkin-Berley 1976 portfolio and Parasol's first, in 1979. Reuters picked up the human-interest angle—"Berenice Abbott, at 84, Retains the Spirit of a

Rebel"—for a story of penniless youthful travel and independent old age. The *Times* customized its version of the unsigned Reuters piece with a dour portrait, Berenice squinting stoically from under her blond wig; freelancer Gary Guisinger had found her an unfriendly sitter.[71]

In 1983 Berenice bought yet more land around her Lake Hebron compound, paying to maintain it and the Blanchard property. Edna Bennett, who had become an independent used bookseller on Long Island, was planning to visit Maine in the spring after seeing their mutual friend Lisette Model. On the back of Edna's letter announcing the plans are Berenice's hasty notes: "vitamin B6 and niacin, cod liver oil, arginine, L-dopa, vitamins E, C, and A, Inositol, and vasopressin." Lisette died suddenly on March 30, and the women reunited instead at her New School memorial service, organized by David Vestal. Berenice had already lost contemporaries Marchal Landgren that February and her loyal Commerce Street housekeeper Alma Richards in March. Her beloved cat Butch died as well.[72]

Two decades earlier, Irene Shwachman and Lisette Model had discussed Berenice's inaction on the Atget archive and agreed that "the future will take care of the problem"—that Berenice's death would force a disposition. At issue now was her own archive, and Berenice was stalling or rebuffing all purchase offers. Through much of 1981, she had negotiated fruitlessly with real estate mogul Jacob Freidus and his wife, Ella Jaffe Freidus—"arranging for final disposition of 'everything'— never wants to do any photography again & so on," Irene reported.[73]

Since 1978, Berenice had been rejecting Bob Feldman's various purchase offers for her negatives and remaining prints, plus her real estate. On the back of one letter from him she cavalierly wrote an ingredient list for what seems to be pancakes or waffles. On another from her attorney urging her to take a payout over time, she penciled, "Cash." She proposed to sign more boards but only if they bore prints whose quality she approved. She and Feldman still could not agree.[74]

Hank reached out to friends who proposed a syndicate to monetize Berenice's archive—all negatives, remaining vintage prints, papers,

equipment, and printed matter, except *Night View*, everyone acknowledging that Berenice's licensing commitment to Joseph French for the lucrative image was still in effect. However, by December 1, 1983, the syndicate deal was off, too. With the portfolio market nearing saturation and her vintage prints mostly gone, Berenice's local attorney bluntly advised her to get her financial affairs in order so that someone she trusted—he implied that the need, due to her age and fraility, was imminent—would be in an authorized position to help her.[75]

Allen Ginsberg, in Maine that summer for a William Carlos Williams festival, came to see her. The meeting was arranged by Hank, who had worked with the legendary record producer John Hammond on Ginsberg's recordings. The poet appreciated her reminiscences of old bohemia and of people he admired, liked her spirited wit and maverick nature, and respected that, gay like him, she had made her own way in the world. Ginsberg had recently rediscovered his own snapshot photographs dating from the 1940s to the 1960s; inspired by Hank's recording of Berenice's comments for the monograph's captions, he began writing descriptions on the lower margins of modern enlargements of his images of the postwar Beat generation. He sent Berenice a handwritten copy of his poem "White Shroud," based on his dream of his mother as a New York shopping-bag lady; the backgrounds of the dream were his favorite Berenice photos, *Night View*, *Herald Square*, *Manhattan Bridge*, and *Streetcar* among them. Berenice said that she didn't like Ginsberg much.[76]

In October 1983, Berenice spoke in a daylong program at New York's Cooper Hewitt museum, cosponsored by Phyllis Lambert and the Canadian Centre for Architecture. Berenice was not well—her old lung troubles had returned. Back in Maine, she checked into the local hospital, and then, soon after her discharge, managed to lock herself out of her house.[77]

By the following January, she had made her will. It left everything to Alice Ross, except for her sable jacket (which was to go to Dorothy Healy) and specific artwork to friends. She planned to go to New York in

February "to close the deal on her photographs, negatives, papers," she told Irene, and return to Maine by the twenty-eighth for an IRS audit. Harry Lunn, interested neither in negatives nor in acquiring another photographer's archive (he had already acquired Walker Evans's), likened Berenice's years-long, multiple-sale machinations to "the last and final appearance of Sarah Bernhardt"—which went on for a decade.[78]

Berenice had turned again to Bob Feldman when Hank's syndicate plan collapsed, and he acted quickly. His good-faith check for the sale, drawn on a London bank, required special handling at her rural one. Their letter of agreement, dated February 17, 1984, confirmed his intention to purchase "all of my photographic works, and all of my letters, manuscripts, notes and other memorabilia, cameras, and all related rights, which I now own, which I hereafter produce or to which I hereafter acquire rights."[79]

Berenice then flew to California to accept the Friends of Photography's Peer Award for a Distinguished Career in Photography, in Carmel. "I didn't like him," Berenice said of the group's founder, Ansel Adams, "and he didn't like me." She did like the other parts of the trip—flying out on Phyllis Lambert's private plane with Harry and staying at the old Biltmore Hotel in Los Angeles, which Phyllis had bought and renovated in the 1970s. Back in New York, she went to the March 6 Armstrong Gallery opening of an exhibition linking her vintage New York work to Lewis Hine's. When Allen Ginsberg raised his camera to take her photograph, Berenice cried, "Oh, don't be a shutterbug!" and directed him to "back away a little" to avoid distortion. He captured Berenice gesturing upward, holding an empty glass from which she had drained an old-fashioned. Harry hosted a celebratory dinner for thirty admirers where Berenice, the *Times* wrote, "picked at salad, rack of lamb and chocolate soufflé, clucking at the excess."[80]

Two days later, Berenice signed Bob Feldman's contract for $290,000 setting May 15 for the actual close of the sale. The deal still wasn't final in Berenice's mind, though by the closing she was to have signed a contract-specified number of mount boards. On March 10 she was inter-

viewed by Man Ray biographer Neil Baldwin. Then she drove back to Maine, where disaster greeted her.[81]

Her safe had been emptied of the Krugerrands and commemorative coins she'd stashed there over the years. Worth several hundred thousand dollars, the horde had been nestled neatly in sturdy champagne truffle boxes, candy sent regularly by Ella Freidus; Berenice had obliviously left the combination posted handily on the adjacent wall. She chose not to pursue the matter with the authorities. All she had left for her old age were memories and real estate, and no choice about surrendering her life's work and its history via the sale she had so long postponed.[82]

23

EPILOGUE

Maine (1984-92)

A work of art is a gift, not a commodity. . . .
a work of art can survive without the market,
but where there is no gift there is no art.

—LEWIS HYDE[1]

I don't work anymore. . . . I didn't like the last things I did. People
should know when to quit. Now, I'm a retired hermit. —BA (1984)[2]

When Berenice said she missed New York for "the things of
civilization," she meant good olive oil and green noodles.
And parties like the March 27 reception for Danielle Mit-
terrand, the wife of French president François Mitterrand. The hosts,
painter Paul Jenkins and his wife, Suzanne, had strong connections in
the Paris fashion and art worlds; they lived in Willem de Kooning's
former loft, across the street from Hank's on Broadway below Union
Square. In addition to Paloma Picasso and Robert Motherwell, Berenice
met Jean-Claude Baker, the "delightful" grown son of Josephine Baker,
one of the performer's eight adopted children, a "rainbow tribe" she

said, from various backgrounds and ethnicities; Berenice subsequently considered herself his godmother.[3]

She was in poor health for much of the rest of 1984. With the Feldman purchase fully finalized, he sent art consultant Valerie Gray Kestner to help process and transfer Berenice's collection. Harry Lunn and Marlborough went their separate ways, dividing up their remaining prints, including original Atgets and prints by Berenice.[4]

On July 9, one of the few dates Berenice specifically noted in her annual log, she had lunch with Susan Brown Blatchford, a Maine transplant from New Jersey, who was twice divorced (from the same man). They had been acquainted since Susan, a thirty years younger fan of photography, introduced herself at the University of Maine in 1970. As a teenager she had lived one summer in Los Angeles next door to fashion photographer George Hoyningen-Huene; she later studied with *Harper's Bazaar* photographer Martin Munkacsi, and with Edward Kaminski, a teacher of Lee Friedlander, among others. Susan graduated from junior college before marrying John Blatchford, a Bangor, Maine, estate and trust attorney, with whom she had four daughters. By the early 1980s she was on her own, studying library science at Simmons College in Boston. Several times, she drove up from there in her MG to visit Berenice; once, she took her out sailing overnight on her boat the *Adventuress*, with her friend Mildred Cummings, founder of Maine Coast Artists. Berenice proved a good sailor, despite the nighttime cold, and was especially impressed by Susan's handling such a big boat. Her skill as a photographic printer was another winning factor. With her bobbed light-brown straight hair and stocky, strong body, she must have reminded Berenice in no small way of Elizabeth.[5]

After the May 15 closing of the sale to Bob Feldman, Berenice had largely taken to her bed, regretful and confused about contract provisions concerning her personal property. Her remaining file prints were placed before her to sign in pencil on the back, but Susan temporarily suspended the archive inventory, allowing Berenice to recover her strength. The inventory was complete by summer's end, and Algis

Kemezys drove the archive down to New York in a box truck. He brought Berenice a little black-and-white kitten, a tiny creature she cuddled happily for his camera.[6]

I had no idea I was getting older; I never worried about it . . .

it's so natural . . . slow; you're not aware of it. —BA[7]

"YOU TAKE ME in as your heir and I'll take care of you until the end." That was how Susan Blatchford described her "deal" with Berenice. With the deaths in 1984 and 1985 of her friends Lee Witkin, Carlton Bauer, Laura (called Laurie, Mrs. Howard) Thompson, and Julia Reiner, mortality loomed heavily for Berenice. Susan's protectiveness seemed merely calculating to some Maine friends; to others more distant it seemed exploitive. But most were grateful and relieved that a difficult situation had been resolved—no one else close to Berenice was willing to live in the Maine woods and be her caregiver. "Vibrant companionship" was I. Bernard Cohen's term for their relationship. Though Berenice would occasionally complain that she was too fat or a bad cook, Susan readily consulted with old friends about how to please her. Neither Susan nor her family thought Berenice would live as long as she did; Harry Lunn said aloud what many thought privately, that she would not have endured as long without Susan's care.[8]

Bob Feldman placed portions of Berenice's prints with buyers but kept her memorabilia and negatives together. Berenice sold the big Blanchard house, now emptied of her work and antique furniture, which had been separately consigned in 1983 to a local dealer. In March 1985, photography collector and New Jersey industrialist, Ronald A. Kurtz, an MIT-educated materials scientist and trustee, purchased Berenice's archive from Feldman, who had been a classmate of his younger brother's at Brown University. Graciously, Ron Kurtz wrote to introduce himself and his wife, Carol, and to assure Berenice that he would treat her archive "with love and respect." Todd Watts, whom Kurtz would

keep on as Berenice's printer, alerted him that the arthritis in Berenice's hands made it hard for her to sign more than a few mount boards at a time.[9]

That spring Berenice attended an American Academy and Institute of Arts and Letters meeting in New York, where, on a speakers' platform with other members, she became drowsy after a heavy lunch with wine. She visited with Maria Morris Hambourg and Allen Ginsberg, and served as a bridesmaid in Hank O'Neal's wedding to Shelley M. Shier, his Canadian-born business partner. Harry Lunn and the newlyweds came to Maine for Berenice's eighty-seventh birthday, which they celebrated in Portland before returning to Monson for rounds of Parcheesi games. By all accounts Berenice played competitively, stashing the dimes she won in a small drawstring purse and challenging losers, "Had enough?" Her distant Bunn family cousin George Harvey traveled up from Connecticut with his wife. Cheryl Greaney, her partner, and their baby son were soon welcome visitors in the Monson cabin as well. Robert Creeley brought her an inscribed copy of his recent book, *Mirrors* (1983). The Kurtzes visited and discussed plans for an exhibition of Berenice's work at MIT. Leslie Katz reported that January's earlier Marlborough show had people "riveted"; Bob Feldman's partner, Diane Bucci, invited Susan and Berenice to sail right up to the Parasol Gallery, in Sag Harbor, Long Island, where she was showing a proof of Todd's 48 × 36 inch print of *Night View*, but they stayed put.[10]

Although Berenice canceled plans or declined invitations to travel to Italy, Japan, and Spain, she did go with Susan to Boston for the MIT exhibition that fall. Arriving a few days ahead of their Ritz-Carlton reservation, the women stayed with the Shwachmans. Hurricane Gloria left them without electricity for two days. Berenice shared with Irene the petty photo-world complaints she dared not confide to her new associates, and Irene was left with the impression that Berenice had become more contentious with advancing age. It was her way of protesting her diminishing autonomy, but it made for sour company. Nevertheless, MIT's retrospective was a huge hit. Ron Kurtz had met Hank and would

Berenice in her Commerce Street studio, New York, late 1943. Arnold Newman

soon meet Harry, who was relieved by Ron's competent protection of Berenice's interests. For the rest of her life, these three men would commemorate Berenice's birthday every year in Maine and together hold fast her standing in the art world.[11]

In New York in January 1986, Berenice sat for a portrait by Arnold Newman, whose archive Ron Kurtz had begun representing. As a young man in the 1940s, Newman had photographed American artists; Berenice was the first woman and one of the few photographers he included in his 1980 roundup, *Artists: Portraits from Four Decades.* Newman cajoled and wheedled her. "Come on, give me that suspicious little smile again. You look mad." When he turned away to fuss with a film holder, she gave Newman's young female assistants a brief, face-transforming "smile of the most poignant sweetness." They went to lunch at the nearby Café des Artistes, in the building where Berenice had lived after coming back from Paris in 1929. She washed down her bluepoint oysters and grilled swordfish with Amstel Light beer.[12]

She and Susan spent that winter in Florida—Berenice's first out of Maine in twenty years. Their hostess was Helen Cummings Cook Vanderbilt, widow of former Rhode Island governor William H. Vanderbilt and a relative of Susan's friend Mildred Cummings and her daughter, Daphne. Berenice ran into her former Miami dealer Barry Fellman, who was surprised that she had really "sold off everything," and glad to see her in such good health. Nineteen eighty-six also brought an honorary degree from Ohio State University for which Susan and Berenice drove down to the Kurtzes' New Jersey home and flew out to Columbus together. The eighty-eighth birthday gathering in Maine started a tradition of group portraits taken by Hank at the Monson house.[13]

The big log house saw Susan's domestic improvements—new curtains, a heavy glass coffee table, a smart Italian leather sofa bed, and a pair of black leather Eames chairs facing the large-screen television. Side by side, Berenice and Susan sat to eat dinner from bamboo trays or to watch videos that Susan turned up, reissues of bygone classics and, increasingly, recent histories of the arts and of the New York of Berenice's heyday. On November 1, at the Center for the Arts in Orono, Berenice met poet May Sarton at a celebration of distinguished Maine women. Sarton noted Berenice's "enchanting" purple outfit and "sturdy" black moccasin-style oxfords, plus the "keen, merry, intelligent awareness" of her very blue eyes. The aging awardees endured speeches and music, Sarton wrote, perched on hard straight chairs under the audience's constant stare.[14]

At the end of the year the Martina Hamilton gallery exhibited all ten of Todd Watts's 30 × 40 inch prints of Berenice's photographs: eight of New York City, *Milliken's Store* from the Maine series, and *Van de Graaff Generator* from 1950. En masse, it was quite a sight, and one of the earliest presentations of oversize photographs that would become customary by the end of the century. Ron Kurtz was left in charge of the gallery, while Berenice and gallerist Hamilton took actor Dustin Hoffman, a potential buyer, to lunch. At the Cosmopolitan Club, Berenice embarrassed Hamilton, a club member, by becoming completely drunk.[15]

Photographers crowded around Berenice at the reception of a small show of her work at the New York Academy of Sciences in January 1987. "Take away the cameras!" she cried, trying to shield her face with a napkin. "Modern photographers are like mosquitoes. They dance around you snapping, snapping and still snapping hoping one image comes out," she said. Later she told an interviewer that "you couldn't have torn me out of New York" when she was younger. "But now I go down there for a few days, and I get so wound up. I have to get out fast to keep my sanity." She complained that she once had been the youngest but now was "the oldest person around" and longed to meet some other "old people." She met a contemporary in Ron Kurtz's elegant mother, Claire. "It's so nice to see someone my own age," she said, greeting Berenice warmly at her son's home. "People our age are dead," Berenice responded in her Ohio deadpan.[16]

In October 1987, Berenice had pneumonia again and a third hernia operation, two years after the last one. She ended her 1987 log, "Mostly tired." Four months in Florida with Susan and Daphne Cummings restored her. In July 1988, the company Ron Kurtz founded to license Berenice's images and market her modern prints, Commerce Graphics Ltd. (named for Berenice's street in Greenwich Village), issued a hand-some catalog, organized and with an essay by the young art historian Cheryl Finley. Ironically, its freelance graphic artist was the daughter of George Farkas, House of Photography's ill-fated industrial designer. Berenice found one of the plates miscropped, but the handsome print-ing served well to introduce her work to a new audience, as did the simultaneous publication of Aperture's *Masters of Photography* volume, illustrated with Todd Watts's 1981 unsentimental portrait of her on the back cover.[17]

On July 11, Berenice was in New York to become a Chevalier in the French Order of Arts and Letters. At the presentation ceremony, Conseiller culturel adjoint Patrick Talbot noted the "fortuitous series of encounters" that shaped Berenice's destiny, including Atget; the

"extraordinary rectitude" of her "professional life" and work; and "a dimension that puts her in the heart of modernism and links her to all that is dynamic in the tradition of western art"—he even reached back for comparison to Leonardo da Vinci and Michelangelo regarding her scientific work.[18]

For this heady event, Berenice sat next to her "godson," Jean-Claude Baker, who was resplendent in a red jacket. Afterward, while Susan hovered nearby, Berenice stood to receive well-wishers, including Morris Engel, a longtime favorite. At his studio she praised his new color panoramas of New York street life for providing an idea of contemporary civilization. "I mean, what if we had pictures like that of the fall of Rome?" For the last time, Berenice also visited Eyre de Lanux, who found it "too painful" to talk about their old Paris years.[19]

Berenice's ninetieth birthday celebration included an afternoon excursion on the historic Moosehead Lake steamboat *Katahdin*; one photograph shows an unsteady Berenice leaving the gangplank on the arm of Harry Lunn, who looks concerned. The landmark birthday occasioned "quite a few" articles; equally important to Berenice was her visit with the forty or so students of tiny Monson Elementary School. It was also the year that both Irene Shwachman and Liz Upham, the partner of long-divorced Sally Nerber, died.[20]

> I always thought that there was nothing
> smarter than an old woman. —BA[21]

IN THE SUMMER of 1989, Berenice was videotaped by Kay Weaver and Martha Wheelock for their Ishtar Films feature-length documentary *Berenice Abbott: A View of the 20th Century*, released in 1992. She decided to have a formal portrait taken, submitting herself to international portraitist Yousuf Karsh, whom she admired. He made the trip to Monson from Ottawa, Canada. He remembered Berenice as "both professional observer and active collaborator." One portrait is severe, before the tow-

Ninetieth Birthday Gathering, Monson, Maine, *July 17, 1988*. Standing, L–R: *Daphne Cummings, Shelley M. Shier, Harry H. Lunn Jr., Ronald A. Kurtz, and Laura Volkerding*. Seated: *Carol Kurtz, Berenice Abbott, and Ben Raeburn*. Hank O'Neal

ering oversize print of her 1950 *Van de Graaff Generator*. The other is softer; she is almost smiling, and her eyes are kind. As in poses of decades earlier, she holds a hand to her cheek. She gave the Karsh team explicit driving directions back home—a metaphor, Karsh said, "of Berenice taking the most direct course, not wasting time on inessentials."[22]

In 1989 the New York Public Library organized a retrospective exhibition that toured from Tokyo to Portland, Maine; its catalog anthologized Berenice's most salient writings on all facets of her photography. For the opening, Harry Lunn sent a stretch limousine to ferry Berenice from her hotel a block away. She emerged on Fifth Avenue to the sight of a huge maroon exhibition banner with white lettering—"sour cream

Portrait of Berenice Abbott, *Monson, Maine, August 1989.* Yousuf Karsh

on borscht" as she had requested, in the library's center portal. She mounted the long stairs and barely sat down during the two-hour event. In 1990 the Smithsonian Institution Press reissued her Horizon Press monograph, and Berenice sketched celebration plans for her one hundredth birthday, including custom napkins to be printed "1898–1998." For the Smithsonian film *Quantum Universe*, Harvard astrophysicist Margaret Geller asked why it took so long for her science work to be recognized. Berenice, her intent blue eyes piercing right through Geller, said, "They were stupid!"[23]

In August 1991, Berenice could barely acknowledge the collapse of the Soviet Union, embodiment of her mythical communist ideals. She said she didn't understand all the fuss over the charges of sexual harassment raised in Congress's confirmation hearings for Supreme Court nominee Clarence Thomas—"men always talk dirty."[24]

Though she wanted very much to live into the twenty-first century, she now used a hospital bed and an oxygen tank in her downstairs bedroom. She enjoyed the busy hummingbird feeder Susan had hung outside the window. In early December, Berenice asked her physician how long she might live if she stopped eating, and he said a week or two. Ten days later, Berenice was gone, the official cause of death given as "bronchiectasis"—destructive thickening of the large airways, traceable to the Spanish influenza of her youth and decades of cigarette smoking.[25]

Obituaries listed no survivors, but Susan received many condolences offering a sympathetic perception of her role. In February 1992, a Saturday morning memorial was held at the New York Public Library, recorded for broadcast later by the Voice of America. Harry Lunn sent flowers and Ron Kurtz paid for the event. Speakers included I. Bernard Cohen, Grace Mayer, and Yousuf Karsh. Photographer Laura Volkerding, who had celebrated Berenice's ninetieth birthday in Monson, wrote to Susan that she "once read that modernism began with Victor Hugo's funeral; perhaps with Berenice's death it has ended. She outlived everyone else in her era and certainly outranks them in my opinion."[26]

Berenice had purchased a cheap plot in the "new" Blanchard ceme-
tery, only to complain about the village's fees for routine maintenance.
(In a discussion of funerals in 1973 with Blanchard friends, she had said
that she wanted her body to be eaten.) Her gravestone was a boulder
on the Monson property that she and Susan agreed would be dug up
and moved when the time came. In mid-July 1992, Susan invited friends
to what she called a "regretta," a private gathering to memorialize the
boulder's marking the spot where the casket of Berenice's ashes had
been buried in the spring; its plain bronze plaque read:[27]

<div align="center">

BERENICE ABBOTT

PHOTOGRAPHER

JULY 17, 1898

DECEMBER 9, 1991

</div>

On July 18, a bright and breezy day with churning cumulus clouds
overhead, a small group stood around Berenice's grave in an open,
grassy area. Ron Kurtz said that in Berenice's work he still found the
original magic of photography. Cheryl Greaney said Berenice's recent
"playfulness and sparkle" taught her how not to be afraid of death. Sally
Nerber acknowledged their six decades of unquestioning friendship.
Harry Lunn described how Berenice stood in for his mother, close to
Berenice's age, by being the one he could phone to share funny articles
and converse about life, art, and politics. Then, following a tradition
he had begun recently, Harry offered Berenice the year's hot French
perfume, picked up as he dashed through Charles de Gaulle Airport.
It bore the name of Salvador Dalí and came in a bottle the artist had
sculpted. Dalí was an artist neither of them particularly liked, Harry
said. But "she loved the bottles the kookier they were." He briefly
placed the peculiar blue-green object on the boulder—in the spirit, he
said, of Walker Evans's photographs of southern graves decorated with
Coca-Cola bottles—and then sprayed the scent around the area as a
substitute for incense.[28]

Susan, allowing that Berenice believed in no religion (and ignoring her astrology fascination), read Mark Twain's famed eulogy to his eldest daughter, which ends, "Good night, dear heart; good night, good night." The clouds grew gray, the wind picked up, and leaves shook. Susan gave a stern look, as if to say, don't make anything of this, but it was over in an instant and the group went back to Monson for a buffet lunch.

When Ishtar's film opened, in December 1994, at New York's Cinema Village, the *New York Times* faulted it for leaving Berenice's personal life unexplored. Twenty years later, when German publisher Gerhard Steidl produced *The Unknown Berenice Abbott*, a monumental, five-volume thematic illustrated compendium, *Bookforum* complained that it left viewers in the dark about her feelings toward her subjects. But Berenice relentlessly held that her feelings were evident in her photographs—first, in the images' content: the choices of subject and the selection of specifics; then, in their communicative means: printing, distribution, and presentation. In the end, proud and thorny Berenice Abbott—who wanted to be remembered as a "self-taught risk taker"—prevailed on her own terms to protect her privacy and retain autonomy as the most aesthetically versatile and hard-nosed photographer of the twentieth century.[29]

ACKNOWLEDGMENTS

As the idea for this biography gelled in 1991 Berenice Abbott told me to read two books for background: Mathew Josephson's Greenwich Village memoir Life Among the Surrealists (1962) and Meryle Secrest's biography of Paris expatriate painter Romaine Brooks Between Me and Life (1976); months later, she hinted broadly that parallels with her own artistic trajectory lay in a personal favorite, Willa Cather's Song of the Lark (1915).

After Berenice died, friends, relatives and colleagues—many no longer living—offered stories, recollections, opinions, impressions, documents, introductions, leads, and advice. To all I am grateful, chief among them: Susan B. Blatchford and family; Ronald A. and Carol Kurtz; Harry H. Lunn Jr.; Hank O'Neal; Joan Schenkar; and Todd Watts; plus Berenice's friends, Ella Jaffe Freidus, Shirley Kaufman, Leticia Kent, Sally Valentine Nerber, and Mignon Shepard; and Irene Shwachman's children Alan Shwachman and Elizabeth Passman Nelson.

So many others were generous with their time and recollections: Helen B. Andrejevic, Virginia Pratt Bardeen, Peter Barr, Miles Barth, Timothy Baum, Harold Becker, Ruth Bernhard, Louise Bernikow, Theresa Bernstein, Lili Corbus Bezner, Cheryl Black, Beverly Brannan, Mosette Broderick, Gail Buckland, Carolyn Burke, Kenneth Burke, Eleanor Carr, Vivian Cherry, Bronia (Perlmutter) Clair (interviewed by Joan Schenkar), I. Bernard Cohen, Miriam Colwell, William Conklin, Roger Conover, Julian Cox (Getty Museum), Anna Craycroft, Lynn Davis, Jean C. DeIeso, Steve Dietz, Lucy B. Dillon, Gaby Divay, Vivian Ducat, Charles H. Duncan (Richard Pousette-Dart Foundation), Arnold and Dorothy Eagle, Douglas Eklund, Allen Ellenzweig, Jane L. Ellison, Mary Engel, Morris Engel, George Ermakoff, Catherine Evans, Ben Fairbank, Barry Fellman, Michael Flomen, Harris Fogel, Charles Henri Ford, Abe Frajndlich, Lee Friedlander, William Frucht, L. Damon and Sara Gadd, Irene Gammel, Cecile W. Gardner (Boston Public Library), Peter Gay, Helen Gee, Frank Genovese, George Gilbert, Ariel Goldberg, John Goodman, Cheryl Greaney, Maurizia M. Grossman, Gary Guisinger, Crissie Haft, Martina Hamilton, David Harris, George Harvey, Peter Higdon, Robert Ipcar, Lisa Jacobs, Buffie Johnson, Philip Johnson, Jennifer Josephy, Mary Virginia Junk, Molly Kalkstein, Kevin Kampman, Jodi Kanter, Yousuf Karsh, Leslie Katz and Jane Mayhall, Paul Katz, Peter Kayafas, Christoph Keller and Jan Levy, Rowena Kennedy-Epstein, Algis Kemezys, Cal Kowal, Isaac Lagnado, Eyre de Lanux, Kay Larson, Carl Leavitt, Gail Levin, Sol Libsohn and Bess Tremper, Barbara (Mrs. Bert) Little and family, Michael Lorenzini (NYC Department of Records and Information Services), Sara J. MacDonald, John B. Mahaffie, Steven Manford, Rose Marasco, Grace Mayer, Ellen (Blatchford) McDermott, Sheila McGrath, James McQuaid, Barbara Michaels, Peter Michels, Sarah M. Miller, Steve Miller, May (Malkin) Milstein, Margaretta K. Mitchell, Regina Monfort, Jennifer Marck Moran (City and Country School, NYC), Juliette Moran (courtesy Ken Werner), Gaëlle Morel, Lida Moser, and Dona Munker.

Also: Francis M. Naumann, Dale Neighbors, Dianora Niccolini, Mary Panzer, Richard Pare (for Phyllis Lambert), Olivia Peirce, Jed Perl, Marcuse Pfeifer, Rodney Phillips, Carol A. Pinsky, Jill Quasha, Alice Quinn, Kristin V. Rehder, Ellie Thurman Reichlin, Peter Reznikoff, Peter Ride, Helen Ann Robbins, Naomi and Walter Rosenblum, Nina Rosenblum, Jeff Rosenheim, Elizabeth Roth, Elisabeth (Hitchings) Sekaer Rothschild, Charles Rotkin, Bill Rukeyser, Nigel Russell, Robert Károly Sarlós, Naomi Savage, Elizabeth and Larry Schaaf, Edward and Pearl Schwartz, Julia Newman Scully, Meryle Secrest, Toshi Seeger (courtesy John Cohen), Leo Seltzer, Caroline Shaper (Fayette County Probate Court and Archives Center, Washington Court House, Ohio), Nancy Shawcross (Rare Book and Manuscript Library, University of Pennsylvania), Meredith Ann TeGrotenhuis Shimizu, Anne Skillion, Catharina Slautterback (Boston Athenaeum), Tony Smith, Sanford J. Smoller, Fred Spira, Sally Stein, G. Thomas Tanselle (Guggenheim Foundation), Jerry L. Thompson, Dennis Traub, Jeremy Treglown, Anne Wilkes Tucker, Gary Van Zante (MIT Museum, plus assistants Shanna Lee Strunk and Amber Sinicrope), Sandra Weiner, Todd Weinstein, Murray Weiss, Richard Whelan, Richard White, Donald Windham, Clark Worswick, and Bonnie Yochelson.

I am grateful to former colleagues at, first, the New York Public Library—especially Jack Best, Sharon Frost, Janet Murray, David Lowe and Anthony Troncale in the Photography Collection, and also Lenore Cowan, Peter Gay, Rodney Phillips, Gunther Pohl, Bobby Rainwater, Roberta Waddell, Mary Yearwood, and the Exhibitions Program Office staff; and more recently, to many at the Museum of the City of New York.

This biography's long gestation witnessed the transformation of bibliographic and archival research from site visits to digital access: Archives of American Art, Smithsonian Institution; Beinecke Rare Book and Manuscript Library (Moira Fitzgerald and Anne Marie Menta), Yale University; Boston Athenaeum; Center for Creative Photography (Leslie Calmes, Amy Rule, and Leslie Squyres), University of Arizona; Cleveland (Ohio)

Metropolitan School District; Cleveland Museum of Art; Cleveland Public Library; Columbia University Libraries (Avery Library, Butler Library, Columbia Center for Oral History, Gabe M. Wiener Music and Arts Library, Mathematics Library, Rare Book and Manuscript Library, Science and Engineering Library, and Teachers College Library); Columbus (Ohio) City Schools; Columbus Public Library; Commerce Graphics Ltd, Inc.; Commerce Graphics Ltd, Inc. (especially Natalie Evans, Cheryl Finlay and Helaine Pardo); George Eastman Museum (Rachel Stuhlman, Library, and Joe R. Struble, Photography Collection); Getty Research Institute, Special Collections; Harry H. Ransom Center, University of Texas; Houghton Library and Lamont Library, Harvard University; Lesbian Herstory Archives; Manuscript Division, Library of Congress; Metropolitan Museum of Art (Department of Photographs and Thomas J. Watson Library); MIT Museum Archives; and Museum of Modern Art (Photography Department and Archives).

Also: New York Public Library (General Research and Humanities Division; Henry W. and Albert A. Berg Collection of English and American Literature; Irma and Paul Milstein Division of United States History, Local History and Genealogy; Manuscripts and Archives; Miriam and Ira D. Wallach Division of Art, Prints and Photographs; Rare Books; Prints and Photographs Division, Schomburg Center for Research in Black Culture; and Science, Industry and Business Library); Newberry Library, Manuscripts and Archives; Ohio State University, Rare Books, William Oxley Thompson Memorial Library; Pennsylvania State University, Eberly Family Special Collections Library; Rutgers University Libraries, Special Collections and University Archives, Archibald S. Alexander Library; Sarah Lawrence College Archives; SNCC Legacy Project (Emmie Schrader Adams, Matt Herron, Danny Lyon, and Sharlene Kranz); US Department of Justice, Federal Bureau of Investigation (via FOIPA); University of the Arts (Philadelphia), University Libraries and Archives; University of Maryland Libraries, Special Collections, Hornbake Library (Beth Alvarez); and University of New Hampshire Library, Milne Special Collections and Archives.

Along the way, I received welcome support from the National Endowment for the Humanities (1993), NYPL's Dorothy and Lewis B. Cullman Center for Scholars and Writers (2002–2003), and Commerce Graphics Ltd, Inc. (2014), which enabled, respectively, long-distance research, sustained writing, and editorial assistance.

I also thank Women Writing Women's Lives Biography Seminar for welcoming me in 2011, and the late Suzanne Wasserman for inviting me to present a session in 2014; member Carla Peterson graciously introduced me to the Frances Goldin Literary Agency, where Ellen Geiger—happily, amazingly, an Abbott fan and collector—successfully took on my project. I am grateful to my editor Jill Bialosky—Ohio-born like Berenice—for her enthusiasm and insight, plus her able colleagues, Janet Byrne, Eleen Cheung, Julia Druskin, Rebecca Homiski, Penelope Lin, Ingsu Liu, Elizabeth Riley, Maria Rogers, and Drew Elizabeth Weitman. My developmental editor extraordinaire Louise Bernikow helped me write what I thought I was saying all along!

Without the steadfast forbearance of my beloved and collaborative husband, Ron Schick; our treasured daughters, Madeline and Lauren, just children when they knew Berenice; plus my stalwart siblings, Bill and Elaine, and our mother who marveled at my 1990s laptop computer, I would have given up long ago. My dad, a coinventor of the ultramodern 1960s Bulova Accutron watch, died before I learned that Berenice had worn one.

Responsibility for this work is ultimately mine, of course; your "brickbats & contributions," as Berenice's life-partner, Elizabeth McCausland, once urged on a totally different, long-ago occasion, will be most welcome.

JVH ~ January 3, 2018

NOTES

PRINCIPAL ARCHIVES AND ABBREVIATIONS

AAA: Archives of American Art, Smithsonian Institution, Washington, DC.

AC/BA: Arnold Crane interview with Berenice Abbott, Blanchard, ME, Nov. 1968, typed transcript. Arnold Crane interviews of photographers, [ca. 1968–1971], Archives of American Art, Smithsonian Institution.

ALS: Autograph letter signed.

AMS: Autograph manuscript.

AWT/BA: Anne Wilkes Tucker interviews with Berenice Abbott, July 1975 and earlier, transcript, notes, and personal files. Author consulted same on 10/19/1993.

BA: Berenice Abbott.

BA autobiog: Berenice Abbott autobiographical sketch [February 1954 (and later?)], original and edited typescripts. Elizabeth McCausland papers, Archives of American Art, Smithsonian Institution. Revised versions reveal McCausland's increasingly heavy editorial hand; wherever possible, Abbott's original vocabulary and phrasing are quoted.

BA BlkJ: Berenice Abbott, Black Journal. Berenice Abbott papers, 1927–1992, Mss-Col 17972, Manuscripts and Archives Division, The New York Public Library.

Gift of Susan Brown Blatchford. Abbott started using the bound, lined, page-numbered volume in 1946; it contains annual highlights, plus ideas for projects and inventions, often undated, with partial index.

BA memorial: Public memorial service for Berenice Abbott held at The New York Public Library, Saturday morning, 2/8/1992, radio broadcast by Voice of America. Author's audio recording.

BAOH: Berenice Abbott Oral History, interviews by James McQuaid and David Tait, Blanchard, ME, July 1975; typed, bound, and indexed transcripts. George Eastman Museum Library, Rochester, NY, and MIT Museum, Cambridge, MA.

Barr diss: Peter Barr, "Becoming Documentary: Berenice Abbott's Photographs, 1925–1939" (PhD dissertation, Boston University, 1997).

BY:CNY: Bonnie Yochelson, *Berenice Abbott: Changing New York* (New York: New Press, 1997).

CD: City directory.

CG: Commerce Graphics Ltd. Inc., holder of Abbott's archive from 1985 until 2015. The archive was then divided and mostly transferred to MIT Museum, Cambridge, MA, and to Ryerson Image Centre, Toronto, ON, Canada.

CNY: *Changing New York*, Abbott's Federal Art Project, 1935–1939; references to specific images include the project number, title, and date.

CCP: Center for Creative Photography, University of Arizona, Tucson, AZ.

CTL: Carbon typed letter.

CTS: Carbon typescript.

CWA: In conversation with the author.

EMCC: Elizabeth McCausland, and EMCC/AAA: Elizabeth McCausland papers, 1838–1995, bulk 1920–1960. Archives of American Art, Smithsonian Institution.

ES: Edward Schwartz, and ES&PS: Edward Schwartz and Pearl Schwartz, in conversation with the author, Toms River, NJ, 9/12/1992.

FBI/BA and FBI/EMCC: Federal Bureau of Investigation, US Department of Justice, files for BA and EMCC (1951–1955), received Apr. 1998, highly redacted, HQ100-383988 4 [BA] and HQ100-408191 1 [EMCC], retrieved by FOIPA No. 395904 [author].

HDW: Hudson D. Walker, and HDW/AAA: Hudson D. Walker papers, 1920–1982. Archives of American Art, Smithsonian Institution.

HHL: Harry H. Lunn Jr. in conversation with the author, NYC, 5/18/1995.

HON/BA: Hank O'Neal, *Berenice Abbott, American Photographer* (New York: McGraw-Hill, 1982).

IS: Irene Shwachman diary entry (in the form of a bulletin date, mm/dd/yyyy, 1959–ca. 1980s), and IS/CCP: Shwachman's papers, Irene Shwachman Collection, AG91, Center for Creative Photography, Tucson, AZ.

Ishtar: Martha Wheelock and Kay Weaver, *Berenice Abbott: A View of the 20th Century* (Studio City, CA: Ishtar Films, 2007). First released 1992. Abbott was filmed in Monson, ME, summer 1989.

JVH: Julia Van Haaften (author).

MCNY: Museum of the City of New York.

MoMA: Museum of Modern Art, NYC.

N-YHS: New-York Historical Society.

NYPL: The New York Public Library.

NYT: *The New York Times* (newspaper).

OH: Oral history.

PC: Postcard.

"Regretta": Remarks at Berenice Abbott's graveside gathering, Blanchard, ME, 7/18/1992, audio recording by the author.

SBParis: Abbott's scrapbook of her press clippings and printed ephemera while in Paris, Commerce Graphics Ltd. Inc.

SBB/BA: Berenice Abbott papers, 1927–1992, MssCol 17972. Gift of Susan Brown Blatchford. Manuscripts and Archives Division, The New York Public Library.

TLS: Typed letter signed.

XC: Xerox copy.

EPIGRAPHS

1 Irene Shwachman, 11/26/1959 diary entry, IS/CPP.

2 Erla Zwingle, "A Life of Her Own," *American Photographer* 16 (Apr. 1986), 66.

3 *Photo Notes* (Oct. 1944), 1.

4 BA, "Photography today—and tomorrow," 1946, TS ["Not for publication"], Beaumont Newhall papers, Houghton Library, Harvard University.

5 Avis Berman, "The Unflinching Eye of Berenice Abbott," *ARTnews* 80, no. 1 (Jan. 1981), 88.

INTRODUCTION

1 Alvin Langdon Coburn, "The Relation of Time to Art," *Camera Work* 36 (Oct. 1911), 72–73.

2 Harvey V. Fondiller, "I Wish I'd Taken That," *Brief* 1 (June 1953), 87.

3 [Joseph Mitchell, cf. Peter Barr attribution], "Woman with Camera Snaps Revealing History of New York Life in Its Homeliest of Garb," *New York World-Telegram*, 11/11/1932, edition not microfilmed, known only from BA's scrapbook, CG; BA, *A Guide to Better Photography* (New York: Crown Pub-

lishers, 1941), 96; AC/BA, 31; BA, "Eugène Atget," *Creative Art* 5, no. 3 (Sept. 1929), 656.

4 BA, *Guide*, 71.

5 BA to John Storrs, ALS, Berlin, n.d. [dateable through internal evidence to early 1922], John Henry Bradley Storrs papers, AAA; Peter Barr, "The Reception and Sources of Berenice Abbott's Paris Portrait Style, 1925–1929," *History of Photography* 34 (Feb. 2010), 59; BA, *The World of Atget* (New York: Horizon Press, 1964), viii.

6 Ishtar.

7 "Art: Abbott's New York," *Time* 33, no. 15 (4/10/1939), 39; Hank O'Neal, phone CWA 4/30/1991.

CHAPTER 1. BIG LIE ALL MY LIFE

1 Eleanor Roosevelt, *The Autobiography of Eleanor Roosevelt* (New York: Harper & Brothers, 1961), 22, quoted in Blanche Wiesen Cook, *Eleanor Roosevelt* (New York: Viking, 1992), 1:71.

2 BAOH, 4, 8.

3 Census data is inconclusive about Abbotts in and around Hinton, WV.

4 *Ancestry.com* is the source for most BA family documentation, and hence continually subject to updating; Mary Virginia Junk, phone CWA, 7/8/1992.

5 James Alfred Ellis, *History of the Bunn Family of America* (Chicago: Romanzo Norton Bunn, 1928), 249–250; *History of Ross and Highland Counties* (Cleveland: Williams, 1880; Evansville, IN: Unigraphic, 1978); R. A. Stewart, *Index of Printed Virginia Genealogies* (Baltimore: Genealogical Pub. Co., 1965); BA, phone CWA, 7/10/1991, and CWA, Monson, ME, 11/8/1991; BAOH, 4, 106.

6 Cleveland CD, 1888–89 to 1891–92; Cincinnati CD, 1892–93 to 1896–97; 1910 US Census, Cleveland, OH; Springfield CD, 1896 and 1900; Springfield Historical Society, courtesy Carleton Bauer, to BA, 9/27/1982; BA to Springfield City Health Dept., TLS, Nov. 1960, and ms reply on verso; A. LeRoy Bell to Clark County Historical Society, 1982, and Clark County Probate Court birth records, SBB/BA.

7 BA, CWA, Monson, ME, 11/8/1991; ES&PS; Divorce petition to Alice Abbott of Hamilton County, OH, Clark County (Springfield), OH, Court of Common Pleas petition, May 8, 1900, SBB/BA; Springfield 1901–02 CD; Carl C. Degler, *At Odds: Women and the Family in America from the Revolution to the Present* (Oxford: Oxford University Press, 1980), 168–169, 171–172.

8 BAOH, 4, 8; Cincinnati CD, 1900–01; Julia Dean, "The Last Apprentice

(diary)," Julia Dean Photography, accessed 7/17/2012, http://juliadean.com /category/berenice-abbott-blog/page/13/; BA, phone CWA, 7/10/1991.

9 Chillicothe CD, 1902; BA, phone CWA, 7/10/1991.

10 BA, phone CWA, 7/10/1991; BAOH, 6.

11 Ishtar; BAOH, 6, 8; IS, 1/22/1960 and 6/3/1965; BA, CWA, Monson, ME, 11/8/1991.

12 BA, phone CWA, 7/10/1991; BAOH 6, 8–10; Columbus CD, 1908–09; SBB, phone CWA, 6/2/1993.

13 BA, CWA, Monson, ME, 8/4/1991; BAOH, 11–13; BA, phone CWA, 7/10/1991.

14 IS, 1/22/1960; BAOH, 10.

15 BAOH, 13–14; Melvin H. Rodman, MD, TMS, "Miss Berenice Abbott," n.d. [dateable from external evidence to 8/17/1959], IS/CCP; Margaretta K. Mitchell, *Recollections: Ten Women of Photography* (New York: Viking Press, 1979), 12; BA, CWA, n.d.

16 Cleveland CD, 1911–12; BA, CWA, Monson, ME, 8/3/1991; BAOH, 11; IS, 6/3/1965, IS/CCP.

17 BAOH, 12.

18 Robert R. Weiner and Carol A. Beal, "The Economic Base," in *The Birth of Modern Cleveland, 1865–1930*, eds. T. F. Campbell and E. M. Miggins (Cleveland: Western Reserve Historical Society, ca. 1988), 21; BAOH, 543.

19 BAOH, 4, 8; C. E. Abbott death certificate, file #25840; "Dies, Poison Vial Near; Salesman Found Dead After Leaving Farewell Note," *Cleveland Plain Dealer*, 4/30/1915.

20 Susan B. Blatchford, CWA, and Hank O'Neal, CWA, early 1990s; BAOH, 4, 8; BA, phone CWA, 7/10/1991.

21 AWT/BA; BA, CWA, Monson, ME, 8/4/1991 and 11/9/1991; Reuters, "Berenice Abbott, at 84, Retains the Spirit of a Rebel," *NYT*, 2/17/1983; Julia Dean, "The Last Apprentice [diary]," Julia Dean Photography, 8/1/1978, accessed 6/29/2011, http://juliadean.com/k6.

22 AWT/BA; BAOH, 32, 36; IS, 3/31/1964; BA, phone CWA, 7/10/1991, and CWA, Monson, ME, 8/4/1991.

23 BAOH, 657.

24 BA to Frieda Gaeth, ALS, pmk. 3/30/1917, CG; Helen Jupp Williams to BA, ALS, after 4/20/1949, CG; Lillian Faderman, "Introduction," "'The Loves of Women for Each Other,'" chap. 1, and "A Worm in the Bud," chap. 2, in *Odd Girls and Twilight Lovers: A History of Lesbian Life in Twentieth-Century America* (New York: Columbia University Press, 1991), 1–92.

25 BAOH, 606.

26 BA to Frieda Gaeth, ALS, pmk. 3/30/1917, CG.

27 BAOH, 31; BA autobiog; IS, 7/16/1959.

28 BAOH, 12; Thomas C. Mendenhall, ed., *History of the Ohio State University*, vol. 2 (Columbus: Ohio State University Press 1926), 30; Mendenhall, *History*, vol. 4 (1934), 147.

29 BA autobiog; Margaret Batterham Waters to JVH, TLS, 4/29/1993; Columbus CD, 1918; BAOH, 35–36.

30 *The Sansculotte* 1, nos. 1–3 (Jan.–Apr. 1917), Ohio State University Archives; Ludwig Lewisohn, *Up Stream* (New York: Boni and Liveright, 1922), 164, quoted in Carl Wittke, "Campus Publications During the War," in Mendenhall, *History*, vol. 4 (1934); Hans Bak, *Malcolm Cowley: The Formative Year*s (Athens: University of Georgia Press, 1993), 66, 32; Louis Lozowick, interview with William C. Lipke, 1/11/1970, Louis Lozowick papers, AAA; IS, 4/21/1960 and 9/20/1968.

31 Waters to JVH, TLS, 4/29/1993; BAOH, 606.

32 Waters to JVH, TLS, 9/28/1992 and 10/15/1992; BAOH, 31; IS, 10/31/1959; BA, CWA, Monson, ME, 8/4/1991; Junk, phone CWA, 7/8/1992.

33 BAOH, 35; Ross Wetzsteon, *Republic of Dreams: Greenwich Village: The American Bohemia, 1910–1960* (New York: Simon and Schuster, 2002) 70–71; BA, CWA, Monson, ME, 8/4/1991.

34 Mitchell, *Recollections*, 12; Alice C. Steinbach, "Berenice Abbott's Point of View," *Art in America* 64 (Nov.–Dec. 1976), 77; BAOH, 24–25, 27, 107, 350; BA, CWA, Monson, ME, 8/4/1991; BA's Ohio State University transcript, 1917–1918.

35 BA autobiog; *First Hundred Years: A Family Album of the Ohio State University, 1870–1970* (Columbus: Ohio State University Press, 1970), 48; BAOH, 32–33.

36 BAOH, 36; BA, CWA, Monson, ME, 8/4/1991; BA autobiog; BAOH, 36–37; Waters to JVH, TLS, 9/28/1992.

37 Junk, phone CWA, 7/8/1992; "An Interview with Robert Creeley; Conducted by Steve Luttrell," *The Café Review: A Quarterly Poetry & Arts Publication* 6 (Spring 1995), 40; Reuters, "Berenice Abbott," *NYT*, 2/17/1983; IS, 7/10/1967.

38 IS, 6/3/1965; AWT/BA; BA, CWA, Monson, ME, 8/4/1991; BA autobiog; BAOH, 105.

CHAPTER 2. CENTER OF EVERYTHING

1 James Oppenheim, "The Story of the Seven Arts," *American Mercury* 20 (June 1930), 157.

2 BAOH, 46.

3 BA autobiog; BA, CWA, Monson, ME, 8/4/1991; Malcolm Cowley, "Her Name

Was a Singing Line of Verse," review of *The Poet and Her Book*, by Jean Gould, *Book World*, 5/18/1969, 5, quoted in Anne Cheney, *Millay in Greenwich Village* (University, AL: University of Alabama Press, 1975), 59.

4 BAOH, 363–364; Hutchins Hapgood, *A Victorian in the Modern World* (New York: Harcourt, Brace, and Co., 1939; Seattle: University of Washington Press, 1972), 318; Arthur Gelb and Barbara Gelb, *O'Neill* (New York: Harper, 1962), 283–284.

5 Rick Beard and Leslie Cohen Berlowitz, eds., *Greenwich Village: Culture and Counterculture* (New Brunswick: Rutgers University Press for Museum of the City of New York, 1993), ix, quoted in BY:CNY, 10.

6 Helen Deutsch and Stella Hanau, *The Provincetown: A Story of the Theatre* (New York: Farrar & Rinehart, 1931; New York: Russell & Russell, 1972); Robert Károly Sarlós, *Jig Cook and the Provincetown Players: Theatre in Ferment* (Amherst: University of Massachusetts Press, 1982); Gelb, *O'Neill*, 343+.

7 BAOH, 42–44; Christopher Gray, "The Village Site of Eugene O'Neill's 'Iceman' Saloon," *NYT*, 6/3/2001; Dorothy Day, *The Long Loneliness: The Autobiography of Dorothy Day* (New York: Harper, 1952; San Francisco: Harper & Row,1981), quoted in Gelb, *O'Neill*, 359.

8 BAOH, 42–44, 905; BA autobiog; Holger Cahill OH, interviews by Joan Pring, 1957, Columbia University, transcript, 59.

9 BAOH, 44; Cahill OH, 84.

10 AWT/BA; Henry Wysham Lanier, *Greenwich Village, Today & Yesterday* (New York: Harper, 1949), 146–148; Hapgood, *Victorian*, 198; BA, CWA, Monson, ME, 8/4/1991; BAOH, 50, 606–607.

11 Gelb, *O'Neill*, 298, 831; BAOH, 44; Lanier, *Greenwich*, 146–148.

12 BA autobiog; Gelb, *O'Neill*, 286.

13 Harry W. Lawton and George Knox, "Editors' Introduction" to *The Valiant Knights of Daguerre: Selected Critical Essays on Photography and Profiles of Photographic Pioneers*, by Sadakichi Hartmann (Berkeley: University of California Press, 1978), 1–31; Cahill OH, 81; William Bryk, "King of the Bohemians," *New York Sun*, 1/26/2005.

14 Robert Schulman, *Romany Marie: The Queen of Greenwich Village* (Louisville, KY: Butler, 2006), 144.

15 Holger Cahill, "Prologue to Sadakichi" (read before Hartmann lecture, "Art by the Few for the Few," Romany Marie's, New York, 1/22/1933), "Contemporary Portraits of Sadakichi Hartmann," Modern American Poetry: An Online Journal and Multimedia Companion to *Anthology of Modern American Poetry* (Oxford University Press, 2000), eds. Cary Nelson and Bartholomew Brinkman, accessed 10/28/2012, http://www.english.illinois.edu/maps/poets/g_l

/hartmann/portraits.htm; Gene Fowler, *Minutes of the Last Meeting* (New York: Viking, 1954), 18; Benjamin De Casseres, "Five Portraits on Galvanized Iron," *American Mercury* 9 (Dec. 1926), 398, quoted in Lawton and Knox, "Editor's Introduction" to *Valiant*, Hartmann, 315n4, and quoted in George Knox, introduction to *The Life and Times of Sadakichi Hartmann, 1867–1944* (Riverside, CA: University Library, 1970), 1; IS, 5/11/1963; BA, CWA, Monson, ME, 8/4/1991.

16 BAOH, 58; AWT/BA.

17 Matthew Josephson, *Life Among the Surrealists* (New York: Holt, Rinehart and Winston, 1962), 44; Malcolm Cowley, *Exile's Return* (New York: Norton, 1934), 17–18.

18 Ralph Werther, *The Female-Impersonators* (New York: The Medico-Legal Journal,1922; New York: Arno Press, 1975), quoted in Molly McGarry and Fred Wasserman, *Becoming Visible: An Illustrated History of Lesbian and Gay Life in Twentieth-Century America* (New York: Penguin Studio, 1998) 59, 65; C. Grand Pierre, ed., *Greenwich Village in Poetry* (New York: Greenwich Village Weekly News, n.d.), quoted in Steven Watson, *Strange Bedfellows* (New York: Abbeville Press, 1991), 225.

19 Faderman, *Odd Girls and Twilight Lovers;* Harry Kemp, *Don Juan's Notebook* (New York: privately printed, 1929), quoted in Cheryl Black, *The Women of Provincetown, 1915–1922* (Tuscaloosa: University of Alabama Press, 2002), 137.

20 Erwin Leiser, *Das furchtlose Auge Berenice Abbott* (Erwin Leiser Filmprod, 1984), video; BAOH, 42; Mitchell, Recollections, 12; Arthur Frank Wertheim, *The New York Little Renaissance: Iconoclasm, Modernism, and Nationalism in American Culture, 1908–1917* (New York: New York University Press, 1976), 236; David E. Shi, *Matthew Josephson, Bourgeois Bohemian* (New Haven: Yale University Press, 1981), 20, 31.

21 BAOH, 45.

22 Josephson, *Surrealists*, 40; Janet Flanner, *Paris Was Yesterday* (New York: Viking, 1972), 15; Edmund Wilson, *The Twenties* (New York: Farrar, Straus and Giroux, 1975), 369; Bak, *Cowley*, 105.

23 BA, CWA, Monson, ME, 11/11/1991; Kenneth Burke to Malcolm Cowley, ALS, 5/28/1918, Penn State Library; 1920 US Census, New York; BA autobiog, and BAOH, 45; Andrew Field, *Djuna: The Formidable Miss Barnes* (London: Secker & Warburg, 1983; Austin: University of Texas Press, 1985), 67–70, 50–57; Phillip Herring, *Djuna: The Life and Work of Djuna Barnes* (New York: Viking, 1995), 104, 326n11.

24 Christine Stansell, *American Moderns: Bohemian New York and the Creation of a*

New Century (New York: Metropolitan Books, 2000), 147ff; Shi, *Matthew Josephson*, 25, 43; Bak, *Cowley*, 104; BAOH, 45.

25 Susan Jenkins Brown, *Robber Rocks; Letters and Memories of Hart Crane, 1923–1932* (Middletown, CT: Wesleyan University Press, 1969), 11; Butler also sat for a portrait by BA in Paris, and adding to the mix were the building's regular tenants—two especially memorable, poor, elderly women, a developmentally disabled boy, and on the first floor an Australian draft evader who played Chopin on weekends; Shi, *Matthew Josephson*, 31; Kenneth Burke, CWA, Andover, NJ, 8/17/1992.

26 Bak, *Cowley*, 115–120, 508n30–31.

27 Bak, *Cowley*, 115, 209–210; as early as summer 1919, Burke is at work on "Berenice and 'Florio'" [spelled with third *e*] though claimed its flavor if pursued would leave him "sans testicles," Kenneth Burke to Malcolm Cowley, CTL, 6/21/1919, Penn State Library.

28 Kenneth Burke, "Ultra-Modern Love," with comments and additions by Malcolm Cowley, Malcolm Cowley Papers, Series A: Cowley-Works-Burke/Juvenilia, Newberry Library, Chicago, IL.

29 BA, CWA, Monson, ME, 11/9/1991; Kenneth Burke, CWA, Andover, NJ, 8/17/1992, and Herring, *Djuna*, 105; Burke to "Bill," CTL, 9/3/1969, Penn State Library, and Burke to Watson, CTL, 9/4/1969, Penn State Library; Burke to Malcolm Cowley, CTL, 6/21/1919, Penn State Library.

30 Jig Cook to Susan Glaspell, ALS, 9/10/[1918], George Cram Cook papers, Berg Collection, NYPL; Agnes Boulton, *Part of a Long Story* (Garden City, NY: Doubleday, 1958), 24–25.

31 Berman, "The Unflinching Eye," 89; Susan Brown Blatchford said BA smoked her first cigarette on Armistice Day, 1918; Deutsch and Hanau, *The Provincetown*, 41; BAOH, 46; Gelb, *O'Neill*, 388–389.

32 BA, CWA, Monson, ME, Aug. 1988; Provincetown Players playbill, 1/17/1919, with ms annotations by Percival S. Winner indicating cast changes due to influenza: Bernice [note spelling] Abbott to Alice Macdougal; John Rose to Percy Winner; Hutchinson Collins [who later died] to O.K. Liveright; and W. Clay Hill to Percy Winner, Berg Collection, NYPL; BA, CWA, Monson, ME, 11/11/1991; Herring, *Djuna*, 105; BAOH, 47; Alfred W. Crosby, *America's Forgotten Pandemic: The Influenza of 1918* (Cambridge: Cambridge University Press, 1989), 57–61, 311.

33 BAOH, 47–48; BA, CWA, Monson, ME, 11/11/1991; Waters to JVH, TLS, 9/28/1992; Burke to Lily Batterham, ALS, Monday [eve? Jan. 20?] 1919, Kenneth Burke papers, Penn State Library.

34 BAOH, 47–48.

35 BA, CWA, Monson, ME, 8/4/1991, 11/9/1991, and 11/11/1991; BA autobiog, and IS, 10/3/1959; BAOH, 57; Schulman, *Romany Marie*; Sarlós, *Jig Cook and the Provincetown Players*, 99; Susan Glaspell, "Bernice," in *Plays* (Boston: Small, Maynard, 1920); Susan Glaspell, *The Road to the Temple* (New York: F. A. Stokes, 1927), 222.

36 BAOH, 53–54.

37 BAOH, 53, 204; 1920 US Census (taken January 8, *Ancestry.com*, accessed 7/16/2013) records BA living alone: 300 West 10th Street, a still-extant five-story walk-up with two apartments per floor; Jay Shockley et al., *Weehawken Street Historic District: Designation Report* (New York: New York City Landmarks Preservation Commission, 2006); BA BlkJ, 33.

38 BA, CWA, Monson, ME, 8/4/1991; BAOH, 213–214, Gisi v. Freytag-Loringhoven, "Afterword," in Irene Gammel, *Baroness Elsa: Gender, Dada, and Everyday Modernity: A Cultural Biography* (Cambridge, MA: MIT Press, 2002), 390–391 (unpublished version comprising an interview with BA, Monson, ME, late 1980s, transcript, in SBB/BA).

39 BAOH, 213–214, and BA, CWA, Monson, ME, 8/4/1991; research and literature on Elsa and Greve/Grove has grown since the 1980s: Robert Reiss, " 'My Baroness': Elsa von Freytag-Loringhoven," in *New York Dada*, ed. Rudolf Kuenzli (New York: Willis Locker & Owens, 1986), 81; Francis Naumann, *New York Dada, 1915–23* (New York: Abrams, 1994), 168–175; Gammel, *Baroness Elsa*. On Greve/Grove: Klaus Martens, *F. P. Grove in Europe and Canada: Translated Lives* (Edmonton, AB: University of Alberta Press, 2001), and "The Frederic Philip Grove/Felix Paul Greve (FPG) Collections in Archives & Special Collections," University of Manitoba, accessed 1998, http://www .umanitoba.ca/libraries/units/archives/collections/fpg/descr.shtml; Douglas O. Spettigue, *FPG: The European Years* (Ottawa: Oberon Press, 1973). Elsa v. Freytag-Loringhoven, "Kentucky," MS original, 1 sheet, in SBB/BA.

40 BAOH, 62–65; BA, CWA, Monson, ME, 8/4/1991; Douglas O. Spettigue and Paul I. Hjartarson, introduction to *Baroness Elsa*, by Elsa von Freytag-Loringhoven (Ottawa: Oberon Press, 1992), 14; George Biddle, *An American Artist's Story* (Boston: Little, Brown, 1939), 140–141.

41 Elsa's manuscripts are mostly in her papers in the McKeldin Library, University of Maryland; her poems have been collected: Elsa von Freytag-Loringhoven, *Mein Mund ist lüstern: I got lusting palate*, ed. Irene Gammel (Berlin: Edition Ebersbach, 2005); Claude McKay, *A Long Way From Home* (New York: L. Furman, 1937; New York: Harcourt, Brace & World, 1970), 104.

42 IS, 8/9/1960; BAOH, 52, 53; Djuna Barnes, "A Night Among the Horses," *The Little Review* 5 (Dec. 1918), 3–10.

43 IS, 7/23/1960; BA, CWA, Monson, ME, 11/11/1991; mysteriously, there is a "Bernice Abbott" in the 1920 New York CD (the only year the name appears) at 40 Jane Street, another small northwest Village street, but BA never mentioned that address in any account; BA autobiog.

44 BAOH, 109–110; Man Ray, *Self Portrait* (Boston: Little, Brown, 1963; New York: McGraw-Hill, 1979), 92–93.

45 *Portrait of a Sculptor* survives in two prints: (1) Man Ray's exhibition print, which was acquired by the Tokyo Fuji Art Museum, Francis Naumann to JVH, TLS, 5/15/1992, and email 5/30/2016, and (2) Sylvia Beach's presentation, Sylvia Beach Papers, Princeton University Library (BA in 1989 denied giving it to Beach, per BA, CWA, Monson, ME, 8/4/1991); for example, see the portrait by Jessie Tarbox Beals of a "bobbed-hair miss" who is anonymously "an interesting seventeen-year-old aviatrix," reproduced in Alexander Alland, *Jessie Tarbox Beals* (New York: Camera/Graphic Press, 1978), 78; Neil Baldwin, *Man Ray: American Artist* (New York: C. N. Potter, 1988), 68, 70–71; BAOH, 63–64; BA, p slip–size notes evidently for a talk, n.d., SBB/BA; IS, 6/26/1961; AC/BA, 9.

46 IS, 7/10/1959 and 9/23/1960; Jerry Tallmer, "To See Real Life: That Takes Guts," *New York Post*, 12/22/1982; also BA, CWA, Monson, ME, 1991; Man Ray's divorce from Adon Lacroix Ray was made final, Case #1512, New York Supreme Court, New York County (1937); AC/BA, 9–10; BA autobiog.

47 BAOH, 53–55, 109, 440; Calvin Tomkins, *Duchamp: A Biography* (New York: Henry Holt, 1996), 36–37, 153; IS, 9/23/1960.

48 Tomkins, *Duchamp*, 210, 224; Francis Naumann, "Marcel Duchamp's Letters to Walter and Louise Arensberg, 1917–1921," *Dada/Surrealism* 16 (1987), 219; BAOH, 55.

49 IS, 10/3/1959 and 3/27/1960; BA, CWA, Monson, ME, Aug. 1988; Internet Movie Database (accessed 8/29/2006 and 9/24/2014); *A Philistine in Bohemia*, directed by Edward Griffith (Vitagraph Studios, 1920), shown at Cinefest 28, Syracuse, NY, Mar. 2008; Steve Lewis, "Walter Albert Reviews Two Short Silent Films," *Mystery*File* (blog), 2/12/2011, accessed 9/24/2014, http://mysteryfile.com/blog/?p=7919; BAOH, 60–62; O. Henry, *The Voice of the City: Further Stories of the Four Million* (New York: McClure, 1908), 209–217; Norma Millay to Kathleen Millay, ALS, 10/23/1919, Kathleen Millay collection of papers, Berg Collection, NYPL.

50 BA autobiog.

51 BA, CWA, Monson, ME, 11/11/1991; Gorham Munson, *The Awakening Twenties* (Baton Rouge: Louisiana State University Press, 1985), 110–112.

52 BAOH, 122; Shi, *Matthew Josephson*, 53–54; IS, 3/27/1960 and 6/3/1965; BAOH, 59–60.

53 Elsa to Djuna Barnes, ALS, quoted in "Elsa Baroness von Freytag-Loringhoven," *transition* 11 (Feb. 1928), 26, quoted in Naumann, *New York Dada*, 170; signed, titled vintage Muray print, viewed at Joel Soroka Gallery, AIPAD, New York, N.Y., 2001 (negative in Muray Collection, George Eastman Museum, Rochester, N.Y.; Arturo Schwarz, *Man Ray, Carte varie e variabili* (Milano: Gruppo Editoriale Fabbri, 1983), 115, 136, and *Man Ray* (Milano: Skira, 2011), catalog for exhibition of the same name, curated by Guido Comis, Marco Franciolli, and Janus, shown at Museo d'arte della città di Lugano, Switzerland, 3/26–6/19/2011; Sil, "American Photographer Berenice Abbott is Our Lesbian Mini Bio #10," *Spanglish in Lesbilandia* (blog), 5/26/2014, accessed 9/22/2014, http://www.spanglishinlesbilandia.com/featured/american-photographer-berenice-abbott-is-our-lesbian-mini-bio-10/.

54 Marcel Duchamp and Man Ray, eds., *New York Dada* (New York: s.n., April 1921); Gammel, *Baroness Elsa*, 294, 296, 465n15; John Unterecker, *Voyager: A Life of Hart Crane* (New York: Liveright, 1969), 193, 215.

55 Munson, *Awakening Twenties*, 147.

56 John Russell, "Her Camera Now Depicts a Still Life in Maine," *NYT*, 11/16/1980.

57 Mitchell, *Recollection*, 12; passport applied for 1/22/1921, *Ancestry.com*, accessed 9/7/2013; application #133645, US address 11 Christopher Street NYC, issued 1/25/1921, extended on 6/20/1922 [address, BA's mother in Cleveland, OH], and valid until 6/25/1924, cf. BA/FBI; BA US passport, SBB/BA; BAOH, 204.

58 Leslie Katz, BA memorial; BA quoted in Gisela Baronin Freytag v. Loringhoven "Afterword" in Gammel, *Baroness Elsa*, 394; Russell, "Her Camera"; BAOH, 120, 123; IS, 7/23/1960; Junk, phone CWA, 7/8/1992.

59 Edna St. Vincent Millay to Allan Ross Macdougall, 4/7/1920, in *Letters of Edna St. Vincent Millay* (Westport, CT: 1952), 92–94; BAOH, 120–121; Shi, *Matthew Josephson*, 41.

CHAPTER 3. BLAZING CHISELS

1 Guillaume Apollinaire, "American Lady," translated by Billy Klüver, in Billy Klüver and Julie Martin, *Kiki's Paris: Artists and Lovers, 1900–1930* (New York: Abrams, 1989), 10.

2 Ishtar.

3 BA autobiog; BAOH, 121–123, 132, 195; AWT/BA says $3.00; in other accounts BA says $6.00; IS, 10/31/1959.

4 BA to John Storrs, ALS, Paris, n.d. [Apr. or May 1921], Storrs papers, AAA; Arlen J. Hansen, *Expatriate Paris: A Cultural and Literary Guide to Paris of the*

1920s (New York: Arcade, 1990), 133–134; BA to Storrs, ALS, Paris, 5/23/1921, Storrs papers, AAA; BA, CWA, Monson, ME, 11/9/1991; BAOH p.124a-126; IS, 10/28/1960, IS/CCP.

5 Zwingle, "A Life of Her Own," 57; cf. Irene Shwachman regarding a letter from BA (Nov. 1959), poem is now lost?

6 BA, CWA, Monson, ME, 8/4/1991; Nina Hamnett, *Laughing Torso* (London: Constable, 1932), 170–171; BA autobiog; BA said she had a lot of rapport with Hamnett and even shared an apartment at one time, though they didn't particularly like each other.

7 BA autobiog; James Charters, *This Must Be the Place: Memoirs of Montparnasse* (London: Herbert Joseph, 1934), 108; Hansen, *Expatriate Paris*, 99; in 1991, as BA continued to speak of Tommy Earp, I lacked the presence of mind to ask about "Rachelle"; nor did BA ever mention that name again, BA, CWA, Monson, ME, 8/4/1991.

8 "Pernod (Susie) Suze Fine" is imitation absinthe, gentian, and a cheap French brandy very much like ethylated spirits; Hamnett, *Laughing Torso*, 159–160; BAOH, 129–130.

9 BA to Storrs, ALS, Paris, n.d. [May 1921]; BA to Storrs, ALS, near Brignoles, Provence, 7/19/1921; BA to Storrs, ALS, Berlin, n.d. [dateable from internal evidence to early 1922]; all, Storrs papers, AAA.

10 AWT/BA.

11 BAOH, 59, 125–127, 130–131; Mary Ann Anderson, "Berenice Abbott, American Photographer" (master's thesis, Ohio State University, 1981), 12; AWT/BA; BA to Storrs, ALS, Paris, 10/3/[1921, from external evidence], Storrs papers, AAA.

12 BAOH, 193; AWT/BA.

13 HON/BA, 62; Phyllis Rose, *Jazz Cleopatra: Josephine Baker in Her Time* (New York: Doubleday, 1989), 252–253.

14 Henri Pierre Roché, *Jules et Jim* (Paris: Gallimard, 1953); BA to Storrs, ALS, 5/23/1921, Storrs papers, AAA; the ballet was likely De Falla's *Cuadro Flamenco*.

15 BA to Storrs, ALS, 5/23/1921, Storrs papers, AAA; *Dadaglobe Reconstructed*, with contributions by Adrian Sudhalter, Anne Sanouillet, Michel Sanouillet, Cathérine Hug, Samantha Friedman, Lee Ann Daffner, and Karl Buchberg (Zürich: Scheidegger & Spiess, 2016), catalog for exhibition of the same name, shown at the Kunsthaus Zürich, 2/5–5/1/2016, and at MoMA, 6/12–9/18/2016; Naumann, "Marcel Duchamp's Letters to Walter and Louise Arensberg, 1917–1921," 220.

16 Harold Loeb quoted in Hansen, *Expatriate Paris*, 59; Flanner, *Paris Was Yesterday*, xii; Denise Hooker, *Nina Hamnett: Queen of Bohemia* (London: Constable, 1986), 133.

17 BA, CWA, Monson, ME, 11/9/1991; IS, 9/26/1962.

18 BAOH, 177–178; incorporated later into an enlarged Café Rotonde, which along with the Select and the Dôme comprised the three great Montparnasse expatriate watering holes; Hamnett, *Laughing Torso*, 199–202.

19 BA autobiog; Viva King, *The Weeping and the Laughter* (London: Macdonald and Jane's, 1976), 100–101; BA to Storrs, ALS, Paris, 5/23/[1921, dateable by internal evidence], Storrs papers, AAA.

20 Meryle Secrest, "An Attic Studio Hides a Woman's Vision," *Washington Post*, 8/17/1969; Hamnett, *Laughing Torso*, 199–202; Klüver and Martin, *Kiki's Paris*, 104; BAOH, 140–140A; Hank O'Neal provided Wiéner and Doucet recordings, which my husband and I re-sequenced, to play as a background loop before and after BA's memorial in NYC, Feb. 1992.

21 Robert McAlmon and Kay Boyle, *Being Geniuses Together: 1920–1930* (San Francisco: North Point Press, 1984), 23; Shari Benstock, *Women of the Left Bank: Paris, 1900–1940* (Austin: University of Texas Press, 1986), 357–362.

22 BA autobiog.

23 BAOH, 201–202, 292–293; BA did not answer when OH interviewers asked which was "her" café; BA autobiog.

24 BAOH, 199; IS, 12/22/1959 and 6/26/1961.

25 BA to Storrs, ALS, Paris, 5/23/1921, Storrs papers, AAA.

26 For example: André Gide and Frederick Philip Grove [Felix Paul Greve], *Ein Liebesversuch und andre Novellen* (Berlin: Oesterheld & Co., 1907); BA autobiog; BAOH, 173–174; Maria van Rysselberghe, "Cahiers de André Gide," 4, in *Les Cahiers de la Petite Dame*, vol. 1, 1918–1929 (Paris: Gallimard, 1973), 84–87, translated by JVH; slightly different version in George D. Painter, *André Gide: A Critical Biography* (London: Weidenfeld & Nicolson, 1968), 95; Russell, "Her Camera."

27 Though Élisabeth was "Beth" to her English and other American friends, Berenice at the end of the summer still referred to her as "Miss Rysselberghe"; BA to Storrs, ALS, 8/20/1921, Storrs papers, AAA; BA, CWA, Monson, ME, 8/4/1991; Enid McLeod, *Living Twice: Memoirs* (London: Hutchinson Benham, 1982), 39–44; BAOH, 174–175; other travelers were met in Brignoles; André Gide to BA, ALS, Paris, 7/7/1921, SBB/BA.

28 BA to Storrs, ALS, Brignoles, 7/19/1921, Storrs papers, AAA; BA to Storrs, ALS, Brignoles, 8/20/1921; Gide to BA, ALS, Paris, 7/7/1921, SBB/BA; BAOH, 174.

29 Man Ray to Tristan Tzara, n.d. [probably 6/8/1921, cf. 151, Francis Naumann, *Making Mischief*, with Beth Venn (New York: Whitney Museum of American Art, 1996), exhibition catalog, reproduced 143]; p. 2 via photographic copy

exhibited in *Making Mischief*, Whitney Museum of American Art, NYC, Nov. 1996–Feb. 1997; both leaves reproduced in *Perpetual Motif* (Washington, DC: National Museum of American Art, 1988),150, fig.121.

30 Marcel Duchamp to Man Ray, telegram draft?, Paris, n.d. [before 7/14/1921], Carlton Lake Collection, Harry Ransom Center, University of Texas at Austin: "I have arranged for a room for you in a little hotel where Tzara lives. He may be gone when you arrive—I suppose you will land about the 22nd. // Marcel" (no envelope); Marcel Duchamp to Man Ray; see also Baldwin, *Man Ray*, 82.

31 James Michael Kempf, *The Early Career of Malcolm Cowley* (Baton Rouge: Louisiana State University Press, 1985), 56; Bak, *Cowley*, 209–210, 528n77; Hansen, *Expatriate Paris*, 82–83; BAOH, 200; US Passport records, cf. *Ancestry.com*, accessed 9/7/2013.

32 BAOH, 127, 130–131; BA, CWA, summer 1989.

33 BA to Storrs, ALS, Paris, 10/3/[1921, from external evidence], Storrs papers, AAA.

34 Tommy Earp to St John Hutchinson, ALS, 10/16/1921, Mary Hutchinson Collection, Harry Ransom Center, University of Texas at Austin; Edna St. Vincent Millay to Cora Millay, 6/15/1921, in *Letters* (1952), 119; BAOH, 133; BA, CWA, Monson, ME, 8/4/1991; BAOH, 127, 130–131, 177; Flanner, *Paris Was Yesterday*, xxii–xxiii; BA to Storrs, ALS, Berlin, 10/16/[1921, from external evidence], Storrs papers, AAA; BA said she paid for her Paris studio through December 1921 because subletting was not allowed; 3, rue Vercingétorix is in an area completely urban renewed in the 1960s; Hansen, *Expatriate Paris*, 177; BA to Storrs, ALS, Berlin, 12/6/[1921], Storrs papers, AAA; BAOH, 134, 195; Anderson, "Berenice Abbott, American Photographer," 12, quoting her interview with BA in Monson, ME, Apr. 1981, says Storrs found BA "a small studio in the rue Edgar-Quinet, a neighborhood Abbott described as a 'working class area'"; however, this address appears nowhere else; BAOH, 134, and BA, CWA, Monson, ME, 11/9/1991, about the apartment's features.

35 Brenda Maddox, *Nora: The Real Life of Molly Bloom* (Boston: Houghton Mifflin, 1988), 216–217; both organizations were curtailed by the rise of fascism by the end of the 1920s; Lillian Faderman, *Surpassing the Love of Men* (New York: Morrow, 1981), 388.

36 Charters, *This Must Be the Place*, 287; Edna St. Vincent Millay to Charles Ellis, Paris, 7/21/1921, in Letters, 120–121; Hank O'Neal, *"Life Is Painful, Nasty & Short—In My Case It Has Only Been Painful and Nasty": Djuna Barnes, 1978–1981: An Informal Memoir* (New York: Paragon House, 1990), 136–137; BA autobiog; also BAOH, 136–137; IS, 9/23/1960 and 6/26/1961; BA, CWA, Monson, ME, 11/8/1991.

37 Sylvia Beach, *Shakespeare and Company* (Lincoln: University of Nebraska Press, 1959), 58, 74; Tom Zito, "The Good Old Days—Paris in the '20s," *San Francisco Chronicle*, 5/18/1976.

38 BA to Storrs, ALsS, Landsberger str 81 b. Hellwich, Berlin C-25, 1/14/1922 and 2/24/[1922], Storrs papers, AAA.

39 BAOH, 135, 196.

40 McAlmon, *Being Geniuses Together*, 63–64 (these references and quotations from McAlmon's original 1938 text [London: Secker & Warburg] were excised from Kay Boyle's 1968 revised and annotated edition of the same title); Robert McAlmon, *Distinguished Air (Grim Fairy Tales)* (Paris: printed for Contact Editions at the Three Mountains Press, 1925); McAlmon's was the first of such accounts capped by Christopher Isherwood's collection, *Goodbye to Berlin* (London: Hogarth, 1939), whose most well-known iteration is the Broadway musical *Cabaret*; Edward White, *The Tastemaker: Carl Van Vechten and the Birth of Modern America* (New York: Farrar, Straus and Giroux, 2014).

41 BA to Storrs, ALS, Landsberger str. 81 bei Hellwich, Berlin C-25, dated "— Feb. — Friday" [Feb. 1922], Storrs papers, AAA; BA mistakenly wrote "Hermann Lembruch" meaning the sculptor; BA to Storrs, ALS, 2/24/[1922], Storrs papers, AAA.

42 For the best writing on Barney, see George Wickes, *The Amazon of Letters: The Life and Loves of Natalie Barney* (New York: G. P. Putnam, 1976) and Joan Schenkar, *Truly Wilde; The Unsettling Story of Dolly Wilde, Oscar's Unusual Niece* (New York: Basic Books, 2000); Josephson, *Surrealists*, 324–326; Faderman, *Surpassing the Love of Men*, 368–373; Maddox, *Nora*, 275.

43 IS, 4/13/1960; BA kept in touch with Fritzi, who was later in the "unglamorous" parts of the film industry and weathered WWII, with care packages; BA to Storrs, ALS, Landsberger str. 81 bei Hellwich, Berlin C-25, 2/24/[1922, from internal evidence]; SBB, CWA, Monson, ME, 1/24/1992 and 4/11/1992.

44 BAOH, 123–124; Alfred Allan Lewis, *Ladies and Not-So-Gentle Women* (New York: Viking, 2000), xiv–xvi.

45 FBI/BA; and Ellis Island Immigration Service records for 8/12/1922, *Ancestry.com*; BA autobiog; BAOH 134, 195.

46 MacDougall, inscription on verso flyleaf in *Select Epigrams from the Greek Anthology* (London: Longmans, Green, and Co., 1917): "To // Thelma because // she loved it. // from // Dougie // Paris 14 ag[?]. // 1922," and inscription on recto flyleaf: "<u>Ex Libris</u> // Allan Ross Macdougall // New York // <u>1920</u> // <u>Arklos[?] to Berenice</u>" (ink is smeared), in the possession of Hank O'Neal, who noted the many dusty, untouched books of Thelma's in Barnes's possession; O'Neal, *"Life Is Painful,"* 137, 146; BA, CWA, Monson, ME, 8/4/1991.

47 BA to Storrs, ALS, bei Hellwich Landesberger Str 81, Berlin, n.d. [dateable to winter 1923 by internal evidence].

48 BAOH, 136–138.

CHAPTER 4. WHY NOT ME?

1 Cowley, *Exile's Return*, 133.

2 BAOH, 146, 147.

3 Man Ray, *Self Portrait*, 128–131; Man Ray and Tristan Tzara, *Les Champs délicieux: Album de photographies* (Paris: Société générale d'imprimerie et d'édition, 1922).

4 BAOH, 203; Secrest, "An Attic Studio" (to the end of her life BA alluded to having endured times of extreme poverty in Paris and New York without resorting to prostitution, cf. Ishtar); AC/BA, 11; BAOH, 57, 141; also BA, essay dated Dec. 1975, in portfolio (New York: Witkin-Berley, 1976).

5 Baldwin, *Man Ray*, 103; Carolyn Burke, *Becoming Modern; The Life of Mina Loy* (New York: Farrar, Straus and Giroux, 1996), 326; Klüver and Martin, *Kiki's Paris*, 111, 228f8.

6 BA, Witkin-Berley portfolio; BA, *Guide*, 28–29.

7 Man Ray, interviewed by Arnold Crane, 1968, transcript, 8–10, AAA; BA in *Das Furchtlose Auge*, directed by Erwin Leiser (1984), videocassette (VHS); IS, 5/11/1963; AC/BA, 10–12; BAOH, 142–143 (details of this account also appear in BA autobiog); Mitchell *Recollections*, 12; BA, *Guide*, 28–29; Philippe Soupault, "The Present State of Photography" (1931), in *Photography in the Modern Era*, ed. Christopher Phillips (New York: Metropolitan Museum of Art/Aperture, 1989), 50.

8 William Carlos Williams, *Autobiography* (New York: Random House, 1951), 199–200; Paul L. Mariani, *William Carlos Williams: A New World Naked* (New York: McGraw-Hill, 1981), 224, 244; Williams later asked Sylvia Beach to "tear that sweet eyed photo of myself" by Man Ray from her portrait gallery wall in her bookshop and "bury it behind some Encyclopedia," for he thought it was too typically French with its languorous sad eyes; Flanner, *Paris Was Yesterday*, 12; IS, 8/8/1962; Dennis Traub, phone CWA, 6/12/2012.

9 Williams, *Autobiography*, 220–221.

10 O'Neal, *"Life Is Painful,"* 32–33; Klüver and Martin, *Kiki's Paris*, 102, 108; Noel Riley Fitch, *Sylvia Beach and the Lost Generation* (New York: Norton, 1983), 116–118; IS, 6/15/1964; Zito, "The Good Old Days—Paris in the '20s"; Hansen, *Expatriate Paris*, 269; see also Bricktop's autobiography, *Bricktop*, with James Haskins (New York: Atheneum, 1983).

11 Djuna Barnes, "The Grande Malade," *Selected Works* (New York: Farrar, Straus and Cudahy, 1962), 23–24, a revision of "The Little Girl Continues," *This Quar-*

ter 1, no. 2 (1925); this story is also cited in Klüver and Martin, *Kiki's Paris*, 228f2 and 229f5, and in McAlmon and Boyle, *Being Geniuses Together*, 114–116.

12 Djuna Barnes, "The Models Have Come to Town," *Charm* (Nov. 1924) and reprinted in *Djuna Barnes: Interviews*, ed. by Alyce Barry (Washington, DC: Sun & Moon Press, 1985).

13 IS, 10/4/1962; Dafna Allon, *Remembering Tylia* (Dornoch, Sutherland: New Fountainhead Press, 1999), 215; Anne Frank, *Journal de Anne Frank (Het achterhuis)*, trans. T[ylia] Caren [Tylia's anagram for *nacre*, French for "mother-of pearl"] and Suzanne Lombard (Paris: Calmann-Lâevy, 1950); Janet Flanner [Genêt, pseud.], Letter from Paris, *The New Yorker*, (11/11/1950), 142; Bronia Clair, interviews by Joan Schenkar, 10/26/1996 and Apr. 1999; Joan Schenkar to JVH, email, 12/5/1998.

14 Secrest, "An Attic Studio."

15 Norma Millay to Kathleen Millay, ALS, 6/16/1924, Kathleen Millay papers, Berg Collection, NYPL; Fitch, *Sylvia Beach*, 198–199; Josephson, *Surrealists*, 291.

16 Charters, *This Must Be The Place*, 132; Mary V. Dearborn, *Queen of Bohemia: The Life of Louise Bryant* (Boston: Houghton Mifflin, 2000), 263n341, which cites Virginia Gardner interview with BA, n.d., Virginia Gardner papers, The Tamiment Library and Robert F. Wagner Labor Archives, New York University, and Field, *Djuna*, 133; Gregory Woods, *Homintern: How Gay Culture Liberated the Modern World* (New Haven: Yale University Press, 2016), "France and Its Visitors," chap. 4, e-book, n.p., n8, a lively account that does not mention BA at all but which also references, for dance halls, Florence Tamagne, *A History of Homosexuality in Europe: Berlin, London, Paris, 1919–1939, Vol. I & II* (New York: Algora, 2007), 68–72.

17 BA, CWA, Monson, ME, 8/4/1991; Robert Schanke, *Shattered Applause: The Lives of Eva Le Gallienne* (Carbondale: Southern Illinois University Press, 2010), xvii, discusses a similar situation.

18 Robert W. Marks, "Chronicler of Our Times," *Coronet* 4 (Dec. 1938), 163.

19 Susan Trausch, "Portrait of the Photographer," *Boston Globe Magazine*, 11/11/1988, 52; Ishtar; AC/BA, 12, 15.

20 AC/BA, 11; Jill Berk Jiminez, ed., *Dictionary of Artists' Models* (Chicago: Fitzroy Dearborn, 2001), 22.

21 Jacqueline Bograd Weld, *Peggy, the Wayward Guggenheim* (New York: Dutton, 1986), 107; Josephson, *Surrealists*, 315; BA, "Berenice Abbott," in *Peggy Guggenheim and Her Friends*, ed. Virginia M. Dortch (Milan: Berenice, 1994), 42.

22 The negative of this image is in CG, now at the Ryerson Image Centre, Toronto; Peggy Guggenheim, *Out of This Century: The Informal Memoirs of Peggy Guggenheim* (New York: Dial, 1946), 47.

23 AC/BA, 2; IS, 8/21/1963.

24 BAOH, 142–143; Tomkins, *Duchamp*, 260–261.

25 AC/BA, 12–13

26 AC/BA, 13–15; Sarah Carlton, "Berenice Abbott: Photographer," *American Girl* 14 (Aug. 1931), 12.

27 BAOH, 182, 192; more than thirty years later, the hearer found this observation of BA "very apt," IS, 5/31/1960; Secrest, "An Attic Studio."

28 Ishtar; BA, CWA, Aug. 1988; BAOH, 156; *Der Querschnitt* VII, no. 5 (May 1927), 358–359, in ill. section, credited to Photo Abbot [*sic*]; Bronia Clair, interview by Joan Schenkar, 10/26/1996; Janine Mileaf, "Between You and Me: Man Ray's Object to Be Destroyed," *Art Journal* 63, no. 1 (Spring 2004), 4–23; Man Ray's early and life-long interest in "ballistics," see his *Self Portrait*.

29 Ishtar; BAOH, 187; HON/BA, 63.

30 AC/BA, 13–15; HON/BA, 10; Trausch, "Portrait of the Photographer," 57; C. G. Cupic, "Berenice Abbott: 'The World Today Has Been Conditioned to Visualize,'" *International Herald Tribune*, 6/13/1979.

CHAPTER 5. SEXLESS BIRD CATCHER

1 Soupault, "The Present State of Photography" (1931), in *Photography in the Modern Era*, 50.

2 Russell, "Her Camera."

3 BAOH, 152–153; "Établissements Union, Pierre Lemonnier, Photographie, Optique, Projection" to "Mme Bérénice A. Abbott" at 9 rue Bréa, Feb. 1926, receiving a 25 percent professional discount; in May she bought darkroom supplies from "Kolen & Delhumeau, Fabrique d'Accessoires Métalliques, pour la Photographie," CG.

4 Riley, *Sylvia Beach*, 100; Man Ray to Sylvia Beach, ALS, n.d., Beach Papers, Princeton University Library; Tallmer, "To See Real Life."

5 BA, *Guide*, 137; Trausch, "Portrait of the Photographer," 20; ill. caption in Maddox, *Nora*, n.p.; James Joyce, *Finnegans Wake* (London: Faber & Faber, 1939), 171.

6 Elsa always spelled BA's name "Bernice," as it was when they met in 1918; Gammel, *Baroness Elsa*, 367–368; the glass negatives of the snapshots are in BA's archive without identification; the snapshot prints are in Barnes's papers without credit or source.

7 Jean Cocteau, untitled poem, *Exposition Bérénice Abbott: Portraits photographiques*, exhibition flyer, copies in CG, quoted in "Berenice Abbott," *Current Biography* 3, no.7 (July 1942), 1–2.

8 BAOH, 156; IS, 9/3/1960; T. S. Eliot, Jacques Maritain, and Pierre Reverdy,

Frontières de la poésie (Paris: Plon, 1927), and Jean Cocteau, *Opéra, œuvres poétiques, 1925–1927* (Paris: Stock, 1927).

9 Romeo Martinez, "Berenice Abbott," *Camera* 43, no. 4 (Apr. 1964), 3+; Martinez's description suggests that BA's sculpture was also on view, a detail not mentioned elsewhere; about this time BA began a small, octavo-size scrapbook for press clippings and printed ephemera, CG; Robert Enright, *Stranger to Paris: Au Sacre du Printemps Galerie* (Toronto: Jane Corkin Gallery, 1992), 9–17; Hansen, *Expatriate Paris*, 78.

10 BA, CWA, Monson, ME, 8/4/1991; Irene Gammel, "Lashing with Beauty: Baroness Elsa and the Emergence of Assemblage Art in America," in *The Art of Baroness Elsa von Freytag-Loringhoven* (New York: Francis M. Naumann Fine Art, 2002), 14, catalog for exhibition of the same name, shown at Francis M. Naumann Fine Art, NYC, Apr.–June 2002; Francis M. Naumann, "New York Dada: Style with a Smile," in *Making Mischief*, 10, 12–14, 16; the portrait is now in the MoMA; Papers of Baroness Elsa von Freytag-Loringhoven, University of Maryland, n.d.; BA apparently photographed the assemblage—cf. a double-weight 8 × 10" print with notes in soft red pencil on verso that seem to be a portrait sitting print order, "1 face / 1 profile / 2 pour Jean / 6 face / 6 grande," plus calculations for costs in francs, CG.

11 Flanner, Letter from Paris, *The New Yorker* (4/16/1927), 98; "Around the Studios," *New York Herald of Paris*, 12/26/1926, CG.

12 Hansen, *Expatriate Paris*, 65–67; BAOH, 17–18, 153, 196–197.

13 Papers of Baroness Elsa von Freytag-Loringhoven, University of Maryland; most of Elsa's handwritten letters are undated; the archive has been reprocessed since I consulted it in Sept. 1998.

14 BAOH, 152; Guggenheim, *Out of This Century*, 71, 76–77, 81; BA, in *Guggenheim and Her Friends*, 42; IS, 10/28/1959.

15 Russell, "Her Camera."

16 Flanner, *Paris Was Yesterday*, 42–43; Josephson, *Surrealists*, 315.

17 Carol Seajay, "Visual Conceptions: A Review of Two Slideshows," review of *Lesbian Images in Photography: 1850–1980*, by Joan E. Biren, and *Erotic Images of Lesbians in the Fine Arts*, by Tee Corinne, *off our backs* 10, no. 3 (Mar. 1980), 18–19, 28, accessed late 1990s, http://www.cla.purdue.edu/waaw/Corinne/Seajay.htm; Tee Corinne, "Dyked Out in Paris: 1926," *The Blatant Image*, no. 1 (1981), 48–49; BA never mentioned this novel; in 1991 BA recommended Meryle Secrest's 1974 biography of Romaine Brooks to me for background; Faderman, *Surpassing the Love of Men*, 322–323; Fitch, *Sylvia Beach*, 279–280; Bertha Harris, "The More Profound Nationality of Their Lesbianism: Lesbian Society in Paris in the 1920's," *Amazon Expedition: A Lesbian Feminist Anthology*, ed.

Phyllis Birkby (Washington, NJ: Times Change Press, 1973), 77–88; Steven Moore, afterword to *Ladies Almanack . . . Written & Illustrated by a Lady of Fashion* (Elmwood Park, IL: Dalkey Archive Press, 1992), 87–88.

18 BAOH, 161; Wilson, *The Twenties*, 85; HON/BA, 48, 62.

19 BAOH, 176, 180–182.

20 Fitch, *Sylvia Beach*, 236; Beach, *Shakespeare*, 111–112.

21 BAOH, 53, 124–124a, 161–162; the sculpture was last seen in a 1930s photograph by Leonie (Mrs. Harold) Sterner, of Lincoln Kirstein holding the work aloft, that was used to illustrate the front dust jacket of Kirstein's *Mosaic: Memoirs* (New York: Farrar, Straus and Giroux, 1994); Kirstein's assistant Jerry Thompson did not recall seeing the sculpture in Kirstein's home when he photographed there for Lincoln Kirstein and Jerry L. Thompson; Lincoln Kirstein, *Quarry: A Collection in Lieu of Memoirs* (Pasadena, CA: Twelvetrees Press, 1986).

22 HON/BA, 54; Mitchell, interview, SBB/BA; Ishtar.

23 HON/BA, 35; Steinbach, "Berenice Abbott's Point of View," 79; HON/BA, 46.

24 Peter Adam, *Eileen Gray: Architect/Designer*, rev. ed. (1987; repr., New York: Harry N. Abrams, 2000), 184–185; Stefan Hecker and Christian Müller, *Eileen Gray* (Barcelona: Gustavo Gili, 1993), 9; Peter Adam, *Eileen Gray: Her Life and Work: The Biography* (München: Schirmer/Mosel, 2008), 93–94; Lillian Morrison, CWA, NYC, 11/27/2000; James Hepburn to BA, TLS, 9/8/1983, SBB/BA; James Hepburn, preface to *The Writings of Anna Wickham: Free Woman and Poet*, by Anna Wickham (London: Virago, 1984), xxi–xxii; Edna St. Vincent Millay, *Letters*, 153–154.

25 McAlmon to Beach, ALS, n.d. [1926?], Beach papers, Princeton University Library; BAOH, 183–184.

26 HON/BA, 53; Flanner, *Paris Was Yesterday*, xiv; HON/BA, 61; BAOH, 178–179; Josephson, *Surrealists*, 345; Massot, copy no. 000 (the actual number of the copy), formerly in BA collection, Monson, ME, present location unknown.

27 Hansen, *Expatriate Paris*, 268; BAOH, 185–186; HON/BA, 73; *Jazz: l'actualité intellectualle*, nos. 1–15 (Dec. 1928–Mar. 1930).

28 "La photographie est fort belle," *Paris Times*, Jan. 1928, in SBParis, 23, CG.

29 HON/BA, 35.

30 HON/BA, 38; Honor Moore, *The White Blackbird: A Life of the Painter Margarett Sargent* (New York: Viking, 1996), 182–183, 224; McKean to BA, ALS, Oct. 1928, CG; Virginia Pratt Bardeen, remark written in NYPL exhibition visitors' book, fall 1989, and CWA, Kalamazoo, MI, 6/27/1992; Helen Andrejevic, CWA, NYC, 10/1/1992; the family's visiting card is among those in SBParis, CG.

31 BAOH, 211.

32 *transition*, no. 3 (June 1927), 149; tearsheet also in SBParis, 13, pasted flat to 19–20; in 2015 another BA poem surfaced, a dozen lines called "Birthdays," a typescript shared in the late 1930s, probably with poet Flora Pousette-Dart, on which BA wrote, "Hooray! I <u>did</u> write a 'poem' once. Had forgotten it. It burst from my fevered brain about twenty years ago. It emerged from an old box of papers & greeted me in wan reproach for my denial of offspring. At the time it came hissing from my emotional center. I was looking at a birthday cake with its lighted candles. Please bury & forget," Pousette-Dart Estate, NYC, http://www.richardpousette-dart.com/; "Birthdays: A Poem by Berenice Abbott," *Brooklyn Rail*, Nov. 2015, accessed 11/27/2015, http://www.brooklynrail.org/2015/11/verbatim/birthdays-a-poem-by-berenice-abbott.

33 Ishtar; Jean-Claude Baker, *Josephine: The Hungry Heart* (New York: Random House, 1993), 6; Rose, *Jazz Cleopatra*, 17–18; Hansen, *Expatriate Paris*, 217; Josephine Baker management to BA, TLS, 12/29/1927, CG; Anthony Tommasini, "Music Review: Thwacking and Squeaking as the Audience Crows," *NYT*, 2/15/2000.

34 *Paris Times*, 12/17/1926, clipping in SBParis, 9; BA, CWA, Monson, ME, 8/4/1991; John Fout, "*Berliner Illustrirte* and Photojournalism in Germany, 1929–1935," in *Picture Magazines Before Life: Exhibition* (Woodstock, NY: Catskill Center of Photography, 1982), 1–5, and Peter Gay, *Weimar Culture* (New York: Norton, 1968); *Die Querschnitt* 7, no. 5 (May 1927), 358–359, ill. section, credited to Photo Abbot [*sic*].

35 Dora Omankowsky's name appears also as Omankowski/Omanousky in sexologist Magus Hirschfeld's guestbook, Cagnes-sur-Mer (March 1935), 118, cf. Magnus-Hirschfeld-Gesellschaft Mitteilungen 45 (July 2010), accessed August 2017, now offline; IS, 8/23/1960; Klüver and Martin, *Kiki's Paris*, 169, and Detroit Institute of Arts, *Picturing Paris, 1850 to the Present* (Detroit: Detroit Institute of Arts Founders Society, 1995), 7.

36 BAOH, 209; Germaine Krull and Florent Fels, *Métal* (Paris: Librairie des arts décoratifs, 1927; Paris: A. Calavas, 1928).

37 Wayne Andrews, *The Surrealist Parade* (New York: New Directions, 1990), 78–79; Josephson, *Surrealists*, 330–331; BAOH, 165; Bronia Clair, interview by Joan Schenkar for JVH, Paris, 10/26/1996; Elvis Mitchell, "Delicate Moral Questions Under the Nazis in France," *NYT*, 10/8/2002; Jimmy Ernst, *A Not-So-Still Life: A Memoir* (New York: St. Martin's/Marek, 1984), 15.

38 *Sima* (Paris: Musée d'art moderne de la ville de Paris, 1992), 26, 76–78, catalog for exhibition of the same name, shown at Musée d'art moderne de la ville de Paris, Apr.–June 1992.

39 Gotthard Jedlicka, "Auf dem linken Seine-Ufer," *Pariser Tagebuch* (Berlin and

Frankfurt am Main: Suhrkamp, 1953), 173–174; BA to Grace Mayer, MoMA, TLS, 7/5/1978, BA photo file, MoMA; Anne Umland, Adrian Sudhalter, and Scott Gerson, eds., *Dada in the Collection of the Museum of Modern Art* (New York: Museum of Modern Art, 2008); IS, 9/29/1960; BA, CWA, Monson, ME, 8/4/1991.

40 BAOH, 217; BA, CWA, Monson, ME, 8/4/1991; IS, 9/29/1960; O'Neal, *"Life Is Painful,"* 57, 54; see especially Gammel, *Baroness Elsa,* "The Baroness's Last Dada Dance in Paris," chap. 14, [362]–389.

41 BAOH, 153,196–197; IS, 8/21/1963; "Sunday Morning: Berenice Abbott," *CBS News Sunday Morning,* filmed in Monson, ME, aired Nov. 1981; Flanner, *Paris Was Yesterday,* xi; *Chicago Tribune,* 5/5/1928, clipping in SBParis, CG; Fitch, *Sylvia Beach,* 173; BA, *Guide,* 54.

42 HON/BA, 45; BAOH, 160; Maddox, *Nora,* 240, 244; Carol Shloss, *Lucia Joyce: To Dance in the Wake* (New York: Farrar, Straus and Giroux, 2003).

43 BA's 1943 résumé, trans. EMCC, HDW/AAA; Florent Fels, "The First Salon Independent de la Photographie," trans. Robert Erich Wolf, in *Photography in the Modern Era,* 25, quoted in BY:CNY, 11; Marja Warehime, *Brassaï: Images of Culture and the Surrealist Observer* (Baton Rouge: Louisiana State University Press, 1996), 9; BA, interview by Carolyn Burke, re Mina Loy, 3/12/1978, notes shared with JVH; IS, 6/10/1965; BAOH, 187.

44 Hansen, *Expatriate Paris,* 217–219; *Vogue* to BA, bills and correspondence, June–Aug. 1927, CG; Kim Sichel, *Germaine Krull: Photographer of Modernity* (Cambridge, MA: MIT Press, 1999), 89; BAOH, 168–169; HON/BA, 46.

45 BAOH, 205–206, 208; Fels, "The First Salon Independent de la Photographie," in *Photography in the Modern Era,* 23–26; Florent Fels, "Le Premier Salon Indépendant de la Photographie," *L'Art Vivant* 4, 6/1/1928, 445.

46 Clipping dated "jeudi 14 juin 1928" with BA translation typescript, 6/24/1928, SBParis, 30, CG; translation also in BA's application to the John Simon Guggenheim Foundation, 1935, EMCC/AAA.

47 A journal "in a new spirit and with new technical means," to "bring France a new format, the illustrated reporting of world news . . . and will bring life everywhere to eye level" (Warehime, *Brassaï,* 8); Katia Hirshman to BA, TLS, 6/8/1928, CG.

48 Russell, "Her Camera"; *Variétés* 1, no. 3 (7/15/1928); HON/BA, 40; BA, CWA, Monson, ME, 11/10/1991.

49 *Variétés* 1, no. 6 (10/15/1928); HON/BA, 72.

50 Hans Hildebrandt, "Die Fifo in Stuttgart," *Photographische Mitteilungen* 66, no. 10 (May 1929), 211, and BA's *Buddy Gilmore, Paris*; Ute Eskildsen, *Film und Foto der Zwanziger Jahre: eine Betrachtung der Internationalen Werkbundausstellung "Film und Foto" 1929* (Stuttgart: Gerd Hatje, 1979).

1 Leo Stein, *Appreciation: Painting, Poetry and Prose* (New York: Crown, 1947); Brenda Wineapple, *Sister Brother: Gertrude and Leo Stein* (New York: G.P. Putnam's Sons, 1996), 405.

2 Anne Herendeen, "Paris and Its Soul: A Magical Record," *NYT*, 6/30/1929.

3 Literature on Atget has grown since BA wrote about him, and his basic biography is well-known; Peter Barberie, ed., *Looking at Atget*, with contributions by Beth A. Price and Ken Sutherland (Philadelphia: Philadelphia Museum of Art, 2005), 88, catalog for exhibition of the same name, shown at the Philadelphia Museum of Art, 9/10–11/27/2005.

4 BAOH, 229; BA, interview by Roger Smith about *The World of Atget*, *The Creative Person*, Chicago PBS-TV station WTTW in association with WNET, aired 1966, b/w 16mm half-hour reel, Indiana University Audio-Visual Center; Eugène Atget, *Atget, Photographe de Paris* (Paris: H. Jonquières, 1930), 21; Eugène Atget, *Rue du Petit Thouars*, from the album "Photo Album - E. Atget coll. Man Ray 1926," purchased by George Eastman Museum, 1976:0118:0023, accessed 7/1/2011, http://collections .eastman.org/objects/126961/; BA, *The World of Atget* (New York: Horizon, 1964), viii, x; Herman Melville, "Hawthorne and His Mosses," pts. 1 and 2, *The Literary World* (8/17/1850, 8/24/1850); cf. Edmund Wilson, *The Shock of Recognition: The Development of Literature in the United States Recorded by the Men Who Made It* (Garden City, NY: Doubleday, Doran and Co., 1943).

5 BA, "Eugène Atget," 651; BA, *World of Atget*, viii.

6 Carlton, "Berenice Abbott: Photographer," 12–13, 35; Ishtar; André Calmettes, quoted in BA, *World of Atget*, xii; BAOH, 221, 227, 229; Paul Hill and Tom Cooper, "Man Ray," *Camera* (Feb. 1975), 40; John Fuller, "Atget and Man Ray in the Context of Surrealism," *Art Journal* 36, no. 2 (Winter 1976–1977), 130–138.

7 Queens College exhibition, 1957, text panel, BA Scrapbook 6, CG.

8 Julien Levy, *Memoir of an Art Gallery* (New York: Putnam, 1977), 91; *Man Ray: Photographs* (Paris: Centre Pompidou, 1982; New York: Thames & Hudson, 1982), 38.

9 AC/BA, 21; BAOH, 219, 226; Ishtar.

10 Maria Morris, "Summary of interview with Berenice Abbott, April 19, 1978," 2, Atget Archives, MoMA Photography Dept.; BAOH, 225; BA, *World of Atget*, xxxi; BA, "Eugène Atget, Forerunner of Modern Photography," pts. 1 and 2, *U.S. Camera* 1, no. 12 (Autumn 1940), 20–23, 48–49,76; no. 13 (Winter 1940), 68–71.

11 Morris, "Summary," 2.

12 Trausch, "Portrait of the Photographer," 20; BA, *Guide*, 132–133, plate 43; BA, *World of Atget*, ix, plate 133; David Harris, *Eugène Atget: Unknown Paris* (New York: New Press, 2003), 15; HON/BA, 64–65.

13 Queens College exhibition, 1957, text panel, Scrapbook 6, CG; parallels text in BA, "Eugène Atget, Forerunner of Modern Photography," pts. 1 and 2; quotation from HON/BA, 64–65; BA, "Eugène Atget, Forerunner of Modern Photography," pts. 1 and 2; Ishtar.

14 HON/BA, 12; BAOH, 197–198; image reproduced HON/BA, 12; Calmettes' card is still in SBParis, CG: "André Calmettes / Directeur Artistique du Théatre Municipal de Strasbourg 29. rue St Guillaume, Paris VIIe and 1 rue Ehrmann, Strasbourg (Bas Rhin)"; André Calmettes to BA, ALS, 10/28/1928, SBB/BA; Julia O. Reiner to Art Center of the Oranges, East Orange, NJ, TLS, 11/15/1928; "Julia O. Reiner Leaving Agency," *Trenton Evening Times* (Trenton, NJ), 5/28/1959, and "Julia Reiner," obituary, *Trenton Evening Times*, 10/2/1985.

15 Levy, *Memoir*, 93; SBB, phone CWA, 1/18/1995; Reiner to BA, ALsS, 7/28/1968, 8/4/[1968], 4/21/1969, and 4/1/[1970?], CG; BAOH, 228, 234–236; *Man Ray: Photographs* (1982), 38; BA would later suggest that Man Ray's resentment over her winning the Atgets produced his lopsided account of their acquaintance in his 1963 memoir *Self Portrait*.

16 BAOH, 206–208.

17 Fels, "The First Salon Independent de la Photographie," in *Photography in the Modern Era*, 23–26; BAOH, 205–206; "Avec Bérénice Abbott c'est la figure humaine ramenée à ses lignes essentielles: recherché de style et de caractère," *L'Art vivant* 4 (6/15/1928), 486; "Pour Atget, Fels nous a dit récemment son génie."

18 Roger W. Baines, *'Inquiétude' in the Work of Pierre Mac Orlan*, Faux Titre: Études de langue et littérature françaises, vol. 192 (Amsterdam: Rodopi, 2000); Pierre Mac Orlan, "The Literary Art of Imagination and Photography," trans. Robert Erich Wolf, in *Photography in the Modern Era*, 27–30; Pierre Mac Orlan, "L'Art littéraire d'imagination et la photographie," *Les nouvelles littéraires* (9/22/1928); BA, *World of Atget*, xxvi; Roland Barthes, *La chambre claire: note sur la photographie* (Paris: Gallimard, 1980); first English edition: Richard Howard, trans., *Camera Lucida: Reflections on Photography* (New York: Hill and Wang, 1981).

19 BA, *World of Atget*, xiii; Rosa Reilly, "Berenice Abbott Records Changing New York," *Popular Photography* 3 (Sept. 1938), 9; BA, review of *Summer's Children*, by Barbara Morgan, *American Photography* (Nov. 1951), 678–679.

20 Elliott Arnold, "The Way Berenice Abbott Feels about Cities and Photography, Her Exhibit is Like an Artist Painting Portraits of His Beloved," *NY World-*

Telegram, 10/21/1937; Marks, "Chronicler of Our Times"; Jacob Deschin, "Abbott on Photography," *NYT*, 1/18/1953.

21 BA, "Photographer as Artist," *Art Front* 16 (Sept.–Oct. 1936), 7.

22 BA BlkJ, 34.

23 BA's résumé, 1931 Guggenheim application, 4, CG.

24 Such portraits include Pierre Minot and the background of Lucia Joyce's dancing pictures, spring 1929; IS, 5/11/1969; BA to Mm. Blackman, CTL, 10/22/1934: "4,218 original prints of different subjects; 3,681 duplicate original prints; 1,415 original plates, of which ten are cracked," CG; *Photography in the Modern Era*, 18–22.

25 Visas on BA passport: revised in NY for France (3/27/1929), arrived in France (4/5/1929) and left again (4/20/1929), SBB/BA; AC/BA, 17; Els Barents, ed., *Fotografie in Nederland, 1940–1975* ('s-Gravenhage: Staatsuitgeverij, 1978), n.p.; ship passenger lists, *Ancestry.com*; passport visa stamps, and original bills of lading and haulage, SBB/BA; Morris, "Summary," 1; *New York Post* (4/15/1929), *NYT* (4/28/1929), and *Herald Tribune* (n.d.) clippings, SBParis, CG; Janet Flanner, "Letter from Paris," *The New Yorker* (5/4/1929) and "The Dale Collection," *NYT*, 4/28/1929.

26 AC/BA, 37.

27 BA, "The Art of Photography" (interview), *Exploring the Arts & Sciences*, directed by Leah Plotkin, WQXR [Interstate Broadcasting Company, "New York's High-Fidelity Station"], Federal Theatre Radio Division, WPA, broadcast #58, aired 9:45–10:00 p.m., 1/2/1939, transcript prepared 1/3/1939 from the live broadcast, CG.

28 *Charlotte News* (Charlotte, NC), 4/17/1932: "And the pictures of New York by Berenice Abbott combine the artistic flare of the greatest of Atget's disciples"; *NYT*, 9/29/1932: "[T]he moment you enter the gallery you realize that this is New York caught in the tradition of the famous French photographer Eugène Atget. Then you recall that it was Miss Abbott who, a few seasons ago, purchased and brought to this country the Atget collection. As a disciple she here concerns herself with an approach to subject strongly resembling Atget's, although it is only fair to note that, particularly in views of skyscraper developments, the American photographer succeeds in asserting her own personality, her own artistic credo. More palpably Atgetesque, and always rich in local color, are bits of old New York—the drugstore, for instance, that still sells only drugs"; *Parnassus*, Dec. 1934: "She is a true disciple of Eugène Atget, whose photographs constitute the most complete and beautiful document of that much painted city, Paris"; Walker Evans, also profoundly influenced by Atget's photographs, was also called "a sort of New York Atget" in 1932 by Katherine Grant Sterne, in "Photographs That Interest," *NYT*, 2/4/1932,

quoted in James R. Mellow, *Walker Evans* (New York: Basic Books, 1999), 164–165; Frank Crowninshield, editor of *Vanity Fair*, wrote, "Berenice Abbot [*sic*] (the veritable Eugène Atget of our time)" in *U.S. Camera Annual 1939*, ed. T. J. Maloney (New York: William Morrow, 1938); Todd Webb, new to NYC in 1946, saw a parallel between his work and Atget's: "[W]hen Berenice told us about him it seemed to me that I was doing about the same in New York as Atget had done in Paris about a half-century earlier," Todd Webb, *Looking Back: Memoirs and Photographs* (Albuquerque: University of New Mexico Press, 1991), 27–28; Carlton, "Berenice Abbott: Photographer," 12–13; Marks, "Chronicler of Our Times," 166.

29 BA, "Eugène Atget," 651.

30 EMCC marginalia in BA autobiog; IS, 11/30/1959.

31 BA, "The Art of Photography" (radio interview).

32 BA to Ansel Adams, CTL, 6/14/1940, CG; Siegfried Giedion to BA, ALS, 6/15/1939, and BA to Giedion, CTL 6/21/1939, CG.

33 BA alterations to Anne Wilkes Tucker typed MS, 1973, AWT/BA.

34 Gene Thornton, "Berenice Abbott: She Is Decisive," *NYT*, 9/16/1973; Alan G. Artner, "New York's Visual Power, Seen through Abbott's Loving Lens," *Chicago Tribune*, 10/17/1976.

35 Sale contract between Julien Levy and BA, 5/4/1930, SBB/BA; BA to Mm. Blackman, CTL, 10/22/1934: "$50,000+" CG.

36 Leslie Katz, BA memorial; Barbara Michaels, CWA, NYC, 6/7/1989; John Goodman, CWA, NYC, 1/20/1995.

37 Marks, "Chronicler of Our Times," 166; IS, 9/3/1960.

38 Beaumont Newhall, ed., *Photography, Essays & Images: Illustrated Readings in the History of Photography* (New York: Museum of Modern Art; Boston: distributed by New York Graphic Society, 1980); Grace Mayer and Leslie Katz, BA memorial.

CHAPTER 7. NO SCRUPLES

1 Thomas Wolfe, *The Web and the Rock* (New York: Harper & Brothers, 1939), 315.

2 BA to Ralph W. Price, Korner & Wood Co., Cleveland, CTL, 9/20/1928, CG.

3 BA subsequently sent a long reply, CTL, 9/12/1928, CG; replies were published in *transition* 14 (Summer 1928), 111–112.

4 BAOH, 191; Barr diss, 86; André Siegfried, *America Comes of Age; A French Analysis*, trans. H. H. Hemming and Doris Hemming (New York: Da Capo, 1974), 347, 350; Siegfried, "European vs. American Civilization," in *America Comes of Age*, 347–354.

5 FBI/BA; Walter L. Davis, "Girl Wins Paris by Camera's Art," *Cleveland Plain Dealer*, 11/18/1928; E. L. T. Mesens to BA, TLS, Bruxelles, 9/25/1928, and Ernst Mayer to BA, Berlin, 1/15/1929, CG; Gustav Stotz to BA, TLS, 1/9/1929, CG; Eugène Jolas to BA, 1/7/1928 [*sic*, 1929], CG, all quoted in Barr diss, 62.

6 Reiner to BA, ALS, 11/18/[1969?, not determinable from internal evidence], CG; BA used Reiner's name and address as her emergency contact: "c/o W. W. Oppenheim [Reiner's father], 366 Park Ave, Orange, NJ," SBB/BA; Davis, "Girl Wins Paris by Camera's Art"; BA to Deufot, TLS, 1/2/1929, CG.

7 Reference to "slush" and exalted feelings occurs repeatedly: BA, 1936 draft report on CNY, CG.

8 BA, 1936 draft report on CNY, CG; EMCC, "Camera Eye Records Ever 'Changing New York,'" *Springfield Sunday Union and Republican* (Springfield, MA), 10/24/1937; AC/BA, 16; Carlton, "Berenice Abbott: Photographer," 23; BA's Guggenheim application, 1931, CG, quoted in BY:CNY, 13.

9 BA to Storrs, ALS, from Berlin, n.d. [dateable from internal evidence to early 1922], Storrs papers, AAA; Steinbach, "Berenice Abbott's Point of View," 8; Christopher Gray, "Streetscapes/Hotel des Artistes," *NYT*, 5/14/2000; Elizabeth Hawes, *New York, New York: How the Apartment House Transformed the Life of the City, 1869–1930* (New York: Knopf, 1993), 173: "Only the most successful artists could afford to live there."

10 "An Interview with Robert Creeley; Conducted by Steve Luttrell"; no dual-city letterhead examples survive in Abbott's papers; one was found in Samuel Putnam Papers, Princeton University Library; AC/BA, 17, and AWT/BA; BA soon learned she could not count on fees, BAOH, 419; prints that appeared in Maud Kok's "Atget, 1856–1927" (*Elsevier's geïllustreerd maandschrift* 39, Aug. 1929, 94–97) came from a source other than BA, and Kok would not pay her anything; an editor of *De Groene Amsterdammer* (name not legible in signature) advised BA to pursue rights from her French studio (as the US was not a signatory to the Berne Convention), cf. TLS, 6/20/[1930], CG; in the letter, the editor also wonders if *Elsevier's* obtained the prints direct for the Maude Kok article or if they got them from *Jazz: l'actualité intellectuelle*, which also printed a selection; the editor then teased BA, "Please note I could steal all your foto's [*sic*], I know to find, if I wanted to!"

11 Album now held by the Metropolitan Museum of Art; Barr describes its contents in Barr diss, 63n14; the Met digitized the album and includes its pages among the BA online holdings, available at http://www.metmuseum.org/art/collection/; searching the terms "Album Berenice Abbott" on 8/16/2017 resulted in thirty-one object records showing album pages.

12 Barr diss, 106–107, 110–113; May 30 was the old fixed date and "Decoration

Day" the original name for Memorial Day, the federal holiday held on the last Monday in May since 1971; *Das Furchtlose Auge*, Leiser (1984); Bertha A. Houck, "Clay, Canvas and Camera," *The Spur* 15, no. 4 (Oct. 1937), 78.

13 Morris, "Summary," 1; the backs of many of the prints in the Met's black album carry ink stamps of the sort that drugstores and other mass developers placed on their products; Berman, "The Unflinching Eye," 92; EMCC, "The Photography of Berenice Abbott," *Trend* 3, no. 1 (Mar.–Apr. 1935), 18; Audrey McMahon, preface [dated Jan. 1939] to *Changing New York*, by BA (New York: Dutton, 1939), v; Ishtar; BAOH, 283, 399.

14 BA, "Eugène Atget," 651–656; with language borrowed from Robert Desnos, "Le spectacles de la rue: Eugène Atget," *Le Soir*, 9/11/1928, clipping in SBParis, 40, CG.

15 Morris, "Summary," 1; Barr diss, 60–82; *Variétés* 1, no. 4, 8/15/1929, and *Variétés* 1, no. 8, 12/15/1929.

16 Morris, "Summary," 2.

17 *Architectural Record* 67, no. 5 (May 1930), 408–409; *Architectural Forum* 52, no. 5 (May 1930), 748–749.

18 BA, CWA, Monson, ME, 8/4/1991; Morris, "Summary," 4; *hocus-pocusy*: BA used this stock phrase often; Irene Shwachman recorded it 5/29/1959; see also AWT/BA; Berman, "The Unflinching Eye," 88, and BA, CWA, Monson, ME, 8/4/1991; whatever Stieglitz's true intentions at the time toward Atget, Stieglitz's unconfirmed exhibition plans appeared in NY newspapers a few weeks later; *The New Yorker* mentioned the Anderson Galleries, 5/4/1929, and *NYT* mentioned the Intimate Gallery next season, 4/28/1929; Webb, *Looking Back*, 28.

19 Morris, "Summary," 2; BAOH, 356.

20 BA, CWA, Monson, ME, Nov. 1991.

21 Ibid.

22 Davis, "Girl Wins Paris by Camera's Art."

23 "Dizzy Heights Have No Terrors for This Girl Photographer, Who Braves Numerous Perils to Film the Beauty of Iron and Steel," *New York Sun*, 4/25/1929, quoted in Vicki Goldberg, *Margaret Bourke-White* (New York: Harper & Row, 1986), 66, 99; AWT/BA; BAOH, 21–22; Tirza True Latimer, *Women Together/Women Apart: Portraits of Lesbian Paris* (New Brunswick, NJ: Rutgers University Press, 2005), 34+; BA, phone CWA, 5/28/1991.

24 BY:CNY, 14; see Metropolitan Museum of Art acc. no. 1979.678.1–.8, a whole page devoted to Chinatown, http://www.metmuseum.org/art/collection/search/291970, accessed 8/16/2017.

25 BAOH, 163–164.

26 David Burner, *Herbert Hoover: A Public Life* (New York: Knopf, 1979), 248, quoted in Terry A. Cooney, *Balancing Acts: American Thought and Culture in the 1930's* (New York: Twayne Publishers, 1995), 2–3; Cowley, *Exile's Return*, 301.

27 Ruth Morris, "Fits Art to Age: Miss Abbott Identifies Photography with America," *Brooklyn Eagle Sunday Magazine*, 12/14/1930, 5.

28 Ann Sass, "The Photography of *Fortune*, 1930–1965," in *Picturing Business: The Photography of* Fortune, *1930–1965* (New York: International Center of Photography, 2000), pamphlet for exhibition of the same name, shown at the International Center of Photography, NYC, 2/19–5/14/2000; BA's demure portrait of the magazine's star photographer, Margaret Bourke-White, was also in the back of the book; BA, CWA, Monson, ME, 11/8/1991.

29 Margaretta Mitchell quoting BA, notes for her book on women photographers, 1970s, SBB/BA; "Sunday Morning: Berenice Abbott," *CBS News Sunday Morning*; AC/BA, 18–19; [Mitchell], "Woman with Camera"; BA's published portraits for *Fortune* included Transamerica chairman Elisha Walker (Jan. 1931), Bowery Savings Bank president Henry Bruère (Feb. 1931), Armour and Co.'s Hiram J. Halle (Apr. 1931), and entertainer-businessman Rudy Valee, with the caption: "[I]n his office where he receives propositions from publishers who want him to plug their songs over the radio" (Jan. 1933); other magnates *Fortune* assigned were rare book dealer Dr. A. S. W. Rosenbach, IBM president Thomas J. Watson, United Press executives August Bickel and Hugh Baillie, liquor industry executives Daniel Weiskopf (as Prohibition was repealed), Emil Schwarzhaupt, and Mason Day.

30 Nancy Grove, *Isamu Noguchi: Portrait Sculpture* (Washington, DC: Smithsonian Institution Press for the National Portrait Gallery, 1989), 8, 12; BA photographs for Noguchi are reproduced in Grove: *Birth*, marble (1934), 15, and *Death (Lynched Figure)*, monel metal (1934), 16; HON/BA, 37; IS, 1/3/1967; Noguchi, *Berenice Abbott* (1929), bronze, 13¾ × 9 × 9¾", object no. NPG.86.140, National Portrait Gallery.

31 Mariani, *Williams*, 293.

32 BAOH, 162–164.

33 AC/BA, 16; IS, 10/12/1962; his full name was Isaac Edward Cecil De Hirsh DeTannerier Gilmont Margules; John Driscoll and Michael St. Clair, *De Hirsh Margules* (New York: Babcock Galleries, 1994), exhibition catalog; "De Hirsh Margules Dies at 65; A Greenwich Village Notable," *NYT*, 2/4/1965; Bernard Weinraub, "The 'Village' Mourns Lost Baron and Recalls the Old, Vivid Days," *NYT*, 2/8/1965; "Margules, 'Village' Artist-Poet, Left $100,000," *NYT*, 2/16/1965; "City News Sends Its Last Bulletin On Affairs of the Seven Mil-

lion," *NYT*, 2/12/1942; Schulman, *Romany Marie*, 117–120; the known prints by Margules are held by the Photography Collection, NYPL; the print of Reiner identifies her as Julia Oppenheim Delton, acc. no. 95PH014.001-002, Wallach purchase and gift of Mrs. Harrison Horblit, 1992; Schulman, *Romany Marie*, 8–10, and picture well reproduction of mimeo flyer for "Do You Remember" Evening, 4/1–3/1939; "Marie Marchand, 'Village' Figure; Tea Room Operator Known as Romany Marie Dies—Aided Artists, Writers," *NYT*, 2/23/1961; Cahill OH, 60.

34 BA, CWA, Monson, ME, 11/9/1991, and BAOH, 179; BA mistakenly thought Violette a granddaughter of Emperor Napoleon; Francis Rose, *Saying Life* (London: Cassell, 1961), 84; Hamnett, *Laughing Torso*, 228–229; David L. Lewis, *When Harlem Was In Vogue* (New York: Knopf, 1981), 213.

35 SBB, phone CWA, 1/18/1995; BA, CWA, Monson, ME, 11/9/1991; Flanner, *Paris Was Yesterday*, xiv; Secrest, "An Attic Studio"; BAOH, 179.

36 IS, 9/30/1959; "Êtes-Vous Polygame?" [Are you polygamous?], interview with BA, Max Ewing, and Doris Ewing, and "Isn't It Awful?" a lament by Princess Eugène Murat (BA) and Max Ewing (dialogues), 7/27/1929, "Speak-O-Phone personal phonographs," aluminum instantaneous phonodisc, Max Ewing Papers, Beinecke Library, Yale University, gift of Carl Van Vechten, 1943.

37 Francis Wyndham, "Ursula," in *Mrs. Henderson and Other Stories* (London: Cape, 1985), 53 –123, tells the story of his fabled aunt under the pseudonym Ursula; "Edna Thomas," obituary, *NYT*, 7/24/1974; to stay in the United States legally, Wyndham married Howland Spencer in May 1930 whose blackmail threats ("is practising the Lesbian perversion with a noted actress as black as the ace of spades!") were squelched by Wyndham's scandal-averse father; during World War II, Olivia Wyndham served in the Women's Army Corps as a embedded photographer in the Pacific and spent the rest of her career with the US Veterans Administration.

38 HON/BA, 39; the Savoy opened at the height of the Harlem Renaissance in 1926, on Lenox Avenue between 140th and 141st Streets, one of the first racially integrated public places in the country; its two bandstands, and its block-long, spotlighted, spring-loaded ballroom floor, accommodated several thousand dancers a night; see Mark the Savoy, *Savoy Ballroom 1926–1958*, accessed 2002, http://www.savoyplaque.org/; IS, 3/27/1960.

39 Andrea Barnet, *All-Night Party: The Women of Bohemian Greenwich Village and Harlem, 1913–1930* (Chapel Hill: Algonquin Books, 2004), 147–158; A'Lelia Bundles, *On Her Own Ground: The Life and Times of Madam C. J. Walker* (New York: Scribner, 2001), 250+; BA, CWA, Monson, ME, 11/9/1991; HON/BA, 59; Bundles, "A'Lelia Walker's Grand Harlem Funeral: August 1931,"

offical website and blog of A'Lelia Bundles, 8/16/2011, accessed 2/7/2016, http://www.aleliabundles.com/2011/08/16/alelia-walkers-grand-harlem -funeral-august-1931/. A novel has been written about Walker, but no biography has yet appeared: Ben Neihart, *Rough Amusements: the True Story of A'Lelia Walker, Patroness of the Harlem Renaissance's Down-Low Culture* (New York: Bloomsbury, 2003).

40 McAlmon, *Being Geniuses Together*, 321 (not in Kay Boyle's 1968 revised edition); also Sanford J. Smoller, *Adrift Among Geniuses: Robert McAlmon, Writer and Publisher of the Twenties* (University Park: Pennsylvania State University Press, 1975), 238–239; Carl Van Vechten, *The Splendid Drunken Twenties: Selections from the Daybooks, 1922–1930*, ed. Bruce Kellner (Urbana: University of Illinois Press, 2003), 171, 271.

41 Franz Schulze, *Philip Johnson: Life and Work* (New York: Knopf, 1994), 93–94; Eugene R. Gaddis, *Magician of the Modern: Chick Austin and the Transformation of the Arts in America* (New York: Knopf, 2000), 186–187; Margaretta K. Mitchell, *Ruth Bernhard: Between Art & Life* (San Francisco: Chronicle Books, 2000), 58.

42 Mitchell, *Ruth Bernhard*, 58; BA, CWA, Monson, ME, 8/2/1991; Cahill OH, 59; case label accompanying Reginald Marsh's *Chop Suey Dancers* (1929) for NYPL exhibition *Becoming Visible*; Molly McGarry and Fred Wasserman, *Becoming Visible: An Illustrated History of Lesbian and Gay Life in Twentieth-Century America* (New York: Penguin Studio, 1998), based on the NYPL exhibition; George Chauncey, "Long-Haired Men and Short-Haired Women: Building a Gay World in the Heart of Bohemia," in *Greenwich Village: Culture and Counterculture*, eds. Rick Beard and Leslie Cohen Berlowitz (New Brunswick, NJ: Rugers University Press, published for the Museum of the City of New York, 1993), 162–163; Ruth Bernhard, phone CWA, 1/20/1998.

43 Mitchell, *Ruth Bernhard*, 57.

44 Gaddis, *Magician of the Modern*, 321, 333, 424–425.

45 BA, CWA, Monson, ME, 8/4/1991 and 11/10/1991; IS, 1/9/1961.

46 Unterecker, *Voyager*, 562–563.

47 Mellow, *Walker Evans*, 72–73; Miles Huddlestone, *James Stern: A Life in Letters, 1904–1993* (Wilby, Norwich: Michael Russell, 2002), 40; James Stern, "Memoirs: Walker Evans," *London Magazine* 17, no. 3 (Aug.–Sept. 1977), 5; Stern met Evans in the 1940s while working at Time Inc.

48 Edited by Angel Flores, it lasted four issues; Mellow, *Walker Evans*, 98–99, 111; Mellow says Evans often let letters from Skolle pile up before replying, so Evans may have met BA much earlier than this reply of 2/25/1930.

49 Unterecker, *Voyager*, 619, 635–637.

50 BA, CWA, Monson, ME, n.d. [likely Aug. 1988] and 11/9/1991; "An Interview with Robert Creeley; Conducted by Steve Luttrell"; BAOH, 188–189; IS, 1/9/1961.

51 BA to Samuel Putnam, ALS, 1/5/1931, Putnam Papers, Princeton University Library.

52 Leslie Katz, "Interview with Walker Evans," *Art in America* 59, no. 2 (Mar.–Apr. 1971), 83; Katharine Grant Sterne, "American Photographs: A Retrospective Exhibition," *Parnassus* 3, no. 7 (Nov. 1931), 7–8.

53 Edward Brunner, "Harry Crosby as Photographer," Modern American Poetry: An Online Journal and Multimedia Companion to *Anthology of Modern American Poetry*, ed. Cary Nelson (New York: Oxford University Press, 2000), accessed 2/4/2003, http://www.english.uiuc.edu/maps/poets/a_f/crosby/photographer.htm; *Variétés* 2, no. 10, 2/15/1930.

54 Geoffrey Wolff, *Black Sun* (New York: Random House, 1976), 284–294; Edward Brunner, "Harry Crosby's 'Brief Transit,'" *Modern American Poetry*, accessed 2/20/2003, http://www.english.uiuc.edu/maps/poets/a_f/crosby/bio.htm; Edward Germain, introduction to *Shadows of the Sun: The Diaries of Harry Crosby*, by Harry Crosby, ed. Edward Germain (Santa Barbara: Black Sparrow Press, 1977), 7–17; Robert McAlmon to Sylvia Beach, TLS, Guadalajara, Mexico, 3/3/1930, Beach papers, Princeton University Library.

55 BAOH, 117.

56 *Das Furchtlose Auge*, Leiser (1984); AC/BA, 19; see, for example, BA, reply letter to Harry Bull of *Town and Country* and *International Studio*, 4/28/1930, CG; presumably her sale of a Joyce portrait to *Time* in early 1930 was more professionally handled.

57 Ruth Pickering to BA, TLsS, 3/25/1929 and 3/28/1929, with BA to Pickering, CTLs, 3/1/1930 and 4/2/1930, CG; Barr diss, 60; BAOH, 627–628; J. Walter Thompson agency to BA, TLS, 2/3/1930, CG.

58 HON/BA, 69; Evelyn Scott to BA, TLS, 7/7/1929, SBB/BA; Elsa von Freytag-Loringhoven, "The Art of Madness," *The Little Review* 6, no. 9 (Jan. 1920), 29, quoted in *The Art of Baroness Elsa Von Freytag-Loringhoven*, [26]n23; BA, CWA, Monson, ME, 8/2/1991, 8/4/1991, and 11/8/1991.

59 BA resume, typescript, 4, dateable from internal evidence to 1930–1931 (possible preparation for Guggenheim fellowship application), CG.

60 Carolyn Burke, "Loy-alism: Julien Levy's Kinship with Mina Loy," in Ingrid Schaffner and Lisa Jacobs, eds., *Julien Levy: Portrait of an Art Gallery* (Cambridge, MA.: MIT Press, 1998), 63–66; Katherine Ware and Peter Barberie, *Dreaming in Black and White: Photography at the Julien Levy Gallery* (Philadelphia, PA: Philadelphia Museum of Art, 2006), treats the family relationships and BA's portraiture of some members.

61 José Clemente Orozco, *An Autobiography*, trans. Robert C. Stephenson (Austin: University of Texas Press, 1962), 40–41, quoted in Reba Williams, "The Weyhe Gallery Between the Wars, 1919–1940" (PhD dissertation, CUNY, 1996), 131.

62 Julie Reiner was corresponding with magazines, such as *House & Garden*, from her home in Orange, NJ, about licensing Atgets for reproduction, while BA was selling modern Atget prints to individuals, for the high price of $30 each, cf. correspondence in CG; BA sale contract with Levy, signed and dated May 2, 1930, SBB/BA. Barr diss, 140, analyzes the first year of work: BA made at least 285 such prints through Apr. 1931.

63 Ingrid Schaffner, "Alchemy of the Gallery," in *Julien Levy: Portrait of an Art Gallery*, 27–28; IS, 6/29/1960; Julien Levy to BA, TLS, n.d., CG.

64 BA, "Eugène Atget," *Encyclopedia of Photography* (New York: Greystone Press, 1967), 302; Berman, "The Unflinching Eye," 92; Edward Weston, "Photography—Not Pictorial," *Camera Craft* 37, no. 7 (July 1930), 313, 318;

65 BY:CNY, 14; Berman, "The Unflinching Eye," 92; [Mitchell], "Woman with Camera"; BA, CWA, Monson, ME, 8/2/1991; Elisabeth Sekaer Rothschild, CWA, Hastings-on-Hudson, NY, 10/24/1995; BAOH, 373–374; BA or HON, CWA, n.d.

66 "Photo Berenice Abbott, New-York / 42nd," in *L'art moderne primitif*, by Maurice Casteels (Paris: Les Éditions Henri Jonquières, 1930; German ed., 1930; US/UK eds., 1931), plate 88. Evans, plates 14, 87, in Casteels, *L'art moderne primitif*: Mellow did not know what BA did with Evans's photographs, *Walker Evans*, 111–112.

67 Pierre Mac Orlan's article on the "social fantastic" appeared in *Crapouillot* for Jan. 1929; an album of Atget's Paris photographs, credited to BA's collection, in a special number that May; Barr diss, 142–143; Pierre Mac Orlan, "Preface to *Atget photographe de Paris*," trans. Robert Erich Wolf, in *Photography in the Modern Era*, 48

68 Davis, "Girl Wins Paris by Camera's Art"; BA to Knopf, 12/8/1928, 12/17/1928, and 1/4/1929; Knopf to BA, 12/20/1928 and 4/8/1929; E. Weyhe to BA, TLS, 3/4/1930, all CG; Barr diss, 141, terms the German-language edition "unauthorized"; BAOH, 245, calls it "bootlegged" then concedes she might have received a fee; Eugène Atget, *E. Atget. Lichtbilder*, trans. Oscar Camille Recht (Paris and Leipzig: Henri Jonquières, 1930); with the exception of being quoted by Walter Benjamin in this essay, Recht's impact on 20th-century photography history is virtually nonexistent; BAOH 245.

69 BY:CNY, 14, fn22; Paris: A. Fayard et cie, 1930; not to be confused with Firmin Roz's book about the post-WWI period, *Les États-Unis d'Amérique* (Paris: F. Alcan, 1927), which BA herself confused with her earlier reading, and called

it "another scathing picture of America"; BA, CWA, Monson, ME, 11/8/1991; German edition: "übertragen und bearbeitet von Camille Recht (Paris, Leipzig: Henri Jonquières c1930)"; illustrations in Firmin Roz: plates XXVIII and XXIX, copyrighted "Henri Jonquières," implying a licensing agreement.

70 IS, 6/26/1961; BAOH, 157–158; HON/BA, 49; *The Little Review* 12, no. 2 (Spring 1929), 46; Massot reported his unhappiest moment was discovering his "sweetheart had true lesbian tastes"—could that sweetheart have been BA?

71 Maximillian Gauthier, "Le Salon de l'Araignée," *L'Art vivant* 6 (6/1/1930), 449; Hamnett, *Laughing Torso*, 171; BA, CWA, Monson, ME, 11/9/1991.

72 SBB, phone CWA, 1/18/1995 and 2/20/1997; IS, 8/16/1960; Max Ernst to BA, plain paper "certificat" ALS, 6/4/1930, Mendon (S et O), CG, giving BA the following "tableaux" by him: (1) *Tête de jeune fille*, 65 × 54 cm, (2) *Oiseau*, 24 × 19 cm, (3) *Forêt*, 35 × 17 cm, and (4) *Fleur*, 24 × 19 cm; IS, 11/30/1959 and 3/30/1961; BAOH, 165, 292; HHL.

73 IS, 8/9/1960 and 8/16/1960.

CHAPTER 8. REALIZING NEW YORK

1 Katherine Grant Sterne, "The Camera: Five Exhibitions of Photography," *NYT*, 12/6/1931.

2 Lillian Sabine, "Berenice Abbott, of New York City," *Abel's Photographic Weekly*, 3/7/1931, 263.

3 Julien Levy to BA, TLS, 9/30/1930, CG.

4 Julien Levy, *Memoir of an Art Gallery*, 93.

5 Walker Evans, "The Reappearance of Photography," *Hound & Horn* 5 (Oct.–Dec. 1930), 126; Ruth Green Harris, "Art That Is Now Being Shown in the Galleries," *NYT*, 12/7/1930; Morris, "Fits Art to Age," 5.

6. Cf. Exhibition checklists in Lincoln Kirstein Scrapbook 2–3, MoMA Library, NYC. Kirstein *Mosaic* 169–75. Berenice soon turned to American folk art as a subject.

7 Kirstein, *Mosaic*, 83; Mellow, *Walker Evans*, 87–92, 143; Frederick Brown, *An Impersonation of Angels: A Biography of Jean Cocteau* (New York: Viking, 1968), 243, quoted in Mellow, *Walker Evans*, 143; Lincoln Kirstein, diary [n.d.], 357, Dance Collection, NYPL, and Brown, *Impersonation of Angels*, 243, quoted in Mellow, *Walker Evans*, 143.

8 Lincoln Kirstein Scrapbook 3, MoMA Library, NYC.

9 The subjects were André Gide, Jean Cocteau, and Cocteau's hands, André Maurois, Eugéne Atget, Paul Cross, Parker Morse Hooper, Buddie Gilmore, and James Joyce; Kirstein, *Mosaic*, 109; showing New York's building skyscrapers and

the congestion of the city, Evans's image, plate 87 (called "Un Coin de New-York" in the book's inserted plate list) is the recto of BA's image, plate 88 ("New-York, 42e rue"); Gaddis, *Magician of the Modern*, 141; Sterner's photography is largely unknown; Sterner was also interested in filmmaking and seems to have known of other mutual acquaintances such as Marjorie Fairbanks in Boston; BAOH, 53; Kirstein *Mosaic* dust-jacket illustration; Jerry Thompson, phone CWA, 1/27/1998.

10 Samuel Putnam to BA, CTLs, Paris, 12/9/1930 and 2/16/1931; BA to Putnam, ALS, 1/5/1931, Putnam Papers, Princeton University Library; co-author with Raymond Mortimer of *The New Interior Decoration: An Introduction to Its Principles, and International Survey of Its Methods* (New York: C. Scribner's Sons/London: B. T. Batsford, 1929); Cecil Beaton, *Photobiography* (London: Odhams Press, 1951), 34; Christopher Reed, "A Vogue That Dare Not Speak its Name: Sexual Subculture During the Editorship of Dorothy Todd, 1922–26," *Fashion Theory: The Journal of Dress, Body & Culture* 10, no. 1–2 (Mar. 2006); Sandhya Kimberley Lachmansingh, "'Fashions of the Mind': Modernism and British *Vogue* under the Editorship of Dorothy Todd" (MPhil thesis, University of Birmingham, 2011), PDF, accessed 9/18/2014, http://etheses.bham .ac.uk/1578/1/Lachmansingh11MPhil.pdf; Dorothy Todd to Putnam, TLS, Paris, 2/11/1931, Putnam Papers, Princeton University Library; BA to Putnam, ALS, 2/28/1931, Putnam Papers, Princeton University Library; Pierre Mac Orlan and Germaine Krull, *Germaine Krull* (Paris: Gallimard, 1931).

11 "Notes on New Contributors," *New Review* 2 (May–June–Jul. 1931), 155; Harry V. Anderson, "Contemporary American Designers," *Decorators Digest* 4, no. 4 (Apr. 1935), 44–48, 101; Putnam to BA, CTL, 12/9/1930, Putnam Papers, Princeton University Library; William J. Hennessey, *Russel Wright: American Designer* (Cambridge, MA: MIT Press, 1983), 18, 19, 88n6; *New Review* 2, no. 5 (Apr. 1932), opposite pp. 49 and 73; Ezra Pound and E. E. Cummings, *Pound/ Cummings: The Correspondence of Ezra Pound and E. E. Cummings*, ed. Barry Ahearn (Ann Arbor: University of Michigan Press, 1996), 17.

12 *Hooverville, Central Park. 1932.*, object no. 93PH036.003, NYPL, http://wallach printsandphotos.nypl.org/catalog/3858; Burner, *Herbert Hoover*, 248, quoted in Cooney, *Balancing Acts*, 2–3; "The Artists' Unions: Builders of a Democratic Culture," *Art Front* 3, nos. 3–4 (Apr.–May 1937), and Biddle, *An American Artist's Story*, quoted in Francine Tyler, "Artists Respond to the Great Depression and the Threat of Fascism: The New York Artists' Union and Its Magazine Art Front (1934–1937)" (PhD dissertation, New York University, 1994), 19–20.

13 Sylvia Beach to BA, TLS, 2/6/1931, CG; Lucia Joyce to BA, n.d. [1931], SBB/ BA; BA to Julien Levy, CTS, 4/29/1931, CG.

14 Carl Van Vechten to BA, ALsS, 5/14/1931, 5/15/1931, and 5/10/1932, CG;

Carl Van Vechten OH, 1960, transcript, 252, Columbia University Library; Saul Mauriber, ed., *Portraits, the Photography of Carl Van Vechten* (Indianapolis: Bobbs-Merrill, 1978); Carl Van Vechten to BA, ALS, 11/11/1937, CG.

15 HON/BA, 67; BA to Eugen Boissevin, TL, Austerlitz, NY, 2/6/1940; Edna St. Vincent Millay papers, Library of Congress; Peter H. Beard et al., *Animal Attractions*, ed. Diana Edkins (New York: Harry N. Abrams in association with the Humane Society of New York, 1995); Millay to BA, ALsS, 10/1/1931 and 1/26/1932, CG; Nancy Milford, *Savage Beauty; The Life of Edna St. Vincent Millay* (New York: Random House, 2001), 335, 523n334; Elizabeth Breuer, "Edna St. Vincent Millay," *Pictorial Review* 33 (Nov. 1931), 2.

16 Smoller, *Adrift Among Geniuses*, 243; Robert McAlmon to Richard Johns, TLS, facsimile reproduced in Stephen Halpert and Richard Johns, eds., *A Return to* Pagany: *The History, Correspondence, and Selections from a Little Magazine, 1929–1932* (Boston: Beacon Press, 1969), 263, 276; *Pagany* 2, no. 2 (Apr.–June 1931), opposite p. 44.

17 Carlton, "Berenice Abbott: Photographer," 12–13, 35; Ishtar.

18 BA, *The View Camera Made Simple* (Chicago: Ziff-Davis Pub., 1949), 4; BAOH, 371, 396, 399; Trausch, "Portrait of the Photographer," 56; Edie Clark, "The Black and White of Berenice Abbott," *Yankee* 52 (Dec. 1988) 79; Ishtar; BA, *Beach Scene*, in HON/BA, 80, and *Scène de plage, 1931* in "La grand-mère de choc de la photo américaine: Berenice Abbott," *Photo* 185 (Feb. 1983), 85.

19 Charters, *This Must Be The Place*, 286; Greene to BA, telegram, 9/15/1931, with BA's penciled reply on verso, CG.

20 AC/BA, 17; IS, 5/2/1960.

21 Raymond Holden, *The New Yorker*, to BA, TLS, 11/11/1931, CG; I. N. Phelps Stokes to Hardinge Scholle, 11/18/1931, quoted in BY:CNY, 16; AWT/BA.

22 BA to Hardinge Scholle, MCNY, 11/26/1931, quoted in BY:CNY, 16; Hardinge Scholle to I. N. P. Stokes, 11/19/1931, quoted in BY:CNY, 16; Grace Mayer, BA memorial; BAOH, 304–305.

23 Variant poses and prints held by the Metropolitan Museum of Art and MoMA; Stephen Birmingham, *"Our Crowd": The Great Jewish Families of New York* (New York: Harper & Row, 1967); BAOH, 304–305; BA, CWA, Monson, ME, 8/4/1991.

24 Atheneum to BA, TLS, 11/11/1931, CG; *Newer Super-Realism* (Hartford: Wadsworth Atheneum, Nov. 1931), nos. 15–17; Gaddis, *Magician of the Modern* (New York: Knopf, 2000), 162, 447n41, 42, 48; IS, 3/30/1961; HHL.

25 "Jiminy Christmas," *The New Yorker* (11/21/1931), 58, 60–61.

26 BA to Putnam, ALS, 2/27/1931, Putnam papers, Princeton University Library; BAOH, 247; AWT/BA; Schaffner, "Alchemy of the Gallery," 24; BA's presti-

gious selection included James Joyce, Princess Bibesco, and Buddie Gilmore; E. F. Dechert to BA, TLS, 3/22/1932, CG; perhaps the source of the one original Brady print, a portrait of the photographer himself, BA soon came to own.

27 IS, 10/24/1959 and 11/30/1959.

28 IS, 1/3/1963; EMCC, TM for the record, n.d. [dateable from internal evidence to May 1964], CG.

29 BAOH, 253; Joella Levy to BA, TLS, 3/21/1932, CG; Julien Levy Gallery statements to BA for 1931, 1/6/1932, and for 1932, 12/31/1932, CG; Walter Gutman, "News and Gossip," *Creative Art* 9 (Dec. 1931), 503; Schaffner, "Alchemy of the Gallery," 23, 36; Ware and Barberie, *Dreaming in Black and White*; none of these applied photography objects are believed to have survived.

30 Dore Ashton, *A Joseph Cornell Album* (New York: Viking, 1974), x–xi; copy no. 8 (of an edition of 10) is held by the Spencer Collection of NYPL, inscribed to Cornell's friend, NYPL Picture Collection curator Romana Javitz; Dawn Ades, "The Transcendental Surrealism of Joseph Cornell," in *Joseph Cornell*, ed. Kynaston McShine (New York: Museum of Modern Art, 1980), 35, 73n; P. Adams Sitney, "The Cinematic Gaze of Joseph Cornell," in *Joseph Cornell*, 73, 15n; also, Deborah Solomon, *Utopia Parkway: The Life and Work of Joseph Cornell* (New York: Farrar, Straus and Giroux, 1997), 76; Mary Ann Caws, ed., *Joseph Cornell's Theater of the Mind: Selected Diaries, Letters, and Files* (New York: Thames & Hudson, 1993), 100, 124; in *View* 2, no. 4 (Jan. 1943), 10–16.

31 [Mitchell], "Woman with Camera."

32 "Julia Reiner," obituary; BA, CWA, Monson, ME, 11/8/1991; *New Review* 3 (Aug.–Oct. 1931), 290; William Patrick Patterson, *Ladies of the Rope: Gurdjieff's Special Left Bank Women's Group* (Fairfax, CA: Arete Communications, 1999); IS, 9/29/1960; Tobias Churton, *Aleister Crowley: The Biography: Spiritual Revolutionary, Romantic Explorer, Occult Master and Spy* (London: Watkins, 2011), 292.

33 BY:CNY, 16; Ishtar; BA, CWA, Monson, ME, 11/9/1991; *Rockefeller Center, 1932*, in BA, *New Guide to Better Photography* (New York: Crown, 1953), 9, plate 49; also in BA's 1932 MoMA photo mural and the Center's 1940 commemorative volume, *The Last Rivet: The Story of Rockefeller Center, a City Within a City as Told at the Ceremony in Which John D. Rockefeller, Jr., Drove the Last Rivet of the Last Building, November 1, 1939* (New York: Columbia University Press, 1940).

34 Richard Whelan, *Alfred Stieglitz* (Boston: Little, Brown, 1995), 533–534, 624n23.

35 BAOH, 211, 250–251; Mellow, *Walker Evans*, 126–131; Louis Eilshemius to BA, ALS, 4/15/1932, CG; Paul J. Karlstrom, *Louis Michel Eilshemius* (New York: Abrams, 1978), 35–41; he had been championed by Duchamp before WWI and exhibited at the Société Anonyme in 1920, when BA might have first met

him; she even owned a few of his paintings that she traded when moving back from Paris to New York; IS, 11/30/1959; Valentine Thomson to BA, TLS, 5/14/1932, CG.

36 *Hound & Horn* 5, no. 3 (Apr.–June 1932); there is no table of contents listing, accompanying text, nor contributor's note; BA's pictures are *Lower Manhattan*, *Sailor's Bethel*, *Union Square*, and *Waterfront*; clipping from *Charlotte News* (Charlotte, NC), 4/17/1932, in Lincoln Kirstein Scrapbook 3, MoMA Library; perhaps the author was reporter-writer Joseph Mitchell, the North Carolina native who became acquainted with BA around this time and greatly admired her work, remaining a friend all her life; Mellow, *Walker Evans*, 166; *Modern Photography: At Home and Abroad* (Buffalo, NY: The Gallery, 1932), catalog for exhibition of the same name, shown at Albright Art Gallery, 2/7–2/25/1932; most of the Philadelphia loans came from the Levy Gallery; exhibition listings in BA's 1936 Guggenheim application, Guggenheim Foundation Archives; "Ancestors, An Exhibition of the Photography of Mathew Brady and Eugène Atget, Mar. 21–Apr. 25" (Philadelphia: The Galleries, n.d. [1932?]), brochure for exhibition of the same name, Ayer Galleries, Philadelphia; Ayer to BA, TLS, 3/22/1932, CG; Maurice Sachs, *The Decade of Illusion: Paris, 1918–1928*, trans. Gwladys Matthews Sachs (New York: Knopf, 1933), 177n2; "Showing of Hands Popular; Studies by American and European Photographers," *Minneapolis Institute of Arts Bulletin* 21(10/8/1932), 127; Gutman, "News and Gossip," 85.

37 "Photography and the Plastic Arts," *American Artist* (Summer 1937), clipping in EMCC/AAA.

38 Julien Levy, "Photo-Murals," in *Murals by American Painters and Photographers* (New York: Museum of Modern Art, 1932), 11; Nelson Rockefeller and Lincoln Kirstein, foreword to *Murals by American Painters and Photographers*, 5; Levy, *Memoir of an Art Gallery*, 114.

39 The exhibitors included well-known Edward Steichen, Charles Sheeler, and Margaret Bourke-White, who specialized in modern cities and industry, but overall the work was wildly varied; like BA, Maurice Brattner used a fragmentary image of the newly completed Rockefeller Center tower for his work, a superimposed multi-image sandwich bordered in newsprint; another photomural was tossed together by "Little and Levy"—Emma H. Little, photo archivist and picture editor for *NYT*, and Joella Loy Levy—into a collage of *NYT* rotogravure sections; other photographers included Levy Gallery affiliates Hendrick V. (Drix) Duryea and Robert E. Locher, who co-produced a still-life with marble and steel forms; Arthur Gerlach, with moving machine forms; William M. Rittase; Stella Simon; Luke H. Swank; and George Platt Lynes; "Exhibition to Include Photo-Mural Section," *Springfield Sunday Union and Republican* (Springfield,

MA), 4/17/1932; BAOH, 252–255; exhibition binder 16, Photo Dept., MoMA, and *MoMA Exhibition Spelunker*, accessed 2/12/2017, http://spelunker.moma .org/exhibitions/2982/; Julia Blanshard, "Six American Women Win Places In Exhibit of Modern Murals," *Manitowoc Herald-Times*, 6/6/1932; pictures were Georgia O'Keeffe, BA, Mrs. Joella Levy, Mrs. Stella Simon, Jane Berlandina, and Mrs. Emma H. Little, cf. "Genealogy Bank," accessed 7/8/2016.

40 *ARTnews* (5/7/1932), clipping in BA Oversize Scrapbook, CG; Edward Alden Jewell, "The Museum of Modern Art Gives Private Showing Today of Murals by American Painters," *NYT*, 5/3/1932; *Popular Photography* 6, no. 7 (Feb. 1940), 19, quoted in BY:CNY, 9; the florid language suggests EMCC's input; BAOH, 252 –255; MoMA wall label cited in "Feminist Sensibility," special issue, *Harvard Advocate* 106 (Winter 1973), 37–38n5, with Walker Evans a close second; *MoMA Exhibition Spelunker* shows BA in 41 exhibitions, 1932–1986, accessed 2/12/2017, http://spelunker.moma.org/constituents/255/, and Evans in 49, 1933–1989.

41 BAOH, 187; BA to Putnam, ALS, 3/13/1932, Putnam Papers, Princeton University Library.

42 "These Photographs Delight," *NYT*, 5/8/1932; the *Delft* photograph is likely BA's *Cherry Street (1931)*.

43 Hamnett, *Laughing Torso*; Mariani, *Williams*, 298; "Photographs by Berenice Abbott," 9/26–10/15/1932, "Chronology of Exhibitions," in Schaffner and Jacobs, *Julien Levy: Portrait of an Art Gallery*, 174; Lewis Mumford, "The Art Galleries: Mr. Bloom's Anniversary—And a Disciple of Atget," *The New Yorker* (10/15/1932), 10, 66.

44 Margaret Breuning, "Art Gallery Showings . . . Berenice Abbott," *New York Evening Post*, 10/1/1932; Edward Alden Jewell, "Art: Photographs by Miss Abbott," *NYT*, 9/29/1932; "Art Roster," *NYT*, 10/2/1932; Melvin Geer Shelley, "Around the Galleries," *Creative Art* 11 (Oct. 1932), 143–144; Hardinge Scholle to BA, TLS, 9/30/1932, SBB/BA; BY:CNY, 15.

45 "Chronology of Exhibitions," in *Julien Levy: Portrait of an Art Gallery*, 174–175; BA made notes from the catalog on the verso of a letter to her from *New Yorker* writer Raymond Holden, 11/11/1931, deposited in CG, providing the name of Isaac Newton Phelps Stokes, compiler of the monumental work *The Iconography of Manhattan Island* (New York: R. H. Dodd, 1915–1928), as a possible supporter, helped "many years ago" by Holden's father; IS, 10/28/1959; Lisa Jacobs, CWA, 2/23/1998; Levy correspondence examples in CG and SBB/BA.

46 BA to A. J. Wall, TLS, 12/19/1932, N-YHS.

47 N-YHS Trustees Minutes, 12/20/1932, N-YHS.

48 The *New Yorker* 8 (11/12/1932); [Mitchell], "Woman with Camera"; a copy with

printed newspaper banner and date is held in BA's scrapbook; microfilm available at NYPL for this date lacks this article or section.

49 "Berenice Abbott – U.S.A.," *Photographie 1932* (Paris: Arts et Métiers graphiques, 1932), 37; IS, 5/16/1960; BAOH, 334, 370, and HON/BA, 180.

50 At Alfred Barr's suggestion a man wearing a sandwich board paraded out front to draw attention to the "rejects," cf. Philip Johnson OH, 1991, MoMA; Philip Johnson, phone CWA, 3/29/1993; Henry-Russell Hitchcock Jr. and Philip Johnson, *The International Style: Architecture Since 1922* (New York: Norton, 1932); Philip Johnson to BA, TLS, 2/1/1933, CG.

51 Philip Johnson, phone CWA, 3/29/1993; Franz Schulze, *Philip Johnson: Life and Work* (New York: Knopf, 1994), 23–34, 88–89, 92; he received no compensation from MoMA and paid his own secretary's salary as well as that of the librarian, and later the film archivist; AWT/BA.

CHAPTER 9. REALIZING AMERICA

1 Lewis Mumford, *Technics and Civilization* (New York: Harcourt, Brace, 1934), 340.

2 BA, "The Art of Photography" (interview), *Exploring the Arts & Sciences*, directed by Leah Plotkin, WQXR, Federal Theatre Radio Division, WPA, aired 9:45–10:00 p.m. EST, 1/2/1939, transcript, 9, CG.

3 BA, CWA, Monson, ME, 11/9/1991; Ishtar; BY:CNY, 16; BA, "Changing New York," in *Art for the Millions: Essays from the 1930s by Artists and Administrators of the WPA Federal Art Project*, ed. Francis V. O'Connor (Greenwich, CT: New York Graphic Society, 1973), 158; Samuel Untermyer to BA, TLS, 6/15/1933, CG; J. Clarence Davies to Grace Mayer, 6/25/1933, quoted in BY:CNY,17.

4 HON/BA, 130; BAOH, 393–394; BA, *Guide*, 104.

5 MoMA, *Art in Our Time: An Exhibition to Celebrate the Tenth Anniversary of the Museum of Modern Art and the Opening of Its New Building* (New York: Museum of Modern Art, 1939), 342; BA, Guide, 104; Fortune ran the image in July 1939; original print in Time Inc. Archives measures 9 × 2 in.; cf. Time Inc. and Grey Art Gallery & Study Center, *Life, the First Decade* (New York: Time, 1979); MoMA's print of *Exchange Place*, object no. 1.1941, given anonymously, measures 9 5/16 × 2 ½ in. (23.6 × 6.3 cm); IS, 9/30/1960; HON/BA, 148.

6 Ishtar; Margaret Geller, "Photography, Science, and Life: Berenice Abbott," *Image* (Rochester, NY: George Eastman House, Spring 2005), accessed 4/27/2006, http://eastmanhouse.org/inc/the_museum/imageonline.php; Todd Watts, phone CWA, summer 2012. Recounting this story, BA said "shortest" day of the year, not "earliest" sunset, but that may be what she aimed for. The earliest

sunset occurs around December 7 at 4:32 p.m.; the solstice (the shortest day) on December 21–22, with sunset at 4:38–4:39. The earlier date in December provides a few more minutes of evening darkness before office workers turn out their lights to leave at 5:00 p.m., valuable leeway during a less-than-half-hour period when two other atmospheric factors—clear air and moonless sky—have to be present to allow a crisp exposure. I thank Janet Byrne for bringing this two-week solar distinction—between shortest day and earliest sunset—to my attention.

7 BA to Storrs, from Berlin, n.d. [dateable from internal evidence to early 1922], Storrs papers, AAA; BA, "Eugène Atget," *Creative Art*, 651.

8 There was no public mention, reproduction, or cited exhibition of BA's *Night View, New York* before 1934; Sasse's photo is dateable from the set-back office building in the left foreground, Ely Jacques Kahn's 1400 Broadway, which ground broke in Jan. 1930, topped out in Aug. 1930, but was not expected to be occupied until the following January—hence no office lights Nov. through Dec. 1930; office lights are present in BA's photograph; Arthur Sasse is credited on the *New York, The Wonder City* jacket and p. 37 cut, captioned and credited " 'New York's Great White Way and Theatrical District From the top of the Empire State Building': International News Photo, Inc."; p. 191 contains a promotional blurb for International News Photos, Inc., [note difference from image credit] citing it as "a Wm. Randolph Hearst enterprise with offices all over the world" and notes "The beautiful picture of New York's Great White Way at night (see page 37), is an example of the great work done by Arthur Sasse—one of the artists on the International's force"; noted in "Latest Books Received," *NYT*, 12/21/1931: William Parker Chase, *New York, the Wonder City; An Illustrated Story of New York with Statistics and General Data Concerning New York's Vastness, New York's People, New York's Activities and New York's Intimate Inside Life in the Year 1932* (New York: Wonder City Pub., 1931); reprinted by New York Bound in 1983, without the night view illustration on the cover or inside; reprint reviewed in David Dunlap, "A Cityscape Bookshelf," *NYT Book Review*, 9/7/1997.

9 In 2015 Doyle Galleries sold a print (Sale 15BP02, Lot 665) made no later than 1935 that measured 6 7/8 × 4 3/4 in., mounted in a manila paper presentation folder; NYPL's original contact print, acquired from BA in 1940 for its NYC View file, measures 6 5/16 × 4 5/8 in. and was captioned "New York at Night. Empire State Building, 350 Fifth Avenue, West Side, 34th and 33rd Streets (General View North), Manhattan," catalog ID b19806373, accessed 12/27/2017, http://digitalcollections.nypl.org /items/510d47dd-8c76-a3d9-e040-e00a18064a99; BA, *Guide*, 71.

10 *New York Herald of Paris*, 8/31/1933, and *Beaux-Arts*, 9/24/1933; *Photographie*

1933–1934 (Paris: Arts et Métiers graphiques), 17; "Notes and Comments," *Camera Craft* 41 (Feb. 1934), 96.

11 "The Exchange Is at Once the Broker's Business, His Club and His Fraternity," *NYT*, 11/5/1933; Edward Alden Jewell, "Art Show Theme Is Social Unrest," *NYT*, 12/16/1933.

12 *Stock Exchange: II*, in BA, *Guide*, 25–26, plates 13–14, and in *New Guide*, plates 38–39; NYSE *Year Books*, from the 1932–1933 issue (Jan. 1934) through the 1937 issue (Jan. 1938); Clark, "The Black and White of Berenice Abbott," 111.

13 John Powys to BA, ALsS, 11/1/1933, n.d., and [12/24]/1933, CG.

14 BAOH, 255+.

15 BAOH, 256; IS, 5/11/1963; Janine A. Mileaf and Carla Yanni, *Constructing Modernism: Berenice Abbott and Henry-Russell Hitchcock* (Middletown, CT: Davidson Art Center, 1993).

16 Mellow, *Walker Evans*,138; BA, phone CWA, 12/30/1988; BA, *Stone Bridge in the Fenway, Boston*, in Henry-Russell Hitchcock, *The Architecture of H. H. Richardson and His Times* (New York: Museum of Modern Art, 1936), ill. 76; a print loaned from MoMA's Architecture and Design Dept. files appeared in NYPL's 1989 BA exhibition *Modern Vision*, catalog no. 160.

17 Henry-Russell Hitchcock, introduction to *Urban Vernacular of the Thirties, Forties, and Fifties* (Middletown, CT: Wesleyan University, 1934), n.p., exhibiton catalog; IS, n.d. [date untraceable]; HON/BA, 16; Carla Yanni, "Henry-Russell Hitchcock's American Cities, Making an American History for Modernism," in *Constructing Modernism*, 8, fig. 3.

18 BAOH, 339–340; Ishtar.

19 Henry-Russell Hitchcock Jr., unpublished introduction to *Changing New York* (1939), Special Collections, Olin Library, Wesleyan University, quoted in Janine A. Mileaf, "Reading *American Cities*: 1930s Photographs by Berenice Abbott," in *Constructing Modernism*, 21.

20 Gilbert Seldes and Leigh Irwin, eds., *This Is New York: The First Modern Photographic Book of New York* (New York: David Kemp, 1934); "Books and Authors," *NYT*, 8/26/1934; Alexander King, "Is Photography Art?" *Americana* (Sept. 1933), 2; BA, "Plastic America," *Americana* (July 1933), 9; the October 1933 issue contains BA's "Town and Country" views of Trinity Churchyard and Coney Island, cf. Meredith Ann TeGrotenhuis Shimizu, "Photography in Urban Discourse: Berenice Abbott's Changing New York and the 1930s" (PhD dissertation, Northwestern University, 2010), 72.

21 Inscribed copy was in SBB/BA; Michael G. Kammen, *The Lively Arts: Gilbert Seldes and the Transformation of Cultural Criticism in the United States* (New York: Oxford University Press, 1996), 197, 212, 435n90, 437n7; Darwin Payne,

The Man of Only Yesterday: Frederick Lewis Allen (New York: Harper & Row, 1975), 121–125.

22 BA BlkJ, 12/30/1956, 254.

23 IS, 9/3/1960 and 7/21/1963; "Marchal Landgren," obituary, *NYT*, 2/18/1983; "New Exhibitions," *NYT*, 3/1/1934; Howard Devree, "A Round of Galleries," *NYT*, 3/11/1934; *Brooklyn Daily Eagle*, 3/4/1934; BAOH, 571–572; HON/BA, 190.

24 "Berenice Abbott," *Current Biography* 3, no. 7 (July 1942), 1–2; BAOH, 265–266.

25 Eudora Welty to BA, TLS, 8/9/1934, CG; William Kimmel (Registrar's Office, New School University), phone CWA, 4/11/2003; Pearl Amelia McHaney, ed., *Eudora Welty as Photographer* (Jackson: University Press of Mississippi, 2009).

26 BAOH, 266, 310; New School, *Catalog* (1934–1935), 52; IS, 10/5/1960 and 11/12/1966; Sol Libsohn, CWA and Tony Troncale, Roosevelt, NJ, 4/21/1993 (notably, both Angela Calomiris and Clemson Kalisher also told Anne Tucker in the 1970s that Berenice was a "lousy teacher"); BA, New School class notes, CG.

27 Charles Rotkin, CWA, NYC, 3/28/1996; *Das Furchtlose Auge*, Leiser (1984); Margaretta Mitchell quoting BA, notes for her book on women photographers, 1970s, SBB/BA.

28 BAOH, 267; IS, 11/12/1966 and 10/20/1967; *Das Furchtlose Auge*, Leiser (1984).

CHAPTER 10. FANTASTIC PASSION

1 A. J. Liebling, "Apology for Breathing," in *Back Where I Came From* (New York: Sheridan House, 1938).

2 BA to EMCC, ALS, 10/29/1934, CG.

3 Lewis Mumford, "The Art Galleries: Modes and Moderns," *The New Yorker* (11/3/1934), 50; P. S., "Current Exhibitions," *Parnassus* 6, no. 8 (Jan. 1935), 25, quoted in BY:CNY, 18; Howard Devree, "Photographic Art," *NYT*, 10/9/1934.

4 EMCC, "New York City as Seen In Abbott Photographs," *Springfield Sunday Union and Republican* (Springfield, MA), 10/21/1934.

5 Susan Dodge Peters, "Elizabeth McCausland on Photography," *Afterimage* 12, no. 10 (May 1985), 10; Steve Yates, *The Transition Years: Paul Strand in New Mexico* (Santa Fe, NM: Museum of Fine Arts, Museum of New Mexico, 1989), 29–30; EMCC, *Hot Nights & Other Poems* (Springfield, MA: private printing, 1934); Waldo Frank, Lewis Mumford, Dorothy Norman, Paul Rosenfeld, and Harold Ordway Rugg, eds., *America & Alfred Stieglitz: A Collective Portrait* (Garden City, NY: Doubleday, Doran, 1934).

6 Mig Shepard, CWA, NYC, 6/10/1992 and 6/30/1992; AWT/BA; Zwingle, "A

Life of Her Own," 57; SBB, phone CWA, 11/01/1995; 1880, 1900, 1910 US Census, Wichita, KS.

7 "Behind the Front Page," in *Purple Pastures, Smith College Class of 1920 Reunion Booklet* (1930), 15, quoted in Peters, "Elizabeth McCausland on Photography," 10; EMCC, AAA.

8 Grace Mayer, BA memorial; BAOH, 426; EMCC to BA, TLS, 10/23/1934, and BA to EMCC, ALS, 10/29/1934, CG.

9 EMCC to BA, 11/5/1934, CG, quoted in BY:CNY, 19; Henry-Russell Hitchcock to EMCC, TLS, 10/30/1934, EMCC/AAA.

10 Marchal Landgren to EMCC, TLS, 11/18/1934, EMCC/AAA; EMCC, "The Photography of Berenice Abbott," 8.

11 Milton Meltzer, *Violins & Shovels: The WPA Arts Projects* (New York: Delacorte Press, 1976); William F. McDonald, *Federal Relief Administration and the Arts: The Origins and Administrative History of the Arts Projects of the Works Progress Administration* ([Columbus]: Ohio State University Press, 1969); Francis V. O'Connor, ed., *The New Deal Art Projects: An Anthology of Memoirs* (Washington, DC: Smithsonian Institution Press, 1972), republished as *Art for the Millions: Essays from the 1930s by Artists and Administrators of the WPA Federal Art Project* (Greenwich, CT: New York Graphic Society, 1973).

12 BA, CWA, Monson, ME, 8/4/1991; IS, 1/3/1963; Audrey McMahon, interview by Dr. Eleanor Carr, 3/7/1977 [*sic*, 1967], audio recording, JVH files, for Eleanor Carr, "The New Deal and the Sculptor" (PhD dissertation, New York University, 1969); Proposal submitted to Frances M. Pollack February 1935, cf. confidential memo to "Mr. Kaufman" n.d. TC, CG; "Frances M. Pollak to BA, TLS, 5/9/1935, CG.

13 EMCC, Guggenheim Foundation application, 11/1/1935, EMCC/AAA; EMCC, "Log of a trip made with Berenice Abbott," ms notebook, and three marked gas station maps, EMCC/AAA.

14 "Hard Times Bear Down Heavily On West Virginia Coal Miners," *Springfield Sunday Union and Republican* (Springfield, MA), 6/30/1935; Malcolm Ross, "The Spotlight Plays in the Coal Pits," *NYT*, 7/14/1935.

15 IS, 9/3/1960 and 4/23/1965; Ella Jaffe Freidus, CWA, 7/10/1992; re sex: in particular, violence such as then-recent Andrew Crispo Gallery murder in 1985, treated in David France, *Bag of Toys: Sex, Scandal, and the Death Mask Murder* (New York: Warner Books, 1992).

16 EMCC, Guggenheim application, 11/1/1935, EMCC/AAA; an 8 × 10" print in Tamiment's *Daily Worker* print file *Housing—Hoovervilles* bears BA's West 53rd St. stamp with her name crossed out.

17 BAOH, 462.

18 EMCC, Guggenheim application, 11/1/1935, EMCC/AAA.

19 Malcolm Cowley, *The Dream of the Golden Mountains: Remembering the 1930s* (New York: Viking, 1980), 300–304; Elliott Arnold, "The Way Berenice Abbott Feels About Cities and Photography, Her Exhibit is Like an Artist Painting Portraits of His Beloved," *NY World-Telegram*, 10/21/1937; Walker Evans, diary 9/18/1935, acc. no. 1994.250.97, Walker Evans Archive, Metropolitan Museum of Art; Virginia-Lee Webb, *Perfect Documents: Walker Evans and African Art, 1935* (New York: Metropolitan Museum of Art, 2000); Elizabeth Sekaer Rothschild, CWA, Hastings-on-Hudson, NY, 10/24/1995.

20 BAOH, 649.

21 G. Thomas Tanselle, ed., "Chronology," *The John Simon Guggenheim Memorial Foundation, 1925–2000: A Seventy-Fifth Anniversary Record* (New York: John Simon Guggenheim Memorial Foundation, 2001), 41.

22 EMCC to her mother, CTL, 10/14/1935, EMCC/AAA.

23 EMCC to her mother, 12/4/1935, EMCC/AAA; also BAOH, 655.

24 IS, 3/27/1960; BAOH, 250–251; BA, phone CWA, 1/11/1991.

25 BAOH, 250–251, 363, 651; NYC Certificate of Occupancy, Manhattan: prerenovation, as of 12/3/1929, units are all "non-housekeeping"; IS, 3/27/1960, and 6/3/1965; Ishtar; BA/FBI—a confidential informant reported on the arrangement, 11/3/1952; Leticia Kent, phone CWA, 6/15/1992.

26 BAOH, 16; I. Bernard Cohen, BA memorial; Greek-key doorway: there was no door—the passage between rooms was a light baffle, two opposing three-sided cube-walls, like a symmetrical maze.

27 WPA budget: past year's average monthly rent for 4-D was about $32.00, CG; BAOH, 258, 651; Mig Shepard, CWA, 6/10/1992 and 6/30/1992.

28 Julien Levy sale report for 1936, CG; BAOH, 652–654.

29 Fellowship application for 1936, and Recommendations for Berenice Abbott, 1936, "Group Regional Books," Guggenheim Foundation Archives.

30 BAOH, 116.

31 May Milstein (née Malkin), CWA, NYC, 12/14/1993; BAOH, 307–308.

32 About $35.00 a week BA recalled in 1968; AC/BA, 19; BAOH, 309–310; Peter M. Rutkoff and William B. Scott, *New School: A History of the New School for Social Research* (New York: Free Press, 1986), 263n4; Leticia Kent, CWA, NYC, 9/16/1993; Mayer was later dean of the Adult Division.

33 BA, phone CWA, 5/17/1989; BAOH, 115–116; every image was assigned a sequential number and dated, titled and geo-located by the research staff; they generated supporting materials—mimeographed worksheets, well-researched essays about the economic or social history of the business or industry depicted, maps, and newspaper clippings; the research files were in flux, as BA replaced

images and simply discarded others, though all were retained for the project's background records, now at MCNY; BY:CNY, 23–24; Leticia Kent, CWA, NYC, 9/16/1993.

34 BAOH, 313; Milstein, CWA, 12/14/1993; she recalled Arnold Eagle (his wife, Dorothy, became her close friend), David Robbins, Lew Jacobs (public health documentary), and Helen Levitt (manhole covers).

35 BA CWA, Monson ME, 8/2/1991; BAOH, 312–313; Susan Trausch, "Portrait of the Photographer," *The Boston Globe Magazine* (Dec. 11, 1988), 56–57; BA phone CWA 5/17/1989; Ishtar.

36 BA, CWA, Monson, ME, 8/2/1991; *Blossom Restaurant, 103 Bowery, Manhattan,* 10/3/1935, ref. no. CNY# 26, NYPL; HON/BA, 167; BA's meticulous camera placement and patience had been presaged that summer by a handheld view of a similar restaurant window taken by Walker Evans's friend Ben Shahn, *Bethune Street*, published in *U.S. Camera Annual* (1935), 83; HON/BA, 167; *Country Store: interior, Ewen Avenue, Spuyten Duyvil, Bronx,* 10/11/1935, ref. no. CNY# 12; and *Ewen Avenue No. 2565 (Bar and grill), Spuyten Duyvil, Bronx,* 10/11/1935, ref. no. CNY# 8; Houck, "Clay, Canvas and Camera," 78; BA, CWA, Monson, ME, 8/2/1991, re *Palisade Avenue No. 2505, Spuyten Duyvil, Bronx,* 10/11/1935, ref. no. CNY# 13; BAOH, 322; *Waterfront, South Street, Manhattan,* 10/15/1935, ref. no. CNY# 32; *Mori's Restaurant, 144 Bleecker Street, Manhattan,* 11/21/1935, ref. no. CNY# 46; BA, CWA, Monson, ME, 8/2/1991; *Minetta Street, Nos. 2, 4, 6, Manhattan,* 11/21/1935, ref. no. CNY# 43; IS, 2/16/1961.

37 *Unemployed and Huts, West Houston – Mercer St., Manhattan,* 10/25/1935, ref. no. CNY# 34; *Huts and Unemployed, West Houston and Mercer Street, Manhattan,* 10/25/1935, ref. no. CNY# 36; *Huts and Unemployed, West Houston and Mercer St., Manhattan,* 10/25/1935, ref. no. CNY# 35; BAOH, 375–376; HON/BA,166; *Murray Hill Hotel, Manhattan,* 11/19/1935, ref. no. CNY# 38; *Murray Hill Hotel, Manhattan,* 11/19/1935, ref. no. CNY# 39; *Murray Hill Hotel, from Park Avenue and 40th Street, Manhattan,* 11/19/1935, ref. no. CNY# 37; *Murray Hill Hotel, 112 Park Avenue, Manhattan,* 11/19/1935, ref. no. CNY# 41 (left man in hat is her assistant, per BA, CWA, Monson, ME, 8/2/1991); and *Murray Hill Hotel, Manhattan,* 11/19/1935, ref. no. CNY# 40; HON/BA, 107; *Gasoline Station, Tenth Avenue and 29th Street, Manhattan,* 12/23/1935, ref. no. CNY# 59; later she replaced this image in the final project with *Gasoline Station, Tremont Avenue and Dock Street, Bronx,* 7/2/1936, ref. no. CNY# 141; she then felt free to use the negative of the "rejected" image for her own purposes; *Daily News Building, 42nd Street Between Second and Third Avenues, Manhattan,* 11/21/1935, ref. no. CNY# 45.

38 *Seventh Avenue Looking South from 35th Street, Manhattan,* 12/5/1935, ref. no.

CNY# 55, and *Seventh Avenue Looking North from 35th Street, Manhattan,* 12/5/1935, ref. no. CNY# 56; Christie's catalog sale, Apr. 1999?, Lot 5; Jane Ellison (Roy Ellison's daughter), phone CWA, 10/10/2003; records of crimes classed as "violations" or "misdemeanors" are not retained by the NYC Police Department.

39 *Fifth Avenue, Nos. 4, 6, 8, Manhattan* [popularly called "Fifth Avenue Houses"], 3/20/1936, ref. no. CNY# 87; HON/BA, 108; BAOH, 334, 336.

40 J. A. Ward, *American Silences: The Realism of James Agee, Walker Evans, and Edward Hopper* (Baton Rouge: Louisiana State University Press, 1985); Mellow, Walker Evans, 217.

CHAPTER 11. CREATIVE DOCUMENTARY

1 "WPA Federal Art Project Issues Three-and-a-half Year Report" for release Sunday, 5/21/1939; release is dated 5/17/1939, WPA collection, AAA.

2 Arnold, "The Way Berenice Abbott Feels."

3 *El', Second and Third Avenue Lines, Bowery and Division Sts., Manhattan,* 4/24/1936, ref. no. CNY# 111; BY:CNY, 384; *Department of Docks and Police Station, Pier A, North River, Manhattan,* 5/5/1936, ref. no. CNY# 97; HON/BA, 116; BAOH, 356; *Frame House, Bedford and Grove Streets, Manhattan,* 5/12/1936, ref. no. CNY# 117; *Firehouse, Battery, Manhattan,* 5/12/1936, ref. no. CNY# 118; *West Street Row: II, 217–221 West Street, Manhattan,* 5/12/1936, ref. no. CNY# 115; *Stone and William Street, Manhattan,* 5/12/1936, ref. no. CNY# 116; see a version in NYPL (purchase acq.), and BY:CNY, 343.

4 All on 5/14/1936: *Willow and Poplar Street, looking East, Brooklyn* [*sic*, view is actually looking toward Manhattan], ref. no. CNY# 119; *Joralemon Street, No. 135, Brooklyn,* ref. no. CNY# 120; *Willow Street, No. 104, Brooklyn,* ref. no. CNY# 121; *Willow Street, No. 113, Brooklyn,* ref. no. CNY# 122; *Willow Place no. 70, Brooklyn,* ref. no. CNY# 123; *Willow Place, Nos. 43–49, Brooklyn,* ref. no. CNY# 124; *Brooklyn Facade, 65–71 Columbia Heights, Brooklyn,* ref. no. CNY# 125; *Willow Street, Nos. 131–137, Brooklyn,* ref. no. CNY# 126; HON/BA, 154; *Travelling Tin Shop, Brooklyn,* 5/22/1936, ref. no. CNY# 92; *Brooklyn Bridge, Water and Dock Streets, Looking Southwest, Brooklyn,* 5/22/1936, ref. no. CNY# 113; *Warehouse, Water and Dock Streets, Brooklyn,* 5/22/1936, ref. no. CNY# 93.

5 *Herald Square, 34th and Broadway, Manhattan,* 7/16/1936, ref. no. CNY# 144; *Herald Square, 34th and Broadway, Manhattan,* 7/16/1936, ref. no. CNY# 145a; *Herald Square, 34th and Broadway, Manhattan,* 7/16/1936, ref. no. CNY# 145; *Union Square, 14th Street and Broadway, Manhattan,* 7/16/1936, ref. no. CNY#

151; HON/BA, 123; BAOH, 371; *Greyhound Bus Terminal, 33rd and 34th Streets Between Seventh and Eighth Avenues, Manhattan,* 7/14/1936, ref. no. CNY# 142; *Penn Station, Interior, Manhattan,* n.d., ref. no. CNY# 143-1; *Penn Station, Interior, Manhattan,* n.d., ref. no. CNY# 143-3; and *Penn Station, Interior, Manhattan,* n.d., ref. no. CNY# 143-2; BY:CNY, 373; HON/BA, 102; Ishtar; *Lebanon Restaurant (Syrian), 88 Washington Street, Manhattan,* 8/12/1936, ref. no. CNY# 161; BA, CWA, 8/2/1991; Louis Eilshemius to BA, ALS, 9/10/1936, CG.

6 BAOH, 359; *Sumner Healey Antique Shop, Third Avenue near 57th Street, Manhattan,* 10/8/1936, ref. no. CNY# 169; and *Sumner Healey Antique Shop, 942 Third Avenue and 57th Street, Manhattan,* 10/8/1936, ref. no. CNY# 170—BA made five exposures and kept two for the project, BY:CNY, 384; that day she also photographed *Third Avenue Car Barn, Third Avenue and 65th Street, Manhattan,* 10/8/1936, ref. no. CNY# 171; *Park Avenue and 39th Street, Manhattan,* 10/8/1936, ref. no. CNY# 172; BY:CNY, 381; *Children's Aid Society Grounds, Cropsey and Eighteenth Avenues, Brooklyn,* 10/27/1936, ref. no. CNY# 175; *2442 Crospey [sic] Avenue, Brooklyn,* 10/27/1936, ref. no. CNY# 176; *Children's Aid Society Summer Home, Cropsey and Eighteenth Avenues, Brooklyn,* 10/27/1936, ref. no. CNY# 177; *Fort Lowry Hotel, 8868 17th Avenue, Brooklyn,* 10/29/1936, ref. no. CNY# 178; *Rheinlander Row: II. Seventh Avenue Between 12th and 13th Streets, Manhattan,* 10/29/1936, ref. no. CNY# 179; *Fourth Avenue, No. 154, Brooklyn,* 10/29/1936, ref. no. CNY# 180, *Billboards and Signs, Fulton Street Between State Street and Ashland Place, Brooklyn,* 10/29/1936, ref. no. CNY# 181; *Cropsey Avenue No. 1736, Brooklyn,* 10/29/1936, ref. no. CNY# 182; *Belvedere Restaurant, Bay 16th Street and Cropsey Avenue, Brooklyn,* 10/29/1936, ref. no. CNY# 183; *Gansevoort Street, No. 53, Manhattan,* 10/29/1936, ref. no. CNY# 184.

7 WPA to BA, TS memo, 11/17/1936, CG; BAOH, 322–323; Van Wyck Brooks, Clifton Fadiman, Lillian Hellman, Edna St. Vincent Millay, Lewis Mumford, Dawn Powell, Samuel Putman, and artists Meyer Shapiro, Stuart Davis, and Rockwell Kent, Committee Appeal letter, Feb. 1937, CG.

8 *St. Mark's Church: Sky-writing Spiral, East 10th Street and Second Avenue, Manhattan,* 3/23/1937, ref. no. CNY# 214; *St. Mark's Church, East 10th Street and Second Avenue, Manhattan,* 3/23/1937, ref. no. CNY# 215; *St. Mark's Church (Cloister), 10th Street and Second Avenue, Manhattan,* 3/23/1937, ref. no. CNY# 216; *St. Mark's Church, statue in courtyard, East 10th Street and Second Avenue, Manhattan,* 3/23/1937, ref. no. CNY# 218; *Brooklyn Bridge, Pier 21, Pennsylvania Railroad, Manhattan,* 3/23/1937, ref. no. CNY# 225; BY:CNY, 348; *General View, Looking Southwest to Manhattan from Manhattan Bridge, Manhattan,* 3/30/1937, ref. no. CNY# 227; Houck, "Clay, Canvas and Camera," 78; *Gen-*

eral View from Penthouse, 56 Seventh Avenue, Manhattan, 7/14/1937, ref. no. CNY# 254; HON/BA, 128; BAOH, 385–386.

9 *South Street and James Slip, Manhattan*, 4/1/1937, ref. no. CNY# 228, and *Oyster Houses, South Street and Pike Slip, Manhattan*, 4/1/1937, ref. no. CNY# 232; *Father Duffy, Times Square, Manhattan*, 4/14/1937, ref. no. CNY# 255; HON/BA, 135; Berman, "The Unflinching Eye," 92; BY:CNY, 388; EMCC, "Camera Eye Records"; *Triborough Bridge, East 125th Street Approach, Manhattan*, 6/29/1937, ref. no. CNY# 233; *Triborough Bridge, Steel Girders, Manhattan*, 6/29/1937, ref. no. CNY# 234; *Triborough Bridge (Cables), Manhattan*, 6/29/1937, ref. no. CNY# 241; "Noted Photographer's Vintage Photos of the RFK," MTA News, 1/26/2013, accessed 2/4/2016, http://www.mta.info/news/2013/01/26/noted-photographers-vintage-photos-rfk.

10 Federal Art Project, *Art As a Function of Government: A Survey* (New York: Supervisors Association of the WPA Federal Art Project, 1937), 1; EMCC to Audrey McMahon, TS memo, 7/15/1937, EMCC/AAA.

11 BY:CNY, [25]n62; BA to Charles C. Adams, CTL, 8/15/1937, and Audrey McMahon to BA, TMS, 8/25/1937, CG.

12 Arnold, "The Way Berenice Abbott Feels"; *Gay Street, No. 14–16, Manhattan*, 11/16/1937, ref. no. CNY# 263; Ruth McKenney, *My Sister Eileen* (New York: Harcourt, Brace, 1938), and Marion Meade, *Lonelyhearts: The Screwball World of Nathanael West and Eileen McKenney* (Boston: Houghton Mifflin Harcourt, 2010).

13 *Patchin Place with Jefferson Market Court in Background, Manhattan*, 11/24/1937, ref. no. CNY# 268; BAOH, 339; Alfred Kazin, "An Experiment in the Novel: Djuna Barnes, in 'Nightwood,' Makes a Strange Excursion in the Technique of Fiction," *NYT*, 3/7/1937; IS, 9/27–29/1959, 10/16/1959.

14 *Garibaldi Memorial, Tompkins Avenue, corner Chestnut, Staten Island*, 11/30/1937, ref. no. CNY# 269 (see BAOH, 340–341); *Hope Avenue, No. 179, Staten Island*, 11/30/1937, ref. no. CNY# 270; *St. Mark's Place, No. 340-344, Staten Island*, 11/30/1937, ref. no. CNY# 271; *St. Mark's Place, No. 340–348, Staten Island*, 11/30/1937, ref. no. CNY# 272; BY:CNY, 393–394.

15 MCNY, *Annual Report 1937* (New York: 1938), 25; *DePeyster Statue, Bowling Green, Looking North on Broadway, Manhattan*, 7/23/1936, ref. no. CNY# 154; EMCC, "Camera Eye Records"; BAOH, 355.

16 Marchal Landgren papers, AAA, and BA Scrapbook 2, CG; SBB/BA holds a briefer mimeographed flyer that incorporates the changes written into her proof-copy; the unpublished catalog credited the following FAP staff, who have remained largely unknown: Frances Fein, Sidney Friend, Boris Stackcliff, Helen Schwartz, and Mack Young on the project's technical side, and James F. Brough-

ton, Sally Sands, and Charles White on research; unfortunately, these workers did not finish writing the captions for the exhibited prints and thereby lost the chance to have their achievement noted in the exhibition, BY:CNY, 26; George Parsons, introduction to *Louis Lambert*, by Honoré de Balzac, trans. Katharine Prescott Wormeley (Boston: Roberts, 1889) [info courtesy Dan Houston to JVH, email via , 9/17/2000]; a dear friend of EMCC was William Hobart Royce, the rare book salesman and Balzac bibliographer (and 1943 author of *Balzac Was Right, a Sonnet Sequence*), whose portrait BA took a year or so later; *Changing New York*, exhibition shown at Federal Art Gallery, April 1939; mimeographed catalog in Holger Cahill papers, AAA; BAOH, 611–613.

17 "New York Pictured for Future in Show / City Museum Exhibit Opening Today Reveals Aspects of Changing Metropolis / Woman's Two-Year Work / 125 Prints by Bernice [*sic*] Abbott," and "The New York of Today Goes into a Museum's Archives as a Pictorial Record for Posterity," *NYT*, 10/20/1937.

18 Guest list, CG; also includes Nathan Asch, Ruth Ford (future actress and sister of Charles Henri Ford, both friends of Djuna Barnes), fashion photographer Louise Dahl-Wolfe, Martha Graham, Chenoweth Hall, the Julien Levys (plus the painter Julien Levi) and others in the Levy gallery circle, Kenneth McPherson, Anne Tracy Morgan, Paul Outerbridge, Betty Parsons, Anna Paterno, Elliott Paul, Samuel Putnam, Evelyn and Cecilia Rouhana, Yakov Table, the Peter Sekaers, the Paul Strands, Nathan Straus, Edna and Lloyd Thomas plus Olivia Wyndham, and Yvor Winter.

19 IS, 1/9/1961, CCP; BA, CWA, Monson, ME, 8/3–4/1991; *McSorley's Ale House, 15 East 7th Street, Manhattan*, 11/1/1937, ref. no. CNY# 258; Marks, "Chronicler of Our Times," 166; Leo Seltzer, CWA, NYC, 2/23/1999; HON/BA, 253; two images survive in CNY project files, but did not make the final cut.

20 Torrey-Hohoff, press release, 9/30/1937, CG; BY:CNY, 27; clippings in BA Scrapbook 2, CG; Houck, "Clay, Canvas and Camera," 78.

21 *U.S. Camera Annual 1939*; "Chronology of Exhibitions," in *Julien Levy: Portrait of an Art Gallery*, 173, 180; Robert M. Coates, "Art Galleries," *The New Yorker* 8 (12/18/1937), 78; BA, interview by William R. McCue, *Candidly Speaking Camera Club*, WBNX, Bronx, NY, 15 minutes, broadcast Saturday night, 11/20/1937, transcript in BA Scrapbook 2, CG.

22 *Daily Worker* (NY), 11/3/1937; EMCC, "Changing New York: Symphony of Seven Million," *Daily Worker*, 11/29/1937; and *The Forward*, 10/31/1937, all clippings in BA Scrapbook 2, CG.

23 *Art Front* 3, no. 8 (Dec. 1937), 17; EMCC, "American Photography in Representative Show," *Springfield Sunday Union and Republican* 10/24/1937.

24 "A Woman Photographs the Face of a Changing City," *Life* 4, no. 1 (1/3/1938),

40–46: Fifth Ave. houses (half-page), El at Hanover Sq., Bleecker St. cheese store, sailing ship with potatoes, Manhattan skyline from Daily News, Brooklyn colonial homes; in the same issue ran a companion piece on "bad boy" Cecil Beaton, "A Man Photographs the Faces of Lovely Ladies"; Beaton's own book of New York photography was released later in the year, but the English circle that had included BA in the 1920s was out of touch; Carle Semon to BA, ALS, 1/5/1938, CG; Samuel H. Friedman, director, FAP Dept. of Information, "Credit to WPA," letter to the editor, *Life* 4, no. 5 (1/31/1938), 2.

25 Dorothy Giles, "Soul Clinics," *Hearst's International Cosmopolitan* 103 (Dec. 1937), 65 (also in BA Scrapbook 2, CG).

26 Grace Mayer to BA, ALS, 2/11/1938 (formal "Dear Miss Abbott"; signs full name), CG; *Snuff Shop, 113 Division Street, Manhattan,* 1/26/1938, ref. no. CNY# 277; BAOH, 335; *Hardware Store, 316 Bowery, Manhattan,* 1/26/1938, ref. no. CNY# 276; HON/BA, 126; *Facade, 180 West 58th Street, Manhattan,* 2/15/1938, ref. no. CNY# 283.

27 *Starrett-Lehigh Building: II. 601 West 26th Street, from Eleventh Avenue and 23rd Street Looking Northeast Past the West Side Express Highway, Manhattan,* 3/1/1938, ref. no. CNY# 286; *John Watts statue, from Trinity Churchyard Looking Toward One Wall Street, Manhattan,* 3/1/1938, ref. no. CNY# 284; *Steam + Felt-Hats, 65 West 39th Street, Manhattan,* 3/1/1938, ref. no. CNY# 285.

28 BA, "The Art of Photography" (interview), WQXR, 1/2/1939, transcript, 5, [CG/WPA].

29 Reilly, "Berenice Abbott Records," 94–95; BAOH, 372; *Shelter on the Water Front, Coenties Slip, Pier 5, East River, Manhattan,* 5/3/1938, ref. no. CNY# L01; BA had photographed Coenties Slip earlier—in her first MCNY show, the image is dated 1929; I. L. Hopkins to BA, TLS, 6/9/1938, CG.

30 IS, 1/3/1963 (there are no 35mm images in the project); BA receipt on letterhead to Lisette Model, CTS, 1/3/1942, CG; Lisette Model OH, 1/28–30/1977, George Eastman Museum Library.

31 BA, CWA, Monson, ME, 11/8/1991; BA, *Guide,* 141–142, 145.

32 Rosa Reilly to BA, 5/26/1938, CG; BAOH, 377–379; Reilly, "Berenice Abbott Records," 95.

33 *Hester Street, Between Allen and Orchard Streets, Manhattan,* 5/3/1938, ref. no. CNY# L02; IS, 5/23/1960; *Roast Corn Man, Orchard and Hester Streets, Manhattan,* 5/3/1938, ref. no. CNY# L03; HON/BA, 149; *Wall Street, from Roof of Irving Trust Co. Building, Manhattan,* 5/4/1938, ref. no. CNY# L05; *Broadway to the Battery, from Roof of Irving Trust Building, Manhattan,* 5/4/1938, ref. no. CNY# L06; *Wall Street District, from Roof of Irving Trust Co. Building, Manhattan,* 5/4/1938, ref. no. CNY# L07; *Waterfront, from Roof of Irving Trust Build-*

ing, Manhattan, 5/4/1938, ref. no. CNY# L08; *Wall Street, Showing East River from Roof of Irving Trust building, Manhattan*, 5/4/1938, ref. no. CNY# L09; *Financial District Rooftops, Looking Southwest from One Wall Street, Manhattan*, 5/4/1938, ref. no. CNY# L10; see also City Landscape in Guide, plate 29, which is not among the final CNY images from this series: "Deardorff Triamapro; 1/25 second; f/16. Held in hands and swings used. Taken from roof of Irving Trust Company Building at 1 Wall Street, New York." The other photographs are coded *L*, and taken with the Linhof; Walker Evans used a Deardorf Triampro camera for his Bethlehem 1936 photo reproduced in Guide, plate 41; plate 31 is a photo of the camera, "the most flexible of the American-made hand and stand cameras"; BAOH, 396; BA, "The Art of Photography" (interview), Exploring the Arts & Sciences, WQXR, Federal Theatre Radio Division, WPA, 1/2/1939, transcript, CG; Jill Quasha, CWA, NYC, 4/27/1993.

34 *Rothman's Pawn Shop, 149 Eighth Avenue, Manhattan*, 5/18/1938, ref. no. CNY# 297[dscrd]; *Rothman's Pawn Shop, 149 Eighth Avenue, Manhattan*, 5/18/1938, ref. no. CNY# 297; IS, 2/16/61, re Mack Young; *Pingpank Barber Shop, 413 Bleecker Street, Manhattan*, 5/18/1938, ref. no. CNY# 300—the interior was painted in a watercolor by Perkins Harnly for the Index of American Design, cf. BY:CNY, 366; *Flam and Flam, 165 East 121st Street, Manhattan*, 5/18/1938, CNY# 298; *Flatiron Building, 23rd Street and Fifth Avenue, Manhattan*, 5/18/1938, ref. no. CNY# 299—HON/BA, 163: the other version of this building was from a height, in a building up the street but thinks this is the better version; no doubt in her mind that this building looks better from street level, and was very careful to pick precise location to set camera; see also BA pre-CNY image in Seldes, *This Is New York*.

35 *Normandie, North River, Manhattan*, from Pier 88, *French Line, Manhattan*, 9/14/1938, ref. no. CNY# L18; cf. BY:CNY, 375, re discarded image; *Charles Lane, Between West and Washington Streets, Manhattan*, 9/20/1938, ref. no. CNY# L19; BAOH, 414.

36 *Cathedral Parkway No. 542, Manhattan*, 10/25/1938, ref. no. CNY# 311; *Consolidated Edison Powerhouse, 666 1st Avenue, Manhattan*, 11/9/1938, ref. no. CNY# L31; *Contrasting No. 331, East 39th Street with the Chrysler Building (left) and the Daily News Building (right), Manhatan*, 11/9/1938, CNY# L30; BA, CWA, Moonson, ME, 8/3/1991; *Fifth Avenue Theatre: 28th Street Facade, 1185 Broadway, Manhattan*, 11/2/1938, ref. no. CNY# 309; *Fifth Avenue Theatre Interior: 28th Street L, 1185 Broadway, Manhattan*, 11/2/1938, ref. no. CNY# 310; *Fifth Avenue Theater Interior, Showing Orchestra, Boxes, First and Second Balconies, 1185 Broadway, Manhattan*, 11/2/1938, ref. no. CNY# L23; *Fifth Avenue Theater Interior: Showing Chandelier, Rotunda and Second Balcony, 1185 Broad-*

way, *Manhattan,* 11/2/1938, ref. no. CNY# L24; *Fifth Avenue Theater Interior: Showing [?] Detail of Proscenium Arch,* 1185 *Broadway, Manhattan,* 11/2/1938, ref. no. CNY# L25; *Fifth Avenue Theatre: Chandelier and [?] Proscenium Arch,* 1185 *Broadway, Manhattan,* 11/2/1938, ref. no. CNY# L26; *Fifth Avenue Theater Interior: Drinking Fountain Behind Scenes,* 1185 *Broadway, Manhattan,* 11/2/1938, ref. no. CNY# L27; *Fifth Avenue Theater Interior: Entrance from* 1185 *Broadway, Manhattan,* 11/2/1938, ref. no. CNY# L28; *Fifth Avenue Theater Interior: Showing Section of Orchestra and First Balcony,* 1185 *Broadway, Manhattan,* 11/2/1938, ref. no. CNY# L29; *"El," Sixth Avenue Line,* 28*th Street Station, Manhattan,* 11/10/1938, ref. no. CNY# L33—first of the NY elevated trains to be torn down, cf. BY:CNY, 372; *Studios,* 51 *West Tenth Street, Manhattan,* 11/10/1938, ref. no. CNY# 312; *Jefferson Market Court and* 647–661 *Sixth Avenue, Manhattan,* 11/10/1938, ref. no. CNY# L32; BA's GSA National Personnel Records Center report, n.d, copy provided 1993, by Francis V. O'Connor [same in CG: W. C. Grade 311, 39 hrs./wk. at $183.33/mo. to W. C. Grade 309, 39 hrs./wk. at $166.66/mo.].

37 BA, "The Art of Photography" (interview), WQXR, 1/2/1939, transcript, 11, CG.

38 BA Fellowship application for 1936, Guggenheim Foundation Archives.

39 BY:CNY, 21; cf. Hardinge Scholle to Holger Cahill, 2/4/1936; Cahill to Scholle, 2/7/1936; Scholle to Cahill, 2/13/1936; Cahill to Scholle, 2/14/1936; WPA file, MCNY, quoted in BY:CNY, 31fn98; BA to Audrey McMahon, "Protection of CNY series," CTS memo, CG/WPA; Grace Mayer to BA, TLS, 4/24/1940, CG; gift receipt, 4/22/1940, WPA file, MCNY, quoted in BY:CNY, 31; Yochelson notes that BA made a second complete set of photographs for the "Index of American Design" (IAD); when the FAP was dissolved in 1943, the IAD collection went to the Metropolitan Museum of Art temporarily before moving to the new National Gallery of Art in Washington, DC, but the CNY prints stayed behind, along with the project's research files; in 1949, the Met transferred the archive to MCNY; BY:CNY, 31fn96; in addition to formal allocations to other institutions, a dozen stray negatives and more than two thousand duplicate file prints came to the Picture Collection of NYPL, probably in 1943 when the FAP project was ended and the nearby midtown office closed.

40 Mellow, *Walker Evans,* 309; Beaumont Newhall OH, 1/3/1965, transcript, AAA; Marion E. Opton to BA, ALS, 10/8/1936, CG, and Gertrude Hamilton (Mrs. Harold Allen) Whitlock, of Nonkanahwa at Kerhonkson, NY, to BA, ALS, n.d. [dateable from internal evidence to early 1938], CG.

41 FAP audit, 8/7/1936, in US Works Progress Administration, Federal Art Project files, AAA; "Outline for Photographing" carbon copy in CG; Lewis Mumford, *Sticks and Stones,* 2nd ed. (New York: Harcourt, Brace, 1933), 193,

quoted in BY:CNY, 21–22fn52; re CNY "codes," for example, "Material Aspect" (I) was divided into "Buildings" (A) and "City Squares" (B); "Buildings" was further broken down into four subcategories: "historical" (1), "picturesque" (2), "architecturally important" (3), and "deluxe" (4); each category held a checklist of specific targets; for example, "Buildings, historical" (i.e., code I.A.1.) contained Murray Hill Hotel, Empire Theater, Civic Repertory, De Vinne Bldg. on Lafayette St., 45 Grove St., and Fifth Ave. & 69th St.—Harriman Residence; the codes were intended to sort and re-group by type; in 1992 the National Endowment for the Arts funded a project (which JVH conceived and directed) to inventory the NYPL's holding of BA's CNY prints; the automated database contained these codes and allowed for their analysis; it shows the uneven balance BA achieved among her anticipated subjects while also demonstrating the intellectual rigor of the conceptual organization; unfortunately, while much of the NEA-supported effort eventually provided metadata to NYPL Digital Gallery, which launched in 2005, there was no opportunity to publish this extensive index; the codes appear in NYPL Digital Gallery metadata but are not retrievable, accessed 3/8/2017, https://digitalcollections.nypl.org/collections/changing-new-york#/?tab=about.

42 "Changing New York," Oct. 1936; draft submitted to Emanuel Benson, CG; O'Connor, *Art for the Millions*, 158–162, quoted in BY:CNY, 22; *Murray Hill Hotel, from Park Avenue and 40th Street*, ref. no. CNY# 37; *Murray Hill Hotel*, ref. no. CNY# 38; *Murray Hill Hotel*, ref. no. CNY# 39; *Murray Hill Hotel*, ref. no. CNY# 40; and *Murray Hill Hotel, 112 Park Avenue*, ref. no. CNY# 41.

43 Ishtar; Marks, "Chronicler of Our Times," 169; *Tempo of the City: I. Fifth Avenue and 44th Street, Manhattan*, 5/13/1938, ref. no. CNY# R01.

44 BA, "Notes on Research," memorandum, n.d. [after Nov. 1936 from internal evidence], CG, quoted in BY:CNY, 25.

45 *Manhattan Bridge, From Bowery and Canal Street, Manhattan to Warren and Bridge Street, Brooklyn, Manhattan*, 11/11/1936, ref. no. CNY# 173, and *Manhattan Bridge, Manhattan*, 11/11/1936, ref. no. CNY# 185; unsourced newspaper clipping in BA Scrapbook 2, CG.

46 BA, "The Art of Photography" (interview), WQXR, 1/2/1939, transcript, 9, CG.

47 BA to Emmanuel Benson, typescript draft?, n.d., replying to EB to BA, TLS, 10/23/1936, CG.

48 MoMA, *Photography, 1839–1937*, with an introduction by Beaumont Newhall (New York: Museum of Modern Art, 1937), exhibition catalog; the 3,000-copy press run sold out in days and a revised version appeared in 1938 as *Photography, a Short Critical History* by Newhall, reusing the original catalog introduction and plates, with a revised and expanded text; Edward Alden Jew-

ell, "Photographic Art Is Placed on View," *NYT*, 3/17/1937, quoted in Mellow, *Walker Evans*, 356; MoMA press release #11, for release 3/13–14/1937, and #12, [immediate], accessed 9/20/2017, https://www.moma.org/docs/press_archives/378/releases/MOMA_1937_0018_1937-03-04_37304-10.pdf?2010, and https://www.moma.org/docs/press_archives/379/releases/MOMA_1937_0019_1937-03-12_31237-12.pdf?2010.

49 EMCC, "Camera Evolves Into Machine That Snatches Speed from Tempo of the Times," *Springfield Sunday Union and Republican* (Springfield, MA), 3/21/1937; BA, "Photography as Art and Document," *Art Front* (June/July 1937), 16–17; Tyler, "Artists Respond to the Great Depression," 310–311; Ben Lifson, "The Genius of Eugène Atget," *Saturday Review* 8 (Oct. 1981), 24; Louis Aragon, "Painting and Reality," *Art Front* (Jan. 1937); Paul Strand, "Correspondence on Aragon," *Art Front* (Feb. 1937), 18.

50 BA, "The Art of Photography" (interview), WQXR, 1/2/1939, transcript, 5, CG.

51 BY:CNY, 28, 34n78.

52 "Prospectus for Photographic Book, Changing New York," n.d., AWT/BA.

53 EMCC, "Definition of Form for Book of Changing New York Photographs," TS, 1/20/1938, AWT/BA.

54 "Outline for Changing New York Commentary," AWT/BA; BY:CNY, 28–29.

55 BA to John MacCrae Jr., Vice-President, E. P. Dutton & Co., Inc., 6/12/1938, quoted in BY:CNY, 29; EMCC to L.L., "Memorandum on Changing New York," 6/10/1938, AWT/BA; EMCC adapted this information to an article, "Photographic Books," *Complete Photographer* 6 (1941), 2783–2793; BY:CNY, 28.

56 Kammen, *The Lively Arts*, 303; Mellow, *Walker Evans*, 393.

57 BY:CNY, 29–30; McMahon to Rothschild, "Complete file of the original captions of the Abbott Book," 7/14/1938, BA files, MCNY, quoted in BY:CNY, 29.

58 BY:CNY, 30–31.

59 BY:CNY, 30; BA to I. N. P. Stokes, CTL, 7/14/1938, and Stokes to BA, TLS, 8/16/1938, SBB/BA; BA to Lewis Mumford, CTL, 8/25/1938, CG; BA to HRH, CTL, 9/15/1938, CG.

60 EMCC to A. McMahon CT, memo, 10/5/1938, CG; Federal Writers' Project, *New York City, New York Panorama: A Comprehensive View of the Metropolis, Presented in a Series of Articles Prepared by the Federal Writers' Project of the Works Progress Administration in New York City* (New York: Random House, 1938); BA to A. McMahon, CT memo, 10/6/1938, CG.

61 Henry-Russell Hitchcock, "Introduction," TMSs, Oct. 1938, Henry-Russell Hitchcock Papers, Wesleyan University Library; BY:CNY, 31; McMahon, preface to *Changing New York*, v–vi.

62 McDonald, *Federal Relief Administration and the Arts*, 458; BA, CNY, ref. nos. CNY# R02–CNY# R14 and code III.E.4; "R" (for Rolleiflex) series, the handheld roll-film camera BA took up in her project's last year; see most of the images in the art center series at *Changing New York*, NYPL Digital Gallery, accessed 3/12/2017, https://digitalcollections.nypl.org/collections/changing -new-york#/?tab=about, and "Berenice Abbott," MCNY Collections Portal, accessed 3/12/2017, http://collections.mcny.org/Explore/Highlights/Berenice %20Abbott/; BY:CNY, 22, notes that BA made lists of remaining subjects suitable for each camera.

63 *Here Is New York*, by Helen Worden; *A Key to New York*, by Rosalie Slocum and Ann Todd; *Portrait of New York*, by Felix Riesenberg, with photos by Alexander Alland; *How Do You Like New York?* by Eva T. McAdoo; *A Landmark History of New York* by Albert Ulmann; *Trylongs and Perisites* by Oley O'Leahy (satire); cf. esp. Ralph Thompson, Books of the Times, *NYT*, 5/1/1939; *Time* (4/10/1939); Siegfried Giedion to BA, ALS, 6/15/1939, CG.

64 BA to Ansel Adams, CTL, 6/14/1940, CG; BA, CWA, 11/8/1991; Model OH; EMCC, "Berenice Abbott . . . Realist," *Photo Arts* 2, no. 1 (Spring 1948) 48, and variant draft for same, MSs 1947–1948, in EMCC/AAA.

65 MoMA exhibition binder, Ex. 36; other photographers: Ansel Adams, Harold E. Edgerton, Walker Evans, Man Ray, Ralph Steiner, and Brett Weston; BA, CWA, Monson, ME, 11/8/1991; IS, 9/26/1960, mentions film showing in NYC, 10/22/1960.

66 "Plea Made to Save Writers Project," *NYT*, 6/15/1939; May Milstein to JVH, ALS, 1/5/1994; Sid Grossman to Photo League members, mimeo notice, 8/16/1939, CG; BA's GSA National Personnel Records Center report—last entry on document: in her sign-off, BA still uses the title "supervisor" though she was demoted to Asst. Supervisor in Dec. 1938; BA asked Manhattan Borough President Stanley Isaacs if NY could not afford an official photographer, she told IS, 12/22/1959; BA, CWA, 8/3/1991; BAOH, 309.

67 FBI/BA, following two lines are redacted; passport held in SBB/BA; AWT/BA.

CHAPTER 12. FRIENDLY INTERPRETER

1 Vannevar Bush, "As We May Think," *Atlantic Monthly* 176, no. 1 (July 1945), 3.

2 AC/BA, 33.

3 BAOH, 499–501; BA, "Science Manifesto," CTS, 4/24/1939, copies in CG and SBB/BA; transcription in *Berenice Abbott, Photographer: A Modern Vision: A Selection of Photographs and Essays*, ed. JVH (New York: New York Public Library,

1989), 58; facsimilie in Ron Kurtz, *Berenice Abbott: Documenting Science* (Göttingen: Steidl, 2012); *transition* 14 (Fall 1928): George Anthiel composed music for car horns and airplane propellers; Paul De Kruif's *Microbe Hunters* was a bestseller.

4 BA autobiog; Mumford, *Technics and Civilization*, 340–341; Donald L. Miller, *Lewis Mumford: A Life* (New York: Weidenfeld & Nicolson, 1989), 327; BA BlkJ, 248; N. I. Bukharin et al., eds. *Science at the Cross Roads: Papers from The Second International Congress of the History of Science and Technology 1931*, Routledge Revivals (Hoboken: Taylor and Francis, 2013), http://public.eblib.com /EBLPublic/PublicView.do?ptiID=1539306; Louis Lozowick, "Manhattan Panorama," *New Masses* 4 (5/2/1939), 25, quoted in Barbara Beth Zabel, "Louis Lozowick and Technological Optimism of the 1920s" (PhD dissertation, University of Virginia, 1978), 39–45.

5 BA, "My Favorite Picture," *Popular Photography* 6, no. 7 (Feb. 1940), 19.

6 Terry A. Cooney, *Balancing Acts: American Thought and Culture in the 1930's* (New York: Twayne Publishers, 1995), 26–31; "The World in the Camera's Eye," *NYT*, 6/30/1935; "Pure Science Seen as Main Hope To Save a 'Confused' Social Order," *NYT*, 1/12/1938, clipping EMCC filed away, EMCC/AAA.

7 BA, "Manifesto," signed in all caps: "Berenice Abbott / New York City / April 24, 1939."

8 BA's 1935 Guggenheim application, 10, EMCC/AAA; "Ballantine's Ale," *Fortune* XVII, no. 6 (June 1938), 64+; *Time Out for Beer* appeared with full camera data ("Taken with a Rolleiflex; 1/1000 second; f/22; 2 flash bulbs") in BA, *Guide*, plate 7; "Farmers of the Future will Have Smaller Farms, Better Crops," *Life* 8, no. 23 (6/5/1939); Job 3657 in Time Inc. picture files: "Scientists Play Marbles"—BA photographs rolling steel ball along curved metal strips, clipping in BA Scrapbook 3, CG; articles appeared in *Life* (2/20/1939) and *Fortune* (Apr. 1939).

9 BAOH, 267–268, 270; BA to Wilson Hicks, Time Inc., CTS, 1/28/1939, CG.

10 BAOH, 514; ellipsis in original transcript, BAOH, 267.

11 HON/BA, 19; BA to Charles C. Adams, CTL, 4/24/1939, SBB/BA; BA, "Science Manifesto."

12 Charles Dollard, assistant to the president, Carnegie Corporation, to BA, TLS, 3/25/1940, CG; BAOH, 506.

13 Muriel Rukeyser, *Willard Gibbs* (Garden City, NY: Doubleday, Doran, 1942), 439; Charles H. Caffin, "Is Herzog Among the Prophets?" *Camera Work* 17 (Jan. 1907), 21; quoted in Zabel, "Lozowick," 29.

14 Mitchell *Recollections*, 13; "Text of Oppenheimer Lecture Ending the Columbia Bicentenary," *NYT*, 12/27/1954; Charles Percy Snow, *The Two Cultures and the Scientific Revolution* (Cambridge: Cambridge University Press, 1959).

15 BAOH, 502–504; "Notes of Camera World" *NYT* 2/11/1940; IS, 7/1/1962; Rob-

ert C. Cook, "Some Pictures are Worth Ten Thousand Words, But—!" *Journal of the Biological Photographers Association* 8, no. 3 (Mar. 1940), 135–140; conference program in *Science News Service* 8, no. 1 (Sept. 1939), 43+; AC/BA, 33.

16 BAOH, 543–544; Linda Dalrymple Henderson, *Duchamp in Context: Science and Technology in the Large Glass and Related Works* (Princeton, N.J.: Princeton University Press, 1998); Man Ray, *Électricité: dix rayogrammes de Man Ray et un texte de Pierre Bost* (Paris: Compagnie parisienne de distribution d'électricité, [1931]); Stefanie Spray Jandl, "Man Ray's *Électricité*," *Gastronomica: The Journal of Food and Culture* 2, no. 1 (Winter 2002), 12–15.

17 Laurence S. Critchell Jr., to BA, CTL, 5/1/1939, CG; [Macmillan editor] to BA, TLS, 10/30/1941, CG; Critchell wrote the official history of his unit, the 501st Parachute Infantry Regiment, in *Four Stars of Hell* (1947) and won an O. Henry Award in 1947; he was later a public relations man in Detroit for Ford Motor Company; sometime later, BA and EMCC prepared a dozen-page book dummy with photographs mounted on brown paper, CG.

18 BA to National Roster, CTL, 10/31/1942, CG; EMCC to "mother," CTS, 1/8/1943, EMCC/AAA; *Harper's Bazaar* (Dec. 1943); Mig Shepard, CWA, NYC, 6/10/1992 and 6/30/1992; Volunteer Service Photography (now called the Josephine Herrick Project for its 1941 founder) printed ephemera in BA SB 5, CG.

19 Registered letter 433744, 4/1/1942, sent by BA to herself, TL signed by Wilkinson, with envelope, SBB/BA.

20 BA BlkJ, 224.

21 BAOH, 279–281; Austen C. Fairbanks to BA, ALS, 4/11/1942, SBB/BA.

22 Austen C. Fairbanks to BA, ALS, Swarthmore, PA, 5/4/1942, CG; Milton E. Lowry to BA, TLS, 9/2/1942, CG; Samuel A. Shacter to BA, TLsS, 6/25/1945 and 8/7/1945, CG; unsigned contract between Joseph Gelb and Herbert Gelb (Joseph Gelb Co.) of 12 East 32nd St. and Morris Bell, CG; BA to F. E. Carlson, GE Lamp Dept., Nela Park, Cleveland, OH, CTL, 9/4/1945, CG; Harold Edgerton to BA, TLS, 1/31/1946, CG; BAOH, 645; Milton Schwartz invoice to BA, "Harpers expenses," TLS, 10/19/1948, CG.

23 BA's 1942 Guggenheim application, submitted in late 1941, Guggenheim Foundation Archives.

24 BA to Gerald Wendt, CTL, 8/11/1941, CG, and his reference in the Guggenheim Foundation Archives, 1942 grant year.

25 BAOH, 503–504; Giedion's late 1920s book *Bauen in Frankreich; Eisen, Eisenbeton* was illustrated with his own photographs very much in the technological heroic style of Germaine Krull's contemporary *Métal*; 1942 grant year, Guggenheim Foundation Archives.

26 Unsigned, TMS with ms alterations, [1943], fr0847, HDW/AAA.

27 BAOH, 267–268; Charles Rotkin CWA, NYC, 3/28/1996; HDW to BA, TLS, 10/22/1941, CG; the fee included developing and $5 for each print to distribute to trade papers.

28 Charles Rotkin, CWA, NYC, 3/28/1996; "Self Portraits," *Popular Photography* 8, no. 5 (May 1941), 46–49.

29 "Paris in the Early 1900s," *Harper's Bazaar* (Apr. 1941), tearsheets in BA Scrapbook 3, CG; BA to Charles Boyer, CTSs, 5/8/1940 and 6/12/1940; BA to Boyer, receipt countersigned with exhibition restriction crossed out, TMS, 4/1/1946; Mrs. Emil Ganso for Weyhe Gallery to BA, TLS, 4/17/1946; BA to Julien Levy, canceled check for $50.75, 4/20/1946, all CG.

30 BA to John Barrett Jr., CTL, 6/20/1941, CG; "Art Notes," *NYT*, 11/6/1941; BA to Julien Levy, CTL, 7/11/1942, CG.

31 BA, CWA, Monson, ME, 11/8/1991; "Notes of the Camera World," *NYT*, 11/23/1941; "Screen Notes," *NYT*, 12/19/1934; "Antique Cameras," *NYT*, 2/13/1955; BAOH, 554–555; "Women in Photography," *Minicam* 5, no. 6 (Feb. 1942), 48–49; William C. Estler to EMCC, TLS, [4/2/1944], and EMCC to Estler, CTL, 8/7/1944, EMCC/AAA.

32 Dan Schneider to BA, TLS, 7/22/1941, CG; portrait taken in 1944; Helen Ann and Rossell Hope Robbins to JVH, TLS, 10/5/1989, JVH files.

33 "Berenice Abbott," *Current Biography*, 1–2.

34 By Jacques Cattell Jr., whose late father had published the *American Men of Science* series among others; Hamilton Watch Co., Lancaster, PA, to BA, TLS, 12/4/1944, and BA to Hamilton, CTL, 1/3/1945, CG; BA BlkJ, 1–7.

35 March 1944 document in HDW/AAA; BA to Thomas J. Watson, CTL, 2/26/1944, CG; Dwayne Orton, Director of Education, IBM, to BA, TLS, 3/9/1944, CG; I. Bernard Cohen, BA memorial; BA to Nancy Newhall, ALS, 5/14/[1944], Newhall papers, Getty Center; "Marinoble" is also "Marynoble" in PA records.

36 Pfizer archivist could find no record of BA in 1999 while I was preparing my last exhibition at NYPL, on BA's science photography, cf. email exchange, NYPL Photography Collection curator's exhibition files; BA to Ferdinand Reyher, ALS, 7/14/1946, Ferdinand Reyher papers, University of Maryland Libraries.

37 BA BlkJ; ES&PS.

38 H. Felix Kraus, "Modern Photography," *Tricolor* 3, no. 15 (June 1945), 62; Beaumont Newhall, *Focus: Memoirs of a Life in Photography* (Boston: Little, Brown, 1993), 166–167, 169; Newhall to BA, TLS, 7/8/1946, CG.

39 BA, phone CWA, 12/30/1988; Leticia Kent, phone CWA, 6/15/1992, and Ella Friedus, phone CWA, 8/18/1992.

40 MoMA installation photo, 1948: *Bud and Leaf, Termite Architecture, Soap Molecule, Fish, Leaf Dew,* and *Beetle,* plus an Abbott Distorter self-portrait, Exhib.

Notebooks, MoMA archives; Charlotte Liebtag Grant and H. Keith Cady, *American High School Biology* (New York: Harper, 1948) and Clarence M. Pruitt, "Review," *Science Education* 33 (Oct. 1949), 311 (see chapter 16).

41 IS, 11/28/1959; AC/BA, 32–33; BAOH, 281; BA didn't publish the method until 1982, in her monograph with Hank O'Neal; regarding vintage enlargements of "Changing New York" images, several stamped and coded 16 × 20 inch prints were among the thousands transferred from FAP to NYPL Picture Collection in the early 1940s.

42 Terri Weissman has written about BA's quest for realism and her varied, evolving use of the word in *The Realisms of Berenice Abbott: Documentary Photography and Political Action* (Berkeley: University of California Press; Washington, DC: Phillips Collection, 2011); BAOH, 580–581.

43 HON/BA, 26; Barnett Bildersee, "Berenice Abbott's Toughest Job," *PM* (n.d. [1947?]), n.p., clipping in BA Scrapbook 3, CG; ES&PS.

44 ES&PS; Sandra Weiner, phone CWA, 1/19/1995.

45 ES&PS (same in ES to JVH, TLsS, 1/18/2003 and 5/2/2003).

46 Kay Reese and Mimi Leipzig, "ASMP 60th: An Interview with Berenice Abbott," *American Society of Media Photographers*, accessed 5/28/2005, http://asmp.org/1960th/; Art Directors Club of New York, *Annual of Advertising Art* 24 (1945) unpaged.

47 "Mary Bartlett Cowdrey," obituary, *NYT*, 6/10/1974; BA photos of the shop, accessed 3/6/2014, http://www.oldprintshop.com/history.htm; Bartlett Cowdrey to BA, TLS, 8/21/1945, CG; IS, 11/26/1959; James Henry Wright, *U.S. Ship "Constellation,"* 1850s?, acc. no. 48.495, Boston Museum of Fine Arts.

48 Georges de La Fouchardière, *La chienne, roman* (Paris: A. Michel, 1930); published in English as *Poor Sap* (New York: Knopf, 1930); BA to Fritz Lang, CTL, Beverly Hills, CA, 4/18/1945, CG; Nan Grant, Universal Pictures, to BA, TLS, 6/7/1945; Fritz Lang, Diana Productions, to BA, TLS, 6/23/1945; Nan Grant to BA, 6/28/1945.

49 Cf. MSs for EMCC, "Berenice Abbott – Realist," *Photo Arts* 2, no. 1 (Spring 1948), EMCC/AAA; BA BlkJ, 256, 259.

50 BAOH, 575; IS, 9/3/1960; Rowena Kennedy-Epstein, CWA, NYC, 7/28/2017; Muriel Rukeyser, "Certain Ways of Seeing, May 26, 1946," AMS, Muriel Rukeyser papers, Library of Congress; BA to Rukeyser, ALS, 8/5/1948, Rukeyser papers, Berg Collection, NYPL.

51 Rukeyser, *Willard Gibbs*; Muriel Rukeyser, *The Life of Poetry* (New York: A. A. Wyn, 1949); Ronald Kurtz Collection of Berenice Abbott Books and Other Materials, MIT Museum (Summer 2013); Muriel Rukeyser, "An Unborn Poet, for Alice Walker," in *The Collected Poems of Muriel Rukeyser*, eds. Janet E.

Kaufman and Anne F. Herzog, with Jan Heller Levi (Pittsburgh: University of Pittsburgh Press, 2005), 591–593.

52 *The New Vision: Forty Years of Photography at the Institute of Design*, edited with interviews by Charles Traub, essay by John Grimes, photographs by students and teachers of the Institute of Design (Millerton, NY: Aperture, 1982), and Mark B. Pohlad, "A Photographic Summit in the Windy City: The Institute of Design's 1946 'New Vision in Photography' Seminar," *History of Photography* 24, no. 2 (Summer 2000), 148–154; Max Tharpe and Jane Bell Edwards, "From a Student's Notebook," *Popular Photography* 21, no. 6 (Dec. 1947), 53–56, 174, 176; L. Moholy-Nagy to BA, TLS, 2/24/1944, and BA to L. Moholy-Nagy, CTS, 3/7/1944, CG; Siegel OH, George Eastman House; Tharpe and Edwards, "From a Student's Notebook," 147; Sandra Weiner, CWA, NYC, 2/14/1997.

53 L. Moholy-Nagy to John T. Sargent (Doubleday), TLS, 7/18/1946, CG; BAOH, 455, 574; BA to Rukeyser, ALS, Tuesday, [8/20 or 27]/1946, Rukeyser papers, Library of Congress; BA, phone CWA, 12/30/1988; Sargent to BA, TLsS, 8/28/1946 and 9/18/1946, CG; Leslie Ann Minot, " 'Kodak As You Go': The Photographic Metaphor in the Work of Muriel Rukeyser," in *"How Shall We Tell Each Other of the Poet?": The Life and Writing of Muriel Rukeyser*, eds. Anne F. Herzog and Janet E. Kaufman (New York: St. Martin's, 1999), 264–276.

54 EMCC to Rukeyser, TLS, 8/15/1946, Rukeyser papers, Berg Collection, NYPL; BA, CWA, Monson, ME, 11/10/1991; SBB, phone CWA, 11/01/1995; Robert Fuhring, executive secretary, American Society of Media Photographers, to BA, TLS, 11/7/1947, CG; *Photo Notes* (Nov. 1947), 8.

55 EMCC to Rukeyser, TLS, 8/15/1946, and BA to Rukeyser, ALS, 8/16/1946, Rukeyser papers, Berg Collection, NYPL; ES to JVH, TLS, 5/4/2003; the friendship with Ruth Lindsay was intense, from 1944 to 1953, when it ended abruptly, leaving EMCC devastated because, as BA told Irene Shwachman, "Elizabeth's antagonistic personality" made it difficult for anyone to help her when she most needed a friend (or a psychiatrist, Shwachman added), IS, 8/3/1960; "Check List" TMS, datelined "Lindsay Cove, N.Y., April 17, 1948," EMCC/AAA; David Hare OH for AAA, transcript, 26; Esther Newton, *Cherry Grove, Fire Island* (Boston: Beacon Press, 1993), 203–234.

56 Sandra Weiner, CWA, NYC, 5/1/1994, 7/11/1994, and 1/10/2001; BA to Rukeyser, ALS, Tuesday, [8/20 or 27/]1946, Rukeyser papers, Library of Congress.

57 I. Bernard Cohen correspondence with Rukeyser in 1936–1937, Rukeyser papers, Berg Collection, NYPL; Cohen, "Reminiscences of I. Bernard Cohen: Oral History, 1985," Spencer Foundation Project, transcript, Columbia University OH Dept.; Cohen to BA, TLS, 12/11 [or 17]/1943, CG; Cohen, BA

memorial; Cohen to BA, TLS, 2/1/1946, CG; BA BlkJ, 1–7. See also Joseph W. Dauben, Mary Louise Gleason and George E. Smith "Seven Decades of History of Science: I. Bernard Cohen (1914–2003), Second Editor of Isis," *Isis* 100, No. 1 (March 2009), 4–35.

58 "Technical Photographic Exhibition, Photographic Society of America," *The Scientific Monthly* 65 (July 1947), 22; BA's 1947 entry postcard and acceptance, SBB/BA; Alexander J. Wedderburn, "Photography in Science," *The Scientific Monthly* 66 (Jan. 1948), 9–16; "Photography in Science Competition and Salon," *Science* 105 (8/1/1947), 99, and *Science* 107 (2/27/1948), 212.

CHAPTER 13. PHOTOGRAPHY COMMUNITY

1 Marshall McLuhan, *Gutenberg Galaxy* (Toronto: University of Toronto Press, 1962), 41.

2 BA BlkJ, 7/4–8/1956, 40, 46.

3 Frederick J. Kiesler, "Design-Correlation," *Architectural Record* 81 (May 1937), 53–59; Ecke Bonk, *Marcel Duchamp: The Portable Museum: The Making of the Boîte-en-valise* (London: Thames & Hudson, 1989), 198–200.

4 Marcel Duchamp to BA, ALS, 5/22/1938; BA to Duchamp, CTLS, 6/11/1938, CG; Tomkins, *Duchamp*, 316n496; Bonk, *Marcel Duchamp*, 152.

5 "To document the portrait of contemporary America, beginning with major American cities," claimed their October 1937 proposal; Guggenheim Foundation Archives.

6 *Vogue* (Feb. 1938), 66–70; BA to Charles Henri Ford, CTLS, 3/31/1938, CG.

7 BAOH, 391–393.

8 1st International Photographic Exposition: Catalog of Exhibits, Program of Events: Grand Central Palace, New York, N.Y., April 18–24 Inclusive, 1938 (New York: The Exposition, 1938), 22.

9 Howard Devree, "A Reviewer's Notebook; Camera Work by Two," *NYT*, 4/10/1938; Torrey-Hohoff press release, CG SB2, HDW, "Oral history interview with Hudson Dean Walker," 1965, transcript, HDW/AAA; gallery list in CG, cited in BY:CNY, 27, 34n72; a full-face portrait, signed by BA and mounted, acquired by NYPL Photography Collection, acc. no. 100PH054.002.

10 Elisabeth Sekaer Rothschild, CWA, 10/24/1995; American Group, Inc., *Roofs for 40 Million; An Exhibition on Housing* (New York: American Group, n.d. [1941?], catalog for an exhibition of the same name, shown at the 7th Floor Galleries, La maison française, Rockefeller Center, NYC, 4/9–5/1[/1941?].

11 [Robert Disraeli speaks] *Photo Notes* May 1938; BA, *Guide*, 131.

12 *Trois siècles d'art aux États-Unis: exposition organisée en collaboration avec le*

Museum of Modern Art, N.Y. (Paris: Éditions des musées nationaux, 1938), catalog for exhibition of the same name, shown at Musée du Jeu de Paume, Paris, 5/24–7/28/1938; "In Brief," *NYT*, 8/14/1938; Ernst, *A Not-So-Still Life*, 111–112.

13 Ishtar; Malcolm Cowley, *The Flower and the Leaf: A Contemporary Record of American Writing Since 1941*, ed. Donald W. Faulkner (New York: Viking, 1985), 244; the British publication was not reviewed in *NYT*; Nina Hamnett to EMCC, ALS, 5/24/1938, EMCC/AAA.

14 Arthur Garland Dove, *Power House*, 1931, oil composition on board, Smith College Museum of Art, gift of EMCC, 1954; Edward August Landon, *Picture Framing: Modern Methods of Making and Finishing Picture Frames* (New York: American Artists Group, 1945); BA to Arthur Dove, TLS, pmk. 6/12/1938, Arthur Dove papers, AAA; the unidentified snapshots bear scant identifications; they were found in the mid-1990s by an antiques picker in the New York metro area and traded up, until they reached the Photography Collection, Miriam and Ira D. Wallach Division of Art, Prints and Photographs, NYPL, in 1996, acc. no. 96PH020.

15 Albert O. Bassuk to BA, TLS, 11/23/1936,CG; Leonard F. Winston to BA, TLS, 5/12/1938, CG; "Trips to the World's Fair," *NYT*, 3/14/1937; "Opening of Hobby Guild of America World's Fair Hobby Olympics," 3/15/1937; Phineas Zolot to BA, TLS, 8/2/1938, CG.

16 "Nathaniel Pousette-Dart Dead," *NYT*, 10/18/1965; BA likely appreciated Pousette-Dart's feminism as husband of musician, poet, and suffragette Flora Louise Dart, whose surname he incorporated into his own; Charles H. Duncan and Richard Pousette-Dart, *Absence/Presence: Richard Pousette-Dart As Photographer* (Utica, NY : Munson-Williams-Proctor Arts Institute, 2014); Alfred Stieglitz to BA, ALS, 7/4/1938, CG; Aline Kistler for AAL to John W. McFarlane, Service Dept., Eastman Kodak Co., CTL, 4/21/1938, CG; June 1938 BA correspondence with Stryker, all CG.

17 BA, *Photography* (New York: Art Adventure League, Inc., 1938), lessons 1–6; copies held in the MoMA Library and in Richard Pousette-Dart Archive, NYC; "Art Adventure Fair Soon; Will Show Amateurs Opportunities for Recreation," *NYT*, 9/19/1938; "Arts Fair Opens Tonight; Industry Museum Seeks to Promote Use of Leisure," *NYT*, 9/27/1938; "Art Adventure League Starts Classes," *NYT*, 10/27/1938.

18 Tay von Hohoff to BA, TLS, 12/1/1938, CG; possibly in light of Edward Steichen's eminent retirement and recent praise of BA and other young photographers, in *Time* (1/10/1938), cf. clipping in BA Scrapbook 2, CG.

19 Faurest Davis to BA, TLS with mss note, 12/29/1939, and BA to FD, CTL, 1/18/1940, CG; Reviewed in *Arizona Daily Star* 2/4/1940 and *Tucson Daily Cit-*

izen 2/3/1940: "striking contrast to the Adams and Weston landscape work that preceded it." CG SB3; published as "Civic Documentary Photography" in *Proceedings of the Conference on Photography: Profession, Adjunct, Recreation* (New York: The Institute of Women's Professional Relations, 1940), 71; Romana Javitz, interview by Richard K. Dowd, 2/23/1965, transcript, 8, AAA; Leslie Katz, BA memorial.

20 Mary Alinder, *Ansel Adams: A Biography* (New York: H. Holt, 1996), 165–168; MoMA exhibition binder, Ex. 121; "Photography Gains Recognition as an Art; Modern Museum Sets Up Department for It," *NYT*, 12/31/1940; MoMA exhibition binder, Ex. 162; Peter Galassi, *American Photography, 1890–1965, from the Museum of Modern Art* (New York: Museum of Modern Art; distributed by H.N. Abrams, 1995), 38.

21 Note cards with 1943 *Scholastic Magazine*, TLS, about student art exhibition at Macy's, CG.

22 "Nat Wartels," *NYT*, 2/8/1990; Diane Cyr, "Ten inducted into Publishing Hall of Fame," *Folio: The Magazine for Magazine Management* (Jan. 1988), accessed 1/22/2010, http://findarticles.com/p/articles/mi_m3065/is_n1_v17/ai_6244119; BA to Robert Simon, CTL, 3/3/1941, CG; BAOH, 652; clippings in BA Scrapbook 3, CG; Allan Ross Macdougall to BA, ALS, Ridgefield, CTS, 8/9/1941, CG; Minor White to BA, ALS, 10/22/1941 CG.

23 "Documenting the City," *Complete Photographer* 22 (1942); "Nadar: Master Portraitist," *Complete Photographer* 51 (1943); "View Cameras," *Complete Photographer* 53 (1943); Willard Morgan to EMCC, TLS, 12/17/1939, EMCC/AAA; 6/13/1941 diary entry, quoted in Joan Schenkar, *The Talented Miss Highsmith* (New York: St. Martin's, 2009), 227–228; a likely party attendee was Village friend of BA and Highsmith, Bonnie Lavon Yoder (later Muir) whose son Joseph Muir worked with Berenice in the early 1970s before opening a photography business in Portland, cf. BlkJ 176, Cheryl Greaney CWA 6/25/2012, BA *New Yorker* datebook May 22, 1981. BA Collection, MIT Museum 2012, "Bonnie L. Muir, 97," *Portland Press Herald/Manie Sunday Telegram*, 11/1–2/2015, http://obituaries.pressherald.com/obituaries/mainetoday-pressherald/obituary.aspx?n=bonnie-l-muir&pid=176296805&fhid=16699#sthash.8TETvCxk.dpuf, accessed 11/21/2015.

24 Alice Goldfarb Marquis, *Alfred H. Barr, Jr.: Missionary for the Modern* (Chicago: Contemporary Books, 1989), 187, quoted in Mellow, *Walker Evans*, 462; BA, CWA, Monson, ME, 8/4/1991; Charles Henri Ford, CWA and Joan Schenkar, NYC, 1996/1997; Peggy Guggenheim, *Confessions of an Art Addict* (New York: Macmillan, 1960), 92; Guggenheim, *Out of This Century*, 310; IS, 3/8/1961.

25 *Herman Landshoff: Photographs*, exhibit shown at the Fashion Institute of Tech-

nology, NYC, 6/18–7/27/2002, exhibition website, accessed 1/15/2010, http://www.lookonline.com/hermanlandshoff.html; Susan Davidson and Philip Rylands, eds., *Peggy Guggenheim & Frederick Kiesler: The Story of Art of This Century*, with contributions by Dieter Bogner et al. (New York: Guggenheim Museum Publications, 2004), 20 (Lynes) and 67 (Landshoff); Ernst, *A Not-So-Still Life*, 222–223; EMCC to Willard D. Morgan, CTL, 11/22/1942, EMCC/AAA; W. B. Laughead to BA, CTL, 11/5/1943, HDW/AAA.

26 William Estler to EMCC, 4/2/1944, TLS; EMCC to Tait's Shoe Store, CTS on PA letterhead, 7/31/1943; EMC to "mother," CTS, 8/10/1943, all EMCC/AAA; HDW to Lee Opsahl, CTM, 6/1/1943, HDW/AAA; IS, 5/25/1959 and 1/3/1960; William B. Laughead Papers, Library and Archives, Forest History Society, Durham, NC, and W. H. Hutchinson, "The Caesarean Delivery of Paul Bunyan," *Western Folklore* 22, no. 1 (Jan. 1963), 1–15; newpaper clippings from Reno, NV, and Westwood, CA: "Famous Photographer Visits Here," n.d., CG.

27 HDW to BA, CTL, New York, 9/29/1943; HDW to Mrs. Murray Benton, De Young Museum, 1/6/1944; W. B. Laughead to HDW, TMS, 12/27/1944; and HDW to Mrs. J. Glen Liston, Seattle Art Museum, CTS, 1/7/1946, HDW/AAA; Susan Rand Brown, "'Lost' Photos Exhibit is Poetic Justice," *Advocate Summer Guide*, 8/23/1979; Hank O'Neal, *Berenice Abbott: The Red River Photographs* (Provincetown, MA: Fine Arts Work Center in Provincetown, 1979).

28 Paul Strand to BA, TLS, 4/25/1944, CG; BAOH, 264; IS, 8/19/1959; EMCC to Milton Brown, 1/9/1945, EMCC/AAA.

29 "Paris in the Early 1900s," tearsheets in BA Scrapbook 3; Robert Simon to BA, TLsS, 4/7/1944 and 4/28/1944; BA to Robert Simon, CTL, 5/1/1944, CG; IS, 11/30/1959, CCP; "Arthur Zaidenberg—Artist, 88," obituary, *NYT*, 4/19/1990; *Drawing the Human Figure* appeared in several US and UK editions in 1944 and later; IS, 4/13/1960 and 9/3/1960.

30 BA BlkJ, 262.

31 BAOH, 511; Henri Cartier-Bresson and E. Tériade, *The Decisive Moment* (New York: Simon and Schuster, 1952); EMCC, "The Instant in Photography," flyer for exhibition of the same name, EMCC/AAA; BA, CWA, Monson, ME, 11/9/1991; James McQuaid, phone CWA, 7/12/2011.

32 Weegee to BA, ALS, n.d., CG; Dorothea Lange to BA, ALS, 1/20/1947, CG; CG SB4; BA to Joe Rosenthal, CTL, 4/10/1945, CG; BAOH, 510–511; *The Exact Instant*, MoMA Exhibitions and Events, accessed 8/29/2017, https://www.moma.org/calendar/exhibitions/3245.

33 Webb, *Looking Back*, 66.

34 Richard Wright, "Huddie Ledbetter," *Daily Worker*, 8/12/1937, quoted in R. Serge Denisoff, *Great Day Coming: Folk Music and the American Left* (Urbana:

University of Illinois Press, 1971), 60, 63n113; cf. IS, 12/2/1959, 12/22/1960, and IS, 7/1/1962: BA once photographed a nude black male for "a proper Bostonian," a female friend who was having an affair with him; a print from BA's files of a seated back view of an unidentified, mature black male could be this image; it was exhibited and illustrated in Marcuse Pfeifer Gallery, *The Male Nude: A Survey in Photography: [An Exhibition Held] June 13–July 28, 1978 [at the] Marcuse Pfeifer Gallery, New York City* (New York: The Gallery, 1978); Marcuse Pfeifer to JVH, email, 6/1/2014; Tiny Robinson and John Reynolds, eds., *Lead Belly: A Life in Pictures* (Göttingen: Steidl, 2008), uses many documents from Sean Killeen's Lead Belly Collection, now in Cornell University Library, relating to the tour Fairbanks organized.

35 HON/BA, 189, 253; ES&PS; BA to US Veterans Affairs, CTL, 2/10/1947, CG; apprenticeship program approved June 1950 by the New York State Apprenticeship Council, cf. TLS and accompanying "Apprenticeship Standards" document, CG. Anna Craycroft addressed this effort in her installation, cf. Dan Byers, and Claire Bishop, *The Artist's Museum* (Boston, Mass: Institute of Contemporary Art, 2016), exhibition catalog.

36 Subjects listed in BA to M. Valotaire, CTL, 10/28/1949, CG; *NYT* 2/28/1949; George Jones, Harper & Brothers to BA, TLS 3/7/1949; Francis Trevelyan Miller and Robert S. Lanier, eds., *The Photographic History of the Civil War in Ten Volumes* (New York: The Review of Reviews Co., 1912); BA and Henry Wysham Lanier, *Greenwich Village: To-Day and Yesterday* (New York: Harper, [1949]), 146–148; BAOH, 416–417; George Jones, Harper & Bros., to BA, TLS, 10/7/1948, CG; *NYT*, 2/28/1949; George Jones, Harper, to BA, TLS, 3/7/1949, confirms the title page as "Photo Impressions by / BA // Text by / Henry W. Lanier."

37 BAOH, 417–418; IS, 10/8/1959; Gail Levin, *Edward Hopper: An Intimate Biography* (New York: Knopf, 1995), 410, 623n13–14; stove acquired in 1967.

38 BA BlkJ, 245, cf. Dr. Melvin H. Rodman, "Miss Berenice Abbott," TMS, n.d. [8/17/1959 from external evidence], IS/CCP; George Jones to BA, TLS, 6/28/1949, CG (also noted in BA BlkJ and crossed out); Grace Mayer to BA, ALS, 8/23/1949, SBB/BA.

39 Bookstore announcement; Eleanor Roosevelt, "My Day," 10/25/1949, unsourced clipping; Grace Mayer to BA, letter, 10/27/1949; *NY Herald Tribune*, 11/20/1949; Lew Ney, "Two Important Books on Greenwich Village in October Publication by Harper and Brothers," *Caricature* (Nov. 1949), clipping; *The Villager*, clipping; a mimeo program from the event; and a photo ill. story in the *NY Sun*, Friday, 11/11/1949, all in BA Scrapbook 5, CG; Clementine Wheeler, ed., *Greenwich Village Gourmet: Studio Cookery; Favorite Recipes of 100 Prominent*

Village Artists, Writers, Musicians, Dancers, People of the Theatre (New York: Bryan Publications, 1949), 37.

40 AWT/BA; Constance Warren to EMCC, TLS, 2/5/1944, EMCC/AAA; IS, 9/26/1962 and 1/16/1965.

41 Walter Rosenblum, CWA, LIC, NY, 4/10/1995; BAOH, 437–438, 566; Walter Rosenblum, OH, 1979, Columbia University Oral History Research Office, transcript, 120, 133; Model OH, 1/28–30/1977, n.p., AWT/BA; Zwingle, "A Life of Her Own," 67; Alexey Brodovitch and Edwin Denby, *Ballet: 104 Photographs* (New York: J. J. Augustin, 1945).

42 BAOH, 310–311; Clem Kalisher, interview by Anne Tucker, Mar. 1975, AWT/BA; *NS Bulletin* 5, no. 1 (9/1/1947), 104.

43 BA BlkJ, 250, 266; Marcel Bovis to BA, ALS, 12/16/1947, CG; Marie de Thézy, ed. *Paris 1950 photographié par le Groupe des XV* (Paris: Direction des affaires culturelles, [1982?]) 20, 35, 113.

44 BAOH, 537.

45 HON/BA, 226, 253; BAOH, 537.

46 BA to Harold Edgerton, CTL, 1/11/1941, CG; Ethel J. Cogley, secretary to Mr. Conant (director of MIT Photographic Service), to BA, TLS, 11/13/1940, CG; HRH to EMCC, TLS, 10/30/1934, EMCC/AAA; Florence C. O'Connor, Boston Camera Club, to BA, TLS, 2/4/1941, CG.

47 Arthur Frederick Jones, "Morris and Essex," *American Kennel Gazette* (7/1/1938); "Dogdom," 10/3/1941, and "Tail Waggings," 9/25/1942, *Springfield Republican*; Sally Valentine Nerber, CWA, Wellfleet, MA, 8/23/1993; lifelong friend Sally met BA in the early 1930s as the teenaged classmate of Marge Fairbanks's son Austin at the historically progressive Cambridge School of Weston, MA; in straitened circumstances, Marge, who had Cordon Bleu training, worked as the school's dietician to pay her son's tuition; on weekends she would host students at her home in nearby Harvard, MA, where BA was also a frequent visitor; Sally, who was reared entirely by servants after her mother's death, loved Fairbanks's hominess and learned to cook; at Olivet College in MI, Sally met her husband, John Nerber, who edited the literary magazine *Tiger's Eye* in the late 1940s and was the "wonderful guy" who served briefly as BA's publishing agent.

48 Helen Gee, CWA, NYC, 3/1/1996; see also Helen Gee, *Limelight: A Greenwich Village Photography Gallery and Coffeehouse in the Fifties: A Memoir* (Albuquerque: University of New Mexico Press, 1997).

49 Helen Gee to BA, TLS, 9/17/1954, CG.

50 Marchal Landgren to BA, TLS, 6/25/1955; Landgren to BA, TLS, 6/29/1955, and Landgren to BA, TLS, 7/16/1955, CG; IS, 4/29/1960.

51 Yale University Art Gallery to BA, TLS, 9/7/1955, CG; Charles Buckley to

EMCC, ALS, 8/12/1955, EMCC/AAA; Susan Strickler, Currier Museum of Art director, quoted in "Buckley Mourned by Art Community," *Nashua Telegraph*, 7/1/2011, accessed 4/1/2013, http://www.nashuatelegraph.com/news /local-news/2011/07/01/buckley-mourned-by-art-community/; EMCC to Buckley, CTL, 8/15/1955, and Buckley to BA, PC reply, date illegible, CG; BA BlkJ, 170–171; Buckley to BA, TLS, 10/12/1955, CG; ephemera in BA Scrapbook 6, CG; EMCC to Joe Fulton, CTL, 12/5/1955, EMCC/AAA (BA recently loaned them her Noguchi portrait bust—newly obtained from the artist).

52 IS, 1/12/1960; *Village Voice*, 1/18/1956 and 9/11/1957; BA Scrapbooks 4, 6, CG.

53 Norman F. Boas to BA, TLsS, 12/20/1955, 3/28/1956, and 5/16/1956, CG; BA BlkJ, 171; A. Hyatt Mayor, *Faces in American Art* Metropolitan Museum of Art press release; "Other Museum Activities," New Series, *Metropolitan Museum of Art Bulletin* 16, no. 2 (Oct. 1957), 72.

CHAPTER 14. HOUSE OF PHOTOGRAPHY

1 Anatole Broyard, *Kafka Was the Rage: A Greenwich Village Memoir* (New York: Carol Southern, 1993), 7.

2 BA to Maxine Block, *Current Biography*, CTL, 7/11/1942, CG.

3 BA, "My Ideas on Camera Design," *Popular Photography* 4 (May 1939), 13, 73–76; Lynn Franklin, *Profiles of Maine* (Waldoboro: Maine Antique Digest, 1976), 20; BA to Marcel Valotaire, CTL, 3/24/1947, CG; BA, "Photographer as Artist," 4–7.

4 BA, "My Ideas on Camera Design," 74; BA BlkJ, 16–17, 22–23; friends and other acquaintances considered and declined as possible investors included Marjorie Fairbanks, Julia Scribner, Roy Neuberger, Marchal Landgren, and Jimmy Ernst; House of Photography stock certificate, Ferdinand Reyher papers, University of Maryland Libraries; BA to Muriel Rukeyser, ALS, 6/29/[1947], Rukeyser papers, Library of Congress; BAOH, 288.

5 BA, CWA, Monson, ME, 8/31/1988; the registered letters are all dated in Jan. 1947, CG; their registration is noted in BA BlkJ, 243.

6 BA, CWA, Monson, ME, 8/31/1988; "Shutter Shudders," *American Magazine* 146 (Nov. 1948), 117, CG; BA to Muriel Rukeyser, ALS, 8/5/1948, Rukeyser papers, Berg Collection, NYPL; "Abbott Distorter," *Modern Photography* (Nov. 1949), 48–49, 110; BAOH, 90–91, 287; Lillian Sabine, "Berenice Abbott, of New York City Pt.1," *Abel's Photographic Weekly* (2/28/1931), 231; SBB/BA holds an unmarked 4 × 5" b/w print of the portrait.

7 Lackenbach & Hirschman to BA, TLS, 10/16/1946, CG; cocky House of Pho-

tography advertising copy doesn't quote Berenice, but the clippings attribute its words to her, flyers and BA Scrapbook 5, CG: *ASMP Newsletter* (Aug. 1948); *Washington Post*, 7/17/48; *Montgomery Advertiser* (Montgomery, AL), n.d., AP byline; *Omaha Sunday World-Herald*, 5/30/48; House of Photography IRS tax return for FY 1949, CG; BA to J. J. Kuscher, Besseler Compnay, TLC, 3/24/1956, CG.

8 Reviewed in *ARTnews* (Summer 1948), 16, 21; all-male Phillips Academy became co-ed in 1973, merging with Abbot Academy, founded for women in 1829. BA BlkJ, 30-31, 240, 275 and small black diary (address book), SBB/BA.

9 BA, *Guide*, 124; re C-Thru Ruler Company, Hartford, CT; J. G. Dombroff, Willoughby's president, to BA, TLS, 2/27/1952, CG.

10 MBW to BA, Western Union telegram, 7/24/1948, CG BA, CWA, Monson, ME, 8/29/1988.

11 "Invention idea" [Photographer's "Carry-All" Jacket], reg. letter #432331, letterhead, notarized and witnessed by EMCC, 1/28/1947; and memo to self, 1/28/1947, both CG; BA to Malvina Javitz, CTL, 10/14/1948, CG; BA, CWA, Monson, ME, 8/29/1988; the example exhibited at NYPL in 1989 and MIT Museum in 2012 is now in the MIT Museum collection, via CG.

12 BAOH, 92; there was also a plan for a movie camera version, as noted in a document witnessed by Lisette Model, but not notarized, CG; BA to Marcel Valotaire, CTL, 10/22/1949, lists them in order of their appearance in the picture wells; after p. 18: 4 "Little Frame House," 9 "Japanese Lapidary," 12 "Minetta Street-Cats," 13 "Café Lafayette," 15 "Opening at Whitney"; after p. 50: 1 "Minetta Street," 3 "Sculptor's Courtyard," 4 "Sam Kramer," 6 "Outdoor Art Show," 10 "Romany Marie," 15 "The Square, Sunny Days"; after p. 82: 2 "New School," 6 "7 Macdougal Alley," 9 "Street Signs," 11 "Zito Bakery," 14 "Trinidad Dancer"; after p. 114: 2 "Evening Shoppers," 6 "Bar at Joe's," 7 "Dining on Octopus," 9 "Market, Bleecker Street," 13 "Cheese Shop"; BA BlkJ, 160 [index entry 297 undated]; Ruth Walker to BA, letter, Jan. 1956, CG; Ruth Walker to BA, telegram, 2/25/1957, with citation to Roy R. Grinker, Norman Arnold Levy, and Paul Clancy Bucy, *Neurology* (Springfield, IL, Baltimore, MD: C. C. Thomas, 1943), fig. 166 on p. 476, fig. 167 on p. 478.

13 Statement to herself, 6/29/1949, CG; BAOH, 94.

14 George Farkas, Inc., of Miami Beach, various correspondence, 1952, CG.

15 Charles Rotkin, CWA, NYC, 3/28/1996; BA BlkJ, 246–247; BAOH, 289–291.

16 Mary Roche, "New Yorkers Win Furniture Award" and "From the Past Years' Designs, Decorators Choose," *NYT*, 2/18/1949; Thomas Hine, "Miami Swank," *Humanities* 28, no. 6 (Nov./Dec. 2007); BA/Farkas correspondence, June 1955; prints held by University of Miami Historical Photograph Collection,

Series X: Miscellaneous Photos, accessed 9/30/2011, http://merrick.library
.miami.edu/u?/umiscel, 63; BAOH, 93.

17 BA BlkJ, 276, 10/15/1951; Fred Spira, CWA, NYC, 10/13/1992.

18 BA BlkJ, 275, 279.

19 BAOH, 95–97, 99; Ansco and United States Camera Corp. declined in Febru-
ary; Aremac Associates, Realist Inc., G. A. Burbridge Co., Carl Zeiss, and Hueb-
ner Co. in March; Bell & Howell Co., Argus Cameras, Beauline Industries, Inc.,
American Cinefoto Corp., Beattie-Colman, DeJur-Amsco Corp., Kinder Co.,
Chas A. Hulkcher Co., and Obex Mfg. in April; Nikon in May; Williams, Brown
& Earle, Inc., Fearless Camera, P.D.Q. Camera Co., Wild Heerbrugg Instrument
Inc., Marvel Product Co., E. B. Meyerowitz Inc., Ampro Corp., Compass Instru-
ment & Optical Co. in June; Revere Camera Co., Keystone Camera Co., Rayflex
Co., and Busch Camera Corp. in August; Wollensak, Gordon Enterprises, Vec-
tron, Inc., and Bolsey Corporation of America in September; and Herold Prod-
ucts, Grunlach Mfg., and Three Dimension Co. in October; Henry Lester, Graflex
and BA series of correspondence, July 1958, CG; originally submitted 7/23/1953,
by attorney Joseph Hirschmann; US Patent No. 2,860,556, CG.

20 IS, 1/19/1961; BAOH, 100, 288.

CHAPTER 15. PHOTO LEAGUE

1 John Berger, "Introduction" to *Permanent Red* (London: Methuen, 1960),
reprinted in *Selected Essays*, ed. Geoff Dyer (New York: Pantheon, 2001), 9; a
helpful guide to nonphotographic American art and progressive politics during
the 1930s–1940s is Andrew Hemingway, *Artists on the Left: American Artists and
the Communist Movement, 1926–1956* (New Haven, CT, and London: Yale Uni-
versity Press, 2002).

2 BAOH, 439.

3 Clara Mayer to BA, TLS, 6/27/1946, CG; per New York Consolidated Laws,
art. 61, §3002.

4 Louis Francis Budenz, *The Techniques of Communism* (Chicago: Henry Reg-
nery Co., 1954), 208–209; FBI FOIPA files on both Berenice and Elizabeth
McCausland obtained in April 1998; Leticia Kent, phone CWA, 6/15/1992; Kent
introduced BA to Jacobs, cf. Peter L. Laurence, *Becoming Jane Jacobs* (Philadel-
phia: University of Pennsylvania Press, 2016), 312n3; the Jacobs family visited
BA in Maine in 1965 and BA later visited them in Toronto, into 1979; whether
they met earlier, or only after Jacobs sought photographs of Greenwich Village
for her 1961 *The Death and Life of Great American Cities*, is unclear.

5 Tyler, "Artists Respond to the Great Depression."

6 Matthew Baigell and Julia Williams, introduction to *Artists Against War and Fascism* (New Brunswick, NJ: Rutgers University Press, 1986), 13, 85–86; Jose Orozco to BA, ALS, 3/2/1932, CG; from many versions of the portrait, BA chose plate 33 in her *Guide*; EMCC, "Artists Thrown Into World of Reality Present Their Case at the Recent Congress," *Springfield Sunday Union and Republican*, 3/1/1936; Fred J. Ringel, "Gilbert Wilson: Mural Painter," *Scribner's* (May 1937), 45+; Eliot Elisofon, "Letter for the Photo League and the American Artists Congress," *Photo Notes* (Feb. 1939), 1–2.

7 "Photo League Renovation Party," *NY World Telegram*, 12/9/1939; the history of the organization is treated in: Lili Corbus Bezner, *Photography and Politics in America: From the New Deal into the Cold War* (Baltimore, MD: J. Hopkins University Press, 1999); Claire Cass, Stephen Daiter, Tom Fredrickson, and Anne Wilkes Tucker, *This Was the Photo League: Compassion and the Camera from the Depression to the Cold War* (Chicago, IL: Stephen Daiter Gallery [u.a.], 2001), exhibition catalog; Mason Klein and Catherine Evans, *The Radical Camera: New York's Photo League, 1936–1951* (New Haven, CT: Yale University Press, 2012).

8 Leah Ollman, "The Photo League's Forgotten Past," *History of Photography* 18 (Summer 1994), 157, quoting *Photo Notes* (Mar. 1938), *Photo Notes* (Oct. 1938), 1, and *Photo Notes* (Dec. 1938), 2; BA, CWA, Monson, ME, 8/4/1991.

9 *Photo Notes* (Aug. 1938), 1, 3.

10 James A. Fasanelli, "Lotte Jacobi: Photographer," quoted in Kelly Wise, ed., *Lotte Jacobi* (Danbury, NH: Addison House, 1978), 28; Wise, *Lotte*, 8, 19, 26.

11 EMCC, "Show of Photographs at US Camera Salon," *Springfield Sunday Union and Republican*, 10/4/1936, and EMCC, "American Artists Give Work to Fight Fascism," *Springfield Sunday Union and Republican*, 10/11/1936.

12 Elizabeth Noble [pseud. EMCC], "New Horizons," *Art Front* 2, no. 9 (Sept.–Oct. 1936), 9.

13 Man Ray to Louis Lozowick, ALS, 11/21/1936, Louis Lozowick papers, AAA; founder Stuart Davis's phrase to distinguish those with an exhibition and gallery history from the newcomers seeking training in the FAP; Bernarda Bryson Shahn OH, 1983, transcript, 22–24, AAA; American Artists' Congress, *America Today: A Book of 100 Prints Chosen and Exhibited by the American Artists' Congress* (New York: Equinox Cooperative Press, 1936); Isabel Cooper, "Correspondence: American Congress versus Photography," *Art Front* 2, no. 10 (Nov. 1936), 13, citation courtesy AWT/BA; John Mahaffie with JVH, email exchange, 9/1/2017 to 9/6/2017, about the naturalist illustrator Isabel Cooper Mahaffie.

14 "Photography and the Plastic Arts," *American Artist* (Summer 1937); "Exhibition in Defense of World Democracy" flyer in EMCC/AAA; "Photographic

Exhibit Tuesday," *NYT*, 2/28/1937; Susan Platt, "Feisty Women," *Art Journal* (Summer 1999), 108; *Photo Notes* (Feb. 1939), 4; Max Yavno to EMCC, TLS, 2/14/1939, EMCC/AAA..

15 Beaumont Newhall, "Documentary Approach to Photography," *Parnassus* 10, no. 3 (Mar. 1938), 3–6; Newhall, *Focus*, 68; BA, foreword to *Photo Story: Selected Letters and Photographs of Lewis W. Hine*, by Lewis Hine, ed. Daile Kaplan (Washington, DC: Smithsonian Institution Press, 1992), xiii; AC/BA, 2; Fran McCullough, "Berenice Abbott on Photographing Lewis Hine," *Hastings Historian* (Fall 1990), 15; IS, 1/9/1960, and BA, CWA, Monson, ME, 11/10/1991; Hine to EMCC, 12/1/1938, quoted in Daile Kaplan, ed., *Photo Story*, 135; Marks, "Chronicler of Our Times," 166; AWT/BA.

16 Hine, *Photo Story*, 141; BA, CWA, Monson, ME, 11/10/1991; IS, 1/19/1961; BA, foreword to *Photo Story*, xiii; AWT/BA; Walter Rosenblum, in *Lewis Hine, Ellis Island: Memories & Meditations*, ed. with an introduction by Michael Torosian (Toronto: Lumiere Press, 1995), 34; ES&PS; Ralph Blumenthal, "Shadows Cast by Forgery; The F.B.I. Investigates Complaints About Lewis Hine Prints," *NYT*, 8/16/2001; Richard B. Woodward, "Too Much of A Good Thing: Photography, Forgery, and the Lewis Hine Scandal," *Atlantic Monthly* (June 2003), 67–76; cf. exhibition booklet in EMCC/AAA; not in digitized version, box 22.17, exhibition at Riverside Museum, 1938–1939, accessed 11/11/2016, http://www .aaa.si.edu/collections/container/viewer/exhibition-riverside-museum-281207; BA, *Guide*, plate 45; AC/BA, 2.

17 FBI/BA, and FBI/EMCC; Toshi Seeger, phone CWA, before 2000.

18 BA, Small 1946/47 diary, SBB/BA; Elizabeth K. Dilling, *The Red Network: A "Who's Who" and Handbook of Radicalism for Patriots* (Chicago: privately printed, 1934), 243.

19 Russell Campbell, "Film and Photo League, Radical Cinema in the 30s: Introduction," *Jump Cut* 14 (1977), 23–25, accessed 3/16/2011, http://www.ejumpcut .org/archive/onlinessays/JC14folder/FilmPhotoIntro.html; Leah Ollman, *Camera as Weapon: Worker Photography between the Wars* (San Diego: Museum of Photographic Arts, 1991); Daniel Frontino Elash, "Exploring New Sources on the Workers Film and Photo League," in *Overcoming Silence*, 6/9/2010, accessed 3/16/2011, http://redchannels.org/writings/RC003/RC003_WFPL .html; Dilling, *The Red Network*, 243; "Cunard Anthology On Negro Is Issued; Daughter of a London Hostess Publishes 855-Page Volume After Several Years' Work," *NYT*, 2/17/1934; Nancy Cunard, *Negro: Anthology, Made by Nancy Cunard, 1931–1933* (London: N. Cunard at Wishart & Co., 1934).

20 Mellow, *Walker Evans*, 463, 469, 474, 522–523.

21 "Folk Magazines: Irwin Silber," in *"Wasn't That A Time!": Firsthand Accounts of*

the Folk Music Revival, ed. Ronald D. Cohen (Metuchen, NJ: Scarecrow Press, 1995), 95; for humanistic background, though primarily literary, Lawrence H. Schwartz, *Marxism and Culture: The CPUSA and Aesthetics in the 1930s* (Port Washington, NY: Kennikat Press, 1980), chap. 4, "American Intellectuals and the Party," chap. 5, "Intellectuals and the Party Line," and chap. 8, "The Aesthetics of the Popular Front," 51–68, 86–96; Morris Engel, CWA, NYC, early 1990s; Paul Katz, phone CWA, 8/4/2011.

22 BAOH, 443–444; BA, CWA, Monson, ME, Aug. 1988; Lisette Model OH; Helen Gee, CWA, NYC, 3/1/1996.

23 BAOH, 443–444; BA, CWA, Monson, ME, Aug. 1988; Model OH; FBI "Photo League" released under FOIPA as Rep. ND 100-79069, 10, courtesy George Gilbert.

24 Anne Tucker, "Photo League" outline, 12/14/1976, AWT/BA.

25 Rosalie Gwathmey to Nancy Newhall, TLS, 12/5/[1948], copy courtesy AWT/BA; Sally Stein kindly shared a digital image copy of the exhibition catalog, courtesy Catherine Evans, and also quoted Barbara Morgan to Nancy Newhall, letter, 11/15/1948, concerning BA's subject, Sally Stein to JVH, email, 3/29/2012; BAOH, 439; AWT/BA; "This Is the Photo League" exhibition catalog, unpaged, reproduced one of BA's 1928 James Joyce portraits.

26 Nancy Newhall to Rosalie Gwathmey, CTL, 12/9/1948, courtesy AWT/BA.

27 Lisa E. Davis, "The FBI's Lesbian, Eleanor Roosevelt, and Other Tales from the Red Scare," *Rethinking Marxism* 21, no. 4 (2009), 621–633; Davis, *Undercover Girl: The Lesbian Informant Who Helped the FBI Bring Down the Communist Party* (Watertown, MA: Charlesbridge, 2017); Angela Calomiris, *Red Masquerade* (New York: Lippincott, 1950), 75.

28 FBI/BA; referenced FBI informers' reports are dated 12/3/1941, 3/27/1942, 8/30/1945, and 4/17/1947; New York letters are dated 9/1/1949 and 5/3/1949.

29 Miriam Colwell OH, 2005, AAA; FBI/BA; "You Can't Talk, It's Un-American"; the ad listed names including BA's as "Just a few of the outstanding Americans who are supporting this fight"; see *Treason in Congress: The Record of The House Un-American Activities Committee*, by Albert E. Kahn, with an introduction by O. John Rogge (New York: Publications Committee / Literature Division, Arts, Sciences and Professions / PROGRESSIVE CITIZENS OF AMERICA / 39 Park Avenue, New York, N.Y., 1948).

30 Budenz, *Techniques of Communism* (1954), 34; FBI/BA: an informant [redacted name] and Alexander Trachtenberg mentioned BA activity in recruiting members for this committee; "Sponsors of the World Peace Conference," *NYT*, 3/24/1949; the National Council of the Arts, Sciences, and Professions was cited as a Communist front by HUAC (report released 4/19/1949, rev. 4/26/1950),

FBI/BA; Phillip Deery, *Red Apple: Communism and McCarthyism in Cold War New York* (New York: Empire State Editions, Fordham University Press, 2014), 114–115; BA's "Security Index Card" was marked "communist" but not "tabbed" COMSAB or DETCOM for roundup in the event of civil unrest or foreign invasion, similar to the custodial detention of Japanese Americans in WWII; cf. "4,500 Petition Against H-Bomb," *Daily Worker*, 10/31/1950; Mig Shepard, CWA, NYC, 6/10/1992.

31 FBI/BA.

32 FBI/EMCC.

33 FBI/BA.

34 *Jay Street, No. 115, Brooklyn*, 5/22/1936, ref. no. CNY# 90, NYPL; BAOH, 374; *Talman Street, between Jay and Bridge street, Brooklyn*, 5/22/1936, ref. no. CNY# 129; HON/BA, 125.

35 IS, 10/9/1959; BA, Small 1946/47 diary, SBB/BA.

36 FBI/BA.

37 Mig Shepard, CWA, NYC, 6/10/1992 and 6/30/1992; ES&PS; Leticia Kent, CWA, NYC, 6/15/1992; Thurber Lewis, Amkino, to EMCC, TLS, 11/8/1939, awarding an annual theater pass to any Amkino film, EMCC/AAA; BA wrongly called it "Girl of Stalingrad," IS, 10/20/1959; it was a favorite she shared with New School colleague Jean Benoit-Levy, a French refugee; J. Hoberman, "They Died with the Camera On," *NYT*, 4/13/2014.

CHAPTER 16. IT HAS TO WALK ALONE

1 Clement Greenberg, "The Camera's Glass Eye: Review of an Exhibition of Edward Weston," *The Nation* (3/9/1946), in his *The Collected Essays and Criticism*, vol. 2, Arrogant Purpose 1945–1949, ed. John O'Brian (Chicago: University of Chicago Press, 1986), 60.

2 BA, *Guide*, 56.

3 James Sloan Allen, *The Romance of Commerce and Culture: Capitalism, Modernism, and the Chicago-Aspen Crusade for Cultural Reform* (Chicago: University of Chicago Press, 1983), xiv; Julie Jones, "Putting the European Avant-garde to Work for Capitalism: Walter P. Paepcke and the Alliance of Art and Business in the United States (1930–1950)" [English translation of "L'avant-garde européenne au service du capitalisme"], *Études photographiques*, 24 (Nov. 2009), posted online 5/20/2014, accessed 6/8/2016, http://etudesphotographiques.revues.org/3432.

4 BA, "Photography at the Crossroads," *Universal Photo Almanac* (1951), 42–47; IS, 9/2/1959; John W. Smith, "The Nervous Profession: Daniel Catton Rich and The Art Institute of Chicago, 1927–1958," *Art Institute of Chicago Museum*

Studies 19, no. 1 (1993), 58–79+, and David Travis, "Photography at The Art Institute of Chicago," *Bulletin of the Art Institute of Chicago* 70, no. 3 (May–June 1976), 7; in 1957, Pollack published *The Picture History of Photography, from the Earliest Beginnings to the Present Day* with Harry Abrams Inc. for whom he did editorial consulting; BA to Peter Pollack, ALS, 2/27/1951 and 9/5/1951, Art Institute of Chicago Archives.

5 *Blurbs*, Publicity Club of Chicago, in BA Scrapbook 5, CG; IS, 10/13/1959.

6 BAOH, 434–436.

7 Aspen Institute for Humanistic Studies Program: A 10-Day Conference on Photography at Aspen, CO; 9/26–10/6/1951, folding brochure, CG; IS, 10/13/1959; Allen, *Romance of Commerce*, 266.

8 John Morris, "An American from Paris," *Vanity Fair* (Feb. 2012), 107; BAOH, 616; IS, 5/25/1959.

9 BAOH, 617.

10 BAOH, 617.

11 BA, "What the Camera and I See," *ARTnews* 50 (Sept. 1951), 5–6, 37.

12 BAOH, 617; EMCC to Philip Morton, "About Abstraction," CTS, 4/28/1951— private and confidential, EMCC/AAA; *Das Furchtlose Auge*, Leiser (1984).

13 AWT/BA; Johann Peter Eckermann, *Gespräche mit Goethe* [Conversations with Goethe, Conversations with Eckermann], 1836, rev. and enl. in 1848; BA, talk typescript prepared by the Institute, 9–10, CG; Dorothea Lange to BA, ALS, 5/14/1952, CG.

14 BAOH, 617; others on the "Modern Photography" panel were Walker Evans, Gjon Mili, Wright Morris, Homer Page, Irving Penn, Ben Shahn, and Charles Sheeler; Alinder, *Ansel Adams*, 252–253; IS, 8/14–20/1959, and 9/2/1959; Beaumont Newhall, "The Aspen Photo Conference," *Aperture* 3, no. 3 (ca. 1955), 3; this article, a diaristic account of the panels and conference, originally appeared in *Modern Photography* in 1952; Newhall, *Focus*, 210.

15 BA, "It Has to Walk Alone," *Infinity*, ASMP News, 1 (Nov. 1951), 6–7, 14.

16 BA to World Wide, CTS, n.d., for licensing her James Joyce portrait without permission, CG.

17 Day, *The Long Loneliness*; BA, interview with Carolyn Burke re Mina Loy, 3/12/1978, notes, kindly shared with JVH; Arvonio was a photographer friend of writer James Baldwin and painter Beauford Delany, best known for his atmospheric nighttime short of New York City's Times Square, "Abstract in Concrete" (1958); BAOH, 366–367, 377–379; Mig Shepard, CWA, NYC, 6/18/1992, and Ella Freidus, CWA, NYC, July 1992.

18 "Camera Notes," *NYT*, 2/17/1952; "Excerpts from a Talk by Berenice Abbott Given at the Village Camera Club Inc., 65 Bank Street," pamphlet, July 1952,

CG; Joseph Albers, Chairman of the Dept. of Design at Yale University, to BA, TLS, 3/6/1952, CG

19　"With best wishes, and affection, [signed] Man Ray," MR to BA, TLS, Paris, 5/7/1952, CG; IS, 11/24/1959, 5/9/1960, and 1/19/1961; Dorothea Lange to BA, ALS, 5/14/1952, CG. Titles for photographs produced in series for specific government or other nonprofit assignments, were formalized upon entering art museum collections; this example in the Metropolitan Museum of Art is titled *Cotton Picker, Eloy, Arizona,* acc. no. 1987.1100.22, http://www.metmuseum .org/art/collection/search/265266; MoMA's is called *Migratory, Cotton Picker, Eloy, Arizona,* https://www.moma.org/collection/works/56948.

20　Barry Fellman to BA, TLsS, 10/2/1979 and 10/13/1979, SBB/BA.

21　Nathan Resnick, Long Island University Press, to Muriel Rukeyser, CTL to BA 8/1/1952, CG; Herbert Michelman, Crown Pub., to BA, TLS, 7207 Bay Drive, Normandy Isle, Miami Beach, FL, 8/11/1952, CG; EMCC to John and Blanche Leeper, CTL, summer 1954; EMCC to Louise and Norman Willis, CTL, 9/9/1954, EMCC/AAA.

22　"Excerpts from a Talk by Berenice Abbott Given at the Village Camera Club," CG.

23　Jacob Deschin, "Fine Prints by Strand; His French Studies May Answer Old Question; Abbott on Photography," *NYT,* 1/18/1953; IS, 9/30/1959.

24　William Estler to BA, TLsS, 1/7/1953 and 5/22/1953, CG.

25　This magazine is rare, see BA Scrapbook 6, CG; first in a series by Harvey V. Fondiller, "I Wish I'd Taken That," *Brief* 1 (June 1953), 82–89.

26　Ishtar; BA BlkJ, 130–131; cf. *Remembrance of Things Past,* vol. 1, *Swann's Way* and *Within a Budding Grove* (New York: Vintage, 1982), 212–213, and 288, quoting Nathaniel Hawthorne, "The Artist of the Beautiful," in *Mosses from an Old Manse* (1846), SBB/BA; BA found the Freud quote in Daniel E. Schneider, *The Psychoanalyst and the Artist* (New York: Farrar, Straus, 1950); there is no evidence that BA ever attempted analysis (or could afford it), but as an autodidact, she was often on the lookout for modern, nonmystical paths to greater insight; Van Wyck Brooks, *Opinions of Oliver Allston* (New York: E. P. Dutton, 1941); BA also sought further information on the cuneiforms, noting in BA BlkJ, 212–213, the culture's entwinment of "religion, art, and science," as descibed in Susanna Hare, "The Assyrian Phenomenon: An Introductory Essay," in Charles Sheeler, *The Great King, King of Assyria: Assyrian Reliefs in the Metropolitan Museum of Art* (New York: Metropolitan Museum of Art, 1945); BA to Van Wyck Brooks, ALS, 10/20/1952, Rare Books and Manuscripts, University of Pennsylvania Libraries; Brooks to BA, TLS, 10/27/1952, CG.

27　On view 10/23–11/29/1953; cf. "Wright's Pavilion to Open Thursday," *NYT,*

10/18/1953, "House of Wright Is Previewed Here; Architect Shows First Guests Through 'Usonian' Home—Opening Due Tomorrow," *NYT*, 10/21/1953, and "Throngs Inspect Wright's Exhibit; Visitors Marvel at Architect's Display of Work in House Near Guggenheim Museum," *NYT*, 10/23/1953; IS, 2/25/1964; BAOH, 571–572.

28 IS, 1/28/1961.

29 Jacob Deschin, "European Pictures: Exhibitions," *NYT*, 5/31/1953; Jacob Deschin, "Amateurs' Activity; Photographic Exhibitions Which Tell Their Story," *NYT*, 6/7/1953; BA, phone CWA, 5/30/1991; Mirza Ahmad Sohab, Director, Caravan of East and West, to BA, 3/24/1954, CG; Grant and Cady, *American High School Biology*; Super-Sight subjects were corn, an eye, grass roots, oak leaf, penicillin mold, and termite action, cf. Caravan Gallery press release, in MoMA Photo Dept., and list attached to BA invitation letter, CG; Jacob Deschin, "Three Fine Shows," *NYT*, 5/16/1954.

30 BA, "Changing New York," Oct. 1936, draft submitted to Emanuel Benson for proposed FAP publication, *Art for the Millions*, CG; published in O'Connor, *Art for the Millions*, 158–162.

31 John Atlee Kouwenhoven, *The Columbia Historical Portrait of New York: An Essay in Graphic History in Honor of the Tricentennial of New York City and the Bicentennial of Columbia University* (Garden City, NY: Doubleday, 1953); Wayne Andrews, "New York as It Was and as It Is," *NYT*, 11/8/1953; IS, 10/16/1963; BA to Lewis Adams, Architectural League, CTL, 2/11/1954, SBB/BA.

32 Russell, "Her Camera."

CHAPTER 17. LITTLE OLD AMERICA

1 Hawthorne, "The Artist of the Beautiful"; copied by BA into her journal, ca. 1946, BA BlkJ.

2 Russell, "Her Camera."

3 IS, 8/26/1959, 12/7/1959, 8/30/1963; EMCC, *Marsden Hartley* (Minneapolis: University of Minnesota Press, 1952); BA autobiog.

4 Damon and Sara Gadd, phone CWA, 3/9/1993; Clark, "The Black and White of Berenice Abbott"; references to dates and itinerary are from Mrs. Gadd's log book, unless otherwise noted, CG

5 BA, CWA, Monson, ME, 8/2/1991; Damon and Sara Gadd, phone CWA, 3/9/1993.

6 Damon and Sara Gadd, phone CWA, 3/9/1993.

7 HON/BA, 209, 211, 253.

8 Damon and Sara Gadd, phone CWA, 3/9/1993; still operating as the Driftwood

Inn Resort, added to the National Registry of Historic Places in 1994, accessed 9/2/2017, http://www.verobeachdriftwood.com/; BAOH, 509–510.

9 EMCC to Hermann Warner William Jr., Director, Corcoran Gallery of Art, CTL, 9/23/1954, EMCC/AAA.

10 Damon and Sara Gadd, phone CWA, 3/9/1993; Zwingle, "A Life of Her Own," 67.

11 Mary Squire Abbot to EMCC, TLS, 9/9/1954, EMCC/AAA; Mary Squire Abbot to BA, TLS, 3/28/1955, CG; Kay Boyle to BA, ALsS, 11/5/1954 and 11/10/1954, CG; [writer name and ID missing], Random House, to Mary Squire Abbot, McIntosh & Otis, TLS, 4/1/1955, CG; Maria Leiper to Kay Boyle, TLS, 11/29/1954, CG; IS, 1/28/1961; Ron Kurtz and Hank O'Neal, *The Unknown Abbott*, vol. 5 (Göttingen: Steidl/[New York]: Commerce Graphics, 2013).

12 Mary Squire Abbot to BA, TLS, 6/30/1955, CG; "Meyer Berger, 60, of *Times* Is Dead; Reporter Got Pulitzer Prize in '50—Covered Trials and Gangs in Prohibition Era," *NYT*, 2/9/1959; Hilaire Hiler to BA, TLS, 5/16/1957, CG; Kay Boyle to BA, ALS, 6/11/1957, CG; William Raney, McGraw-Hill, to BA, TLS, 7/17/1957, CG.

13 AC/BA, 36; GAMMA agency stamps on print versos in CG; BAOH, 509.

14 Clark, "The Black and White of Berenice Abbott," 112.

15 Ishtar; IS, 3/27/1960; Malcolm Cowley and Kenneth Burke, *The Selected Correspondence of Kenneth Burke and Malcolm Cowley, 1915–1981* (Berkeley: University of California Press, 1990), 81–100; Waldo Peirce, Diana Emery Hulick, and Robert F. Brown, *Waldo Peirce: A New Assessment, 1884–1970: Exhibition Organized by the Art Collection, University of Maine at Orono, November 16, 1984– January 25, 1985* (Orono: University of Maine, 1984); Miriam Colwell, oral history, 2005, transcript, https://www.aaa.si.edu/collections/interviews/oral-history-interview-miriam-colwell-12673, SI/AAA.

16 EMCC to H. Parks Holcomb, Stratford, NH, CTL, 5/3/1945, EMCC/AAA; Russell, "Her Camera"; BAOH, 16, 161, 539.

17 IS, 12/7/1959, and 8/30/1963; I. Bernard Cohen, BA memorial; BAOH, 471.

18 BAOH, 475; EMCC to William Hobart Royce, CTL, 9/11/1961, CG.

19 Henry David Thoreau, Sophia E. Thoreau, and William Ellery Channing, *The Maine Woods* (Boston: Ticknor and Fields, 1864), 89–90; BAOH, 476; IS, 6/24/1959, and 8/30/1963; BA to IS, ALS, Sunday [7/24/]1960, IS, ES&PS, and ES to JVH, TLS, 4/17/2003; Roy Bongartz, "The Unflinching Eye of Berenice Abbott," *Down East* 25 (Sept. 1978), 57.

20 Gretchen Berg, interview, ca. 1979/1982, transcript, SBB/BA; BA to Solita Solano, ALS, 1/2/1971, Janet Flanner and Solita Solano papers, Library of Congress; ES&PS.

21 Vincent A. Hartgen to BA, TLS, 3/29/1956, CG; BA to Hartgen, MS draft copy, 12/12/1956, CG.

22 BA BlkJ, 190, [Dec. 1955] 297, and [n.d.] 171–172; IS, 6/24/1959; BA Federal and NYS tax returns for 1956 and 1957; BAOH, 599; Francis S. Merritt to BA, TLS, June 1957, CG.

23 EMCC to Helen Kantnor, CTL, 1/26/1964, EMCC/AAA; BA BlkJ, 171–172; Shirley Kaufman, CWA, NYC, 4/8/1998; IS, 6/3/1965; Leticia Kent, CWA, NYC, 9/15/1993.

24 Jo Hopper to BA, ALS, 9/14/1956, CG.

25 O'Neal, *"Life Is Painful,"* 145–146, 201–212; timed by the clock in the background; date is from the Djuna Barnes archive calendar, University of Maryland Library, 38; only one image was ever published: Louis Kannenstine, *The Art of Djuna Barnes: Duality and Damnation* (New York: New York University Press, 1977).

26 "400 Back Federal Arts Bill," *NYT*, 6/4/1957; press release, June 6 (Thurs.), CG.

27 Helen Gee, CWA, NYC, 3/1/1996; Gee, *Limelight*, 217–220; "Camera Notes: Miss Abbott's Portraits," *NYT*, 12/29/1957.

28 Author portrait for Leslie George Katz, *Invitation to the Voyage* (New York: Harcourt, Brace, 1958).

29 James R. Mellow, "Leslie and Jane and Others," in *A Tribute to Leslie George Katz*, eds. Peter Kayafas and Jane Mayhall Katz (New York: Eakins Press Foundation, 1997), 79–82; Peter Kayafas, "Eakins Press Foundation: History," accessed 9/2/2017, http://www.eakinspress.com/history_of_the_press.cfm; BAOH, 259–260, 296–299; IS, 5/16/1960; John Pfeiffer, *Behind the Label: This Is the Story of Miles Laboratories, Its Affiliated Enterprises and Its Scientific Approach to the Development and Marketing of Products* (Elkhart, IN: Miles Laboratories, 1960).

CHAPTER 18. PSSC

1 J. Robert Oppenheimer, "The Future of Civilization in the Scientific Age," lecture, Tokyo, 9/21/1960, quoted in Mark Wolverton, *A Life in Twilight* (New York: St. Martin's Press, 2008), 180.

2 BAOH, 597.

3 Awareness of the need to improve American science education dated back to the dawn of the atomic age at the end of World War II, but the commitment to do so only began in earnest a decade later, in 1955, with the White House Conference on Education and the Soviet Union's successful detonation of a hydrogen bomb. The United States' intense response to *Sputnik* two years later quintupled

government funding, galvanized readiness within the educational community, and spurred public demand for change. National Science Foundation funding was complemented by substantial grants from the Alfred P. Sloan Foundation, the Ford Foundation, and the Fund for the Advancement of Education. John L. Rudolph, "The State of Science in America," chap. 2, and "PSSC: Engineering Rationality," chap. 5, in *Scientists in the Classroom: The Cold War Reconstruction of American Science Education* (New York: Palgrave, 2002); Jack S. Goldstein, *A Different Sort of Time: The Life of Jerrold R. Zacharias, Scientist, Engineer, Educator* (Cambridge, MA: MIT Press, 1992), 161; BAOH, 113.

4 AC/BA, 34; Anthony P. French, "Setting New Directions in Physics Teaching: PSSC 30 Years Later," *Physics Today* 39 (Sept. 1986), 30–34; Elbert P. Little, "The Physical Science Study: From These Beginnings," *Science Teacher* 24, no. 7 (1957), 316; quoted in Rudolph, *Scientists in the Classroom*, 119; Elbert P. Little, "PSSC: A Physics Program," *Educational Leadership* 17 (Dec. 1959), 169, 192; Goldstein, *A Different Sort of Time*, 161; BAOH, 511–512.

5 BAOH, 512+; early PSSC draft units were *The Universe* and *Optics and Waves*; future units were to be *Mechanics* and *Electricity and Atomic Structure*; "George H. Waltz, Jr.," obituary, *NYT*, 10/2/1961; Richard K. Winslow to BA, TLS, 2/3/1958, CG; Richard K. Winslow to BA, TMS, 2/6/1958, SBB/BA.

6 Newton Henry Black and Elbert Payson Little, *An Introductory Course in College Physics*, 4th ed. (New York: Macmillan, 1956); "University Builds Darkroom for Yardling Photographers," *Harvard Crimson*, 2/20/1937, accessed 11/15/2008, http://www.thecrimson.com/article.aspx?ref=199064; Walter H. Waggoner, "Dr. Elbert Little, Educator; Advanced Physics Teaching," obituary, *NYT*, 7/22/1983; IS, 11/30/1959, 5/2/1960; AC/BA, 34–35, AAA; BAOH, 513+, 597.

7 BA, *Photographs* (New York: Horizon Press, 1970; Washington, DC: Smithsonian Institution Press, 1990), 132.

8 HON; I. Bernard Cohen, BA memorial.

9 BAOH, 518–519; AC/BA, 35; Lisette Model OH; New School University Archives for course catalogs.

10 EMCC to HDW, TLS, 7/28/1958, HDW/AAA; Joe Fulton to EMCC, TLS, 11/9/1958, EMCC/AAA; IS, 8/14/1959, 8/16/1960, and 8/30/1960; Melvin H. Rodman, "Miss Berenice Abbott," TM, n.d. [8/17/1959, from external evidence], in IS/CCP.

11 *PSSC Newsletter* 2 (Feb. 1959), MIT Museum Archives; BAOH, 523.

12 "ESI 'PSSC Personnel' Jan 5, 1959," mimeograph memo, CG; ESI org. chart, 11/14/1958: In additon to Cohen, Little, Morrison, and Strickland, the relative newcomers were Thomas J. Dillon, Uri Haber-Schaim, James M. Henry, Arthur K. Kerman, Benjamin T. Richards, Eric M. Rogers, Bruno Rossi, and

Robert C. St. George, plus (Miss) Rena Walters, the unit's secretary (all women in the chart have marital status titles; the men of course do not), mimeographed, 2 pp., CG; James Gleick, "Jerrold R. Zacharais, Atomic Physicist, Dies," *NYT*, 7/18/1986; Goldstein, *A Different Sort of Time*, 150, 152, 161, 164–165, and "The Trouble with Education," chap. 7; BA autobiog.

13 "Albert V. Baez—In Memoriam," *UNESCO in the Spotlight* (3/27/2007); Albert V. Baez to BA, ALS, 10/22/1958, SBB/BA.

14 BAOH, 114–115, 532, 543.

15 Trausch, "Portrait of the Photographer," 58; AC/BA, 34–35; BAOH, 514; and BA, CWA, Monson, ME, 2/9/1989; Bongartz, "The Unflinching Eye," 57; Berman, "The Unflinching Eye," 93.

16 Arthur Jubenville, first head of the PSSC's apparatus division, had taken photographs of equipment for the project, cf. Joseph Harrington III, "Science Study Committee States High School Physics Needs Overhaul," *The Tech* 78, no.12 (Mar. 1958), 3; his name is not in the late 1958 PSSC organization chart or early 1959 ESI personnel list, CG; BAOH, 517, 523; BA, Sarah Lawrence College Writer's Conference in Honor of Muriel Rukeyser, 12/9/1978, audio recording of the panel, Sarah Lawrence College, Bronxville, NY, Sarah Lawrence College Archives.

17 BAOH, 517, 523.

18 BAOH, 545; Jean P. Dietz, "Photography IS Art, Says Woman Expert," *Boston Globe*, 11/18/1959.

19 HON/BA, 220.

20 Frank Genovese to JVH, email, 11/10/2011; HON/BA, 220–221; IS, 9/3/1960.

21 BA, *New Guide*, plate 9, *Drawing with Light*; BAOH, 537.

22 HON/BA, 226, 253.

23 Ishtar; HON/BA, 216–217; "Portraits of Natural Laws," *NYT*, 5/17/1959.

24 IS, 2/12/1960; BA met the Angus Camerons through Sidney Cowell, rather than her Weston hosts, the Nerbers.

25 Levin, *Edward Hopper*, 522 for Murray Crane stove, and 638n7 which erroneously says the stove never went to BA; however, it went to Maine in 1967 and then back to NYC when NYU restored the space.

26 *Who's Who Among American Women: A Biographical Dictionary of Notable Living American Women* (Chicago: Marquis-Who's Who, 1958), noted in *New School Bulletin* 16, no. 35 (5/11/1959); IS, 8/26/1959; Clara W. Mayer to Dr. Elbert P. Little, CTL, 5/25/1959, New School University Archives; "New School Honors 3; Buildings Are Named for Men Who Helped Institution," *NYT*, 5/18/1959; *New School Bulletin* 16, no. 37 (5/25/1959)—founder Alvin Johnson, trustee J. M. Kaplan, and sponsor Albert A. List; William Conklin, phone CWA, 9/26/2011; BA BlkJ, 172; IS, 4/18/1960; Leticia Kent, CWA, NYC, 9/15/1993.

27 Clara W. Mayer to BA, CTL, 5/1/1959, New School University Archives.

28 IS, 8/26/1959 and 8/16/1960; "Portraits of Natural Laws"; "The New Shows," *NYT*, 5/17/1959.

29 BA BlkJ, 172; SBB, CWA, Monson, ME, 10/29/1992; IS, 7/16/1959; HON/BA, 232–233.

30 Ben Fairbank to BA, ALS, 8/8/1976, SBB/BA; BAOH, 75; Ben Fairbank, CWA, NYC, 1/11/1996.

31 Harriet Gibney to Lowenherz, CTL, 8/26/1959, CG; IS, 8/26/1959.

32 Janet Flanner, "Letter from Paris," *The New Yorker* (3/21/1959), 156; Kitty Cannell to Marianne Moore, ALS, 1/5/1960, Marianne Moore Collection, Rosenbach of the Free Library of Philadelphia.

33 BA to Marianne Moore, ALS, 7/31/1959, Marianne Moore Collection, Rosenbach; IS, 1/3/1960 and 1/19/1960; Marianne Moore to BA, PCAS, 2/3/1960, SBB/BA.

34 Ben Fairbank, CWA, NYC, 1/11/1996; D. C. Jarvis, *Folk Medicine; A Vermont Doctor's Guide to Good Health* (New York: Holt, 1958); noted on the back of a 6/17/1959 letter from *Popular Photography* asking for PSSC pictures, SBB/BA; IS, 8/26/1959 and 8/31/1959.

35 Irene Shwachman, *We Grew Up in Manhattan: Notes for an Autobiography* (Boston: Photographic Resource Center at Boston University, 1984); BA at 73 Allerton Rd.; Shwachman at 130 Lake Ave.; Shwachman to BA, CTL, 5/18/1959, IS/CCP; IS, 5/25/1959, 7/10/1959, 2/28/1960, and 5/23/1960.

36 IS, 5/25/1959, 5/23/1960, and 7/10/1959; Liz Shwachman Passman to SBB, ALS, 12/10/1991, SBB/BA; Alan Shwachman, phone CWA, 7/6/1993.

37 IS, 6/18/1959, 6/24/1959, 8/14–20/1959, and 10/10/1959.

38 He diagnosed a staph infection and emphysema, among other irregularities, and prescribed aureomycin resulting in her considerable improvement; Harry Shwachman, MD, to Melvin H. Rodman, MD, CTL, 8/19/1959, IS/CCP; BAOH, 651; New England Deaconess Hospital Discharge Summary for "Abbott, Berenice A.," TS, 6/21/1962, IS/CCP.

39 IS, 9/2/1959, 10/3–7/1959, and 12/3–4/1959; "Cope" was the maiden name of Strickland's wife, Dorothy Anne.

40 IS, 9/2/1959 and 8/26/1959; HON/BA, 216–217; IS, 9/14/1959.

41 Walter Muir Whitehall to BA, TLS, 2/27/1958, CG; Boston Athenæum cataloging record of 25 photographs acquired Feb. 1958, acc no. 1958.12[.1-25], "Berenice Abbott Boston Photographs," *Boston Athenæum Digital Collections*, accessed 10/19/2012, http://cdm.bostonathenaeum.org/cdm/landingpage/collection /p16057coll8; Walter Muir Whitehill, *Boston: A Topographical History* (Cambridge, MA: Belknap Press of Harvard University Press, 1959); IS, 2/28/1960

and 9/3/1960; Kim Sichel, et al., *Photography in Boston, 1953–1985* (Cambridge: MIT Press, 2000); Carl Chiarenza, "Remembering Carl Siembab," *Big Red & Shiny: An Art Journal* 60 (3/25/2007); BAOH, 528.

42 Grace Mayer to BA, ALS, 7/28/1959, SBB/BA; IS, 7/10/1959, 8/14–20/1959, and 8/31/1959.

43 IS, 9/27–29/1959.

44 IS, 9/27–29/1959; Ella Jaffe Freidus, CWA, NYC, 7/10/1992; Mig Shepard, CWA, NYC, 7/10–31/1992.

45 IS, 9/27–29/1959.

46 BA BlkJ, 116; Nicholas Dean in *Boston Herald*, 11/22/1959; Dorothy Adlow in *Christian Science Monitor*, 11/9/1959; IS, 10/3–7/1959, 10/21/1959, 11/10/1959, and 8/9/1960.

47 IS, 10/14/1959, 11/10/1959, and 12/2/1959; Kathleen Cannell, "Women Today: Obscurities Clarified By Film," *Christian Science Monitor*, 12/18/1959.

48 BA to Irene Shwachman, ALS, 11/16/1959, IS/CCP; "A Physicist on the Go: Jerrold Reinach Zacharias," *NYT*, 11/16/1959.

49 Harriet Gibney to Julia Newman, TLS, 10/13/1959, JVH files; IS, 10/19/1959 and 10/24/1959; Julia Newman Scully, CWA, NYC, mid-1990s; Julia Newman, "Profile No. 1: Berenice Abbott, Pioneer—Past and Present," *US Camera* 23 (Feb. 1960), 34–39, 112; George Waltz, "Camera Catches Law of Nature," *Popular Science* 176 (Feb. 1960), 92–94.

50 Harriet Gibney blank form letter in CG; IS, 1/19/1960; BAOH, 529.

51 IS, 11/24/1959; ES&PS. The Atget portfolio acquired by Schwartz is now in the NYPL, acc. no. 95PH069.002 (no. 32), Gift of Edward and Pearl Schwartz.

52 HON/BA, 215; BA to Susan Dodge Peters, CTL, 10/27/1978, SBB/BA; the eye appeared on the dust jacket back of Rukeyser's *The Traces of Thomas Hariot* (New York: Random House, 1971); Susan Dodge Peters, *Berenice Abbott: Photographs from Two Series* (Bronxville, NY: Sarah Lawrence College Gallery, 1978).

53 BA BlkJ, 278–279 (11/24/1946); IS, 7/12/1960; HON/BA, 230; BAOH, 521–523, 535.

54 IS, 9/29/1960; Trausch, "Portrait of the Photographer," 63.

55 IS, 8/31/1959, 2/24/1960, 2/28/1960, 4/21/1960, and 7/26/1960; Kristin V. Rehder to JVH, email, 10/19/2010–9/1/2011, 4/22/2016.

56 IS, 1/27/1960, 3/27/1960, and 4/29/1960.

57 IS, 9/22/1959 and 9/23/1959; PSSC communication, n.d., CG; IS, 1/19/1960, 1/22/1960, 1/27/1960, and 3/1/1960.

58 IS, 1/22/1960 and 2/12/1960 (the volume was not among those transferred to MIT Museum by Susan Blatchford's heirs in 2014); IS, 4/6/1960, 4/26/1960; 5/16/1960, and 8/9/1960.

59 IS, 4/25/1960 (addendum), 3/31/1964, and 5/30/1964.

60 IS, 2/18/1960, 2/19/1960, 1/22/1960, 5/2/1960, and 8/5/1960.

61 IS, 3/10/1960, 4/13/1960, 4/25/1960, and 4/29/1960.

62 Ishtar.

63 Winslow to BA, TLS 5/21/1959 SBB/BA: NYPL holds a selection, acc. no. 92PH001, of variously-sized BA "science" prints with a few draft captions by Little; the assemblege suffered smoke damage during a fire at Little's home, and was given after BA's death by Mrs. Little to Susan Blatchford; Cope stayed with the program as it morphed into Educational Development Corp., mentoring photographer Elsa Dorfman who joined in 1965; "Meeting Elsa Dorfman," *The F Blog*, accessed 5/10/2008, ; IS, 5/19/1960, and Irene Shwachman, "Images of Berenice," TS, 1962–1963, IS/CCP; IS, 5/23/1960 and 5/26/1960.

64 IS, 5/23/1960, 5/31/1960, and 8/17/1960; Arthur H. Benade, *Horns, Strings, and Harmony* (Garden City, NY: Anchor Books, 1960); Science Study Series, S11; *PSSC Newsletter*, no. 3 (Oct. 1959); R. J. Whitaker, "PSSC's Science Study Series," *Physics Teacher* 36, no. 8 (1998), 503–506.

65 IS, 4/6/1960, 5/31/1960 and 8/9/1960.

66 BAOH, 540, 545; Shwachman initially (mistakenly) thought BA seemed "very proud of the whole thing, as she should be"; upon inspecting the volume, she recognized the flaws: IS, 8/9/1960; BA to A. Baez, draft, 7/7/1962, IS/CCP; Francis Lee Friedman, "Appendix 3: Acknowledgments," PSSC, *Physics* (Boston: Heath, 1960), 643.

67 BAOH, 524–527; Russell, "Her Camera."

CHAPTER 19. ELIZABETH

1 Ruth Green Harris to EMCC, ALS, 6/4/[1945], EMCC/AAA.

2 IS, 7/22/1965.

3 EMCC to Howard M. Jones, Harvard Univiversity, CTL, 9/16/1947, EMCC/AAA; EMCC, memo to self about the event, TS, 5/29/1945, EMCC/AAA; *American Contemporary Art* II, no. 3–4, (1945), 2–6.

4 Mitchell, *Ruth Bernhard*, 57–58; Zwingle, "A Life of Her Own," 57.

5 ES&PS; Leticia Kent, CWA, NYC, 9/16/1993; ES to JVH, TLS, 4/20/2003.

6 Howard Devree, "Maurer Paintings Going on Display," *NYT*, 11/4/1949; EMCC, *A. H. Maurer, 1868–1932* (New York: A. A. Wyn for Walker Art Center, 1951), catalog for exhibition of the same name, shown at Walker Art Center, Minneapolis, 9/11–10/16/1949, and at Whitney Museum of American Art, NYC, 11/6–12/11/1949.

7 United States National Capitol Sesquicentennial Commission, *American Proces-*

sional, 1492–1900 (Washington: Corcoran Gallery of Art, 1950), exhibition catalog; IS, 10/9/1959; EMCC to Harold et al., CTL, 8/24/1951, EMCC/AAA.

8 EMCC to Joe Fulton, CTL, 4/7/1957, EMCC/AAA; EMCC to John and Blanche Leeper, CTL, n.d. [dateable to summer 1954], EMCC/AAA; EMCC to W. Joseph Fulton, CTL, 1/26/1954, EMCC/AAA.

9 IS, 8/14–20/1959, 12/22/1959, and 1/3/1963; EMCC to Donald Gallup, Yale University Library, CTL, 10/5/1954, EMCC/AAA; EMCC to John and Blanche Leeper, CTL, 9/9/1954, EMCC/AAA; EMCC to Theresa and Joe Fulton, CTL, 9/9/1954, EMCC/AAA; EMCC to Louise and Norman Willis, CTL, 9/9/1954, EMCC/AAA.

10 IS, 11/30/1959; Helen Gee, CWA, NYC, 3/1/1996.

11 IS, 7/12/1960 and 8/16/1960; BA to Beaumont Newhall, ALS, 6/5/1957, Newhall papers, Getty Center; *Village Voice*, 5/22/1957.

12 BA, Small Black Notebook, ca. 1979, SBB/BA.

13 IS, 7/16/1959; SBB, phone CWA, 1/18/1995.

14 ES&PS; BA BlkJ, 172–173; IS, 4/13/1960, 5/9/1960, and 9/30/1960; Shwachman to BA, CTL, 7/20/1960, IS/CCP; BA to Shwachman, PC, Guilford, ME, pmk. 7/8/1960, IS/CCP; "Holger Cahill, 67, Art Expert, Dies," *NYT*, 7/9/1960; BA to Shwachman, PC, Abbot Village, ME, pmk. 7/14/1960, IS/CCP.

15 BA to Shwachman, ALS, pmk. 7/25/1960, IS/CCP; Dr. Harry Shwachman to Dr. James A. Bougas, Overholt Clinic, Boston, CTL, 4/12/1962, IS/CCP; IS, 3/28/1960 and 4/13/1960.

16 Charles E. Buckley, Currier Gallery of Art, to BA, CTL, 9/7/1960, box 7, SBB/BA; EMCC to Charles E. Buckley, CTL, 8/15/1960, EMCC/AAA; Buckley to EMCC, TLS, 8/24/1960, CG; EMCC to Buckley, CTL, 9/2/1960, EMCC/AAA.

17 IS, 11/30/1959 and 8/9/1960.

18 IS, 9/3/1960 and 9/26/1960.

19 EMCC, "A Field Trip in the Hartley Country" (1960), EMCC/AAA.

20 EMCC, "Berenice Abbott: The Artist's View of Physics," *Metronome* 77 (Nov. 1960), 28 (one of a series on photography, from Mathew Brady to Roy DeCarava, commissioned by photographer/picture editor Herb Snitzer); BAOH, 529–530.

21 IS, 6/14/1960; Olive Pierce, phone CWA, 10/4/2010; IS, 8/9/1960, 9/3/1960, 10/20/1960, 10/28/1960, 11/3/1960, 12/18–19/1960, 1/19/1961, 1/28/1961, and 3/1/1961; Matthew Josephson to BA, TLS, 8/28/1961 CG.

22 BA to Muriel Rukeyser, ALS, 11/16/1960, Rukeyser papers, Berg Collection, NYPL; BA, CWA, Monson, ME, 11/10/1991; Air Force Cambridge Research Labs contract with BA, SBB/BA; IS, 2/16/1961, 3/1/1961, and 6/14/1961.

23 IS, 3/10/1961, 3/30/1961, 4/29–30/1961, 5/5/1961, 10/4/1962, 8/12/1963, and 8/18–22/1963.

24 "Mickey" to "Mimi," ALsS, 5/5/1961 and 5/21/1961, SBB/BA; witnesses to BA's will are Frank Kleinhof, 18 Prospect Ave., Port Washington, NY; Alma Richards, 160 West 142nd St., NY, NY, 30 (zone number in use before zip codes); Georgia [illegible, Neae{?}, the elevator operator], 50 Commerce St., NY; and EMCC; 3/13/1962, signed copy in SBB/BA; IS, 3/30/1961; EMCC to Ilene and George Haering Forsyth, CTL, 6/10/1961, CG.

25 BAOH, 462.

26 BAOH, 649–651; Walter Rosenblum, CWA, LIC, NY, 4/10/1995.

27 EMCC to William Hobart Royce, CTL, 9/11/1961, CG; EMCC to Gay and Harald H. Lund, CTL, 9/11/1961, CG; BAOH, 650; Donelson F. Hoopes to EMCC, TLS, 6/6/1961, EMCC/AAA; IS, 10/3/1961.

28 BA to Shwachman, ALsS, 7/9/1961, 8/1/1961, and 8/29/1961, IS/CCP; Peter Freuchen, *Book of the Eskimos* (Cleveland: World Publishing Company, 1961); ES&PS, and to JVH, TLS, 1/18/2003.

29 Mig Shepard, CWA, NYC, 6/10/1992 and 6/30/1992; ES & PS.

30 Leonard Louis Levinson, *Wall Street: A Pictorial History* (New York: Ziff-Davis, 1961); IS, 8/3/1962; Mig Shepard, CWA, NYC, 7/10–31/1992.

31 John H. Fenton, "Global Research on Heart Urged; Dr. White Tells A.M.A. Group Diet and Exercise May Hold Vital Clues to Disease," *NYT*, 12/3/1955; Dr. Harry Shwachman to Dr. James A. Bougas, Overholt Clinic, Boston, CTL, 4/12/1962; Bougas to HS, TLS, 5/29/1962, IS/CCP.

32 ES&PS; ES to JVH, TLS, 4/17/2003; George Gilbert, CWA (for Ed Schwartz), NYC, 11/24/1992; EMCC to Irene and Harry Shwachman, TLS, 6/29/1962, IS/CCP; IS, 6/7/1962, 7/1/1962, and 9/2/1962, and IS, 2/25/1964.

33 Postcard of a detail of Rubens's *Peace and War* showing "Pan with Cornucopia and a Leopard": "a cat is a cat / is a leopard," signed Rj in block monogram; Romana Javitz to EMCC, PC, pmk. 9/7/1960, CG; Shwachman to BA, CTL, 7/25/1961, IS/CCP; EMCC to Gay and Harald H. Lund, CTL, 9/11/1961, CG.

34 EMCC to Joe Fulton, CTL, 6/29/1962, EMCC/AAA; BA to Shwachman, PC, pmk. 7/16/1962, IS/CCP; IS, 8/3/1962; BA to Shwachman, ALS [misdated May 24], pmk. 7/24/1962, IS/CCP.

35 IS, 8/3/1962.

36 BA to A. Baez, draft letter, 7/7/1962, IS/CCP; BAOH, 520; IS, 7/1/1962, 9/2/1962, and 8/12/1963.

37 Shwachman to BA, CTL, 12/2/1962, IS/CCP; Shwachman to EMCC, TLS, 12/20/1962, EMCC/AAA; IS, 11/28/1962; EMCC to Mrs. Carmine Dalesio,

CTL, 12/21/1962, EMCC/AAA; Mig Shepard, CWA, NYC, 6/10/1992 and 6/30/1992.

38 AC/BA, 31.

39 BA to Muriel Rukeyser, ALS, 7/10/1959, Rukeyser papers, Library of Congress; Rukeyser, *The Traces of Thomas Hariot.*

40 Sidney Cowell, 8 × 10" photographs in "Berenice Abbott" vertical file, MoMA; IS, 7/21/1963, 8/18–22/1963, and 8/29/1963; BA to Lotte Jacobi, ALS, [9/22/1963 from internal evidence], Lotte Jacobi Papers, University of New Hampshire Library.

41 IS, 8/12/1963, and 8/18–22/1963.

42 IS, 7/21/1963; BA to Eyre de Lanux, ALS, [Sept. 1963], Eyre de Lanux papers, AAA; IS, 5/10/1963.

43 IS, 8/29/1963 and 10/16/1963.

44 BA to Shwachman, PC, pmk. 9/28/1963, IS/CCP; IS, 10/16/1963 and 2/25/1964; BA to Shwachman, ALS, n.d. [dateable to end of Dec. 1963], IS/CCP.

45 Ken McCormick, Doubleday, to BA, TLS, 4/18/1963, SBB/BA; IS, 5/30/1964 and 8/19/1964; Francis Steegmuller to BA, 10/17/1966 and 10/29/1967, SBB/BA; BA to Shwachman, ALS, 3/30/1964, IS/CCP; BA to Shwachman, ALS, pmk. 8/3/1964, IS/CCP; Kay Boyle to BA, ALS, 10/17/1964, CG.

46 IS, 1/3/1963, 5/30/1964, and 6/15/1964; Ella Jaffe Freidus, CWA, NYC, 7/10/1992.

47 IS, 8/18–22/1963, 3/31/1964, 5/30/1964, 6/15/1964, 6/21/1964, and 7/21/1964; BA to Shwachman, ALS, 3/30/1964, IS/CCP; BAOH, 532; BA to Shwachman, ALS, pmk. 5/18/1964, IS/CCP; ES to JVH, TLS, 4/24/2003; Velma Varner to BA, TLS, 7/6/1964, SBB/BA; Velma Varner to Valens, blind CTL, 7/14/1964, SBB/BA; Velma Varner to Red Valens, TLS, 7/28/1964, SBB/BA.

48 BA to Shwachman, PC, pmk. 4/23/1964, IS/CCP; IS, 6/15/1964, 10/25/1964, and 6/3/1965.

49 Bridge opened 11/21/1964; Shirley Kaufman, CWA, NYC. 4/8/1998; ES to JVH, TLS, 4/26/2003; IS, 12/9/1964; Victorian cards, CG.

50 Geller, "Photography, Science, and Life," *Image* (Spring 2005), accessed 11/12/2011, http://www.eastmanhouse.org/inc/the_museum/geller3.php.

51 IS, 8/19/1964, 8/30/1964, 10/26/1964, 11/16/1964, 12/9/1964, 1/16/1965, and 4/23/1965.

52 Emmie Schrader Adams to JVH, email, 1/30/2012 (she spelled Bingham's first name "Kathleen"); Matt Herron to JVH, email, 1/31/2012; IS, 4/2/1965 and 6/3/1965; Medical Examiners #4287: 66 yrs., 5 mos., 14 dys., Manhattan Cert. #10486.

53 IS, 6/3/1965.

54 IS, 4/23/1965; "McCausland, Elizabeth," *NYT*, 5/16/1965; "Elizabeth McCausland, 66, Dies; Taught and Wrote on Art in U.S.," *NYT*, 5/17/1965; IS, 10/3/1961: "Hilda Doolittle, Poet, Dead at 75," *NYT*, 9/29/1961; however, the announcement "Miss MacPherson to Wed," *NYT*, 4/18/1950, alluded to their complicated relationship.

55 IS, 6/3/1965 and 8/13/1965; BA, CWA, Monson, ME, 8/2/1991.

56 IS, 5/21/1965; AWT/BA.

57 BAOH, 427–428, 430; IS, 6/3/1965, IS/CCP; AWT/BA; ES&PS.

58 IS, 5/21/1965 and 6/3/1965.

59 IS, 6/3/1965.

60 EMCC, "Burliuk: A Fable," in *David Burliuk: 55 Years of Painting* (Long Beach, NY: Lido Galleries, 1962); IS, 8/14–20/1959 and 6/7–9/1965.

61 IS, 6/10/1965; photograph and negative transferred from NYPL Picture Collection to Wallach Division, acc. no. 89PH016.084 (reproduced as "Raindrops on a Window, taken November 1951," in Edna Bennett, "How Large Should a Print Be?," *Modern Photography* 16 (Nov. 1952), 47; Coburn "Coby" Britton to BA, ALS, 6/10/1965, SBB/BA.

62 IS, 6/10/1965.

63 IS, 6/3/1965 and 7/19/1965; BA to Shwachman, ALS, 6/18/1965, IS/CCP; Judy Lerner to Philip Wittenberg, 8/13/1965, and TLS re new will, 7/30/1965, SBB/BA.

64 Leticia Kent, CWA, NYC, 7/27/1992; IS, 8/19/1966; Jacob Friedus to BA, TLS, 1/25/1975; Stuart E. Hayes to BA, TLsS, 5/15/1975, 5/28/1975, and 6/18/1975; Doane Eaton to John Largay, Real Estate, Bangor, ME, CTL, 7/21/1975; 1979 IRS Tax Return, 4/5/1980, preparer Paul W. Noble of Guilford, ME, all SBB/BA.

CHAPTER 20. SELL ATGET!

1 John Szarkowski, Maria Morris Hambourg, and Eugène Atget, *The Work of Atget*, vol. 1, Old France (New York: Museum of Modern Art, 1981), dedication.

2 AC/BA, 38.

3 BA to Marchal Landgren, telegram, 6/13/1965, 12:59 p.m., SBB/BA; White House Invitation, SBB/BA; James T. Bennett, *Subsidizing Culture: Taxpayer Enrichment of the Creative Class* (Somerset, UK: Taylor and Francis, 1991), 155+; Isabelle Storey, *Walker's Way: My Years with Walker Evans* (Brooklyn, NY: PowerHouse, 2007); IS, 6/14/1965, 6/20/1965, and 8/19/1966.

4 Squaw Mountain Inn to BA, TLS, 7/17/1965, SBB/BA; IS, 8/13/1965 and 8/19/1966; E. G. Valens to BA, TLS, 9/24/1965, SBB/BA.

5 Arthur Lubow, *Diane Arbus: Portrait of a Photographer* (New York: HarperCol-

lins, 2016); IS, 8/19/1966; Franklin, *Profiles of Maine*, 18–21; Berman, "The Unflinching Eye," 88.

6 IS, 6/3/1965, 4/8/1966, and 8/19/1966.

7 W. G. Rogers, Greenwood Farm in Gallitzin, PA, to BA, TLsS, correspondence, 1965–1967, SBB/BA; Gisèle Freund, *Le monde et ma caméra* (Paris: Denoël, Gonthier, 1970), published in English in 1974; W. G. Rogers, "Speaking of Books: *Ladies Bountiful*," *NYT*, 1/14/1968; W. G. Rogers, *Ladies Bountiful: A Colorful Gallery of Patrons of the Arts* (New York: Harcourt, Brace & World, 1968), 14.

8 Helen Kentnor, Taos, NM, to BA, 11/5/1965, CG; IS, 8/19/1966; BAOH, 397–398.

9 Cupic, "Berenice Abbott: 'The World Today Has Been Conditioned to Visualize'"; IS, 8/19/1966; BAOH, 170, 199, 610; AC/BA, 8, 26–27; HON/BA, 61; Man Ray, *Self Portrait*.

10 IS, 8/19/1966 and 3/19/1967; BAOH, 397–398.

11 IS, 8/19/1966; cf. W. Somerset Maugham, "Looking Back," *Show: The Magazine of the Arts* 2, nos. 6–8 (June-Aug. 1962), though BA could have had access to a copy of Maugham's *The Partial View* (London: Heinemann, 1954), which contained his *Summing Up* (1938) and *A Writer's Notebook* (1949)—both are more circumspect, cf. Selina Hastings, *The Secret Lives of Somerset Maugham* (London: John Murray, 2009), 423–427, 521. Notably, Maugham died in December 1965, his demise well covered in the media, cf. AP's "Somerset Maugham Is Dead at 91," obituary, *NYT* (12/16/1965).

12 IS, 7/31/1966; BA to John Howard Griffin, ALS, 8/1/1966, Harry Ransom Center, University of Texas at Austin.

13 IS, 8/24/1966; BAOH, 468–490.

14 IS, 8/19/1966 and 8/24/1966; BAOH, 468–490; BA, CWA, Monson, ME, 5/28/1991; some of this work appears in Kurtz and O'Neal, *The Unknown Abbott*, vol. 5.

15 Smithsonian Institution (U.S. National Museum) to BA, TLS, 10/21/1966, SBB/BA; the exhibition prints and crates are now in the MIT Museum; IS, 11/12/1966 and 1/3/1967.

16 BA's antipathy to curator Szarkowski could stem from contact in 1951 when he was Walker Art Center staff photographer for EMCC's Alfred Maurer retrospective, whose negatives BA printed for the catalog: EMCC, *A. H. Maurer*, 277; IS, 3/19/1967.

17 IS, 3/19/1967.

18 IS, 3/30/1967; Gretchen Berg, interview, TS, 1979/1982, SBB/BA; AC/BA, 5.

19 IS, 3/30/1967; BA to ES&PS, ALS, 4/9/1967; annotated photographs by ES, JVH files; Miles Barth, CWA, NYC, 1/29/2013.

20 IS, 3/30/1967 and 4/3/1967.

21 IS, 7/10/1967; BA BlkJ, 174.

22 Bert Little, Research and Development, Macalaster Scientific Corporation, to BA, TLS, 4/10/1967, CG; Little to BA, TLS, 4/17/1968, CG.

23 BA applied 3/27/1967 to renew copyright for CNY book; copyright office earlier told Dover Publications, cf. XC in BA file 12/29/1970, that there was no valid renewal, SBB/BA.

24 BA to A. Hyatt Mayor, CTL, 8/7/1956, CG.

25 Mannikin image reproduced in BA, *The World of Atget*, plate 17; IS, 2/7/1960, and IS, 3/2/1960; David Vestal, "Berenice Abbott's The World of Atget," *Infinity* 9 [*sic*, 14], no. 1 (Jan. 1965), 27; IS, 10/12/1962; AWT/BA; cancelled BA check to Julien Levy, 3/23/1950, SBB/BA.

26 Edward Alden Jewell, "Art; Old French Photographs Shown," *NYT*, 12/16/1931; Herbert J. Seligmann, "To the Art Editor" and "Note by E. A. J.," *NYT*, 2/28/1932; Jacob Deschin, "Two-man Exhibit," *NYT*, 4/9/1950; AWT/BA; BA BlkJ, l (3/5/1950), 86.

27 E. Weyhe, "Report of Sales of Atget Photographs for 1944–1948," 3/22/1951: $100.00 less 1/3 commission; also 6/12/1951: reprint of Atget's *Cabaret* for $10.00, less 1/3 commission = $6.67, with handwritten note: "50%; I owe Julien $3.33; was reprint already paid for? B.A.," CG; "Yesterday's Paris—Plus Ça Change," *NYT Magazine* (11/25/1951); "Art: Yesterday Paris," *Time* (1/7/1952); EMCC, "Atget," *New School Bulletin* IX, no. 3 (9/17/1951).

28 A. Hyatt Mayor to BA, "Here is my attempt at Atget," n.d., cover letter in IS/CCP, with copies and transcriptions assembled by Shwachman in 1960s to help BA market Atget collection; A. Hyatt Mayor, "The World of Atget," *Metropolitan Museum of Art Bulletin*, new ser., 10 (Feb. 1952); Ben Lifson, "The Genius of Eugène Atget," *Saturday Review* 8 (Oct. 1981), 30.

29 "Who Remembers Paris in the Twenties?," *Flair* 1, no. 3 (Apr. 1950); BA BlkJ, 295–296 (ca. Oct. 1952).

30 Ferdinand Reyher to Beaumont Newhall, ALS, 5/26/1947, Beaumont Newhall Papers, 1947–1969, MS Am1857.1, Houghton Library, Harvard University; AWT/BA; IS, 4/13/1960 and 8/30/1963.

31 IS, 8/14/1959 and 5/9/1960; BAOH, 586–595; AWT/BA; Man Ray interview with Arnold Crane, 10/1968, transcript AAA, 1; Del Zogg, "Provenance of Atget Photographs in the Collection of George Eastman House," *Image* 31, no. 1 (June 1988); Newhall, *Focus*, 216; James K. Lyon, *Bertolt Brecht's American Cice-*

rone, published in the series Abhandlungen zur Kunst-, Musik- und Literatur-wissenschaft Bd.234 (Bonn: Bouvier 1978): see especially "Introduction: Brecht and Ferdinand Reyher," "Reyher the Man," 4–25, and "Reyher's Writings Between 1946–50," 134–141; James K. Lyon, *Berthold Brecht in America* (Princeton, NJ: Princeton University Press, 1980), esp. chap. 22, "Ferdinand Reyher," 215–220. Reyher had been writing a never-completed novel about an itinerant nineteenth-century photographer, and relied on Atget's technical practice for details; he died of a stroke in Cambridge, Massachusetts, in 1967, but the "Tin" manuscript survives, cf. Lyon, *Berthold Brecht*, 375n15 (first of two notes both numbered 15).

32 Sally Valentine Nerber, CWA, Wellfleet, MA, 8/23/1993; BA, *The World of Atget* (1964); Donald M. Stewart, Stanford University Press, to John Nerber, TLS, 11/10/1952, CG.

33 Beaumont Newhall to BA, TLS, 3/29/1951, CG; BA to Beaumont Newhall, ALS, 6/9/1951, CTL to Ferdinand Reyher, Ferdinand Reyher papers, University of Maryland Libraries (another copy, CG).

34 Hyman Swetzoff to BA, TLS, 10/8/1953, CG; Mary Emma Harris, *The Arts at Black Mountain College* (Cambridge, MA: MIT Press, 2002), 183; IS, 7/10/1959; Andrew Oates to BA, TLS, 4/1/1955, CG; James R. Mellow, "Boston," *Art Digest* (4/1/1955); Mellow, "Leslie and Jane and Others," in *A Tribute to Leslie George Katz*, 79–82; BA to Irving S. Olds, CTL, 4/12/1955, CG.

35 Beaumont Newhall, George Eastman House, to BA, TLS, 6/28/1955; Minor White, George Eastman House, to BA, TLS, 6/28/1955, CG; White to BA, TLS, 4/11/1956, CG; these negatives were eventually returned to BA, and subsequently reunited with the larger holding at MoMA by 2013.

36 BA BlkJ, 171.

37 Ibid; see also IS, 8/17/1960 and 10/4/1962 re partial denture.

38 April 1956 announcement in W. Eugene Smith papers, CCP; a second one dated July 1956 has different typeface with BA phone number on regular letterhead—text is same, CG; EMCC to Charles Buckley, CTL, 8/8/1956, CG; Lily [no last name], Met Museum, to EMCC, ALS on Met Museum note letterhead, 3/20/1956, EMCC/AAA; introductory typed draft also in EMCC/AAA; Molly Kalkstein, "Inside the Box: Photography and the Portfolio Format," master's thesis (Toronto: Ryerson University, 2013) 54–63, accessed 12/3/2017, http://digital.library.ryerson.ca/islandora/object/RULA:2585.

39 "Abe Lerner," obituary, *NYT*, 11/16/2002; Ira Cohen, Scholler Paper Corp., to EMCC, TLS, 3/28/1956, EMCC/AAA; ES&PS; H. Roger-Viollet contract, May 1956, CG; BA BlkJ, 171.

40 Toronto clipping in BA Scrapbook 6, CG; IS, 9/2/1959; George Wittenborn to BA, TLS, 5/24/1956, with BA MS annotation. CG.

41 Order form from "Hyatt"; BA to A. Hyatt Mayor, CTL, 8/7/1956, CG; IS, 10/3–8/1959.

42 Ansel Adams to BA, TLS, 8/1/1956, CG; Ben Maddow to BA, ALS, order form, n.d., CG; Marianne Moore to BA, AS PC, 11/15/1956, CG; Christopher Bishop to BA, TLS, [Jan. 1957], CG; it is not known if any of these prospects purchased a portfolio.

43 "Doors, Trees, Shop Fronts, Reflections, Streets," BA BlkJ, 254 (5/10/1949); Paul Strand to BA, ALS, 5/24/1956, CG; BA to Paul Strand, ALS, n.d., received 6/11/1956 in France, Paul Strand papers, CCP; Paul Strand to BA, ALS, 12/2/1956, CG.

44 Depending on subject, and difficulty of printing, done to order after sale, Helen Gee, CWA, NYC, 3/1/1996; Minor White, "Atget, A Portfolio," *Image* 6 (1957), 46.

45 Atget exhibition materials in BA Scrapbook 6, CG; Stanley T. Lewis, Queens College, to BA, TLS, 6/5/1957, CG; BA to Beaumont Newhall, ALS, 6/5/1957, Newhall papers, Getty Center.

46 BA to Marchal Landgren, ALS, n.d. [dateable from internal evidence to 6/9/1962], Marchal Landgren papers, AAA.

47 IS, 8/14–20/1959; 10/8/1959; BA BlkJ, 172–173, 230–245; IS, 1/9, 1/22, 1/27, 2/12, 2/18, 2/24, and 4/18 (all 1960).

48 IS, 3/28/1960, 5/16/1960, 10/14/1960, and 6/14/1961; Macmillan contract, Jan. 1961, CG.

49 · IS, 4/25/1960; Marks, "Chronicler of Our Times," 166; Edward Real to BA, TLS, 4/11/1960, SBB/BA.

50 IS, 5/16/1960 and 11/3/60; Eugene Ostroff to BA, TLS, 6/13/1962, CG; Marchal Landgren to BA, CTL, 9/27/1962, Landgren papers, AAA; Landgren to BA, TLsS, 5/3/1963, 6/25/1963, and 7/4/1963, CG; Landgren to BA, CTL, 3/7/1962, Landgren papers, AAA; Landgren "Atget" TS, 3/12/1962, with BA to Landgren, ALS, 3/12/1962, Landgren papers, AAA.

51 IS, 12/21/1961, 11/28/1962, 5/10/63, 8/12/1963, and 8/18–22/1963; Harold Becker with BA contract, Joe Reynolds witness, 2/20/1962, CG; Harold Becker, phone CWA, 9/21/2011; David Vestal to JVH TLS 6/7/2012. JVH.

52 Eugène Atget, Berenice Abbott, and Věra Hrůzová, *Eugène Atget* (Praha: Státní nakl. krásné literatury a umění, 1963); BA, "Eugène Atget, Forerunner of Modern Photography," pts. 1 and 2; IS, 11/21/1961, 12/21/1961, and 2/25/1964; BAOH, 581–583; BA Contract with Horizon Press, Inc., 1/24/1964, CG.

53 AWT/BA; BAOH, 652; IS, 2/10/1964 and 3/31/1964.

54 Philip Wittenberg to Julien Levy, CTL, 5/28/1964, SBB/BA; BA to Wittenberg, CAL, 6/25/1964, CG; IS, 5/30/1964, 6/15/1964, and 7/21/1964.

55 BA to John H. Griffin, ALS, 5/1/1965, John H. Griffin Collection, Harry Ransom Center, University of Texas at Austin; ES&PS; IS, 6/23/1964 and 7/21/1964.

56 IS, 5/30/1964, 6/15/1964, and 6/23/1964; Julien Levy to BA, TLS, 8/3/1964, CG.

57 IS, n.d. [dateable by internal evidence to early to mid-Feb. 1968].

58 Roger Smith to BA, TLS, 4/21/1966, and CTL, 6/8/1966, SBB/BA; National Education Television and Radio Center, *Atget* (Bloomington: Released by Indiana University Audio-Visual Center, 1967), 1 film reel (30 min.), b/w, 16 mm; IS, 7/31/1966.

59 Nathan Lyons, ed., *Photographers on Photography: A Critical Anthology* (Englewood Cliffs, NJ: Prentice-Hall, 1966), 15–22, ills. 1–3; IS, 10/5/1967 and 10/20/1967.

60 BA to ES&PS, ALS, 9/24/1967, JVH files; ES&PS; John Howard Griffin to Cornelia and Irving Sussman, TLS, 8/20/1965, John Howard Griffin Papers, Columbia University Libraries; BA to John Howard Griffin, ALS, 8/1/1966, Harry Ransom Center, University of Texas at Austin.

61 IS, 10/30/1967, continued in 11/5/1967; UT at Austin University Art Museum, "Abbott visit itinerary," 11/2/1967, CG; Sarah Shelby, UT at Austin University Art Museum, to BA, TLS, 11/3/1967, CG.

62 Letters and itineraries from the University of Texas at Austin, 11/2/1967+, CG; BA BlkJ, 62; BAOH, 595; Marian B. Davis, Photographs by Eugène Atget from the Collection of Berenice Abbott: November 3–December 1, 1967, the Art Museum of the University of Texas at Austin (Austin, TX: The Museum, 1967), exhibition catalog; BA to ES&PS, ALS, 11/7/1967, JVH files; IS, 10/20/1967, 10/30–11/25/1967, and 1/17/1968; cf. blank release for a book tentatively titled State O'Maine, CG; Warren Roberts to BA, TLS, 2/29/1968, SBB/BA.

63 Maria Morris, "Summary of interview with Berenice Abbott, April 19, 1978," 4, MoMA Photo Dept.

64 BA to John Szarkowski, CTL, 3/1/1968, SBB/BA; IS, n.d. [dateable by internal evidence to early to mid-Feb. to early Mar. 1968].

65 Contract copies in SBB/BA; BA to Paul Vanderbilt, TLC, 11/6/1951, CG; IS, 8/16/1960; Philip Wittenberg to H. Lee Lurie, TLS, countersigned 5/7/1968, SBB/BA.

66 BA to Wittenberg, ALS, 5/29/1968, SBB/BA; BAOH, 596.

67 IS, 3/31/1964, 9/20/1968, 9/22/1968, and 10/21/1969; "Museum Acquired Pictures by Atget," *NYT*, 9/22/1968; MoMA Press Release no. 87 (Sunday,

9/29/1968), MoMA Archives; SBB, phone CWA, 1/18/1995; Julie Reiner to BA, ALsS, 7/28/1968, 8/4/1968, 4/21/1969, 4/1/[1970?], CG.

68 AC/BA, 37–38; BAOH, 652–654.

69 BA BlkJ, 17; though BA's profit was real in 1968, almost a half century later, a single very well-preserved Atget original print sold at Christie's New York for more than the entire collection, cf. Eugène Atget (1857–1927), *Saint-Cloud*, 1926, cataloging and details: "Lot 207 / Sale 2586. Price Realized $60,000, Photographs 4–5 October 2012, Property of the Jane and Leslie Katz Charitable Trust / Provenance, From the artist, to Berenice Abbott, to Jane Mayhall Katz and Leslie George Katz"; BA to Marchal Landgren, ALS 9/29[1968], ML Papers, AAA; AC/BA, 43; IS, 11/1968 and 10/21/1969.

70 IS, 9/20/1968 and 10/21/1969.

71 Kristen V. Rehder to JVH, email, 10/19/2010; the word was also a favorite of Louise Young, whose memorial mentioned it: Lynne Spichiger, "Louise Young," text, Rehder to JVH, email, 10/18/2010; BA to Marchal Landgren, ALS, 10/29/1968, Landgren papers, AAA; income of $10,200 and cost basis of $4,800, in 1928 until 1968 due the Atget sale, cf. tax form copies, 4/12/1969 for calendar 1968, cf. Paul W. Noble, BA Guilford, ME, tax preparer, SBB/BA.

CHAPTER 21. HOTCAKES

1 Hilton Kramer, "The Best in Their Line," *NYT*, 2/7/1971.

2 Lynn Franklin, "Photography: Looking Forward to the Next Millennium," *Maine Sunday Telegram*, 12/26/1971.

3 International Center of Photography, Master Photographs: From "Photography in the Fine Arts" Exhibitions, 1959–1967: An Exhibition from the Permanent Collection of the International Center of Photography (1130 Fifth Avenue, New York, NY 10128): The Center, 1988; Beaumont Newhall to BA, TLS, 11/16/1962, CG; IS, 11/28/1962; Six Photographers: An Exhibition of Contemporary Photography Sponsored by the College of Fine and Applied Arts, University of Illinois, Urbana (Urbana: University of Illinois, College of Fine and Applied Arts, 1961).

4 Jerry Miller, J. S. Miller – Photographic Prints, 409 East 88th St., NYC, to BA, TLsS, 4/9/1963 and 5/22/1963, CG; Joe Fulton, Oklahoma Art Center, to BA, TLS, Aug. 1963, CG; IS, 8/18–22/1963, 10/16/1963, 11/4/1963, and 3/31/1964; Richard Jaquish to BA, TLS, 6/15/1963, CG; "Fine Photographs," *Image* 12, no. 1 (1963).

5 A. D. Coleman, "Latent Image: Group 10," *Village Voice*, 1/30/1969; Bob Greger and Laura Greger, Group 10, to BA, TLS, 12/5/1968, CG; "Check it

out!," http://www.photo-circle.com/, in Al Kaplan, "Cleaning Up A Row Of Loose Ends," *The Price of Silver*, 10/13/2007, accessed 2/10/2012, http://thepriceofsilver.blogspot.com/2007/10/blog-post_13.html; Jacob Deschin, "Photography," *NYT*, 1/26/1969, and BA, draft response, n.d., CG; Philip Wittenberg to BA, CTL, 1/29/1969, SBB/BA.

6 Lee D. Witkin to BA, TLS, 1/2/1969, CG; Witkin Gallery Press Release no. 1, n.d., CG; Lee Witkin to BA, TLS, 1/30/1969, CG; Jacob Deschin, "Photography: Atget Cross-Section," *NYT*, 5/11/1969; Lee Witkin, *A Ten Year Salute: A Selection of Photographs in Celebration* (Danbury, NH: Addison House, 1979), 116.

7 Lee Witkin to BA, TLS, 8/15/1969, CG; BA to Lee Witkin, ALS, 8/25/1969, Lee Witkin Papers, CCP; BAOH, 212.

8 David Haberstich, Smithsonian Institution, to BA, TLS, 4/25/1969, CG; *Das Furchtlose Auge*, Leiser (1984); Secrest, "An Attic Studio."

9 IS, 10/21/1969; BA BlkJ, 175; Julia Dean, "The Last Apprentice [diary]," Julia Dean Photography, 9/21/1978, accessed 7/17/2012, http://juliadean.com/category/berenice-abbott-blog/page/7/;Todd Watts, phone CWA, 3/21/2012; Jack Sullivan and Coburn Britton, *Letters from Jack: Sex & Hell in Manhattan and Backwoods Maine: Being the Jack Sullivan–Coburn Britton Correspondence, 1971–1982*, ed. John Anderson ([United States]: Xlibris Corp., 2002), 40, 41, 45–46.

10 Checklist for *Atget*, exhibition shown at MoMA, 12/1/1960–3/22/1970: "Atget: [exhibition], December 1, 1969 through March 22 [*sic*, 24], 1970: checklist, [...] 118 works from the Atget collection donated [!] by Berenice Abbott to the Museum," Atget 1969–70 exhibition file, MoMA Library; Jacob Deschin, "Museum Samples Atget," *NYT*, 11/30/1969; Tom Halstead to BA, TLsS, 3/26/1972, 11/16/1972, 12/18/1972, and 12/19/1972, SBB/BA.

11 ES&PS.

12 BA BlkJ, 174–175; IS, 1/17/1968 and 10/21/1969; Sol Libsohn, CWA and Tony Troncale, Roosevelt, NJ, 4/21/1993; BA to ES&PS, ALS, 11/7/1967, JVH files; BA to Shwachman, ALS, 11/22/1967, IS/CCP.

13 IS, 8/31/1970.

14 ES&PS; ES to JVH, TLS, 4/26/2003; MCNY agreement, TLS, Mar. 1970, CG.

15 BA, *Photographs*; David Vestal to JVH, TLS, 6/7/2012, JVH files; Model quoted by William Frederick Tropp to BA, ALS, 9/6/1983, SBB/BA.

16 BA to Solita Solano, ALS, 1/2/1971, Janet Flanner and Solita Solano papers, Library of Congress; Mig Shepard, CWA, NYC, 6/10/1992 and 6/30/1992.

17 BA BlkJ, 194.

18 John Szarkowski, MoMA, to Dr/M Schwachman [*sic*], TLS. 11/30/1970, IS/CCP; IS, 8/29/1970; AWT/BA; BAOH, 497–498; Hilton Kramer, "Miss

Abbott: 63 Photographs At the Modern," *NYT*, 12/11/1970; Shwachman to John Szarkowski, electrostatic copy, 1/11/1971, IS/CCP.

19 Nancy Bicknell Taber, "Harper's Bazaar Cites Maine Woman," *Maine Sunday Telegram*, 1/24/1971; Jim McQuaid notes, MoMA BA vertical file; Tom Halstead, TLS, Nov. 1971, SBB/BA; ES to JVH, TLS, 4/20/2003, JVH files; Sullivan, *Letters from Jack*, 26, 156; Denise Lassimonne and Howard Ferguson, *Myra Hess* (New York: Vanguard Press, 1966).

20 IS, 1/21/1972; ES&PS; ES to JVH, TLS, 4/20/2003, JVH files.

21 Franklin, *Profiles of Maine*, 18–21; Berman, "The Unflinching Eye," 88; IS, 9/19/1971; "The Concerned Photographers Lecture Series," International Center of Photography, accessed 6/4/2012, http://lectures.icp.edu/about/Concerned .html.

22 IS, 12/2/1971 and 12/12/1971; BA to M/M Edward Schwartz, ALS, pmk. 12/6/1971, JVH files; organized by Becky Hatch, cf. her correspondence 3/3– 4/5/1972, SBB/BA; Jewett Arts Center, Main Corridor Gallery: BA, Maria [sic] Cosindas, Nell Dorr, Lotte Jacobi, Wendy Snyder MacNeil, Esther McLean, Barbara Morgan, Gerda Peterich, Olive Pierce, Hope Zanes; BA to Solita Solano, ALS [Solano annotated it, "the famous photographer"], 6/18/1972, Janet Flanner and Solita Solano papers, Library of Congress.

23 Carl Willers to BA, TLsS, 9/28/1972 to Dec. 1973, SBB/BA; Jo-Ann Conklin, *Photographs from the Collection of Carlton Willers* ([Iowa City?]: University of Iowa Museum of Art, 1993), 8; Dennis Traub, phone CWA, 6/12/2012; BA BlkJ, 176–177; IS, 5/25/1973; perhaps the values parallel, or reflect awareness of, similar personal numerical naming, such as Eileen Gray's of her famed 1920s house, E. 1027, on the French Riviera.

24 Anne Tucker, *The Woman's Eye* (New York: Knopf [distributed by Random House], 1973); Tucker to BA, TLS, countersigned as accepted by BA, 3/6/1973, AWT/BA; Tucker to BA, TLS, 10/19/1973, SBB/BA; BAOH, 659–661; BA to Tucker, ALS, n.d. [May/June 1973], and BA to Tucker, ALS, n.d., received 6/6/1973, AWT/ BA; IS, 5/25/1973; Doane Eaton to BA, TLS, 1/3/1974, SBB/BA.

25 BAOH, 498; Hilton Kramer, "Berenice Abbott," *NYT*, 9/15/1973; BA BlkJ, 176–177; Lee Witkin to BA, TLS, 7/23/1973, SBB/BA; recipe on verso, BA Witkin Gallery exhibition announcement, SBB/BA; Sullivan, *Letters from Jack*, 163.

26 BAOH, 603–604.

27 IS, 5/25/1973; BAOH, 603–604; Grace Glueck, "One Art Dealer Who's Still a High Roller," *NYT*, 6/24/1991.

28 Hank O'Neal's website, accessed 6/6/2012, http://www.hankoneal.com/;

Eddie Condon and Hank O'Neal, *The Eddie Condon Scrapbook of Jazz* (New York: St. Martin's Press, 1973); O'Neal, BA memorial; O'Neal, CWA, Monson, ME, NYC, 7/17–19/1998, and NYC, 4/20/1999.

29 Juliette M. Moran, interview by Laura Sweeney, 2001, transcript in "Women in Chemistry Oral History Project," MS 650, Archives of Women in Science and Engineering, Special Collections Department, Iowa State University Library; HON, CWA, NYC, 2/23/1993; Juliette M. Moran, CWA, NYC, 11/11/1994 (portfolio #31, showing the Parthenon in 1923 and Moran's Paris street).

30 Todd Watts, phone CWA, 3/21/2012; cf. BA, *Herald Square, 34th and Broadway, Manhattan*, 7/16/1936, ref. no. CNY# 145, NYPL; BAOH, 371.

31 IS, 12/12/1971 and 1/21/1972; Harvey Doane Eaton, *How to Find Facts* (Washington, DC: Army Industrial College, 1938); BA to Macmillan Publishers, CTL, 2/28/1973, CG; Doane Eaton, draft, 11/11/1973, and to BA, TLS, Dec. 1973, SBB/BA.

32 Kay Larson, "Talking to Berenice Abbott," *Boston Real Paper* 3, no. 9, 2/27/1974, 16+, and Larson, "Art Around Town," *Boston Real Paper* 3, no. 10, 3/9/1974, 35+; Kay Larson to JVH, email, 7/7/2012; event announcement, IS/CCP; IS, 2/5/1974 and 2/10/1974; Olive Pierce, phone CWA, 10/4/2010; Shwachman to BA, TLS XC, 2/11/1974, IS/CCP.

33 Lee Witkin to BA, 12/26/1973, SBB/BA; IS, 3/31/1964; 1040 IRS for 1973 (4/8/1974), SBB/BA. Lee Witkin to BA, ALS, 3/8/1974; Witkin to BA, TLS, 6/21/1974; and Witkin to BA, ALS, 6/30/1974, SBB/BA.

34 *Man Ray: Photo Graphics* and *Arnold Crane Photographs*, 1/11–2/3/1974; IS, 2/5/1974 and 2/10/1974; BAOH, 600–603; IS, 2/5/1974 and 2/10/1974; BA to Marchal Landgren, ALS, 4/23/1974, Landgren papers, AAA.

35 HHL to BA, CTL, 2/11/1974; BA to HHL, ALS, 2/19/1974; HHL to BA, CTL, 3/2/1974; JVH files; HHL to BA, signed receipt on BA's Blanchard ME letterhead, 7/30/1975, CG; HHL; *Cocteau's Hands* in exhibition recorded in Julie Saul, ed., *Jean Cocteau: The Mirror and the Mask: A Photo-Biography*, with an essay by Francis Steegmuller (Boston: D. R. Godine, 1992).

36 IS, 5/11/1969, 2/5/1974, and 2/10/1974; Dan Berley to BA, ALS, 5/20/1974 (for 50 portfolios), SBB/BA.

37 Doane Eaton to BA, TLS, 1/3/1974, SBB/BA; BAOH, 408–410; Todd Watts, phone CWA, 3/21/2012; BAOH, 409–410; their practice was similar for specific popular images such as *Night View* and others BA sold directly to individuals— even so, *Night View* was then Witkin's overall second-best-selling print.

38 Jane Merrill Filstrup, "The Education of Dan Berley," *Connoisseur* 210 (May 1982), 108–111; Dan Berley to BA, TLS, 6/28/1974, SBB/BA.

39 Lida Moser, CWA, NYC, 8/24/1998; BAOH, 77–80; Lida Moser, "Printing

Session with Berenice Abbott," *NYT*, 11/30/1975; BA to Dieuzaide, CTL, 7/3/1977, SBB/BA; Dan Berley to BA, TLS, 5/21/1975, SBB/BA.

40 BAOH, 493–494; Lynn Davis, phone CWA, 1/7/2001; BA BlkJ, 177; Todd Watts, phone CWA, 3/21/2012.

41 Lynn Davis, phone CWA, 1/7/2001; AWT/BA; BAOH, 66, 353–354, 361.

42 Lida Moser, CWA, NYC, 8/24/1998; BAOH, 77–80; Moser, "Printing Session with Berenice Abbott." BA BlkJ, 177.

43 BA Witkin-Berley Prospectus, SBB/BA; BA to Joseph Veach Noble, Director, MCNY, CTL, 9/10/1974, CG; John Veach Noble to BA, XC, 9/20/1974, CG; Steve Miller, CWA, NYC, 9/27/2011; BAOH, 316–320, 342.

44 BA IRS 1974 return, 3/20/1975, SBB/BA; BAOH, 494–495.

45 BAOH, 494–495; Sullivan, *Letters from Jack*, 224, 226.

46 Alden C. Wilson, Executive Director, Maine State Commission on the Arts and Humanities, TLS, 10/29/1974, CG; Bongartz, "The Unflinching Eye," 54; ES&PS, and CWA, 4/17/2003; SBB, CWA, n.d.

47 BAOH, 408.

48 Richard Blodgett, "Blow Up—The Story of Photography In Today's Art Market," *NYT*, 10/12/1975; HHL to BA, TLS, 2/2/1975, SBB/BA; BAOH, 559.

49 Local people tried to hire her for portrait work: Doane Eaton to BA, TLsS, 10/26/1973 and 1/3/1974; and Bill Cummings, TLS, 5/13/1975, SBB/BA; Ben Raeburn to BA, ALS, BA felt pen notes on verso, 11/25/1975, SBB/BA; Frances Fralin, Corcoran Gallery, to BA, 12/2/1975, JVH files, cf. "History of Corcoran Exhibitions," accessed 6/26/2012, http://www.corcoran.org/exhibitions/past-exhibitions/archives/1976.

50 BAOH, 285, 347–348; Pierre Levai, Marlborough, and Harry Lunn, Graphics Int., to BA, TLS, 7/28/1975, SBB/BA; Edith Evans Asbury, "Rothko Lauded as Estate Suit Begins," *NYT*, 2/15/1974; Kate Rothko v. Bernard J. Reis, Theodoros Stamos, and Morton Levine, "For a Decree Revoking Letters Testamentary of the Last Will and Testament of Mark Rothko," 1976, Supreme Court of the State of New York, Appellate Division; Paul Katz, phone CWA, 8/4/2011.

51 Steven Lewis, James McQuaid, and David Tait, *Photography: Source & Resource; A Source Book for Creative Photography* (State College, PA: Turnip Press; distributed by Light Impressions, Rochester, NY, 1973); Jim McQuaid, phone CWA, 7/12/2011.

52 BAOH, 112–113, 186; Jim McQuaid, phone CWA, 7/12/2011; BA, interview by James McQuaid and David Tait, *Interview with Berenice Abbott*, 2 vols., 1978, transcript; the original reel-to-reel audio tapes were among materials Susan Blatchford gifted to NYPL, but are not among those processed as of July 2012.

1 John Duka, "For the Fine Art of Collecting Photography, a Newfound Status," *NYT*, 11/19/1980.

2 BA to Stuart E. Hayes, CTL, 1/3/1976, JVH files.

3 Secrest, "An Attic Studio"; Harold Jones to Bob Feldman, TLS, 6/2/1975, replying to his of May 6, with clipping of "New Museum Focuses on Photography," *NYT*, 5/16/1975; Jones to BA, TLsS, 7/22/1975 and 10/6/1975, SBB/BA.

4 BAOH, 352; BA to Paul Katz for Marlborough Gallery Inc. and to Harry Lunn for Graphics International Ltd., signed letter of agreement, 7/30/1975, CG; HHL; Paul Katz, phone CWA, 8/4/2011.

5 BA BlkJ, 177; SBB, CWA, Monson, ME, 1/30/1999.

6 Corcoran Museum press releases, Marchal Landgren papers, AAA; "How a Street Photographer Became an Artist," *NYT*, 11/2/1975; Sullivan, *Letters from Jack*, 333; Joan Murray, "Berenice Abbott and Lisette Model," *ArtWeek*, n.d. clipping in Focus Gallery records, AAA; Graphics International to Helen Johnson, Focus Gallery, TL, 10/9/1975, and press release, Focus Gallery Records, AAA.

7 BA, *10 Photographs* (Roslyn Heights, NY: Witkin-Berley Ltd., 1976). Edition of 50.

8 HHL; Loretta Baum, Marlborough, to BA, TLS, 8/13/1975, CG; receipts to Paul Katz on BA letterhead, 10/4/1975, CG; Lee Marks, Marlborough, to Harry H. Lunn Jr., TLS, France, 8/21/1975; Lunn to BA, CTL, 11/6/1975; Lunn to BA, CTL, 12/20/1975; and BA to Mr. Hayes, CTL, 1/3/1976; and Lunn to BA, CTL, 1/15/1976, all JVH files; Lunn to Lee Witkin, TLS, 1/15/1976, Witkin papers, CCP (also Lunn to BA, CTL, CG); Witkin to BA, TLS, 11/3/1975, and typed list of 69 prints returned to BA, with Witkin to BA, ALS, 1/21/1976, SBB/BA.

9 IS, 9/29/1979; BA BlkJ, 179–180; Leticia Kent, CWA, NYC, 9/16/1993; Lisette Model, *Lisette Model* (Washington, DC: Lunn Gallery/Graphics International, 1976), Edition of 75; see also BA, "Introduction," in Model, *Lisette Model* (Millerton, NY: Aperture, 1979); Hilton Kramer, "Photography," *NYT*, 11/25/1979; Patricia Schwarzwalder, Graphics International, to BA, TLS, 10/25/1977, CG; Ralph Steiner to BA, TLS, 5/12/[1974], SBB/BA.

10 Todd Watts, phone CWA, n.d. 2012; see, for example, Lee D. Witkin and Barbara London, *The Photograph Collector's Guide* (Boston: New York Graphic Society, 1980), 29–45.

11 HHL; *Berenice Abbott*, exhibition shown at Marlborough Gallery, NYC, 1/6–24/1976, and at Lunn Gallery/Graphics International Ltd., Washington, DC, 4/3–5/10/1976; exhibition opening invitations in MoMA BA file, also in

Marchal Landgren papers, AAA, and in IS/CCP; Tony Smith, phone CWA, 2/23/2012; Ella Jaffe Freidus, CWA, NYC, 7/10/1992.

12 Agreement signed by Harry H. Lunn Jr. for Graphics International and Pierre Levai for Marlborough, plus BA, who dated her signature 1/6/1976, SBB/BA; Leslie Katz to BA, TLS, 4/8/1975, SBB/BA; ES&PS.

13 Hilton Kramer, "Art: The Photography of Berenice Abbott," *NYT*, 1/10/1976; Gene Thornton, "Abbott's Old-Fashioned Modernism," *NYT*, 1/11/1976.

14 HHL; Paul Katz, Marlborough, to Bettmann Archive, CTL to BA with ms note, 3/6/1976, CG; Maria Morris, "Summary of interview with Berenice Abbott, April 19, 1978," 2, MoMA Photo Dept.

15 HHL; Tom Zito, "Abbott: Glimpses of the Artiste," *Washington Post*, 4/3/1976; Zit[o], "Subject of Her Photos 'Humanoids,' Mostly," *Times-Picayune* (New Orleans, LA), 5/16/1976; Zito, "The Good Old Days—Paris in the '20s."

16 Marlene Park to Harry H. Lund [*sic*, Lunn] Jr., Graphics International, TLS, 4/1/1976, and Maurizia Grossman for Lunn to Marlene Park, CTL, 6/9/1976, JVH files; Marlene Park and Gerald E. Markowitz, *New Deal for Art: The Government Art Projects of the 1930s with Examples from New York City & State* (Hamilton, NY: Gallery Association of New York State, 1977); Hank O'Neal, *A Vision Shared: A Classic Portrait of America and Its People, 1935–1943* (New York: St. Martin's, 1976); O'Neal to BA, TLS, 6/27/[1976, dateable from external evidence], SBB/BA; Farah Jasmine Griffin, *Harlem Nocturne: Women Artists & Progressive Politics During World War II* (New York: Basic Civitas, 2013); James "Jim" Ringo to BA, TLS, 7/11/1967, SBB/BA; HON, CWA, NYC, 4/19/2011.

17 BAOH, 561.

18 Cheryl Greaney to BA, ALS, 6/19/1975, and BA BlkJ, 178–179; Greaney, phone CWA, 6/25/2012.

19 Greaney, "Regretta"; custom-made enlarger cost more than $6,000, and had a range of Schneider lenses; it was so tall it required a ladder to install the components required for differently sized negatives—Greaney set it up in the morning and "put it to bed at night"; Greaney, phone CWA, 6/25/2012; Leticia Kent, CWA, NYC, 9/16/1993.

20 Greaney, phone CWA, 6/25/2012.

21 BA BlkJ, 178; Frances Doughty to BA, 9/19/1976, CG, cf. Doughty, "Lesbian Biography, Biography of Lesbians," *Frontiers: A Journal of Women Studies* 4, no. 3, "Lesbian History" (Autumn 1979), 76–79; Sullivan, *Letters from Jack*, 127.

22 Paul Katz, Marlborough, to BA, 9/30/1976, CG; HON to BA, TLS, 8/25/1976, CG; IS entries for Oct. 1976; Lunn to BA, CTL, 8/19/1976, JVH files; Artner, "New York's Visual Power, Seen through Abbott's Loving Lens"; Mitchell, *Recollections*, 13.

23 Arthur Rothstein to BA, TLS, 12/1/1976, SBB/BA; cf. *Blossom Restaurant* inscribed to Rothstein: Doyle, New York, "The Arthur Rothstein Photograph Collection," Sale 11AR01, Lot 160 (10/13/2011); BA BlkJ, 178; Shelby family Christmas note to BA, Dec. 1976, CG; James F. Dickinson, Westbrook College, to BA, TLsS, 4/14/1977 and 6/21/1977, SBB/BA; Bongartz, "The Unflinching Eye," 53.

24 "Dorothy Murphy Healy," Maine Women's Hall of Fame, University of Maine at Augusta, accessed 6/27/2012, http://www.uma.edu/mwhof-dhealy.html; Greaney, "Regretta."

25 Dorothy Healy to BA, TLsS, 6/14/1977, 8/15/1977, and 9/1/1977, SBB/BA; BA BlkJ, 46 (12/5/1977); Cheryl Greaney, phone CWA, 6/25/2012.

26 Hank O'Neal, "For Berenice's 100th Birthday: The Summer of 1978," unpublished TS distributed 7/18/1998 in Monson, ME, JVH files; Julia Dean, "The Last Apprentice, 1978–1979 and Epilogue," Julia Dean Photography, 2010, accessed 2011–2012, http://juliadean.com/category/berenice-abbott-blog/page/15/, [navigation for this blog is in chronological order, newer to older]; OH interviewer Jim McQuaid and his wife joined BA and prepared the turkey for Thanksgiving 1977, cf. Art Siegel OH, Oct. 1977, George Eastman Museum Library.

27 Marius B. Péladeau to BA, TLS, 1/30/1978, CG; Norma Boom Marin to BA, 7/29/1978, CG; Michael Sundell to BA, TLS, 2/1/1978, SBB/BA, see also Michael G. Sundell, *Berenice Abbott: Documentary Photographs of the 1930s* (Cleveland: New Gallery of Contemporary Art Cleveland, 1980); Morrill Cody to BA, TLS, re *The Women of Montparnasse*, by Morrill Cody with Hugh D. Ford (New York: Cornwall Books, 1984), 1/1/1978, SBB/BA; Andrew Field to BA, 2/17/1978, and later, SBB/BA.

28 O'Neal, *"Life Is Painful,"* xiii, 1–2, 4, 29, 144–145.

29 Acknowledgments in *Women, the Arts, and the 1920s in Paris and New York*, eds. Kenneth W. Wheeler and Virginia Lee Lussier (New Brunswick: Transaction, 1982), vii; BA, CWA, Monson, ME, 11/8/1991; Janet Flanner, *Darlinghissima: Letters to a Friend*, ed. Natalia Danesi Murray (New York: Random House, 1985), 495; BA, "Notes," SBB/BA; Leslie Bennett, "Creative Women of the 20s Who Helped to Pave the Way," *NYT*, 4/10/1978.

30 Ella Jaffe Freidus, CWA, NYC, 7/10/1992.

31 Ute Eskildsen, Museum Folkwang Essen, to BA, TLS, 3/28/1978, CG; ES&PS; ES to JVH, TLS, 4/17/2003, JVH files; Anne Tucker, *Photographic Crossroads: The Photo League/Carrefour Photographique: La Photo League* (Ottawa: National Gallery of Canada for the Corporation of the National Museums of Canada, 1978), exhibition catalog; Lida Moser, CWA, NYC, 8/24/1998; Christopher Lehmann-Haupt, "Books of The Times; 'Lens Is Uncritical' Form of Photograph," *NYT*,

5/31/1978, and Anne Tyler, "The Artist as an Old Photographer; Theroux," *NYT Book Review* (6/18/1978); IS, 12/9/1964; BA to Lee Witkin, ALS, n.d., Witkin Gallery papers, CCP; Rose Hass to BA, TLS, 6/5/1978, SBB/BA.

32 O'Neal, "For Berenice's 100th Birthday." Despite her intentions, Anne Tucker let lapse her 1970s work on McCausland. No monograph or biography has yet appeared on the "critic with a conscience," cf. Susan Noyes Platt, "Elizabeth McCausland: Art, Politics, and Sexuality," in *Women Artists and Modernism*, ed. Kary Deepwell (Manchester, UK: Manchester University Press, 1998); Susan Noyes Platt, *Art and Politics in the 1930s: Americanism, Marxism, Modernism* (New York: Midmarch Arts Press, 1999), chap. 5, "Critic with a Conscience: Elizabeth McCausland at the *Springfield Republican*," 65–79; and Susan Dodge-Peters, "Elizabeth McCausland on Photography," *Afterimage* 12 (May 1985), 10–15, cited in Terri Weissman, *The Realisms of Berenice Abbott*, 217n9. Dean, "The Last Apprentice," accessed 6/29/2011, http://juliadean.com/k6.

33 Trausch, "Portrait of the Photographer"; Julia Dean, "The Last Apprentice," Julia Dean Photography, 10/14/1978, accessed 7/17/2012, http://juliadean .com/category/berenice-abbott-blog/page/5/, and "The Last Apprentice," 11/28/1978, accessed 7/17/2012, http://juliadean.com/category/berenice-abbott -blog/page/4/.

34 BA BlkJ, 179; Julia Dean, "The Last Apprentice," Julia Dean Photography, accessed 7/17/2012, http://juliadean.com/category/berenice-abbott-blog/page /9/; Crissie Haft, phone CWA, 7/16/2012; O'Neal, "For Berenice's 100th Birthday"; Bongartz, "The Unflinching Eye," 57; AWT/BA.

35 Robert Feldman, Parasol Press Ltd., to BA, ALS, 7/25/1978, SBB/BA; Maurizia Grossman, Graphics International, to BA, TLS, 9/22/1978, CG; Dean, "The Last Apprentice," 11/28/1978, http://juliadean.com/category/berenice-abbott-blog/page/4/; "Berenice Abbott Photographs," list on Marlborough letterhead, annotated, n.d., CG.

36 Dr. Mary H. Hudson to Dr. Harry Shwachman, TLS, 8/3/1978, IS/CCP; Dr. Shwachman to Dr. Hudson, CTL, 8/9/1978, SBB/BA; HHL; Dean, "The Last Apprentice," 10/14/1978, http://juliadean.com/category/berenice-abbott-blog /page/5/; Crissie Haft, phone CWA, 7/16/2012; BA's New York portfolios, *New York*, plus *II*, *III*, and *IV* (all 1979): 12 silver prints each from original negatives of the 1930s, published by Parasol Press, Ltd., NY, in editions of 60 numbered editions plus five artist's proofs, lettered A–E, cf. Nancy Tousley, *The Berenice Abbott Portfolios* (Calgary, AB: Glenbow Museum, 1982), 46–47; all mounted prints are all signed "BERENICE ABBOTT" by the artist in pencil at the lower right and numbered or lettered by the artist in pencil at the lower left; *Faces of the '20s* and first *NY* are on 51 × 41 cm mounts; other three NY portfolios are larger, on

76 × 61 cm mounts, cf. Parasol Press, "Berenice Abbott," Parasol Editions Gallery, accessed through early 2012, http://www.parasolpress.com/ and http://www.parasolpress.com/parasol-editions/abbott_berenice/index.html.

37 BA, in Sarah Lawrence College Writer's Conference in Honor of Muriel Rukeyser, 12/9/1978, audio recording of the panel, Sarah Lawrence College, Bronxville, NY, Sarah Lawrence College Archives.

38 Jane Cooper to BA, TLS, 7/5/1978, CG/S; Susan Dodge Peters to BA, ALS, 8/30/1978, SBB/BA; on view Nov. 26–Dec. 20 before traveling to SUNY New Paltz in early 1979; Rukeyser, "An Unborn Poet, for Alice Walker," in *The Collected Poems of Muriel Rukeyser*, 200–201.

39 Beverley van Dijk, Sarah Lawrence College, to BA, TLsS, 12/20/1978 and 2/1/1979, CG/S; Sarah Lawrence College Writer's Conference in Honor of Muriel Rukeyser, 12/9/1978, audio recording; Christine Gratto, Learning from Performers, Harvard University, TLsS, 11/16/1978 and Dec. 1978, CG; BA, *Slide Talk by Photographer Berenice Abbott*, Learning From Performers (Cambridge, MA: Office for the Arts at Harvard & Radcliffe, 1978), 2 audiotape reels, 106 min., Harvard University Archives, accessed 7/12/2012, http://www.worldcat.org/title/slide-talk-by-photographer-berenice-abbott/oclc/77065303; ironically, the previous Carpenter Center guest in the series had been gallerist Julien Levy, who spoke and showed films for two days; Hugh Gourley III, Colby College, to BA, TLS, 12/4/1978, CG.

40 BA BlkJ, 185–186; Julia Dean, "The Last Apprentice," 8/22/1978, accessed 7/17/2012, http://juliadean.com/category/berenice-abbott-blog/page/10/; "The Last Apprentice," 11/28/1978, accessed 7/17/2012, http://juliadean.com/category/berenice-abbott-blog/page/4/; and "The Last Apprentice," 2/8/1979, accessed 6/29/2011, http://juliadean.com/Rn; O'Neal, "For Berenice's 100th Birthday"; Julie Dean to Alice Ross, PC, pmk. 2/27/1979, SBB/BA; Mary Virginia Junk, phone CWA, 7/8/1992.

41 IS, entries after Dec. 1978, and 5/20/1979; Galerie Zabriskie to BA, various dates, SBB/BA; Virginia Zabriskie, *Au revoir Paris: 22 ans d'art à la Galerie Zabriskie* (Paris: The Gallery, 1998), 7; Susan Joy Slack, *Zabriskie: Fifty Years* (New York: Ruder Finn, 2004); Hilton Kramer, "Berenice Abbott," *Art & Antiques* 9, no. 2 (Feb. 1992), 75–77; Hilton Kramer, "Virginia Zabriskie: Her Paris Adventure Showed Atget, Abbott," *New York Observer*, 2/21/2005; Jane Mayhall to BA, TLS, 3/11/1979, SBB/BA; Hilton Kramer, "Critic's Notebook: Berenice Abbott," *NYT*, 7/9/1979.

42 IS, 5/20/1979; Russell, "Her Camera"; Cupic, "Berenice Abbott: 'The World Today Has Been Conditioned to Visualize'"; Lunn, "Regretta"; Leticia Kent, phone CWA, June 1991; Hilton Kramer, "Photography," review of *Atget's*

Gardens: A Selection of Eugène Atget's Garden Photographs, by William Howard Adams (Garden City, NY: Doubleday, 1979), *NYT*, 11/25/1979; William M. Kuhn, *Reading Jackie: Her Autobiography in Books* (New York: Nan A. Talese/ Doubleday, 2010), 40–41+.

43 Ben Raeburn to HON, TLsS, XC to BA, 5/10/1979, and Raeburn to BA, ALS, n.d. [missing from this correspondence are copies Raeburn refers to as O'Neal's edited MSs, though marks on the letters and notes indicate they were likely clipped together], SBB/BA; Paul Katz to BA, TLS, 6/27/1979, SBB/BA; BA BlkJ, 179–180; IS, 12/22/1980; Kuhn, *Reading Jackie*, 62; HON/BA.

44 Ruth Bernhard, phone CWA, 1/20/1998; Mitchell, *Ruth Bernhard*, 58.

45 Helen Ann and Ross Robbins to BA, ALS, 7/16/1979, SBB/BA; Sophie Victor and Stephen Greene to BA, ALS, 6/15/1979 (two versions), and Stephen Greene to BA, TLS, 10/6/1979, SBB/BA; BA and Bob Feldman signed letter of agreement, XC, 8/16/1979, SBB/BA.

46 Phyllis Lambert to BA, TLS, 11/14/1979, SBB/BA; IS, 11/3–18/1979.

47 Dennis W. Traub, phone CWA, 6/12/2012; cf. IRS filings and audit for 1979— income averaging helped BA reduce her tax bill of $17,000+ by $2,000+ on an adjusted gross income of $55,000+ ($196,000+ in 2017), in SBB/BA; Juliette Moran, CWA, NYC, 11/11/1994; HHL.

48 Cheryl Greaney, phone CWA, 6/25/2012; BAOH, 295; Phyllis Lambert to BA, TLS, 11/14/1979, SBB/BA; IS, 11/3–18/1979; BA and Guardian Trust Co. contract, 3/13/1980, SBB/BA; HHL; Cheryl Greaney, CWA, 6/25/2012; BA, small black ring binder with lined paper, devoted mostly to this topic, SBB/BA.

49 Leticia Kent, CWA, 6/15/1992 and 9/9/1993; Charles Rotkin, CWA, 3/28/1996; Greaney, "Regretta"; IS, 9/29/1979; Anne-Marie Schiro, "Modern Museum, 50, Has a 20's Party," *NYT*, 11/15/1979; Honor Moore to BA, TLS, 1/18/1980, SBB/BA; Louise Bernikow to JVH, email, 3/25/2014.

50 IS, 5/20/1979; Algis Kemezys, phone CWA, 9/26/2012; Mig Shepard, CWA, NYC, 7/10–31/1992; BA BlkJ, 180.

51 "Seen & Heard at ArtExpo – Berenice Abbott Portfolio," *The Photograph Collector* 2, no. 3 (3/15/1981), 1; Bob Feldman to BA, ALS, 4/28/1981, SBB/BA; Feldman to BA, CTL, 1/6/1980, and bill of sale to BA, TLS, 1/30/1980, SBB/ BA; Todd Watts, phone CWA, 3/21/2012.

52 Robert Feldman, Parasol Press, with BA letter of agreement, CTL, 11/5/1979, SBB/BA; Todd Watts didn't print the "French *Night View*" image in this quantity; Abbott archive purchaser Ron Kurtz has conjectured that the distinctive 1980s prints of *Night View* still in circulation are from the deal with French, for in 1985 French tried to sell the remainder of his batch to Kurtz; BA seems to have resumed processing orders for her former dealers, too, cf. Graphics Inter-

national and related files, such as "Price list, 7/17/1980," in CG, and Witkin Gallery files in SBB/BA; B. Cohen to BA, ALS, 8/31/1981, SBB/BA.

53 BA BlkJ, 179–180, 186; James "Jim" Ringo to BA, TLS, 11/19/1974, SBB/BA; "Erwin Leiser, a Maker of Films About the Nazi Era, Dies at 73," *NYT*, 8/26/1996; Dennis P. Curtin and Joe DeMaio, *The Darkroom Handbook: A Complete Guide to the Best Design, Construction, and Equipment* (Marblehead, MA: Curtin & London, 1979); *Das Furchtlose Auge*, Leiser (1984); Leiser to Bill Sloan, MoMA Film Dept., TLS, Jan. 1982, MoMA Photo Dept.; Erwin Leiser, *Auf der Suche nach Wirklichkeit: meine Filme 1960–1996* (Konstanz: UVK-Medien, 1996), 156–158.

54 Malcolm Cowley to Kenneth Burke, TLS, n.d. [dateable to about 11/20/1980 from internal/external evidence], Burke papers, Penn State Library; Bob Feldman to BA, CTL, 11/13/1980, and XC of BA's signed copy, 11/20/1980, SBB/BA; Malcolm Cowley, Leon Edel, Berenice Abbott, Daniel Keleher, and Laurie H. Rippon, *Exile's Return: A Literary Odyssey of the 1920s* (New York: Limited Editions Club, 1981); Michael Halsband, "Self-Portrait," *ARTnews* 80 (Jan. 1981), 6; Berman, "The Unflinching Eye," 86–93.

55 Russell, "Her Camera"; John Russell to BA, ALS, 10/18/1980, SBB/BA; BA to Mary Ann Anderson, telegram, 1/26/1981, SBB/BA; Lorraine Davis for BA to Robert W. Wagner, Ohio State University, CTL, 2/12/1981, SBB/BA; Anderson, "Berenice Abbott, American Photographer," 4 [copy in SBB/BA]; Mary Ann Anderson to BA, TLS, 5/5/1981, SBB/BA.

56 Berman, "The Unflinching Eye," 93.

57 Jean C. DeIeso, phone CWA, 8/28/2012.

58 Bowman 1981 correspondence in SBB/BA; Leticia Kent, CWA, NYC, 9/15/1993; Ella Freidus, CWA, NYC, 7/12/1992; IS, 7/15/1981; BA BlkJ, 181.

59 New School to BA, Apr. 1981 correspondence and June 1981 program, SBB/BA; Ronald Reagan to BA, telegram, 6/4 or 5/1981, SBB/BA; Lee Marks to BA, various TLsS, 1981–1982, SBB/BA; BA BlkJ, 181; Jacob Deschin, "Viewpoint: Award to Berenice Abbott," *Popular Photography* 88 (Dec. 1981), 46; AIPAD Award program, 11/6/1981, SBB/BA.

60 Zabriskie Gallery info and ICP flyer in IS/CCP; Houk Gallery reception notice in Witkin Gallery papers, CCP; BA BlkJ, 181; Cornell Capa to BA, TLS, 11/20/1981, SBB/BA.

61 BA BlkJ, 181; Szarkowski and Hambourg, *The Work of Atget*, vol. 1; Ben Lifson, "The Woman Who Rescued Atget's Work," *Saturday Review* 8 (Oct. 1981), 30–31; Kay Larson "Abbott and Atget," *New York Magazine* 14 (12/7/1981), 150–151; Marcuse Pfeiffer Gallery press release, IS/CCP; Vicki Goldberg, ed., *Photography in Print: Writings from 1816 to the Present* (New York: Simon & Schus-

ter, 1981); Richard Whelan, "Are Women Better Photographers Than Men?" *ARTnews* 79, no. 8 (Oct. 1980); Caroline Bird, *What Women Want* (1979), title page inscription to BA, in Lucy B. Dillon (Blatchford-Abbott) publication collection, donated to MIT Museum 2012.

62 Andy Grundberg, "In New York City, Berenice Abbott Found Her Best Subject," Photography View, *NYT*, 12/12/1982; BA BlkJ, 182 [Ella Friedus bought and then donated 29 prints]; IS, 4/4/1982; Lee Marks to BA, TLS, 2/3/1982, SBB/BA; Mrs. Mary Miller, Springfield, OH, to BA, TLS, 1/19/1982, SBB/BA; BA to Paula Gerson, CTL, 2/10/1982, SBB/BA; Women's Caucus for Art, *Women's Caucus for Art Honor Awards: Berenice Abbott, Elsie Driggs, Elizabeth Gilmore Holt, Katharine Kuh, Charmion Von Wiegand, Claire Zeisler: [4th Honor Award Ceremony for Outstanding Achievement in the Visual Arts]*, San Francisco: Women's Caucus for Art, 1982; BA to JEB Gallery, CTL, 4/22/1982, SBB/BA; IS, 4/4/1982 and 5/21/1982; Dianora Niccolini, ed., *Women of Vision: Photographic Statements by Twenty Women Photographers* (Verona, NJ: Unicorn, 1982); Dianora Niccolini to JVH, email, 8/29/2012; Nina Rosenblum Allentuck to BA, TLS, 5/11/1982, CG.

63 ES&PS; ES to JVH, TLS, 4/17/2003, and ES to JVH, ALS, 5/27/1995, JVH files; ES to HON, ALS, 4/28/1982, fair copy of original in JVH files; HON to ES, ALS, 5/30/1982, JVH files.

64 Willa Percival, International Photography Society, Washington, DC, to BA, TLS, 3/25/1982, SBB/BA; Barbara Nosanow, National Museum of American Art, business correspondence and event photos, 1982, SBB/BA; Lillian Hellman to BA, TLS, 8/14/1982, SBB/BA; IS, 4/29–30/1961 and 7/3/1982; SBB, CWA, Monson, ME, Apr. 1992; I. Bernard Cohen, BA memorial; Jules Feiffer quoted in Deborah Martinson, *Lillian Hellman: A Life with Foxes and Scoundrels* (New York: Counterpoint, 2005), 5, 371n16.

65 Lillian Hellman, Vineyard Haven, MA, to BA, TLS, 6/25/1982, annotated by BA in phone conversation with Hellman, SBB/BA; Herbert Mitgang, "Arts Medals Presented," *NYT*, 5/19/1983.

66 Kevin Kampman to BA, ALsS, 3/10/1982 and earlier, CG; Kevin Kampman, phone CWA, 9/5/2012; BA BlkJ, 182; Mary Virginia Junk to BA, ALS, n.d., pmk. 9/27/1982, SBB/BA; Junk, phone CWA, 7/8/1992; Mig Shepard, CWA, NYC, 7/10–31/1992; Bill McCuddy to BA, ALS, 9/27/1982, SBB/BA; Zwingle, "A Life of Her Own," 67.

67 Kornelia Kurbjuhn to BA, TLsS, 5/17/1982 and 6/14/1982, SBB/BA; HON, phone CWA, 9/21/2012.

68 BA BlkJ, 181; IS, 4/4/1982; special edition description, TS, 4 pp., in Witkin Gallery papers, CCP; Jackie Onassis, Doubleday, to John [Canaday], TLS,

11/3/1981, and ALS, 12/14/1982, SBB/BA; "Witkin Gallery Shows: 1969–1999," accessed 5/24/2012, http://www.witkingallery.com/chronology.html; Ray F. Patient to BA, TLS, n.d. [dateable to early 1983], SBB/BA.

69 Grundberg, "In New York City"; JVH, "Berenice Abbott: American Photographer," *Library Journal* 107, no. 22 (12/15/1982), 2333; Tom Goss, "Berenice Abbott American Photographer," *Print* 37, no. 5 (Sept./Oct. 1983), 112; Tallmer, "To See Real Life" (BA photo by Louis Liotta); Evelyne Daitz to BA, ALS, 12/22/1982, SBB/BA; Lillian Katz, Port Washington (NY) Public Library, to BA, TLS, 1/5/1983, SBB/BA; Daitz to BA, Witkin Gallery statement, 1/28/1983, SBB/BA.

70 Trausch, "Portrait of the Photographer."

71 IS, 7/3/1982; Todd Watts, phone CWA, 3/21/2012; *Retrospective* portfolio (Parasol Press, 1982), accessed 9/5/2012, http://www.parasolpress.com/parasol-editions/abbott_berenice/; Todd Watts to BA, TLS, 10/8/1982, SBB/BA; Joseph C. French to BA, TLS, 2/3/1983, SBB/BA: *New York at Night/Night View* appears in first NY portfolio, cf. Tousley 46, in size 34.5 × 27.2 cm (13.5 × 10.7 in., or trimmed 14 × 11in.); Reuters, "Berenice Abbott, at 84, Retains the Spirit of a Rebel"; Gary Guisinger, phone CWA, 9/15/2012.

72 BA BlkJ, 182–183; Edna Bennett to BA, TLS, 3/18/1983, SBB/BA.

73 IS, 8/31/1960 and 7/15/1981, cf. "Freidus" folder in SBB/BA; Miles Barth, CWA, NYC, 1/29/2013.

74 Michael N. Appell to Bob Feldman, TLS XC, 8/17/1978, SBB/BA; Feldman to BA, TLS, 8/1/1980, SBB/BA; Feldman to BA, TLS, 9/24/1980, SBB/BA; Feldman to BA, TLS, 11/29/1980, SBB/BA; Stuart E. Hayes to BA, TLS, 12/16/1980, SBB/BA; Feldman unsigned TL of agreement, 8/19/1981, SBB/BA; Bob Feldman to BA, TL, 4/29/1982, SBB/BA; IS, 4/4/1982; Feldman to Hayes, XC, 7/2/1982, SBB/BA; HHL.

75 HON to BA, TLS, copies to John Moore and Juliette Moran, 4/13/1983, SBB/BA; Verrill & Dana to BA, TLsS, 5/11/1983 and 5/22/1983, SBB/BA; typescript: "CONFIDENTIAL: PRIVATE PLACEMENT MEMORANDUM / BERENICE ABBOTT ASSOCIATES (A Maine Limited Partnership) ... September 29, 1983," JVH files; HON to JVH, email, 7/12/2011; HON rough inventory of BA collection: existing negatives / mounted prints / unmounted prints / papers correspondence, 11/20/1983, SBB/BA; Michael T. Healy to BA, TLS, 12/15/1983, SBB/BA.

76 Leticia Kent, CWA, NYC, 9/16/1993; "Allen Ginsberg, Interviewed by Thomas Gladysz, June 1991," accessed 6/17/2010, http://www.scribd.com/doc/32540890 /Allen-Ginsberg-Interview-read-in-Fullscreen-zoom; "An Interview with Robert Creeley; Conducted by Steve Luttrell"; Bill Morgan, *I Celebrate Myself: The*

Somewhat Private Life of Allen Ginsberg (New York: Viking, 2006), 566–567; Allen Ginsberg to BA, TLS and ALS, 10/5/1983, SBB/BA.

77 BA BlkJ, 182–183; Phyllis Lambert to BA, TLS, 11/9/1983, SBB/BA; IS, 10/16/1983.

78 BA "Will," 1/11/1984, SBB/BA; Paul Katz, phone CWA, 8/4/2011; IS, 1/14/1984; HHL.

79 BA to Bob Feldman, TLS, 2/17/1984, and signed by BA, 3/8/1984, photocopies in SBB/BA.

80 "Berenice Abbott and Paul Caponigro Receive 1983 Peer Awards," *Friends of Photography Newsletter* 7, no. 3 (Mar. 1984), and "Peer Awards Ceremony Honors Berenice Abbott and Paul Capinigro," *Friends of Photography Newsletter* 7, no. 4 (Apr. 1984); IS, 2/28/1984 and 5/26/1984; BA, CWA, Monson, ME, 11/8/1991; BA BlkJ, 183; Friends of Photography press release, MoMA BA vertical file; Richard F. Shepard, "Going Out Guide," *NYT*, 3/10/1984; "Allen Ginsberg, Interviewed by Thomas Gladysz, June 1991"; Morgan, *I Celebrate Myself*, 573, 584; Ginsberg misdated the print of this image in NYPL's collection (acc. no. 84PH012.088) "Fall 1984"; Susan Heller Anderson and Maurice Carroll, "New York Day by Day: Beautiful View at 85," *NYT*, 3/8/1984.

81 BA BlkJ, 183; Bob Feldman to BA, TLS, 2/6/1984, SBB/BA; Feldman to BA, TLsS, 3/8/1984 and 3/9/1984, countersigned by BA, SBB/BA; Baldwin, *Man Ray*, 395.

82 Hank O'Neal, CWA, NYC, n.d.; Paul Katz, phone CWA, 8/4/2011; Ella Freidus, CWA, NYC, 7/10/1992; BA BlkJ, 183; Cheryl Greaney, phone CWA, 6/25/2012; Jean C. DeIeso, phone CWA, 8/28/2012; IS, 9/27–29/1985.

CHAPTER 23. EPILOGUE

1 Lewis Hyde, "Introduction," in *The Gift: Imagination and the Erotic Life of Property* (New York: Random House, 1983), xi.

2 Anderson and Carroll, "New York Day by Day."

3 Anderson and Carroll, "New York Day by Day"; French Embassy engraved card for a reception in honor of Mme. Francoise Mitterrand, Tuesday, 3/27/1984, 6:15 p.m., at 831 Broadway, NYC, SBB/BA; BA BlkJ, 183; Ella Jaffe Freidus, CWA, NYC, 7/10/1992.

4 Lunn to BA, TLS, 5/21/1984, SBB/BA; HHL.

5 BA BlkJ, 183; SBB, CWA, Monson, ME, 7/17–19/1998; "Susan Douglass Brown Blatchford, Monson," obituary, *The Daily Maine*, accessed 6/14/2009, http://www.thedailyme.com/Obituaries/susan_d_b_blatchford.html.

6 SBB, CWA, Monson, ME, 12/8/1992; Stuart E. Hayes, Dover-Foxcroft, to

Raymond L. Cunliffe, Berry, Dunn, McNeil & Parker Certified Public Accountants, Bangor, TLS, and copy of annotated version of Feldman-BA contract, 12/12/1984, SBB/BA; Algis Kemezys to JVH, email, 9/25/2012, and phone CWA, 9/26/2012; Algis Kemezys, "Portrait of Berenice Abbott," *Blogs – Salon.com*, 3/20/2010, accessed 9/26/2012, http://open.salon.com/blog/alkeme/2010/03/20/portrait_of_berenice_abbott.

7 Ishtar.

8 SBB, CWA, Monson, ME, 7/17–19/1998; BA BlkJ, 183, 184; I. Bernard Cohen, BA memorial; Freidus, CWA, NYC, 7/10/1992; Lunn, "Regretta."

9 See Clark Worswick, *Berenice Abbott, Eugène Atget* (Santa Fe, NM: Arena Editions, 2002); IS, 6/30/1985, 9/27–29/1985; SBB, CWA, 1/30/1999; BA BlkJ, 183; BA to John Vigue, ALS, 8/9/1984, returned by USPS as undeliverable, SBB/BA; Ron Kurtz's company, Kulite Tungsten Corporation, specialized in the material in lightbulb filaments, a connection to electricity possibly not lost on Berenice; Kurtz to BA, ALS, 3/21/1985, SBB/BA; Todd Watts, phone CWA, 3/21/2012; Clark, "The Black and White of Berenice Abbott," 75.

10 IS, 3/5/1985, 6/30/1985, and 9/27–29/1985; Hank O'Neal to BA, ALS, PC from Paris with Shelley M. Shier and Lunn, SBB/BA; Clark, "The Black and White of Berenice Abbott," 75; Annie and George Harvey to BA, ALS, 5/11/1980, SBB/BA; George Harvey to SBB, TLS, 12/15/1991, SBB/BA (Creeley book in Lucy B. Dillon SBB publication collection 2012, donated to MIT Museum); birth announcement for Matthew Thomas Greaney Houser, 7/19/1985, SBB/BA; SBB, CWA, Monson, ME, ca. 1991; Leslie Katz to BA, ALS, 1/27/1985, SBB/BA; Diane Bucci to BA, TLS, 5/22/1985, SBB/BA; BA BlkJ, 183–184.

11 IS, 9/10/1985 and 9/27–29/1985; Joan Loria to Ron Kurtz, CTL, 11/21/1985, SBB/BA; HHL.

12 Arnold Newman, *Artists: Portraits from Four Decades* (London: Weidenfeld and Nicolson, 1980); Zwingle, "A Life of Her Own," 54; Newman's new BA portrait illustrated the poster for his Art Institute of Chicago William A. Reedy Memorial Lecture, "In Search of Portraits," Feb. 1987.

13 SBB, CWA, Monson, ME, 7/17–19/1998; Jane Geniesse, "Small Entrepreneurs, Vanderbilt by Name," *NYT*, 2/3/1980; "Helen C. Vanderbilt Used Wealth For Good," *Sarasota Herald-Tribune* (Sarasota, FL), 9/24/1997; Barry Fellman, Exposure Fine Photography Prints, Books, & Consulting to Charles [no last name], TLS, n.d., MoMA BA vertical file [cf. Barry Fellman to BA, TLsS, 10/2/1979 and 10/13/1979, SBB/BA, and Fellman to BA, TLsS, 2/4/1980 and 3/17/1980, BA to Fellman, CTL, 10/27/1980, CG, Barry Fellman, phone CWA, 8/6/2012]; IS, 9/27–29/1985 and 5/7/1986; SBB, CWA, Monson, ME, 12/8/1992; Ben Raeburn to BA, ALS, 7/11/1986, SBB/BA; Hank O'Neal, *Birth-*

day Gathering Monson, Maine July 17, 1986, image no. 6/42, Hank O'Neal official website, accessed 7/15/2012, http://www.hankonealphoto.com/berenice -abbott.html.

14 May Sarton, *After the Stroke: A Journal* (New York: Norton, 1988), 184.

15 BA BlkJ, 184; Ron Kurtz, CWA, NYC, 9/14/2010; Todd Watts, phone CWA, 3/21/2012; Martina Hamilton, phone CWA, after 3/20/2012; Watts also made a few 40 × 50 inch prints of *Fifth Avenue Houses* and *Night View,* the last Berenice managed to sign in Monson; he said Ron Kurtz never considered making posthumous prints..

16 Clark, "The Black and White of Berenice Abbott," 112, 116; SBB, CWA, Jan. 1999; Hank O'Neal, *The Beauty Of Physics Show New York City January 30, 1987,* image no. 26/42, Hank O'Neal official website, accessed 9/15/2012, http://www .hankonealphoto.com/berenice-abbott.html; BA and Hank O'Neal, *The Beauty of Physics* (New York: New York Academy of Sciences, 1986), catalog of the exhibition held 1/30–3/27/1987; Algis Kemezys, CWA, 9/26/2012, and his "Portrait of Berenice Abbott"; BA, CWA, Monson, ME, 8/4/1991; Ron Kurtz, "Regretta," and Kurtz, CWA, NYC, 2/9/1996; Andy Grundberg, "Critic's Choices; Photography," *NYT,* 3/1/1987; BA to Grace Mayer, Erice Prize press release annotated, n.d., BA photo file, MoMA; Cherrystone Gallery press release (June 1987), SBB/BA; BA, *Berenice Abbott, Fotografie: Scuola Grande San Giovanni Evangelista, 26 Giugno–27 Luglio 1986;* Leslie George Katz, "Berenice Abbott as a Pioneer," in *Berenice Abbott* (New York: Ikona Gallery, 1986); Paul Katz, phone CWA, 8/4/2011; Tallmer, "To See Real Life."

17 BA BlkJ, 184–185; Cheryl Finley, *Berenice Abbott* (East Rutherford, NJ: Commerce Graphics, 1988); Ron Kurtz, CWA, NYC, 1/12/2012; JVH, *Berenice Abbott* (New York: Aperture Foundation, 1988; completely rev. ed., 2015).

18 Commerce Graphics Ltd. press release 7/13/1988; transcript of Talbot remarks, JVH files.

19 Freidus, CWA, NYC, 7/10/1992; Clark, "The Black and White of Berenice Abbott," 114–115; SBB, CWA, Monson, ME, before 2000.

20 Hank O'Neal photographs, accessed 9/15/2012, http://www.hankonealphoto .com/berenice-abbott.html; BA BlkJ, 185.

21 Ishtar.

22 Yousuf Karsh, BA memorial; IS, 6/10/1965; Yousuf Karsh, *Karsh: American Legends: Photographs and Commentary* (Boston: Bullfinch Press, 1992).

23 JVH, ed., *Berenice Abbott, Photographer;* BA, 1989+ diary, SBB/BA; Geller, "Photography, Science, and Life," *Image* (Spring 2005), 28–29, www.eastman house.org/inc/the museum/geller1.asp; also called *George Easman House Image Online,* http://www.eastmanhouse.org/inc/the_museum/geller3.php; Heidi

Wendell Brown, "The Quantum Universe," *Smithsonian World*, directed by Sandra Wentworth Bradley (Alexandria, VA: PBS Video, 1991).

24 Mig Shepard, CWA, NYC, 6/30/1992.

25 ES&PS; ES to JVH, TLS, 4/17/2003, JVH files; Freidus, CWA, NYC, 7/1/1992 and 7/10/1992; Paul Katz, phone CWA, 8/4/2011; Todd Watts, phone CWA, 3/21/2012 and 8/3/2012.

26 Laura Volkerding to SBB, ALS, Dec. 1991, SBB/BA.

27 "Condolences" folder, SBB/BA; ES&PS; Sullivan, *Letters from Jack*, 122.

28 Lunn, "Regretta."

29 Twain adapted the lines from a poem entitled "Annette" written by Robert Richardson (sometimes identified as a native of Australia), cf. Albert Bigelow Paine, *Mark Twain: A Biography; the Personal and Literary Life of Samuel Langhorne Clemens* (New York: G. Wells, 1923).

29 Ishtar; Stephen Holden, "Black and White and Fervent," film review of *Berenice Abbott: A View of the 20th Century*, *NYT*, 12/4/1994; young adult author George Sullivan misattributed this review to another in the *NYT*, of the NYPL exhibition, cf. George Sullivan, *Berenice Abbott, Photographer: An Independent Vision* (New York: Clarion Books, 2006); Kurtz and O'Neal, *The Unknown Abbott*; Prudence Peiffer "The Ongoing Moment," review of *The Unknown Abbott*, by Kurtz and O'Neal, *Bookforum* 20 (Feb./Mar. 2014), 22–23; BA, CWA, Monson, ME, 11/8/1991.

BIBLIOGRAPHY

BOOKS BY BERENICE ABBOTT

1930 *Atget, photographe de Paris*, preface by Pierre MacOrlan; the reproductions are credited to Abbott's collection (Paris: Henri Jonquieres; New York: E. Weyhe); and a facsimile, *Atget: Photographe de Paris* (New York: Errata Editions, 2008), edited by David Campany; also published as *Eugene Atget: Lichtbilder*, preface by Camille Recht (Leipzig: Henri Jonquieres, 1930), and *Eugene Atget: Lichtbilder*, altered and edited by Gabrielle Forberg and Dietrich Leube (Munich: Rogner and Bernhard, 1975).

1939 *Changing New York* (New York: E. P. Dutton), with commentaries by Elizabeth McCausland, coproduced by the Federal Art Project; reprinted as *New York in the Thirties, as Photographed by Berenice Abbott* (New York: Dover Publications, 1973).

1941 *A Guide to Better Photography* (New York: Crown).

1944 *Drawing the Human Figure* (New York: Crown), text by Arthur Zaidenberg.

1948 *The View Camera Made Simple* (Chicago: Ziff-Davis); Little Technical Library series.

1949 *Greenwich Village: Yesterday & Today* (New York: Harper), text by Henry Wysham Lanier.

1953 *New Guide to Better Photography* (New York: Crown).

1960 *Physics*, for the Physical Sciences Study Committee, Educational Services, Inc. (Boston: Heath).

1964 *Magnet* (Cleveland: World), text by Evans G. Valens.

1964 *The World of Atget* (New York: Horizon Press).

1965 *Motion* (London: Longman Young Books; Cleveland: World Publishing; reprinted 1970); and "1st Cadmus edition" (Eau Claire: E. M. Hale, 1968), text by Evans G. Valens.

1968 *A Portrait of Maine* (New York: Macmillan), text by Chenoweth Hall.

1969 *The Attractive Universe: Gravity and the Shape of Space* (Cleveland: World Publishing), text by Evans G. Valens.

SELECTED WORKS ABOUT BERENICE ABBOTT

Abbott, Berenice. *Berenice Abbott, Photographer: A Modern Vision: A Selection of Photographs and Essays*. Ed. by Julia Van Haaften. New York: New York Public Library, 1989.

———. *Photographs*. New York: Horizon Press, 1970; repr. Washington, DC: Smithsonian Institution Press, 1990.

Abbott, Berenice, and Hank O'Neal. *Berenice Abbott, American Photographer*. New York: McGraw-Hill, 1982.

———. *Berenice Abbott: Sixty Years of Photography*. London: Thames & Hudson, 1982.

House, Michael. *Eugène & Berenice: Pioneers of Urban Photography*. Hamilton, NJ: Films for the Humanities & Sciences, 2009. DVD.

Kurtz, Ron, ed. *Berenice Abbott*. Göttingen: Steidl, 2008. 2 vols.

———, ed. *Berenice Abbott: Documenting Science*. Göttingen: Steidl, 2012.

Kurtz, Ron, and Hank O'Neal, eds. *The Unknown Abbott*. Göttingen: Steidl, 2013. 5 vols. (1, New York: Early Work 1929–1931; 2, The American Scene 1930–1935; 3, Deep Woods, the Logging Photographs; 4, Greenwich Village 1935–1950; 5, U.S. 1, U.S.A.).

———, eds. *Berenice Abbott: Paris Portraits 1925–1930*. New York: Steidl/Commerce Graphics, 2016.

Levere, Douglas. *New York Changing: Revisiting Berenice Abbott's New York*. New York: Princeton Architectural Press and Museum of the City of New York, 2005.

Mileaf, Janine A., and Carla Yanni. *Constructing Modernism: Berenice Abbott and Henry-Russell Hitchcock: A Recreation of the 1934 Exhibition, the Urban Vernacular of the Thirties, Forties, and Fifties: American Cities before the Civil War*. Middletown, CT: Davison Art Center, Wesleyan University, 1993.

Morel, Gaëlle, Sarah M. Miller, and Terri Weissman. *Berenice Abbott*. Ed. by Gaëlle Morel. Paris: Éditions Hazan; Toronto: Ryerson Image Centre, 2012.

Sullivan, George. *Berenice Abbott, Photographer: An Independent Vision* (New York: Clarion Books, 2006). YOUNG ADULT.

Tousley, Nancy. *The Berenice Abbott Portfolios*. Calgary, AB: Glenbow Museum, 1982.

Van Haaften, Julia. *Berenice Abbott*. New York: Aperture Foundation, 1988, 1997; new and completely rev., 2015.

Weaver, Kay, and Martha Wheelock. *Berenice Abbott: A View of the 20th Century*. Sherman Oaks, CA: Ishtar Films, 1992. VIDEO. Studio City, CA: Ishtar Films, 2007. DVD.

Weissman, Terri. *The Realisms of Berenice Abbott: Documentary Photography and Political Action*. Berkeley: University of California Press, 2011. (Based on her 2006 dissertation.)

Worswick, Clark. *Berenice Abbott, Eugene Atget*. Santa Fe, NM: Arena Editions 2002.

Yochelson, Bonnie. *Berenice Abbott: Changing New York*. New York: New Press and Museum of the City of New York, 1997.

DISSERTATIONS ABOUT BERENICE ABBOTT

Barr, Peter. "Becoming Documentary: Berenice Abbott's Photographs, 1925–1939." Boston University, 1997.

Graves, Lauren C. "Navigating the Built Environment: Reading Berenice Abbott's 'Changing New York.'" Temple University, 2016.

Shimizu, Meredith Ann TeGrotenhuis. "Photography in Urban Discourse: Berenice Abbott's Changing New York and the 1930s". Northwestern University, 2009.

CREDITS

69 © Man Ray Trust / Artists Rights Society (ARS), NY / ADAGP, Paris 2017.

71 © Man Ray Trust / Artists Rights Society (ARS), NY / ADAGP, Paris 2017.

74 Getty Images © Berenice Abbott / Commerce Graphics.

76 Silver print 9 1/16 × 6¾ in. (23 × 17.1 cm), The Museum of Fine Arts, Houston, The Manfred Heiting Collection, 2002.220 © Berenice Abbott / Commerce Graphics; courtesy Ronald A. Kurtz.

81 Getty Images © Berenice Abbott / Commerce Graphics.

86 Silver print, Djuna Barnes papers, Special Collections and University Archives, University of Maryland. © Berenice Abbott / Commerce Graphics, courtesy Ronald A. Kurtz.

87 Gouache, metallic paint, and tinted lacquer with varnish, metal foil, celluloid, fiberglass, glass beads, metal objects, cut-and-pasted painted paper, gesso, and cloth on paperboard, 8⅝ × 9¼ in. (21.9 × 23.5 cm). From the collection of Mary Louise Reynolds. Digital Image © The Museum of Modern Art / Licensed by SCALA / Art Resource, NY.

89 Getty Images © Berenice Abbott / Commerce Graphics.

92 Silver print, Library of Congress. (Digital ID: LC-DIG-ppmsca-23769) © Berenice Abbott / Commerce Graphics, courtesy Ronald A. Kurtz.

101 Oil on canvas, 75 × 51 cm., Inv. No.: O 9637, Photographs © National Gallery in Prague 2017. © 2018 Artists Rights Society (ARS), New York / ADAGP, Paris.

105 Getty Images.

115 Getty Images © Berenice Abbott / Commerce Graphics.

117 Silver print, 95PH014.002, Photography Collection, Miriam and Ira D. Wallach Division of Art, Prints and Photographs, The New York Public Library, Astor, Lenox and Tilden Foundations.

120 Albumen silver print, 6 15 / 16 × 8 11 / 16" (17.6 × 22.1 cm). Abbott-Levy Collection. Partial gift of Shirley C. Burden. Digital Image © The Museum of Modern Art / Licensed by SCALA / Art Resource, NY.

121 Silver print, 8 × 10 in. Miriam and Ira D. Wallach Division of Art, Prints and Photographs: Photography Collection, NYPL (Image ID: 1219154).

122 Courtesy The AP and The Idaho Statesman.

130 Manuscripts and Archives Division, The New York Public Library, Astor, Lenox and Tilden Foundations © Berenice Abbott / Commerce Graphics, courtesy Ronald A. Kurtz.

132 Getty Images © Berenice Abbott / Commerce Graphics, courtesy Ronald A. Kurtz. Courtesy Metropolitan Museum of Art.

135 Getty Images © Berenice Abbott / Commerce Graphics.

140 National Portrait Gallery, Smithsonian Institution © 2017 The Isamu Noguchi Foundation and Garden Museum, New York / Artists Rights Society (ARS), New York.

142 Silver print, 95PH014.001, Photography Collection, Miriam and Ira D. Wallach Division of Art, Prints and Photographs, The New York Public Library, Astor, Lenox and Tilden Foundations.

143 Getty Images © Berenice Abbott / Commerce Graphics.

163 Silver print, Beinecke Library, Yale University © Van Vechten Trust.

173 Getty Images © Berenice Abbott / Commerce Graphics.

181 Getty Images © Berenice Abbott / Commerce Graphics.

185 Getty Images © Berenice Abbott / Commerce Graphics.

199 Getty Images © Berenice Abbott / Commerce Graphics.

202 Silver print, Elizabeth McCausland papers, 1838–1995, bulk 1920–1960 Archives of American Art © Berenice Abbott / Commerce Graphics courtesy Ronald A. Kurtz.

207 Silver print, 8 × 10 in. Miriam and Ira D. Wallach Division of Art, Prints and Photographs: Photography Collection, NYPL (Image ID: 482799).

209 Silver print, 8 × 10 in. Miriam and Ira D. Wallach Division of Art, Prints and Photographs: Photography Collection, NYPL (Image ID: 1219157).

212 Silver print, 8 × 10 in. Miriam and Ira D. Wallach Division of Art, Prints and Photographs: Photography Collection, NYPL (Image ID: 482823).

218 Gelatin silver print. Amon Carter Museum of American Art, Fort Worth, Texas P1978.26 © Brooklyn Museum.

219 Silver print, 8 × 10 in. Miriam and Ira D. Wallach Division of Art, Prints and Photographs: Photography Collection, NYPL (Image ID: 482568).

225 Silver print, 8 × 10 in. Miriam and Ira D. Wallach Division of Art, Prints and Photographs: Photography Collection, NYPL (Image ID: 482794).

230 Silver print, 8 × 10 in. Miriam and Ira D. Wallach Division of Art, Prints and Photographs: Photography Collection, NYPL (Image ID: 482743).

236 Silver print, 8 × 10 in. Miriam and Ira D. Wallach Division of Art, Prints and Photographs: Photography Collection, NYPL (Image ID: 482593).

253 Silver print. Kay Simmon Blumberg (1909-2004) / Museum of the City of New York. 95.24.4.

254 Courtesy Popular Photography. Abbott photograph © Berenice Abbott / Commerce Graphics, courtesy Ronald A. Kurtz.

259 Photographic Archive. The Museum of Modern Art Archives, New York. Digital Image © The Museum of Modern Art / Licensed by SCALA / Art Resource, NY. Abbott photographs © Berenice Abbott / Commerce Graphics, courtesy Ronald A. Kurtz.

266 Silver print, Berenice Abbott Archive, MIT Museum, Gift of Ronald A. & Carol Kurtz.

277 Silver print, Image / Sheet: 23.5cm × 18.5cm (9¼ × 7 5/16 in.). Mount: 34cm × 26.6cm (13⅜ × 10½ in.). National Portrait Gallery, Smithsonian Institution. NPG.92.159.

282 Private collection. *Take This Hammer, Lead Belly Legacy Volume One* by Lead Belly, Folkways Records FP4, courtesy of Smithsonian Folkways Recordings. (p) © 1950. Used by permission. © Berenice Abbott / Commerce Graphics, courtesy Ronald A. Kurtz.

285 © Berenice Abbott / Commerce Graphics, courtesy Ronald A. Kurtz.

287 Silver print. Private Collection.

294 MIT Museum, Berenice Abbott Archive, MIT Museum, Gift of Ronald A. & Carol Kurtz © Berenice Abbott / Commerce Graphics, courtesy Ronald A. Kurtz.

295 MIT Museum, Berenice Abbott Archive, MIT Museum, Gift of Ronald A. & Carol Kurtz.

296 Silver print, Berenice Abbott Archive, MIT Museum, Gift of Ronald A. & Carol Kurtz © Berenice Abbott / Commerce Graphics, courtesy Ronald A. Kurtz.

297 Silver print, 14.1 × 10.9cm (5 9/16 × 4 5 16 in.). National Portrait Gallery, Smithsonian Institution, Washington DC (NPG.92.55).

309 Silver print, 8 × 10 in. Miriam and Ira D. Wallach Division of Art, Prints and Photographs: Photography Collection, NYPL (Image ID: 482592)

313 Silver print, 5 × 7 in. Private collection, courtesy George Gilbert's Family Collection

319 Silver print, 8 × 10 in. Miriam and Ira D. Wallach Division of Art, Prints and Photographs: Photography Collection, NYPL (Image ID: 482636)

324 Original negative and digital scan © Robert C. Bishop Photography LLC.

338 Getty Images © Berenice Abbott / Commerce Graphics.

343 Silver print. Private collection. Estate of Edward & Pearl Schwartz.

363 From *Christian Science Monitor*, December 18 © 1959 Christian Science Monitor. All rights reserved. Used by permission and protected by the Copyright Laws of the United States. The printing, copying, redistribution, or retransmission of this Content without express written permission is prohibited. Courtesy Irene Shwachman

Papers, CCP. Abbott photographs © Berenice Abbott / Commerce Graphics, courtesy Ronald A. Kurtz.

365 Getty Images © Berenice Abbott / Commerce Graphics.

370 From PHYSICS: Physical Science Study Committee, Student Edition. Copyright © 1960 by D.C. Heath and Company under arrangements with Educational Services Incorporated. All rights reserved. Reprinted by permission of the publisher, Houghton Mifflin Harcourt Publishing Company.

387 Silver print. Manuscripts and Archives Division, The New York Public Library, Astor, Lenox and Tilden Foundations. © The Waintrob Project for the Visual Arts. Courtesy David Stekert.

401 Silver print. Private collection. Courtesy Alan Shwachman and Elizabeth Shwachman Nelson.

405 Later silver print. Courtesy Metropolitan Museum of Art, David Hunter McAlpin Fund, 1956 (56.610.15).

424 Silver print. Manuscripts and Archives Division, The New York Public Library, Astor, Lenox and Tilden Foundations, courtesy estate of Dr. Isidore M. Samuels.

438 George Daniell Archive, Gina Teator DeJoy.

448 Courtesy Hank O'Neal.

456 Getty Images © Berenice Abbott / Commerce Graphics.

462 Silver print. Private collection. Courtesy Algis Thomas Kemezys.

479 Getty Images.

483 Courtesy Hank O'Neal.

484 Silver print, 92PH024, Photography Collection, Miriam and Ira D. Wallach Division of Art, Prints and Photographs, The New York Public Library, Astor, Lenox and Tilden Foundations, Gift of the photographer © Yousuf Karsh.

TEXT PERMISSIONS

Text by BA: © Berenice Abbott / Commerce Graphics, courtesy Ronald A. Kurtz.

Text by Irene Schwachman: Irene Shwachman Papers, AG

91, Center for Creative Photography, University of Arizona, courtesy Alan Shwachman and Elizabeth Shwachman Nelson.

INDEX

Page numbers in italics refer to images.
An italicized *n* following a page number refers to an endnote.
"BA" refers to Berenice Abbott.